MATTHEW BARNEY

THE CREMASTER CYCLE

NANCY SPECTOR

GuggenheimMUSEUM

Published on the occasion of the exhibition
Matthew Barney: The CREMASTER Cycle

Organized by the Solomon R. Guggenheim Museum, New York

Museum Ludwig, Cologne
June 6–September 1, 2002

Musée d'Art Moderne de la Ville de Paris
October 10, 2002–January 5, 2003

Solomon R. Guggenheim Museum, New York
February 21–June 4, 2003

This exhibition is sponsored by **H U G O B O S S**

Additional support is provided by Pitti Immagine
and the Young Collectors Council

Major sponsorship for this exhibition catalogue is made possible by
a generous grant from the Adam D. Sender Charitable Trust

ISBN: 0-8109-6935-1

Guggenheim Museum Publications
1071 Fifth Avenue
New York, New York 10128

Hardcover edition distributed by
Harry N. Abrams
100 Fifth Avenue
New York, New York 10011

Design: J. Abbott Miller and Roy Brooks, Pentagram Design
Production: Tracy L. Hennige, Elizabeth Levy
Editorial: Meghan Dailey, David Frankel, Stephen Frankel, Elizabeth Franzen, Stephen Hoban, Jennifer Knox White

Printed in Germany by Cantz

Cover: Field Emblem with *CREMASTER* arms

Opening and closing sequences: *Goodyear Gates*, 1997 (detail)
The Drones' Exposition, 1999 (detail)
Crown Imperial, 2002 (detail)
Quocunque Jeceris Stabit, 1995 (detail)
Proscenium, 1997 (detail)

CONTENTS

Preface
xii

Acknowledgments
xiv

Only the Perverse Fantasy Can Still Save Us
NANCY SPECTOR
2

The Cremaster Glossary
NEVILLE WAKEFIELD
92

CREMASTER 1
116

CREMASTER 2
168

CREMASTER 3
244

CREMASTER 4
322

CREMASTER 5
394

Personal Perspectives
480

Film Credits
504

List of Works
510

Exhibition History
514

Bibliography
517

Screening History
519

Lenders to the Exhibition

Collection of Cristina and Thomas Bechtler, Switzerland
Peggy and Ralph Burnet
Fondation Cartier pour l'Art Contemporain, Paris
Stefan T. Edlis Collection
Astrup Fearnley Collection, Oslo
Courtesy of Barbara Gladstone
Goetz Collection, Munich
The Carol and Arthur Goldberg Collection
Solomon R. Guggenheim Museum, New York
Emanuel Hoffmann-Stiftung, Permanent loan to
 Museum für Gegenwartskunst, Basel
The Dakis Joannou Collection, Athens
Collection Emily Fisher Landau, New York
Collection of Rachel and Jean-Pierre Lehmann
Museum Boijmans Van Beuningen, Rotterdam
Museum of Contemporary Art, Chicago
The Museum of Modern Art, New York
Colombe Nicholas and Leonard Rosenberg, New York
San Francisco Museum of Modern Art
Adam D. Sender
Walker Art Center, Minneapolis
Paul F. Walter
Collection of Mr. and Mrs. Jeffrey R. Winter
Three private collectors who wish to remain anonymous

Sponsor's Statement

This fascinating exhibition features the works of Matthew Barney, an artist who has a longstanding association with the Guggenheim Museum and also with Hugo Boss.

In 1996, Matthew Barney won the inaugural Hugo Boss Prize, which is awarded every two years to an artist making an exemplary contribution to contemporary art. The current exhibition in New York marks a further milestone in the relationship between Hugo Boss and this distinctive artist.

The exhibition's central theme—the *Cremaster* cycle—is courageous, contemporary, and extremely moving. We hope that you derive great pleasure from exploring this remarkable artist and his creative genius.

Bruno Sälzer
Chairman and CEO

HUGO BOSS

Preface

From his first gallery show in 1991 to the completion of his epic, five-part *Cremaster* cycle in 2002, Matthew Barney has developed an entirely unique aesthetic vocabulary that draws freely from ancient mythology, Hollywood movies, professional sports, biological systems, medical processes, psychological pathologies, hardcore music, and spiritualist tendencies, among other areas. He blends these references into fluid and allusive narrative structures that are articulated through film, sculpture, drawing, and photography. His is an expansive notion of aesthetic form. Virtually every medium—from performance to graphic rendering to book design to sculptural installation—is utilized to realize the narrative thrust of his art. The scale of Barney's vision is vast; his imagination is fertile and his touch inimitable.

This exhibition focuses exclusively on Barney's extraordinary *Cremaster* cycle. Working out of sequence, the artist has produced five *Cremaster* episodes since 1994—numbers *4, 1, 5, 2*, and, premiering on the occasion of this presentation, *3*. We are particularly honored that Barney featured the Solomon R. Guggenheim Museum as one of the locations in *Cremaster 3*. For the purposes of his narrative, he transformed the building's Frank Lloyd Wright rotunda into an arena complete with blue Astroturf, white athletic padding, oculus emblem, and banners. In this environment he staged a competition that metaphorically encapsulates and completes the entire *Cremaster* project. The exhibition installation at the Guggenheim will replicate this site-specific structure; the very architecture of the building will thus reflect the five chapters of the series. A large-scale, five-channel video installation suspended in the center of the atrium will continuously show the sequence from *Cremaster 3* filmed in the Guggenheim and thus create a spiraling, self-reflexive meditation on the cycle in its final form. The extensive and interconnected body of work produced during the course of this eight-year project will fill the entire rotunda and adjacent galleries. The presentation will bring together sculpture, photographs, and drawing with video versions of the films to underscore the fundamental interrelationship between the objects and the moving images in the *Cremaster* cycle. We will also screen the artist's five, 35-mm *Cremaster* films in the museum's Peter B. Lewis Theater on a daily basis through the run of the exhibition.

In presenting this comprehensive view of Matthew Barney's *Cremaster* cycle, the Guggenheim Museum continues its tradition of exhibiting the work of significant young artists while their careers are still in formation. Founded as an institution devoted to collecting and displaying the most innovative art of the present, the Guggenheim recognizes its ongoing responsibility to provide a forum for the critical examination of contemporary culture. The Guggenheim's commitment to Barney's work began in 1996, when he was awarded the museum's inaugural Hugo Boss Prize for excellence and innovation in the visual arts. As his contribution to the presentation of award finalists, the artist exhibited photographs and the video vitrine from his just completed *Cremaster 1*. We acquired this film for the permanent collection and have continued to collect the remaining *Cremaster* films as he produces them. It was at this time that Nancy Spector, Guggenheim Curator of Contemporary Art, began collaborating with the artist to plan an exhibition of the entire *Cremaster* cycle upon its conclusion. This inspired leap of faith found great support within the institution as we witnessed the unfolding of Barney's increasingly exceptional *Cremaster* series. I would like to recognize

Nancy Spector's longstanding dedication to this project and the level of expertise she has brought to bear on its fruition.

The exhibition *Matthew Barney: The Cremaster Cycle* at the Guggenheim is preceded by its presentation in Europe at the Museum Ludwig, in Cologne and the Musée d'Art Moderne de la Ville de Paris. I wish to thank my colleagues, Kasper König, Director of the Museum Ludwig and Suzanne Pagé, Director of the Musée d'Art Moderne de la Ville de Paris, for their support of this exhibition and its tour. A presentation of this scale and complexity could never have been realized without the lenders who so generously entrusted their works to the three museums for the duration of the exhibition tour. Their names appear elsewhere in this volume (except for those who wish to remain anonymous), but I would like to express my gratitude to them for allowing us to realize such a comprehensive undertaking. This may be the only occasion when virtually all of the works created for the *Cremaster* cycle will be seen together at one time.

At a time when it is increasingly difficult to secure funding for the presentation of contemporary art, particularly in its more radical and challenging manifestations, a number of private individuals have generously made resources available to us. I would like to personally thank Laura and Stafford Broumand; Ulla Dreyfus-Best; Danielle and David Ganek; Jill and Sandy Heller; Dakis Joannou; Todd Levin; Nancy Magoon; Nina and Frank Moore; and Allison and Neil Rubler, for their critical support of this exhibition. Hugo Boss, in its continuing relationship with the Guggenheim, has provided major sponsorship for this exhibition. I would especially like to acknowledge Dr. Bruno Sälzer, Chairman and CEO, Philipp Wolff, Director of Communications, and Hjoerdis Jahnecke, Art Sponsorship, for their ongoing commitment to contemporary art and their belief in this project. I would also like to acknowledge Pitti Immagine of Florence, Italy, which has provided essential sponsorship for this project. In particular, I would like to mention Raffaello Napoleone, CEO, and Lapo Cianchi, Communications and Special Projects Manager, whose inspired approach to arts sponsorship has enabled us to realize this important undertaking. I must also thank the Broad Art Foundation for their generous support. In addition, I wish to thank the Adam D. Sender Charitable Trust for its contribution in support of this catalogue. Sotheby's Inc. of New York has also provided valuable assistance. The Guggenheim's own Young Collectors Council has rallied to the cause of contemporary programming at the museum and donated a significant portion of their acquisition funds to support the realization of Matthew Barney's site-specific installation; for this, I am most appreciative. I would also like to acknowledge Dakis Joannou, Rachel Lehmann, and Allison Lane Rubler, Cochairs of the Honorary Committee charged with organizing the benefit for contemporary programming held on the occasion of the premiere of *Cremaster 3* at the Ziegfeld Theater in New York. I must also express my thanks to Barbara Gladstone, the artist's representative, who has provided essential support to the realization of this major exhibition.

And finally, my utmost gratitude goes to Matthew Barney, without whose prodigious talent and extraordinary spirit this project would never have been imaginable.

Thomas Krens
Director, The Solomon R. Guggenheim Foundation

Acknowledgments

The *Cremaster* cycle is a force field, an entity with its own energy and momentum that has evolved and expanded during the past eight years. Its creator, Matthew Barney, developed and nurtured this total work of art with passion, brilliance, great humor, and an attention to detail that can only be described as fetishistic. It has been a privilege for me to witness this process, and I am most grateful to Matthew Barney for sharing his time and his thoughts with me. Since our collaboration began in 1996, this exhibition and accompanying volume have unfolded in tandem with the *Cremaster* cycle. They are clearly separate from the artist's five-part opus in that both book and show summarize, like a catalogue raisonné, all the works of art created during its evolution. Yet, they each retell the narrative of the *Cremaster* project in new and distinct ways as if outgrowths of this polymorphous and ever-enlarging aesthetic system.

Barney has envisioned the exhibition, which will be designed specifically for each of its three venues, as a survey of the films, sculptures, photographs, and drawings associated with the cycle. At the same time he has added new layers to the symbolic matrix that articulates the series. Sculptures created for *Cremaster 3*, the final installment of the series, function as three-dimensional metaphors for the other *Cremaster* chapters. When installed on the different levels of the Guggenheim's spiraling rotunda, these sculptures will conflate past and present by knitting together the five-part cycle into one, cohesive whole. This book, conceived as an encyclopedia of the *Cremaster* project, similarly amalgamates beginnings and endings to recount the narrative of each installment. In the individual sections devoted to each *Cremaster* chapter, Barney has combined selections from his original storyboards—including concept drawings, snapshots, clippings, color samples, and the like—with reproductions of finished artworks in a sequential structure that follows the plot of each film. Elsewhere in this volume, which focuses as much on Barney's innovative sculpture as it does on his lush cinematic imagery, we have intermixed elements from all five installments to create a complete, integrated overview of the project. Think of this as a user's guide or source book for the entire *Cremaster* cycle.

This exhibition and publication have been achieved through the essential support of many gifted individuals. A very special thanks is reserved for the staff of the Barbara Gladstone Gallery, which exclusively represents the artist: Rosalie Benitez, Ivy Shapiro, and Carter Mull have been most helpful with all of our myriad inquiries over the past six years of planning. Barbara Gladstone's personal and professional support of this project has been absolutely critical to its success, and for this I am most grateful. The staff of Barney's studio is unrivaled in energy, stamina, and goodwill. Chelsea Romersa, Associate Producer; Matthew D. Ryle, Production Design; Jessica Frost, Production Supervisor; and Kristin Schattenfield, Production Manager have worked closely with us on every aspect of the exhibition, publication, and filming, making the experience as enjoyable as it was efficient. The tour of this exhibition would not have been possible without the collaboration of Kasper König, Director, Museum Ludwig, Cologne, and Suzanne Pagé, Director, Musée d'Art Moderne de la Ville de Paris. I would like to thank them for believing in the importance of this project.

I would also like to extend my appreciation to those who provided their invaluable assistance with the research necessary for the planning stages of the exhibition and the production of this book, as well as those who have been enthusiastic champions of the project from its inception: Hans Rasmus Astrup, Astrup Fearnley Museet for Moderne Kunst, Oslo; Florian Berktold, Kunsthalle Wien; Klaus Biesenbach, P. S. 1, Long Island City, New York and Kunst-Werke, Berlin; Gwen Bitz, Walker Art Center, Minneapolis; Francesco Bonami, Museum of Contemporary Art, Chicago; Laurence Bossé, Musée d'Art de la Ville de Paris; Shaun Caley, Regen Projects, Los Angeles; Eileen Cohen; Karen Cooper, Film Forum, New York; Aileen Corkery, Temple Bar Productions, Dublin; Adrienne Csengery; Chris Dercon, Museum Boijmans Van Beuningen, Rotterdam; Anne Dressen, Musée d'Art Moderne de la Ville de Paris; Deborah Drier; Tom Eccles, Public Art Fund, New York; Peter Fleissig; Mark Fletcher; Richard Flood, Walker Art Center, Minneapolis; Christine Frohnert, Museum Ludwig, Cologne; Michael Gabellini, Gabellini Associates, New York; Julia Garimorth, Musée d'Art Moderne de la Ville de Paris; Carol and Arthur Goldberg; Elsa Guigo, Musée d'Art Moderne de la Ville de Paris; Kathy Halbreich, Walker Art Center, Minneapolis; Ben Hartley; Karin Hartung, Portikus, Frankfurt; Gergely Kaposi; Joseph King, Walker Art Center, Minneapolis; Gerhard Kolberg, Museum Ludwig, Cologne; Gunnar Kvaran, Astrup Fearnley Museet for Moderne Kunst, Oslo; Todd Levin; Trond Liland, Astrup Fearnley Museet for Moderne Kunst, Oslo; James Lingwood, Artangel, London; Christine Litz, Museum Ludwig, Cologne; Dave Lombardo; Michael Maggiore, Film Forum, New York; Judith McNally; Louise Neri; Thyrza Nichols Goodeve; Hans-Ulrich Obrist; Maja Oeri; Lisa Overduin, Regen Projects, Los Angeles; Robert Priewasser, Kunsthalle Wien; Grazia Quaroni, Foundation Cartier d'Art Contemporain, Paris; François Quintin; Jacqueline Rapmund, Museum Boijmans Van Beuningen, Rotterdam; Vivian Rehberg, Musée d'Art Moderne de la Ville de Paris; Karel Schampers; Christian Scheidemann; Rainald Schumacher, Goetz Collection, Munich; Julie Stevens; Mark Taylor; Lodovica Busiri Vici; Theodora Vischer, Laurenz Foundation, Basel; Christina von Schilling; and Emily Wei.

At the Guggenheim Museum numerous colleagues provided their expertise to insure the realization of this challenging project. I am especially indebted to Joan Young, Assistant Curator, and my partner in planning for all aspects of this exhibition and publication. Her attention to detail, keen understanding of the material, and utmost sensitivity in all areas curatorial were essential to the success of this undertaking. There would have been no exhibition without her unwavering commitment to the project. We were aided by Nat Trotman, Project Curatorial Assistant, who elevated caption writing to an art form and conducted very creative research for this book's "Cremaster Glossary."

An exhibition of this scale could not have happened without the sustained support of Thomas Krens, Director of the Solomon R. Guggenheim Foundation. Lisa Dennison, Chief Curator and Deputy Director, was a constant source of encouragement. I would also like to thank Judith Cox, Deputy Director; Jane DeBevoise, Deputy Director for Program Administration and Operations; Laurie Beckelman, Deputy Director for

Special Projects; and Marc Steglitz, Deputy Director, Finance and Operations, for their oversight of the project. Marion Kahan, Exhibition Program Manager, deftly managed the logistical details of this exhibition's international tour; Anna Lee, Director of Global Programs, Budgeting and Planning, and Christina Kallergis, Senior Financial Analyst, Global Programs, compiled and interpreted all the budgets associated with a project of this scale. Alexia Hughes, Associate Registrar, ably coordinated the intricate details of transporting the works in the exhibition. Barry Hylton, Senior Exhibition Technician, supervised the efforts of our installation team. Paul Kuranko, Media Arts Specialist, managed the audio/visual components of the installation. Michael Lavin, Director of Theater and Media Services, generously assisted us with procuring screening times in the theater and supervised the presentation of the *Cremaster* films. Gina Rogak, Director of Special Events, spearheaded the museum benefit held on the occasion of the premiere of *Cremaster 3*, and coordinated all special events associated with the exhibition. Kendall Hubert, Director of Corporate Development, worked tirelessly to procure exhibition sponsorship. Helen Warwick, Director of Individual Giving and Membership, masterminded the formation of the Matthew Barney Exhibition Committee, which has helped us achieve our funding goals.

I must single out Anthony Calnek, Managing Director and Publisher, who enthusiastically supported my efforts to create the definitive guide to the *Cremaster* cycle. I am most grateful to him for allowing me to pursue this fantasy of a book, which, I hope, does justice to Barney's exceptional art. Elizabeth Levy, Managing Editor/Manager of Foreign Editions, meticulously handled all details of production, and Elizabeth Franzen, Manager of Editorial Services, oversaw all content with great care. Ellen Labenski, Associate Photographer, carefully photographed the hundreds of items reproduced in the *Cremaster* storyboard sections as well as sculptures from *Cremaster 3*. Elisabeth Jaff, Associate Preparator for Paper, fastidiously organized the storyboard items to ensure their security and accessibility. I am particularly indebted to David Frankel, who edited my essay with great sensitivity and a keen knowledge of the artist's work. I would like to thank author Neville Wakefield, whose brilliant response to my invitation to compile a *Cremaster* glossary is appropriately creative and perverse. Again, I wish to cite Joan Young, who conducted and edited a number of the interviews with Barney collaborators that complete this book. J. Abbott Miller of Pentagram designed this elegant publication; his inspired take on the encyclopedia format helped to conceptualize the very tenor of the volume.

And finally, my heartfelt thanks are reserved for Matthew Barney, whose endlessly permutating artistic universe is one of pure potential.

Nancy Spector
Curator of Contemporary Art, Guggenheim Museum

I wish to thank:

Nancy Spector for her vision, dedication, and stamina toward the realization of this exhibition and book; additionally, Thomas Krens and the Guggenheim Foundation, and especially Joan Young and the Exhibitions Department and Publications Department of the Guggenheim Museum.

Barbara Gladstone for her uncompromising commitment throughout the years that this project spans; additionally, Rosalie Benitez, Ivy Shapiro, Carter Mull, Stacey Tunis, Jay Tobler, Mark Fletcher, and the entire staff of Barbara Gladstone Gallery, past and present.

Chelsea Romersa and Matt Ryle for their strength and courage; additionally, Jessica Frost, Hal McFeely, Kanoa Baysa, Chris Hanson, Kristin Schattenfield, Nick Emmet, Dow Kimbrell, Michael Koller, Melissa Lockwood, Andrea Stanislav, Tom Johnson, Robert Wogan, Chloe Piene, Paul Pisoni, Lalena Fisher, and everybody at the studio, past and present.

Peter Strietmann, Jonathan Bepler, Gabe Bartalos, Chris Winget, Michael James O'Brien, Thomas Kearns, and Linda LaBelle for their years of brilliant work on the *Cremaster* cycle.

Kasper König, Gerhard Kolberg, Christine Litz, Christine Frohnert, and Petra Mandt at the Museum Ludwig; Suzanne Pagé, Laurence Bossé, and Julia Garimorth at the Musée d'Art Moderne de la Ville de Paris; and Artefact.

Marsha Gibney, Bob Barney, Tracy Barney, Björk Gudmundsdóttir, and Isadóra Bjarkardóttir Barney for the warmth in their hearts.

Matthew Barney

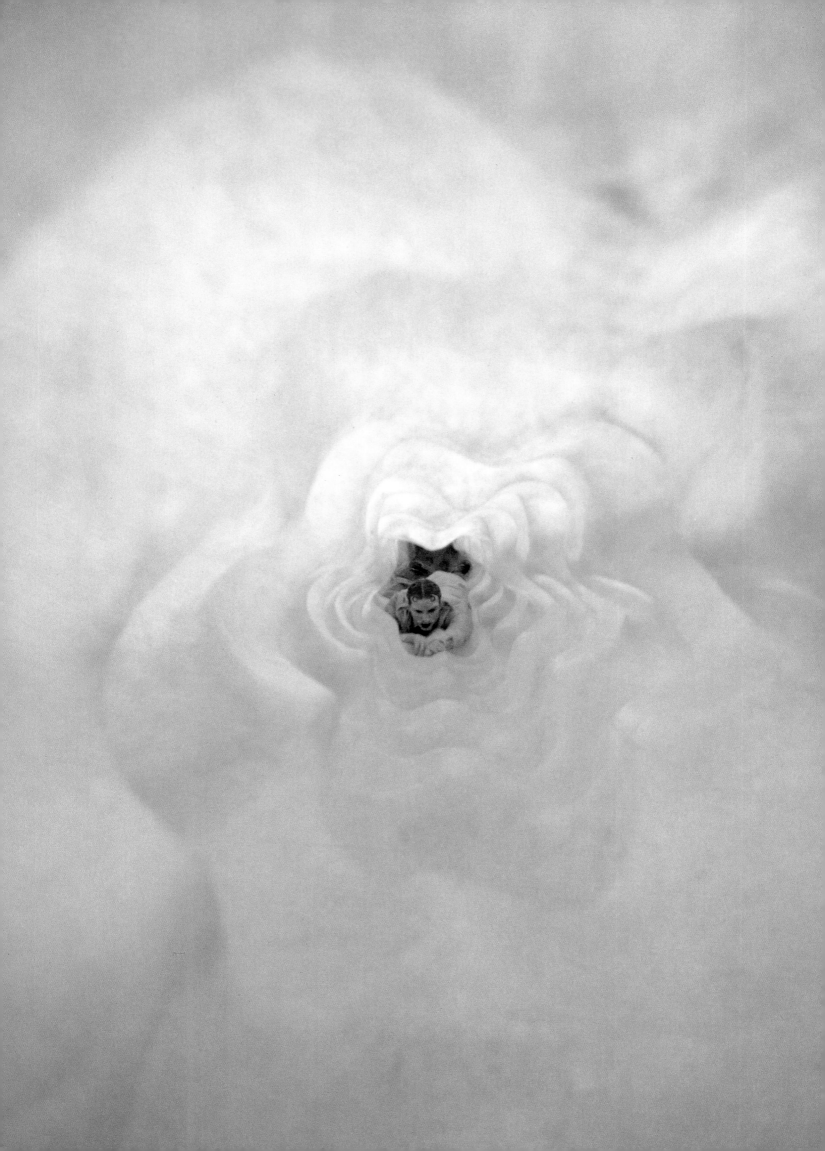

ONLY THE PERVERSE FANTASY CAN STILL SAVE US

NANCY SPECTOR

PART I | Pre-Cycle

HYPERTROPHY (incline), 1991

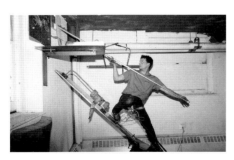

Drawing Restraint II, 1988

THE FIELD

Matthew Barney's five-part *Cremaster* cycle is a self-enclosed aesthetic system. Born out of a performative practice in which the human body—with its psychic drives and physical thresholds—symbolizes the potential of sheer creative force, the cycle explodes this body into the particles of a contemporary creation myth. Since its inception in 1994, the *Cremaster* cycle has unfolded in time as well as space to render visible some of the processes by which form—in its biological, psychological, and geological states—comes to be. Barney's visual language is protean: drawing and film unite to engender photography and sculpture, which, in turn, produce more drawing and film, in an incestuous intermingling of materials that defies any hierarchy of artistic mediums. Driven by a narrative impulse, the iconography is multivalent and allusive. Objects and images, always striking, bizarre, and seductive, function simultaneously on various levels of meaning. Created out of sequence—*Cremaster 4* (1994) was realized first, then followed by *Cremasters 1* (1995), *5* (1997), *2* (1999), and *3* (2002)—the cycle has at least two sets of beginnings, at least two endings, and many more points of entry. It is a polymorphous organism of an artwork, continuously shifting guises and following its own eccentric set of rules, many of which Barney has employed since his earliest body-centric projects.

The first and perhaps most fundamental of these rules involves the proposition that form cannot materialize or mutate unless it struggles against resistance in the process. This idea developed out of Barney's own experience as an athlete, when he built strength and endurance by withstanding repetitive physical stress. The phenomenon of athletic training, in which the body strives to surpass threshold after threshold of corporeal limitation, plays a central role in the conceptual underpinnings of his work. So does the psychosocial dimension of organized sports, a ritualized realm of competition, exhibitionism, and idolization that is associated in our collective cultural unconscious with masculine identity. Barney premised his approach to the creation of form on the technique of hypertrophic muscle development, which involves the tearing down of tissue through repetitive stress in order to enlarge specific areas of the body. On the Nautilus machine one can isolate and exert virtually any individual voluntary muscle mass: adductor, biceps, flexor, gluteus maximus, pectoral, quadriceps, triceps, and so on. Barney's first artworks, made while he was still in college, were performance-based situations during which he applied this biological model to the practice of drawing. Conceived as studio experiments, the earliest of the *Drawing Restraint* series (1988–93) involved the use of physical resistance in an attempt to create that fundamental component of drawing, a graphic mark. In his obstacle course of a studio—which resembled some hybrid version of Gold's Gym and

The title of this essay is a quote from Johann Wolfgang von Goethe, which was used as an epigram by Rosemary Jackson in her book *Fantasy: The Literature of Subversion* (London and New York: Methuen, 1981). This quotation also appears as the epigram for Bryant Frazer's review of Jörg Buttgereit's cult horror films *Nekromantik* (1987) and *Nekromantik 2* (1991) featured on the Web site http://www.deep-focus.com/flicker/nekroma2.html. I have been unable to locate the actual source for this quote, however. Researchers at the Goethe Institut in New York believe it to be an erroneous citation (phone conservation, January 21, 2002). Nevertheless, the fact that *Nekromantik* is one of Barney's favorite zombie films adds a certain synchronicity to its presence here, despite my doubt about its source (Barney, conversation with the author, February 21, 2001). Its meaning in relation to Barney's art will, I hope, become clear in the pages that follow.

This essay has benefited from the helpful guidance of many colleagues. I would like to acknowledge Nat Trotman, Stephen Hoban, and Joan Young for their critical research assistance. Most important, I would like to thank my good friend and colleague Thyrza Nichols Goodeve, whose own innovative and profoundly insightful writings on Matthew Barney's work have been a constant source of inspiration.

an S/M fetish club—Barney climbed ramps, swung from rings, strained against tethers, jumped on a minitrampoline, and pushed blocking sleds in an effort to record the lines of a sketch, a self-portrait, a diagram. Employing tools that further complicated the process by their unwieldiness in scale, weight, or rigidity, he produced images that functioned both as indices of the energy expended to complete them and as representational markings.

Drawing Restraint II, 1988

Though evocative of 1970s Process art, which incorporated the act of making into the material presence of the finished work, Barney's *Drawing Restraint* project delves into more psychosexual sources that circulate around the libidinal aspects of expenditure.[1] Strenuous athletic competition requires the suppression of any drives extraneous to the goal of winning. Sexual desire, the quest for socialization, and other appetites must be sublimated in order for the body to operate at peak performance level. For Barney the game itself is of lesser interest than the accumulation, storage, and release of energy in this controlled corporeal environment. His art contemplates the potential of "creative repression" to define new "internal thresholds," new inner processes by which force may be harnessed and form generated.[2] It also acknowledges how the eroticism inherent in sport—with its emphasis on bodily perfection, its struggle between opposing parties, its exertion, its sweat—invokes the fact that desire, like the exhausted muscle, grows when subjected to self-imposed restraint. The Marquis de Sade, ever the expert on the relationship between conflict and sexual pleasure, articulated this in his introduction to *120 Days of Sodom*: "There is nothing," he explained, "that can set bounds to licentiousness.... The best way of enlarging and multiplying one's desires is to try and limit them."[3]

Drawing Restraint II (document), 1988 (detail)

As part of his early work Barney identified a three-part internal system that processes the ebb and flow of different energies in the body, moving from desire to discipline to productivity.[4] The first zone or level, which he labeled "Situation," contains pure raw drive. In this state the energy is unorganized and essentially useless, but definitely sexual and ripe with potential. In a drawing of the fetal reproductive system prior to the process of sexual differentiation, Barney rendered this zone of possibility visible through the metaphor of embryonic development. For the first six weeks after conception, embryos of both XX and XY varieties hover in a gender-neutral condition; growth buds called anlagen wait inertly for sex chromosomes to trigger their inexorable division into male or female states. When so catalyzed, a pair of undifferentiated gonads develop into either ovaries or testicles. Sets of internal ducts, either wolffian or mullerian, become seminal vesicles or fallopian tubes respectively, and the genital tubercule—a minute protruding nub of tissue—grows into either clitoris or penis. As anatomical destiny is realized, the different sex hormones—estrogen, progesterone, and androgen—are activated to

1. Process art—specifically Richard Serra's early work, with its emphasis on physicality and materiality—was an important source for Barney's initial sculptural investigations.
2. Barney, in an interview with Glen Helfand, "Matthew Barney," *Shift 14* 6, no. 2 (1992), p. 38. "The work," Barney goes on, "has to do with the suspension of competition, or spending stored potential that has built up. That can be taken on several layers—the sexual layer of spending the libido, athletic notions. People have these strange rituals of repression during game season."
3. Marquis de Sade, quoted in Georges Bataille, *Eroticism: Death and Sensuality*, trans. Mary Dalwood (San Francisco: City Lights Books, 1986), p. 48. Neville Wakefield has referred to the Sadean dimensions of Barney's interest in psychological and physical restraint;

see his article "Matthew Barney's Fornication with the Fabric of Space," *Parkett*, no. 39 (March 1994), pp. 118–24.
4. Barney discusses this system in his interview with Jérôme Sans, "Matthew Barney: Modern Heroes," *Art Press*, no. 204 (July–August 1995), p. 26: "What I ended up doing was trying to locate different areas inside of myself where different energies were. And I thought that if a diagram could be made in an attempt to locate them, and even if they continued to move, then I could always locate them." He also mentions it in the interview "Travels in Hypertrophia: Thyrza Nichols Goodeve Talks with Matthew Barney," *Artforum* 33, no. 9 (May 1995), p. 117. And he described this three-part diagram as central to the themes of his work during a lecture at the 92nd Street Y, New York, on February 12, 1998.

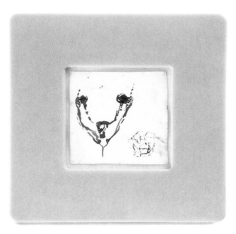

Condition 88, 1988

unit BOLUS, 1991

perform both offensive and defensive functions: they promote development of certain gender-specific organs while guaranteeing the atrophy of others.[5] This momentary state of genital indeterminacy is emblematic for Barney; it functions in his work as a symbol for unadulterated potential, providing him with a metaphoric vocabulary with which to organize and describe his own aesthetic system.

"Condition," the second of Barney's interior zones, is a visceral "disciplinary funnel" that processes the body's crude energy.[6] Its anatomical analogue is the digestive tract. If phase one consists of creative but undirected force, then the second level manages this force with the goal of making it useful. Processed through the stomach and upper intestines, the raw energy is churned up, broken down, and distilled. Extending the metaphor of digestion, the third and final zone, "Production," makes this force manifest in the world via anal and oral channels.

Once Barney diagrammed this tripartite structure, he became interested in the idea of short-circuiting the entire system by skipping the Production stage. The internal matrix would then oscillate exclusively between Situation and Condition, between desire and discipline, in a never-ending, self-referential, autoerotic cycle. According to the artist, "If Production is bypassed . . . the head goes into the ass,"[7] and the form goes into a "tailspin."[8] Barney represented this concept in the sculpture *unit BOLUS* (1991), which, like much of his early work, fuses biomedical terminology with the trappings of the locker room. In physiological terms a bolus is a wad of ingested or digested food. Here it serves as the title for a cast-petroleum-jelly dumbbell maintained by a refrigerated rack. The artist described this inherently malleable, double-headed form as a "mouthpiece that could also be inserted anally," an action that would essentially "close the circle" and seal off the body in a hermetic, perfectly self-contained state.[9] In his video performance *FIELD DRESSING (orifill)* (1989), Barney emulated this condition by filling each of his body's orifices—ear, nose, mouth, anus, penis—with petroleum jelly. The strenuous repetitive action that produced this state required lowering himself from the ceiling wearing nothing but a harness, scooping the substance up from a trough on the floor, and inserting it into the desired aperture.

The self-enclosed organism—an instrument of narcissistic gratification—has its place in the history of art. It is manifest in Marcel Duchamp's *Bride Stripped Bare by Her Bachelors, Even* (1915–23), with its intimations of a ceaseless, mechanical masturbatory cycle. In the lower, bachelor-inhabited realm of the work, an elaborate automated system of interconnected parts—malic molds, chocolate grinder, sieves, scissors, rams, mirrors, oculist witnesses, glider—churns away, forever secluded from the realm of the bride above but defined in opposition to it. "The bachelor," according to Duchamp,

5. For a detailed though dated account of sexual differentiation at the embryonic level, see John Money and Patricia Tucker, *Sexual Signatures: On Being a Man or a Woman* (Boston and Toronto: Little, Brown and Company, 1975). The authors' description of prenatal development alludes to a state of inner conflict, one that humorously parallels Barney's concept of hypertrophic growth through restraint: "Your hormone mix steered you at the fork in the prenatal road where your embryonic internal genetic structures . . . found their destiny. One set of structures began to develop, the other to wither away. . . . It takes a male hormone mix to make the wolffian structures develop, and it takes that special temporary hormone called simply 'mullerian-inhibiting hormone,' which is secreted during this period by the testicles, to keep the mullerian structures from pursuing their ambition to become a uterus, fallopian tubes, and upper vagina. . . . Development as a male requires effective propulsion in the male direction at each critical stage" (pp. 46–47). On the sexism intrinsic to such accounts of sexual differentiation and gender development, which posits the male element as an active force and the female as passive, see Anne Fausto-Sterling, "How to Build a Man," in Maurice Berger, Brian Wallis, and Simon Watson, eds., *Constructing Masculinity* (New York and London: Routledge, 1995), pp. 127–34.

6. Barney, lecture of February 12, 1998.

7. Barney, quoted in Goodeve, "Travels in Hypertrophia," p. 117.

8. Barney, quoted in the interview "Matthew Barney: A Conversation with Jeanne Siegel," *Tema Celeste*, no. 40 (spring 1993), p. 67.

9. Barney, lecture of February 12, 1998.

"grinds his chocolate himself."[10] This onanistic model, marked by a relentless erotic pulse, appears again and again in the trajectory of shared sensibilities (or obsessions) that extends from Duchamp to Barney. It resides in Vito Acconci's *Seedbed* (1972), a performance/sculpture in which the artist lurked underneath a false floor masturbating to the fantasy of those walking above him. It exists in early videotaped studio exercises of Bruce Nauman's, such as *Bouncing in the Corner II* (1969), in which the artist's incessantly repetitive actions serve to abstract his body into images of its own erogenous zones. And it informs Richard Serra's film *Hand Catching Lead* (1971), a meditation on process that shows the artist's hand attempting to grasp pieces of lead as they fall through the space of the frame. The continuous motion of Serra's opening and flexing grip is pulsatile, and this effect, like the performances of Acconci and Nauman, privileges a visceral cadence or intense corporeal friction over the pure, disembodied optics of modernist art.[11]

In Barney's onanistic universe, the body—which is always a sign for a more abstract operative structure—attempts to close in on itself through mechanisms of self-restraint. The will is thus regimented by an erotics of physical control that penetrates into the deepest recesses of the organism. If this pulsating cycle of desire and discipline repeats itself enough times, according to the artist, "Something that's really elusive can slip out—a form that *has* form, but isn't overdetermined."[12] At the very outset of his practice Barney created a graphic symbol for this concept of self-imposed resistance and the creative potential it harbors. His "field emblem"—an ellipsis bisected horizontally by a single bar—signifies the orifice and its closure, the hermetic body, an arena of possibility. The motif is ubiquitous in Barney's œuvre. Like a traditional heraldic emblem it encapsulates and translates the artist's complex symbology into visual shorthand. But the field emblem also functions like a corporate logo, ensuring a certain brand identity by virtue of its constant presence in the work. Mixing the archaic and the pop, this graphic image epitomizes Barney's unique aesthetic language, which is continuously evolving in its construction of a new-millennium mythology.

In addition to the anthropomorphic connotations of the field emblem, it also suggests an architectural framework, a "floor plan for actions," an empty stage on which the ritual preparations for self-mastery can be enacted.[13] At once body and stadium, the emblem represents an interstitial zone through which interior and exterior forces blend in a provocative mix of biology, activity, and edifice.[14] Barney's early sculptures and frames for drawings and photographs rehearse the permeable membrane between human and inhuman in their inclusion of (self-lubricating) Teflon and of metals such as titanium and stainless steel, which are used for external prosthetics and surgical implants.[15] These are substances that enter and extend the biogenetic body

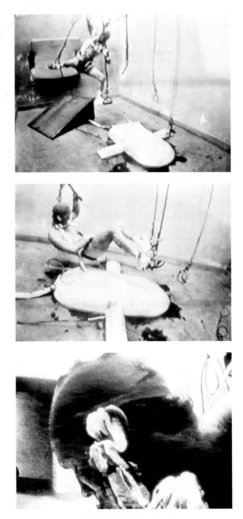

Video stills from *FIELD DRESSING (orifill)*, 1989

10. In the copious notes accompanying this work, Marcel Duchamp discloses that the glider or chariot chants the following litanies: "Slow life/Vicious Circle/Onanism/Horizontal/Buffer of Life/Bachelor life regarded as an alternating rebounding on this buffer." Quoted in Richard Hamilton, *The Bride Stripped Bare by Her Bachelors, Even*, a facsimile of Duchamp's *Green Box*, trans. George Heard Hamilton (Stuttgart, London, and Reykjavik: Edition Hansjörg Mayer, 1976), n.p. The connection between Barney and Duchamp was first articulated by Stuart Morgan in "Of Goats and Men," *Frieze*, no. 6 (January–February 1995), pp. 34–38, where he wrote, "As in Duchamp, the self-sufficiency of the artist's fictive universe was paraded, changes of state were proposed and sexual definitions were blurred . . . and like that of Duchamp, Barney's sustaining myth involved sexuality, or the differences between male and female" (p. 35).

11. This idea and specific examples are indebted to Rosalind Krauss's reading of the antimodernist impulse in Duchamp's work in general and of his *Anémic Cinéma* (1925) in particular. Krauss has identified the erotic "pulse"—often manifest in time-based work—as the link between visuality, the body, and art, arguing that vision is inseparable from corporeality. "In its diastolic repetitiveness, [the pulse] associates itself with the density of nervous tissue, with its temporality of feedback, of response time, of retention and protension, of the fact that, without this temporal wave, no experience at all, visual or otherwise, could happen." See Yve-Alain Bois and Krauss, *Formless: A User's Guide* (New York: Zone Books, 1997), p. 135.

12. Barney, quoted in Goodeve, "Travels in Hypertrophia," p. 117.

13. Barney, lecture of February 12, 1998.

14. "This motif represents the orifice and its closure—

Video still from *BLIND PERINEUM*, 1991

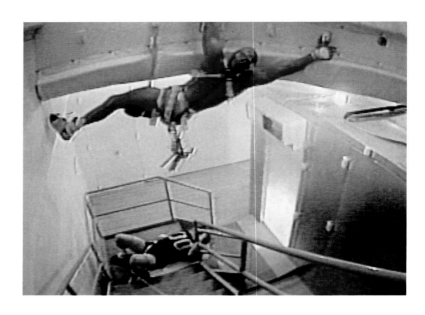

into a cybernetic organism, fusing the evolved with the constructed, the living with the artificial. In some of his objects Barney even included speculums and sternal retractors—the actual devices used to open the body up to outside intervention/alteration/extension. In videotaped actions such as *MILE HIGH Threshold: FLIGHT with the ANAL SADISTIC WARRIOR* and *BLIND PERINEUM* (both 1991), the body is so expanded that it becomes the playing field itself. Conversely, the site of performance becomes a corporeal cavity that the artist must negotiate while dangling from the ceiling in a full-body harness.[16] He traverses its surface with titanium ice screws, which hang from his belt and penetrate his anus. Subtitled *Fornication with the Fabric of Space*, these climbs convert the pitch in which they occur into an eroticized anatomical interior.

With his simple diagram of the field emblem Barney libidinizes architectural space and the surrounding environs, which come to represent the externalization or materialization of inner drives. As in J. G. Ballard's novel *The Atrocity Exhibition* (in which a military weapons range transmogrifies into the visage of Elizabeth Taylor, and a multilevel parking garage embodies erotic compulsions in its morphological resemblance to female anatomy),[17] body becomes landscape, and landscape becomes body. The artist's efforts to map a somatic topography—or, inverting the metaphor, to dissect a geographical organism—will reveal yet another state of undifferentiation, in which all organic and inorganic matter is fused. These zones of potential, akin to the gender indeterminacy of the five-week-old embryo, will

or the body and its self-imposed restraint—and as the body explodes in scale, it forms the stadium and field that house the video actions." Barney, quoted in "Matthew Barney: A Conversation with Jeanne Siegel," p. 67.

15. "I started out," Barney has explained, "using prosthetic plastic as frames for drawings. The drawings became an internal space that a prosthetic orifice opened up to reveal. After that I started making frames that had speculums made from the same prosthetic material with the possibility that the orifice constructed its own speculum to open it wider so one could see deeper into this internal space." Barney, quoted in Sans, "Matthew Barney: Modern Heroes," p. 31.

16. In her brief but probing text on Barney's first public exhibition, held at the Stuart Regen Gallery, Los Angeles, in 1991, Leslie Dick brings a Lacanian reading to the artist's video-action *FLIGHT with the ANAL*

SADISTIC WARRIOR that anthropomorphizes the architecture of the performance space: "The 'Mirror Stage' examines a moment when the infant, before language, has the mental capacity to (mis-)recognize itself in the mirror, yet lacks the gross motor skill to hold itself upright. It is held to the mirror by its mother, or stuck in an apparatus of support: a sling, a harness, a 'trotte-bébé.' Barney makes his way across the space of the gallery, naked, harnessed, inverted, dangling, displaying the rock-climbing equipment (hooks, ice screws) that hangs from his body like jewelry, enabling his ordeal. The architecture of the gallery itself becomes an exploded maternal body, a ceiling from which the muscular yet infantilized body hangs suspended." See Dick, "Matthew Barney," in Howard Singerman, ed., *Public Offerings*, exh. cat. (Los Angeles: Museum of Contemporary Art, and New York: Thames and Hudson, 2001), pp. 20–21.

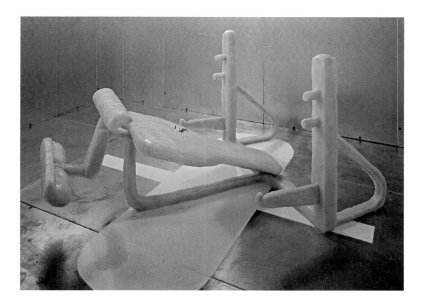

TRANSEXUALIS, 1991 (interior)

serve as the eccentric and mutating settings for Barney's epic *Cremaster* project. But before this cycle could find its form, Barney had to introduce conflict into the system.

THE HUBRIS PILL

Barney's early objects and installations imagine the perfectly engineered body. Well-equipped mise-en-scènes for the rituals of athletic training, they offer wrestling mats, curl bars, dumbbells, and weight-lifting benches as so many propositions for hypertrophic development. Metabolic substances such as sucrose, glucose, amino acids, and anabolic steroids—the core ingredients of living matter—serve as sculptural mediums. And like the molten lead that Serra used in *Casting* (1969), they stress preparation and process over the stasis of an inert artwork.

This is the arena in which the body is sculpted, where contenders for the ultimate physique subject themselves to extreme regimens of resistance training, doping their bodies on cocktails of painkillers and performance-enhancing stimulants that range from the standard but illegal anabolic or androgenic steroids to more bizarre chemical compounds. (For example, Naoko Takahashi of Japan, winner of the women's marathon at the 2000 Olympics, credits her stamina to drinking the stomach secretions of giant killer hornets.) Barney acknowledges this athletic will-to-power, this compulsion to achieve the humanly impossible within the very human confines of

17. For a discussion of J. G. Ballard's fusion of body and site in *The Atrocity Exhibition* (San Francisco: Re/Search Publications, 1990; 1970)—an important source for Barney—see Gregory Stephenson, *Out of the Night and into the Dream: A Thematic Study of the Fiction of J. G. Ballard* (New York, Westport, Conn., and London: Greenwood Press, 1991), p. 64.

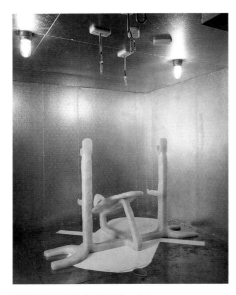

TRANSEXUALIS (decline), 1991 (interior)

(right) TRANSEXUALIS (decline), 1991 (detail)

the physical body. In each of the walk-in coolers of his twin *TRANSEXUALIS* installations (both 1991), he included—along with cast-petroleum-jelly exercise benches—human chorionic gonadotropin, a hormone found only in the urine of pregnant women. Secreted by the growing placenta shortly after implantation in the uterus, HCG ensures the viability of pregnancy by stopping ovulation and promoting hormone secretions in the growing embryo. Because exogenous HCG has characteristics almost identical to those of the luteinizing hormone (LH), which stimulates the fetal testes to produce testosterone, athletes use it to increase muscle mass and endurance.

Barney's inclusion of HCG in the refrigerated units of *TRANSEXUALIS* metaphorically transforms these arctic gymnasiums into wombs, uterine cavities where life itself is conceived and nurtured. This is Duchamp's bachelor-machine model metamorphosed into architecture. Entirely self-sufficient, these installation-cum-organisms propose the possibility of creation through parthenogenesis, a kind of virgin birth, elevating the human reproductive cycle to that of the gods.[18] Such autonomous procreation would signal the deification of man. But this is the realm of the impossible, the longed-for zone of omnipotence that, as a fantasy, drives the weight lifter and the bodybuilder to deny the reality of their flesh. It is the other side of the always receding performance wall that lures an athlete into attempting the suprahuman, whatever the risks.[19] The mad desire to become a deity on earth is pure hubris, a disease of the soul that afflicts the most ambitious, creative, and inquisitive.[20] It is the power that surges through the hypertrophic body,

18. The myth of the bachelor machine has other art-historical precedents besides Duchamp, including, in particular, Dada and Surrealist art such as Francis Picabia's *Girl Born Without a Mother* (ca. 1916–18) and Max Ernst's *Self-Constructed Small Machine* (1919). For an analysis of this literary and aesthetic trope, see my essay "Neither Bachelors nor Brides: The Hybrid Machines of Rebecca Horn," in *Rebecca Horn*, exh. cat. (New York: Guggenheim Museum, 1993), pp. 54–67.

19. Professional bodybuilders, who are cited here as a paradigm for all extreme-sport aficionados, are inherently outlaws, for their practice depends on the use of steroids, which, according to the Anabolic Steroids Control Act of 1991, are illegal unless prescribed for medicinal purposes. Steroid abuse can be lethal, but for the bodybuilder the benefits apparently outweigh the dangers. Here is one devotee's paean to the sport: "Bodybuilders are their own test pilots, breaking the

bonds of gravity, stretching their own envelope, the human frame, piercing the ceiling and propelling onward into the etherized air above to the great beyond. The danger is the allure. How much are you willing to suffer to achieve your aims? Like rocket-fuel-powered drag racers, solo sailors and speed skiers, they run a fine line between bravery and bravado, fearlessness and folly." Sam Fussell, "Bodybuilder Americanus," in Laurence Goldstein, ed., *The Male Body: Features, Destinies, Exposures* (Ann Arbor: University of Michigan Press, 1994), pp. 49–50.

20. For an insightful and beautifully crafted discussion of hubris in relation to Barney's work, particularly his *Drawing Restraint 7* (1993), see Neville Wakefield's untitled essay in *Matthew Barney: PACE CAR for the HUBRIS PILL*, exh. cat. (Rotterdam: Museum Boymans-van-Beuningen, 1995), pp. 15–19.

the psychic drive behind the excess of extreme self-discipline. And it finds form in Barney's sculptural imagination in the shape of a pill: *Anabol [A]: PACE CAR FOR THE HUBRIS PILL* (1991).

Whether steroid, hormone, or placebo, the hubris pill is a catalyst for conflict.[21] As an excess of pride, a rebellion against the natural order of things, hubris always begets retribution. This is its curse. The gods of ancient Greece routinely smote those who aspired to their ranks, lusted after their paramours, or challenged their authority. Barney's *Drawing Restraint 7* (1993)— a deadly tournament between two satyrs attempting to create form in the back of a moving limousine—recalls this memory of defiance and its punishment. This is the myth of Marsyas, the woodland satyr who dared to play the music of the gods and was flayed for his trespasses. In Barney's retelling of the legend, a third, much less developed, hybrid creature futilely chases his own tail in the front of the vehicle. Attempting to complete the circle, to close off and complete his own form, the "kid" pursues the intangible space of hubris, the elusive sphere of immortality on earth. In Barney's cosmology the hubris pill is a reminder of the seductive danger of these anabolic dreams.

If the hypertrophic quest were ever fully realized—if the organism should attain a purely hermetic state—that would be the end of the story. In fact there would *be* no story. This state of nothingness, a void approaching that of the Lacanian Real, is the true horror of hubristic yearning for omnipotence. As the artist himself has said, "With a particular type of horror, you can really fit your head up your ass—turn yourself inside out to form a kind of visceral landscape—where you can chase the demons around."[22] Barney's art tests the edge of this void but never succumbs to the fall. It remains emphatically narrative, rehearsing process instead of completion, confronting the inner conflicts experienced by an organism in search of psychic and physiological transcendence. These elusive interior forces are manifest materially in the work as separate characters who represent different facets of the same drives. In the first cycle of projects constituting Barney's early work—which begins with *The Jim Otto Suite* (1991), courses through *[facility of INCLINE]* (1991), *OTTOshaft* (1992), and *[facility of DECLINE]* (1991), and ends with *RADIAL DRILL* (1991)—the conflict is personified in the figures of Harry Houdini and Jim Otto.[23] As individuals who have captured the artist's imagination, both of them embody the athletic paradigm, but to divergent ends.

Escape artist extraordinaire, Houdini symbolizes hermetic practices; he is the "Character of Positive Restraint" who refuses differentiation, seeking instead to seal off and transform his body through extreme discipline. In reality, Houdini's metamorphoses—escapes from locked trunks, jail cells, handcuffs, and the like—were the result of rigorous physical preparation coupled

HYPOTHERMAL PENETRATOR, 1991

21. Barney has described the hubris pill as "a glucose tablet, a kind of placebo in this narrative that's full of binary relationships between something like a placebo and steroids, between differentiated form and undifferentiated form, between the state of hubris and a state that sits just on the other side of the threshold, some omnipotent, heightened state that comes out of this hermetic state of understanding." Quoted in an interview with Jonathan Romney, "Matthew Barney," *Transcript* 3, no. 3 (1999), p. 99.

22. Barney, quoted in "Matthew Barney: A Conversation with Jeanne Siegel," p. 67. Richard Flood recounts a scene from one of Barney's favorite films, *Society* (Brian Yuza, 1989), in which "the protagonist shoves his fist up the antagonist's anus, grabs his head, pulls it into the body and out through his ass." See Flood, "Notes on Digestion and Film," in *PACE CAR for the HUBRIS PILL*, p. 30.

23. Like Barney's *Cremaster* cycle, this series of works was created out of order.

Video still from *MILE HIGH Threshold: FLIGHT with the ANAL SADISTIC WARRIOR*, 1991

with an intuitive understanding of the forms that would shackle him. Barney often cites the claim that Houdini could pick locks that had yet to be invented by anticipating and then ingesting their mechanisms through his finely tuned instincts.[24] Jim Otto, the legendary center for the Oakland Raiders who finished his fifteen-year career with two artificial knees, is for Barney an inverted mirror to Houdini: though equally fanatical about his métier, and as seemingly immune to pain, he is open, extroverted, theatrical. If Houdini operates through internalization, Otto—whom Barney describes as the "hypothermal penetrator"—achieves through outward aggression. A celebrated offensive player, Otto exulted in the field of competition. His relevance to Barney's narrative system, however, is primarily pictorial: the double-zero insignia on his football uniform suggests a twin orifice, a "roving rectum," a body susceptible to mutation, penetration, and differentiation.

Otto and Houdini are two incarnations of an internal horizon that arcs toward hubris. The outward-looking Otto seeks to consume or incorporate what is separate from him in a mad fusion with the universe. His foil, the introspective Houdini, strives for omnipotence through the exercise of sheer will. They enter into combat over which direction the organism will take. Struggle ensues and the narrative unfolds. These characters, as two mutations of the will, function like a system of checks and balances. Their internal struggle maintains the system by holding it taut between implosion and explosion. The *TRANSEXUALIS* project, with its related video actions, *MILE HIGH Threshold: FLIGHT with the ANAL SADISTIC WARRIOR* and *BLIND PERINEUM*, is essentially one protracted chase scene between Otto and the Character of Positive Restraint (Houdini). As the action begins, the Character of Positive Restraint, played by Barney, is attempting to fill in his nemesis' dual zeros before lacing together his own anus and mouth with a synthetic cord and the titanium ice screws used for his climb. It is once again the metaphor of prenatal development that provides the artist with his vocabulary: the battle between Otto and Houdini circulates around the notion of an embryo's inevitable drift toward differentiation. Each character has a different relationship to this process and, thus, a different set of desires. In Freudian terms these might be defined as the pleasure principle versus the reality principle. Barney represents the path of anatomical differentiation through a metaphoric device that involves fluctuating temperatures and their effect on the (male) body. Otto, for instance, is particularly sensitive to climatic change, since he is an entity pervaded by orifices (hence, the different temperatures in the walk-in coolers of *TRANSEXUALIS*, the colder of which was meant to disable him).

In the bioscape of Barney's art temperature change invokes the ascension or descension of the testicles, a normal biological function governed by the

24. For Barney on Houdini, see Helfand, "Matthew Barney," p. 38; Sans, "Matthew Barney: Modern Heroes," p. 28; and Goodeve, "Travels in Hypertrophia," p. 68. Houdini's self-discipline was extraordinary. One example may suffice: "Houdini disciplined himself to endure cold water and to hold his breath while submerged. Getting up at seven in the morning, he headed straight for the bath. . . . There he subjected himself to ever colder water and ever longer submersion. He chilled the bathwater with ice, bringing its temperature down, in one trial or another, to fifty-two, fifty-one, forty-nine, forty-eight degrees (when a doctor stopped him); several times down to forty-five; and at least twice down to thirty-six degrees, barely above freezing. After a while he got used to being bone cold. . . . Houdini also practiced staying immersed in the tub . . . [and] occasionally at least, he combined the two grueling exercises. He would then practice staying underwater in an ice bath. Once he held out for thirty-eight seconds." Kenneth Silverman, *Houdini!!!: The Career of Ehrich Weiss* (New York: HarperCollins Publishers, 1996), p. 112.

cremaster muscle. This action of suspension or retraction protects the male reproductive system—in particular the production and maintenance of sperm—by regulating testicular temperature. Since live sperm need air-conditioning for survival, the testicles normally hang freely in the scrotum. But when it is too cold (or the subject experiences fear), the testicles are drawn upward into the warmer climes of the body. Though still unnamed as such in Barney's metaphoric universe, the cremaster muscle and its effects operate as a symbol in his earliest works.[25] The character he plays in *FIELD DRESSING (orifill)*, for instance, descends from the heated zone of the ceiling to the refrigerated vessel of petroleum jelly below, which is sculpted in the shape of the field emblem. After filling each orifice, he retracts to the ceiling before beginning the process anew. Here the performing body transmutes into its "part object"—human being to testicle, gestalt to sex organ—in a chain of signification that reveals the permeability of meaning itself.[26]

Testicular migration and its role in prenatal sexual differentiation may well be the ur-symbol of Barney's entire conceptual practice. The downward developmental slide of the testes into the awaiting scrotal sac, which occurs during the seventh month of fetal growth, is in many ways the final somatic stage in the making of a man. It is not the conclusion of this embryonic evolution, however, that is of foremost interest to the artist, even though his references to male anatomy may seem to suggest otherwise. Rather, it is the path traveled between the states of ascension (female) and descension (male)—and all the possible detours that can occur along the way—that activates and organizes Barney's mythological system. Strict gender binarism is but a modern invention dating from the late eighteenth century, when the "one-sex" model, premised on ancient beliefs in the essential sameness of the male and female reproductive systems, was discredited. Until that time, woman was perceived as an inversion of man. But over the next century the concept of one male paradigm from which all variation flowed gave way to a system of stark contrast and conflict, a development that coincided with the emergence of psychoanalysis and its fundamental fracture between genders and generations.[27] Today, however, the picture is more complex. In recognition of the many biological gradations between female and male that result from chromosomal hybridization, biologist and gender theorist Anne Fausto-Sterling identifies five different sexes: males, females, hermaphrodites (one testis and one ovary), male pseudo-hermaphrodites (testes and some aspects of the female genitalia but no ovaries), and female pseudo-hermaphrodites (ovaries and some aspects of the male genitalia but no testes).[28] Modern medical science may have routinely used surgical intervention to "fix" unruly bodies, seeking to eradicate any sexual variation that does not conform to the conventional, heterosexually oriented, binary

25. Barney has spoken about how his interest in body temperature dovetailed with his discovery of the function of the cremaster muscle: "Well, it's an interesting thing that happens in the way that the [cremaster muscle] responds to temperature or fear, and around that time [I found out about it], I was making these pieces which dealt with temperature—walk-in refrigerators in which Vaseline was cast in a particular form that was held in place by temperature. I was also thinking a lot more at that point about the kind of stories that nearly take place in the body, the kind of action films that were going on inside a body or an abstracted body." Quoted in Amy Jean Porter, "Fluid Talk: A Conversation with Matthew Barney," *Circa*, no. 22 (summer 2000), pp. 30–31.

26. See Bois and Krauss on the "Part Object" in *Formless*, pp. 152–61, for a discussion of its function in Surrealist art and literature to destabilize meaning.
27. For a detailed historical analysis of the "one-sex" model and its replacement in the modern age by sexual dimorphism, see Thomas Laqueur, *Making Sex: Body and Gender from the Greeks to Freud* (Cambridge, Mass.: The MIT Press, 1990). Also citing this source, Wakefield describes the organizing principle of Barney's work as both "pre-modern and post-analytical"; see "Matthew Barney's Fornication with the Fabric of Space," p. 123.
28. Anne Fausto-Sterling, "How Many Sexes Are There?" *New York Times*, March 12, 1993, p. A29.

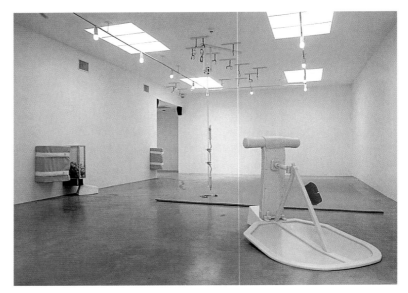

REPRESSIA, 1991 (detail)

(right) Installation view of *[facility of INCLINE]* showing
REPRESSIA, 1991

classification system, but the recognition and acceptance of intersexed people is gaining currency.

Gender mutability has a key narrative function in Barney's art, but it is not subject matter in itself. The artist acknowledged early on that "the ratios of sexuality seem to be changing, [and] that's where I think it entered my work. There's a proposed organism . . . that at certain points has a gender, but it's not necessarily a human gender. It has a ratio that fluctuates, 1:10, 2:9, wherever it ends up. Obviously there are articulations that are specifically masculine and feminine, but I think there's a lot of space in between that has to do with other points on the graph."[29] Gender is raw material for Barney. He molds it much as he molds space. The feminine and the masculine, or some combination thereof, become zones of articulation within the narrative. In *MILE HIGH Threshold: FLIGHT with the ANAL SADISTIC WARRIOR* Barney's Character of Positive Restraint propels himself through a space demarcated by fluctuating temperatures and shifting sexual morphologies, areas that function as units of concealment or hunting-blind-like traps. During the *[facility of INCLINE]* version of the *TRANSEXUALIS* project, which took place in Los Angeles at the Stuart Regen Gallery, the Character of Positive Restraint moves through the Masculine Jim Blind, which is signified by a drop in temperature intended to disable Otto. Leaving the domain of *TRANSEXUALIS*, he encounters the Androgynous Jim Blind, which is manifest as an architectural detail: a skylight and gate represented by the *case BOLUS* (1989–91) sculpture. He then drops from the ceiling onto the field of *REPRESSIA* (1991), represented by a

29. Helfand, "Matthew Barney," p. 38. Though much has been made of the transgressive and liberatory possibilities of an undifferentiated "third sex" in relationship to Barney's work, the politics of gender binarism are not critically important to the artist. Like sports, anatomy, and genre, sexual difference is merely one among many narrative vehicles or filters through which Barney explores the creation of form. See in particular Jerry Saltz, "The Next Sex," *Art in America* 84, no. 10 (October 1996), pp. 82–91. Barney himself has said, "I'm less interested in the external debate about gender, which I don't think my work is about. It's more about the endless possibilities this organism can take on, the fact that it can occupy a field that is designated as feminine or masculine or androgynous, but I'm not more interested in one than another." Quoted in Sans, "Matthew Barney: Modern Heroes," p. 28.

yellow wrestling mat punctured by an orifice, where he enters the Feminine Jim Blind by donning a costume: a West Coast, Lana Turner–like, poolside number. As documented in the video *DELAY OF GAME* (1991), the Character of Positive Restraint appears in drag as camouflage to hide from Otto, who tries to engage her in competition by offering her a "snap." This football maneuver—in which the center flips the ball backward between his legs to the quarterback—is rendered in Barney's symbolic system by the exchange of a cultured pearl. Otto hands the pearl to his disguised opponent, who rejects the snap by dropping the gem into an incision on the mat held open by a sternal retractor. In the *[facility of DECLINE]* version, performed in the Barbara Gladstone Gallery in New York, the Character of Positive Restraint undergoes similar transformations, only here she disguises herself in elegant evening wear, as shown in the video *RADIAL DRILL* (1991).

Before Barney expanded the biological model of differentiation outward to encompass the five-part organism he calls the *Cremaster* cycle, Otto and Houdini played one more round in *OTTOshaft*, a three-channel video installation that in many ways augured this extensive project. Staged, filmed, and initially exhibited in an empty underground parking garage in Kassel, Germany, as part of the *Documenta IX* exhibition in 1992, this performative sculpture (or sculptural performance) extended Barney's then-signature mode of presentation. As had been the case with his *FIELD DRESSING* and *TRANSEXUALIS* exhibitions, previously recorded actions played on video monitors in the environment where they had originally taken place, like an echo or memory of what had transpired. "I always think of those videos," the artist once explained, "as only a possible narrative of what might have happened in that space; rather than being truths, they're proposals."[30] The sculptural elements used in the video appeared in proximity to the monitors to concretize the action and give form to its propositional function. More so than in the earlier video actions, the setting of *OTTOshaft* became a character unto itself: the garage's glass-topped elevator shaft and low-ceilinged concrete ramps, the clinical-white tiles of an underpass, and three other elevator shafts dispersed throughout the *Documenta* site transmuted into the portals and channels of a body awaiting entry and passage as well as the bag, chanter, and drones of an environmental bagpipe. The cold, white, ever-nocturnal light of the underground space had its own menacing temperament, making the garage a "vessel that holds the psychology" of the piece.[31] This intensification of the role of location in the work's dramatic flow reflected Barney's growing interest in establishing nonhierarchical relationships between place and protagonist in his increasingly narrative projects. He was inspired at the time by horror films, such as Stanley Kubrick's *The Shining* (1980), in which the setting, the Overlook Hotel—an empty off-season resort in the Colorado

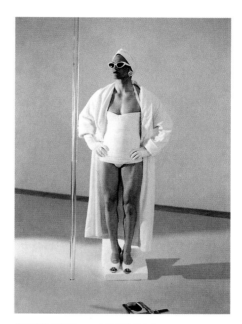

DELAY OF GAME (manual A), 1991 (detail)

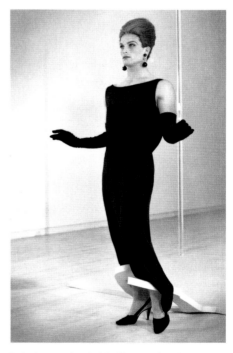

Production photo from *RADIAL DRILL*, 1991 (detail)

30. Barney, quoted in Goodeve, "Travels in Hypertrophia," p. 68.

31. When asked what the most memorable scene in film was for him, Barney replied, "Maybe when the lightbulbs start bleeding in [Sam Raimi's] *Evil Dead II* [1987]—it's a real classic, cabin-in-the-woods horror film. That would be very influential to me in the sense that the evil lives in the architecture rather than the person. Even if there is some antagonist circumnavigating the cabin, it's the cabin which is still the vessel that holds the psychology." Quoted in Porter, "Fluid Talk," p. 31.

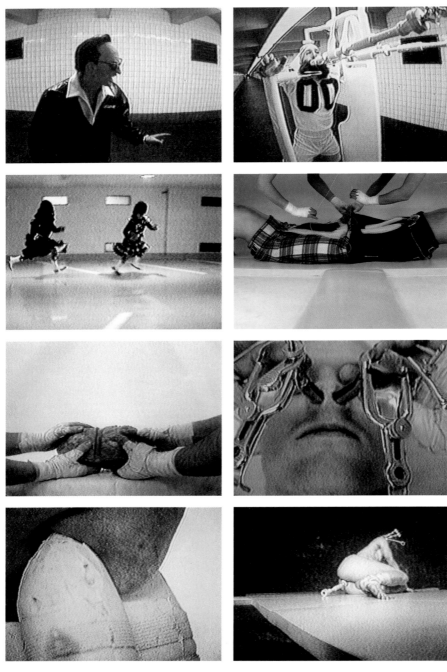

Video stills from *OTTOshaft*, 1992

Rockies—is the very embodiment of evil. Imbued with psychic and somatic dimensions, the architecture is the film's main character.[32]

With the sterile, incubator-like garage urging them on, Otto and the Character of Positive Restraint plot to hijack the hubris pill and force it to achieve its most distant horizon of possibility, which is imagined in the form of a bagpipe. Taking the pill hostage, they induce a metabolic transfer of energies. Following a biological model of digestion, they impel the pill to travel from glucose (the pill's existing state of potential) to hard candy (a glucose-sucrose blend) to pure sucrose. After passing through petroleum jelly, it moves on to the starches—tapioca—and then meringue. If they are able to make it reach the state of pound cake, a complex carbohydrate, with the penultimate addition of eggs, the bagpipe will play "Amazing Grace" and thereby communicate with God. Written by John Newton, an ex-libertine and ex-slave trader who became a minister in the Anglican church, "Amazing Grace" (ca. 1760–70) is one of America's most popular hymns. Its place in *OTTOshaft* as the musical embodiment of ultimate hubris evokes the myth of Marsyas (in a pre-*Drawing Restraint 7* moment), who elicited the wrath of Apollo by playing all too well upon the flute. But this transcendent state is never fully realized; the pound cake is split in two, ensuring that the organism will never find absolute equilibrium. The structure of the piece mirrors this fundamental rift. The two halves of the narrative, embodied by Otto and the Character of Positive Restraint, continually come together only to divide. The image itself is partitioned into three separate video channels: In *OTTOdrone* the metabolic choreography uncoils through the labyrinth of the garage. In *AUTOdrone* the Character of Positive Restraint is shown repeatedly filling his orifices with medical dilators and bagpipe drones, in a Houdini-esque attempt to try on or even become the musical instrument. And in *OTTOshaft* he scales various elevator shafts throughout the Documenta site, as if inside the chanter and drones of an enormous bagpipe.

In *OTTOshaft* the dialectical relationship between Otto and Houdini opens up or fans outward to include other cast members, who are not discrete beings but multiple incarnations of the states embodied by the leading characters. The opening episode of *OTTOdrone* is a training sequence. Al Davis, the notorious Machiavellian manager of the renegade Oakland Raiders, is drilling Otto on how to play the bagpipe, teaching him the notes to "Amazing Grace." Although seemingly separate individuals—for the prosthetically enhanced Al Davis figure truly resembles the real-life football magnate—Otto and his coach are manifestations of a single entity. Combined, they suggest the process of discipline applied to raw potential, or, in Lacanian terms, the integration of the Law of the Father.[33] But Al—"Just win, baby"—Davis is no benevolent father figure. He is the one who masterminds the theft

32. Barney has described the film as "a piece of biological horror that is essentially architectural." See James Lingwood, "Keeping Track of Matthew Barney," *TATE: The Art Magazine,* no. 6 (summer 1995), p. 52. Kubrick used tracking shots intensively in the hotel's interior to invoke this zone of evil formally. Richard T. Jameson has described his technique: "Those spaces draw Jack [Jack Nicholson's character in the film]. Kubrick sees to it that they draw us as well. It's not merely a matter of corridors obsessively tracked. Virtually every shot in the film (whether the setting be the Overlook or not) is built around a central hole, a vacancy, a tear in the membrane of reality: a door that would lead us down another hallway, a panel of bright color that somehow seems more permeable than the surrounding dark tones, an infinite white glow behind a central close-up face, a mirror, a TV screen . . . a photograph. From the moment we lose the consoling sense of focus and destination supplied by that island picturesquely centered in the lake, we are careening through space." See Jameson, "Stanley Kubrick: *The Shining,*" *Film Comment* 16 (July–August 1980), p. 30.

33. The fact that Barney's mother plays Al Davis in *OTTOshaft* adds an interesting twist to any psychoanalytic reading of the piece.

of the hubris pill and forces its metabolic conversion, regardless of the consequences. The embodiment of hubris, he compels Otto to strive for the ultimate hypertrophic condition, a total mastery of the body that, in the end, can result in an implosion from within.[34] (The Teflon and stainless steel that gradually replaced the ligaments, cartilage, and joints in Otto's knees have migrated to become the primary materials for Barney's sculptures.)

Otto's character is further fractured or triangulated into a chorus of three bagpipers wearing the Black Watch tartan, uniform of the British monarchy's own military band.[35] Al Davis joins them in full Highlander regalia. The Character of Positive Restraint meets the challenge and dons a disguise, filtering it through the Feminine Jim Blind of *RADIAL DRILL* and *DELAY OF GAME*. Transforming himself into a bagpiper, he wears the Dress Stewart tartan, a red-and-white plaid that draws its color scheme from the *arisaid*, an ancient Scottish dress for women that was predominantly white.

The hubris pill, in its successive metabolic states, is passed back and forth between the two teams, Black Watch and Dress Stewart. At one point in the narrative, two kilts, each representing an opposing side, are sewn together with cord and petroleum jelly. Here the organism is attempting to remain undifferentiated, to maintain a state of equilibrium that in the end proves impossible. When Otto and the Character of Positive Restraint come together for their final battle, switching between the tartans and their customary dress—the double zeros for the former (in both home and away colors) and the body harness for the latter—it is clear that neither will overpower the other nor preserve the momentary harmony of their union. The joined kilts unravel.

ZONE OF TRANSITION

OTTOshaft is a gate to the *Cremaster* cycle. "It was a project," explains Barney, "that admitted to itself that it can never achieve equilibrium, but it continued to try by enacting these rehearsals where equilibrium was exhibited."[36] The *Cremaster* cycle would take this principle as a governing force, extending and amplifying it over five installments, each of which imagines the possibility of symmetry only to experience some form of failure. *OTTOshaft* marked the end of the *Otto* cycle and, with it, a strain of humid, testosterone-driven, locker-room iconography in Barney's work. But the underlying theme of a system in conflict with itself to remain undifferentiated, when all determining factors point toward differentiation, informs the *Cremaster* project as a whole. The original biological metaphors of ascension and descension inherited from the *Otto* works are played out in the cycle's first three installments (*Cremasters 4, 1, and 5*), but eventually give way to a more abstracted and perhaps more generous understanding of form and its internal development.

34. For a perceptive and detailed analysis of *OTTOshaft* that speculates on the dangers of hubristic hypertrophy for the body, see the booklet by Sean Rainbird, *A Twentieth-Century Enigma: Matthew Barney's Ottoshaft, 1992* (London: Tate Foundation, 2001).

35. The first military companies formed in the Scottish Highlands in 1677 came to be known as the Black Watch because of their dark tartans. Their responsibilities initially required guarding against cattle thieves and blackmailers, but eventually they engaged in battle, in particular during the Jacobite uprisings of 1715 and 1745. Each company had its drums and bagpipes, which is how the instrument became associated with warfare. As Sir Walter Scott once proclaimed, "Twelve Highlanders and a bagpipe make a rebellion." Quoted in Francis Collinson, *The Bagpipe: The History of a Musical Instrument* (London and Boston: Routledge, 1975), p. 166.

36. Barney, lecture of February 12, 1998.

Barney first deployed some of the key structural strategies of the *Cremaster* cycle in *OTTOshaft*, formulating them in relationship to the increased complexity of the piece. Filmed in multiple locations with a larger cast than in previous projects, *OTTOshaft* also involved a more elaborate story line. This intensification of narrative prompted more intricate forms of character development, but not in the conventional sense. For Barney character is embodied as much by place, costume, and prop as by attitude or sensibility. A character may be a dandified satyr, an apprentice Mason, a Celtic island, a baroque opera house, or a chorus of sixty showgirls. As "vectors" or "compulsions"[37] his characters are born from psychological constructs; they are personifications of inner, largely unexplored topographies. In this way they are all facets of a single organism, iterations of one system seeking equilibrium. As the *Cremaster* cycle unfolded in form and content, a corpus of leading characters emerged, each one informing the evolution of the next: the Loughton Candidate of *Cremaster 4*; Goodyear of *Cremaster 1*; the Queen of Chain and her Diva, Giant, and Magician of *Cremaster 5*; Gary Gilmore of *Cremaster 2*; and the Entered Apprentice and Hiram Abiff of *Cremaster 3*. "A lot of the ideas for the characters," explains Barney,

> come during the making of the previous piece. . . . There is an aspect to a character that possibly wasn't articulated in the piece I was working on, and that aspect becomes articulated in the next piece. In that way there is a resistance to character development beyond a certain point, beyond a kind of threshold between a sculptural entity and something that might be an overdetermined element. In that way there is a lack of character development that interests me—the fact that they can quiver between something understood as a character with agency and something that operates more as a state of some sort, or a zone.[38]

In addition to his leading characters, Barney utilizes the dramatic device of the chorus as a connecting fiber in the increasingly layered *Cremaster* narratives. His interest in the choric tradition was first manifest in *OTTOshaft*, with the triplication of Otto into a regimental guard unit. As in Greek tragedy the Black Watch pipers function as a chorus, which comments on and assists with the primary dramatic action; here they participate in the theft of the hubris pill and rehearse "Amazing Grace" by becoming one with the bagpipe. Although choruses manifest differently in each *Cremaster* installment, they play a fundamental role in the cycle. Given Barney's tactical restraint in preventing his main characters from developing beyond a basic

37. Barney uses these terms to describe the characters of the *Cremaster* cycle in Romney, "Matthew Barney," p. 91.

38. Barney, quoted in Sans, "Matthew Barney: Modern Heroes," p. 30.

Concept drawing for *OTTOshaft*, 1992

communicative level,[39] the choruses are often the most accessible entities in the work, providing, in some cases, entertainment, comic relief, and pure visual pleasure. They vary in scale and format with the needs of each film. In *Cremaster 1* eight glacial air hostesses attend to their charge—Goodyear, a fully ascended creature inhabiting two blimps. In *Cremaster 2* the Mormon Tabernacle Choir bears witness to murder, sitting in judgment on a convicted killer. In *Cremaster 3* the Solomon R. Guggenheim Museum, New York, and the Masonic ritual-cum-competition staged in its rotunda provide a choric interlude that alludes to each of the *Cremaster* installments. The trio of fairies in *Cremaster 4* incarnates the three possible paths traveled in the narrative: ascension, descension, and the equivocation between. And the budding hermaphroditic water sprites in *Cremaster 5* assist the fully descended Giant in the process of differentiation.

The most fundamental character or element in each *Cremaster* film is the location in which the narrative takes place. Barney's geographic impulse was to some extent triggered by the impact of the elevator shafts and

39. In speaking of character development, Barney has said, "They're brought to the point where potentially they could be developed one step further and become actual characters, but there is a conscious effort to stop at the point, allow them to be states or fields that aren't really capable of that kind of agency." Quoted in Romney, "Matthew Barney," p. 91.

underground setting on the development of *OTTOshaft*. As a performance artist who has always engaged directly with his sites, Barney has been inclined to weave exhibition venues into the concept of his work. For instance, he very consciously incorporated "West" and "East" Coast sensibilities into the schemes of *[facility of INCLINE]* and *[facility of DECLINE]*, paired projects that originally took place in Los Angeles and New York. Their Feminine Jim Blind characters—the Hollywood starlet and the Manhattan sophisticate—were meant, like any good camouflage, to blend into their particular surroundings.

Location took on a catalyzing role in the *Cremaster* cycle. The entire narrative construct of each installment flowed directly out of its geographic and architectural setting. These spatial coordinates determined the degree of ascension or descension expressed, the identity of the characters, and the order of the cycle itself. They became the individual kernels that, one by one, generated the discrete but interrelated episodes of the *Cremaster* saga. In fact the five locations were the first elements of the project that Barney defined. As early as 1992 he had begun conceptualizing a multipart program through which to further explore the biological model of differentiation so integral to the *Otto* works. The bipolar structure of *OTTOshaft* invited further division into multiple scenarios, with the goal of creating a more complex organism; its eccentric narrative offered a glimpse into the yet untapped cinematic and sculptural fantasies that Barney would create during the ensuing ten years. In a collage drawing created at the time of *OTTOshaft*, Barney laid out a conceptual map of what the *Cremaster* cycle would eventually become. The drawing is a rendering of a bagpipe. The bag section, which is usually tartan, is formed out of photographs of two pipers, their faces masked with halved field emblems and their kilts sewn together—the dialectic of Otto and Houdini held in check by the tension of a single thread. Six bagpipe drones emanate outward from this dual form on which are indicated the elevator shafts in Kassel where Barney planned to stage the various components of *OTTOshaft*: the Neue Galerie (two passenger elevators), the Documenta Halle (one passenger elevator), the Fridericianum (one passenger elevator and one freight), the Tief Garage (one passenger elevator). In a separate but adjacent zone on the paper are written the names of five further locations: "Bronco Stadium; White Sands/Columbia Icefield; Chrysler Building; Ireland; Bath House/Istanbul."[40] Although some of these specified areas would change by the time their respective films were realized—the Bonneville Salt Flats in Utah replaced White Sands; the Isle of Man supplanted Ireland; and the Turkish bath house is now in Budapest—this list of destinations provides a road map to the conceptual topography of the *Cremaster* cycle.

40. To the side of this diagram is a small drawing of two hands pulling at a nub of skin or a bodily orifice with the number six below them. This indicates that the *Cremaster* cycle was originally to have six sections, the last being specifically biological in content. Conversation with the artist, July 18, 2001.

MYTHOLOGICAL DETOURS

The most awful, most secret forces . . . lie at the heart of all things . . . a presence, that was neither man nor beast, neither the living nor the dead, but all things mingled, the form of all things but devoid of all form.
—Arthur Machen, *The Great God Pan*, 1894

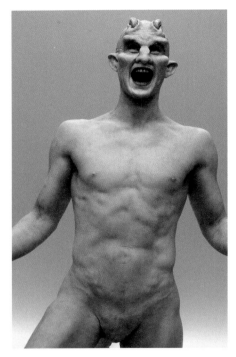

Production photograph from *Drawing Restraint 7*, 1993

Before beginning the *Cremaster* project, Barney created another work that, like *OTTOshaft*, can be read retrospectively as a passage into the cycle. *Drawing Restraint 7*, a three-channel video excursion into the Arcadian world of Greek mythology, inaugurated an entirely new aesthetic vocabulary: the mountaineering *über*-hero look of the Character of Positive Restraint, and Otto's double zeros, gave way to a dreamscape of fantastical hybrid creatures, of dueling satyrs and a yet-to-be-gendered "kid" caught in a furious tailspin. The action is compressed into the gorgeous, Aegean-blue interior of a limousine, which is driving at night across and through the bridges and tunnels connecting Manhattan to the lands surrounding it: Queensborough, George Washington, Brooklyn, Manhattan, Midtown, and Holland. A porous, liminal space, the city-island of Manhattan appears as a fluid region between the terrestrial world and the domain of the gods. Here mutant beings test the limits of hubris. The younger satyr, played by Barney in full-body prosthetic makeup, is the chauffeur. His frantic attempts to catch his own tail—in an effort to close the circle of his being, to secure his predifferentiated condition—is what powers the car in its endless loops through the anatomy of New York. As a technological extension of the satyrs' will-to-power, the limousine is, in the Deleuzian sense, a "desiring machine"—an entity driven by and productive of desire.[41] The challenge for the two older satyrs—one of them being part ram, the other part goat—is to create form, to inscribe a mark in the condensation gathering on the car's moon roof. As they wrestle for access to this process, the goat-man forces the ram into submission, using his horns to trace a line in the mist. Muscles strain, fur flies, hoofs and horns lock, and a drawing is made. Having completed their goal, both satyrs have won *and* lost, for hubris inevitably exacts rebuke. In the end they align their Achilles tendons and flay one another, enacting Apollo's revenge on Marsyas for thinking he could approximate the gods.

As a form the satyr is an anomaly, a disruption in the cosmic order of things. Part man, part beast, this mongrel creature existed in ancient thought as a reminder of the chaos lurking beneath the facade of reality. Pan, the Greek god of fertility and carnal desire, was a satyr. An accomplice of Dionysus, he represented unbridled desire and orgiastic abandon. Barney

41. Gilles Deleuze and Félix Guattari counter the Freudian and Marxist notion of desire as lack with a Nietzschean belief in desire as a limitless energy, writing that "the rule of continually producing production, of grafting producing onto the product, is characteristic of desiring machines or primary production: the production of production." See their treatise *Anti-Oedipus: Capitalism and Schizophrenia*, trans. Robert Hurley, Mark Seem, and Helen R. Lane (Minneapolis: University of Minnesota Press, 1983), p. 7.

has noted that he "was interested in the fact that 'Pan' is the root of 'panic' . . . because Pan leads you to Bacchus—he gives you the moment of unease before you let yourself go."[42] Etymologically, *pan* is the neuter form of the Greek *pas*, meaning "all" or "everything," and in this context it suggests a world where reality is molten, where the boundaries between things and beings evaporate and difference dissolves. Pan is a god of regression, leading the way back to an entirely undifferentiated realm: the time before time, the space before space. This primordial moment antecedes any origin myth; it exists outside of language. Pre-Genesis (and pregenital), it lacks all definition or structure.

The biblical account of creation is premised wholly on the principles of division, differentiation, and categorization: "In the beginning God created the heaven and the earth. And the earth was without form, and void; and darkness was upon the face of the deep. . . . And God said, Let there be light: and there was light . . . and God divided the light from the darkness . . . and God said, Let there be a firmament in the midst of the waters, and let it divide the waters from the waters."[43] This motif of partition extends to all living things, with strict prohibitions against the intermingling or hybridization of seed, fruit, animal, or human.[44] To contest the laws of differentiation is thus to challenge the very word of God. To produce new forms that do not adhere to the divine code of bipolar segregation—strange amalgams, forbidden mixtures, unearthly fusions—is to usurp and distort the role of the Creator. This is the uncontainable will of the demiurge in action. It is revealing here that "hybrid" stems from the Greek *hubris*, which connotes an irreparable violence, a tearing asunder of all that is stable, known, or predictable.[45] As a symptom of hubris, hybridization can undo (or remake) the world.

Playing the role of artist-cum-demiurge, Barney grafted the quintessential myth of hubris onto the biological model of pregenital undifferentiation to render *Drawing Restraint 7*. The resulting artwork—visually lush, and mesmerizing in its otherworldliness—anticipates the fantastical cosmology of the *Cremaster* cycle, in which the laws of difference have been entirely rewritten. In Barney's epic project, terms like "human," "architecture," "landscape," "vehicle," and "animal" designate not separate entities but zones of interpenetration. Taxonomic classifications premised on hierarchy and quantifiable variation yield to the anarchy of hybridization. Characters transmogrify into multiple versions of themselves, cars perform ritual sacrifice, islands have digestive tracts, buildings have diaphragms, bees pollinate people, and playing fields have reproductive systems.

Barney's metamorphic vocabulary—in which intangible ideas acquire palpable form, and the distinction between mind and matter disintegrates—invokes the defining characteristics of literary fantasy. Governed by the

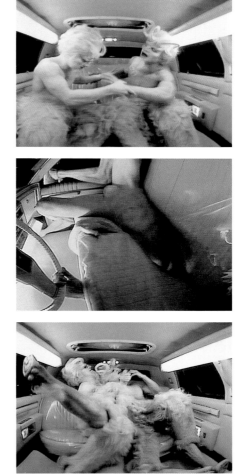

Video stills from *Drawing Restraint 7*, 1993

42. Barney, quoted in Goodeve, "Travels in Hypertrophia," p. 69.

43. Genesis 1:1–6. This idea and much of the following discussion are indebted to the work of the French psychoanalyst and theorist Janine Chasseguet-Smirgel, whose book *Creativity and Perversion* (New York and London: W.W. Norton & Company, 1984) was an important early source for Barney.

44. Chasseguet-Smirgel quotes from Genesis 1:11–12 to make this point: "And God said, Let the earth bring forth grass, the herb yielding seed, and the fruit tree yielding fruit *after his kind*, whose seed is in itself, upon the earth: and it was so. And the earth brought forth grass, and herb yielding seed *after his kind*, and the tree yielding fruit, whose seed was in itself, *after his kind*";

italics mine. *Creativity and Perversion*, pp. 8–9. Chasseguet-Smirgel historically contextualizes the trope of division and its manifestation in Jewish dietary laws, incest taboos, compulsory heterosexuality, etc., as rooted in the struggle of ancient Judaic monotheism (and its patriarchal constructs) against the paganism surrounding it (pp. 6–7).

45. See ibid., p. 9, and Wakefield, *PACE CAR for the HUBRIS PILL*, p. 16. "Hybrid" comes from the Latin *hybrida*, a piglet resulting from the union of a wild boar and a tame sow. *Hybrida* comes from the Greek *hubris* (or *hybris*), meaning wanton violation or violence, excessive pride. See http://www.geocities.com/etymonline/h2etym.htm.

oxymoron, a figure of speech that "holds together contradictions and sustains them in an impossible unity, without progression toward synthesis," the fantastic imagines a new kind of reality.[46] Antirational rather than irrational, the fantastic embraces antinomism and hovers in a realm between the real and the surreal. According to the Structuralist Tzvetan Todorov, within the genre of the fantastic it is not plausible to attribute phantasmic occurrences definitively to rational causes. If so, the genre would be that of the *uncanny*, in which the inexplicable, no matter how horrifying, can be explicated by previous (repressed) events, which adhere to laws of the natural world. On the other hand, it is also impossible in the fantastic to explain the extraordinary by means of magical intervention, as can be done in fairy tales; supernatural causes belong to the genre of the *marvelous*. The fantastic, then, lies between the uncanny and the marvelous, between a past steeped in reality and a future of infinite possibility.[47]

In the realm of the fantastic, the borders we perceive between the organic and the inorganic become irrelevant. The body and its psyche are left susceptible to transformative experience, including the protraction or contraction of time, the distortion of space, and the fusion of subject and object. Such phenomena are common to the realms of madness, dreams, and drug-induced states of dementia. They are also synonymous with the way infants perceive reality until they are able to differentiate themselves from their surroundings. In this way the fantastic corresponds to the first stage in Freud's model of ego development: the primary, narcissistic, autoerotic moment when the infant feels at one with the world.[48] From here, according to Freud, the child will progress from this anal-sadistic stage of self-love to an identification with external objects and then to full genital maturity and (sexual) desire for the other. This psychosexual evolution requires recognition of and respect for difference: between the generations, the sexes, and specific forms of pleasure (i.e., genital versus oral or anal). Yet there remains a fundamental compulsion or instinct to return to the initial, utopian phase, and Freud identifies this instinct as the most extreme form of the pleasure principle: a longing for undifferentiation, a return to point zero.[49] This regressive drive is the foundation for perversion, in which the most sacrosanct partitions—parent/child, male/female, self/world—are utterly eroded.[50] It results in the creation of an anal-sadistic universe, a Sadean realm in which the paternal law is violated on every possible level. In the words of psychoanalyst Janine Chasseguet-Smirgel, it becomes "the universe of *sacrilege*":

> All that is taboo, forbidden or sacred is devoured by the digestive tract, an enormous grinding machine disintegrating the molecules of the mass thus obtained in order to reduce it to

46. Jackson, *Fantasy*, p. 21.
47. Tzvetan Todorov, *The Fantastic: A Structural Approach to a Literary Genre*, trans. Richard Howard (Ithaca, N.Y.: Cornell University Press, 1975).
48. Jackson makes this point in *Fantasy*, pp. 72–73: "The fantastic can be seen as corresponding to the first stage in Freud's evolutionary model, that stage of a magical and animistic thought mode when primitive man and the young child have no sense of difference between self and other, subject and object worlds. Fantasy, with its tendency to dissolve structures, moves towards an ideal of *undifferentiation*, and this is one of its defining characteristics. It refuses difference, distinction, homogeneity, reduction, discrete forms."
49. See ibid., p. 73.
50. See Chasseguet-Smirgel, *Creativity and Perversion*, pp. 2–3.

excrement. The erotogenic zones and different parts of the body become interchangeable and are metamorphosed by a kind of diabolical surgery. . . . I think this recurring theme of the changing of forms—of man's ability not to annihilate things but to dissolve and metamorphose them after breaking down the molecules—means that all things revert to chaos, the original chaos that may be identified with excrement.[51]

The perverse imagination—well rehearsed in Barney's early work, with its specific references to anal sadism, digestion, regression, and morphosis—is what dreams the *Cremaster* cycle. No longer a subject, as it was in the *Otto* cycle, the creative potential of perversion pervades the very genetic code of the *Cremaster* project; it is the conceptual goo—like Barney's signature petroleum jelly—that links each installment, the substance that binds together the drawings, films, photographs, sculptures, and books. On another level the psychoanalytic model of perversion provides Barney with yet another vehicle through which to contemplate the conflicts inherent to the process of differentiation and the utopian promises of its reversal. In the *Cremaster* cycle he amalgamates the psychoanalytic with the biological and the mythological to create a polysemic thematic structure. Like the three running legs of the Manx triskelion—the emblem for *Cremaster 4*—these tropes power the cycle's narrative drive, giving Barney a range of interrelated metaphors with which to shape his sculptural project.

51. Ibid., p. 4.

Artist's conceptual mapping of the *CREMASTER* cycle, showing
locations, ca. 1994

Artist's conceptual mapping of the *CREMASTER* cycle, showing
locations, ca. 1994

PART II | Cycle

OF GEOGRAPHY AND GENEALOGY

The *Cremaster* cycle follows an eastward trajectory, beginning in the American Northwest and ending in Eastern Europe. The first film, *Cremaster 1*, takes place in Boise, Idaho, in the blue-Astroturfed Bronco Stadium of Boise State University. *Cremaster 2* moves back and forth between the Columbia Icefield in Canada and the Bonneville Salt Flats in northern Utah, which form part of the Mormon basin. These two sites connect the longitudinal sweep of the Rocky Mountains, which, as part of the Continental Divide, splits westward-flowing from eastward-flowing waters.[52] New York's classic Art Deco Chrysler Building, designed by William Van Alen and completed in 1930, is the setting for *Cremaster 3*. The film also includes detours to the city's Guggenheim Museum, to the harness track in Saratoga Springs, to Giant's Causeway in Northern Ireland, and to Fingal's Cave, on Staffa, an island in the Scottish Hebrides. The Isle of Man—set in the Irish Sea, and host to the annual TT (Tourist Trophy) motorcycle race—is the location for *Cremaster 4*. And *Cremaster 5*, the final link in the filmic chain, features Budapest's neo-Renaissance Hungarian State Opera House, Gellért Baths, and Lánchíd Bridge.

Preselected for their symbolic valences, these diverse locations form their own constellation, the outline of which metaphorically traces the cyclical path taken by an organism in conflict with itself. Collectively they demarcate a distinct landscape, a unique intercontinental geographic swath that is imbued with narrative. The confluence of place and story in the *Cremaster* cycle reinforces the sculptural dimensionality of the films while literally grounding their metaphoric content in the empirical world. Barney started the project with this map, knowing only the particular sites and the degrees of "ascension" or "descension" they would individually express. It wasn't until he began each chapter that its plot emerged, in response to the history and distinctive traits of each location as well as to the degree of character articulation achieved in the film preceding it.[53]

Taking the cremaster muscle as its conceptual departure point, the project circulates around anatomical allusions to the height of the gonads during the embryonic process of sexual differentiation: *Cremaster 1* represents the most "ascended" state, *Cremaster 5* the most "descended." But as the cycle evolved over the course of a decade, this biological model became less prominent; other paradigms, such as biography, history, and codes of behavior, came to the fore as vessels for Barney's narrative constructs. For this reason, while the *Cremaster* cycle should certainly be viewed in its specified numerical sequence, it should also be experienced in the order it was made (4, 1, 5, 2, 3), for this will reveal the development of Barney's relationship to the material and of his thinking process. As a topographical map, a diagrammatic proposal,

52. Saul B. Cohen, *The Columbia Gazetteer of the World* (New York: Columbia University, 1998), p. 718. Considered the "backbone" of North America, the Continental or "Great" Divide runs along the crest of the Rocky Mountains from Northern Alaska to New Mexico.

53. "It's like a game of add-on," Barney has explained. "The pieces have become more about storytelling: 'character zones' are created for a given project, and as they reach their limit of development (or lack of it), the remaining, unarticulated aspects of that zone become the outline for the next set of characters." Quoted in Goodeve, "Travels in Hypertrophia," p. 69.

CREMASTER 1: The Goodyear Waltz, 1995 (detail)

the *Cremaster* cycle has no definitive beginning or end, no indisputable point of departure. It functions as a loop, particularly in the chronology it subtly reveals.

The *Cremaster* cycle has an autobiographical dimension, which is quietly present throughout its chapters. Muted details of Barney's own life may be detected in his selection of locations for the project, which, when read together, suggest a personal genealogy. Boise is the town in which he grew up. Back then he must have been drawn to the 30,000-seat Bronco Stadium at Boise State University, since he was a serious athlete who played on his high school football team. For Barney, too, the Rocky Mountains represented a geographical partition, dividing his childhood home from New York City, where his mother relocated once his parents separated. After graduating from Yale University, in New Haven, Barney moved to New York, where he lives today.

CREMASTER 1: Red Lounge Manual, 1995

These biographical facts correspond to the first three *Cremaster* install-
ments, with their locations in the American West and in New York. In
Cremasters 4 and *5* the chronology circles back on itself to a time before
birth: the Isle of Man, situated in the Irish Sea midway between England,
Ireland, and Scotland, suggests the artist's own Celtic ancestry (as also, for
that matter, do the allusions to the Irish labor unions of 1930s New York in
Cremaster 3). And Budapest, in turn, is the birthplace of Harry Houdini, né
Ehrich Weiss, who is in many ways Barney's alter ego, as manifest in the *Otto*
cycle's Character of Positive Restraint. This chronological two-step—a
movement forward only to go back (and vice versa)—is given dramatic form
in *Cremaster 2*, which makes its narrative vehicle the life of Gary Gilmore,
the convicted killer immortalized in Norman Mailer's book *The Executioner's
Song* (1979). Said to have been a grandson of Houdini, Gilmore was executed
by firing squad in 1977 for murdering two men. Barney's version of the story
begins with Gilmore's conception, enacted as a séance officiated over by Baby
Fay La Foe, his paternal grandmother and an amateur spiritualist who
supposedly seduced the magician.[54] The narrative proceeds with one of
Gilmore's crimes and with his execution, then arcs backward through crys-
talline layers of glacial ice to reveal the liaison between Houdini and Baby
Fay at the 1893 World's Columbian Exposition, where Houdini performed
one of his famous "metamorphosis" performances. Staged by Barney in the
ice of the Canadian Rockies, this encounter takes on the magnitude of predes-
tination, setting in motion the factors that will determine Gilmore's destruc-
tive actions.[55] It also reinforces the paternal dynamic explored in the film,

54. Every year on October 31, the anniversary of
Houdini's death, fans perform séances in an effort to
contact his spirit.

55. The World's Columbian Exposition actually took place
in Chicago, where a nineteen-year-old Ehrich Weiss
performed as Harry Houdini as part of a magic act called
"The Brothers Houdini." Making a play on words, Barney
transposes this world's fair onto the Columbia Icefield.

which is embodied by the playing of Houdini by Mailer, who, as the author of *The Executioner's Song*, had brought Gilmore to life, so to speak.

The chronology of the *Cremaster* cycle follows a similarly looping trajectory, moving forward in increments only to sweep backward to form a much larger circle in time. The locations of the Isle of Man and Budapest suggest generative forces: places, eras, and individuals that resonate forward, impacting on Barney's consciousness and on his development as an artist. Their position in the order of the cycle also suggests a deliberate temporal confusion and a disregard for generational differences that is a hallmark of the perverse imagination. In a text remarkably relevant to the *Cremaster* cycle, Irving Buchen writes that in perverse literature there is a "curious and disarming fusion of the old and the new, the pagan and the sophisticated. It appears to be moving in two directions simultaneously.... Its paradoxical chronology of progressive regression grants it a circular shape in which ends are buried in origins as the child once again becomes the father of the man."[56]

EMBRYONIC TIME

While the *Cremaster* cycle expands outward in time from the period of an individual life to the passage of centuries, it also describes what is by comparison almost a nanomoment: the first six weeks of an embryo's development. During this fleeting interlude, the just-formed fetus is pure potential. Neither male nor female, it hovers in a realm of gender indeterminacy. Free from defining pronouns and anatomical indicators, the fetus, for one brief instant, occupies a space of possibility. It lingers before the moment of difference, the "either-or" that shapes all future thought and action. The *Cremaster* cycle imagines the prospect of suspending this phase indefinitely, resisting the inexorable impetus toward division. Its five installments ponder this internal struggle against definition, while tracing the passage from full ascension to complete descension.

CREMASTER 1

Cremaster 1, a candy-coated musical revue shot in Barney's hometown, envisions the state of total ascension. It is, therefore, the most undifferentiated of the installments, though the sensibility of the piece is decidedly feminine. Perhaps this is because the developing embryo is always by default female. Every human has at least one X chromosome; it takes the addition of the sex-determining Y chromosome, and the hormones this chromosome triggers, to shift the organism toward some variation of maleness. *Cremaster 1* envisages this zone of willful ambiguity on the expansive blue playing field of Boise's Bronco Stadium at night.

56. Irving Buchen, ed., *The Perverse Imagination: Sexuality and Literary Culture* (New York: New York University Press, 1970), p. 29.

Two Goodyear Blimps—"aerial ambassadors"[57] and corporate icons for the world-famous rubber and tire company—float above the stadium, like the airships that often record and transmit live sporting events. The interior of each blimp is outfitted in futuristic retro chic: shades of the mod-yet-minimalist space station of Kubrick's *2001: A Space Odyssey* (1968) merge with the streamlined ocean-liner sensibility of Warren McArthur. Four air hostesses, uniformed in trimly fitted 1930s suits (designed by Isaac Mizrahi), silently tend to each blimp. The only sound is the soft yet persistent ambient music, which suggests the hum of the engines. In the middle of each cabin sits a white-clothed table, its top decorated with an abstract Art Deco center-piece sculpted from petroleum jelly and surrounded by clusters of grapes. In one blimp the grapes are green, in the other they are purple. Under both of these otherwise identical tables resides Goodyear, a platinum-blonde Hollywood starlet wearing a white satin teddy, gartered stockings, and clear-plastic high-heeled shoes, complete with ankle straps and a bell-like funnel attached to one sole. Miraculously inhabiting both blimps simultaneously, this doubled creature sets the narrative in motion. After prying an opening in the tablecloth(s) above her head, she plucks grapes from their stems and pulls them down into her insulated white cell. With these grapes—which get mysteriously ingested and expelled through the silver funnel on her shoe—Goodyear produces diagrams that direct the choreographic patterns created by a troupe of dancing girls on the field below. The camera switches back and forth between Goodyear's drawings and aerial views of the chorines moving into formation: their designs shift from parallel lines to the figure of a barbell, from a large circle to an outline of splitting and multiplying cells, and from a horizontally divided field emblem to a rendering of an undifferentiated reproductive system. Gliding in time to the effervescent musical score, the smiling chorus girls delineate the contours of a still-androgynous gonadal structure, which echoes the shapes of the two blimps overhead.

Cremaster 1 is pure utopia, a narcissistic paradise of total undifferentia-tion. This is the pleasure principle incarnate. The organism depicted—a compilation of Goodyear, her blimps, her attendants, and her chorus—is suspended in a tautological state of self-identification. Its only referent is itself. And since there is no sense of contradiction or conflict, the organism feels at one with the world. Its only challenge is to try to sustain this ephemeral sense of equilibrium. But Barney adds a subtle reminder of the dangers inherent in the hubris of absolute self-enclosure: the bunches of grapes on each table are the attributes of Bacchus, Greek god of wine, and a symbol of orgiastic abandonment. Such coded references to Dionysian excess in this tightly choreographed musical number of a film hint at the very fine line between self-love and loss of self.

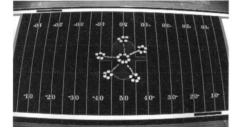

Video still from *CREMASTER 1*, 1995

57. Quoted from the Goodyear Tire and Rubber Company's Web site: http://www.goodyearblimp.com.

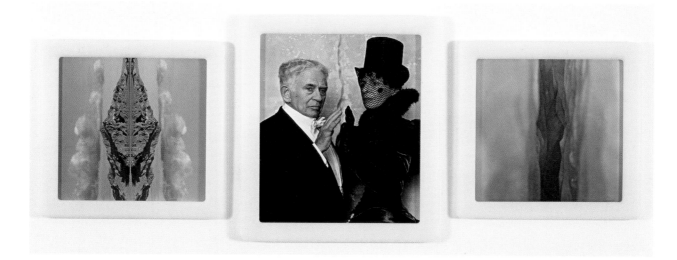

CREMASTER 2

Cremaster 2, based loosely on the life of Gary Gilmore, introduces conflict into the system. On the biological level it corresponds to the next phase of fetal development: the initial stirrings of the drive toward sexual division from an originary state of innate bisexuality. This represents a movement toward the internal reorganization of the still-neutral gonadal structures: "One set eventually regresses and atrophies while the other proliferates and differentiates."[58] In Barney's reinterpretation and abstraction of the process, the organism fights against this progressive division, trying to remain in the state of equilibrium imagined in *Cremaster 1*. *Cremaster 2* embodies this regressive impulse through its looping, two-step narrative and genealogical structure, moving from 1977, the year of Gilmore's execution, to 1893, when Houdini, who may have been Gilmore's grandfather, performed one of his great escapes at the World's Columbian Exposition. The idea of looking forward and backward simultaneously, in a kind of chronological double vision, is manifest in images of landscapes doubled by reflection, a leitmotif of the film. The opening sequence shows the vast horizon line of the Bonneville Salt Flats bisecting a mountain range, which is reflected in the transient lake that seasonally floods the ground. In the Columbia Icefield the camera zooms into crystal-blue glacial crevices, the sides of which appear as mirror images of themselves, as if seen in a kaleidoscope. Rotating these views ninety degrees to create abstract vertical images that recall Rorschach shapes, Barney alludes by mere form to the psychological dimensions explored in the narrative.

CREMASTER 2: Genealogy, 1999

58. John Money, "Psychosexual Differentiation," in Money, ed., *Sex Research: New Developments* (New York: Holt, Rinehart and Winston, Inc., 1965), p. 4.

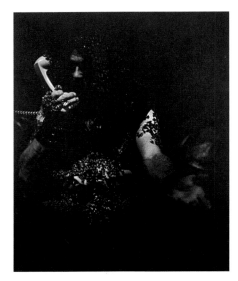

CREMASTER 2: The Man in Black, 1999

Cremaster 2 is structured around three primary interrelated themes—the landscape as witness, the story of Gilmore, and the life of bees—that metaphorically describe the emancipatory potential of moving backward in order to escape one's destiny. The narrative begins and ends in glacial chasms, a device that metonymically suggests the migration of a glacier from northern Utah to southern Canada, its retreat forging the desert-like salt flats, the Great Salt Lake, and the dramatic gorges of the Rocky Mountains, which all play roles in the film. The environment depicted is the barren frontier of the early Mormon settlers, religious separatists carving out their own Zion on American soil, where the ten lost tribes of Israel were one day to reunite. An avenging people with occultist tendencies, the original Mormons taught that redemption could only be obtained through "blood atonement," the actual spilling of a sinner's blood on the earth. Such was the legacy that Gilmore, himself a Mormon, inherited.

Having established the western landscape as a character, Barney proceeds by weaving together Gilmore's biography and the behavior of the bee colony, symbol of Utah and of Mormonism. Both Gilmore's kinship to Houdini and his correlation with the male bee or drone is established in the séance/conception scene in the beginning of the film. All the participants—Fay; her son, Frank; and Frank's wife, Bessie—wear corsets under their turn-of-the-century garb, and they sit in stylized chairs that reiterate the constriction of their wasp waists. Less a fashion than a fetishistic process promising pleasure through the endurance of pain, corseting is a verb.[59] In Barney's depiction of the Gilmore family, it represents an act of extreme control, and alludes to the questions that Gary's execution will raise about the efficacy of volition in the face of destiny. Summoning forth Houdini's spirit, Fay's psychic intervention—complete with ectoplasm and pollen—induces a meditative sex act between Frank and Bessie, which is intercut with scenes of the magician's metamorphosis. At the moment of climax, Frank's torso begins to putrefy, and a bee flies from the hive at the head of his penis. Destroyed during the act of fertilization, as a drone bee is doomed to death after mating with the queen, Frank creates another drone: his son Gary. From the moment of his inception, then, Gary's destiny is sealed.

Gilmore's profound awareness of his own condemnation, of his irreversible role as drone, is expressed in the ensuing scene through a chain of metonymic signifiers that could only come together within the poetic space of the *Cremaster* cycle. The setting is a recording studio where Dave Lombardo, a former member of the thrash speed-metal band Slayer, is pounding out a drum solo to the buzzing sound of thousands of swarming bees. (The score was written by Barney collaborator Jonathan Bepler.) A man in black leather, with the voice of Steve Tucker, lead vocalist of the death metal

59. "Endurance is precisely the quality required for body-sculpture, because the tight-lacer's ultimate objective is to extend the erotic experience in time. Unlike 'pure' sadomasochists, sculptural fetishists aim less for the momentary violent ecstasy than to prolong a state of just-bearable tension." David Kunzle, *Fashion and Fetishism: A Social History of the Corset, Tight-Lacing and Other Forms of Body-Sculpture in the West* (Totowa, N.J.: Rowman and Littlefield, 1982), p. 37.

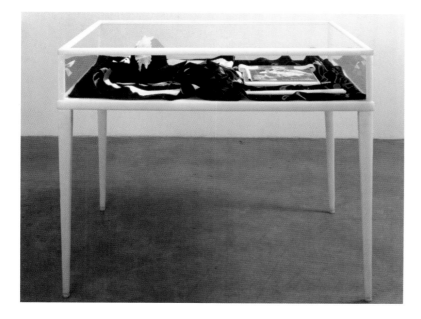

The Cabinet of the Man in Black, 1999, with detail (below)

band Morbid Angel, growls into a telephone. He is shrouded by bees. Collectively these figures allude to the country star Johnny Cash, who is said to have called Gilmore on the night of his execution in response to the convict's dying wish. The lyrics are Gilmore's own, excerpted from letters published in *The Executioner's Song*:

> The ghosts have descended and set upon me with a force
> I smack 'em down but they sneak back and climb in
> Demons that they are tell me foul jokes
> They want to sap my will, drink my strength, drain my hope
> Lost empty foul dream motherfuckers....
>
> Weave a web of oldness
> Oldness pull in harness
> Like oxen a wood creaking
> Tumbrel a gray wood
> Tumbrel through the cobbled streets
> Of my ancient mind

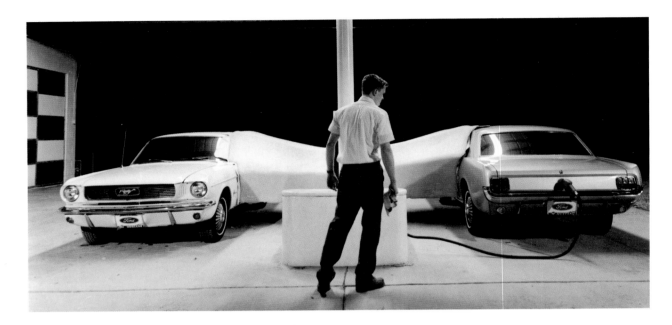

Video still from *CREMASTER 2*, 1999

The transmutation of Cash into the Lombardo/Tucker/death-metal matrix connects Gilmore's lamentations about being haunted by "oldness" to the dark undertow of heavy metal music's flirtation with satanic lore. It suggests that Gilmore's destiny of being annihilated like a drone had its roots in previous lifetimes, in an ancient curse passed through his paternal lineage.[60]

Barney imagines the act that sealed Gilmore's fate—the cold-blooded murder of a young Mormon gas station attendant in Orem, Utah—in both sculptural and dramatic forms. Following Mailer's inferences that Gilmore killed out of a kind of perverse longing for union with his girlfriend, Nicole Baker, Barney represents their relationship through two conjoined cars: the blue and the white 1966 Mustangs that they coincidentally both owned. He connects these vehicles via a honeycomb tunnel, which joins the front seats into one long upholstered channel and traverses the pump island of the filling station where they are parked. Trapped inside this eroticized automotive zone, Gilmore (played by a prosthetically altered Barney) wrestles with his desires, his will, and his destiny. His struggle is conveyed by his frustrated attempts to build an abstracted mountain range—the glacier-hewn Rocky Mountains—out of Vaseline, in an allusion to the trajectory of his own life, moving forward to his execution and backward toward the time of Houdini. Thoughts of Nicole materialize in the plaintive voice of folksinger Patty Griffin, who is shown for a moment, upside down and against a black backdrop, so that her face and hair form the outline of a skull. Gilmore changes

60. Mikal Gilmore, younger brother of Gary Gilmore, suggests this notion of a family curse in his memoir *Shot in the Heart* (New York: Doubleday, 1994). The reference to heavy metal music also functions similarly to Barney's use of the Oakland Raiders as a symbol in his work: the Raiders—whose banner "Commitment to Excellence" appears in the back of the recording studio—are a favorite team of Barney's, just as Slayer is one of his favorite bands.

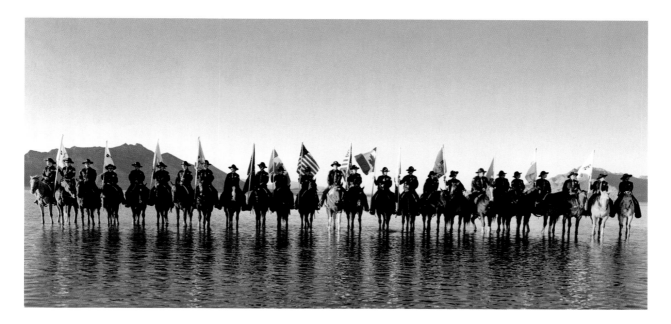

out of prison uniform[61] into jeans and a T-shirt, revealing a tiny bud of a penis and no scrotum to speak of—a condition alluding to Mailer's hypothesis that Gilmore was sexually incompetent and had pederastic tendencies. It is also an anatomical disorder—known as "partial-androgen-insensitivity"—that functions here as a reminder (not without humor) of the undescended testicles in the early stages of embryonic development that are *Cremaster 2*'s thematic paradigm.[62]

In the murder sequence that follows, Gilmore shoots the gas station attendant, Max Jensen, twice in the back of the head on the tiled floor of the station bathroom. He commits his crime seeking some form of consummation or release, approaching this catastrophic act as if, in J. G. Ballard's words, it will be "a fertilizing rather than destructive event."[63] Indeed, it sets in motion the trial and verdict that will condemn him to death, a sentence he embraces despite all efforts to overturn it. (Gilmore's highly controversial execution was the first act of capital punishment performed in the United States in a decade.) Barney stages the judgment of Gilmore in the Mormon Tabernacle Choir's elaborate, pipe-organ-studded hall. Replicated in 1:8 scale and digitally animated, the Choir itself echoes the beehive—industrious, ordered, guarded, defensive. An emblem of the self-contained Mormon community, the Tabernacle/beehive bears witness to the murder of one of its own and seeks vengeance through the doctrine of blood atonement, otherwise known, in contemporary parlance, as state-sanctioned execution. Gilmore welcomes

Production photograph from *CREMASTER 2*, 1999

61. At the time of his murders of Max Jensen and Ben Bushnell, Gary Gilmore was on parole from a twelve-year sentence for armed robbery. This was only one in a string of incarcerations, a fact that interested Barney, for it made his subject more of a blank slate on which to draw character. "Gilmore spent his entire life in prison so he doesn't have a developed life in the world. Conceptually he's more of a vessel than would be somebody who lives in the world." Barney, in an interview with Jonathan Jones, "Lonesome Cowboys: Matthew Barney," *Untitled*, no. 21 (spring 2000), p. 6. reprinted at http://www.postmedia.net (2001).
62. In cases of borderline androgen insensitivity, when "body cells . . . can make only partial use of androgen, . . . the child is born with a clitorine penis lacking a urinary tube and only slightly larger than an ordinary clitoris. The testicles can be felt as lumps in the groin.

The scrotum is partially unfused." Money and Tucker, *Sexual Signatures*, p. 55. Money and Tucker recommend that infants born with this hormonal disorder be surgically transformed into girls, even though they have XY chromosomes.
63. Seeing a potential for transcendence in catastrophe or bodily mutilation, Ballard repeatedly emphasizes technologically induced death. In *The Atrocity Exhibition*, p. 23, he writes, "Apart from its ontological function, redefining the elements of space and time in terms of our most potent consumer durable, the car crash may be perceived unconsciously as a fertilizing rather than destructive event—a liberation of sexual energy." This sensibility is also applicable to the motorcycle crash of *Cremaster 4* and the demolition derby of *Cremaster 3*.

Video stills from *CREMASTER 2*, 1999

death, refusing to appeal his sentence and opting for execution by firing squad, in a literal interpretation of the Mormon belief that blood must be shed in order for a sinner to obtain salvation.[64]

Cremaster 2 stages Gilmore's execution as a prison rodeo in an arena cast entirely from salt in the middle of the flooded Bonneville Salt Flats. In itself a sculpted earthwork, this gleaming white stadium appears in the waters like a mirage, an ethereal receptacle for the ritualistic dream-sequence that ends Gilmore's life. A posse of mounted state troopers begins the proceedings by parading through the arena, making drawings in space like the precision dancers in *Cremaster 1*. Aerial shots capture their formations while revealing the immense, almost otherworldly scale of the Utah landscape surrounding them. Gilmore is lowered onto a Brahman bull; the gates are opened, and he rides to his death. Two mounted sheriffs use a silver rod to measure the distance between the dying bull's head and the ground onto which it slowly falls. Recalling the coroners who attended Gilmore's execution—as witnesses to the four shots to the heart—these men record the absolute moment of death, making certain their prisoner is categorically deceased. In the blinding white light of the salt flats, both man and beast expire. The ring of ten bison that forms around Gilmore's fallen body symbolizes his salvation within the Church of Latter-Day Saints. Barney translated this ceremonial circle from a baptismal font in the Mormon Temple in Salt Lake City; sculpted into the font are bison representing the lost tribes of Israel (Asher, Dan, Ephraim, Gad, Issachar, Manasseh, Naphtali, Reuben, Simeon, and Zebulun), which, according to Mormon belief, were to reunite on American soil and create paradise on Earth.[65]

In Barney's interpretation of the execution, Gilmore was less interested in attaining Mormon redemption than in performing a chronological two-step that would return him to the space of his grandfather Houdini, with whom he identified the notion of absolute freedom through self-transformation. Seeking escape from the bonds of his fate, he chose death in an act of ultimate self-will. "In about 30 hrs. I will be dead," he wrote to Nicole. "That's what they call it—death. Its just a release—a change of form."[66] Gilmore's metaphoric transportation back to the turn of the century is rendered in a dance sequence featuring the Texas two-step accompanied by Nicole Baker's lamentation:

> For lost is my mind
> Silent by dawn
> Loves away stolen
> And hurting is long

64. Richard Flood points out that Gary Gilmore became a "public relations nightmare" for the Mormons because, as a Mormon, he "lost none of his Church's baptismal privileges, including the guarantee of immortality. Through his self-willed Blood Atonement, Gilmore doubly insured that he achieved the eternal glory that was his Mormon birthright; it was the ultimate great escape." Flood, "The Land of the Everlasting Hills," in Matthew Barney, *Cremaster 2*, exh. cat. and artist's book (Minneapolis: Walker Art Center, 1999), n.p.
65. According to Mormon doctrine, two of the twelve tribes were never lost: the tribe of Judah became the Jewish nation and that of Joseph became the Mormons. A photograph of the sculpted baptismal font is included in the original storyboard for *Cremaster 2* and is reproduced on p. 230 in this volume. Barney created banners bearing the insignia of the ten lost tribes, which the mounted police carry into the stadium. He used these banners to divide his artist's book on *Cremaster 2* into sections or sequences.
66. Gary Gilmore, quoted in Norman Mailer, *The Executioner's Song* (New York: Warner Books, 1979), p. 857.

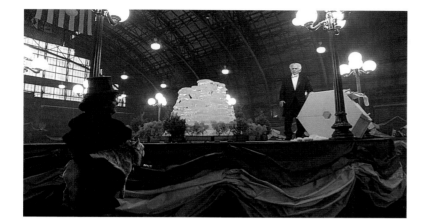

Video still from *CREMASTER 2*, 1999

So ask me no questions
Sing me no songs
Follow me nowhere
I'm already gone

Gilmore leaps into the void in a vain attempt to transcend his position as drone, thinking that Houdini, with his gift for metamorphosis, will hold the key to this esoteric process. In order for Gilmore or Houdini to overcome their rank, they must transform themselves into females: the worker bee or the queen herself.[67] In his metamorphosis performances Houdini would mysteriously switch places with his wife, Bess, from inside a padlocked trunk. Bound, shackled, and even enveloped in a bag, he would escape his constraints time and again to replace Bess on the stage. In the last scene of *Cremaster 2*—staged in the cold, foggy environs of the Columbian Exposition hall—Houdini has just completed his magic act. Ice sculptures of beehives melt around him and his trick cabinet. His accomplices, two uniformed Canadian Mounties, have already left the podium. The queen bee, Baby Fay La Foe (Gilmore), descends upon him, suspecting his plans for transgender transformation and sensing the emergence of a potential opponent for her throne. Her goal is to seduce and vanquish him. Houdini enters into this alliance willingly, certain he will withstand her destructive forces. The result, other than the life of Gary Gilmore, remains unknown.

CREMASTER 3

Cremaster 3, the last film of the cycle to be completed, forms the spine of the entire opus. As the central chapter of the five installments, it functions like a double mirror, reflecting those before and anticipating those to follow. In the

67. This section is paraphrased from the artist's unpublished notes on *Cremaster 2*.

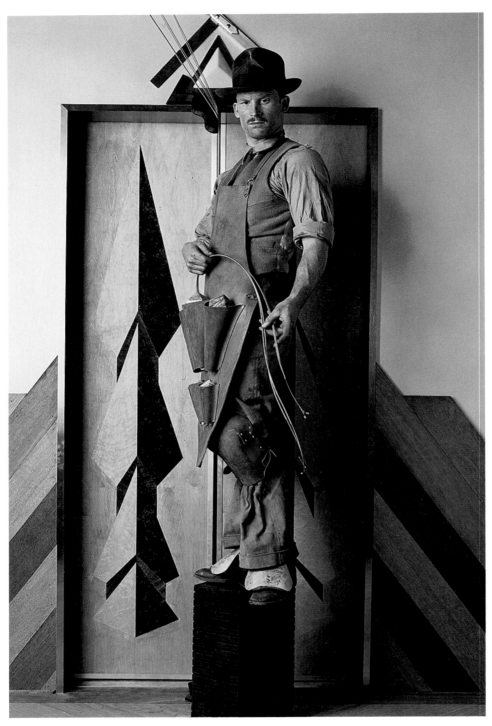

CREMASTER 3: The Song of The Vertical Field, 2002 (detail)

biological course traced by the *Cremaster* cycle, the third phase is one of reassessment, of traveling halfway on the path toward differentiation and recognizing the fact that self-imposed resistance, no matter how powerful, cannot prevent the inexorable division of the sexes. Acceptance, however, is not a passive state: it represents a shoring up of internal resources for the battles between entropy and growth that lie ahead. The most self-reflexive of the cycle's chapters, *Cremaster 3* occupies a space of narcissism. It folds all the other sections into its narrative structure, as if they had been born there and then had flowed outward from this central core. Set largely in New York City, where Barney lives and works, the film is in essence a distillation of his major themes and signature aesthetic devices, filtered through an elaborate symbolic matrix involving Freemasonry, Celtic lore, and Art Deco desires.

The trope of division so critical to the *Cremaster* cycle as a whole is understood in this chapter as a sociopolitical construct through a story line involving Irish labor unions and organized crime in Depression-era New York. The colors of the Irish national flag—orange and green—pervade the scenography. Introduced in 1848 as an emblem of the Young Ireland Movement, the flag symbolized a fusion of perceived opposites: the green represented the older Gaelic and Anglo-Norman faction of the country; the orange signified the Protestant population; and the white between them an everlasting peace.[68] Barney uses the combination of, or partition between, these colors as a structural element throughout the project—much as he uses the blue and yellow palette of *Cremaster 4*. Partitioning is also a model for the ritualized processes of introspection associated with Freemasonry, which professes personal transcendence through the idea of separating from and killing off one's lower self; a Masonic candidate must "lose his life to save it."[69]

In *Cremaster 3* Barney fuses together these varied references as so much raw material with which to fabricate a fantastical account of the construction of the Chrysler Building. And like the Masonic lodge, which, as symbolic architecture, represents the sacred temple within every worthy candidate, Barney's Chrysler tower is itself a character.[70] This extravagant folly of a building—a "paroxysm of detail"—is the personification of inner potential.[71] The progression of its erection symbolizes the fortification of self through the perfectly disciplined will, a process described in a remark by the legendary football coach Vince Lombardi that serves as the epigram for the film: "Character is the integration of habits of conduct superimposed on temperament. It is the will exercised on disposition, thought, emotion, and action. Will is the character in action."[72] As in his pre-*Cremaster* works, Barney invests an architectural space with psychological and physiological depths. The Chrysler Building becomes an organism, host to inner, antagonistic forces at play for control of and access to the process of (spiritual)

68. The designer of the Irish flag, Thomas Francis Meagher, stated that "our tri-colour, my friends, will be this: A tri-colour orange, white, and green. This we will present to the Irish people. The white would symbolize the peace between the green of the Catholics and the orange of the Protestants." Reg. A. Watson, *The Life and Times of Thomas Francis Meagher* (Tasmania, Australia: Anglo-Saxon-Keltic Society, 1996), p. 8.
69. W. L. Wilmshurst, *The Meaning of Masonry* (New York: Grammercy Books, 1980), p. 126.
70. "Man himself is a lodge. And just as the Masonic Lodge is 'an assemblage of brethren and fellows met to expiate upon the mysteries of the Craft, so individual man is a composite being made up of various properties and faculties assembled together in him with a view to their harmonious interaction. . . . A man's first entry into a Lodge is symbolical of his first entry upon the science of knowing himself. His organism is symbolized by a

four-square or four-sided building. . . . The East of the Lodge represents man's spirituality. . . . The West (or polar opposite of the East) represents his normal rational understanding." Ibid., pp. 91–92.
71. "Paroxysm of detail" is Rem Koolhaas's description of the Chrysler Building, in *Delirious New York: A Retroactive Manifesto for Manhattan*, 1978 (reprint ed. New York: The Monacelli Press, 1994), p. 129.
72. Vince Lombardi, quoted in David Maraniss, *When Pride Still Mattered: A Life of Vince Lombardi* (New York: Simon & Schuster, 1999), p. 406. Lombardi goes on to say, "The character, rather than education, is man's greatest need and man's greatest safeguard, because character is higher than intellect. While it is true the difference between men is in energy, in the strong will, in the settled purpose and in the invincible determination, the new leadership is in sacrifice, it is in self-denial. . . . This gentlemen, is the distinction between great and little men."

transcendence. These factions find form in the struggle between the Architect, Hiram Abiff (played by Richard Serra), and the Entered Apprentice (played by Barney), who participate in a hubristic relationship defined by betrayal, punishment, and revenge. Both characters are working on the creation of the building, its design and construction respectively. The narrative of the film follows their ascent through the tower.

The Architect and the Apprentice are reenacting the Masonic myth of Hiram Abiff, purported chief architect of Solomon's Temple, who possessed knowledge of the secret mysteries of the universe. Biblical accounts of the Temple make no mention of the name "Hiram Abiff," but do refer to a Hiram of Tyre, a skilled craftsman hired by Solomon to embellish the Temple structure with metalwork. This Hiram cast the two monumental, freestanding brass pillars that flanked the east vestibule of the Temple.[73] Measuring some twenty-seven feet in height and six feet in depth, these columns were named Jachin, which is thought to mean "He establishes," and Boaz, which is believed to mean "In Him is strength."[74] According to Masonic legend, this same Hiram of Tyre/Hiram Abiff was accosted by three apprentice stonemasons who demanded that he divulge the secret name of God. When he refused, they killed him with a blow to the forehead with a setting maul, then hastily buried his body. When the body was found, King Solomon disinterred it, using the grip of a Master Mason, which incorporates the Five Points of Fellowship: foot is placed to foot, knee to knee, breast to breast, hand to back, and mouth to ear. So embraced, Hiram Abiff came back to life and whispered the phrase "*Maha byn*," an untranslatable term that stands as a surrogate for the words of divine knowledge lost at Abiff's death, much as the Hebrew word "Jahweh" is a surrogate for the name of God.

The murder, burial, and resurrection of Hiram Abiff are reenacted during Masonic initiation rites as the culmination of a three-part process through which a candidate progresses from the first degree of Entered Apprenticeship, to the second of Fellowcraft, to the third of Master Mason.[75] A sacramental brotherhood devoted to the pursuit of inner truth, Freemasonry is premised on an elaborate allegorical system rooted in the vocabularies of architecture, geometry, and ancient mystery. In Freemasonry's use of architectural phraseology, which both conceals and communicates its spiritual teachings, Barney discovered an analogue to his own hermetic structures. He adopted its language as yet another vessel through which to explore internal thresholds and the application of will. Masonic symbols permeate *Cremaster 3*, adding yet another interpretive level to the cycle's already multivalent coded system.

The core of the film takes place in 1930. That year, Prohibition was still law; organized crime—the Syndicate—had infiltrated organized labor in

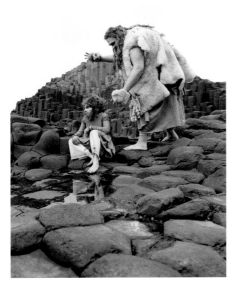

Production photograph from *CREMASTER 3*, 2002

73. On Hiram of Tyre, see 1 Kings chapter 7. Hiram also cast an enormous brass cistern mounted on a circle of twelve life-sized bronze bulls, which symbolized the twelve tribes of Israel under the tutelage of King Solomon. See 1 Kings 7:23, 25. This cistern was the model for the Mormon Temple baptismal font that inspired Barney's ceremonial bison circle in the execution scene in *Cremaster 2*. His subsequent conflation of Masonic and Mormon symbolism in the *Cremaster* cycle reflects the historical overlapping of the two doctrines. Joseph Smith, the founder of Mormonism, was a Freemason and borrowed freely from its rites for Mormon services.

74. Translations of the names of the two columns vary from source to source. One history of King Solomon argues that the names derive from dynastic oracles inscribed in Hebrew on each pillar: the Jachin oracle read "Yahweh will establish . . . your throne forever" and the Boaz oracle read "In Yahweh is the king's strength." See http://www.theology.edu/lec17.htm. Christopher Knight and Robert Lomas argue that the Boaz pillar, meaning "Strength or in it is strength," was named after the great-grandfather of David, King of Israel, and the Jachin, meaning "to establish," was dedicated to a high priest of the temple. See *The Hiram Key: Pharaohs, Freemasons and the Discovery of the Scrolls of Jesus* (Shaftesbury, Dorset; Boston; Melbourne, Victoria: Element, 1997), pp. 7–8.

75. For the story of Hiram Abiff as it is reenacted during Masonic initiation rites, see Knight and Lomas, *The Hiram Key*, pp. 8–18.

Manhattan; there were some 260 Masonic lodges in the city,[76] forty-seven thousand Irish immigrants had settled since 1925,[77] and the Chrysler Building was nearing completion. Commissioned by automobile magnate Walter P. Chrysler for his corporate headquarters, the skyscraper was intended to be the tallest man-made structure on Earth. But when another building under construction—the Bank of Manhattan Tower, a 927-foot-high, sixty-six-story edifice on Wall Street—threatened to surpass the Chrysler Building's initial 925-foot, sixty-five-story design, architect Van Alen and his patron Chrysler schemed to construct, in secret, an additional 180-foot, needle-thin Nirosta-steel spire inside the tower and to hoist it in place through the building's crown. The Chrysler Building won the battle for altitude; a promotional brochure of the period proclaimed that "Into the empyrean, the builder has flung his handiwork seeking to pierce the ever-unfathomable blue above."[78]

Cremaster 3 begins with a prologue steeped in ancient Celtic mythology. The scene opens with an aerial view of the Irish Sea. Two rock formations on either side of the sea—Fingal's Cave, on the Isle of Staffa, and the Giant's Causeway, on the coast of northern Ireland—harbor a story in their identical geology, a dramatic structure of naturally formed hexagonal basalt columns: this is the legend of the Irish giant Fionn MacCumhail, or Finn MacCool, who challenges the Scottish giant Fingal[79] to a fight. As a bridge for his opponent to come from Scotland, he builds the Causeway and extends it out to sea, but as Fingal approaches, the thunderous vibrations of his steps reveal that he is twice MacCumhail's size. The Irish giant's wife, Oonagh, dressed in blue tartan with legs hewn from peat and moss, strategizes how to save his life. Learning that Fingal's Achilles' heel is his brass finger, the secret of his strength, she urges her husband to dress as a baby and bake twenty-one loaves of bread, each with a cast-iron frying pan baked into its heart. In Barney's version each loaf contains a white plastic wedge—the kind used by the fairies to prop up the Hack's tires in *Cremaster 4*. The prologue ends once the preparations are in place and a disguised MacCumhail lies waiting in an enormous cradle for Fingal's imminent arrival.

The main narrative begins deep below the earth, under the foundation of the partially constructed Chrysler Building, on the site of an ancient goat-burial ground. An emaciated female corpse—killed by four shots to the heart—is attempting to dig her way out of a cavernous grave. She is the undead Gary Gilmore, transubstantiated into a woman through a successful metamorphosis achieved in the space of Houdini.[80] Her haunting return marks the transition from *Cremaster 2* to *3*, from the horizontal ending within the recesses of a glacier to the vertical orientation of the Chrysler tower. This bloodied, putrefying incarnation of Gilmore is a portent of evil to come. Unable to stand unassisted, she is carried out of her tomb by five

Video still from *CREMASTER 3*, 2002

76. In 1932, the closest date for which I can locate an exact figure, there were 262 Masonic lodges in New York City. See *Polk's New York City Classified Business Directory 1933–34* (New York: E. L. Polk & Company, 1932), pp. 3885–86, under section entitled "Societies Benevolent and Fraternal—Masonic."

77. Ira Rosenwaike, *Population History of New York City* (Syracuse, N.Y.: Syracuse University Press, 1972), p. 94.

78. Quoted from cover of promotional booklet *The Chrysler Building* (New York: Chrysler Tower Corporation, 1930). The building was the tallest in the world for a few short months before it was surpassed by the Empire State Building, also completed in 1930.

79. In traditional versions of this legend, the Scottish giant's name is Benandonner. But Barney has changed his name to Fingal after the cave in which he dwells. Fingal is a late corruption of Finn MacCool, and Barney's use of it implies a correlation between the two giants,

as if they were two sides of the same being, much in the way the main characters in *Cremaster 3*, Hiram Abiff and the Entered Apprentice, mirror one another in the narrative. The titles of Barney's character vitrines related to *Cremaster 3* attest to this reading: *Fingal: The Case of Hiram Abiff* (2002) and *Fionn MacCumhail: The Case of the Entered Apprentice* (2002). Also, the "play within a play" sensibility of this mythological digression in the film parallels *Cremaster 4*'s fairy sequences, in which the basic conflicts of the narrative are enacted but without the psychological undertow experienced by the main characters. For more on the derivation of Fingal, see www.ealaghol.demon. co.uk/celtenc/celt_f2.htm.

80. While Gilmore may have escaped the status of drone, his death evidently brought no peace, for it is the curse of the zombie to wander the earth forever, without release from terrestrial bonds.

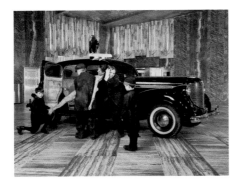

CREMASTER 3: Imperial New Yorker, 2002 (detail)

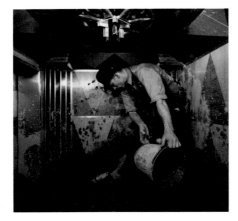

Production photograph from *CREMASTER 3,* 2002

boys—a family of undertakers—who transport her up a series of increasingly refined staircases that culminate in the Chrysler Building's ornate, marble-drenched lobby.[81] Crossing this space, the pallbearers deposit the corpse in the back seat of a Chrysler Imperial New Yorker. Introduced on July 1, 1930, the Imperial is Chrysler's premier luxury car; the New Yorker is a style within this deluxe line. Here it is customized with an interior of plush green velvet. A golden eagle perches on the headrest of the front seat.

During this scene of disinterment, the camera cross-cuts to tightly cropped images of the Entered Apprentice troweling cement over carved Nirosta-steel fuel-tank caps on the rear chassis of five 1967 Chrysler Crown Imperials, each bearing the insignia of a *Cremaster* episode. The colors of the cars likewise represent the respective predominant palettes of each of the five *Cremaster* installments: silver, aqua, green, blue, and black.[82] Packed with cement, these caps will serve as battering rams in a demolition derby about to begin in the Chrysler Building lobby. Here the lobby receptionist gets up from her Nirosta-steel desk to wave a flag indicating the start of the tournament. The '67 Imperials encircle the New Yorker like hunters around an animal in a snare. As outlaws or partners in crime—for Imperials are the only model of car forbidden from competing in demolition derbies—they proceed to pulverize their victim in what appears to be a ritual killing.[83] While the cars are attacking their prey, the Apprentice slips away unnoticed and enters one of the building's twelve elevator shafts, which he proceeds to scale until he reaches an elevator cabin resting between floors. He climbs on top of it and lowers himself inside. Lighting a cigarette, he intentionally triggers the sprinkler system. As the cabin begins to fill with water, he starts pouring cement, using the car as a mold with which to cast the perfect ashlar: a symmetrically hewn stone of superior quality, traditionally used for monumental projects like cathedrals. In Freemasonry the ashlar is one of the most important symbols encountered during the rituals of the First Degree. An Entered Apprentice is taught that "by the rough ashlar we are reminded of our rude and imperfect state by nature, by the perfect ashlar, of that state of perfection at which we hope to arrive."[84] In some Masonic lodges, newly initiated Apprentices are asked to chisel a piece of rough ashlar to signify their readiness to learn the ways of the craft.

By circumventing the carving process and using a shortcut to create the perfect ashlar block, the Entered Apprentice has cheated in his rites of passage. He has laid a false foundation for the development of his character, and he has sabotaged the construction of the building. For this act of insolence he must be punished. Officials of the Syndicate—three cigar-smoking Master Masons, complete with aprons and architectural tools—meet to determine his fate. They gather in the Chrysler Building's Cloud Club bar, on the

81. Though Barney filmed on location in the upper floors of the Chrysler Building, he created 1:1 replicas of the lobby, the Cloud Club bar, and a dentist's office, taking certain liberties along the way.

82. The anachronistic inclusion of 1967 Imperials is a nod toward the work's narcissistic tenor: this is the year of the artist's birth. The demolition derby that will ensue, with the '67 Imperials attacking the '30s New Yorker (the date of which references the birth of the artist's own father), is an enactment of the paternal conflict that informs the entire film.

83. Along with hearses and limousines, Chrysler Imperials are prohibited from participating in general demolition-derby competitions because of the strength of their construction and the power of their engines. See Wakefield, "Imperial 1967," an entry in "The Cremaster Glossary," p. 102, which cites Ed Becker, "Demolition Derby," 1997, at http://www.demoderby.com/demofaq.htm.

84. Harold Meij, "The Ashlar," at http://www3.tky.3web.ne.jp/~jafarr/The%20Ashlar.htm, a Web site devoted to explicating the esoteric symbols invoked in Freemasonry. In his artist's book and *Cremaster 3* lyrics, Barney has chosen to use the archaic spelling of the word: "ashler."

sixty-sixth floor. The club is modeled to invoke the aura of an Irish pub, albeit with distinctly Art Deco touches.[85] The passage between its airy dining room and its wood-paneled bar features tight partitions demarcating the small private booths that in Ireland are called "snugs," rooms originally designed to integrate women into the country's otherwise all-male drinking establishments and later employed as clandestine meeting rooms for members of the IRA.[86] Here the Masons assemble. The carpeted floor of the bar area is divided into two panels—orange and green—on which are superimposed two field emblems. On the orange panel the field emblem is green, and within it are embroidered the symbolic Masonic tools (maul, plumb, square, and level). On the green panel the field emblem is orange and contains the image of a Celtic harp. The bar, with its scalloped Deco lights and stools crafted from compasses, is partly constructed from frozen Vaseline.

After filling the elevator cabin with concrete so that it exceeds the weight of its counterbalance and falls to the bottom of the shaft, the Apprentice enters the Cloud Club, where he is greeted by the Maitre d', played by Irish tenor Paul Brady. Pulling copper cords out of the shaft and affixing them to the directional indicator above the door, the Apprentice makes an elevator into a harp. The Maitre d' also creates a wind organ by placing stone wedges at points in the three elevators' doors. He plays a ballad of the building on this organ, singing in Gaelic,

Video still from *CREMASTER 3*, 2002

> On dried skull and thigh bones,
> A goat grave horizon
> With flat feet of hard stone,
> Rough ashler foundation
>
> This is the song of the vertical field,
> A promising plumb line draped down from the skyline
>
> New beacon, lone witness,
> Base, pillar, pediment,
> A gauging of character,
> Geometry yields judgement
>
> This is the song of the vertical field,
> A towering implement indicates level
> With purest precision, this level shall measure
>
> Gleaming steel arches
> Chrome eagle perches

85. During the Prohibition era, the Cloud Club was an exclusively male speakeasy for the social elite.

86. "The snug was the only place in an authentic Irish pub that ladies could frequent. It was completely separated from the rest of the pub and had its own entrance and windows. The bartender had a small window to pass drinks to the women who were not allowed to be in the same area as the men." Quoted from Conor O'Neill's Traditional Irish Pub tour, www.conoroneills.com/co/tour5.htm. By the mid-nineteenth century, women were ubiquitously drinking in snugs in Ireland so as to be separate from the men in the bar. Also by the mid-nineteenth century, Fenian circles, an Irish nationalist brotherhood, were known to gather in pubs. See Elizabeth Malcolm, "The Rise of the Pub: A Study in the Disciplining of Popular Culture," *Irish Popular Culture 1650–1850*, eds. James S. Donnelly, Jr. and Kerby A. Miller (Dublin and Portland: Irish Academic Press, 1998), pp. 50–77. And by the 1920s and 1930s, secret meetings of the IRA were held in the private snugs of certain sympathetic pubs. See, Kevin C. Kearns, *Dublin Pub Life and Lore: An Oral History* (Dublin: Gill & Macmillan, 1996), p. 38.

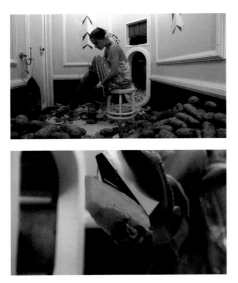

Video stills from *CREMASTER 3*, 2002

All in reflection
The problem in question
This is the song of the vertical field,
The reflection in question, of unsquare detection

White orchid, seed's cycle,
Ice lily, glacial still
Manx gorse, narcissus,
Calla lil', all blooming once

This is the song of the vertical field,
Once upright, this field is now fertile and prone
With desire put forth for a field that will flower,
One narcissus blooms in this untruthful tower

The sound of this Irish air corresponds to on-screen scenes of the building under construction, which are shown intermittently as cutaway shots throughout the film. Workers are seen applying steel cladding to the stone and metal infrastructure. An eagle gargoyle is fitted into place. Scaffolding retreats as the curtain wall is completed. The needle is hoisted into place.

While the Maitre d' plays his song, the Apprentice slips into the bar area, bypassing the trio of Masons, whose meeting is guarded by a watchman. He sits and smokes for a while in one of the lounges, then proceeds to the bar and orders a Guinness stout. The ensuing scene is a surreal, protracted slapstick routine between bartender and Apprentice. Almost everything goes wrong; and these humorous mishaps—falls, spills, broken glass, burst kegs, etc.—result in this court jester of a bartender playing his environment like a bagpipe. The various accidents leading up to his orchestration of the kegs, pumps, and hoses are caused by a woman in an adjoining snug, who is cutting potatoes into pentagonal wedges with blades on her shoes and stuffing them under the foundation of the bar until it is no longer level. Dressed in ethereal chain mail, like some hybrid Celtic archetype of agriculture and warfare, she seems to be the Chrysler Tower's unconscious. Sitting silently in her white cubicle of a room, ritualistically slicing potatoes to set the bar and, by extension, the tower off-center, she signals that all is not well with the building. The result of her actions is registered by the Masons in the other snug, who use a plumb line and level to assess the evenness of the situation.

This interlude is interrupted by a scene shift to Saratoga Springs, in upstate New York, once a popular site among members of the Syndicate who needed to hide from the police when the pressure was on.[87] The Apprentice and his moll—played by the same woman seen cutting potatoes in the bar—

87. See Burton Turkus and Sid Feder, *Murder, Inc: The Story of "The Syndicate"* (Garden City, N.Y.: Permabooks, 1952), p. 17.

are on the backstretch of the Saratoga racetrack watching a harness race. Five teams of two horses each are competing; the jockeys wear satin jackets, each with one of the *Cremaster* insignias emblazoned on its back. *Cremaster 5* is in the lead, followed by an aggressive *Cremaster 3*. But as the horses round the track, it becomes clear that they are all dead: sinewy flesh hangs off the bone, veins and arteries are exposed, blood pools beneath the hoofs. This ghostly race comes to an end with *Cremaster 5* crossing the finish line, but an inquiry is immediately called, because the team has performed a foul on *Cremaster 1*. With *5* disqualified, the *3* team wins the race, and is crowned with a blanket of narcissus.

In the meantime the Apprentice and his moll have fled the zombie track, but not quickly enough. Three hitmen intercept them and force the Apprentice into a tunnel under the track. Here they place in his mouth a silver snaffle, made from two interlocking trowels inscribed with the Masonic square and compass—symbols for morality and justice. Pulling the attached reins taut, they smash his teeth into a railing.[88] The Apprentice is next seen back in the Cloud Club, his mouth mutilated and bleeding. The hitmen escort him into the elevator and take him to a dental office on the seventy-first floor, where he is stripped of his workman's garb. Beneath it he is wearing the costume of the First Degree Masonic initiate, part of which used to be worn by medieval heretics condemned to the gallows;[89] the cloth on the left leg and right arm is rolled up and the right breast is exposed. First Degree candidates also wear aprons of pure white lambskin, signifying the innocence of the newborn child and the state of man before the Fall; accordingly an apron of flesh obtrudes from the Apprentice's navel, covering his lower abdomen. Masonic lore associates the apron with human corporeality; it represents the ephemeral and all-too-mortal body, the great equalizer. As a symbol it is a constant reminder of man's original innocence, the perpetual threat of corruption surrounding him, and the level of personal perfection he can aspire to within the Masonic order.[90] When the Apprentice is helped into the dental chair, one of the hitmen lifts this apron to reveal, in place of genitals, a frozen splash pattern formed by a drop of water falling into a pool of liquid. Like Gilmore's truncated penis, this abstraction functions as an allusion to the *Cremaster* project's overarching biological metaphor. While the Apprentice may be a candidate for only the Second Degree, and is thus still morally undeveloped, he is also, within Barney's symbology, part of an organism struggling with its internal formation. In preparation for the dentist, another of the hitmen melts a sheet of plastic and places it over the Apprentice's face, leaving open an aperture for his trauma of a mouth.

One flight up from the dental suite, on the building's top floor, is the office of the Chief Architect. An elegant Art Deco interior, this chamber is the nerve

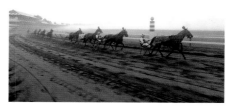

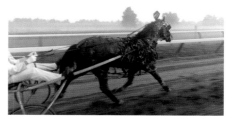

Video stills from *CREMASTER 3*, 2002

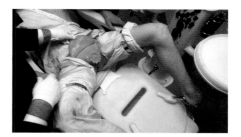

Video still from *CREMASTER 3*, 2002

88. The symbols of Freemasonry are taken from the stonemason's tools. The trowel represents the process of cementing bonds among Masonic brethren. The square teaches "us to regulate our lives and actions by the Masonic rule and line, and so to correct and harmonize our conduct as to render us acceptable to the Divine Being, from Whom all goodness emanates." Compasses "remind us of the Divine Being's unerring and impartial justice." Trevor W. McKeown, "A Masonic Overview," http://www.freemasonry.bcy.ca/Writings/MasonicOverview.html.

89. See Knight and Lomas, *The Hiram Key*, p. 5.
90. "Need I say that the physical form with which we have all been invested by the Creator upon entrance into this world, and of which we will divest ourselves when we leave the Lodge of life, is represented among us by our Masonic Apron? This, our body of mortality, this veil of flesh and blood clothing the inner soul of us, this is the real 'badge of innocence,' the common 'bond of friendship,' with which the Great Architect has been pleased to invest us all." Wilmshurst, *The Meaning of Masonry*, p. 31.

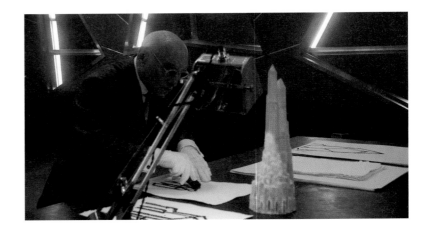

center of the tower, which is in construction all around it, as intermittent shots of scaffolding and steelwork have shown. The Architect is thus drawing the building as it unfolds in space. He refers to models of skyscrapers on the console beside him—three-dimensional renderings of the work of Hugh Ferriss, the architectural illustrator of the 1920 and '30s who produced a well-known body of charcoal studies for a visionary metropolis. Here Barney beautifully conflates the fictional character of the Architect, the historical figure of Ferriss, and the living artist Serra. This reading finds support in a description of Ferriss' 1929 book *The Metropolis of Tomorrow* by the architect Rem Koolhaas, who makes an association between Ferriss' jet-black studies (one thinks here of Serra's oilstick drawings), the notion of an architectural womb, and the idea of overcoming a paternal artistic lineage. Koolhaas imagines a state of creativity entirely germane to the *Cremaster* cycle:

> The genius of Ferriss' production is in the medium of his renderings itself, the creation of an artificial night that leaves all architectural incidents vague and ambitious in a mist of charcoal particles that thickens or thins whenever necessary. Ferriss' most important contribution to the theory of Manhattan is exactly the creation of an illuminated night inside a cosmic container, the murky *Ferrissian Void*: a pitch black architectural womb that gives birth to the consecutive stages of the Skyscraper in a sequence of sometimes overlapping pregnancies, and that promises to generate ever-new ones. Each of Ferriss' drawings records a moment of that never-ending gestation. The promiscuity of the Ferrissian womb blurs the issue of paternity.[91]

91. Koolhaas, *Delirious New York*, p. 117.

The passage also invokes the narcissistic dimensions of *Cremaster 3*, putting into relief Barney's own relationship to Serra's sculptural practice—a point that cannot be dismissed in an analysis of the project.

As we return to the narrative, the Architect descends from his studio down a spiral staircase into the dental lab to confront his opponent. He is carrying the compressed remains of the Imperial New Yorker, which the lobby receptionist has deposited on his desk. In a scene reminiscent of the penal dental surgery in Terry Gilliam's *Brazil* (1985), the Architect fits a pair of dentures into the Apprentice's vacant mouth. This set of gleaming metal false teeth has been fashioned from the remains of the crushed Imperial, which had once been branded with the imprint of the five *Cremaster* insignia (from the Nirosta-steel fuel caps mounted on the cars that crushed it). The moment the teeth click into place, the Apprentice's intestines prolapse through his rectum. This ceremonious disembowelment symbolically separates him from his lower self. For his hubris he is simultaneously punished and redeemed by the Architect—whose own hubris equally knows no bounds.

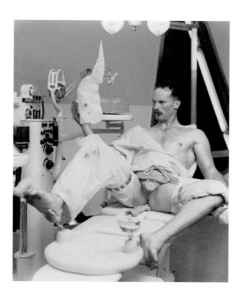

Production photograph from *CREMASTER 3*, 2002

Returning to his office, and anxious about the tower's slow progress, the Architect constructs two columns from large black plates that he lifts into place with a chain hoist: one set of plates is in the shape of a halved field emblem, the other is a pentagon. These eccentric pillars allude to the columns, Jachin and Boaz, that Hiram Abiff designed for Solomon's Temple—potent symbols in Masonic practice.[92] The Architect is constructing his own temple. Meanwhile the Apprentice's broken and dislodged teeth stream out of his intestines in a river of goo, spilling through an indentation in the dental chair to a tray below, where they fall into a line and slowly melt together to form a smooth porcelain rod. His apron of flesh also lengthens to below his groin, marking his passage from Entered Apprentice to Master Mason—an equal of the Architect. He escapes from the dental lab through a panel in the ceiling and begins an ascent to the topmost region of the tower, crawling upward in the space between its steel skin and its metal frame.

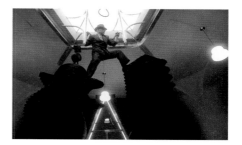

Video still from *CREMASTER 3*, 2002

The Architect uses his columns as a ladder and climbs through an oculus in the ceiling (much as did the spire, which rose to secure the building's ascendancy in the contest for the sky). His aspirations—to reach ever higher, to hew the perfect stone, to dominate the Lodge within himself, to be *the* reflection in the mirror of the building—are the desires of the demiurge. Hubris incarnate, the Architect is attempting to become god on Earth.[93] The next scene describes an apotheosis, the Architect becoming one with his design. This takes place in the room directly beneath the building's spire. Part observation deck, part surveillance zone (replete with antennae), this space is redolent of omnipotence; it is the all-seeing eye on top of the Masonic

92. *A Mason's Examination* (1723) asks "Where was the first Lodge kept?" and answers, "In Solomon's Porch; the two Pillars were called Jachin and Boaz." See http://www.nels.com/mason/systb52.html.

93. "The evolution of man into superman . . . was always the purpose of the ancient Mysteries, and the real purpose of modern Masonry is, not the social and charitable purposes to which so much attention is paid, but the expediting of the spiritual evolution of those who aspire to perfect their own nature and transform it into a more god-like quality." Wilmshurst, *The Meaning of Masonry*, p. 47.

Video stills from *CREMASTER 3*, 2002

pyramid, the central point of a panopticon from which to observe and control the metropolis below. The floor here rises in the center, like an ancient Celtic burial mound. A modern Newgrange or Tara, the mound is covered with mossy grass. The Architect stands on its summit, holding clusters of flowers that correspond to the five *Cremaster* episodes: white orchid (*Cremaster 1*), Rocky Mountain sage (*Cremaster 2*), narcissus (*Cremaster 3*), Irish gorse (*Cremaster 4*), and calla lily (*Cremaster 5*). He wears a black apron, in which are fitted the Mason's sacred tools. On a floor below, twenty construction workers have leaned out of open windows to catch pale green ribbons spilling down from the top of the spire. Tossing the ribbons to one another in an aerial choreography, these men perform a kind of maypole dance until the spire is wrapped entirely in green satin. The ends of the ribbons are then fed up through the ceiling to the room of the Celtic mound, where the Architect's henchmen, the Syndicate killers, attach them to a system of hooks above his head. The same action is then repeated with orange ribbon, so that, like the building's grand spire, the Architect too is wrapped in green and orange, enshrined in the space of his own making. He gathers the ribbons that spill down around him and weaves them into a two-tone braid, attaching the *Cremaster* flower clusters to form a garland. Standing at the pinnacle of the tower, in the very center of the *Cremaster* cycle, the Architect, as master artist, has complete control—if only for an instant—of his creation.

The ceremony enacted on this indoor druid mound recalls Beltane, the ancient Celtic festival that marked the beginning of summer. The rite, which used to be accompanied by dancing and spirit worship, was customarily celebrated on May 1 (also the day of the maypole dance), and culminated in a sacrificial killing by fire. Since hubris always exacts a sacrifice in retribution, this glorification of the Architect in the temple of his own making may just be his last stand. During this sequence the voice of the Maitre d' is heard singing an anthem that proclaims this fate:

> Of glacial ice, a base of stone
> A firm foundation for potential
> One hopeful line, a gesture still
> Toward higher rationale
>
> So lift this hope to vertical
> And build this pillar sound
> From this stone true, the tower did raise
> From th' grace his basis found

O'er poured stone core, a silver skin
High reflection, this surface takes
All-seeing eye, a mirror thin
Paternal estimation makes

Strong character and refined will
Shall build this pillar sound
With this stone true, the tower did hope
For th' grace his basis found

This willful lens, this reflection,
A deceitful claim to see
No longer square, nor level to
The line plumb to the sea

His pride gone ill this beacon still
Will call this pillar sound
With this stone true, the tower did lie
To th' grace his basis found

A silver sphere, an aqua pool
And the blue sea, deeper black
A stone was thrown, horizon cleft
The truthful curve reborne

The pillar on which pride did rest,
That tower lies now level, prone
With this stone true, the tower did fall
From th' grace his basis found

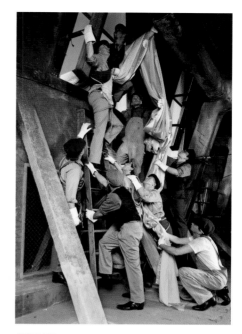

CREMASTER 3: The Dance of Hiram Abiff, 2002 (detail)

At this point in the narrative the film pauses for a choric interlude, which rehearses the secret initiation rites of the Masonic fraternity through allegorical representations of the five-part *Cremaster* cycle, all in the guise of a game. Staged in the arena-like rotunda of Frank Lloyd Wright's landmark Solomon R. Guggenheim Museum, the contest is broadcast via the needle on top of the Chrysler Building. In this sense the game occupies a conceptual space similar to Barney's early performances, which were only viewable on video monitors, to which they were transmitted like televised sports. Though suggestive of activity happening elsewhere simultaneously, these video actions functioned more as proposals about what may or may not have occurred in the space in which they were seen.[94] The game at the

94. Discussing his pre-*Cremaster* work, Barney has said, "In these installations I was working with the model of an audience which is not watching a live situation at all, but the broadcast of an activity that's going on simultaneously somewhere else. Something had happened in that space in which you stand and the video functioned as a proposal for what that may or may not have been." Quoted in Sans, "Matthew Barney: Modern Heroes," p. 31.

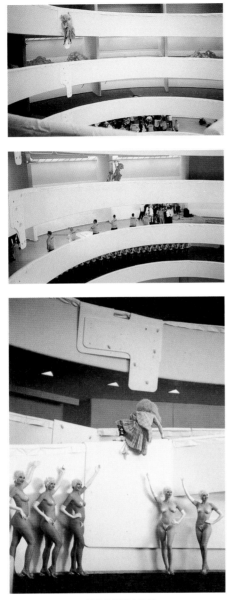

Production stills from *CREMASTER 3*, 2002

Guggenheim—called "the Order"—raises analogous questions, seeming as much like a dream sequence as like the broadcast of a live event. Its one contestant is a fantastical incarnation of the Entered Apprentice, identifiable through his bruised and bloodied mouth. His flesh apron has transmogrified into a full-length skin-colored kilt, its tartan pattern formed by the blue and red vessels of the circulatory system.

The famed spiraling architecture of the Guggenheim has often been compared to a beehive, and in the context of the Order this reference takes on a particular symbolic valence. As we have seen, the beehive and its interior hexagonal honeycomb pattern also appear as visual leitmotivs in *Cremaster 2*, for it is the state emblem of Utah and an important symbol for the Church of Latter-Day Saints. In *Cremaster 3* the beehive-as-Guggenheim relates to Masonic lore, where it signifies industriousness and communal allegiance. According to the Masonic book of rites, or "Monitor," when a candidate attains the Third Degree of Master Mason he is given a beehive as a "hieroglyphical emblem," meaning that its symbolism within Freemasonry is revealed to him: "The Bee Hive is an emblem of industry, and recommends the practice of that virtue to all created beings, from the highest seraph in heaven to the lowest reptile in the dust. It teaches us that we come into the world rational and intelligent beings, so we should ever be industrious ones; never sitting down content while our fellow creatures around us are in want, especially when it is in our power to relieve them without inconvenience to ourselves."[95] The well-documented historical link between Mormonism and Freemasonry—Joseph Smith, founder of Mormonism, was inducted into the Masonic fraternity on March 15, 1842[96]—only enriches the symbolic matrix of the *Cremaster* cycle, the conceptual link between the religion and the fraternal society, and also, through the beehive trope, with the Guggenheim, further demonstrating the fluidity of the artist's representational system. For Barney the architecture of the museum's rotunda creates a hivelike atmosphere, and within this space he envisioned a microcosm of the entire cycle, and rendered it in the form of the Order. This articulation of each installment on the curving ramps of the building in turn served him as a 1:1 scale model for the exhibition of the complete *Cremaster* cycle to be held at the museum in 2003. "The Guggenheim," Barney explains, "has always functioned for me like a hive. It is a place where a honeycomb could be built to systematize the individual parts and make a whole. This is realized in the Order, which is a chorus of the *Cremaster* tribes, and where the adhesive jelly between the levels is stronger than the individual levels. The 'Order' sequence in the film is a model of, or rehearsal for, the *Cremaster* cycle exhibition."[97]

The Order is structured as a pentathlon—the athletic contest, consisting of five discrete events, that originated in the Olympic games of ancient

95. Thomas D. Worrel, "The Symbolism of the Beehive and the Bee," at http://www.abaris.net/freemasonry/beehive.htm. In this transcript of a lecture given at the Mill Valley Masonic Lodge on February 29, 2000, Worrel quotes from a Masonic "Monitor" and speculates that the early stonemasons and cathedral builders would have identified with the communal practices of bees, which construct their hive as both a fortress and a source of nourishment. He points out that in early Masonic writings the Lodge is called a "hive," and any group defections from one Lodge to another are called "swarming."

96. See Smith, *History of the Church*, vol. 4, p. 551, excerpted at http://www.irr.org/mit/masonry.html.

Under the date of March 15, 1842, Smith writes, "In the evening I received the first degree in Free Masonry in the Nauvoo Lodge, assembled in my general business office." The record for the next day reads, "I was with the Masonic Lodge and rose to the sublime degree" (p. 552). See also Leonard J. Arrington and Davis Bitton, *The Mormon Experience: A History of the Latter-Day Saints* (Urbana and Chicago: University of Illinois Press, 1992), p. 55, for an account of the establishment of a Masonic lodge in Nauvoo, Illinois, in 1841, amid an early center of Mormonism.

97. Barney, correspondence with the author, January 2, 2002.

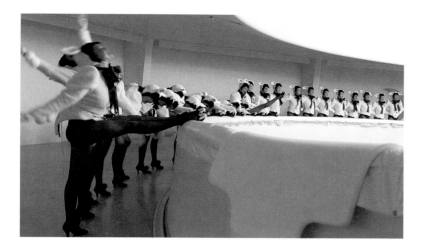

Greece. Barney's events are organized as five "levels" on the museum's ascending ramps; the Apprentice must advance from the ground floor to the top of the spiral, passing through each level and confronting its obstacles. This arduous game is a race, for the Apprentice must complete all his tasks within a specified period of time. For the purposes of the film the lyrical circular space of Wright's rotunda is transformed into an architectural concordance to the *Cremaster* cycle, becoming at once stadium, theater, broadcast studio, and museum of memorabilia. The rotunda floor is covered in *Cremaster 1*'s blue Astroturf, which immediately translates the space into a playing field. White athletic padding runs along the tops of the spiral's parapet wall. Barney's field emblem graces the oculus. And banners for each *Cremaster* installment fly from the museum's vertical axis, the "spine" of the atrium. The atmosphere borders on kitsch in its emulation of televised sport: game show meets the NFL or, perhaps more aptly, *Let's Make a Deal* meets *American Gladiator*.

In a preview of the race itself each of the Apprentice's opponents appears on a revolving stage on the rotunda floor. The stage is turned by five high-heeled hostesses, sporting sequined G-strings and pasties, who inhabit the museum's reflecting pool, which has been transformed into a champagne bubble bath. The opponents appear in ascending order in correspondence to the chronology of the *Cremaster* cycle. Level One is the Order of the Rainbow for Girls, a troupe of Masonic girl scouts who perform precision tap dancing.[98] Conflating the showgirls of *Cremaster 1* with the Masonic First Degree, Barney has costumed this ensemble in little-lamb outfits complete with ears, tails, fishnet stockings, and hoofed tap shoes. Level Two comprises the New York hardcore bands Agnostic Front and Murphy's Law, who play on cast-salt stages to a mosh pit full of punk fans. Their raw musical energy and

98. Although the Masonic fraternities are only for men, there are many subsidiary Masonic groups for women, such as Job's Daughter and the Rainbow for Girls.

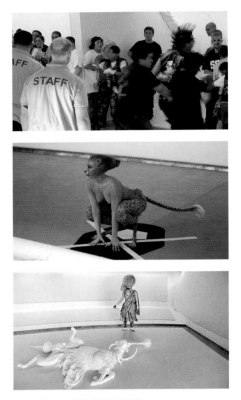

Video stills from *CREMASTER 3*, 2002

antagonistic stance correspond to the sensibility of *Cremaster 2*, which has its share of heavy metal music and salt. Their connection to the Masonic Second Degree will become clear in the puzzle that the Apprentice must solve before leaving this Level and the lyrics of the song they sing in battle with one another.[99]

Cremaster 3 and the Third Degree are represented on the next Level by the double amputee, Paralympic track star, and fashion model Aimee Mullins. Her character, known as the Entered Novitiate, will mutate from a couture model dressed in a white gown and crystal legs to a hybrid Egyptian warrior whose lower body is that of a cheetah. Mullins plays many roles in *Cremaster 3*; an elasticity in her character allows for endless permutation. She has already been seen as Oonagh, the Apprentice's Moll, and the potato-cutting woman in the Cloud Club bar. In the Order, however, where she represents the third *Cremaster* episode and the Third Degree (the ultimate level achieved in Freemasonry), Mullins has a pivotal role: she is, in essence, the Apprentice's (and Barney's) alter ego. *Cremaster 3* is the narcissistic center of the cycle; it resonates with references to the project as a whole, and to Barney's position as its author. As a professional athlete and model, Mullins already echoes aspects of the artist's own biography. Also, her gleaming carbon-fiber prosthetic legs—designed for running, premised on the mechanics of a cheetah's foot—recall the legs that Barney wore in *Drawing Restraint 7*, and make her a female satyr. When the Apprentice/Barney confronts her on Level Three, he is facing himself in all his guises—the prerequisite of the Third Degree.

The opponent on Level Four is an enlarged and abstracted bagpipe, whose bag is made out of a four-horned, flayed Loughton Ram (here cast in white plastic). A breed indigenous to the Isle of Man, this sheep figures prominently in *Cremaster 4*. Its correlation to Masonic ritual is threefold. First, as a grown lamb, it alludes to degrees beyond the third, Master Mason level, of which there are many gradations.[100] Second, the outline of the flayed animal corresponds to the configuration created when two Masons perform the Five Points of Fellowship. And finally, as a bagpipe—recalling the hubristic associations of the bagpipe in *OTTOshaft* (1992)—it equates the Masonic drive for inner perfection with demiurgic impulses. Richard Serra—now appearing not as the Architect but as himself—constitutes Level Five, which symbolizes even higher echelons of moral rectitude within Masonic thought. He is the personification of the male element, the fully descended entity witnessed in *Cremaster 5*. Dressed in protective clothing and gas mask, Serra hurls molten Vaseline against propped plates of prosthetic plastic on the top ramp of the Guggenheim's rotunda.[101] He thereby sets the clock for the Order: the loose Vaseline runs down a trough on the sloping ramps,

99. The lyrics are sung at first by each band leader (call), then by the band (band), and then by the kids in the mosh pit (response): Murphy's Law Call: *From East to West the soul her journey take at many bitter founts her fever slakes* / M L Response: *Back to the East* / M L Call: *Halts at strange taverns by the way to the feast resumes her load, and painful progress makes* / M L Response: *Back to the East* / Agnostic Front Call: *An ever moaning battle, battle in the mist,* / A F Band: *Death,* / A F Response: *In all life* / A F Band: *Lying,* / A F Response: *In all love* / A F Call: *The meanest having power, power upon the highest and the high purpose broken by the worm* / A F Response: *Darkness in the West* / A F Band: *West* / A F Call: *Rational understanding* / A F Response: *West* / M L Band: *East* / M L Call: *Spiritual intuition* / M L Response: *East* / A F Band: *Physical sphere* / M L Response: *North* / M L Band: *Abstract sphere* / A F Response: *South* / A F Band: *Three* / M L Response: *Faith* / A F Band: *Strong* / M L Response: *Hope* / A F Band:

Staves / M L Response: *Mercy* / M L Band: *Three* / A F Response: *Wisdom* / M L Band: *Grand* / A F Response: *Strength* / M L Band: *Pillars* / A F Response: *Beauty* / A F Band: *The perfect cube must pass through* / ALL Response: *I, I, I die daily* / M L Band: *Through the state of the cross* / ALL Response: *I, I, I die daily* / A F Call: *I, I, I, I, I, I, I* / ALL Response: *I, I, I, I, I, I* / A F + All Response: *Die daily* / M L Call: *I, I, I, I, I, I, I* / ALL Response: *I, I, I, I, I, I* / M L + All Response: *Die daily* / ALL Response: *I, I, I die daily, I, I, I die daily, I, I, I die daily . . .* (repeating).

100. In Freemasonry, the Blue Lodge confers the first three degrees (Entered Apprentice, Fellowcraft, and Master Mason). These are the essential rites; any degree earned afterward is merely an elaboration upon the fundamental Masonic principles.

101. In 1968 and '69 Serra experimented with the malleability of lead, creating pieces that directly acknowledged the metal's materiality. It was during the

and the Apprentice must solve all the game's challenges before it reaches the bottom.

The Apprentice first moves through the Levels in ascending order, then returns to tackle tasks not completed or problems unsolved. Scaling the parapet wall, clinging to prosthetic plastic rails as he climbs the hundred-foot spiral, he stops at intervals to play each component of the game. On Level One he passes through a tunnel formed by the high-kicking legs of the Order of the Rainbow and is presented with a baby lamb, which he wears as an apron. Sign of the First Degree, the lamb represents a process of "preparation, self-discipline, and purification."[102] On Level Two the Apprentice must solve a geometric puzzle set into the floor of the mosh pit between the two dueling bands: he must first place the stonemason's tools—which symbolically measure the strength of his character—into the form of a cross, then shape the cross into a perfect cube. This conundrum represents the teachings of Fellowcraft, or the Second Degree: "He who desires to rise to the heights of his own being must first crush and crucify his own lower nature and inclinations; he must perforce tread what elsewhere is described as the way of the Cross; and that Cross is indicated by the conjunction of those working tools (which when united form a cross).... By perfecting his conduct, by struggles against his own natural propensities, the candidate is working the rough ashlar of his own nature into the perfect cube."[103]

On Level Four the Apprentice competes with himself in a caber toss, attempting to throw cast-plastic bagpipe drones into the Loughton Ram and thereby to complete the instrument's form. After many tries he succeeds and returns to Level Three, where he has been blinded by the beauty of the fashion model. Looking into the mirror of his own soul, he is transformed into an apparition of this female element. They embrace each other with the Five Points of Fellowship in a moment of exquisite oneness, and the model whispers the divine words "*Maha byn*" into his ear. But she then abruptly transmutes into the cheetah and attacks. An intense struggle ensues, which continues intermittently throughout the Order, until the Apprentice uses the stonemason's tools to slay the hybrid creature: with a blow of the plumb to her temple, she drops to one knee; hit with the level in the other, she drops to both knees; and struck in the forehead with the maul, she falls dead. Having ceremonially killed off his own reflection, the Apprentice achieves the level of Master Mason. "The death to which Masonry alludes ... is that death-in-life to a man's own lower self which Saint Paul referred to when he protested 'I die daily.'"[104] The final image of the Order shows Mullins seated on a sleigh drawn by five baby lambs. She is dressed in the costume of the First Degree Masonic initiate. Blindfolded, she wears a noose around her neck. Blood spills from her temple and forehead, where she had endured the fatal wounds of the Mason's tools.

Video stills from *CREMASTER 3*, 2002

performance of *Casting* (1969) that the famous photograph of Serra hurling lead was taken, "recording the throwing of molten lead into the 'mold' formed by the angle of the floor and a wall of the Castelli Gallery warehouse space, the resultant cast being pulled away from the angle when hardened to allow for yet another wave of molten liquid." Rosalind Krauss, "Richard Serra: Sculpture," in *Richard Serra*, ed. Hal Foster with Gordon Hughes (Cambridge, Mass.: The MIT Press, 2000), p. 105.

102. Wilmshurst, *The Meaning of Masonry*, p. 35.
103. Ibid., p. 39.
104. Ibid., p. 43. The incantation "I die daily" is among the lyrics sung by the Agnostic Front and Murphy's Law on Level Two.

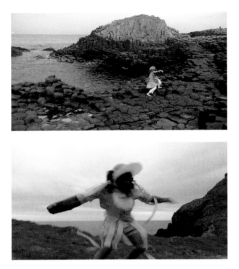

Video stills from *CREMASTER 3*, 2002

During this ritualistic murder sequence—which, as the initiation into the Third Degree, reenacts the death of Hiram Abiff—the camera returns to the very top of the Chrysler Building, where the Architect is basking in the glory of his production. Unbeknownst to him, the Apprentice has escaped the dental lab and is climbing upward, just under the outer skin of the building, toward the crown. At the same moment the Apprentice eliminates the cheetah—his base self—on the ramp in the Guggenheim, he also strikes the Architect dead in the tower, in a second re-creation of Abiff's assassination. But as the Apprentice strikes the Architect's forehead with the maul, the building itself kills the Apprentice by driving the base of its spire through the top of his head. This double murder is reminiscent of the mutual suicide of the satyrs in *Drawing Restraint 7*, where both protagonists self-destructed at the moment of final accomplishment. The Chrysler Building thus remains unfinished, like Solomon's Temple in Masonic lore, which teaches that the conspiracy of the craftsmen to extract the divine secrets from Hiram Abiff delayed the completion of the great structure indefinitely. Their hubris was tantamount to the Fall of Man—they attempted to extort knowledge that was not theirs to have. The Architect and the Apprentice, each in their own way, embodied such hubristic yearnings, and for this they both were punished.

Cremaster 3 ends with a coda that links it geographically and conceptually to *Cremaster 4*, much in the same way that its early zombie scene, depicting the return of Gary Gilmore, connects it to *Cremaster 2*. Upon the satisfactory completion of the Order and the double homicide in and by the Chrysler Building, the film shifts away from its New York setting and returns to the legend of Fionn MacCumhail. Fingal has completed his crossing of the Giant's Causeway and charges toward the door of the MacCumhails' thatch-roofed hut. When he enters their home, he sees what seems to be an enormous baby—the disguised MacCumhail—gnawing on a loaf of bread and wonders, with alarm, how big the father must be if this is the child. Helping himself to some bread, he breaks his teeth on the plastic wedge hidden inside it, and as he is distracted, MacCumhail reaches up, grabs his hand, and bites off his magic finger. Terrified and weakened, Fingal flees back over the Causeway to Scotland, destroying the stone bridge in his wake. MacCumhail flings a stone at him as he rushes away; missing its mark, the stone falls into the ocean to form a new land mass—the Isle of Man, where the next installment of the *Cremaster* cycle will take place.

CREMASTER 4

If *Cremaster 3* is the dark mirror of Narcissus's reflecting pool—an interval of self-examination that leads ever inward—then *Cremaster 4* is pure propulsion. The first of the cycle's installments to be completed, it adheres more

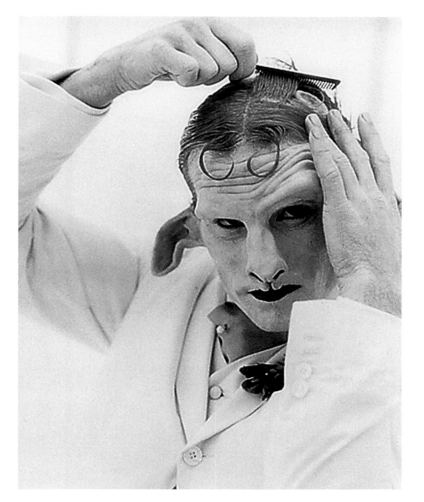

CREMASTER 4: VALVE, 1994 (detail)

closely to the biological model of the project than do the more recently realized chapters; this penultimate episode describes the organism's onward rush toward descension despite its persistent resistance to division and the panic this tension induces. The triangulation of motion, restraint, and sensation is echoed in the narrative's tripartite structure. The logo for this episode is the Manx triskelion: three identical armored legs revolving around a central axis. Set on the Isle of Man, the film absorbs and recontextualizes the island's rich folkloric history, as well as its more modern incarnation as host to the famed Tourist Trophy (TT) motorcycle race.[105] Myth and machine combine to narrate a story of candidacy, which, like that of *Cremaster 3*, involves a trial of the will articulated by a series of passages and transformations. The elliptical path

105. Since its beginning, in 1907, the annual Isle of Man Tourist Trophy has been the premier motorcycle race in the world. An international array of riders converges each year to tackle its treacherous 37.73 mile course of converted farm roads, which historically have no speed limit. In its almost hundred-year existence, at least that many riders have perished driving its 120-mile-an-hour laps. See Michael Browning, "Ton-Up Tonic: The Murderous Isle of Man TT," in Bryan Hanrahan, ed., *Bikes and Bikies* (Melbourne: Lansdowne Press, 1974), p. 15.

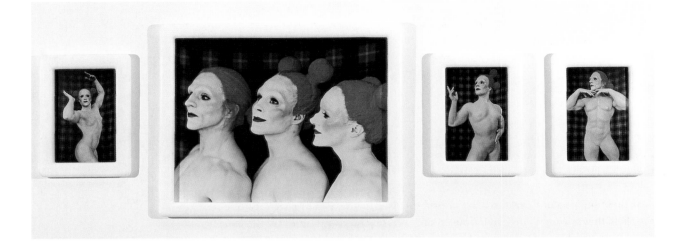

CREMASTER 4: FAERIE FIELD, 1994

traveled in the narrative charts the island's shape and forms an ancient druid circle. A fairy tale in the guise of a road movie, *Cremaster 4* tells of primal initiation rites, dreams of immortality, and magical intervention.

The film comprises three main character zones. The Loughton Candidate (played by Barney) is an impeccably dressed red-haired satyr who wears a white Edwardian suit with a sprig of Manx heather in its lapel. Clearly a relative of the hybrid creatures in *Drawing Restraint 7*, he is also a descendant of a lone Manx satyr named Phynnodderree. Thought to be a fallen fairy or the victim of a curse, in local legend this hairy, muscle-bound creature once roamed the island, creating mischief wherever he went.[106] The Candidate, a dandified gentleman of a satyr, has two sets of impacted sockets in his head—four nascent horns, which will eventually grow into those of the mature, multihorned Loughton Ram. An ancient breed native to the Isle of Man, the Loughton Ram has four curving horns, two arcing upward, two down. For Barney these appendages form a diagram that proposes a condition of undifferentiation, with ascension and descension coexisting in complete equilibrium. The conceptual space between the Candidate and his ram is the "Loughton Field." It is the realm of pure potential that borders on the hubristic threshold of achieving the impossible.

The second character zone is a pair of Grand Prix–style motorcycle side-car teams. The vehicle of the Ascending Hack is bright yellow and the two team members wear yellow body-leather and helmets. They also wear as their team insignia the three-legged Manx triskelion, or "Arms of Man,"

106. For an account of Phynnodderree, see A. W. Moore, *The Folk-Lore of the Isle of Man*, 1891 (reprint ed. Felinfach, Wales: Llanerch Publishers, 1994), pp. 55–58.

superimposed over a blue field emblem. The Ascending Hack will tour the island in a clockwise rotation starting in the lowlands, so that their trajectory traces an "Ascending Field." The opposing team, the Descending Hack, rides an aqua blue motorcycle and dresses entirely in the same color. Their insignia is the Manx triskelion superimposed over a yellow field emblem, and their route around the island will be counterclockwise beginning in the highlands, delineating a "Descending Field."

These primary characters are attended to by a third group, a trio of androgynous red-haired fairies who mirror the three narrative fields of the Candidate and the two racing teams: the Loughton Faerie, the Ascending Faerie, and the Descending Faerie. The hair of the Loughton Faerie is styled in four buns; the Ascending Faerie has two, upright buns; and the Descending Faerie has two buns toward the nape of her neck. Having no volition of their own, these supernatural creatures metamorphose in accordance with whatever field they occupy at any given time. In the film's opening sequence, for instance, in which they facilitate the Candidate's preparations for his passage into the Loughton Field, they are nude, with no visible external genitalia. Their ambiguous, ungendered bodies mirror the Candidate's emergent state. When they appear in the Ascending Field they wear yellow; when in the Descending Field, blue.

Cremaster 4 begins and ends in a small, white, vinyl-padded building on Queen's Pier, a Victorian construction that extends a quarter mile into the mist-laden Irish Sea. As the film starts, the Loughton Candidate is seen parting his hair in a vanity mirror that runs along one interior wall of the structure. In a moment of anticipation he fingers the concave sockets in his head. The attendant fairies fit hooflike white-plastic taps onto his leather brogues and fill his pockets with large pearls, the weight of which will assist him in his efforts to dance his way through the floor. While the Candidate is being prepared (or disciplined) for his journey, the motorcycle race begins. Each team speeds off from the starting line in opposite directions. Their antipodal circumnavigation of the island—like the flow of veins and arteries in the circulatory system of the body—puts them on a potential collision course. This hazard-to-come suffuses the atmosphere of the film like the thick Manx fog that envelops the island.[107]

The camera cuts back and forth between the speeding motorbikes and the Candidate, who is tap-dancing on the white plastic floor, marking out a rhythm to the melody in his head. The friction of his pulsing beat begins to wear away the membrane of the floor, an erosion that continues until it makes a hole large enough to swallow a man. As the bikes vie for the TT title, careening around the island's unyielding landscape of bumpy, unsealed roads, stone walls, mountainous terrain, and furrowed bridges, the camera

PITCH: The Field of the Ascending HACK, 1994

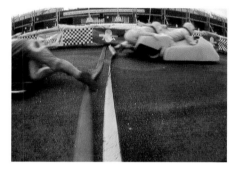

Video still from *CREMASTER 4*, 1994

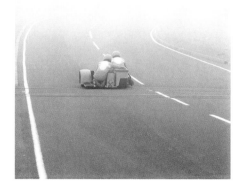

Production photograph from *CREMASTER 4*, 1994

107. The Tourist Trophy's "Mountain circuit runs from the start at Glencrutchery Road in a westerly direction through Braddan, Union Mills, Glen Vine and Crosby until it reaches Ballacraine. At Ballacraine the riders turn right and head north through Glen Helen, Kirk Michael, Ballaugh and Sulby to Ramsey, some 23.5 miles from the start. Now the riders swing south and head up the daunting Mountain climb rising from sea level in Ramsey to some 1,400 ft. at the highest point at Brandywell. On the way they pass through Ramsey Hairpin, The Waterworks, Gooseneck, Guthries Memorial, The East Mountain Gate, Black Hut, The Verandah and the Bungalow. After Brandywell it is nearly all downhill to the finish, some six miles away, through Windy Corner and the 33rd Milestone on through Keppel Gate and the fast run down to Creg-ny-Baa. Then it's on down to Brandish and on up through Hillberry to Signpost Corner. Now just over a mile from the finish the riders swoop through Bedstead corner and the Nook and past the Governors residence on their left to Governors Bridge, from there it's just a short run up Glencrutchery Road to the finish line." See http://www.ttwebsite.com/history/.

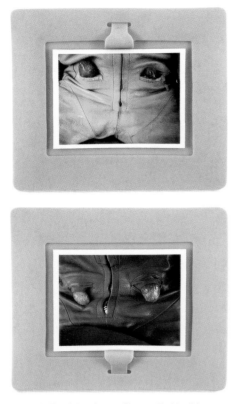

CREMASTER 4: Gob ny Creggan Glassey, 1994 (details)

pulls in for close-up shots of the riders' torsos. Gelatinous gonadal forms—undifferentiated internal sex organs—emerge from slots in their uniforms in a migratory quest for directionality. In the case of the Ascending Hack, the organs move upward toward a second set of slots in the yellow leather. With the Descending Hack, they ooze downward, heading across a blue-leathered thigh toward the outer extremity of the sidecar.

Back at the pier the Loughton Candidate achieves his objective and plunges through the floor into the sea, in a Houdini-esque escape from the isolation chamber of his padded cell. Sinking to the bottom, he traverses the ocean floor toward the island. At the moment of his fall—a transition from the utopian realm of pregenital oneness to that of bifurcation—the Ascending Hack collides with a stone embankment and the Descending Hack pulls off the course for a pit stop, where the three fairies, now dressed in skintight blue jump suits, service their motorcycle. Using a tartan-wrapped hydraulic jack and white vinyl wedges, they prop up the back of the bike and remove its wheel, replacing it with a flesh-toned tire sporting a healthy set of descended testicles. Their action allows the roving organs to move farther down the outer side of the sidecar, but will render the bike useless until they reinstall a working wheel.

The Loughton Candidate reaches land and begins to burrow his way up into the body of the island. He enters a curving viscous channel that he must navigate in order to reach his desired destination: the TT finish line, where the two Hacks will meet in a fusion of yellow and blue. Above, on the beach perpendicular to the pier, a line of raised sand indicates his path inland. As he progresses into the depths of the island, his path becomes increasingly arduous: the channel gives way to a narrow three-sided tunnel filled with bulbous protrusions and petroleum jelly. The Candidate perseveres, contorting his body to pass through the constricted straits and swimming through the oppressive Vaseline goo. Part intestine, part birth canal, this torturous conduit leads him to a bluff high on the island, where the fairies are having a picnic. Dressed in bright yellow dresses over full hoop skirts, the three sprites frolic on a yellow mat that recalls the field from Barney's earlier work *REPRESSIA* (1991). "A play within the play,"[108] this picnic is the site of a "triple option," a football maneuver in which the Ascending Faerie, who has intercepted the hydraulic jack disguised as a thermos, has the choice of keeping, pitching, or passing it. She elects to pitch the thermos to the Descending Faerie, who declines the throw, wanting nothing to do with the process of ascension. The Loughton Faerie tries unsuccessfully to intervene. Their gestures mirror the conflict enacted by the principal characters, but with none of the tension; for them the process is merely a game.

Still mired in his underground tunnel, the Loughton Candidate finally reaches the roadway site where the two competing Hacks will intersect. He

108. This is Barney's description of the picnic scene. See Sans, "Matthew Barney: Modern Heroes," p. 29.

hears their approaching engines through the earth and asphalt above him. The Loughton Ram, with wool dyed red and all four horns decked in ribbons of yellow and blue Manx tartan, stands at this junction—a symbol for the total integration of opposites, the urge for unity that fuels this triple race. But before the three entities—Candidate, Ascending Hack, and Descending Hack—converge, the screen goes white and silent. This blankness bespeaks the annulment of desire, the impossibility of fusion. The Loughton Candidate's dream of transcending his biology to dwell in the space of pure symmetry embodied by the Loughton Ram is shattered. His campaign to turn the blue or yellow of his destiny into green is defeated, and revealed, perhaps, to have been little more than a delusion. He has glimpsed the seductive realm of the anal-sadistic universe, where all difference is abolished, where man and ram and island and motor form one continuous flow of desire. For the hubris of his aspirations he must be disciplined.

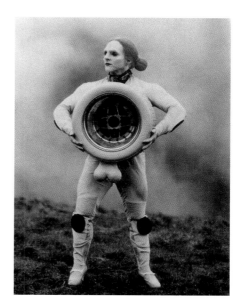

CREMASTER 4: ↑↔↓, 1994 (detail)

In the final sequence the narrative returns to Queen's Pier, where the Ascending and Descending Hacks—still intact and definitively separate—are parked on discrete ramps sloping down from the building's exterior. A white curtain parts to reveal disembodied testicles submerged in Vaseline and bedecked with blue and yellow ribbons. Pincers bearing the Arms of Man emblem pull at yellow and blue cords that pierce the scrotal sac. Indications are thus given that the hormonal drive toward differentiation is well underway (despite the Loughton Candidate's efforts) and that the direction is unquestionably male. In the closing image the camera peers through an open crotch at the top of the frame toward the end of the pier. A tightly retracted scrotum is pierced with white plastic clasps connected to vinyl cords, which trail off to the awaiting Ascending and Descending Hacks, who will drive toward the island to pick up the slack. Full descension is guaranteed. This corrective action is also an attempt to realize symmetry in a situation that inherently lacks it. The male body is by nature structurally uneven; one testicle usually hangs lower than the other in the scrotal sac. Barney has proposed that this condition may be the source of the *contrapposto* pose of the body in classical and classically inspired art; the hip of the male figure is dropped in order to compensate for this anatomical imbalance.[109] In the final scene of the film, the number of plastic clips attached to the scrotum is an odd number: four on the left, three on the right. The Ascending Hack on the right will pull up as it drives away, and the Descending Hack on the left will pull down in an effort to bring the body into alignment, shifting the pelvis into a level position. In *Cremaster 4* the biological turns sculptural, investing a classical morphological trope with a new metaphoric meaning: true creative form may only emerge from the understanding that total resolution (or total symmetry) is never really possible regardless of the amount of discipline applied.

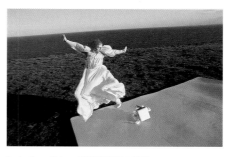

Production still from *CREMASTER 4*, 1994

109. See Lingwood, "Keeping Track of Matthew Barney," p. 53.

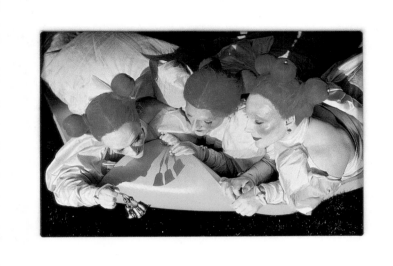

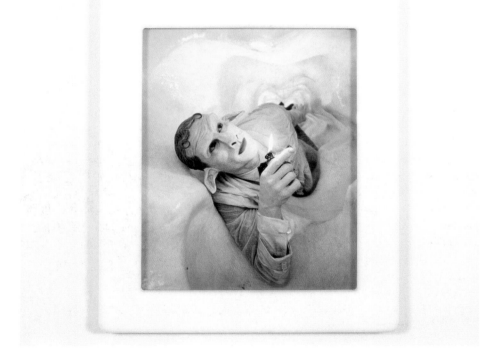

CREMASTER 4: Field of the Ascending Faerie, 1994

CREMASTER 5

As the final link in the narrative chain *Cremaster 5* describes the farthest point from the state of ascension embodied by Goodyear in the pregenital cocoon of her dirigibles. Since that blissful first moment the process of differentiation has been rejected, contemplated, and rehearsed during the ensuing three *Cremaster* installments. When total descension is finally attained in this concluding segment, it is envisioned as a tragic love story, a lamentation on separation and loss set in the romantic dreamscape of late-nineteenth-century Budapest. *Cremaster 5* is cast in the shape of a lyric opera (composed by Jonathan Bepler). Biological metaphors—cellular division, gonadal migration, testicular descension—shift form to inhabit emotional states. Loneliness, longing, spitefulness, and despair are the musical leitmotivs that infuse the orchestral score. The opera's primary characters—the Queen of Chain (played with elegiac beauty by Ursula Andress) and her Diva, Magician, and Giant (all played by Barney)—enact collectively, as a musical ensemble, the final release promised by the project as a whole.

While the differentiation conceived of in the *Cremaster* cycle results in the formation of a man, the tenor of its final chapter is decidedly female. The opera issues from the Queen's memories and the open wound that is her heart. Barney's characters are defined in relation to the mirror of her imagination. There is even the possibility that they only exist as shadows of her desire, figments of a forlorn mind. Like the drama that unfolds when the Loughton Candidate peers at his reflection in the vanity mirror in *Cremaster 4*, the events depicted in the opera may be a dream sequence. This would mean that the Diva, the Musician, and the Giant are projections of the Queen's unconscious desires. Descension—the apotheosis of the *Cremaster* project—would then be merely a mirage, a fantasy forged in the recesses of the Queen's subconscious.[110]

The opera's settings—the neo-Renaissance Hungarian State Opera House, the exoticized, Secession-style Gellért Baths, and the heroic Lánchíd (Chain) Bridge—are similarly extensions of the Queen's desire. They reverberate outward from her body, as if spun from arias of love and loss. Architectural and anatomical structures combine to create emotional spaces that breathe, weep, and expire in unison with their human counterparts.[111] Even Budapest assumes corporeal dimensions. Established in 1873 through the union of three towns, Óbuda, Buda, and Pest, this hybrid city was one year later the birthplace of Ehrich Weiss/Harry Houdini. For Barney, then, it is a place of origin, a procreative vessel, a site of gestation where the resident spirit of the *Cremaster* cycle was born. Patron saint, role model, and inspiration, Houdini presides over the entire project, which in a sense begins and ends with him. The looping chronology of the cycle, synonymous with the temporal arc of *Cremaster 2*, suggests as much.

110. According to Todorov, the "not-knowing" whether a narrative is a dream or a fairy tale is the defining feature of the literary fantastic: "The fantastic, we have seen, lasts only as long as a certain hesitation: a hesitation common to reader and character, who must decide whether or not what they perceive derives from a 'reality' as it exists in the common opinion." Todorov, *The Fantastic*, p. 41.

111. In an interview with Hans-Ulrich Obrist, Barney remarks, "Opera is a model I feel closer to than film. It is related to architecture in a way that the opera house is anatomical. It is built in such a way that amplification is not necessary. It is not unlike being inside a chest, it is sympathetic to the body in the way that the curves work in terms of the acoustics. One can say in a sort of simplified way that the works I make are a bit like constructing a narrative within a body that would take place in an opera house." Published in the brochure accompanying Barney's commission for the Vienna State Opera House curtain, museum in progress, Vienna, 2000.

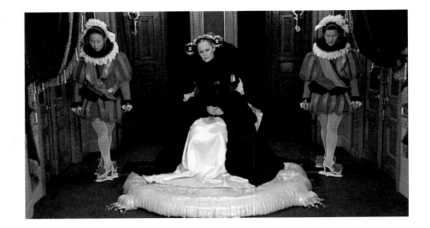

Structured in five acts—like Greek tragedy, which was most typically composed around five conflicts—*Cremaster 5* opens with an overture that introduces the opera's characters and lays out the map of Budapest that the narrative will traverse.[112] The Magician crosses the Lánchíd Bridge on horseback. Cloaked in black, he merges with the night air. The Queen ascends the grand staircase of the opera house with her two ushers, who lift the train of her billowing black skirt. She settles onto her flesh-colored pillow of a throne in the royal booth, and the ushers arrange a fleet of seven white Jacobin pigeons around her. Pearls float on the surface of the tepid pools in the Gellért Baths, partially concealing the Füdőr sprites, who inhabit their underwater realms. The curtain rises to an empty theater, the conductor readies his orchestra, and the opera begins.

As the Queen begins to sing (in Hungarian), her Diva appears on the stage before her, conjured perhaps by the melancholy cadence of her song. He performs a dance of thresholds, delineating the proscenium arch of the stage by laying ribbons across its floor and then scaling its walls and ceiling. He draws its aperture with his body. Her lyrics call out to him:

> Prepare the proscenium arch
> She defines his step
> Toward the painted, icy field
> Inhaling…
> Now, turn to me
> Look through the proscenium arch
> She defines his stance
> On the line before me
> Exhaling…
> Now, turn to me

112. The link between Greek tragedy, grand opera, and the *Cremaster* cycle as a whole can be inferred from the following quotation: "Most Greek tragedies were structured around five conflicts, generally involving two characters in each of five dialogue confrontations. The concept of conflict forms the basis of all successful opera, as it does for all successful theater. The five-part form also would be used again and again in opera, especially in the customary five acts of French nineteenth-century opera, or in the five-part form of Strauss's *Elektra*, a modern version of the ancient Greek play." Ancient roots can thus be established for the aesthetic of *Cremaster 5*: "Other central features of Greek musical tragedies were their elegiac tone and elegance and restraint of presentation." See John Louis DiGaetani, *An Invitation to the Opera* (New York: Anchor Books, 1986), p. 15.

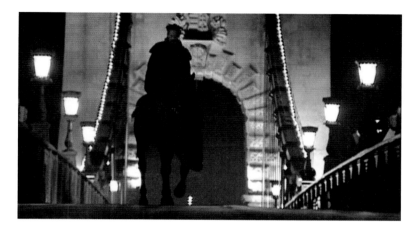

Video still from *CREMASTER 5*, 1997

The choreography of the Diva's climb demarcates the arch as a line of pressure between the space of the stage and that of the audience. Barney's fascination with the tension held in this architectural zone is expressed in a collage he made for the film's storyboard, which juxtaposes an image of the Caspar David Friedrich painting *Der Wanderer über dem Nebelmeer* (*The Wanderer above the Sea of Fog*, ca. 1818) with a photograph of the hardcore vocalist Henry Rollins. In the Friedrich image a man stands with his back to the viewer contemplating a vast landscape obscured by fog. Conversely, the photograph depicts Rollins facing his audience, screaming into the microphone, its cables wrapped tightly around his punching hand. Both figures maintain an authority over the artificial realms they address: painted scene and theatrical audience respectively. One faces away, lost in the reverie of dramatic illusion; the other opens outward to acknowledge the proscenium arch and the spectators beyond. The space between them is a liminal one, where theatrical artifice and the physicality of live performance coexist in a state of perpetual conflict. The Diva character inhabits this middle zone, turning to the side rather than inward or outward. He chooses to remain in the field of indeterminacy located at the precipice of the opera stage. In the vocabulary of *Cremaster 4* he spurns the fields of blue (backstage) and yellow (audience) for that of green (arch), preferring pure potential to categorical definition.

> In the pale blue field
> Solitude—
> The curve of the earth comforts him
> (His pride is false!)
> A willful contrapposto
> The hip rolls upward

Inhaling ... Hubris
Now, turn to me

In the cool yellow field
Pressure—
The dense arena confronts him
(His pride is false!)
Violently hunching forward
Bound to gravity
The diaphragm drops
Projecting ... Hubris
Now, turn to me

In the gilded mint green field
His image is reflected
In a milky highlight
Only red obscures her green

Proscenium ...
Turning through her axis
For a moment—he is free

Video still from *CREMASTER 5*, 1997

During the Diva's performance the Queen's mind wanders to memories of her beloved Magician. She recalls their final embrace during a wintry Budapest dusk; fitting a stirrup onto his boot before he embarks on a journey to perform a death-defying feat, she bids him farewell.[113] Her mourning continues as she reenvisions him standing on the Lánchíd Bridge, preparing for a leap into the dark, frigid waters of the Danube below. Stripped naked, he positions white plastic shackles over his wrists and ankles, then fits molded gloves on his hands and places weighted balls between his toes. Standing on the very edge of a plinth jutting out from the bridge, the Magician embodies the hermeticism of Houdini's practice. He represents every manacled bridge jump, fantastic escape, and metamorphosis the artist performed, as well as every hour of training it took to achieve them.[114] The Magician is seeking transcendence; he is trying to elude the inevitability of definition and to find instead a place of possibility—the kind of possibility manifest in the zeppelins that hover over the goalposts in *Cremaster 1* or manifest in the four curving horns of the Loughton Ram in *Cremaster 4*. His is the hypertrophic impulse; through restraint he will be free. But the Queen misunderstands his actions and thinks he is trying to take his own life. She fears abandonment and fights against his release.

113. This act of preparing the "hero" before an epic journey was first seen in *Cremaster 4*, when the fairies attached cleatlike taps to the Loughton Candidate's shoes.
114. Houdini's manacled bridge jumps, a regular and sensational part of his act, were clearly Barney's source for the Magician's leap. A jump on May 6, 1907, off the Weighlock Bridge in Rochester, New York, was documented on film: "Houdini removes his coat and vest, strips his suspenders and pleated dress shirt, peels off his trousers and stockings. Clad only in long white undershorts, he poses a moment for the movie camera. After a policeman locks him into two pairs of cuffs, he climbs to the topmost truss of the bridge, barechested, holds up his shackled wrists to the crowd, shouts to them ('Goodbye'), and jumps straight down toward the canal. As the plummeting feetfirst white blur splashes into the inky water, one pair of cuffs flies off. In fifteen seconds, Houdini bobs up, the other pair dangling from one wrist; he sinks again, then surfaces with both cuffs unlocked." Silverman, *Houdini*, pp. 114–15.

The 24th of March[115]—in the final freeze of that year
This was our first and painfully, our very last
Over the Danube
I left you there on a bridge of chain

Worthless chain!

I carried away the warmth
Of your impression on my shoulder
Such a hasty departure
Your inevitable final step
In replay at half-speed
For the rest of my life

This divine resistance?!

Without you now
I must pass over the chain each night, alone
My magician, my love
Was this a final act of disappearance?
Could it be, then
That you are still on your way down?

Give me a sign, my dear
In a moment of strength
I will join you in your path

CREMASTER 5: Elválás, 1997 (detail)

Video still from *CREMASTER 5*, 1997

The Queen's focus shifts back to the opera house and the Diva, giving her momentary respite from the sorrow of her memories. The ushers direct her attention to orifices in her throne through which she can see down into the Gellért Baths below her. The camera next moves upward under her skirts to a view between her legs, then returns to the watery environs of the spa, suggesting metonymically that the scene about to unfold takes place within her body. The form of her fleshy throne reiterates this notion. The sculpted stool upon which she sits conforms exactly to the shape of her buttocks; the symmetry of this seat mirrors the two adjacent bathing pools lying beneath her. One bath is forty-five degrees Celsius; the other, forty-seven. The narrow path lying between the pools is a projection of the Queen's perineum; it is in this liminal anatomical space that her Giant resides.

During this interlude the Queen's retinue of birds plummets through the passages in her throne, trailing long satin blue-and-yellow ribbons into

115. March 24, 1874, was Houdini's birthday.

CREMASTER 5: A Dance for the Queen's Menagerie, 1997
(detail)

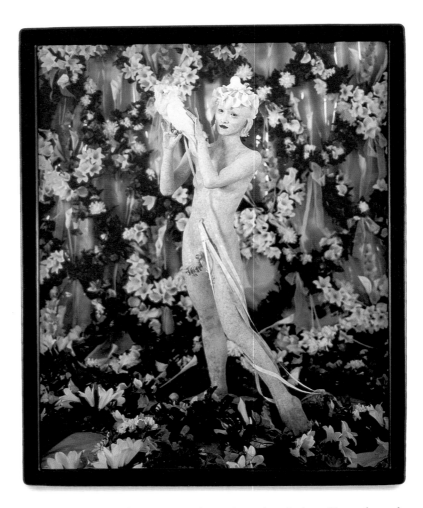

the humid bath. The water sprites stir under their ceiling of pearls. Preadolescent hermaphrodites with breast buds and tiny Art Nouveau penises luxuriate in their aqueous world, fluttering around an underwater mosaic staircase and playfully tickling and embracing one another. These blissful creatures seem to have been plucked from Hungarian folklore; they could be the daughters of the King of the Green Water Fairies, who lived under a lake and traveled in a pearl boat.[116] Carrying the Jacobin pigeons, the Queen's Giant enters the bath. The most baroque of Barney's characters, he is a Neptune figure. His hair is made of clear glass bubbles, his mustache is encased in a crystal swirl so that it looks like a stream of water, his ears are drooping calla lilies, and his legs taper into thigh-high lily blossoms (vestiges of which are visible on the legs of the Magician). Like the

116. The legend of the daughters of the King of the Green Water Fairies may not be Barney's direct source, but the artist often does make use of the indigenous literature and folklore of the culture in which he is working, as, for example, he did on the Isle of Man. See Nandor Pogany, "The Lake of St. Anna," in *The Hungarian Fairy Book* (London: T. Fisher, 1913), pp. 162–76.

Loughton Candidate before him, the Giant lacks external genitalia, save for an abstracted scrotum.

The Queen watches silently from above as the Giant enters the watery path between the two pools, wading through the pearls to hip level. The sprites cluster around him with a garland of seven blue-and-yellow ribbons they have woven together out of those attached to the birds. They reach up through the water and affix the garland to the Giant's scrotum. This gesture resonates with the tense final image of *Cremaster 4*: the seven satin ribbons echo the seven braided cords used to discipline the organs of the Loughton Candidate. Here, however, in the warm, soothing waters of the thermal baths, and with the playful encouragement of the sprites, the cremaster muscle releases and the testicles descend.[117] This climactic moment—the emergence of a fully differentiated state—is rendered visible when the Jacobin pigeons soar upward, wings flapping and ribbons trailing. They pull at the very core of being, achieving ascent within the inescapable course of descent. The blue-and-yellow ribbons (of the Ascending and Descending Fields) have blended to become green ribbons, the color of possibility. The Giant stretches his arms upward to his Queen, offering this option, but she is too distraught to understand freedom in the abstract.

The Queen's thoughts return to the Magician, whom we see leaning at the edge of the bridge, deep in concentration, preparing for his great escape. She relives his leap into the river and swoons from the horror of her recollection. The ushers cushion her fall. At this point the narrative mirrors the path of descension just revealed: having completed his climb, the Diva tumbles to the stage in a tragic accident that ends his existence. A pink substance oozes from the space previously occupied by his head. Meanwhile the Magician plunges to the bottom of the river, landing, manacled, on a sumptuous flowerbed. Calla lilies sway with the tide around him, and two water sprites caress his fallen body and insert a black pearl into his mouth. This gesture invokes the funeral practice in which a pearl is placed in the mouth of a noble to preserve the body and assure long life in the next world. The Queen performs her mournful aria, preparing to join her lover in death:

> Warmth . . .
> Separation . . .
> Descension . . .
> Definition . . .
> Release . . .
>
> Black has finally overcome the threat of red

Video stills from *CREMASTER 5*, 1997

117. Because the baths on either side of the Giant are different temperatures, his testicles descend unevenly, preserving the innately *contrapposto* posture of the male figure and denying pure symmetry.

Video still from *CREMASTER 5*, 1997

My love, I now understand the chain
And within the lock, the lilies are turning
away from the light
We fall, my love, together
Come to me . . . (until now withholding)
Release . . . (until now withholding)
Release. . . .

As the Queen falls into the deep slumber of her sorrow, a thin stream of liquid emanates from her mouth, trickling onto her ruffle and throne, then falling into the pools below. On its descent the stream divides into two droplets that strike the water simultaneously. Two perfect circles resonate outward, filling the surface of the bath with their quiet waves.

These droplets signify two possible endings to *Cremaster 5*, and to the cycle as a whole, deferring any single definitive reading of the project. The first scenario, suggested by the rings radiating outward on the water, adheres to the looping chronology of the series, as exemplified in Gilmore's retreat to the era of Houdini. If *Cremaster 2* can be seen as a microcosm of the entire project, then the cycle itself travels backward in time in order to begin anew. It moves through or rehearses the paternal space of *Cremaster 5* in order to revisit the pregenital space of *Cremaster 1*, recycling itself in a circle of eternal return. The ascent of the birds at the final, long-awaited moment of descension in *Cremaster 5* intimates that the descent may be false or that differentiation is a dialectical process, one state always containing and completing its opposite. The enigmatic shot upward under the Queen's gown toward her genitals suggests that the male state of descension cannot be thought of separately from its female counterpart. Beyond the strictly

biological, this scenario alludes to the notion that conflict itself is critical to the creation of form (psychological, biographical, geographical); it is not some illusory end product.

The second scenario imagines the death or self-destruction of the system through the erroneous assumption that it has failed to achieve some predetermined outcome. Thinking her Magician has died, the Queen takes her own life, which also erases the existence of her Diva. Confusing escape with death, transcendence with rejection, she betrays the true goal of the system, which is to find a way to look beyond itself, to reach the other side of consciousness, form, or definition. Whether it is ever truly possible to fulfill this goal without unleashing the destructive forces of hubris remains an unanswered question. And this is the essential tragedy of the cycle: eternal recurrence. Like the "kid" perennially chasing the inner and ever-elusive threshold of his being, *Cremaster* is in a tailspin.[118]

118. Barney has described the cycle as a tragedy, saying, "In a certain way they [the five chapters] all end up being tragic. In the way that the narratives are never really allowed to resolve themselves in any way, there's something about that which makes them resistant to that kind of heroism. In the way that the satyr chases its own tale [*sic*], I think all these narratives in the end chase their tails, they're sort of in a tailspin. Sometimes it becomes a little more complex and there's a moment in a piece which essentially turns it back onto itself. I don't think it's ever really allowed to describe itself purely as a resolved story." Quoted in Sans, "Matthew Barney: Modern Heroes," p. 30.

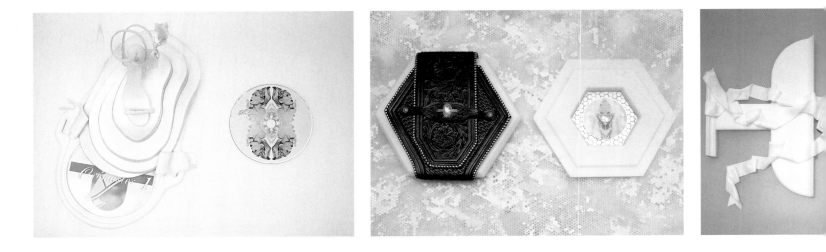

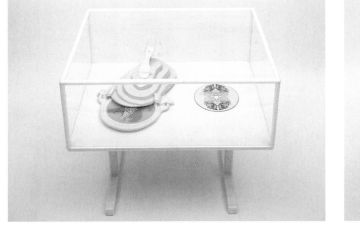

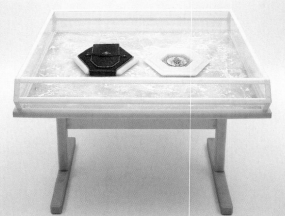

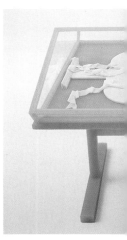

CREMASTER 1, 1995–96
CREMASTER 2, 1999
CREMASTER 3, 2002
CREMASTER 4, 1994–95
CREMASTER 5, 1997
Vitrines, each containing special edition laser disk
or digital video disk of its respective film, two views

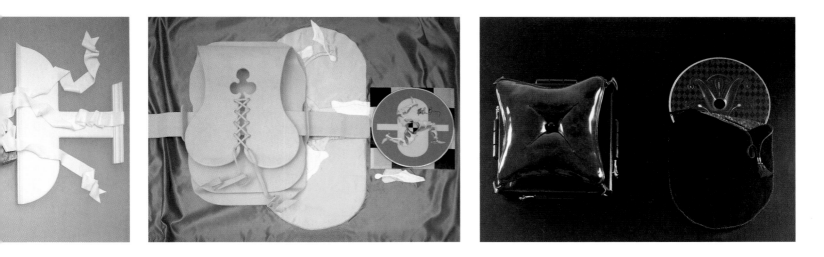

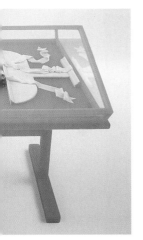

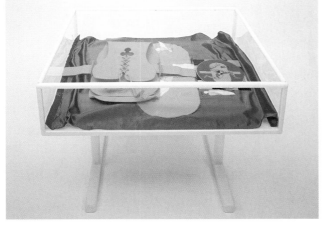

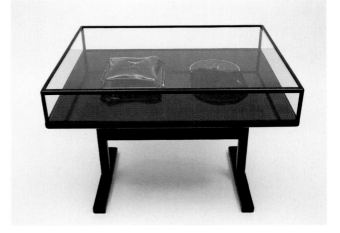

NARRATIVE AND DESIRE

The *Cremaster* cycle is aesthetically polymorphous. Each of the five films has its own distinct look, derived from both the location in which it was made and the period it invokes. Chronologically, the films range from the 1870s, and the birth of Harry Houdini, to the 1970s, and the death of Gary Gilmore, with all sorts of anachronistic moments along the way. Barney is drawn to certain periods because of their design aesthetics, which he utilizes as visual conduits for his narratives. Turn-of-the-century corsetry, Depression-era precision dancing, Art Deco architecture, Victorian physical culture, and Baroque opera are only some of the media with which he sculpts his cinematic vision. Each episode has its own predominant palette and its own logo, which incorporates Barney's field emblem. The logo for *Cremaster 1* is the winged Goodyear boot with a small silver funnel added to the toe; for *Cremaster 2*, a heraldic arrangement of the beehive, the American and Canadian flags, and the dates 1977 (the year of Gilmore's execution) and 1893 (the year of the Columbian Exposition); for *Cremaster 3*, a Masonic coat of arms with a double-headed eagle, the Chrysler Building, and a Celtic harp; for *Cremaster 4*, the Arms of Man punctured by the tunnel that runs under the island; and for *Cremaster 5*, a stylized fleur-de-lis. And while each film can exist on its own as a discrete work of art, an independent entity with its own internal code of conduct, the five come together like the sides of a pentagon to form a single self-enclosed system. Beyond the iconographic links, of which there are many, the films connect through something far more ephemeral: time, a glacial pace that crystallizes action and clarifies tone. This is not to say that all of the *Cremaster* films are slow, but they share an abstract temporality, an intense, deliberate pacing that allows elements usually considered secondary or even tertiary—such as landscape, color, costume, and set—to come to the fore. Characters may be flattened out into zones, but other elements take on emotional depth and psychological complexity. Barney has said that his films move "at the speed of art—which is slow." He has also defined his entire practice as sculptural,[119] discussing the films themselves as if they were three-dimensional entities. He once said of *Cremaster 2*, "It moves slowly and requires that one move around it to understand it, and to visit it repeatedly."[120]

Though emphatically of the 1990s and beyond, Barney's films share (albeit superficially) a strategy mined by the Appropriation artists of the 1980s, such as Jeff Koons, Richard Prince, and Cindy Sherman; the films borrow existing genres to exploit as their own. Barney, however, is not attempting to critique the cinematic or theatrical frames he appropriates in some kind of deconstructive act aimed at popular culture. Rather, he inhabits various genres because they supply vocabularies and aesthetics that will advance his

119. See Linda Yablonsky, "A Portrait of the Artist as a Gun Man," *Time Out New York*, no. 212 (October 14–21, 1999), p. 200. Barney comments on the tempo of his films in this interview. In conversations with the author he has often discussed his œuvre in terms of sculpture. 120. Ibid.

narrative. He thinks of these genres as "host bodies" that the *Cremaster* system can "latch onto" like an opportunistic virus.[121] In order to succeed, each film must perform with the same authority as the genre it occupies; it must act and think like the form that harbors and nourishes it.

Barney's most explicit appropriation occurs in *Cremaster 1*, which seamlessly fuses the symmetrical seduction of precision dancing (as filtered through the sweet wholesomeness of a cheerleading squad) with the exactitude of military formation. Conflating the kinetic extravaganzas of the Hollywood dance director Busby Berkeley with the athletic uniformity of Leni Riefenstahl's Aryan propaganda films, this is a hybrid musical comedy about an embryonic skirmish. Goodyear, the blonde starlet, fights to maintain control over her biological destiny by choreographing the movements of her dance troupe to form diagrams of an undifferentiated system. Emulating Berkeley's famed crane shots, Barney films the chorus girls from above as they glide in and out of position, never once breaking rank or missing a beat. His camera indulges us by zooming in on each beatific face, if just for an instant, then peering through the girls' perfectly synchronized legs with low tracking shots. Their costumes—tiered hoop skirts—are vintage Berkeley, lifted straight out of the "Shadow Waltz" number from *Gold Diggers of 1933* (1933). Here, though, the girls wear the orange and blue of Bronco Stadium. In the Berkeley routine the chorus arranges itself in the shape of a violin, which it then "plays" with a human-formed bow. Barney's use of this kind of representational patterning—he sees gonads where Berkeley sees musical instruments—is more than a formal device; like Berkeley's, his choreographic gestures illustrate the ever-shifting relationship between the individual and the collective.[122] At points in the narrative Goodyear appears on the playing field surrounded by her chorus in an ecstatic union of self and other. She rides a pearl-covered float through their adoring arms, and they create a field emblem miraculously filled with a kaleidoscopic quadrangle made from four views of her smiling face.

Barney explores the tenuous connection between the individual and the crowd throughout the *Cremaster* cycle. While hermetic practices require isolation, there is always the pull of the masses, in which one can lose any sense of individuality. Self-loss is ritualized in the mosh pit, where music fans engage in an energized communal writhing that is as hostile as it is sensual. Included in the Guggenheim sequence of *Cremaster 3* as one of the obstacles through which the Apprentice must pass, the mosh pit is simultaneously enticing and horrifying. The same combination of attraction and repulsion appears in all of Barney's various versions of precision dancing: the routines by the Bronco Stadium girls, the Order of the Rainbow dancers in *Cremaster 3*, the mounted state troopers in the prison rodeo of *Cremaster 2*.

121. Barney, quoted in Romney, "Matthew Barney," pp. 87, 93.
122. "In Berkeley's numbers, the experience of losing oneself in the group, in the big ensemble, is presented as primarily ecstatic. It is a moment of transcendence and sublimation, analogous to orgasm, but erupting beyond the confines of the ego to fuse self and society, sexuality and politics, emotion and ideology." Martin Rubin, "The Crowd, the Collective, and the Chorus: Busby Berkeley and the New Deal," in *Movies and Mass Culture* (New Brunswick, N.J.: Rutgers University Press, 1996), p. 78.

The Berkeley flavor of *Cremaster 1* slides into the chilling sensibility of Riefenstahl. The perfection of precision dancing depends on the sublimation of individual artistic expression, requiring "an intricate technology of form—equal spacing, even extensions, rhythmic synchronizations, and the erasure of interpretive flair."[123]

The friction between total self-absorption, on the one hand, and annihilation of the self through its immersion in the crowd, on the other, is symptomatic of the larger biological/ontological struggle that drives the *Cremaster* cycle. By employing diverse genres, Barney accesses different vocabularies with which to articulate this central conflict. In *Cremaster 2*, for instance, Gilmore's attempt to escape his fate as a drone is cast in the form of a gothic Western. *Cremaster 3*, which envisions the development of character through the fortification of will, is rendered as a mutant zombie/gangster film. The rite of passage described in *Cremaster 4* is cast as a classic road movie tinged with the suave air of a Fred Astaire dance number. And *Cremaster 5*, which recounts the final (and false) release from the cycle, inhabits the structure of an operatic love story. Barney's approach to the genres he borrows from is entirely fetishistic. With his core of collaborators—costume designers, makeup and special effects experts, fabricators, etc.—he absorbs and reenvisions every salient detail so that it can take its place and fulfill its function within the *Cremaster* universe. The translation of appropriated vocabulary into the language of the *Cremaster* cycle is further deepened by Bepler's scores for the five episodes, which rearticulate music from the period, genre, and styles invoked.[124] Like Barney's visual imagery, Bepler's compositions are provocative mixes of the archaic and the contemporary.

The core conflict of the *Cremaster* project—which has been discussed in biological, biographical, and psychosexual terms—can also be read through a literary model. Narrative, after all, is the primary element connecting the various cinematic and dramatic genres that Barney adapts. While narrative structure may usually be a given in the literary arts—including here the theatrical realms of drama and film—it certainly does not occupy that role for contemporary sculpture. Each chapter of the *Cremaster* project includes not only a film but also related objects, installations, photographs, drawings, and an artist's book. Collectively these tell a story, *one* story, which changes its form but not its substance from episode to episode. This narrative is, in essence, a chronicle of the personal quest to reach the next level, to transcend the status quo, to overcome the strictures of the self.

Typologically, the quest-narrative can be broken down into a sequence of two functions, which is endlessly repeatable in an unbroken chain of events. For the semiotician Jurij Lotman these functions—typified as an "entry into

123. John Alliotts, "Precision Dancing," *Dancemagazine* 56, no. 12 (December 1982), p. 42.
124. The musical component of the *Cremaster* cycle is beyond the scope of this essay, but it demands detailed analysis, for it contributes enormously to the project's conceptual rigor. For reasons of brevity, this text will simply acknowledge Jonathan Bepler's prodigious talent as a composer.

a closed space, and emergence from it"—can take any number of forms that are entirely interchangeable. "Inasmuch as closed space can be interpreted as 'a cave,' 'the grave,' 'a house,' 'a woman' (and, correspondingly, be allotted the features of darkness, warmth, dampness)," he explains, "entry into it is interpreted on various levels as 'death,' 'conception,' 'return home,' and so on; moreover all these acts are thought of as mutually identical."[125] In this Structuralist analysis the most fundamental kernel of these narratives is *passage*, the movement from point A to point B, in both temporal and spatial terms. Film theorist Teresa de Lauretis has argued that the "hero" who undertakes this mythical passage is archetypally male, and that the obstacle, whatever its form, is female. If the initial impetus behind the textual generation of myth was to establish distinctions, to convert the seeming randomness of the universe into meaningful order, then, according to de Lauretis, the "primary distinction on which all others depend is not, say, life and death, but rather sexual difference."[126] "In other words," she continues,

> the picture of the world produced in mythical thought since the very beginning of culture would rest, first and foremost, on what we call biology. Opposite pairs such as inside/outside, the raw/the cooked, appear to be merely derivatives of the fundamental opposition between boundary and passage; and if passage may be in either direction, from inside to outside or vice versa, from life to death or vice versa, nonetheless all these terms are predicated on the single figure of the hero who crosses the boundary and penetrates the other space. In doing so the hero, the mythical subject, is constructed as human being and as male; he is the active principle of culture, the establisher of distinction, the creator of differences. Female is what is not susceptible to transformation, to life or death; she (it) is an element of plot-space, a topos, a resistance, matrix, and matter.[127]

The ur-narrative of Western culture—the paradigmatic plot that defines all others—is the story of Oedipus Rex, who unwittingly murdered his father and married his mother. Adopted by Freud to explicate the stages of early psychosexual development, the institution of the incest taboo, and the subjection of the individual to paternal law, the story depends entirely on the structural division between the sexes.[128] The Oedipal story—with its eponymous "complex" and attendant symptoms (castration anxiety, penis envy, incestual desire, fantasies of aggression)—is thus an origin myth.[129] It articulates the formation of self within a patriarchal structure premised on binary thought, which itself depends on an unbridgeable gap between desire and lack. To

125. Jurij Lotman, quoted in Teresa de Lauretis, "Desire in Narrative," *Alice Doesn't: Feminism, Semiotics, Cinema* (Bloomington: Indiana University Press, 1984), p. 118. She is citing Lotman's essay "The Origin of Plot in the Light of Typology," trans. Julian Graffy, *Poetics Today* 1, nos. 1–2 (autumn 1979), p. 168. My discussion of narrative in relation to Barney's *Cremaster* cycle is indebted to de Lauretis's study of the genderizing implications of Western narrative.

126. Ibid., p. 119.

127. Ibid.

128. In a letter dated October 15, 1897, Freud announced his discovery of the Oedipus complex: "One single thought of general value has been revealed to me. I have found, in my own case too, falling in love with the mother and jealousy of the father, and I now regard it as a universal event of early childhood. . . . If that is so, we can understand the riveting power of *Oedipus Rex*, in spite of all the objections raised by reason against its presupposition of destiny. . . . the Greek legend seizes on a compulsion which everyone recognizes because he feels its existence within himself. Each member of the audience was once, in germ and in fantasy, such an Oedipus." Quoted in Janine Chasseguet-Smirgel, "Oedipus and Psyche," *British Journal of Psychotherapy* 15, no. 4 (1999), p. 465.

129. Carla J. Ferstman and J. C. Smith, *Castration of Oedipus: Feminism, Psychoanalysis, and the Will to Power* (New York: New York University Press, 1996), p. 31.

contest the Oedipal bifurcation of thought (mother/father, self/other, female/male, etc.) is to challenge the symbolic order itself, to disrupt the "dominant fiction" upon which our entire social system is based.[130] There is an anti-Oedipal impulse, however, that dates back as far as recorded thought and is personified in the figure of Dionysus. Valuing multiplicity over division, proliferation over lack, fluidity over stasis, and mutability over categorization, this mode of thought follows a trajectory from the ecstatic philosophy of Friedrich Wilhelm Nietzsche to the sociopolitical critique of Gilles Deleuze and Félix Guattari, with detours in the writings of the Marquis de Sade and J. G. Ballard (to name only some of the most illustrative examples). In place of the Oedipal triangulation of "papa, mama, me," which institutes an immutable sensibility of "either/or," Deleuze and Guattari introduce the notion of an undifferentiated "body without organs."[131] This is a body of pure sensation that is at one with the world. Pregenital, prelingual, and entirely self-encapsulated in a utopian realm of pure drive, the "body without organs" is self-generated and, therefore, free from paternal authority.[132] Deleuze and Guattari write,

> The body without organs is an egg: it is crisscrossed with axes and thresholds, with latitudes and longitudes and geodesic lines, traversed by gradients marking the transitions and becomings, the destinations of the subject developing along these particular vectors. Nothing here is representative; rather is all life and lived experience . . . [like the] predestined zone in the egg . . . that is going to be simulated to produce within itself. Nothing but bands of intensity, potentials, thresholds, and gradients.[133]

In psychoanalytic terms, a rejection of the Oedipal complex constitutes a refusal to move beyond the state of primary infantile narcissism in which the subject remains fixed in pregenital unity. The sequential fantasies of the complex—maternal seduction (in order to recover the original sense of oneness), paternal aggression (in order to eliminate competition), and paternal identification (as a resolution to the conflict)—never occur, because the subject feels no separation from his or her mother. According to Janine Chasseguet-Smirgel, "The narcissistic state is fantasized as identical in nature to the fusion between the infant and its mother on the model of the intrauterine situation."[134] The antithesis of Oedipal development is perversion, which is marked by the regressive compulsion to eschew normative sexual maturation by privileging the anal stage over the genital. Abandoning Oedipus means embracing the anal-sadistic universe: the delirious realm of undifferentiation imagined by the *Cremaster* cycle.

130. The term "dominant fiction" is used by Kaja Silverman in arguing that the ideology necessary for the constitution of male identity (i.e., classic masculinity) is the equation between the phallus, as (Lacanian) symbol of power, and the penis. This ideology, she believes, is operative at the deepest psychological level and is perpetuated by the Oedipus complex. See Silverman, *Male Subjectivity at the Margins* (New York and London: Routledge, 1992), p. 16.
131. Deleuze and Guattari, *Anti-Oedipus*, pp. 9–16.

132. "The full body without organs is produced as antiproduction, that is to say it intervenes in the process as such for the sole purpose of rejecting any attempt to impose on it any sort of triangulation implying that it was produced by parents. How could this body be produced by parents, when by its very nature it is such an eloquent witness of its own self-production, of its own engendering of itself?" Ibid., p. 15.
133. Ibid., p. 19.
134. Chasseguet-Smirgel, *Creativity and Perversion*, p. 27.

While the different story lines of Barney's *Cremaster* films adhere to the structure of the quest-narrative, with their primary character(s) enduring various tests of will, the artist's theme, in the end, is profoundly anti-Oedipal. But this is not immediately apparent, for—in another masterful appropriation of genre—the project wears Oedipus's cloak. All of Barney's (male) protagonists—Gary Gilmore, the Entered Apprentice, the Loughton Candidate, and the tripartite Diva/Magician/Giant—undergo a rite of passage through which they must overcome physical and emotional constraints. The tournament staged in the Guggenheim in *Cremaster 3*—the Masonic game called "the Order"—is a microcosm of this cycle-wide motif; it allegorizes each *Cremaster* episode as a specific obstacle—like the Sphinx of ancient Thebes, the monster slain by Oedipus—that the Entered Apprentice must defeat. In the cycle itself the lure of the feminine materializes as one of the challenges faced by the primary characters. As it is dramatized, however, it emerges as less an impediment to be removed than an energy to be absorbed. Gilmore murders out of frustrated passion for Nicole Baker, then seeks release through gender metamorphosis. The Entered Apprentice, the cycle's most narcissistic character, becomes and then slays his female alter ego (who, as an Egyptian cat, invokes the mysterious Sphinx). The Loughton Candidate crawls through the vaginal tunnel under the Isle of Man searching for an option beyond the "either/or" of differentiation. And the Magician, Diva, and Giant seem to exist only as extensions of the Queen's sorrow; they are held captive in her reverie.

The patriarchal side of the Oedipal triangle finds form at various points in the cycle; the Houdini/Mailer/Gilmore axis, for instance, is one of the more overt examples of paternal authority. It is the presence of Serra in *Cremaster 3*, however, that most aggressively suggests the "anxiety of influence" associated with Oedipal conflict.[135] His role as Hiram Abiff or the Architect, foil to Barney's Entered Apprentice, and his cameo appearance in the Order—as himself, at the pinnacle of the Guggenheim's rotunda—establish a "father figure" against which the artist must rail. It is tempting to read *Cremaster 3*, with its biographical allusions, as a personal meditation on the tyranny of artistic influence. Identification with the father (as the successful resolution of the Oedipal complex) would mean adherence to a certain school or style. The murder of the father would indicate freedom from comparison and aesthetic categorization.

That this is of course a simplistic reading of Barney's epic project does not make it entirely untrue, but the artist inhabits the Oedipal narrative only in order to invert many of its terms. In *Cremaster 3*, for instance, Barney does not kill off the paternal figure of Serra as much as he ingests it, making the sculptor's vocabulary consonant with his own.[136] In this way, Mailer, Serra,

135. In his book *The Anxiety of Influence*, a study of artistic lineage, Harold Bloom proposes a theory of literature premised on Oedipal conflict, asking how a young poet can avoid repetition and overcome the domination of "ghostly fathers." See Bloom, *The Anxiety of Influence: A Theory of Poetry* (New York and Oxford: Oxford University Press, 1967), p. 88.

136. This is one way to read the dental-office sequence in *Cremaster 3*: though rendered as an allegory of Masonic initiation rites grafted onto a gangster-film scenario of betrayal and retribution, the scene also alludes to fundamental psychological conflict. The paternal figure of the Architect may have ordered the removal of the Apprentice's teeth (a symbol of castration, according to Freud) and then their replacement, but it is the Apprentice who actually creates something through this process. He ingests and expels his broken teeth, which coalesce to form a perfect porcelain rod that Barney has described as "the internalization and idealization of the paternal phallus." Barney, correspondence with the author, January 2, 2002. For more on the symbolism of teeth, see Freud, *The Interpretation of Dreams*, 1900, English trans. and ed. James Strachey (New York: Anchor Books, 1965), pp. 420–28.

Dave Lombardo, and even Ursula Andress become as much a part of the *Cremaster* cosmology as Houdini and the Queen of Chain. In his adoption and subversion of Oedipal thought, Barney complicates its binary structure. "Female" and "male" strains are clearly operative in the *Cremaster* organism, but they give rise to unexpected behaviors. The "feminine" character zones, Goodyear and the Queen of Chain, are in control of their narratives. Unlike the Sphinx, who appears only as a character in someone else's story, they have ultimate agency; they direct the choreography of their being. The "masculine" character zones, whose protagonists progress from candidacy to apotheosis, allude to an outcome very different from that prescribed by Oedipal development, which privileges the genital over the anal or oral stages. On the biological level, these characters either have miniscule, amorphous penises or lack them entirely. Their anatomy points toward the "male" by scrotum alone. As "bodies without organs," they hover on the edge of gender identification, propose the possibility of self-generation, and imagine a space without difference. These perverse creatures are successfully unformed; their testes are tethered with the cords of pure potential.

SCULPTURAL DIMENSIONS

The *Cremaster* cycle is a counter-myth. Experimental and open-ended, it narrates the story of a subject who exists outside of language—at least outside our rationalistic language premised on the dichotomies of presence and absence, and by extension on all bipolar thought. It is fitting, therefore, that Barney's epic project is predominantly and emphatically visual.[137] All five films together contain approximately ten lines of spoken dialogue. The narrative is almost purely imagistic; it progresses from one scene to another through a network of signifiers that connect on a purely poetic level, with grapes becoming dancers, a car becoming dentures, a tire becoming testicles, and so on. The slippage between seemingly dissimilar elements—as if lubricated by Barney's signature Vaseline—serves to reveal a fundamental elasticity of meaning. It strikes against dualistic analysis and categorization premised on opposition. As one metaphor signifies another, and another, in a spherical chain of allusion, the *Cremaster* cycle rehearses a perpetual collapse of (sexual) difference.[138]

This circular chain unfolds not just cinematically but also through the drawings, photographs, sculptures, installations, and books produced in conjunction with each *Cremaster* episode. These elements radiate outward from the narrative core of every installment, as if moving with centrifugal force out of each film's image bank. There are no ancillary components. The photographs—framed in the artist's signature plastic and often arranged in

137. This is not to discount the importance of the films' soundtracks and musical scores. It is intended, rather, to underscore the fact that the narrative project is to a large extent bereft of the spoken word.

138. This interpretation is drawn from Roland Barthes's Structuralist reading of Bataille's 1926 novel *Histoire de l'oeil*. Barthes sees all of Bataille's spherical metaphors—eye, sun, egg, testicles—as grid coordinates to metaphors of fluidity, tears, yolk, and semen. The two axes of the grid meet to produce impossible but profoundly resonant images such as "the urinary liquefaction of the sky." According to Bois and Krauss, "The action of the grid is not only to set up the factitiousness of every term (the fact that none could have a point of origin in the real world and thus none could serve as the story's privileged term, the one that provides it with its ultimate sense); it is also to declare each term as sexually impossible, the result of a continual collapse of sexual difference, as the grid works to produce the eye as a kind of round phallus." They quote Barthes: "He thus leaves no other recourse than to consider, in *Histoire de l'oeil*, a perfectly spherical metaphor: each of the terms is always a signifier of another (no term is a simple signified), without our ever being able to stop the chain." See Bois and Krauss, *Formless*, p. 155.

diptychs and triptychs that distill moments from the plot—chronicle the films' characters, choruses, animals, and settings. Large in format and lushly colored, they are not generally film stills, moments frozen from the cinematic narrative. Instead of attempting to emulate the cinematic within a static image, as does so much photo-based contemporary art today, they are formally posed shots taken on location, and underscore the essentially photographic condition of film. Their reference could be Hollywood celebrity portraiture in the tradition of George Hurrell, who produced entirely constructed images crafted to promote or commemorate both particular films and individual stars.[139]

The entire *Cremaster* cycle is permeated by drawing. From their position as conceptual studies in Barney's detailed storyboards, drawings delineate the films' thematic flow. As montages of clippings, sketches, maps, and other found materials, the storyboards are in any case preliminary drawings in themselves. Within the films, too, certain characters produce "drawings in space," which are, in essence, sculptural: Goodyear's diagrams translate into the forms of precision dancing; Gilmore renders a landscape in Vaseline; the Architect sketches his own hubris in the shape of a building; the Ascending and Descending Hacks demarcate the circulatory system of the Isle of Man; and the Diva traces a threshold between reality and illusion on the proscenium arch of his stage. Each episode also generates finished works on paper—framed pencil drawings, often accentuated with dabs of Vaseline—that represent key aspects of the project's conceptual framework. These are reproduced along with photographic portraits and film stills in the books Barney creates to accompany each installment.

It is impossible to separate the aesthetic components constituting the *Gesamtkunstwerk* of Barney's *Cremaster* cycle. Collectively they mold an intricate, multidimensional artwork that is sculptural in form. The artist describes himself as a sculptor and considers the overarching sensibility of his five-part epic to be sculptural. Even the storyboards for the individual films wrap around the walls of his studio, compelling viewers to walk through each narrative construct. Barney's camerawork—recording character zones, settings, and objects—also contributes to the three-dimensionality of the *Cremaster* universe. He literally sculpts with cinematography, reinforcing the narrative thrust of each film with the movement of the camera. The aerial shots in *Cremaster 1*, while mimicking Berkeley's signature crane views, accentuate the sensations of buoyancy imagined in a utopian realm of undifferentiation or full ascension. In *Cremaster 2*, the camera continuously zooms in and out, in a perpetual rhythm that embodies the looping chronology of the story, which moves forward in order to revert backward, like the course of the slowly retreating glacier fields. The camera traces a vertical

Drawings from *The Drones' Exposition*, 1999

139. George Hurrell had a long career as a still photographer for such studios as MGM, Warner Brothers, and Columbia. Barney similarly art-directs his photographs but, unlike Hurrell, he does not take them. For the *Cremaster* cycle he has collaborated with photographers Michael James O'Brien (*Cremasters 1, 2, 4,* and *5*) and Chris Winget (*Cremasters 2* and *3*). O'Brien's background in fashion photography perfectly suited the celebrity portrait sensibility.

Goodyear Field, 1996

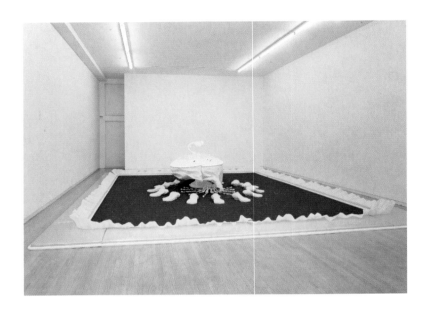

trajectory in *Cremaster 3*, using a boom to glide ever upward to reflect the ascending narrative in the Chrysler Building while it is being erected. In *Cremaster 4* the camera diagrams the topographical circulatory system of the Isle of Man. Positioned at the level of the Hacks' sidecars, it reveals the enclosed, tubelike nature of the racecourse, which consists of miles of narrow, curving hedge-lined roads. To track the Loughton Candidate's underground journey, Barney used lipstick cameras on pole extensions that followed his gyrations through the tunnel, simulating the passage of an endoscope through the bowels and lower intestine.[140] Sweeping circular motions dominate the camerawork in *Cremaster 5*, echoing the shape of the opera house and the pools of the Gellért Baths below. These visual rings extend outward from and return to the Queen of Chain, whose lamentation accompanies and/or imagines the fate of full descension.

Within each film Barney designs and constructs virtually every element, from the microcosmic, such as the crystal sphere at the tip of the water sprites' clitoral penis in *Cremaster 5*, to the macrocosmic, such as the full-scale replica of the Chrysler Building's Art Deco lobby. Every facet contributes to the symbolic matrix of the whole; not a detail goes unnoticed or fails to signify. It can be as frivolous as the little field emblems embossed in the foam in the glasses of Guinness during the bar scene in *Cremaster 3* or as monumental as the cast-salt beehives of the rodeo arena in *Cremaster 2*. All of the films' sculptural components—prosthetics, furniture, costumes—bear content that drives the narrative forward. In *Cremaster 5*, for instance, the

140. Barney, correspondence with the author, January 2, 2002.

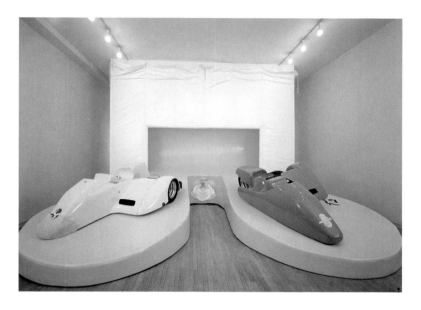

Queen of Chain's gown—a rigid plastic construction cast directly on Andress's body—dictates her very (limited) movements, contributing to the overall effect of mournful languor.[141]

Each episode of the cycle has engendered discrete sculptures, elements of which play highly visible roles in the films. These are not cinematic relics or props but hybrid three-dimensional incarnations of the characters and settings. They exist separately from the films but carry the same content, which is now expressed in space rather than in time. The main sculptures and installations—all produced after their respective film is completed— re-present key architectural moments in the narrative. From *Cremaster 1* Barney fashioned *Goodyear Field* (1996), which amalgamates separate zones of potential, one of preparation, the other of performance: the white table under which Goodyear perches and the blue Astroturf arena. The table is surrounded by the dancers' white-plastic conical hats, out of which spill ovals of cast tapioca. A starburst of high-heeled shoes can be glimpsed under the table, on which a taut speculum holds open the aperture through which Goodyear obtains her grapes. A confection of a sculpture, *Goodyear Field* embodies the essential story line of the film through its architectural references and decorative flourishes. *The Isle of Man* (1994–95) is a sculptural installation that similarly conflates distinct segments of *Cremaster 4*: a monumental vinyl-covered block separates two sloping ramps—which, in the film, hold the Ascending and Descending Hacks—from a mirrored vanity. An abstracted sculptural notation of crinolines (representing those worn by the

141. Barney actually cast three versions of Andress's dress: one for standing, one for sitting, and one for lying down.

Lánchíd: The Lament of the Queen of Chain, 1997

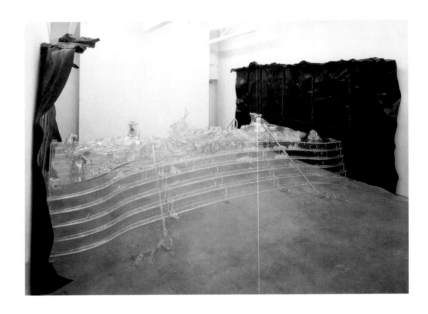

fairies during their fete on a bluff overlooking the ocean) slides off the ledge of the vanity table; and a tunnel burrows through the block from one side to the other, metaphorically connecting the beginning of the film, and the Loughton Candidate's reverie in front of the mirror, to the final scene of the pierced scrotum. It is as if the entire narrative had occurred only in his dreams of fusion and self-discipline. Two other sculptures from *Cremaster 4* reference the triad of fairies whose presence in the film mirrors the conflicting forces at work without any of the emotional or physical friction experienced by the Candidate or the Hacks. *[PITCH] Field of the Ascending Faerie* (1995) is a reincarnation of the yellow mat on which the fairies stage their picnic competition. Complete with thermos and tartan-bordered, antique lace cloth, the square field holds the energy of its absent performers. *[PIT] Field of the Descending Faerie* (1995), constructed from prosthetic plastic, digs directly into the floor, half-burying the hydraulic jack/thermos used in the film to prop up one of the sidecars for a tire change.

The primary sculpture from *Cremaster 5*, *Lánchíd: The Lament of the Queen of Chain* (1997), is a portrait of the Queen that in a way encapsulates the entire film, since all of its imagery flows forth from her mind and the deepest recesses of her body. Entirely transparent, the piece is an acrylic-and-polyurethane cast of the underwater stairway inhabited by the Gellért sprites. It is topped by identical pillow-thrones—here clear as crystal—which mirror one another at either end of the structure. Flanked on either side by free-standing black walls, the staircase transmutes into a stage, upon which the

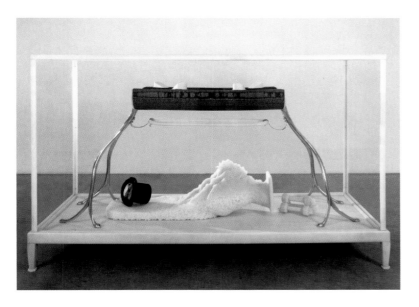

The Cabinet of Baby Fay La Foe, 2000

fantasies of descension may be remembered. The spirit of the Magician is embodied in the installation entitled *The Ehrich Weiss Suite* (1997), an enclosed room containing a photographic triptych showing the Queen's two ushers on either side of the embracing couple; a sculptural black-acrylic reliquary holding the Magician's prosthetic plastic shackles and a glass scepter; a black framed drawing; and seven live Jacobin pigeons. Sealed from the public and visible only through a glass door, this funereal chamber evokes the Magician's hermetic state—self-enclosed but imbued with potential, a condition suggested by the presence of the white, ruffle-collared birds living in the space.

As the cycle progressed chronologically, and each film became exponentially more complex and sophisticated, the amount of sculpture increased accordingly.[142] In its constellation of related drawings, photographs, and banners, *Cremaster 4* has three sculptures. For *Cremaster 1* Barney produced only *Goodyear Field*. *Cremaster 5*, in addition to its crystal staircase/stage, generated two other large installations: *Proscenium* (1997), a hall of banners covered with black satin and synthetic calla lilies, and *The Ehrich Weiss Suite*. And *Cremaster 2*, the fourth completed episode, spawned an outpouring of sculpture. Each of the characters—Baby Fay La Foe, Nicole Baker, Johnny Cash (the Man in Black), Frank and Bessie Gilmore, Gary Gilmore, and Houdini—was assigned his or her own vitrine, which houses specific attributes and sculptural codes for the individual depicted. *The Cabinet of Baby Fay La Foe* (2000), for instance, is a large Plexiglas case containing the

142. At this writing the *Cremaster* cycle is not yet complete, in that the sculptures and photographs for *Cremaster 3* are currently in process, but they, too, relate directly to key architectural elements and lead characters in the film: a frozen cast-Vaseline bar; a piano filled with poured concrete; Hiram Abiff's stacked columns; the cast-plastic ram with bagpipe drones; and the cast-Vaseline chassis of five 1967 Chrysler Imperials.

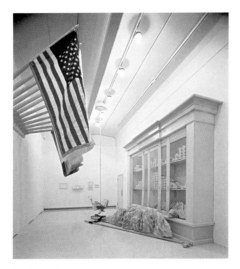

The Drones' Exposition, 1999 (antechamber)

character's sinuous séance table, which is constructed from black polycarbonate honeycomb and stainless steel. Split along the top into two symmetrical halves, the table is an abstraction of the natal cleft, which, according to Barney, is a residual line left over from primary cell division that is manifested on the body in the V-shape on the top of the lips or the triangle at the base of the spine. Baby Fay's top hat, here filled with honeycomb, rests on a bed of salt crystal cast in the form of a mountain range. *The Cabinet of Gary Gilmore and Nicole Baker* (1999–2000) comprises two adjacent vitrines containing the front seats of their respective Mustangs enclosed in a beeswax cast of the car exteriors. The sterling silver bell used by Baby Fay in the séance/conception scene, and worn by the Brahman bull in the rodeo/execution sequence, rests on the floor between them. Cast salt crystals spill out from the interior. Bessie Gilmore's portrait vitrine contains the transparent crystal corset she wears during the séance/conception scene, and Houdini's cabinet consists of the woven polypropylene trunk out of which he escapes during the Columbian Exposition; cast salt barbells fall from its now empty interior. Though morphologically related to the vitrines Barney creates to exhibit the special-edition video disks he produces for each film,[143] these cabinets more closely reference the nineteenth-century natural history museum, whose display cases house a variety of taxonomic specimens: butterflies, seashells, fossils, preserved organs, isolated body parts, etc. The extended Gilmore clan is similarly objectified and presented here as a marvel or curiosity that just might reveal the secrets of the empirical world.

In addition to the portrait cabinets and a beeswax sculpture entitled *Deseret: The Drone's Gate* (1999–2000) that encloses the model of the Mormon Tabernacle Choir like a hive, Barney also produced an environmental-scale installation that collapses the entire narrative of *Cremaster 2* into one integrated sculpture. Entitled *The Drones' Exposition* (1999), the piece consists of two discrete spaces. The first is an antechamber containing a cast-plastic, wall-mounted cupboard that echoes the one that appears in the séance episode and is filled with salt dumbbells. Across from it hang flags embroidered with the Hebrew names of the Lost Tribes of Israel. The mirrored saddle seen in the opening sequence of the film and during the two-step dance number is inverted and suspended from the ceiling on a rotating pole. The silver rod used to confirm Gary Gilmore's death in the execution/rodeo episode rests on the floor as a reference to the symbolic landscape; its prone position indicating the level surface of the salt flats. Lying in front of a cast-salt mountain range, the rod points back toward the retreating glacier field that created the topography featured in the film and the genealogical movement of the narrative. A selection of five framed drawings rounds out the ensemble. The landscape theme continues in the installation's main

143. The films are distributed in editions of ten, with two artist's proofs. Although copies are available for screenings, the edition allows individuals and cultural institutions actually to own the film and the special vitrine that houses it.

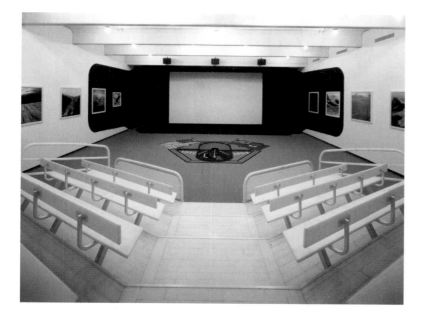

The Drones' Exposition, 1999 (theater)

space with a suite of twelve color photographs of the Columbia Icefield. This room is a theater, where the film itself is projected; acrylic stadium seating rises above a carpet bearing the *Cremaster 2* emblem, and fabric padding cut in the shape of Barney's field emblem frames the movie screen. At once cinema, rodeo, vaudeville hall, and execution chamber, this installation brings the symbiotic relationship between sculpture and film in Barney's art into full relief. It shows how space can be narrated and celluloid sculpted. Its transposition of one form into another, in a Möbius strip of possible meanings, is a mirror to the movement of the project as a whole. The *Cremaster* cycle is in perpetual motion, it is searching for an ending, which it may find only in its beginning—that brief instant of pure equilibrium that just might have been an illusion.

FULL CAPTIONS FOR TEXT ILLUSTRATIONS

2. Production photograph from *CREMASTER 4*, 1994

4. (top) *HYPERTROPHY (incline)*, 1991
Light-reflective vinyl, graphite, and petroleum jelly in paper on
internally lubricated plastic
26.2 x 29.3 x 3.1 cm
The Museum of Modern Art, New York. Gift of R.L.B. Tobin

4. (bottom) *Drawing Restraint II*, 1988
Action/installation, artist's studio, Yale University
Photo: Michael Rees

5. (top) *Drawing Restraint II*, 1988
Action/installation, artist's studio, Yale University
Photo: Michael Rees

5. (bottom) *Drawing Restraint II (document)*, 1988 (detail)
Plastic, photographs, graphite, and crayon on paper with
magnesium carbonate wedge and toe-clip strap
40.6 x 45.7 x 45.7 cm
Whitney Museum of American Art, New York; Purchase, with
funds from the Drawing Committee

6. (top) *Condition 88*, 1988
Ink and graphite on paper with prosthetic plastic frame
39.4 x 39.4 x 1.9 cm
Collection of Leopoldo Villareal

6. (bottom) *unit BOLUS*, 1991
Cast petroleum jelly 8-lb. dumbbell, stainless steel, and elec-
tronic freezing device
71.2 x 45.8 x 25.4 cm
Edition of 5

7. *FIELD DRESSING (orifill)*, 1989
Stills from videoaction, two-channel color video, 00:09:15,
00:25:14
Collection of the artist
Videography: Michael Rees

8. *BLIND PERINEUM* from *[facility of DECLINE]*, 1991
Still from videoaction, color video, 01:17:05
Videography: Peter Strietmann

9. *TRANSEXUALIS*, 1991 (interior)
Walk-in cooler, formed and cast petroleum-jelly decline
bench, human chorionic gonadotrophin, silicon-gel pectoral
form, and two videos with equipment, two monitors (with
brackets), two laser-disk players, and two laser-disk loops
366 x 427 x 259 cm
San Francisco Museum of Modern Art; Accessions Committee
Fund, gift of Collectors Forum, Byron R. Meyer, Norah and
Norman Stone, and Mr. and Mrs. Brooks Walter, Jr.

10. *TRANSEXUALIS (decline)*, 1991 (interior and detail)
Walk-in cooler, formed and cast petroleum-jelly incline bench,
human chorionic gonadotrophin, speculum, silicon-gel
pectoral form, and two videos with equipment, two monitors
(with brackets), two laser-disk players, and two laser-disk
loops
366 x 427 x 259 cm
Astrup Fearnley Collection, Oslo

11. *HYPOTHERMAL PENETRATOR*, 1991
Signed black-and-white photograph in prosthetic
plastic frame
39.4 x 34.9 x 3.1 cm
Edition of 2

12. *MILE HIGH Threshold: FLIGHT with the ANAL SADISTIC
WARRIOR* from *[facility of INCLINE]*, 1991
Still from videoaction, color video, 00:41:42
Videography: Peter Strietmann

14. *REPRESSIA*, 1991 (detail)
Wrestling mat, Pyrex, cast petroleum-jelly and wax
Olympic curl bar, socks, sternal retractor, skeet, saltwater
pearl, petroleum jelly, and two videos with equipment,
two monitors (with brackets), two laser-disk players, and
two laser-disk loops
427 x 549 x 381 cm
Collection of Norman and Norah Stone, San Francisco;
Courtesy of Thea Westreich, Art Advisory Services, New York

14. (right) *[facility of INCLINE]* showing *REPRESSIA*, 1991
Installation, Stuart Regen Gallery, Los Angeles, 1991

15. (top) *DELAY OF GAME (manual A)*, 1991 (detail)
Gelatin-silver print and petroleum jelly in internally lubricated
plastic frame
38.1 x 33 x 2.5 cm
Edition of 2
Photo: Michael Joaquin Grey

15. (bottom) *RADIAL DRILL*, 1991
Production photograph from videoaction, color, black-and-
white video, 00:04:59
Photo: Michael Joaquin Grey

16. *OTTOshaft*, 1992
Three-channel color video installation; *OTTOshaft*, 00:08:54;
OTTOdrone, 00:18:47; *AUTOdrone*, 00:02:02
From top image, left to right: three video stills, *OTTOdrone*;
production still, *OTTOshaft*; video still, *OTTOdrone*; three
video stills, *AUTOdrone*
Videography and Photo: Peter Strietmann
Tate. Presented by the Patrons of New Art through the
Tate Gallery Foundation, 1994

20. Concept drawing for *OTTOshaft*, 1992

22. Production photograph from *Drawing Restraint 7*, 1993
Three-channel color video installation; *Spin*, 00:02:20;
Curl, 00:02:55; *Draw*, 00:03:30
Videography: Peter Strietmann
Photo: Michael James O'Brien

23. *Drawing Restraint 7*, 1993
Video stills from *Draw*

26–29. Artist's conceptual mapping of the *CREMASTER* cycle,
showing locations, ca. 1994
Left to right: Two photographs, Bronco Stadium, Boise State
University, Idaho; photograph, Bonneville Salt Flats, Utah;
photograph, Great Salt Lake, Utah; postcard, Athabasca
Glacier, Columbia Icefield, Canada
Left to right: Two postcards, Chrysler Building, New York;
postcard, Calf of Man/Isle of Man; postcard, Gellért Baths,
Budapest; concept drawing

31. *CREMASTER 1: The Goodyear Waltz*, 1995 (detail)
C-print in self-lubricating plastic frame
85.7 x 70 x 2.5 cm
Edition of 3, 2 A.P.

32. *CREMASTER 1: Red Lounge Manual*, 1995
3 gelatin-silver prints in self-lubricating plastic frames
Center: 52 x 67.3 x 2.5 cm; left and right:
56 x 67.3 x 2.5 cm each
Edition of 3, 1 A.P.

34. Video still from *CREMASTER 1*, 1995

35. *CREMASTER 2: Genealogy*, 1999
3 C-prints in acrylic frames
Center: 71.1 x 60.3 x 2.5 cm; left and right:
55.2 x 55.2 x 2.5 cm each
Edition of 3, 2 A.P.

36. *CREMASTER 2: The Man in Black*, 1999
C-print in acrylic frame (shown unframed)
135.3 x 109.2 x 2.5 cm
Edition of 6, 2 A.P.

37. *The Cabinet of the Man in Black*, 1999
Bridal satin, beaver felt, beeswax, petroleum jelly, nylon,
and *Billboard* magazine in nylon and acrylic vitrine
101 x 121.3 x 95.6 cm
Collection of Peggy and Ralph Burnet

38. Video still from *CREMASTER 2*, 1999

39. Production photograph from *CREMASTER 2*, 1999

40–41. Video stills from *CREMASTER 2*, 1999

42. *CREMASTER 3: The Song of The Vertical Field*, 2002
(detail)
1 of 2 C-prints in acrylic frames (shown unframed)
106.7 x 86.4 x 3.8 cm
Edition of 3, 1 A.P.

44. Production photograph from *CREMASTER 3*, 2002

45. Video still from *CREMASTER 3*, 2002

46. (top) *CREMASTER 3: Imperial New Yorker*, 2002 (detail)
1 of 3 C-prints in acrylic frames (shown unframed)
86.4 x 106.7 x 3.8 cm
Edition of 3, 1 A.P.

46. (bottom) Production photograph from *CREMASTER 3*, 2002

47–50. Video stills from *CREMASTER 3*, 2002

51. (top) Production photograph from *CREMASTER 3*, 2002

51. (bottom) Video still from *CREMASTER 3*, 2002

52. Video stills from *CREMASTER 3*, 2002

53. *CREMASTER 3: The Dance of Hiram Abiff*, 2002 (detail)
1 of 4 C-prints in acrylic frames (shown unframed)
106.7 x 86.4 x 3.8 cm
Edition of 3, 2 A.P.

54. Production stills from *CREMASTER 3*, 2002

55–58. Video stills from *CREMASTER 3*, 2002

59. *CREMASTER 4: VALVE*, 1994 (detail)
1 of 4 C-prints in self-lubricating plastic frames (shown
unframed)
84.5 x 70 x 3.8 cm
Edition of 3, 1 A.P.

60. *CREMASTER 4: FAERIE FIELD*, 1994
4 C-prints in self-lubricating plastic frames
left to right: 44.5 x 32.4 x 3.8 cm, 70 x 84.5 x 3.8 cm,
44.5 x 32.4 x 3.8 cm, 44.5 x 32.4 x 3.8 cm
Edition of 3, 1 A.P.

61. (top) *PITCH: The Field of the Ascending HACK*, 1994
Graphite, lacquer, and petroleum jelly on paper, Manx tartan,
and thread in prosthetic plastic frame
31.8 x 31.8 x 5.1 cm
Private Collection, New York

61. (center) Video still from *CREMASTER 4*, 1994

61. (bottom) Production photograph from *CREMASTER 4*, 1994

62. *CREMASTER 4: Gob ny Creggan Glassey*, 1994 (details)
2 C-prints in prosthetic plastic frames
43.2 x 48.3 x 2.5 cm each
Edition of 3, 1 A.P.

63. (top) *CREMASTER 4: ↑↔↓*, 1994 (detail)
1 of 3 C-prints in self-lubricating plastic frames
(shown unframed)
Left: 42 x 49.5 x 3.8 cm; center and right: 49.5 x 42 x 3.8 cm
Edition of 6, 1 A.P.

90

63. (bottom) Production still from *CREMASTER 4*, 1994

64. *CREMASTER 4: Field of the Ascending Faerie*, 1994
2 C-prints in self-lubricating plastic frames
Top: 60 x 76.2 x 2.5 cm; bottom: 66 x 56 x 2.5 cm
Edition of 6, 1 A.P.

66–68. Video stills from *CREMASTER 5*, 1997

69. (top) *CREMASTER 5: Elválás*, 1997 (detail)
1 gelatin-silver print in acrylic frame (shown unframed)
105.1 x 87.6 x 2.5 cm
Edition of 6, 1 A.P.

69. (bottom) Video still from *CREMASTER 5*, 1997

70. *CREMASTER 5: A Dance for the Queen's Menagerie*, 1997 (detail)
1 of 7 C-prints in acrylic frames
137.2 x 110.5 x 2.5 cm
Edition of 2, 1 A.P.

71–72. Video stills from *CREMASTER 5*, 1997

74–75. (left to right, two views each) *CREMASTER 1*, 1995–96
Silkscreened laser disk, cast polyester, prosthetic plastic, and patent vinyl in self-lubricating plastic and acrylic vitrine
91 x 122 x 130 cm
Edition of 10, 2 A.P.

CREMASTER 2, 1999
Silkscreened digital video disk, nylon, tooled saddle leather, sterling silver, beeswax, and polycarbonate honeycomb in nylon and acrylic vitrine, with 35-mm print
104.1 x 119.4 x 99.1 cm
Edition of 10, 2 A.P.

CREMASTER 3, 2002
2 silkscreened digital video disks, stainless steel, internally lubricated plastic, marble, and sterling silver in acrylic vitrine, with 35-mm print
110.5 x 119.4 x 101.6 cm
Edition of 10, 2 A.P.

CREMASTER 4, 1994–95
Silkscreened laser disk in onionskin sleeve, prosthetic plastic, bridal satin banner, and Manx tartan in self-lubricating plastic and acrylic vitrine
91.4 x 122 x 104.1 cm
Edition of 10, 2 A.P.

CREMASTER 5, 1997
Silkscreened laser disk, polyester, acrylic, velvet, and sterling silver in acrylic vitrine, with 35-mm print
88.9 x 119.4 x 94 cm
Edition of 10, 2 A.P.

83. Drawings from *The Drones' Exposition*, 1999
Graphite and petroleum jelly on paper in nylon frames
Top: 20 x 25.1 x 4.4 cm
Bottom: 23.5 x 30 x 3 cm
Walker Art Center, Minneapolis, T. B. Walker Acquisition Fund and San Francisco Museum of Modern Art through the Accessions Committee Fund, 2000

84. *Goodyear Field*, 1996
Self-lubricating plastic, prosthetic plastic, petroleum jelly, silicone, Astroturf, pearlescent vinyl, cast tapioca, cast polyester, polyester ribbon, costume pearls, speculae, and Pyrex
1.37 x 6.81 x 8.23 m overall
Emmanuel Hoffmann Foundation, On permanent loan to Museum für Gegenwartskunst, Basel

85. *The Isle of Man*, 1994–95
2 600cc sidehacks, wrestling mat, vinyl, silicone, tapioca, polyester, petroleum jelly, internally lubricated plastic, prosthetic plastic, fluorescent light, mirror, satin ribbon, and Manx tartan
4.29 x 5.64 x 7.9 m overall
Museum Boijmans Van Beuningen, Rotterdam

86. *Lánchíd: The Lament of the Queen of Chain*, 1997
Acrylic, cast polyurethane, Vivak, Pyrex, polyethylene, and prosthetic plastic
3.05 x 6.1 x 4.88 m
Astrup Fearnley Collection, Oslo

87. *The Cabinet of Baby Fay La Foe*, 2000
Polycarbonate honeycomb, cast stainless steel, nylon, solar salt cast in epoxy resin, top hat, and beeswax in nylon and acrylic vitrine
150 x 242.6 x 97.2 cm
The Museum of Modern Art, New York, Committee on Painting and Sculpture Funds

88. *The Drones' Exposition*, 1999 (antechamber)
35-mm film (color digital video transferred to film with Dolby SR sound); 2-part sculpture installation: nylon, acrylic, steel, salt, solar salt cast in epoxy resin, chrome-plated engraved brass, leather, sterling silver, brass, lead, Hungarian sidesaddle. carpet, carpet inlay, and quilted nylon; 12 silk flags with 12 nylon poles and 1 wall mount; 5 drawings: graphite and petroleum jelly on paper in nylon frames; and 12 C-prints in acrylic frames
Overall dimensions variable
Walker Art Center, Minneapolis, T. B. Walker Acquisition Fund and San Francisco Museum of Modern Art through the Accessions Committee Fund, 2000

89. *The Drones' Exposition*, 1999 (theater)

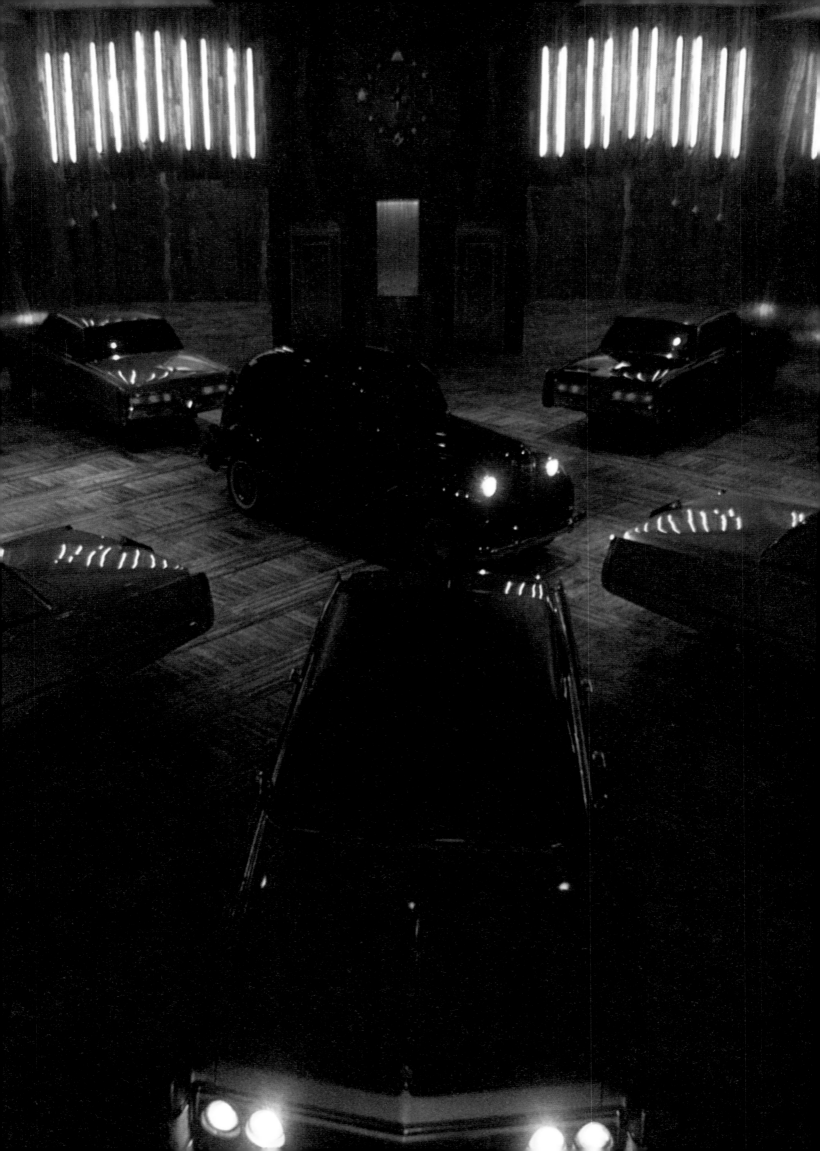

THE CREMASTER GLOSSARY

NEVILLE WAKEFIELD

anus-island

apron

automobile

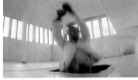

Azazel

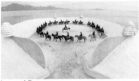

bees of Deseret

anus-island "'I wanted—it was the only thing I wanted—to find out the extreme limit of plasticity in a living shape.'" [Moreau, in] H. G. Wells, *The Island of Dr. Moreau* (New York: Random House, Modern Library, 1996), p. 102

apron "The soul fabricates its own body or 'apron' by its own desires and thoughts (see Genesis 3: 7, 'they made themselves aprons') and as these are pure or impure so will that body be correspondingly transparent and white, or dense and opaque." W. L. Wilmshurst, *The Meaning of Masonry* (New York: Gramercy Books, 1980), p. 135

automobile "I think that cars today are almost the exact equivalent of the great Gothic cathedrals: I mean the supreme creation of an era, conceived with passion by unknown artists, and consumed in image if not in usage by a whole population which appropriates them as a purely magical object." Roland Barthes, *Mythologies*, trans. Annette Lavers (London: Granada, 1973, repr. ed. 1983), p. 88

Azazel "A Hebrew name symbolizing an evil spirit living in the wilderness. It is mentioned in connection with services held on the Day of Atonement (Yom Kippur), in which lots were cast on two goats: one for the Lord and the other for Azazel (Leviticus 16). The goat for Azazel was referred to as the scapegoat. Milton uses the name for the standard-bearer of the rebel angels in *Paradise Lost*." *Benét's Reader's Encyclopedia*, 3rd ed. (New York: Harper & Row, 1987), p. 64

bees of Deseret "God led the Jaredites to a new home in America, and the Book of Mormon records that they carry with them 'Deseret,' which Joseph Smith translated as 'honey bee.' The word 'Deseret' was further mysterious because it is the only word in the Book of Mormon which survives from the ancient and holy language of Adam. This must have appeared to the immigrants to be an important key to the founding of the new Zion. The land of milk and honey, and the word 'Deseret' and its visual symbol, the honey bee, gave great associational importance to the beehive emblems as the Mormons themselves fled from the cities of the unrighteous into the new land.

"Deseret, represented by the working bee pioneers in the beehive Kingdom of God, became the most pervasive symbol in the building of the Great Basin Empire. This symbol, unlike the more formal and sacred icons of Grand Masonry, became a personal and exclusive symbol for the pioneer." Hal Cannon, *The Grand Beehive* (Salt Lake City: University of Utah Press, 1980), unpaginated

bestial deity "Today the man of knowledge might well feel like God become animal." Friedrich Nietzsche, *Beyond Good and Evil*, trans. Walter Kaufmann (New York: Random House, Vintage Books, 1989), p. 84

betrayal "Whether IRA interrogators realize it or not, there was within their pursuit of a confession a latent drive, as in the Catholic sacrament, to obtain a recantation of the betrayer's work. The sinner's former masters must be denounced and their false ideology rejected. The informer must recant his turning in the same way the Inquisition sought a recantation of false belief from a heretic; the betrayer must show that he has been betrayed." Kevin Toolis, *Rebel Hearts: Journeys Within the IRA's Soul* (New York: St. Martin's Griffin, 1997), p. 225

biology "Like other sciences, biology today has lost many of its illusions. It is no longer seeking for truth. It is building its own truth. Reality is seen as an ever-unstable equilibrium. In the study of living beings, history displays a pendulum movement, swinging to and fro between the continuous and the discontinuous, between structure and function, between the identity of phenomena and the diversity of beings." François Jacob, *The Logic of Life: A History of Heredity*, trans. Betty E. Spillmann (New York: Pantheon, 1973), p. 16

bladder "*The bag*: The air reservoir from which air is forced out under pressure of the arm to sound the reeds of the bagpipe. As its name implies, it consists of a flexible bag, which can be fashioned from a number of materials. These include the whole skin of a sheep, dog, goat or kid. The hair of the two latter may be either displayed on the outside of the bag, or turned to the inside. Other materials include animal bladders such as that of a cow or the stomach of a seal; or the bag may in modern times be made of rubber or synthetic equivalents. Sometimes, as in Poland, Hungary and Bohemia, the chanter stock at the front or neck of the bag is ornamented with small wooden horns to imitate animal horns, so that the chanter appears to issue from the head of a horned animal. The bag of the Scottish Highland bagpipe is of sheepskin cut to a special shape and sewn together. Sometimes the bag is enclosed in a cloth or velvet cover, that of the Scottish Highland bagpipe often being of tartan." Francis Collinson, *The Bagpipe: The History of a Musical Instrument* (London and Boston: Routledge & Kegan Paul, 1975), p. 226

blimps "Non-rigid airships, like Goodyear's current blimp fleet, [are] the only type in general use today. The internal pressure of the lifting gas (nonflammable helium) maintains the shape of the envelope, or the airship's polyester fabric skin. The only solid parts are the passenger car and the tail fins. Internal air compartments, called ballonets, are inflated or deflated with air to compensate for ambient pressure differences. These airships have no internal framework." "Airship Types" in "History & Blimp Basics" at http://www.goodyearblimp.com/types.html

blood atonement "2 Nephi 9:35—Wo unto the murderer who deliberately killeth, for he shall die. . . .

"Mosiah 3:11—For behold, and also his [Jesus Christ's] blood atoneth for the sins of

betrayal

bladder

blimps

blood atonement

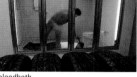
bloodbath

bloodline

those who have fallen by the transgression of Adam. . . .

"Mosiah 3:13–15—And the Lord God hath sent his holy prophets among all the children of men . . . and he appointed unto them a law, even the law of Moses . . . and also holy prophets spake unto them concerning his coming; and yet they hardened their hearts, and understood not that the law of Moses availeth nothing except it were through the atonement of his blood. . . .

"Alma 1:13—And thou [Nehor] hast shed the blood of [Gideon] a righteous man, yea, a man who has done much good among this people; and were we to spare thee his blood would come upon us for vengeance. . . .

"Alma 42:19—Now, if there was no law given—if a man murdered he should die— would he be afraid he would die if he should murder?" *The Book of Mormon: An Account Written by the Hand of Mormon upon Plates Taken from the Plates of Nephi* (Salt Lake City: The Church of Jesus Christ of Latter-day Saints, 1964), pp. 69, 140–41, 196, 299

bloodbath "Among certain ancient mystery societies, a literal blood-bath was used in connection with the concepts of fertility, of regeneration and of resurrection. It was also used as a purification rite. . . . [One] bloody rite of the cult was the taurabolism: 'the initiate crouched in a pit, covered with a grating, over which a bull, garlanded with flowers, was slaughtered. The hot blood drenched the devotee, who eagerly drank in part of his blood bath, believing himself to be re-born thereby for twenty years, or after Christianity had influenced the cult, for eternity.' [Quoted from the entry] 'Mystery Cults' [in] *Collier's Encyclopedia*." A. C. Lambert, "A Private Notebook on Blood Atonement, Blood Sacrifice, Blood Vengeance, Infant Sacrifice, and Mystical and Religious Ideas Concerning the Blood" (unpublished ms., 1958, in the General Collection of the New York Public Library), pp. 141–42

bloodline "[T]he church's martyred founder, Joseph Smith, Jr. . . . would build nearly his entire complex theology on what was essentially a dilemma of bloodline: how one might redeem the dreams and debts of one's heritage, or else perish as the result of unfinished curses. . . .

"Murder and ruin are written across the breadth of Joseph Smith's pre-American panorama, and because violence always demands an explanation or solution, the Book of Mormon's unexamined greatest revelation is a truly startling one: As Moroni looks at the blood-reddened land around him, and as he reviews the full reach of the history that led to this mass extinction, it is plain that the force behind all these centuries of destruction is none other than God himself. It is God who brought these wandering people to an empty land, and it is God who established the legacies that could only lead to such awful obliteration. God is the

hidden architect of all the killing at the heart of America's greatest mystery novel, the angry father who demands that countless offspring pay for his rules and honor, even at the cost of generations of endless ruin." Mikal Gilmore, *Shot in the Heart* (New York: Doubleday, 1994), pp. 10–12

bloodshed "The Old Testament concept of a blood-thirsty God of war and vengeance was preached unmistakably to the Mormons by members of the First Presidency of the Church.

"'The Prophet (Joseph Smith) stood in his own house when he told several of us of the night the visions of heaven were opened to him, in which he saw the American continent drenched in blood, and he saw nation rising up against nation. He also saw the father shed the blood of the son, and the son the blood of the father; the mother put to death the daughter, . . . blood upon the face of the whole earth, except among the people of the Most High. The Prophet gazed upon the scene his vision presented, until his heart sickened, and he besought the Lord to close it up again.' [Jedediah M. Grant, *Journal of Discourses,* vol. 2 (1854), pp. 147–49]." A. C. Lambert, "A Private Notebook on Blood Atonement, Blood Sacrifice, Blood Vengeance, Infant Sacrifice, and Mystical and Religious Ideas Concerning the Blood" (unpublished ms., 1958, in the General Collection of the New York Public Library), p. 16

bloodshed

bodybuilding "Bodybuilding is a subculture of hyperbole. In its headlong rush to accrue flesh, everything about this subculture exploits grandiosity and excess. . . .

"The bodybuilder's perception of the body as being made up of parts (chest, abs, back, arms, legs) . . . fits [our current cultural view of the body as 'partible'] perfectly. It even extends into the psychoperceptual realm, in that bodybuilders view each body part as objectified. The bodybuilder's body is bounded in a series of subcultural perceptions and practices that have to do with absolute control of diet and physical regimen, and viewing it as a system that has to be mastered." Alan M. Klein, *Little Big Men: Bodybuilding Subculture and Gender Construction* (New York: State University of New York Press, 1993), pp. 3, 189

bodybuilding

Bonneville "In spring and winter, the salt flats are usually covered with water because surface moisture at this time neither penetrates nor evaporates readily. The water is, rather, blown about the surface by the wind until it evaporates. Water moving over the surface smoothes the salt, making it almost perfectly flat. The salt flats are said to be one of the only places in the United States where one can see the curvature of the earth over dry land." Tom and Gayen Wharton, *Utah* (Oakland, Calif.: Fodor's, Compass American Guides, 1998), p. 215

Bonneville

Brahman "To overcome the many difficulties still existing in the improved stock, the breeders began to experiment with the humped cattle of [India], the species *Bos indicus,* a type distinct

Brahman

from the cattle common to the United States, which are of the species *Bos taurus*. The Indian cattle are called Brahman or Brahma by the stockmen but are known in South America and Europe as zebus. In the true sense of the term, zebu is correct, while Brahman is derived from the name of Brahma, the Hindu divinity, who is regarded as sacred. The cattle brought to this country represented the more prominent breeds of their native land and were the Nellore, Gir, Guzerat, and Krishna Valley breeds.

"The outstanding characteristics of distinction between the Brahma and the breeds common to this country are the hump on the shoulders and the large, pendulous dewlap, as well as the loose skin in the region of the navel. An additional characteristic of the purebred beast is the color of the hair. This is solid in color, although there is an occasional animal that is not uniform in this respect. The color varies from one part of the body to another, and the blending is subtle. The colors range from white to dark gray, with intermediate hues of pie-crust, tan, and a pinkish-orange; the spotted animal indicates, more or less, cross-breeding.

"From available information it appears that the first importation of Brahma cattle was made in 1849, by a Dr. Z. B. Davis of South Carolina, and consisted of a bull and two cows of the Mysore breed." Clifford P. Westermeier, *Man, Beast, Dust: The Story of Rodeo* (Lincoln: University of Nebraska Press, 1947), pp. 179–80

bridge jump "In the second of his thrilling underwater escapes, Houdini made a suicidal-looking leap from a high city bridge into a river—*manacled.* . . . Attended by Franz Kukol—a gentleman's gentleman in derby hat and wing collar—Houdini removes his coat and vest, strips his suspenders and pleated dress shirt, peels off his trousers and stockings. Clad only in long white undershorts, he poses for a moment for the movie camera. After a policeman locks him into two pairs of cuffs, he climbs to the utmost truss of the bridge, barechested, holds up his shackled wrists to the crowd, shouts to them ('Good-bye') and jumps." Kenneth Silverman, *Houdini!!! The Career of Ehrich Weiss* (New York: HarperCollins, HarperPerennial, 1996), pp. 113–14

bridge jump

broadcast religion "The Tabernacle has become known for both the phenomenal acoustics of the smooth arched ceiling and the massive pipe organ, regarded as one of the finest ever built. From 700 pipes when constructed in 1867, the organ has grown to about 12,000 pipes, five manuals, and one pedal keyboard. . . . The renowned Mormon Tabernacle Choir, 320 voices strong, sings on Sunday mornings over national radio (CBS) and regional TV networks. The choir's radio broadcast, which dates back to 1929, is the longest-running broadcast in the world." Patricia Reilly, ed., *Utah Handbook*, 5th ed. (Chico, Calif.: Moon Publications, 1997), p. 43

broadcast religion

Bronco Stadium "Boise State University, Boise, Idaho. *Bronco Stadium* (1970)

"*Lights:* Yes. *Seating capacity:* 30,000. *Location:* On campus. *Playing surface:* Blue Astroturf. *Special features:* None. *Other uses:* Track and field meets. . . .

"*Team name:* Broncos. *Team mascot:* Bronco. *Colors:* Blue and orange. *Song:* 'BSU Fight Song.' *Conference:* Big West. *First intercollegiate football game:* 1932.

"*Coaches and their tenure:* Tony Knap (1970–75), Jim Criner (1976–82), Lyle Setencich (1983–86), Skip Hall (1987–92), Pokey Allen (1993–96), Houston Nutt (1997), Dirk Koetter (1998–)." Alva W. Stewart, *College Football Stadiums: An Illustrated Guide to NCAA Division I-A* (Jefferson, N.C.: McFarland & Company, 2000), p. 27

Bronco Stadium

Budapest "In terms of its geology Budapest lies in a large tectonic depression zone bounded on the west by the eastern Alps and foothills and on the north and east by the arc of the Carpathian Mountains. This basin is filled with several layers of deposits of diverse origin.

"Deep below the surface lie remnants of the Tisia massif, Paleozoic mountains large areas of which became flattened. . . . During the Mesozoic era these mountains were flooded in several places by the Tethys Sea. . . . The Miocene sea flooded the larger part of the basin. Along the fault line round the edges of the basin violent volcanic activity occurred.

"One consequence of this vulcanism was that the environs of Budapest became endowed with extensive mineral water deposits. The 123 sources exploited within the city's urban area represent the richest reserves of thermal mineral water in Europe. Some have been in use for balneotherapy since Celtic times." *Baedeker Budapest*, 3rd ed. (New York: Macmillan Travel, 1995), pp. 9–10

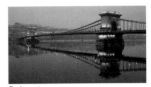

Budapest

candidate's apron "Need I say that the physical form with which we have all been invested by the Creator upon our entrance into this world, and of which we shall all divest ourselves when we leave the Lodge of this life, is represented among us by our Masonic Apron? This, our body of mortality, this veil of flesh and blood clothing the inner soul of us, this is the real 'badge of innocence,' the common 'bond of friendship,' with which the Great Architect has been pleased to invest us all: this, the human body, is the badge which is 'older and nobler than that of any other Order in existence': and though it be but a body of humiliation compared with that body of incorruption which is the promised inheritance of him who endures to the end, let us never forget that if we never do anything to disgrace the badge of flesh with which God has endowed each of us, that badge will never disgrace us." W. L. Wilmshurst, *The Meaning of Masonry* (New York: Gramercy Books, 1980), pp. 30–31

candidate's apron

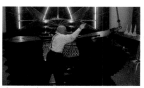

character in action

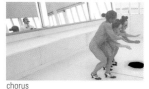

chorus

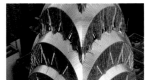

Chrysler Building

character in action "'It takes character to win,' [Coach] said. It's not just the amount of mileage you put in. The insults to the body. The humiliation and fear. It's dedication, it's character, it's pride. We've got a ways to go yet before we develop these qualities on a team basis.'

"'Yes sir.'

"'I've never seen a good football player who didn't know the value of self-sacrifice.'

"'Yes sir.'

"'I've never seen a good football player who wanted to learn a foreign language.'" Don DeLillo, *End Zone* (New York: Penguin Books, 1972), p. 199

chorus "The virgins who proceed solemnly to the temple of Apollo, laurel branches in their hands, singing a processional hymn, remain what they are and retain their civic names: the dithyrambic chorus is a chorus of transformed characters whose civic past and social status have been totally forgotten: they have become timeless servants of their god who live outside the spheres of society. All the other choral lyric poetry of the Hellenes is merely a tremendous intensification of the Apollinian solo singer, while in the dithyramb we confront a community of unconscious actors who consider themselves and one another transformed.

"Such magic transformation is the presupposition of all dramatic art. In this magic transformation the Dionysian reveler sees himself as a satyr, *and as a satyr, in turn, he sees the god,* which means that in his metamorphosis he beholds another vision outside himself, as the Apollinian complement of his own state. With this new vision the drama is complete." Friedrich Nietzsche, *The Birth of Tragedy and the Case of Wagner,* trans. Walter Kaufmann (New York: Random House, Vintage Books, 1967), p. 64

Chrysler Building "The rippling, three-story tall black granite entrances of the Chrysler part like proscenium curtains to reveal the splendors within. The triangular lobby lined in red Moroccan marble is one of the most extravagant to be seen in an American office building. The aesthetics here are pure Expressionist—bizarre, disorientating angles, muted onyx lighting sources, and bold Rouge Flambé patterned marble walls.

"The exterior of the white brick tower might be described as Early Modern Hubcap. It's a gloriously daffy paean to the automobile. A decorative frieze of stylized hubcaps in black brick at the thirtieth floor is topped by silver 'gargoyles' that recall the trademark winged radiator cap of a Chrysler automobile. Eight giant eagle heads crown the next setback. The spire might be seen as an abstraction of an eagle's feather, with the geometric plates resembling interconnecting barbules. The whole building then becomes a great eagle in flight, recalling the fantasy of motion behind the wheel of a Chrysler." Eric Nash,

New York's Fifty Best Skyscrapers (New York: City & Company, 1997), p. 51

Chrysler dreams "The human body as a whole is pictured by the dream-imagination as a house and the separate organs of the body by portions of a house. In 'dreams with a dental stimulus,' an entrance-hall with a high, vaulted roof corresponds to the oral cavity and a staircase to the descent from the throat to the oesophagus." Sigmund Freud, *The Interpretation of Dreams,* trans. and ed. James Strachey with Alan Tyson; 3rd rev. edition ed., Angela Richards (New York: Pelican Books, 1976), p. 320

Chrysler needle "David Michaelis describes the eighty-fourth-floor experience of the Chrysler Building:

"'Inside pyramidal walls four narrow openings face the cardinal directions of the compass. The floor is about a yard square. Directly overhead there is a small trapdoor, inside of which is a small ship's ladder and then another—smaller—Alice sized trapdoor, beyond which is another tiny ladder climbing up into the sepulchral darkness of the needle. The needle is, in fact, a very tall, very slender pyramid, and at the tip stands a lightning rod. . . . Inside the needle, the susurration of the wind diminishes and a sense of tranquility and enchantment and rapture takes over. Everything in and about the needle—its shape, the little ladders—points upward' [in David Michaelis, '77 Stories: The Secret Life of a Skyscraper,' *Manhattan, Inc.* (June 1986)]." Vincent Curcio, *Chrysler: The Life and Times of an Automotive Genius* (New York: Oxford University Press, 2000), pp. 400–01

columnar basalt "Columns are always formed at right angles to the cooling surface, so the higher columns, which were cooling in contact with the sea of molten lava, a level surface, are upright; but the lower columns were cooling in contact with the lithomarge of the weathered lower basalt, and as weathering does not occur consistently, this surface was not always level. Thus the lower columns, though more exactly formed than the upper ones, are sometimes tilted slightly from the vertical." Julia E. Mullin, *The Causeway Coast* (Belfast: Century Services, 1974), p. 22

combat racecar "Here, once again, we must look at the speedometer of the racing engine. The combat racecar: an existential measure of the warrior's being, the dizzying flow of time, a rapidity-tax on the covered meter that ruins the earthly inhabitant, but simultaneously destroys the substance of its conqueror and measures the survivor's remaining hours." Paul Virilio, *Speed and Politics: An Essay on Dromology,* trans. Mark Polizzotti (New York: Semiotext[e], 1982), quoted in Dean Kuipers, *I Am a Bullet: Scenes from an Accelerating Culture* (New York: Crown Publishers, 2000), p. 105

corsetry "In the world of S&M role play, the meaning of the corset is contextual and constructed. The dominatrix wears her corset as armor, its extreme and rigid curvature the

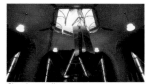

Chrysler dreams

Chrysler needle

columnar basalt

combat racecar

corsetry

crash

curtain call

ultimate sexual taunt at the slave who can look but not touch. The slave, on the other hand, is corseted as punishment. The corseted dominatrix looks and feels impenetrable. By contrast, the corset for the slave both signifies and enforces as sense of discipline. Because of this, the corset is often used in the transformation of male into she-male. It simultaneously gratifies his wish to look like a woman, while punishing him and thus relieving his sense of guilt." "The Return" in "The History of Corsets" at http://elis-abat.netgod.net/corset7.html

crash "Vaughan unfolded for me all his obsessions with the mysterious eroticism of wounds: the perverse logic of blood-soaked instrument panels, seat-belts smeared with excrement, sun visors lined with brain tissue. For Vaughan each crashed car set off a tremor of excitement, in the complex geometries of a dented fender, in the unexpected variations of crushed radiator grilles, in the grotesque overhang of an instrument panel forced on to a driver's crotch as if in some calibrated act of machine fellatio. The intimate time and space of a single human being had been fossilized for ever in this web of chromium knives and frosted glass." J. G. Ballard, *Crash* (New York: Farrar, Straus and Giroux, Noonday Press, 1994), p. 12

cremaster "The cremaster is a thin muscular layer whose fasciculi are separate and spread out over the spermatic cord in a series of loops. It arises from the middle of the inguinal ligament as a continuation of the internal oblique muscle, with some attachments also from the transversus, and is inserted by a small pointed tendon into the tubercle and crest of the pubis and into the front of the sheath of the rectus abdominus. The fasciculi form a compact layer as they lie within the inguinal canal. After passing through the superficial inguinal ring, the muscle fibers form a series of loops, the longest of which extends down as far as the testis, and these are attached to the tunica vaginalis. The intervals between the loops are occupied by fascia, called the cremasteric fascia, which is a fused continuation of the fasciae over the deep and superficial surfaces of the internal oblique. The muscular loops and the fascia together form a single layer, which constitutes the middle fascial tunic of the spermatic cord." Henry Gray, *Anatomy of the Human Body*, 30th American edition, ed. Carmine D. Clemente (Baltimore: Williams & Wilkins, 1985), p. 489

curtain call "Turning an aristocratic entertainment into a public commodity, the proscenium stage nevertheless retained the courtly ending to every performance: the curtain call. For it is at this moment that the actors publicly end their fiction, renounce their roles, and beg approval of the audience in the form of applause. . . .

"A necessary transaction with the audience, the curtain call is a special deal where the actors agree to confess that their strenuous actions and angry words were but the form of play—if the audience, always a potential mob, will in return release the actors from the theater without injury or malice." Dan Isaac, "The Death of the Proscenium Stage," *The Antioch Review* 31, no. 2 (summer 1971), unpaginated

Al Davis "[Los Angeles Raiders' managing partner] Al Davis has often lamented his inability to 'dominate death.'" Mark Heisler, "The Machiavelli of Football," *Los Angeles Times Magazine*, December 15, 1991, p. 21

death "It takes an iron nerve to perceive the connection between the promise of life implicit in eroticism and the sensuous aspect of death." Georges Bataille, *Eroticism*, trans. Mary Dalwood (London: Marion Boyars, 1987), p. 59

death metal "For an articulation of the lawless extremity of nature, death metal is the only genre [of music] which can bond science to emotion in depth enough to describe the confrontation. As civilization became simultaneously more decadent and valueless, a revolution against not only values but the aesthetic moralization of value systems began: the nihilistic and deconstructionist genre of death metal." Spinoza Ray Prozak, "Death Metal" in "Dark Legions Archive" at http://www.anus.com/metal/about/deathmetal.html

decomposition "A duality of 'good' and 'bad' may be found even in the material aspects of death. As long as the process of decomposition takes its course, the cadaver is an impure element. Like the violent disintegration of a society, the physiological decomposition of the corpse leads gradually from a very complex system of differentials to undifferentiated dust. The forms of the living revert to formlessness. And language itself falters in describing the 'remains.' The rotting corpse becomes, in the words of Bossuet, 'cet objet qui n'a de nom dans aucune langue.'" René Girard, *Violence and the Sacred*, trans. Patrick Gregory (Baltimore: The Johns Hopkins University Press, 1979), p. 256

delay of game "*Body-building*: Asexual masturbation, in which the entire musculature simulates a piece of erectile tissue. But orgasm seems indefinitely delayed." J. G. Ballard, "Project for a Glossary of the Twentieth Century," in J. G. Ballard, *A User's Guide to the Millennium: Essays and Reviews* (London: HarperCollins, 1996), p. 278

delineator "[Artist Richard] Serra's work revolves around a matrix of binary opposites: the 'delineated' opposition of floor and ceiling, the opposing orientation of one rectangle to the other and, not least, the oppositional relation set in play between the viewer and the work of art. For a viewer to tread on Serra's work is not to engage in a scenario of transgression and humiliation, however, but in one of transgression and (imminent) punishment. As no visible fastenings restrain the two-and-a-half-ton panel on the ceiling, viewers must wonder how long this

death

death metal

decomposition

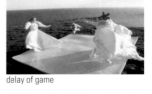
delay of game

delineator

demolition derby

dental atonement

Dino Supreme

Houdini-esque and Herculean feat of engineering will last. . . ." Anna C. Chave, "Minimalism and the Rhetoric of Power," *Arts Magazine* 64, no. 5 (January 1990), p. 58

demolition derby "Whereas most racing mirrors the day-to-day driving experience— surviving accident and obstacles to arrive quickest at the destination—demolition derby rewards the predatory vehicle that can prevent the others from arriving at all, destroying itself in the process. It is a tacit recognition of the great temptation dangling at the end of the road, the true promise of the American dream of mobility: disappearance. Just like Clint Eastwood in *High Plains Drifter*. It's in the national character for Americans to long for a frontier. Beyond the edge of civility and calculation, one disappears. Speed is the key to reaching it. The faster the car the closer to obliteration.

"And closeness to obliteration is really living. Or so the myth.

"The winner of a demolition derby is thus also necessarily the loser. The vehicle survives, not achieving obliteration, and so their relief is frustrated, incomplete. They have slowed their own destruction, and hastened that of their victims. The losers, on the other hand, celebrate the receipt of all that satisfying speed and disappearance." Dean Kuipers, *I Am a Bullet: Scenes from an Accelerating Culture* (New York: Crown Publishers, 2000), p. 108

dental atonement "In the criminal code drawn up by Moses it is made law that if any man do injury to another then shall he give life for life, an eye for an eye, and a tooth for a tooth. Thus that sagacious old law-giver gave equal importance to a life, an eye, and a tooth. It has been argued by some that this must not be translated literally; that Moses only intended to demand that the punishment should fit the crime. But those objections are discounted by the further law he laid down, that if any man knock out his slave's eye or tooth, then must he let that slave go free for the sake of his lost eye or tooth. The price of the tooth was then as high as man's most dearly prized possession—his freedom." Edward Samson, *The Immortal Tooth* (London: John Lane, The Bodley Head, 1939), pp. 83–84

Dino Supreme "Image problems conquered, Sinclair entered the 1960s at its strongest point ever. [The oil-and-gas company was] moving forward to build stations along the nation's ever increasing network of interstate highways and in the suburbs while holding onto their traditional inner-city and rural markets. . . .

"Futuristic modern porcelain station designs were introduced, and [Sinclair's] gasoline brand names underwent a realignment in the early 1960s. First off, Sinclair HC Gasoline, Sinclair's regular grade since 1934, was replaced in 1961 with Sinclair Dino Gasoline. Scarcely a year later, Sinclair Power-X was replaced by Sinclair

Dino Supreme. Gas pumps graphics were redesigned . . . Sinclair specified a porcelain pump sign as part of their gas pump graphics package . . . and the new Dino logo was added prominently to the design. [The new] porcelain station['s] sharp angular lines differ greatly from the earlier Sinclair prototypes." Scott Benjamin and Wayne Henderson, *Sinclair Collectibles* (Atglen, Pa.: Schiffer Publishing, 1997), pp. 127–29

dirigible "There are three categories of airships, Rigid, Semi-Rigid and Non-Rigid." "Airship Types" in "History & Blimp Basics" at http://www.goodyearblimp.com/types.html

drawing restraint "The cremaster muscle draws the testis up toward the superficial inguinal ring." Henry Gray, *Anatomy of the Human Body*, 30th American edition, ed. Carmine D. Clemente (Baltimore: Williams & Wilkins, 1985), p. 490

drone "The term 'drone' has two meanings: (a) a single musical note used as a monotone-accompaniment to the melody—usually, though not invariably, lower than the melody in pitch; and (b) the pipe which produces such a note. Which meaning came first would be difficult to say. The *Oxford English Dictionary* favours the *sound* as the originating term, and the *pipe*, a transference from it. In some bagpipes the drone note can be varied during performance, in which case the pipe is positioned in order to be under the control of the fingers. A change of drone note may also, in some pipe species, be set beforehand by mechanical means. The bag-pipe drone is usually a pipe of cylindrical bore sounded by a single reed, though there are exceptions to both features.

"The number of drones may vary from five to six, though all these are not usually allowed to sound at once, some being shut off by end-stoppers or other means. Drones may issue separately from differently positioned stocks in the bag, or they may be grouped together in a single stock as in the Northumbrian small-pipes. The Scottish Highland bagpipe has three drones—two tenor-drones sounding in unison an octave below the low A of the chanter; and a bass-drone sounding an octave below the tenor-drones. Very many different drone tunings are found throughout the world of the bagpipe. The commonest forms are the tonic alone, the tonic with its octave below and the octave tonic with the fifth between." Francis Collinson, *The Bagpipe: The History of a Musical Instrument*. (London and Boston: Routledge & Kegan Paul, 1975), p. 229

drones "The males of the bee are known as drones. The use of the word drone, meaning a lazy person, arose from the name of the male bee, and it may be reapplied to them as fitting. They are not a useful part of the colony organization in the routine, for they do none of the work of the hive nor do they assist in the gathering. The only function of a drone is that of mating with a young (virgin) queen and in this

dirigible

drone

drones

ectoplasm

excess

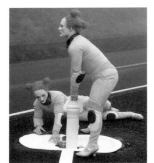

faerie isle

fallen men

act it dies." Everett Franklin Phillips, *Beekeeping: A Discussion of the Life of the Honeybee and of the Production of Honey* (New York: Macmillan, 1949), p. 51

ectoplasm "(ek-to-plasm—there is a tendency in certain circles to pronounce 'plazm,' but this usage is to be discouraged) *n.m.* 1. Part of the human body, external to it, unstable, sometimes soft, occasionally hard, from time to time vaporous, variable in volume, visible only in semi-darkness, making an impression on photographic emulsion, presents to the sense of touch a humid and slippery sensation, leaving in the hand a residue which, when dry, has under microscopic examination the appearance of epithelial cells, without odour or definite taste, in other respects fleeting and transient, whether projected or otherwise, of uncertain temperature, fond of music." Robert Lebel and Isabelle Waldberg, eds., "Encyclopaedia Da Costa" in *Encyclopaedia Acephalica* (London: Atlas Press, 1995), pp. 110–11

excess "Of crucial importance to the creation of Berkeley-esque spectacle is a sense of gratuitousness, of uselessness, of extravagance, of rampant excess, of over-indulgence, of flaunting, of conspicuous consumption, of display for the sake of display, of elements drawing attention to themselves rather than serving a higher, all-encompassing concept such as the narrative." Martin Rubin, *Showstoppers: Busby Berkeley and the Tradition of Spectacle* (New York: Columbia University Press, 1993), p. 41

faerie isle "They confidently assert that the first inhabitants of their Island were fairies, so do they maintain that these little people have still residence among them. . . . If anything happens to be mislaid, and found again, in some place where it was not expected, they presently tell you a fairy took it and returned it; if you chance to get a fall and hurt yourself, a fairy laid something in your way to throw you down, as a punishment for some sin you have committed." George Waldron, *A Description of the Isle of Man* (Manx Society, vol. 11, 1720), quoted in Arthur W. Moore, *The Folk-lore of the Isle of Man* (Douglas, Isle of Man: Brown & Son, 1891), p. 35

fallen men "Andrew Bergman, identifying the fallen woman cycle in his book *We're in the Money*, interprets it as an evagination of the gangster film. Whereas gangster films are masculine power fantasies and inverted success stories, the fallen woman melodramas are 'failure stories' that demonstrate women's dependence and weakness: 'When forced to rely on themselves, the heroines find that only their bodies are marketable. Each picture made evident the fact that no woman could perform work functions not directly related to sex.'" Martin Rubin, "The Crowd, the Collective, and the Chorus: Busby Berkeley and the New Deal," in *Movies and Mass Culture*, ed. John Belton (New Brunswick, N.J.: Rutgers University Press, 1996), p. 75

figure of the goat "The idyllic shepherd of modern man is merely a counterfeit of the sum of cultural illusions that are allegedly nature; the Dionysian Greek wants truth and nature in their most forceful form—and sees himself changed, as if by magic, into a satyr." Friedrich Nietzsche, *The Birth of Tragedy and the Case of Wagner*, trans. Walter Kaufmann (New York: Random House, Vintage Books, 1967), p. 62

Fingal "We think of Fingal and his companions as great-bodied men with large movements, that seem, as it were, to be flowing out of deep influences. They are men that have broad brows, and quiet eyes full of confidence in a good luck, that proves everyday afresh that they are a portion of the strength of things. They are hardly so much individual men, as portions of universal nature itself, like the clouds that shape and reshape themselves momentarily, or like a bird between two boughs, or like the gods that have given the apples and the nuts; yet this but brings them nearer us, for we can remake them in our image as we will, and the woods are the more beautiful for the thought." William Butler Yeats, Preface to Lady Augusta Gregory's *Gods and Fighting Men* (London: J. Murray, 1904), quoted in Paul M. Allen and Joan deRis Allen, *Fingal's Cave, the Poems of Ossian, and Celtic Christianity* (New York: Continuum, 1999), p. 96

Fingal's Cave "Fingal's Cave, a structure which had been architecturally formed entirely out of the spiritual world, stood before them, mirroring their own musical inner depths. . . . Those who beheld it were reminded of mysterious ancient destinies, when they saw how Nature herself appeared to have constructed something which may be likened to a wonderful cathedral. It is formed with great regularity, its countless pillars towering aloft; the ceiling arching above being constructed of the same stone, while below the bases of the pillars are washed by the inrushing foaming waves of the sea, which ceaselessly surge and undulate with thunderous music within this mighty temple. Water drips steadily from stone foundations above, striking the truncated stumps of the stones below, making melodious magical music. Such phenomena exist there." Rudolf Steiner, address presented in Berlin, March 3, 1911, *Rudolf Steiner Gesamtausgabe* (Dornach, Switz.: Rudolf Steiner Verlag), quoted in English translation in Paul M. Allen and Joan deRis Allen, *Fingal's Cave, the Poems of Ossian, and Celtic Christianity* (New York: Continuum, 1999), p. 64

Fionn MacCumhail "In one legend he is the creator of the Giant's Causeway, a peculiar series of volcanic rock formations on the coast of Ireland. One day, Finn grows angry when he hears that a Scottish giant is mocking his fighting ability. He throws a rock across the Irish Sea to Scotland; the rock includes a challenge to the giant.

"The Scottish giant quickly throws a message in a rock back to Finn, stating he can't take

figure of the goat

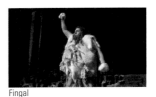

Fingal

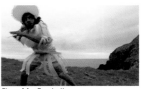

Fingal's Cave

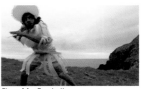

Fionn MacCumhail

up the challenge because he can't swim to reach Ireland.

"Finn doesn't let the Scottish giant off so easily. He tears down great pieces of volcanic rock that lay near the coast and stands the pieces upright, making them into pillars that form a causeway that stretches from Ireland to Scotland. The giant now has to accept the challenge. He comes to Finn's house. Finn, masquerading as an 18-foot baby, bites the Scottish giant's hand and then chases him back to Scotland, flinging lumps of earth after him. One of the large holes he creates fills with water and becomes Lough Neagh, the largest lake in Ireland. One large lump of earth misses the giant and falls into the Irish sea; this lump is now known as the Isle of Man." "Who Was Finn MacCool?" at www.mth.kcl.ac.uk/~tcoolen/finn/maccool.htm

Giant's Causeway

Giant's Causeway "When the world was moulded and fashioned out of formless chaos, this must have been the *bit over*—a remnant of chaos!" William Makepeace Thackeray, *The Irish Sketch-Book* (London: Chapman and Hall, 1843), quoted in Philip S. Watson, *The Giant's Causeway and the North Antrim Coast* (Dublin: The O'Brien Press, 2000), p. 16

glaciation

glaciation "A glacier, whether it be a valley glacier, an ice cap or an ice sheet, is an ice mass at the surface of the earth. It can be considered as an open system with input, storage, transfer and output of mass. It is a system in dynamic equilibrium. . . . The extent of a glacier below the equilibrium line is dependent upon net ablation and ice discharge. If, at the glacier front, the supply of ice per year from upglacier is equal to the net ablation and such a balance is maintained over a number of years, the front will be stationary. If ice discharge is larger, the front will migrate downslope and this will give rise to an extending glacier. If, on the other hand, less ice flows from upglacier than is destroyed by ablation in the frontal zone, then the glacier will retreat." R. A. Souchez and R. D. Lorrain, *Ice Composition and Glacier Dynamics* (Berlin: Springer-Verlag, 1991), p. 3

goats

goats "The Romans practiced a fertility rite by sacrificing a goat and cutting its hide into thongs with which they beat barren women's backs to induce fertility. This was associated with the festival of Lupercalia and it is possible that the name is, in fact, a corruption of Luere per caprum, meaning 'to purify with the goat.'

"The Greeks' caprification rites required human sacrifice in the form of a man and a woman as scapegoats, who were stoned to death. Ritual animal sacrifices to Dionysus were accompanied by singing so-called goat songs in honor of the god. These songs were called tragodiai, the word being the origin of tragedy.

"The Greek god Pan and the Roman Satyr-type gods were sometimes associated with other gods of procreation. Some symbols representing such worship were called fascinum, which is the origin of our word fascinate." Meta Bonney, *The World of Sheep and Goats* (Carmarthen, Wales: self-published, 1993), p. 47

golden plates "The angel Moroni appeared to Joseph Smith in 1823 and told him that there was an ancient record of some of the inhabitants of the Americas that had been preserved on golden plates. . . . The golden plates were engraved with a compact writing system with ties to ancient Egyptian writing. The early writers of the Book of Mormon spoke Hebrew, and the primary spoken and written language of subsequent generations was largely derived from Hebrew. However, the final writers and abridgers of the Book of Mormon used 'reformed Egyptian' for inscribing text onto gold plates. This appears to have been a case of using one writing system (a compact script derived from Egyptian) to convey or transliterate the words of another language. The reformed Egyptian writing system apparently had been passed on from the knowledge of Egyptian shared by Lehi and his son Nephi, the first writers of the original Book of Mormon text." Jeff Lindsay, "A Brief Introduction to the Book of Mormon" at http://www.jefflindsay.com/BOMIntro.shtml

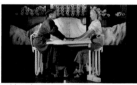

golden plates

"Hollow Earth" theory of the Promised Land "[T]he so-called 'Hollow Earth' or 'Concave Earth Theory' . . . proposes that the lost Ten Tribes [of Israel] live either in a great hollow area somewhere in the region of the North Pole or in an unknown concave area, like a volcano, near or in the North Pole.

"The first recorded appearance of this theory which this author could find in Mormon literature, was in a related statement contained within a sermon given by Elder Orson Pratt, an Apostle, at the 'New Tabernacle' in Salt Lake City in 1875. In this statement, Elder Pratt gave it as his opinion that based upon the information he had received from 'those [people] who have tried to find a passage to the [north] pole' that it was possible 'for the Lord God to cause deep and e[x]tensive valleys, very deep in comparison with high ranges of mountains around them, where the temperature would be comparatively mild, the same as in these mountains here [in Utah],' which would therefore be 'fit for habitation' by such people as the Lost Ten Tribes of Israel." R. Clayton Brough, *The Lost Tribes: History, Doctrine, Prophecies, and Theories About Israel's Lost Ten Tribes* (Bountiful, Utah: Horizon Publishers, 1979, reprint 1997), p. 55

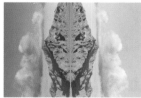

"Hollow Earth" theory of the Promised Land

Houdini "*M.B.*: Houdini . . . relentlessly studied and handled locks, to the extent that when a challenger imposed a foreign lock, Houdini intuitively 'absorbed' the lock, really making it an extension of his own body. In a sense he harnessed the potential energy of a hermetic practice and used it in an attempt to perform an external disappearing act." "Matthew Barney:

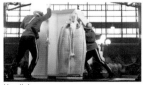

Houdini

Hungarian State Opera House

"I die daily"

Imperial 1967

A Conversation with Jeanne Siegel," *Tema Celeste* (Siracusa, Italy), no. 40 (spring 1993), p. 66

Hungarian State Opera House "Miklós Ybl's neo-Renaissance Opera house was the most culturally significant of the monuments built to commemorate the Millennium celebrations. Completed in 1884, it was also one of the few actually finished in time. . . . Seven kilograms of gold were used to gild the intimate auditorium and 260 bulbs light up the enormous chandelier. Its cultural importance has always been linked to Hungarian national identity. Ybl, who personally supervised every detail, subverted the implied colonialism of the Viennese-favoured neo-Renaissance style by incorporating Masonic allusions, such as the smiling sphinxes and the alchemical iconography on the wrought-iron lampposts." *Time Out Budapest Guide* (London: Penguin Books, 1996), p. 52

"I die daily" "[T]he death to which Masonry alludes, using the analogy of bodily death and under the veil of a reference to it, is that death-in-life to a man's own lower self which Saint Paul referred to when he protested 'I die daily.' It is over the grave, not of one's dead body but of one's lower self, that the aspirant must walk before attaining to the heights. What is meant is that complete self-sacrifice and self-crucifixion which, as all religions teach, are essential before the soul can be raised in glory 'from a figurative death to a reunion with the companions of its former toils' both here and in the unseen world. The perfect cube must pass through the metamorphosis of the Cross." W. L. Wilmshurst, *The Meaning of Masonry* (New York: Gramercy Books, 1980), p. 43

immortality "The public realm is the stage for heroic action, and heroes are spectres of the living dead. The passport which grants access to the public realm, which distinguishes master from slave, the essential political virtue, is the courage to die, to commit suicide, to make one's life a living death. 'One must pay dearly for immortality; one has to die several times while still alive' (Nietzsche, *Ecce Homo* [*The Portable Nietzsche*], p. 660)." Norman O. Brown, *Love's Body* (Berkeley and Los Angeles: University of California Press, 1966), p. 99

Imperial 1967 "Derbies generally prohibit Chrysler Imperials, Hearses, Limos and Convertibles from competing in the general competition . . . they are either fully banned or run in their own heats." Ed Becker, "Demolition Derby" at http://www.demo-derby.com/demofaq.htm

impossible discourse "As with the stage revue and its related forms, a spatial concept is essential to determining the effect of the Warners/Berkeley narrativized film musicals. Spatial elements are exactly aligned with discursive elements in these films. Unlike in the typical film musical, the 'impossible' discourse of the numbers does not encroach on the 'realistic' discourse of the narrative. This distinction is then doubled and reinforced in spatial terms: performance space is kept separate from narrative space, with each having its own qualities, laws, and modes of address. The 'musical-ness' (a quality commonly associated with artificiality, impossibility, antirealism) of the Warners/Berkeley musicals is exclusively concentrated in the space of the musical numbers: a designated, demarcated, 'official' space (e.g., a theatrical stage) in which the impossible can occur." Martin Rubin, *Showstoppers: Busby Berkeley and the Tradition of Spectacle* (New York: Columbia University Press, 1993), p. 39

ineffable God "The true word of a Mason is, not the entire, perfect, absolute truth in regard to God; but the highest and noblest conception of Him that our minds are capable of forming; and this *word* is Ineffable, because one man cannot communicate to another his own conception of Deity; since every man's conception of God must be proportioned to his mental cultivation, and intellectual powers, and moral excellence. God is, as man conceives Him, the reflected image of man himself." Albert Pike, *Morals and Dogma of the Ancient and Accepted Scottish Rite of Freemasonry* (Charleston, S.C.: Supreme Council of the Thirty-third Degree, for the Southern Jurisdiction of the United States, 1881), p. 223

initiation "The path of true initiation into fullness of life by way of a figurative death to one's lower self is the path called in the Scriptures the narrow way, of which it is also said that few there be who find it. It is the narrow path between the Pillars, for Boaz and Jachin stand impliedly at the entrance of every Masonic Temple and between them we pass each time we enter the Lodge." W. L. Wilmshurst, *The Meaning of Masonry* (New York: Gramercy Books, 1980), p. 79

innocence "Only a truly guilty man can conceive of the concept of innocence at all." J. G. Ballard, in *Backdrop of Stars*, ed. Harry Harrison (London: Dobson Books, 1968), quoted in *Re/Search: J. G. Ballard*, ed. V. Vale and Andrea Juno (San Francisco: Re/Search Publications, 1989), p. 163

island of Staffa "The island of Staffa lies almost due north and south, is three-quarters mile long by one-third mile wide, includes an area of 71 acres, its highest point being 135 feet above sea level. Except for the northeastern shore, the coast is rugged, caves having been carved out by storm, tides, and ocean. The entire island of Staffa is of volcanic origin, the last remnant of a fiery stream of lava. The geological formation of the island is threefold in character. First is a basement of tufa, on which rest colonnades of basalt, in pillars, forming the faces and walls of the principal caves, while the latter in turn are overlaid by a mass of amorphous basalt. Fingal's Cave, best known of all caves on Staffa, is situated on the southern side of the island, facing Iona six miles to the south.

impossible discourse

initiation

island of Staffa

It is 227 feet long, 42 feet wide, 60 feet high and 25 feet deep at ebb. On its western side the pillars are 36 feet high, on the east side 18 feet high, and from its mouth to its deepest point a pavement of broken pillars runs along the east wall of the cave." Paul M. Allen and Joan deRis Allen, *Fingal's Cave, the Poems of Ossian, and Celtic Christianity* (New York: Continuum, 1999), p. 71

Jacobin pigeon "*The Jacobin*. This breed was at one time included amongst the German Toys, but to such a high pitch of excellence has it been bred by its many and devoted admirers that it has for a long time now been considered one of our high-class Pigeons.

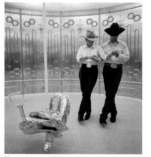

Jacobin pigeon

"The Jacobin is a medium-sized Pigeon, looking larger than it really is by reason of its peculiar hood and chain feathering and its length of flights and tail. . . . Taking the hood first, which, as its name indicates, is the covering of the head, it should rise from the back of the skull in reverse order, and cover the head as far as possible in a regular and unbroken outline. The hood must not be erect, or stiff, but fall gracefully over the skull. The chain should form an unbroken continuation of the reversed feathers in regular sequence on each side of the neck, from the hood to the rose [i.e., a round spot just above the shoulders], extending as far as possible and meeting in the front." C. A. House, *Pigeons and All About Them* (Bradford, England: The Fanciers' Newspaper & General Printing & Publishing Company, 1910), pp. 154–55

kin to the magician "That visit . . . was the first Frank had seen of his mother in twenty years. . . . Fay and Frank talked about [Houdini] like they knew him intimately. Listening to their conversation, Betty had to conclude that Houdini had given Fay the money to send Frank to private school. Then she remembered that Houdini was killed by a boy who hit him in the stomach with a baseball bat, and Frank had told her that his Jewish father, whose name was Weiss, had been killed by a blow to the belly. Then she learned that Houdini's original name was Weiss, and he was Jewish too. . . .

"The boys grew up, however, knowing something of the subject. Gaylen, the third son, didn't like Houdini exactly, but he sure was fascinated, for he used to celebrate the anniversary of his death on October 31, Halloween. He lit candles and had a little ceremony. It always came the day after Frank Jr.'s birthday on October 30. Frank Jr. became an amateur magician and, at 15, belonged to the Portland Magician Society. Gary never made much of it.

"Sitting in the trailer through the heat of July and August, Bessie could hear Brenda teasing him. 'Well, cousin, here you are in jail. Houdini should have taught you how to escape!'" Norman Mailer, *The Executioner's Song* (New York: Warner Books, 1980), pp. 323–24

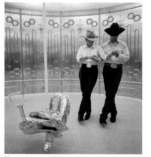

kin to the magician

larval memory "The larva absorbs these shapes into its very being, and in its whole body it feels that in its youth, during the time when it was especially soft, it was housed in that hexagonal cell. . . . It is in the cell that the power resides that gives the bees the ability to work. It is, then, in the environment where we find that which the bee is going to make on the outside." Rudolf Steiner, "Bees and Man" lecture (1923), published in French in Steiner's *Entretiens sur les abeilles* (Paris, 1987), quoted in English in Juan Antonio Ramírez, *The Beehive Metaphor from Gaudí to Le Corbusier*, trans. Alexander R. Tulloch (London: Reaktion Books, 2000), p. 107

larval memory

legs of man "The three legs of man [became] the official armorial bearing of the Island [of Man]. The three legs is, in some ways, one of the most ancient symbols for it is seen on a Greek vase of the sixth century B.C. Like the more widespread swastika or fylfot it is ultimately derived from a design showing the spokes of a wheel, which in turn represent the rays of the sun; and thus it became associated, no doubt, with sun worship. The design was taken to Sicily where it was adopted owing to the appropriateness of the three legs to the shape of that island, and it was used by the rulers of Syracuse on their coins of the fourth century B.C. as an emblem of dominion over that three-cornered island. . . .

legs of man

". . . [A] more likely immediate origin of the Manx arms can be found much nearer home on coins of the Norse-Irish kings of Northern England in the tenth century. Thus a silver coin of Anlaf Cuaran, king of Dublin and York, who died at Iona in 981, bears the triquetra or triple knot, and this design suggests a possible ancestry for the Manx three legs, especially when it is realized that the Manx-Norse seem to have been a branch of this dynasty." R. H. Kinvig, *The Isle of Man: A Social, Cultural, and Political History*, 3rd rev. ed. (Liverpool, England: Liverpool University Press, 1975), pp. 90–91

lobbying "In the fall of 1922, Walter P. Chrysler transferred his trio of engineers from Newark to Maxwell's Jefferson Avenue factory. He enthused over their design of a new high-compression engine that generated more power and less noise than the typical six-cylinder engines of the day. By the fall of 1924 Maxwell was nearly out of money. A prototype of the new model, powered by the new engine, went on display during the New York Auto Show in December [1924]. Chrysler had to lease the lobby of the Commodore Hotel to display his car since the trade show refused [to show] cars that weren't already in production." Doron P. Levin, *Behind the Wheel at Chrysler: The Iacocca Legacy* (New York: Harcourt Brace, 1995), pp. 7–9

locks "[A]ll dependence on the inviolable security of Locks, even of those which are constructed upon the best principle of any in general use, is fallacious." Joseph Brahmah,

lobbying

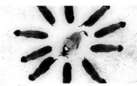

A Dissertation on the Construction of Locks (London: self-published, 1785?; 2nd ed., 1815), p. 6

Loughton ram "The Manx sheep or Loghtan is a very distinctive and distinguished creature. The male is a handsome fellow with four long recurved horns. The female has two somewhat shorter. The wool is reddish brown in colour, and of excellent texture. For generations it was made into Manx homespun cloth of very good wearing quality, left undyed. In shape the sheep is somewhat lean and has a narrow section of somewhat goat-like form." E. H. Stenning, *Portrait of the Isle of Man*, 4th rev. ed. (London: Robert Hale, 1978), p. 131

Lombardi "[Vince] Lombardi's final theme, the seventh block of granite in his speech, concerned two inseparable qualities that he believed distinguish great leaders: character and will. All the men who took Father Cox's ethics class in the mid-'30s had the intertwining definitions pounded into them day after day. *Character is an integration of habits of conduct superimposed on temperament. It is the will exercised on disposition, thought, emotion and action. Will is the character in action.* Character in action, Lombardi asserted at the end of his speech, was the great hope of society. 'The character, rather than education, is man's greatest need and man's greatest safeguard, because character is higher than intellect. While it is true the difference between men is in energy, in the strong will, in the settled purpose and in the invincible determination, the new leadership is in sacrifice, it is in self-denial, it is in love and loyalty, it is in fearlessness, it is in humility, and it is in the perfectly disciplined will. This, gentlemen, is the distinction between great and little men.'" David Maraniss, *When Pride Still Mattered: A Life of Vince Lombardi* (New York: Simon & Schuster, 1999), p. 406

Lost Tribes "Joseph [Smith]'s familiarity with the theory of the Hebraic origin of the Indians seems . . . to have come chiefly from a popular book by Ethan Smith, pastor of a church in Poultney, Vermont. This book, *View of the Hebrews; or the Ten Tribes of Israel in America*, was published in 1823, a second edition in 1825. . . . It may never be proved that Joseph saw *View of the Hebrews* before writing the Book of Mormon, but the striking parallelisms between the two books hardly leave a case for mere coincidence.

"Both books opened with frequent references to the destruction of Jerusalem; both told of inspired prophets among the ancient Americans; both quoted copiously and almost exclusively from Isaiah; and both delineated the ancient Americans as a highly civilized people. Both held that it was the mission of the American nation in the last days to gather these remnants of the house of Israel and bring them to Christianity, thereby hastening the day of the glorious millennium. *View of the Hebrews* made much of the legend that the 'stick of Joseph' and the 'stick of Ephraim'—symbolizing the Jews and the lost tribes—would one day be united; and Joseph Smith's first advertising circulars blazoned the Book of Mormon as 'the stick of Joseph taken from the hand of Ephraim.'" Fawn M. Brodie, *No Man Knows My History* (New York: Knopf, 1945, reprint, New York: Vintage Books, 1995), pp. 46–47

Norman Mailer Partial bibliography: *The Naked and the Dead* (1948), *Barbary Shore* (1951), *The Deer Park* (1955), *The White Negro* (1957), *Advertisements for Myself* (1959), *The Presidential Papers* (1963), *An American Dream* (1964), *Cannibals and Christians* (1966), *Why Are We in Vietnam?* (1967), *The Armies of the Night* (1968), *Miami and the Siege of Chicago* (1969), *A Fire on the Moon* (1970), *The Prisoner of Sex* (1971), *Maidstone* (1971), *Existential Errands* (1972), *St. George and the Godfather* (1972), *Marilyn* (1973), *The Fight* (1975), *Some Honorable Men: Political Conventions 1960–1972* (1976), *Genius and Lust* (1976) *The Transit of Narcissus* (1978), *The Executioner's Song* (1979). . . . " Norman Mailer: His Life and Works" at http://www.iol.ie/~kic/mailer2.html

Norman Mailer

Man's position and geography "The Isle of Man lies in the Irish Sea almost midway between the coasts of England, Ireland, and Scotland, from which it is visible in clear weather. It is about 33 miles long by about 12 broad in the broadest part. Its general form is somewhat like that of an heraldic lozenge, though its outline, as will be seen from the map, is very irregular, being indented with numerous bays and narrow creeks. Its chief physical characteristic is the close juxtaposition of mountain, glen, and sea, which has produced a variety and beauty of scenery unsurpassed in any area of equal size elsewhere." Arthur W. Moore, *The History of the Isle of Man* (London: T. Fisher Unwin, 1900; Manx National Heritage, 1992, reprint ed.), p. 8

Manx arms "The natives say that many centuries before the Christian era the [Isle of Man] was inhabited by Fairies, and that all business was carried on in a supernatural manner. They affirm that a blue mist continually hung over the land, and prevented mariners, who passed in ships that way, from even suspecting that there was an Island so near at hand, till a few fishermen, by stress of weather, were stranded on the shore. As they were preparing to kindle a fire on the beach, they were astounded by a fearful noise issuing from the dark cloud which concealed the Island from their view. When the first spark of fire fell into their tinder box, the fog began to move up the side of the mountain, closely followed by a revolving object, closely resembling three legs of men joined together at the upper part of the thighs, and spread out so as to resemble the spokes of a wheel. Hence the Arms of the Island." Joseph Train, *History of the Isle*

Manx arms

massacre of the males

mediation

membranes

of Man (1845), quoted in Arthur W. Moore, *The Folk-Lore of the Isle of Man* (Douglas, Isle of Man: Brown & Son, 1891; Felinfach: Llanerch Publishers, 1994, facs. reprint), p. 37

massacre of the males "The atmosphere of the city is changed; in lieu of the friendly perfume of honey, the acrid odour of poison prevails; thousands of tiny drops glisten at the end of the stings, and diffuse rancour and hatred. Before the bewildered parasites are able to realise that the happy laws of the city have crumbled, dragging down in most inconceivable fashion their own plentiful destiny, each one is assailed by three or four envoys of justice; and these vigorously proceed to cut off his wings, saw through the petiole that connects the abdomen with the thorax, amputate the fever-ish antennae, and seek an opening between the rings of his cuirass through which to pass their sword." Maurice Maeterlinck, *The Life of the Bee,* trans. Alfred Sutro (New York: Dodd, Mead and Company, Blue Ribbon Books, 1901), pp. 351–52

mediation "According to the spirits, man passed at death into a region of hierarchical spheres, his condition 'superior' to its earthly state but his character and essential identity unchanged. Beginning in the lowest sphere, he 'developed' or 'progressed' upward on a spiral path toward a distant (usually seventh) sphere. . . .

"The religious implication of this millennial impulse was that men no longer needed to depend on church and clergy and scripture for proof of the soul's immortality. . . . Residents of some of the utopian communities of the time took up spiritualism; advocates of socialism, abolition, women's rights, and free love received angelic sanction for their programs; there were even a few plans for the reorganization of society along spirit-dedicated lines." Howard Kerr, *Mediums, and Spirit-Rappers, and Roaring Radicals: Spiritualism in American Literature, 1850–1900* (Urbana: University of Illinois Press, 1972), pp. 10–11

membranes "Most creatures have a vague belief that a very precarious hazard, a kind of transparent membrane, divides death from love; and that the profound idea of nature demands that the giver of life should die at the moment of giving. Here this idea, whose memory lingers still over the kisses of man, is realised in its primal simplicity. No sooner has the union been accomplished than the male's abdomen opens, the organ detaches itself, dragging with it the mass of the entrails; the wings relax, and as though struck by lightning, the emptied body turns and turns on itself and sinks down into the abyss." Maurice Maeterlinck, *The Life of the Bee,* trans. Alfred Sutro (New York: Dodd, Mead and Company, Blue Ribbon Books, 1901), p. 306

Morbid Angel "Original genetic material of death metal, this band formed in 1984 and released its first album in 1987, being inspired by Slayer but eventually moving on to more progressive works. . . .

"*Altars of Madness,* Earache Records, 1989. . . . A strong narrative voice guides each song through its developments as its conflict is unveiled, leading through the seemingly chaotic front to the implications of what will be the revelation. Like black metal and some death metal to follow, Morbid Angel use extensive epiphanies to unify their songs much in the style of later Ozzy period Black Sabbath, although at a much faster pace. Their abilities to encode several rhythms into any part of a riff create songs of boundless potential, aggression and energy unified in a mystical force under a moving rhythm.

"This release is foundational to death metal and highly influential on much of the underground music to follow, including unrelated genres. Trey Azagthoth's maniacal atonal lead guitar inverts symphonies into nihilistic and expressive mas-terpiece works of sculpture, using technique and composition in liberated ways at high speed and high density complexity. Rhythm, as liberated in this album, freed guitar to intermix the speed of chord changes (and the form of the main riff) with the hummingbird wings of strumming frequency, in which was interwoven the wrist motion of the player, adding another layer of whipping, driving tempo to the mixture.

"Epic and meaningful lyrics depoliticize evil in favor of encoding darker more confrontation-al elements of the human soul, namely our weakness and destructability in face of the energy gained through the metaphorical 'ancient ways' of mystical power. Complexity in lyrical meaning hides under metered verse with an intense study of metal vocal rhythm with elements of rock music titrated out, and meta-composi-tion shows on the song and album level that through careful cutting and layering of work into the songs from their youth, Morbid Angel made a vast masterpiece." "Morbid Angel," Dark Legions Archive at http://www.anus.com/metal/morbidangel.html

Mormon doctrine "The Mormons held the burning conviction that the two Prophets of God, Joseph Smith, Jr., and his brother Hyrum Smith, had been 'basely murdered' at Carthage jail in Illinois by 'blood-thirsty assassins' whose crime had not been punished at the hands of the secular governments, but had probably been condoned by the secular government, and that the 'innocent blood' of those two martyrs still 'cried from the ground' up to the throne of God for vengeance. . . .

"Ancient and persisting doctrines about 'sin,' and about some sins being of 'too deep a dye' to be washed away by water or to be cleansed even by the sacrificed blood of the very Son of God, the first-born and the sacrificed Son, but which sins required the very blood of the sinner himself or herself; it was required that the sinner's own blood be spilt upon the ground and the smoke therefrom arise as an expiating and

Morbid Angel

Mormon doctrine

pleasing incense to the blood-demanding god." A. C. Lambert, "A Private Notebook on Blood Atonement, Blood Sacrifice, Blood Vengeance, Infant Sacrifice, and Mystical and Religious Ideas Concerning the Blood" (unpublished ms., 1958, in the General Collection of the New York Public Library), pp. 6–7

Mormonism and Freemasonry "A good deal of the [Mormon] ceremony performed after the rituals of washing and anointing was borrowed from the Freemasons. . . .

"The men were stripped, washed, anointed, and then, as in the Masonic ceremony, dressed in a special 'garment' which was held together with strings or bone buttons, metal being forbidden. According to John C. Bennett, this garment at first was a kind of shirt, which was worn only during the ceremony and then hidden away as a kind of security against Destroying Angels. But it was shortly changed into an unlovely and utilitarian long suit of underwear, which the novice was instructed to wear always as a protection against evil.

"The Masonic square and compass were cut into the garment on the breast and a slash was made across the knee. In the beginning the cut across the knee was apparently deep enough to penetrate the flesh and leave a scar, but this practice was eventually abandoned as a result of protests from the Mormon women. There was also a slash in the garment across the abdomen, symbolic of the disemboweling that would be the fate of anyone who revealed the sacred secrets.

"After swearing an oath of secrecy the initiate was dressed in white robes and permitted to witness a long allegorical drama depicting the creation of the earth and the fall of Adam. Joseph, it is said, took the role of God, Hyrum Smith that of Christ, and Bishop George Miller that of the Holy Ghost." Fawn M. Brodie, *No Man Knows My History* (New York: Knopf, 1945, reprint, New York: Vintage Books, 1995), pp. 279–81

mortality "Anxiety about death does not have ontological status, as existentialist theologians claim. It has historical status only, and is relative to the repression of the human body; the horror of death is the horror of dying with what Rilke called unlived lines in our bodies." Norman O. Brown, *Life Against Death: The Psychoanalytical Meaning of History* (Middletown, Conn.: Wesleyan University Press, 1959, Wesleyan Paperback, 1988), p. 108

moshing "Dancing in a packed scrimmage to heavy metal, hard-core or any other fast, loud rock music. This activity, which is more a form of energetic communal writhing than dancing, was adopted by fans of hard rock during the late 1980s as a successor to slam dancing, headbanging or the characteristic playing of imaginary guitars ('air guitar'). Often, part of the experience is for members of the audience to climb on to the stage then hurl themselves bodily into the crush at the front, a practice

moshing

known as 'stage-diving.' The word mosh is an invention influenced by such words as jostle, mash, mass, squash, crush and thrust." Tony Thorne, *Dictionary of Contemporary Slang* (London: Blooomsbury Publishing, 1997), p. 262

Mustang "The name Mustang gives its owner an image extension; its connotation brings visions of a cowboy astride a spirited horse riding across the plains of the great west. The nickname of the Mustang, "ponycar," also lent itself to a general term for a new breed of car produced in Detroit. Its earliest competitor, the Plymouth Barracuda, was joined by later competitors like the Chevrolet Camaro, the Pontiac Firebird, the Mercury Cougar, and the American Motors Javelin." Jerry Heasley, *The Ford Mustang— 1964–1973* (Blue Ridge Summit, Pa.: Tab Books, 1979), p. 20

Mustang

mythic logos ". . . [T]he kind of logic [which is used] in mythical thought is as rigorous as that of modern science, and that the difference lies, not in the quality of the intellectual process, but in the nature of the things to which it is applied." Claude Lévi-Strauss, *Structural Anthropology,* trans. Claire Jacobson and Brooke Grundfest Schoepf (New York and London: Basic Books, 1963), p. 230

mythopaeic conditioning "Myths narrate not only the origin of the world and all the things in it, but also the primordial events which shaped man into what he is today—mortal, differentiated by sex, organized into a society, forced to work in order to live, and obliged to work in accordance with certain rules. All these are the consequence of events in the primordial times. Man is mortal because something happened in the mythic era, and if that thing had not happened, he would not be mortal but might have gone on existing indefinitely, like rocks, or changing his skin every so often, like snakes, and continuing to live thus renewed. But the myth of the origin of death tells what happened at the beginning of time, and in relating that incident, it establishes why man is mortal." Mircea Eliade, "Myths and Mythical Thought," in Alexander Eliot, *The Universal Myths* (New York: New American Library, Meridian, 1990), p. 25

mythopaeic conditioning

negative neurosis "Sexuality can't be easily rationalized. It has to do with obscure forces that often erupt beyond anyone's control. But violence can be put to use, suspending the crippling effects of rationality. This is the function it assumes in sadomasochism, which is not a gratuitous exercise in private fascism, but a highly ritualistic form of 'social therapy.' By submitting his slave to a dizzying spiral of violence and eroticism, the master promises him more than pleasure: he strips the slave of the inhibitions that prevent him from taking responsibility for his own existence. Death is not the goal here, but the internal horizon (and occasionally the supreme temptation) of a subjective rebirth." Sylvère Lotringer, *Overexposed: Treating Sexual Perversion in America* (New York: Pantheon Books, 1988), p. 16

nuptial flight

opera

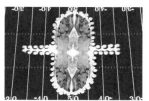
orgasmic fusion

orifice

nuptial flight "Nor does the new bride, indeed, show more concern than her people, there being not room for many emotions in her narrow, barbarous, practical brain. She has but one thought, which is to rid herself as quickly as possible of the embarrassing souvenirs her consort has left her, whereby her movements are hampered. She seats herself on the threshold, and carefully strips off the useless organs, that are borne far away by the workers; for the male has given her all he possessed, and much more than she requires. She retains only, in her spermatheca, the seminal fluid where millions of germs are floating, which until her last day, will issue one by one, as the eggs pass by, and in the obscurity of her body accomplish the mysterious union of the male and female element, whence the worker-bees are born. Through a curious inversion, it is she who furnishes the male principle, and the drone who provides the female." Maurice Maeterlinck, *The Life of the Bee*, trans. Alfred Sutro (New York: Dodd, Mead and Company, Blue Ribbon Books, 1901), pp. 318–19

opera "Most Greek tragedies were structured around five conflicts, generally involving two characters in each of five dialogue confrontations. The concept of conflict forms the basis of all successful opera, as it does for all successful theater. The five-part form also would be used again and again in opera, especially in the customary five acts of French nineteenth-century opera, or in the five-part form of Strauss's *Elektra*, a modern version of the ancient Greek play." John Louis DiGaetani, *An Invitation to the Opera* (New York: Facts on File, 1986; Doubleday, Anchor Books, 1991), p. 15

orgasmic fusion "In Berkeley's numbers, the experience of losing oneself in the group, in the big ensemble, is presented as primarily ecstatic. It is a moment of transcendence and sublimation, analogous to orgasm, but erupting beyond the confines of the ego to fuse self and society, sexuality and politics, emotion and ideology." Martin Rubin, "The Crowd, the Collective, and the Chorus: Busby Berkeley and the New Deal," in *Movies and Mass Culture*, ed. John Belton (New Brunswick, N.J.: Rutgers University Press, 1996), p. 78

orifice "In his discussion of the drives . . . Lacan focuses on the rimlike structure that is characteristic of all erogenous zones in the body (comprising both vagina and anus, as well as others). This formation is not casual (it is not simply that humans are biologically prone to be stimulated at the points where the body exhibits 'openings'), but related to the intrinsic structure of the drive as it turns out from the body, circumvents some object, and then moves back on itself, receding once again in the body where it achieves 'satisfaction.'" Karen Pinkus, *Bodily Regimes: Italian Advertising under Fascism* (Minneapolis and London: University of Minnesota Press, 1995), p. 105

ornament "These extravagant spectacles, which are staged by many sorts of people and not just girls and stadium crowds, have long since become an established form. . . . The bearer of the ornaments is the *mass* and not the people [*Volk*], for whenever the people form figures, the latter do not hover in midair but arise out of a community. A current of organic life surges from these communal groups—which share a common destiny—to their ornaments, endowing these ornaments with a magic force and burdening them with meaning to such an extent that they cannot be reduced to a pure assemblage of lines. Those who have withdrawn from the community and consider themselves to be unique personalities with their own individual souls also fail when it comes to forming these new patterns. Were they to take part in such a performance, the ornament would not transcend them. It would be a colorful composition that could not be worked out to its logical conclusion, since its points—like the prongs of a rake—would be implanted in the soul's intermediate strata, of which a residue would survive." Siegfried Kracauer, *The Mass Ornament: Weimar Essays*, trans. and ed. Thomas Y. Levin (Cambridge, Mass., and London: Harvard University Press, 1995), p. 76

partition "Northern Ireland has been a recognizable entity separated for some 50 years from the rest of Ireland. Formed from 6 of the 9 counties of the Irish province of Ulster, Northern Ireland is a fragmented society of slightly more than 1 ½ million people, at least 900,000 of them Protestant and nearly 600,000 of them Catholic. . . . The Catholic and Protestant communities have lived in uneasy juxtaposition, fragments detached from their origins, and as yet have been unable to establish a common identity or community in Northern Ireland. . . .

"The Orange Order, founded in 1795 to protect Ulster Protestants, was dedicated to Protestant control in Ulster. Its members swore an oath to support the British Crown *only* as long as it maintained a Protestant Ireland. The Order was outlawed by the British for its violent activities, yet despite this it flourished and grew as the prospect of home rule became real. When full-scale rebellion against the English broke out in 1919, the Orange Order played an essential part in organizing and arming Ulster Protestants in their successful defense of Northern Ireland against the Irish Republican Army (IRA)." Richard W. Mansbach, ed., *Northern Ireland: Half a Century of Partition* (New York: Facts on File, 1973), pp. 1, 3

pearl "[P]earls are the result of a morbid state within the mollusc and the tomb of a parasitic worm. When an irritant object enters its shell, the oyster tries to eject it, but failing this it isolates the intruder either by immuring it against the inner shell wall, thus forming a blister, or by encystation, i.e., in a sac, or cyst. Usually, the intruder is a parasitic worm which causes

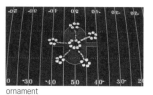
ornament

partition

pearl

a depression on the surface of the mantle, slowly sinking in until it is in a hollow below the surface. Eventually, the hollow is sealed over, the parasite dies, and its skeletal remains receive a coating of conchiolin which hardens to form a nucleus. From then on, secreted fluids from the epithelial cells of the sac cover the nucleus with overlapping fine films of nacreous aragonite. If the oyster can move freely, the nucleus receives concentric layers which form that finest of pearls, a spherical cyst pearl." Alexander E. Farn, *Pearls: Natural, Cultured and Imitation* (London: Butterworths, 1986), pp. 15–16

pearls "Dioscorides and Pliny mention the belief that pearls are formed by drops of rain falling into oyster shells while they are open, with the raindrops thus received being hardened into pearls by some secretions of the animal." *Brewer's Dictionary of Phrase and Fable*, 15th ed., rev. by Adrian Room (London: Cassel, and New York: HarperCollins, 1995), p. 810

pentastar

pentastar "The regular pentagon is a uniform, five-sided structure closely associated with the planet Venus. The Venus goddess was in ancient times both a war and a fertility divinity. The promoters of the Christian ideology sought to suppress the sexual pleasure aspects of this ancient goddess when transforming her to the chaste Virgin Mary. Therefore, they had to carefully retain all the rest of what the goddess stood for, lest they create disobedience and ideological havoc. They were more than happy to retain the aggressive and warmongering aspect: Venus as the goddess of warfare. During the sixteenth, seventeenth and eighteenth centuries the pentagon, as a structure closely associated with the pagan goddess through the celestial movements of the planet Venus, was common as a basic design for fortresses. Reminiscences of this are still to be found . . . in the U.S. Pentagon complex near Washington [D.C.]" . . . [The pentagon form is also] quite frequently used in the business world as a logotype. See, for instance, [the pentastar adopted by the Chrysler Corporation in the late 1920s]." "Symbols" at http://www.symbols.com/encyclopedia/28/2823.html

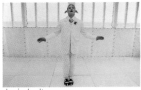
physical culture

physical culture "Casting escapes in a surprising new light, Houdini moved them from the world of Spiritualism to the contemporaneous religion of Strenuosity. He had of course cultivated the brawn and limberness indispensable to his escapes through years of running, swimming, ballplaying, boxing, and circus acrobatics. But he was not alone. The word 'conditioning' came into general use around 1890, as not only Houdini but also millions of other Americans (and Europeans) began devoting themselves to rugged exercise. Cramped by urban life or deskbound at sedentary jobs, they complained that the price of modern civilization was dyspepsia, tameness, and enfeeblement, and

joined in a crusade for physical vigor. It gave birth to many now-familiar revitalizers—rowing machines, 'physical education,' professional trainers, and corn flakes, also producing ten million bicycles a year (in the United States in 1890) and Houdini's Sandow-esque forearms. [Eugen] Sandow himself circulated beefcake pictures of his [own] anatomy, and exhibited it in 'plastic poses' on the stage. Houdini gave his escapes the atmosphere of this Gospel of Health, and the feel of a sporting event. 'If it had not been for my athletic boyhood,' he was later reported saying, 'I would never have been Houdini.'" Kenneth Silverman, *Houdini!!!: The Career of Ehrich Weiss* (New York: HarperCollins, HarperPerennial, 1996), p. 42

Polaris: Mormon star "[According to Matthew W. Dalton in *The Period of God's Work on This Planet* (Utah, 1906), there is a theory,] associated with the Unknown Planet Theory, but somewhat removed from its basic premise that the Lost Ten Tribes are now supposedly on a 'portion of the earth' that has been 'separated, *detached* or taken away from our globe,' and placed on some other 'planet, orb, sphere, and/or near another star somewhere in the universe,' is the 'Narrow Neck Proposition.' This proposition (perhaps better referred to as a kind of 'sub-theory' of the main Unknown Planet Theory) states that 'attached' to the earth by 'a narrow neck of land' are two spheres (invisible or otherwise) which vary in size—one which is connected to the earth 'north of the north pole' and the other which is connected to our globe 'south of the south pole.'" R. Clayton Brough, *The Lost Tribes: History, Doctrine, Prophecies, and Theories About Israel's Lost Ten Tribes* (Bountiful, Utah: Horizon Publishers, 1997), pp. 51–52

Polaris: snowmobile "Allan Hetteen and David Johnson, partners in Hetteen Hoist & Derrick, founded in 1944, while hunting in the winter of 1953 thought there should be a better way than snowshoes for the winter outdoorsman to get around. Their first Polaris Sno-Traveler took form in 1954." John W. Malo, *Snowmobiling: The Guide* (New York: Macmillan, 1971), pp. 114–15

Polaris: snowmobile

polarity: the Lost Ten Tribes "The Prophet Joseph [Smith] once in my hearing advanced his opinion that the Ten Tribes were separated from the Earth; or a portion of the Earth was by a miracle broken off, and that the Ten Tribes were taken away with it, and that in the latter days it would be restored to the Earth or be let down in the Polar regions. Whether the Prophet founded his opinion upon revelation or whether it was a matter of mere speculation with him, I am not able to say." Elder Orson Pratt, from a letter dated December 13, 1875, quoted in R. Clayton Brough, *The Lost Tribes: History, Doctrine, Prophecies, and Theories About Israel's Lost Ten Tribes* (Bountiful, Utah: Horizon Publishers, 1997), p. 50

precision dancing "Oddly enough, the beginnings of contemporary precision dance are found in late nineteenth-century Europe. Some London

precision dancing

prison rodeo

proscenium stage

prosthetic God

productions around that time were based on the Schuhplattler dances of central Switzerland and Austria. The Schuhplattler, imported to London by Viennese ballet mistresses, is actually a courting dance intended to imitate the 'courting' of a cock and hen." John Alliotts, "Precision Dancing," *Dance Magazine* (New York) 56, no. 12 (December 1982), p. 44

prison rodeo "A very unusual, and at the same time very worth-while type of rodeo is held in the State prisons of Texas and Oklahoma. This is an annual event in the Texas State Prison at Huntsville. It is held on four successive Sundays during the month of October; unusual arrange-ments are made in order to cover all the entrants as well as to accommodate the interested public. It is an amateur contest because the participants are all inmates; about three thousand prisoners attend, the majority from several prison farms in southern Texas. . . .

"Rodeo has played, and is continuing to do so, its part in a rehabilitation program of the men who are looked upon as social outcasts. It ranks with the sports of football, baseball, tennis, and basketball, and has much to offer to these unfortunate men." Clifford P. Westermeier, *Man, Beast, Dust: The Story of Rodeo* (Lincoln: University of Nebraska Press, 1987), pp. 397–98

proscenium stage "What the proscenium relationship shapes is the attitude of the voyeur, intently eyeing the thrashing about of other psyches to no good end, witnessing the inability of the victim-hero to salvage his life and in no way being allowed to enter his life or mitigate the absolute mountain of shit that he's going through." Arthur Sainer, *The Village Voice* (New York) 15, no. 4 (January 22, 1970), p. 50

prosthetic God "Long ago [man] formed an ideal conception of omnipotence and omnis-cience which he embodied in his gods. To these gods he attributed everything that seemed unattainable to his wishes, or that was forbidden to him. One may say, therefore, that these gods were cultural ideals. Today he has come very close to the attainment of this ideal, he has almost become a god himself. Only, it is true, in the fashion in which ideals are usually attained according to the general judgement of humanity. Not completely; in some respects not at all, in others only half way. Man has, as it were, become a kind of prosthetic God. When he puts on all his auxiliary organs [e.g., telescope, microscope, camera, gramophone, telephone, etc.] he is truly magnificent; but those organs have not grown on to him and they still give him much trouble at times." Sigmund Freud, *Civilization and Its Discontents*, trans. and ed. James Strachey (New York: W. W. Norton, 1961), pp. 38–39

prosthetics "*Prosthetics* The castration com-plex raised to the level of an art form." J. G. Ballard, "Project for a Glossary of the Twentieth Century,"

in J. G. Ballard, *A User's Guide to the Millennium: Essays and Reviews* (London: HarperCollins, 1996), p. 277

Queen of Chain Partial filmography for Ursula Andress (including roles played): *Sins of Casanova* (1954); *Dr. No* (1962), as Honey Ryder; *Fun in Acapulco* (1963), as Marguerita Dauphin; *4 for Texas* (1963), as Maxine Richter; *Nightmare in the Sun* (1965), as Wife; *She* (1965), as Ayesha (She who must be obeyed); *What's New, Pussycat?* (1965), as Rita; *Chinese Adventures in China* (1965), as Alexandrine Pinardel; *Once Before I Die* (1965), as Alex; *The Tenth Victim* (1965), as Caroline Meredith; *The Blue Max* (1966), as Countess Kaeti von Klugermann; *Casino Royale* (1967), as Vesper Lynd; *Anyone Can Play* (1967), as Norma; *The Southern Star* (1969), as Erica Kramer; *Perfect Friday* (1970), as Britt; *Stick 'em Up, Darlings* (1974), as Nora Green; *Last Chance for a Born Loser* (1975), as Michelle Nolton; *The Loves and Times of Scaramouche* (1975), as Josephine de Beauharnais; *Africa Express* (1975), as Madeleine Cooper; *Sex with a Smile 2* (1976), *The Secrets of a Sensuous Nurse* (1976), as Anna; *Slave of the Cannibal God* (1978), as Susan Stevenson; *The Fifth Musketeer* (1979), as Louise de la Vallière; *Clash of the Titans* (1981), as Aphrodite; *Mexico in Flames* (1982), as Mabel Dodge; *Tigers in Lipstick* (1985), as The Stroller and The Widow; *Cremaster 5* (1997), as Queen of Chain "Filmographies," Internet Movie Database at http://us.imdb.com/Name?Andress,+Ursula

Quocunque Jeceris Stabit "[I]n the Rolls of Arms of the later thirteenth century which are the [Isle of Man's] oldest heraldic manuscripts, there are definite references to the 'three mailed legs' or 'three legs in armour' which are consis-tently attributed to the king of Man. . . . The Latin motto, *Quocunque Jeceris Stabit*, i.e., 'Whichever way you throw, it will stand,' was added later, being first seen on the earliest Manx coinage dating to 1668." R. H. Kinvig, *The Isle of Man: A Social, Cultural, and Political History*, 3rd rev. ed. (Liverpool, England: Liverpool University Press, 1975), pp. 91–92

Raiders "The spirit of [Al] Davis's organization is unabashedly martial, dovetailing with Davis's fascination with military history; at the end of every Raider itinerary are typed the words: 'Let's go to war!' This may be a livelihood for his players, a day in the sun for the fans, but for the 62-year-old managing general partner of the Los Angeles Raiders, all that's at risk is his self-worth. All that is being tested is his will. All that is on the line is his being. . . .

"By 1981, the Raiders were two-time Super Bowl winners, famous for their swashbuckling image. Players such as Ken Stabler and John Matuszak led them in a rowdy conga line through life. Fullback Marv Hubbard used to smash the same picture window in Jack London Square after every victory. Raiders used bizarre

prosthetics

Queen of Chain

Raiders

techniques everywhere. Cornerback Lester Hayes smeared his uniform with Stickum to help him catch the ball, and he practiced in regalia worthy of Cinderella. Only later did Davis recognize that many of his players were in trouble with drugs and alcohol; in the '80s he took steps to clean up their act, detailing an assistant coach to monitor off-field activity. Still, tragedies occurred. Defensive end Lyle Alzado, admitting to having used human growth hormone, contracted cancer. Defensive back Stacey Toran died in a car crash; tests showed a high level of alcohol in his blood. Matuszak died of an overdose of Darvocet, a prescription painkiller." Mark Heisler, "The Machiavelli of Football," *Los Angeles Times Magazine*, December 15, 1991, pp. 20, 24

satyr

Rockettes "It is as if the chorus of a Greek tragedy decided to desert the play it was supposed to support and pursued its own emancipation. The Rockettes, daughters of the multiple sunset, are a democratic chorus line that has finally left its background role and gone to flex its muscles at center stage." Rem Koolhaas, *Delirious New York: A Retroactive Manifesto for Manhattan,* 2nd ed. (New York: Monacelli Press, 1994), p. 217

satyr "The satyr, like the idyllic shepherd of more recent times, is the offspring of a longing for the primitive and the natural; but how firmly and fearlessly the Greek embraced the man of the woods, and how timorously and mawkishly modern man dallied with the flattering image of a sentimental, flute-playing, tender shepherd! Nature, as yet unchanged by knowledge, with the bolts of culture still unbroken—that is what the Greek saw in his satyr who nevertheless was not a mere ape. On the contrary, the satyr was the archetype of man, the embodiment of his highest and most intense emotions, the ecstatic reveler enraptured by the proximity of his god, the sympathetic companion in whom the suffering of the god is repeated, one who proclaims wisdom from the very heart of nature, a symbol of the sexual omnipotence of nature which the Greeks used to contemplate with reverent wonder." Friedrich Nietzsche, *The Birth of Tragedy and the Case of Wagner,* trans. Walter Kaufmann (New York: Random House, Vintage Books, 1967), p. 61

Rockettes

scapegoat

sacrificial crisis "If the gap between the victim and the community is allowed to grow too wide, all similarity will be destroyed. The victim will no longer be capable of attracting the violent impulses to itself; the sacrifice will cease to serve as a 'good conductor,' in the sense that metal is a good conductor of electricity. On the other hand, if there is *too much* continuity the violence will overflow its channels. 'Impure' violence will mingle with the 'sacred' violence of the rites, turning the latter into a scandalous accomplice in the process of pollution, even a kind of catalyst in the propagation of further impurity." René Girard, *Violence and the Sacred,* trans. Patrick Gregory (Baltimore: The Johns Hopkins University Press, 1979), p. 39

scapegoat "A sacrificial animal symbolically bearing the sins of a group. Part of the ancient ritual among the Hebrews for the Day of Atonement laid down by Mosaic law (Leviticus 16) was as follows: Two goats were brought to the altar of the tabernacle and the high priests cast lots, one for the Lord, the other for Azazel. The Lord's goat was sacrificed; the other was the *scapegoat*. After the high priest, by confession, had transferred his sins and the sins of the people to it, it was taken into the desert and allowed to escape." *Benét's Reader's Encyclopedia,* 3rd ed. (New York: Harper & Row, 1987), p. 870

sacrificial crisis

sadomasochism "Sadomasochism is an endless, a vicious cycle; in which subject and object are confused; active and passive, male and female roles are exchanged, in the desire and pursuit of the whole, the combined object." Norman O. Brown, *Love's Body* (Berkeley and Los Angeles: University of California Press, 1966), p. 70

Serra's gas mask "Serra's throwing lead mimes Pollock's flinging paint, but with a difference that makes all the difference. The first aspect of that difference is the gas mask. . . . To the impersonal status of the mask the gas mask adds the depersonalizing conditions of industrial work with associations to repetition, seriality, things-in-a-row all alike, but also associations to labor itself, to a kind of work in which a task is given in relation to a set of materials, in which operations are fixed by matter rather than 'inspiration.' Thus the mask not only collectivizes the notion of 'expression,' but it folds 'creativity' back into the condition of labor." Rosalind Krauss, "Richard Serra: Sculpture," in *Richard Serra,* ed. Hal Foster with Gordon Hughes (Cambridge, Mass.: MIT Press, 2000), pp. 100–01

Serra's gas mask

salt flats "The Hebraic tradition manifests two kinds of lack, expressed by two deserts, emerging one from the other, *heart of everything, in its heart everything.* One is named *Shemama,* despair and destruction, and the other is *Midbar,* which is a desert not of dereliction but instead a field of uncertainty and effort. The *shemama* is, rather, polarity of the City-State (City of Ur—*Our,* light), its desert is the tragical one of laws, ideology, order, as opposed to what could have resulted from wandering." Paul Virilio, *The Aesthetics of Disappearance,* trans. Philip Beitchman (New York: Semiotext[e], 1991), pp. 26–27

salt flats

skyscraper "One of the innumerable versions of the story of the struggle between father and son is the biblical narrative concerning the erection of the Tower of Babel. As in the myth of the Titans, we find here the attempt to climb up to the sky—that is to say, to dethrone the father, to possess oneself of his virility— followed by destruction of the rebels: castration

skyscraper

of the son by his father, whose rival he is. Furthermore, the coupling, rash though it may be, of these two words, the verb 'scrape' on the one hand and, on the other, the substantive 'sky,' immediately evokes an erotic image in which the building, which scrapes, is a phallus even more explicit than the Tower of Babel, and the sky which is scraped—the object of the desire of the said phallus—is the incestuously desired mother, as she is in all attempts at the spoliation of the paternal virility." Georges Bataille, ed., "Critical Dictionary" in *Encyclopaedia Acephalica* (London: Atlas Press, 1995), pp. 69–70

Slayer

Slayer "The musical ancestors of death metal, Slayer took punk speed and simplicity and merged it with the evolving structural language of speed metal and produced angry, evil, subversive tunes which worked against the normative impulse of the society around them.

"*Hell Awaits* [Metal Blade, 1985]

"*Review.* . . . Noise-based as much of the guitar pyrocuneiform is, the power of Slayer's composition is to amplify a simple virus through breakdown into multiple variations of a core rhythm in architectural riffs built from fragmented scales and basic harmonic ideas to emphasize basic mathematical concepts behind the doomscience of lyrics and budding death metal aesthetic. Even the faster speed songs and the savage self-combative moments of thrash carry a complexity borrowed from the progressive rock gods of the previous generation and the metal masters who bestowed their creations with the complex metaphorical language of imagination.

"Rhythmic emphasis comes entirely through guitars, which lead drums because the linear complexity tracking of the song moves fluidly through the variations of riffing which move, ambient, through patterns over the percussive components of the song, allowing drums to maintain greater simplicity and to unleash guitars to freedom of voicing over predictable rhythm upholding self-defined major components of each song. Slayer's composition is often called chromatic, meaning that it uses linear scales, but more appropriately it is nihilistic: a note or chord becomes the basis for invention of new recombinant pieces of information, creating a self-specialized evolutionary compositional space for the conception of each song.

"Nihilism pervades also the virulent lyrics and the haphazard, almost careless method with which guitarists K. King and J. Hanneman drop into a solo and work it through some motions of noise. The core of this comes within the text of Slayer's obsession with the seat of control of violence and death, as well as from the alienated methodology of their major ancestors in hardcore and thrash. However nihilism is not their excuse, only their origin; without pretense they wrest beauty from the essential

deconstruction of music, and from that beauty they create romantic epics of despair and oblivion that influenced all metal, and much of popular music, to follow." Dark Legions Archive at http://www.anus.com/metal/slayer.html

"Slayer Wants To Keep Death Date"

"DESERET NEWS *Slayer Wants To Keep Death Date*"

"Provo (AP) Nov. 1 — Unless he changes his mind and appeals, or the courts and the governor intervene, a 35-year-old parolee convicted of murdering a hotel clerk will keep his Nov. 15 execution date.

"'You sentenced me to die. Unless it's a joke or something, I want to go ahead and do it,' Gilmore said yesterday."

"DESERET NEWS *Houdini Didn't Show*"

"Nov. 1 . . . Halloween was a disappointment to groups trying to make contact with the spirit of escape artist Harry Houdini who died on Halloween 50 years ago.

"Several magicians gathered Sunday in the Detroit hospital room where Houdini died, hoping for a message from the master. All they got on a video tape machine brought to record the event, was interference from a local rock station.

"'It's not even very good music,' said one magician."

"DESERET NEWS"

"Nashville, Tenn. (AP) Nov. 16 — Country music star Johnny Cash says he tried to call Gary Gilmore at the Utah State Prison to urge him to 'fight for his life' only minutes after the convicted murderer was found unconscious in an apparent suicide attempt.

"'I don't know what I would have told a man who was planning to take his life,' Cash said. 'Sometimes it helps, sometimes it doesn't. But I would have tried to talk him out of it.'

"The singer said his first impulse was not to get involved. 'I told him (the attorney) I wasn't looking for any publicity. I thought I had better mind my own business. Who needs that kind of publicity?'

"When Boaz persisted, saying his client wanted to see Cash or visit him, Cash said he decided to call the prison." *Deseret News,* November 1 and November 16, 1975, quoted in Norman Mailer, *The Executioner's Song* (New York: Warner Books, 1980), pp. 484–85, 575

Joseph Smith "In 1823 a young man named Joseph Smith had an encounter with an angel who led him to a cache of golden plates purporting to be the history of the lost tribes of Israel. Out of these new gospels—and out of Smith's own charismatic personality and sense of mission—arose an authentically American religion, the Mormon faith." Fawn M. Brodie, *No Man Knows My History* (New York: Knopf, 1945, Vintage Books, 1995), back cover blurb

snug "By long and sacred tradition Dublin's public houses were an exclusively male domain

snug

Straight Edge

streamlining

swarm

symbolic packaging

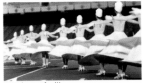

symphony of will

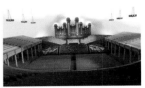

tabernacle

teeth

or, as some crusty old regulars prefer to put it, the 'holy ground.' Inviolable. Especially in the working-class neighbourhoods of the inner city, where old ways die hard, the local pub was the last true bastion of male supremacy. Here in their private sanctuary a man could shut out domestic life and womanhood and 'be himself' in the company of like-minded mates." Kevin C. Kearns, *Dublin Pub Life and Lore: An Oral History* (Dublin: Gill & Macmillan, 1996), p. 40

stasis "Stasis is death." Paul Virilio, *Speed and Politics: An Essay on Dromology,* trans. Mark Polizzotti (New York: Semiotext[e], 1986), p. 13

Straight Edge ". . . I'm a person just like you but I've got better things to do / than sit around and smoke dope cuz I know that I can cope / I laugh at the thought of eating ludes I laugh at the thought of sniffing glue / always want to be in touch, never want to use a crutch / I've got Straight Edge." Lyrics from the song "Straight Edge" by punk band Minor Threat, from the album *Minor Threat* (Dischord Records, 1981), quoted in Craig O'Hara, *The Philosophy of Punk: More Than Noise!!* (San Francisco: AK Press, 1995), p. 122

streamlining "Streamlining as a principle of design had its roots in hydrodynamics and aerodynamics. In the nineteenth century the Scottish physicist William J. M. Rankine determined that the motion of fluids has two forms: laminar flow and turbulent flow. Laminar flow can be visualized as a series of parallel layers in a moving fluid, each with its own velocity and direction without disturbance in its forward motion. Turbulent flow is characterized by eddies or vortexes and can be visualized as a tumbling of the fluid caused by a solid body. The turbulence creates a partial vacuum behind the body, which in turn causes drag and impedes the body's forward progress. When a body immersed in a flow does not cause turbulence, it is said to be streamlined." Howard S. Irwin, "The History of the Airflow Car," *Scientific American* 237, no. 2 (August 1977), p. 98

swarm "That which is not good for the swarm, neither is it good for the bee." Marcus Aurelius, *Meditations,* quoted in Hal Cannon, *The Grand Beehive* (Salt Lake City: University of Utah Press, 1980), unpaginated [see page with fig. 47]

symbolic packaging "Streamlining was a form of symbolic packaging, a visual metaphor of aspiration and progress. It suggested a people who were not content to remain static in the doldrums, but were determined to ride forward, as fast as possible, into a shining future. Perhaps society, too, could be engineered into something smooth and frictionless." Bevis Hillier, *The Style of the Century, 1900–1980* (New York: E. P. Dutton, 1983), pp. 105, 107

symphony of will "Whatever the new theater is, it is *not* an industry, but rather a sometimes-subliminal and a sometimes-conscious protest against the bigification of art forms into industrial

organizations, organizations that can create an orchestra of fifty assembly-line violinists all playing the same note at the same time. And maybe it was the visual symmetry of a symphony orchestra that primarily influenced Busby Berkeley. Where Berkeley's over-choreographed film spectacles of the 1930s originally entertained, they now enlighten; for we are finally aware of the degree to which Berkeley was satisfying a Depression-induced mass-audience craving for abundance and order, a desire for over-supply fulfilled by having a hundred happy chorus girls lifting a hundred right legs in snappy military precision. Hollywood during the Depression was America's triumph of the will." Dan Isaac, "The Death of the Proscenium Stage," *The Antioch Review* 31, no. 2 (summer 1971), unpaginated

tabernacle "To understand the ability of the Latter-day Saints to attempt, in their isolated situation, an undertaking of the proportions of the Tabernacle and its great organ, one must understand the inherent temperament of the Mormon people. Here was not a body of people of one mind and culture leaving the tyranny of a despotic country, but a great mass of emigrants from all corners of the earth, trying desperately to blend their differences in an inhospitable region. Their sufferings were sometimes intense in their chosen mountains and valleys, as they were in the mid-west and on the western trek, and among the suffering, music seems to play a majestic and important role." Kate B. Carter, ed., *The Great Mormon Tabernacle* (Salt Lake City: Daughters of the Utah Pioneers, 1967?), p. 36

teeth "The many modifications of the typical dream with a dental stimulus (dreams, for instance, of a tooth being pulled out by someone else, etc.) are, I think, to be [interpreted as castration]. It may, however, puzzle us to discover how 'dental stimuli' have come to have this meaning. But I should like to draw attention to the frequency with which sexual repression makes use of transpositions from a lower to an upper part of the body. . . . One instance of a transposition of this kind is the replacement of the genitals by the face in the symbolism of unconscious thinking. Linguistic usage follows the same line in recognizing the buttocks ['*Hinterbacken,*' literally 'back-cheeks'] as homologous to the cheeks, and by drawing a parallel between the 'labia' and the lips which frame the aperture of the mouth. Comparisons between nose and penis are common, and the similarity is made more complete by the presence of hair in both places. The one structure which affords no possibility of analogy is the teeth; and it is precisely this combination of similarity and dissimilarity which makes the teeth so appropriate for representational purposes when pressure is being exercised by sexual repression." Sigmund Freud, *The Interpretation of Dreams,* 3rd rev. ed., trans. James Strachey, ed. Angela

threshold

trips to fall

tourist trophy (Isle of Man)

union of Buda and Pest

Richards (London: Penguin Books, 1988), pp. 509–10

threshold "The threshold is the node which separates two opposing worlds, the interior and the open air, the cold and the warm, the light and the shade. To cross a threshold is thus to traverse a zone of danger where invisible but real battles are fought out." Georges Bataille, ed., "Critical Dictionary" in *Encyclopaedia Acephalica* (London: Atlas Press, 1995), pp. 83–84

trips to fall "The episode in Genesis reveals that the accomplishment of the rite of passage leading from one universe to another produces not only a metamorphosis of sight but an immediate camouflage and careful dissimulation of the body. Here one may recall Hannah Arendt's reflection that 'terror is the fulfillment of the law of movement.' In the biblical narrative, fear is simultaneous with seduction precisely because the latter is traversed in a phenomenon of speed such that the anticipation of an accident occurs instantly. Isn't the 'sin' of the first man commonly called the 'fall,' the ancients thus establishing a direct relation between what is conventionally called original sin and this terrestrial pull which they considered to be the first natural motor of the free acceleration of bodies, of their projection but also of their collision?" Paul Virilio, "Moving Girl," in *Polysexuality*, ed. François Peraldi, *Semiotext(e)* 4 no. 1 (1981), p. 243

tourist trophy (Isle of Man) "*Motor-Car and Motor-Cycle Racing [on the Isle of Man.]* The reason for the Island's long association with motor racing is simple. In Great Britain, no road may be closed to the public except by Act of Parliament, and it would provoke great opposition if it were suggested that any circuit of roads should be closed. But in the Island, there is a difference. The Tynwald Court is never so busy as not to be able to consider amending the Highway Act, so as to allow the roads to be closed, at certain times and under certain conditions; and further opposition is very unlikely to be stern in an Island which desires to attract as many visitors as possible." E. H. Stenning, *Portrait of the Isle of Man*, 4th rev. ed. (London: Robert Hale, 1978), p. 149

union of Buda and Pest "The Chain Bridge is, along with Parliament, the dominant symbol of Budapest. As the first permanent bridge across the Danube (1849), it paved the way for the union of Buda, Óbuda, and Pest into a single city. Prior to 1849, people relied on a pontoon bridge that had to be dismantled when ships passed and could be swept away in stormy weather. The initiative for the Chain Bridge came from the indefatigable Count István Széchenyi, the leading figure of Hungarian society during the mid-nineteenth-century Age of Reform. The Scotsman Adam Clark, for whom the square on the Buda side of the bridge is named, came to Budapest to supervise the massive project; he remained in the city until his death many years later. The bridge was blown up by the retreating Nazis in World War II, but was rebuilt immediately after the war." Joseph S. Lieber and Christina Shea, *Frommer's Budapest & the Best of Hungary* (New York: Macmillan, 1996), p. 111

vertex "Late in 1929, after the spire, or 'vertex,' as it was called, of the Chrysler Building was put into place, Walter P. Chrysler, the builder of the Chrysler Building, and William Van Alen, its architect, stepped out onto a scaffolding platform surrounding its summit. They posed for a photographer on opposite sides of the pyramid-shaped needle, each man with one hand on the very tip. At that moment the creators of this monument were in effect standing on thin air, touching the apex of the tallest object ever designed and manufactured by man. On this dazzlingly bright azure day, high up in the empyrean, these men could see vast distances, perhaps a hundred miles, in all directions. 'As the builder and the architect grasped the chrome nickel steel tip of the building, it felt smooth and warm, like the hood of an automobile after a long summer's drive' [in David Michaelis, '77 Stories: The Secret Life of a Skyscraper,' *Manhattan, Inc.* (June 1986)]." Vincent Curcio, *Walter Chrysler: The Life and Times of an Automotive Genius* (New York: Oxford University Press, 2000), p. 402

vertex

Victorian pier "The phenomenon of the Manx holiday season did not occur until the nineteenth century was nearly done. Until then, the Isle of Man might have been Rockall, for all the ordinary Englishman knew about it. Fought for, and over, by medieval kings and barons, used as a port of call for monks travelling between Ireland and England, a haunt of smugglers in the liquor and tobacco trades, a bolt-hole for malefactors and debtors, it held no attraction for 'the quality.' And the working classes, even if they could afford it, would have no reason to go there: what work there was could all be done by the inhabitants.

"The Industrial Revolution changed the picture completely. For the first time in history, Britain's workers began to draw wages from which they could save up. Thrift clubs helped them and there came into being, particularly in the North of England, those annual mass vacations known as 'wakes,' when not only factories, but whole towns would stop work for a week. The urge to be beside the seaside gripped the nation. Previously little-known places like Blackpool, Morecambe and Llandudno found themselves overwhelmed by weavers and spinners, machinists and mill-hands. The railways, shipping companies and town councils seized the opportunity. The 'cheap excursion' arrived, piers were built and lodgings 'not five minutes from the sea' were everywhere.

"The Isle of Man had plenty of sea to offer and, because of its Home Rule fiscal and employment conditions, it could provide accommodation and entertainment at rates that undercut those on the mainland." Bob Holliday, *Racing Round

Victorian pier

the Island: A Manx Tale of Speed on Wheels (London and North Pomfret, Vt.: David & Charles, 1976), p. 15

virtues and vices "For Aristotle . . . *hubris*, unlike anger, involves conduct engaged in for the pleasure it brings. Thus, unrestraint (*akrasia*) arising from desire involves *hubris*, while unrestraint arising from anger does not. Accordingly, monarchs, tyrants, and the wealthy, who are freest to act with deliberate unrestraint, are most likely to engage in hubristic action. . . . If, for Aristotle, the underlying motivation of hubristic behaviour is the affirmation of one's superiority by disgracing or humiliating another person, one arena in which to find such affirmation is in sexual relations. . . .

"In societies where honour and shame are dominant social values, any act which dishonours a family requires vengeance as the only possible means of eliminating or diminishing the stain. . . . Hubristic sexual aggression clearly appears here as a transgression of social norms which dishonours its victims and their relations, and which gives rise to retaliatory or punitive responses. . . . [Certain] acts of sexual abuse motivated by wounded sexual honour also refer to such abuse as *hubris*. Xenophon, for instance, says that a ruler committed an act of *hubris* when he castrated a man who had insulted him by praising the beauty of his concubine. Similarly, Aristotle calls a ruler *hubristes* and *chalepos* because he has a man castrated and forces him to eat his testicles." David Cohen, "Sexuality, Violence, and the Athenian Law of *Hubris*," *Greece & Rome*, 2nd series, vol. 38, no. 2 (October 1991), pp. 173–74, 176

Wingfoot "The responsibility for the adoption of the Wingfoot symbol, known today in every civilized country on earth, rests to a great extent with Frank Seiberling, the founder and for many years president of The Goodyear Tire & Rubber Company. In the old Seiberling home in Akron [Ohio], on a newel post of the stairway there stood a statue of the famous god of mythology known to the ancient Romans as Mercury, and to the Greeks as Hermes. Mr. Seiberling's attention was attracted to the statue, and he felt that the god it portrayed embodied many of the characteristics for which Goodyear products were known. . . .

"Mercury in ancient times was the god of trade and commerce; but it was as a swift messenger for all the gods of mythology that he was best known, and as such he has continued to be known through the centuries. The idea of speed had much to do with Goodyear's selection of the symbol, for the wingfooted Mercury was regarded as a fleet herald of good news. But it is as a herald or carrier of good tidings to users of Goodyear products everywhere that the Wingfoot now stands in the minds of the people of the world." "Origin of Wingfoot as the Goodyear Symbol" at http://www.goodyear.com/corporate/origin.html

Wingfoot

zombie "The unendurable oppression of the lungs—the stifling fumes of the damp earth—the clinging of the death garments—the rigid embrace of the narrow house—the blackness of the absolute Night—the silence like a sea that overwhelms—the unseen but palpable presence of the Conqueror Worm—these things, with the thought of the air and grass above, with the memory of dear friends who would fly to save us if but informed of our fate, and with consciousness that of this fate they can *never* be informed—that our hopeless portion is that of the really dead—these considerations, I say, carry into the heart, which still palpitates, a degree of appalling and intolerable horror from which the most daring imagination must recoil." Edgar Allan Poe, "The Premature Burial," quoted in Jan Bondeson, *Buried Alive: The Terrifying History of Our Most Primal Fear* (New York: W. W. Norton, 2000), p. 9

zombie

CREMASTER 1

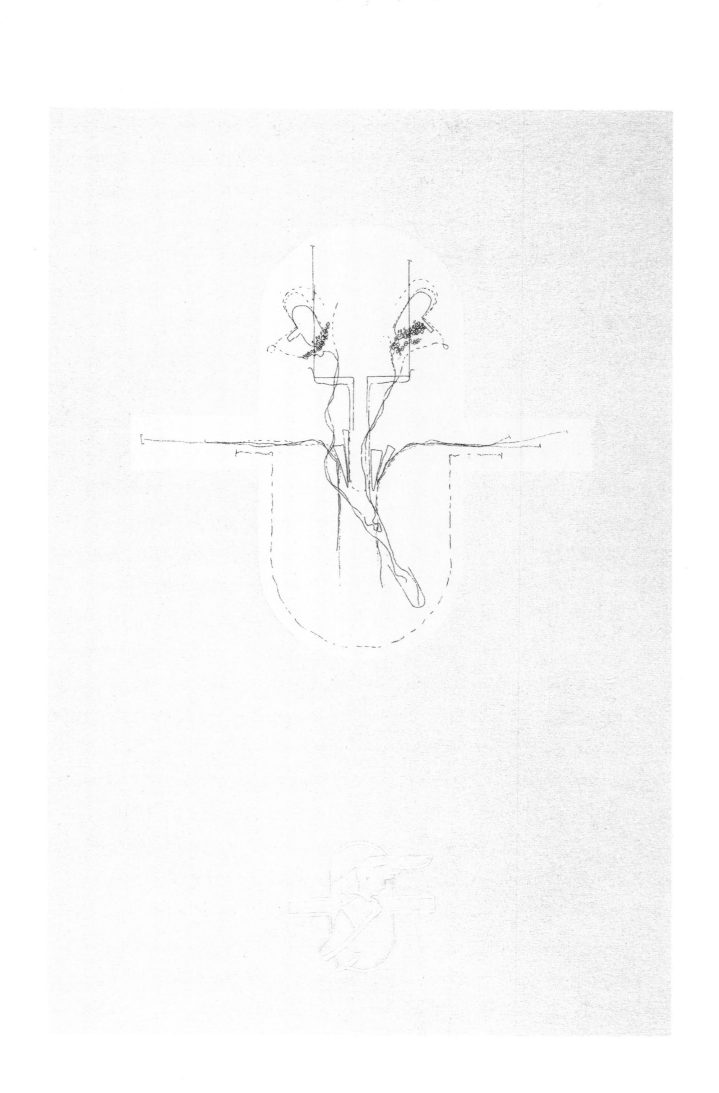

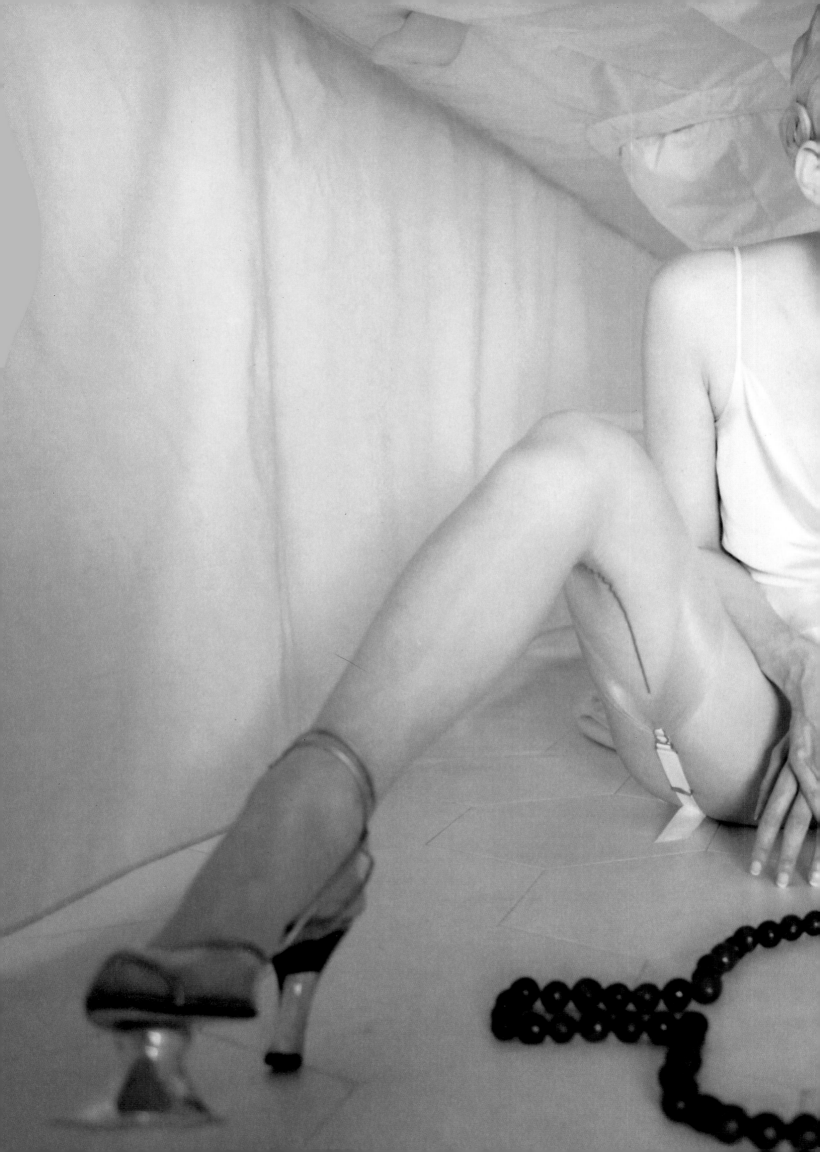

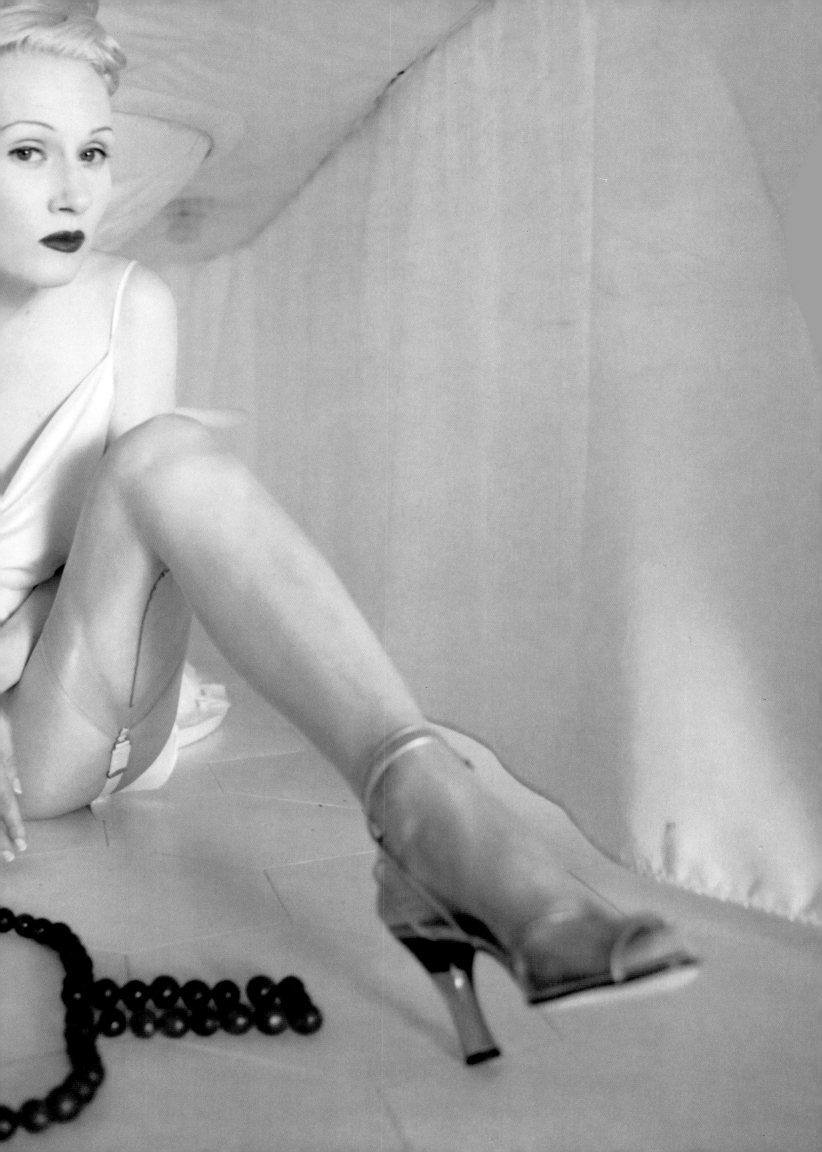

CREMASTER 1

CREMASTER 1

ENTRANCE: SILVER GROUND WITH BLUE LETTERS WITH ORANGE DROP SHADOW.

CREMASTER 1

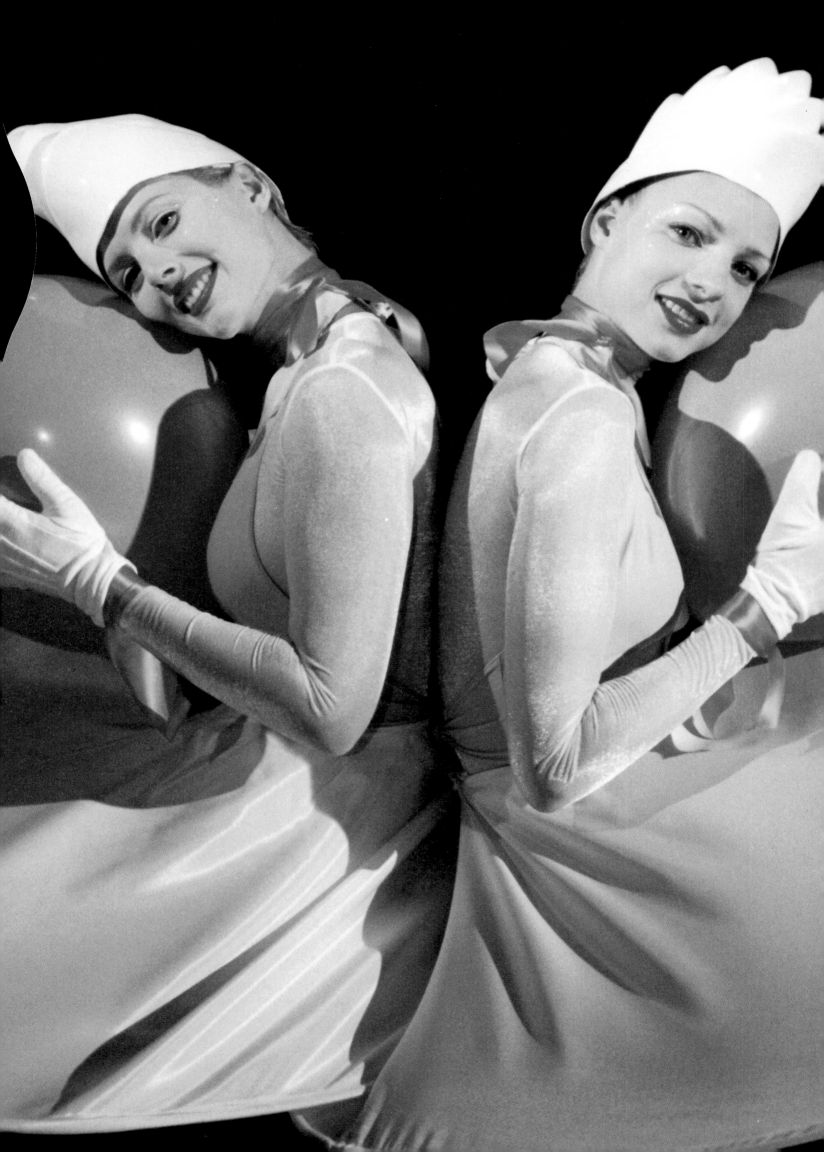

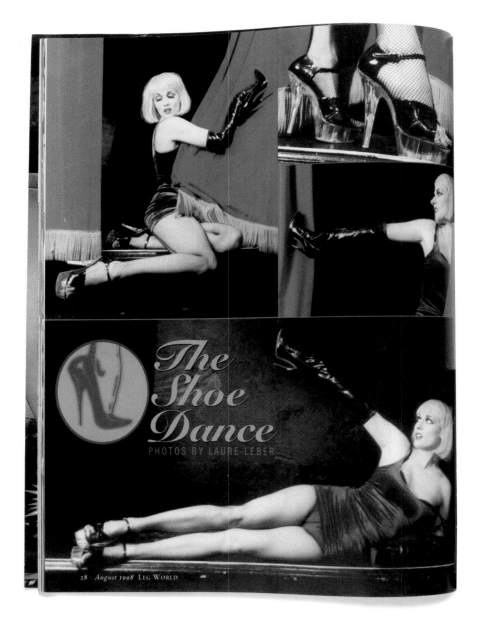

The
Shoe
Dance

PHOTOS BY LAURE LEBER

CREMASTER 1

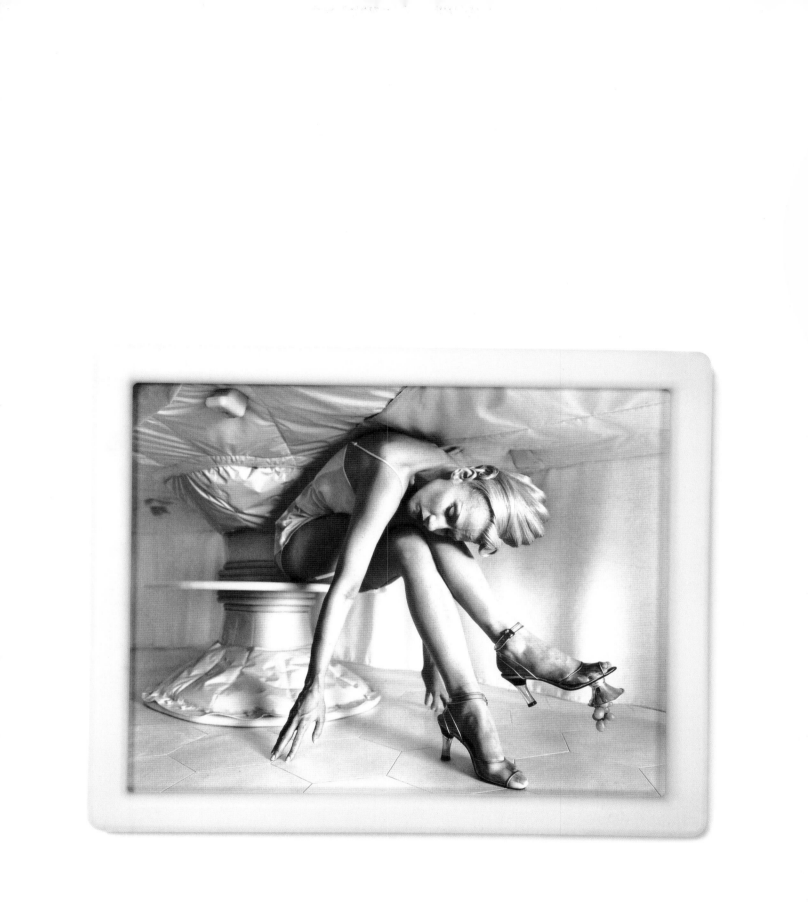

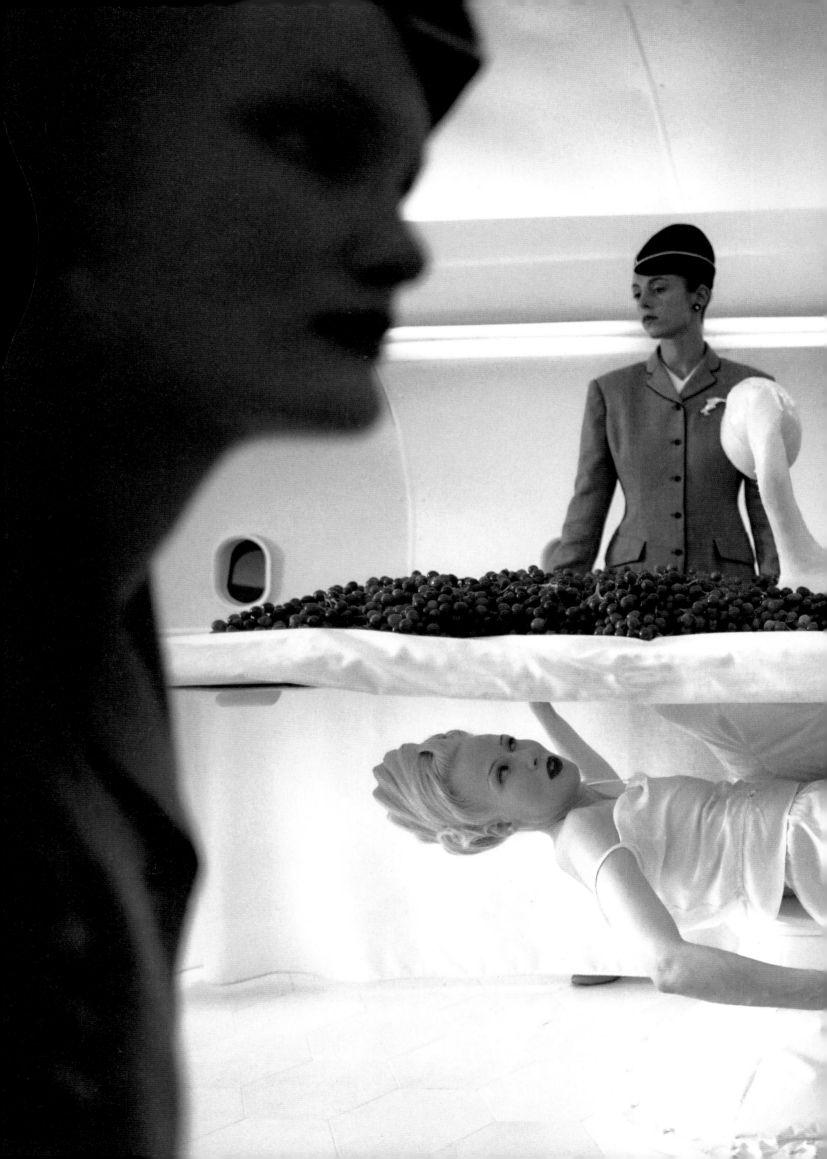

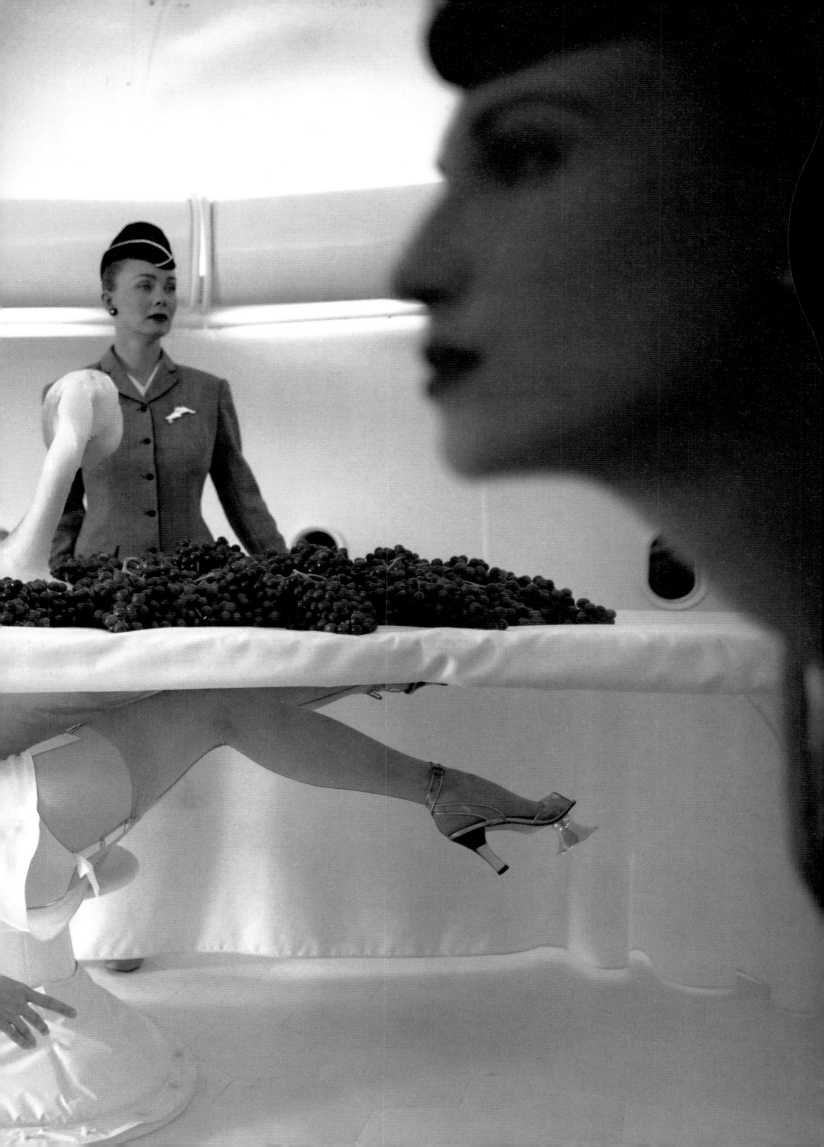

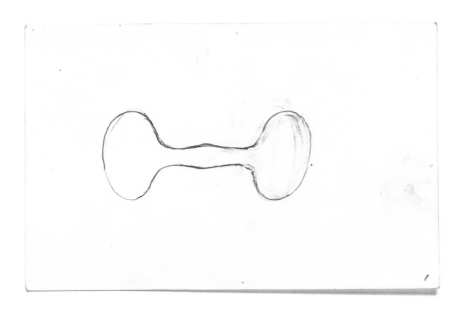

CREMASTER 1

PHASE 1 march toward goal post on baselines — then single file to midfield to make
a double line — after 2 second rest, double line breaks out
into dumbell formation.

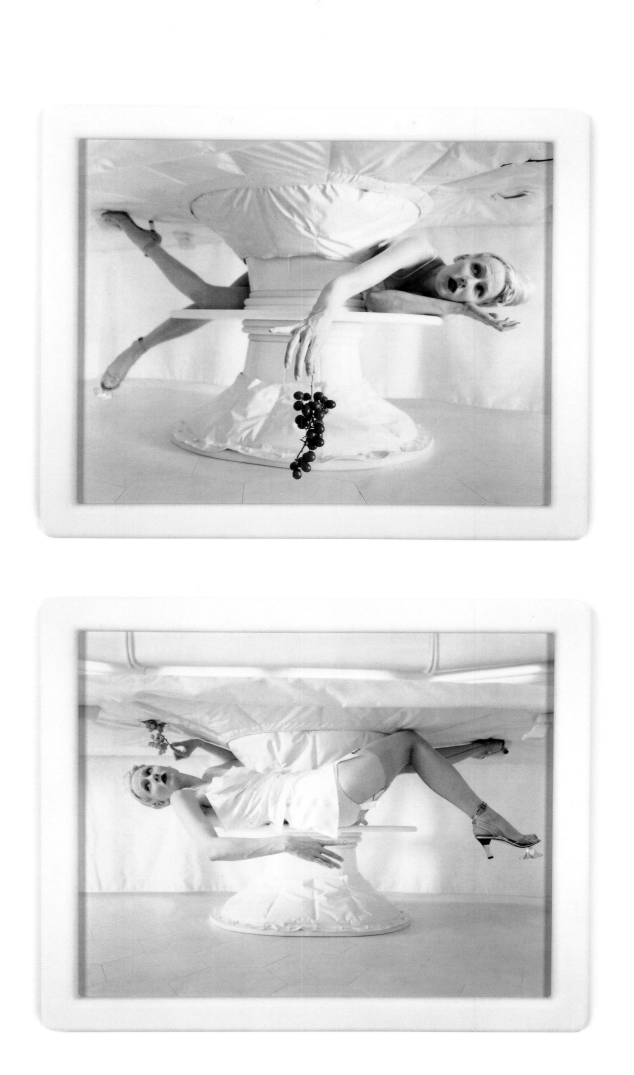

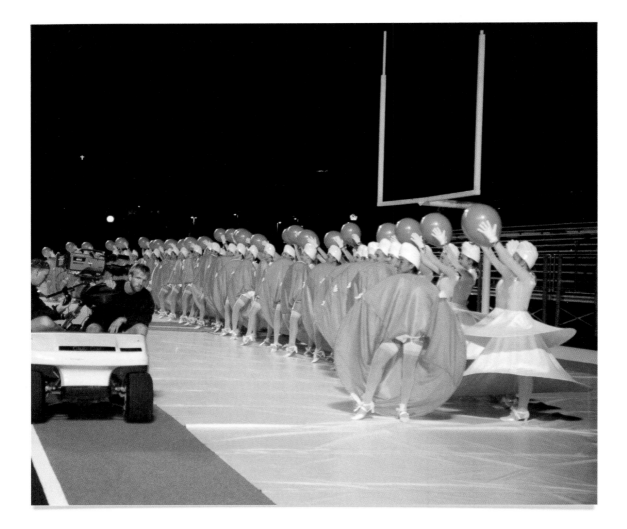

CREMASTER 1

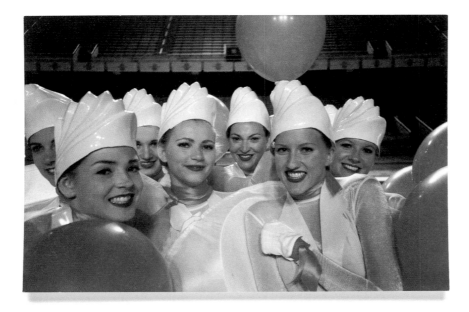

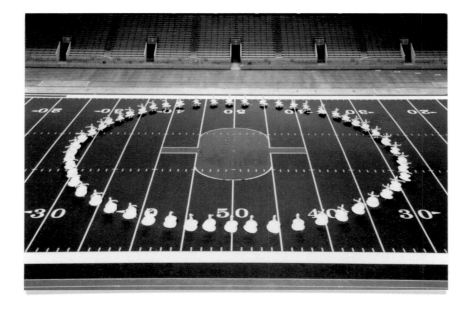

CREMASTER 1

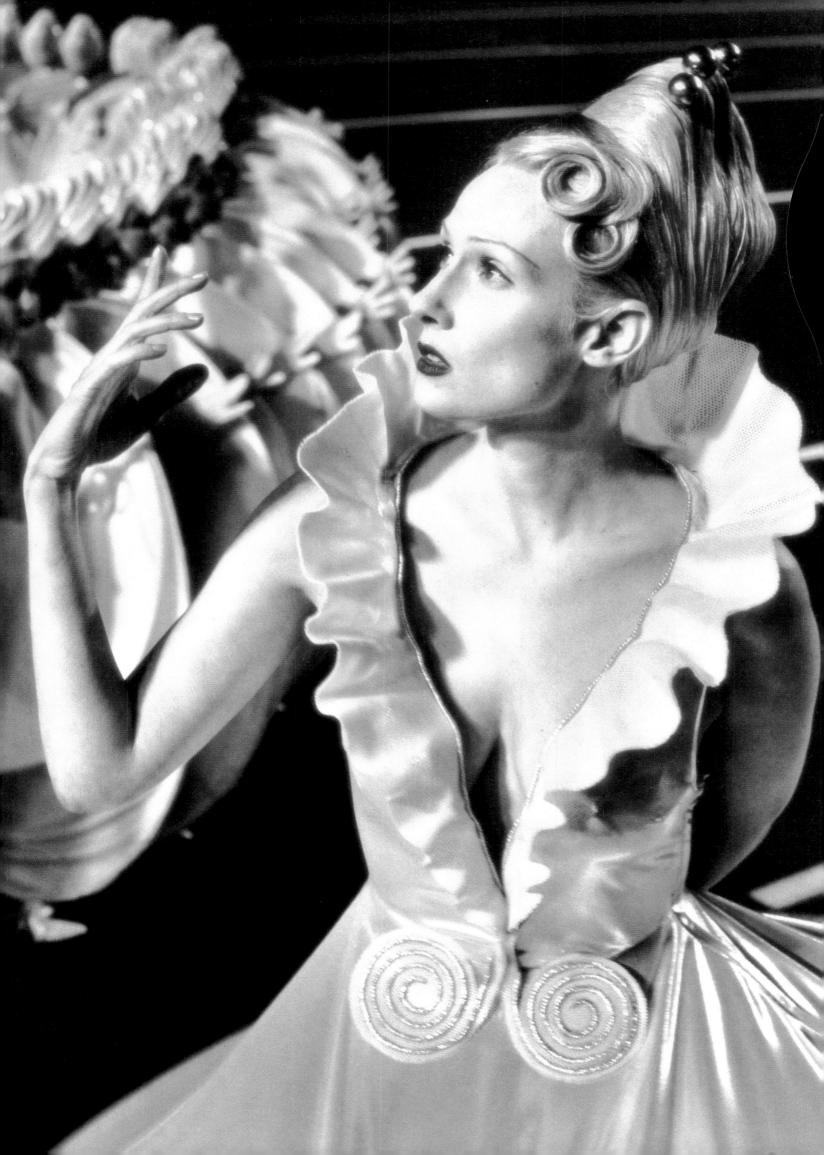

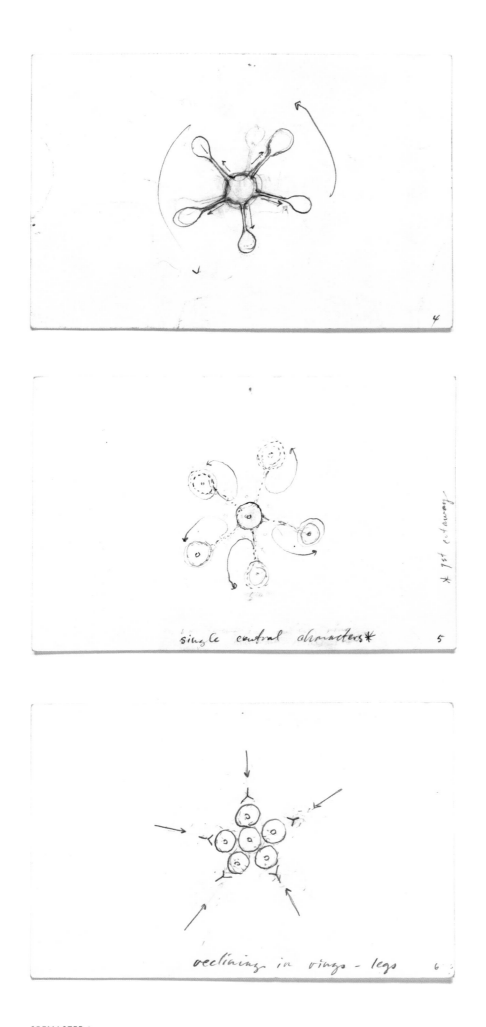

single central characters*

* 1st cutaway

declining in wings - legs

CREMASTER 1

starting position

finished position (counter rotation)

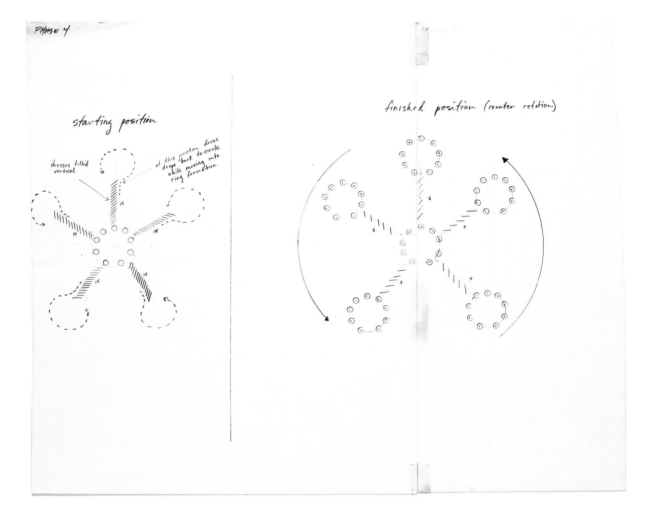

dresses tilted vertical

at this junction dress drops back to circle while moving into ring formation

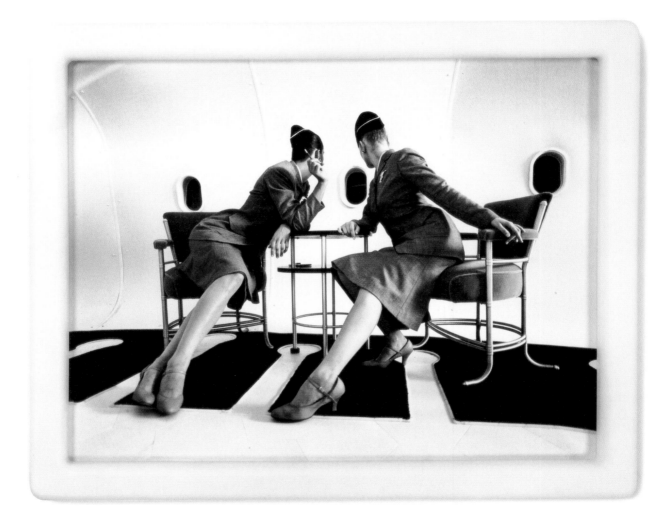

CREMASTER 1

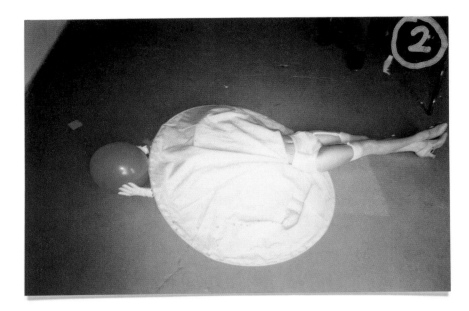

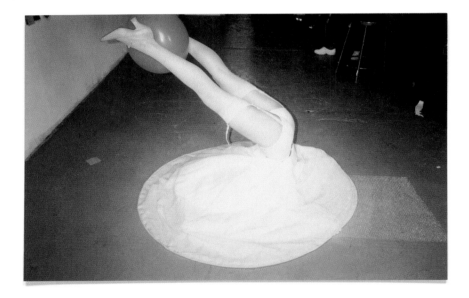

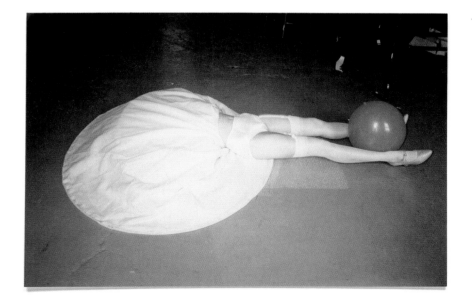

CREMASTER 1

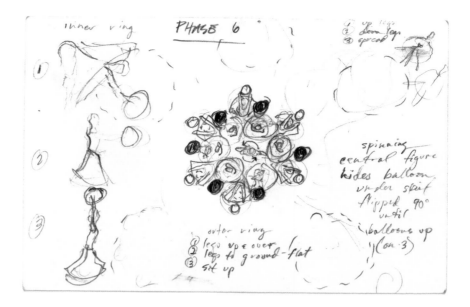

inner ring PHASE 6

① up legs
② down legs
③ spread

spinning
central figure
hides balloon
under skirt
flipped 90°
until
balloons up
(on 3)

outer ring
① legs up & over
② legs to ground-flat
③ sit up

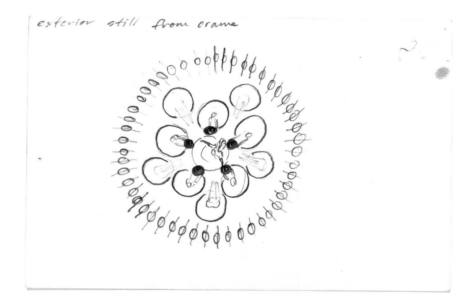

exterior still from crane

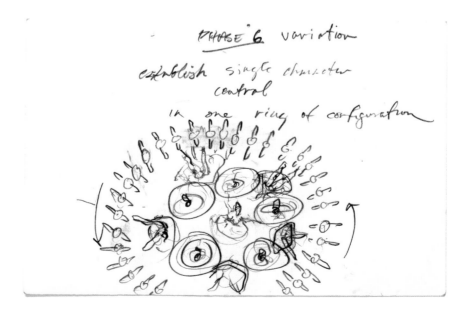

PHASE 6 variation

establish single character
central

in one ring of configuration

. See photographs for steps 1, 2,

. figure A (centers) rotates slowly th

. steps 1, 2, & 3 repeat five times (

. pairs of straight lines stemming from

. balloons are used in phase 6 (see photos) -

. small circles indicate balloons

step 1

step 2

fig D

fig B (inner ring)

fig A (center)

fig C (outer ring)

for figures A, B, C, & D

~out phase 6 with skirt tilted vertical

~-3-2-1-2-3 etc)

~cles denote legs

~ B (light blue), fig C (orange)

step 3

CREMASTER 1

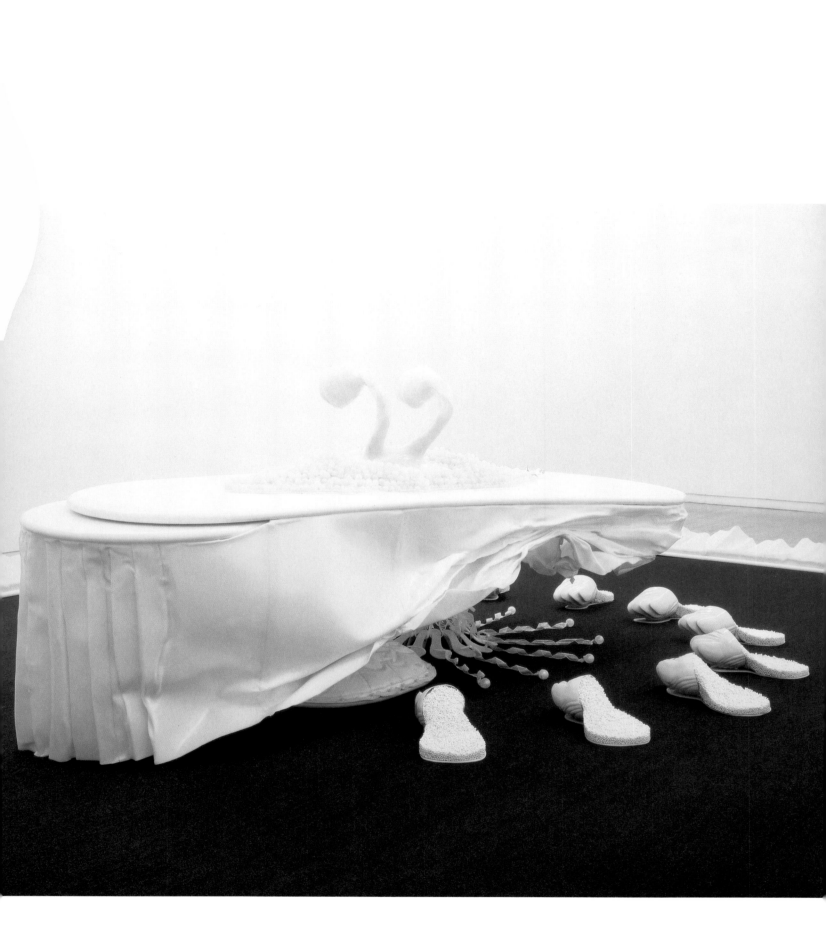

CREMASTER 1

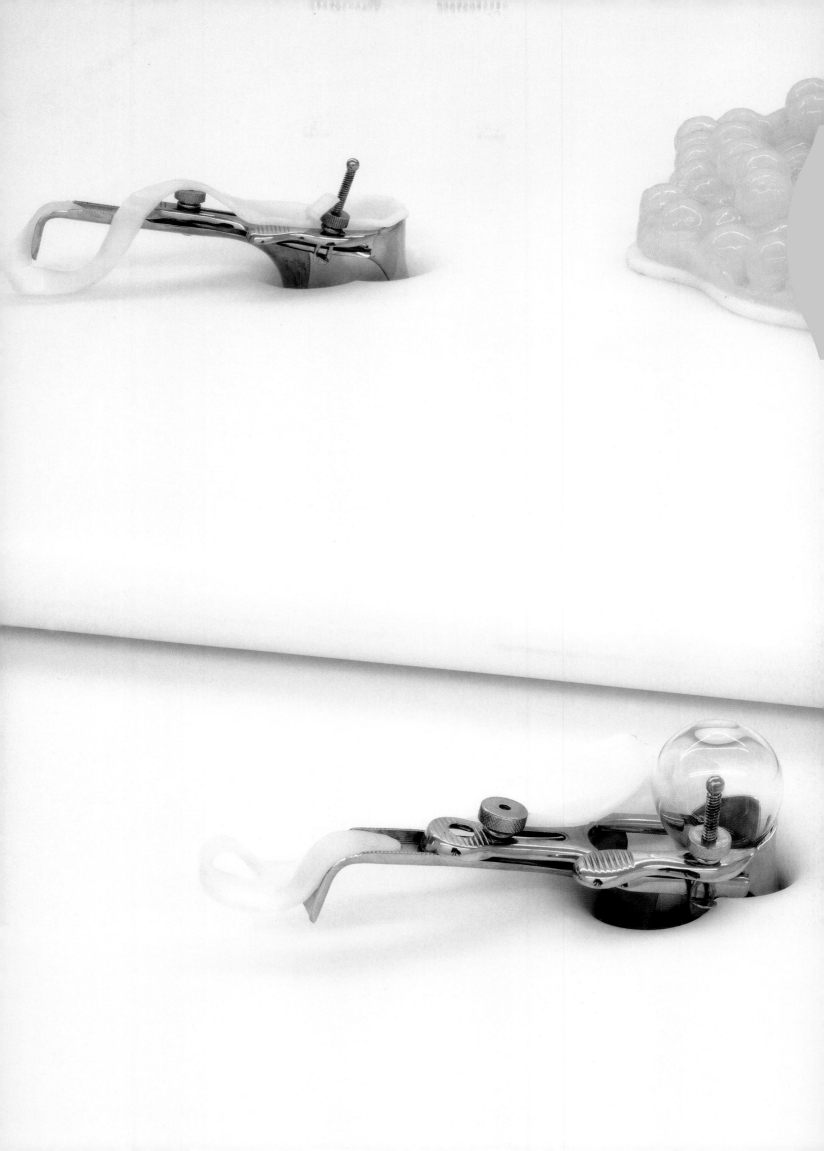

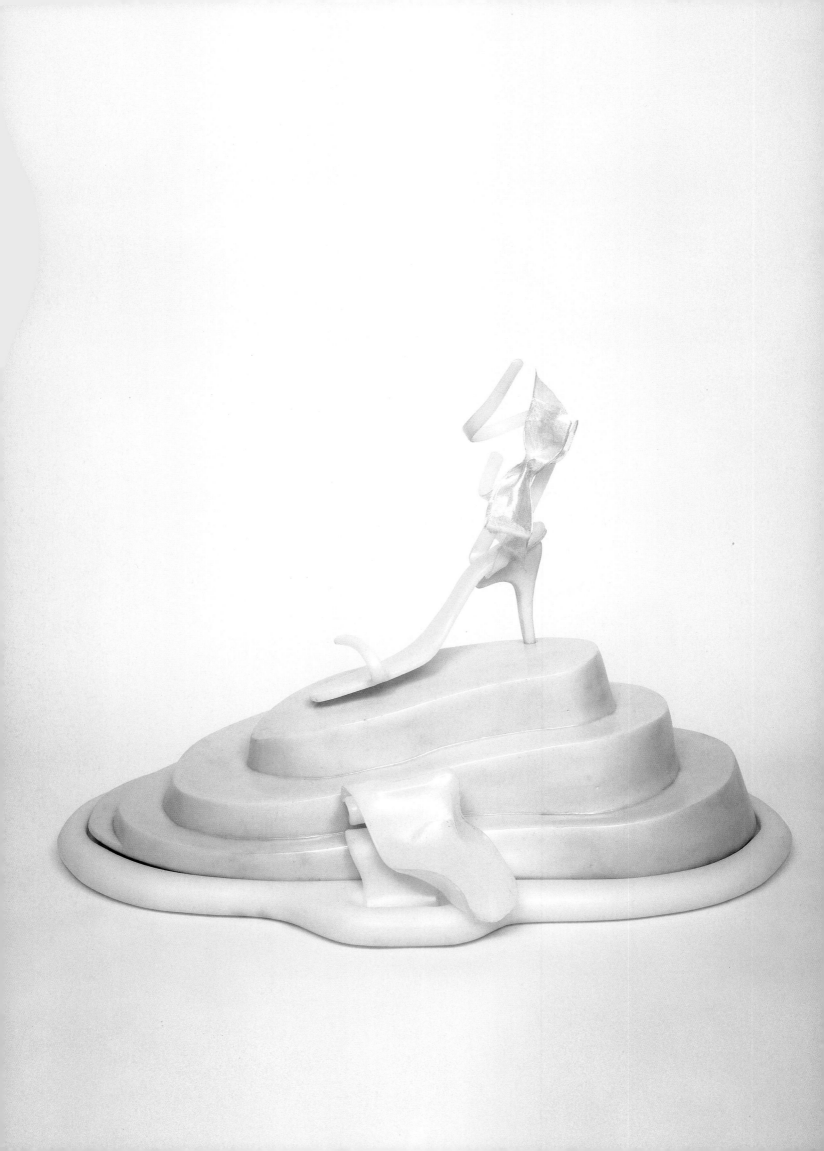

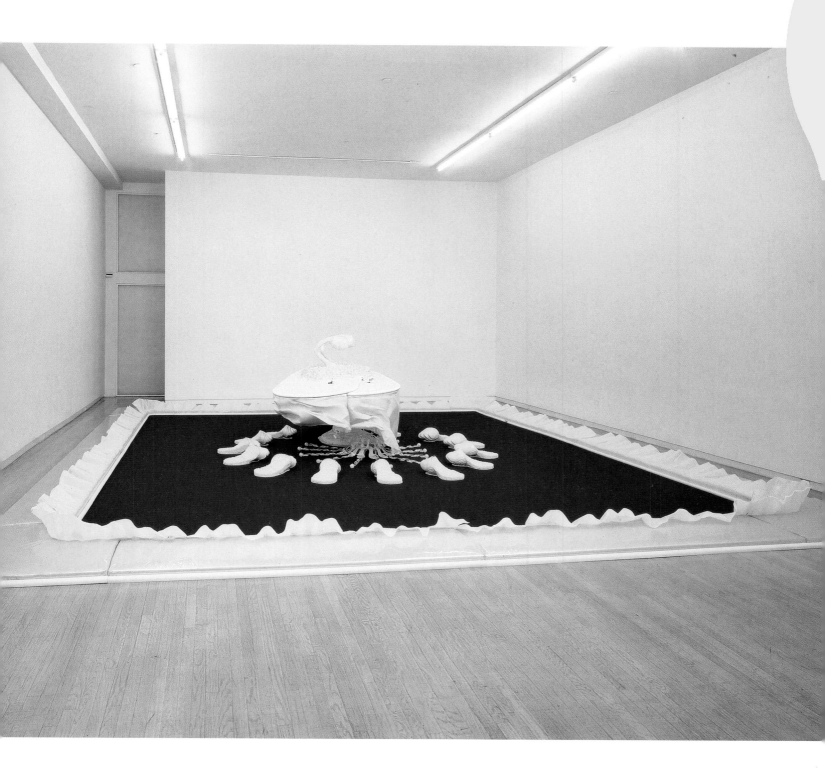

— to start the move into phase 8 we would return to the 6 'pods' from the beginning of phase 6 (with skirts down – all dancers standing)

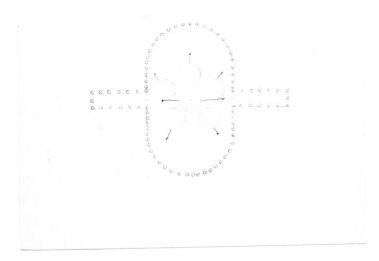

PHASE 9

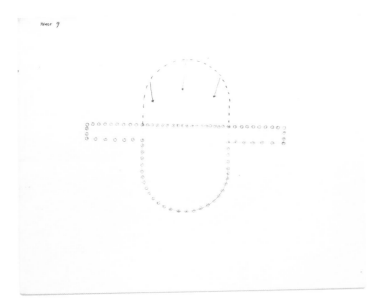

PHASE 10

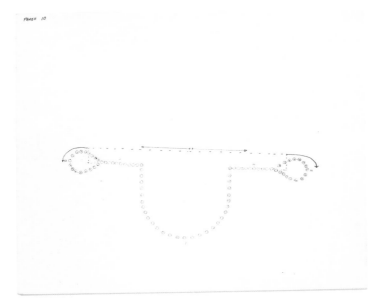

CREMASTER 1

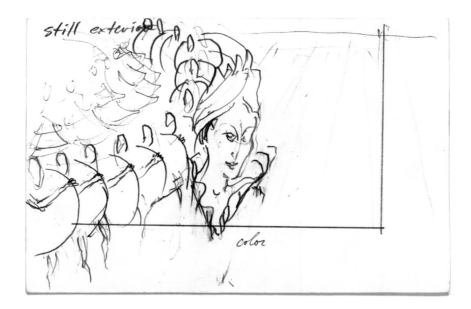

still exterior

color

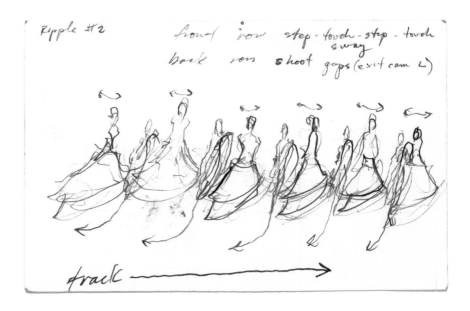

Ripple #2

front row step-touch-step-touch
sway
back row shoot gaps (exit cam L)

track →

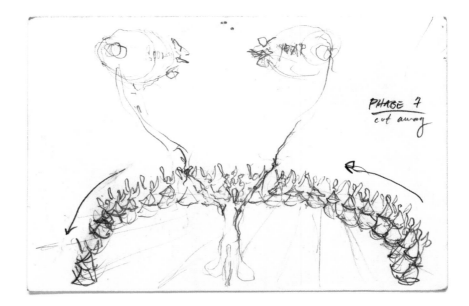

PHASE 7
cut away

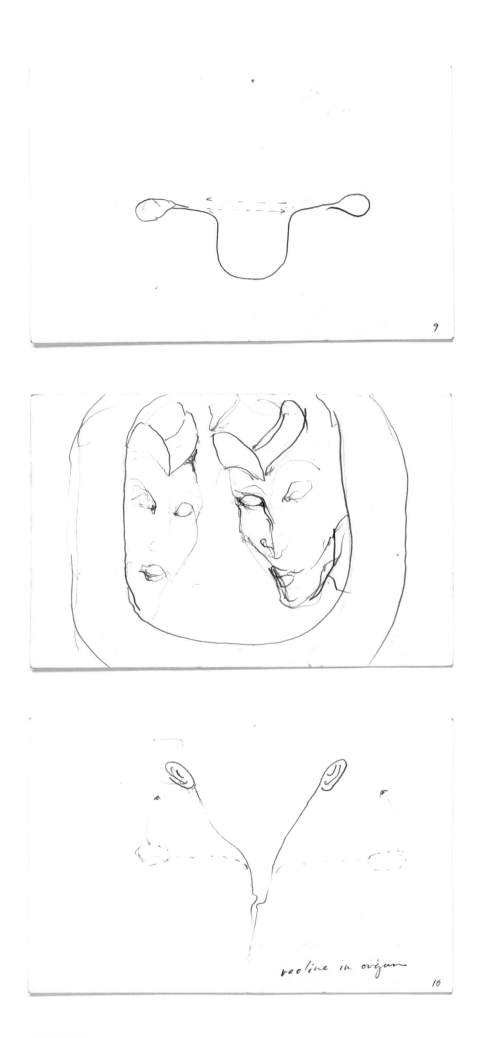

recline in organ

CREMASTER 1

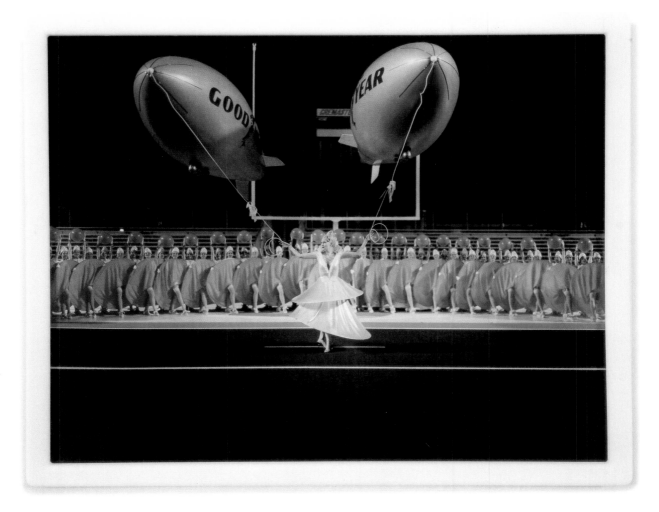

CREMASTER 1

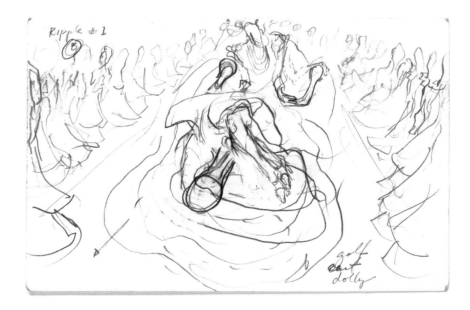

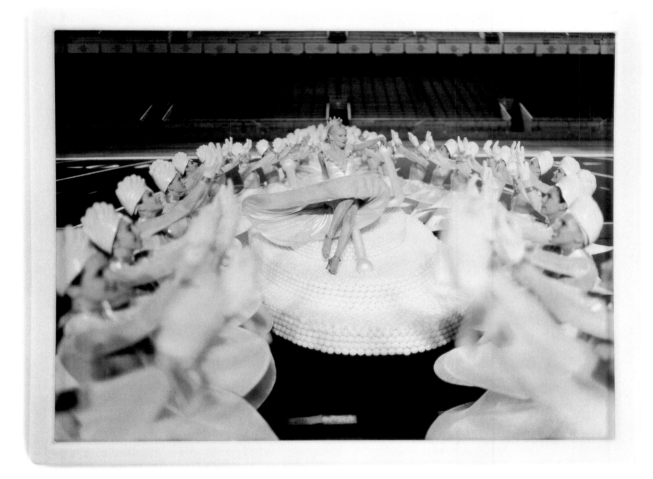

CREMASTER 2

CREMASTER 2

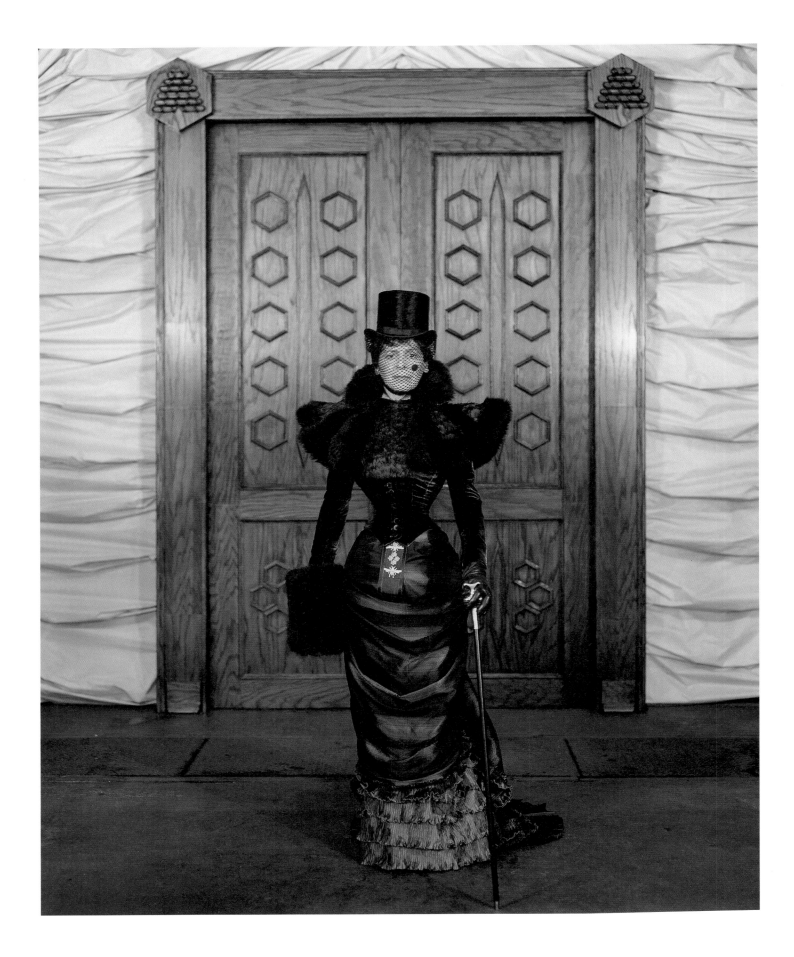

CREMASTER 2

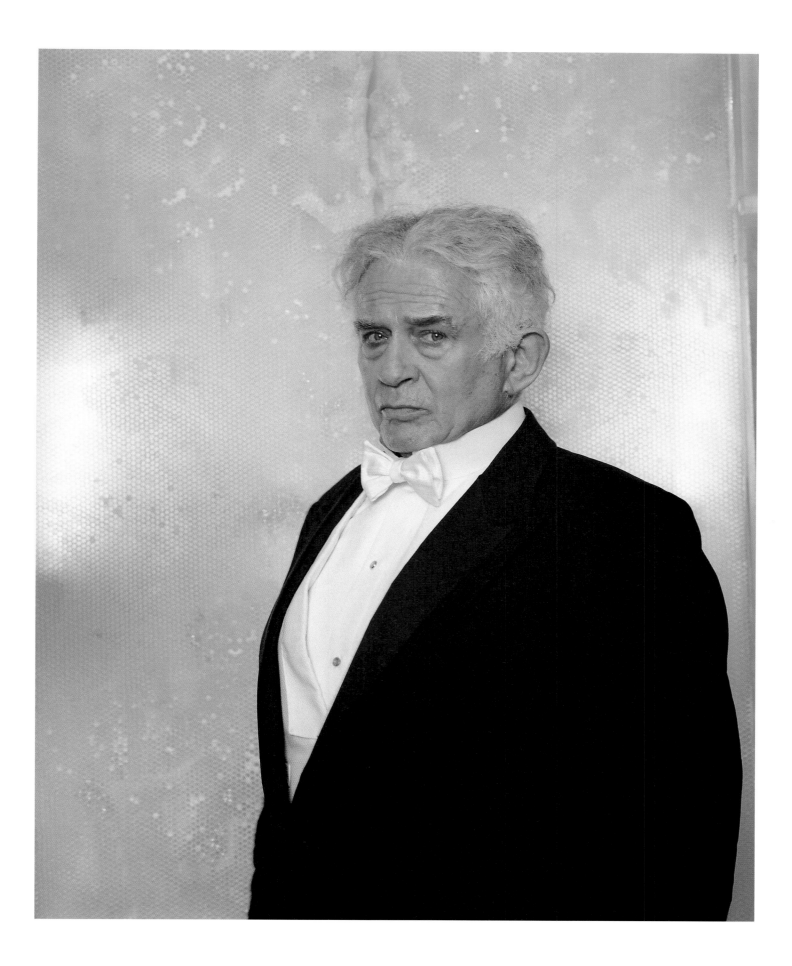

CREMASTER 2

glacier
[columbia
ice field]

glacial lake

great
[salt lake]

glacial desert

[bonneville flats]
(field)

The [] song

descent

POLARIS

main heat

stella

saline area →

Below and right: Lauren, one of Travis Hutchison's 'lifestyle models'. Hers is a 19-inch-waisted life

my and sweet [?] Houdini 1907

metamorphosis 1893

(HH)

ACT I : glacial retreat. SAL

ACT II : ECTOPLASM + let e[?]
force fail, let all iron
every strap, let every kno[?]
and let no one compel me

HH - metamorphosis
Faye → Frank
→ GG - frank under
→ Bessie

ACT III : GARY, NICOLE, THE

2 step

...ould be loosed, every
...oken, every rope or
...g chain be opened,
...I am : Fay Gilmore
 · Frank Gilmore
 · Bessie Gilmore

...y - fingers - droplet

S, SINCLAIR FUEL

CREMASTER 2

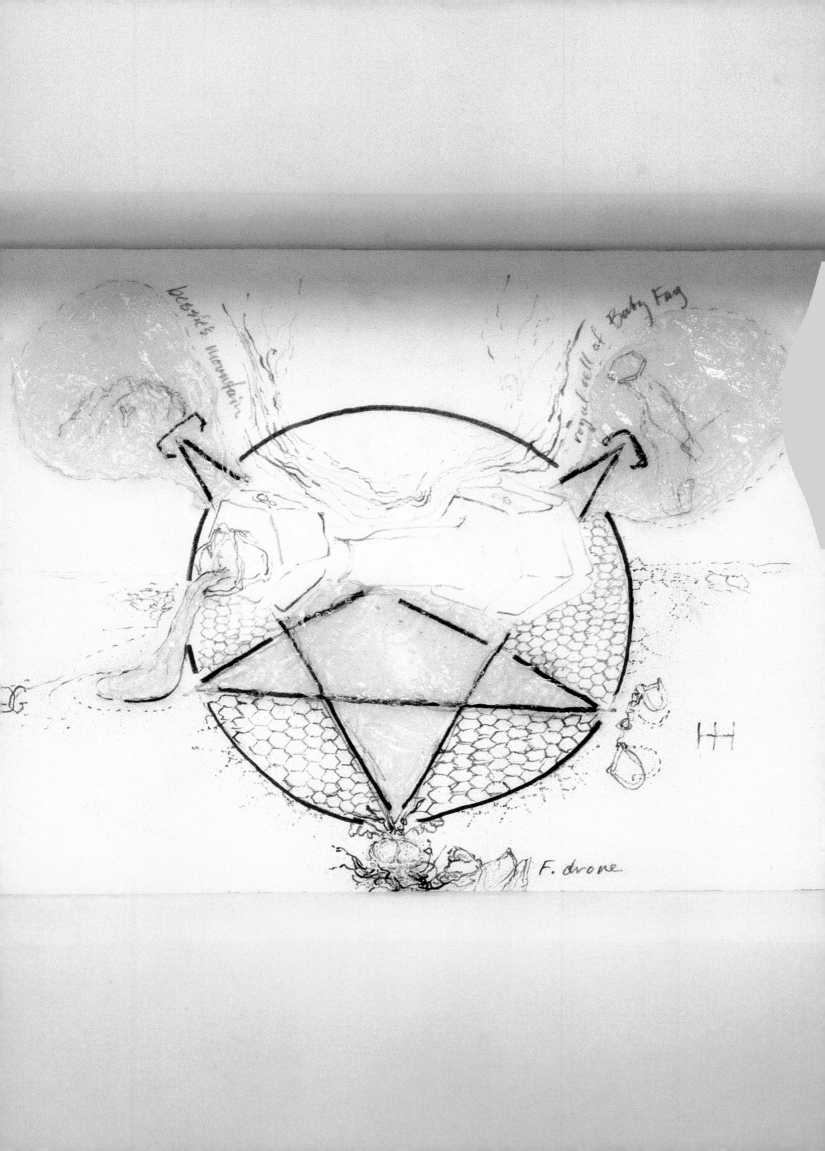

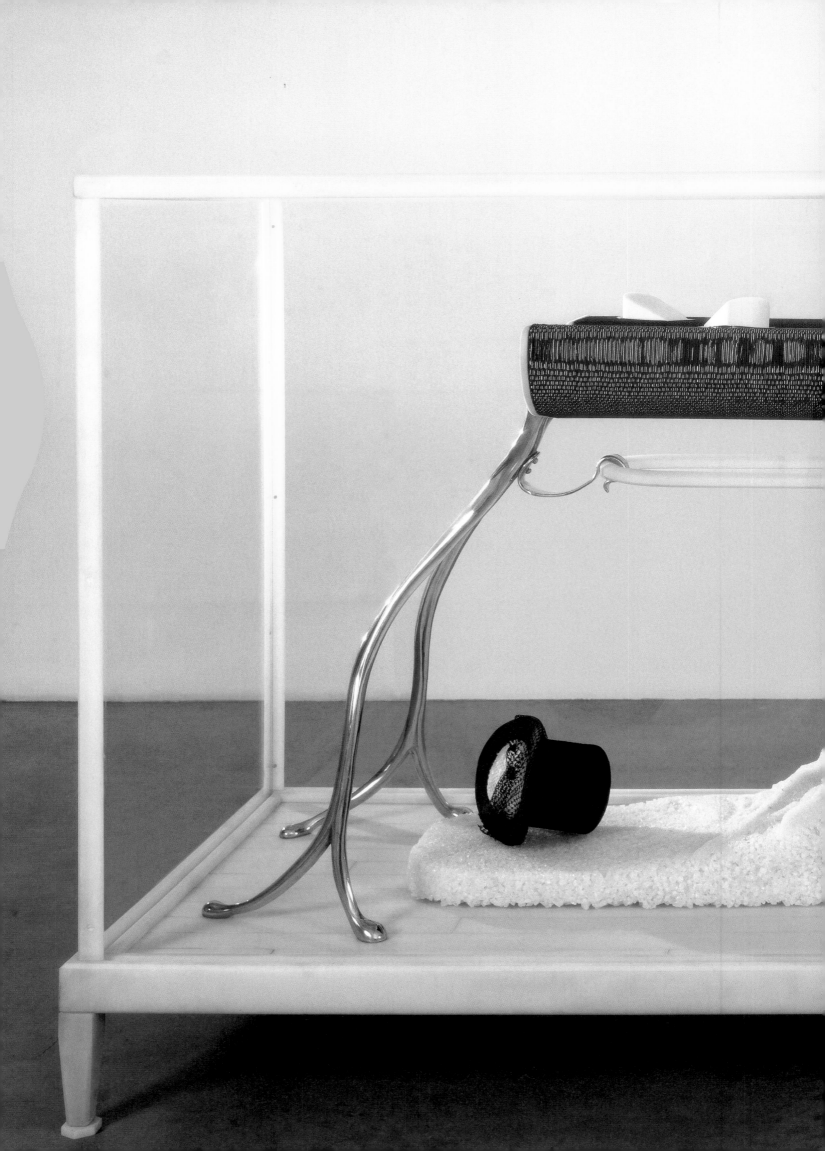

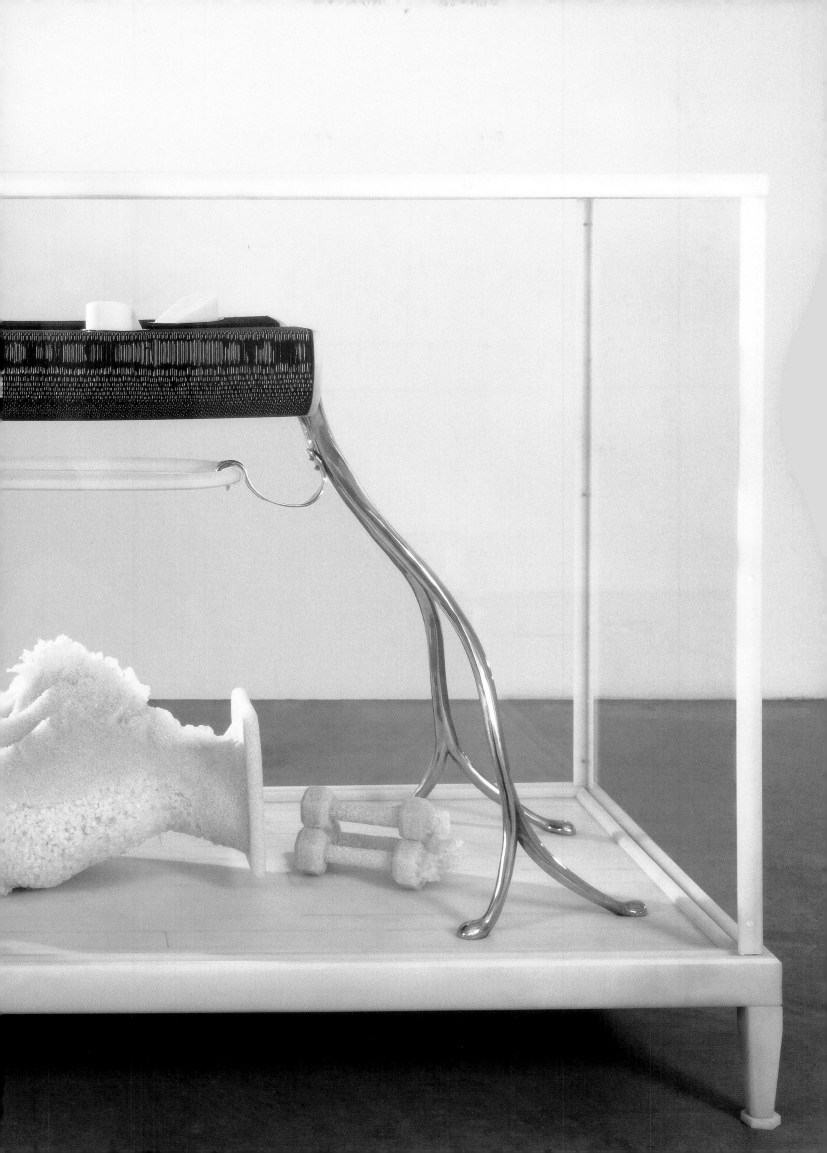

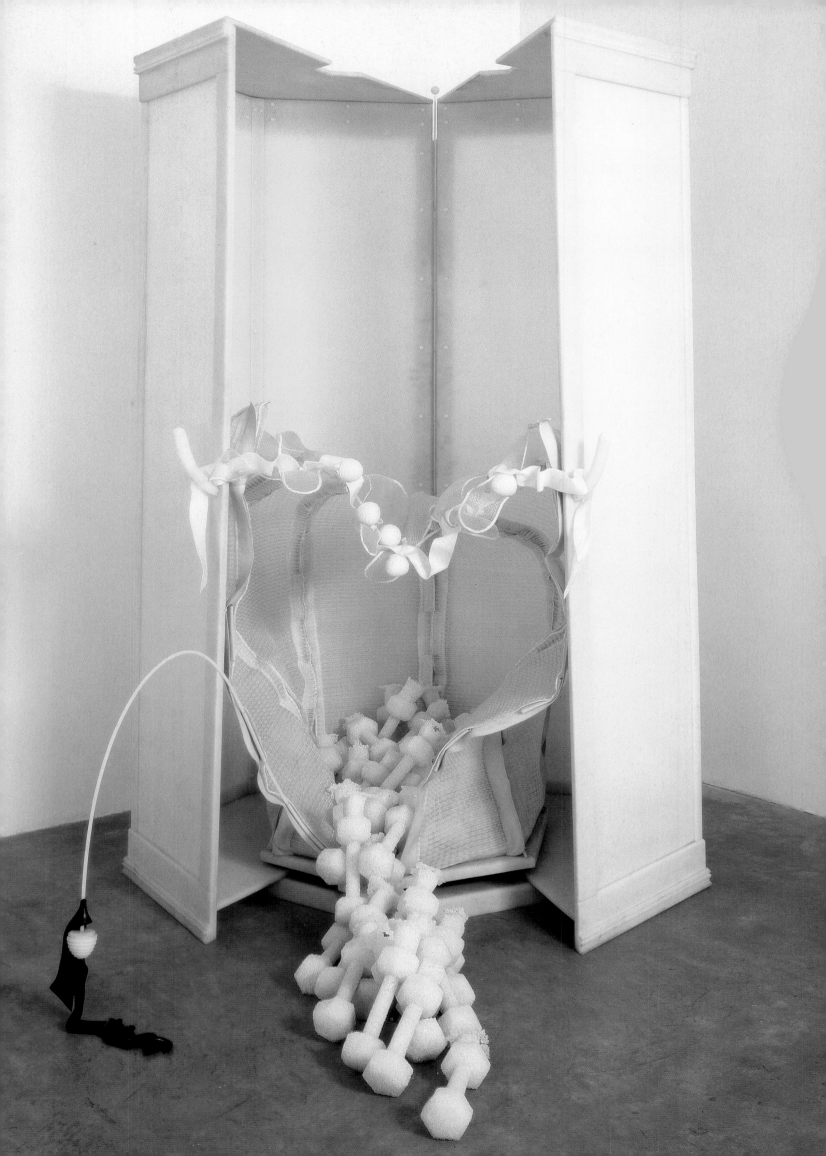

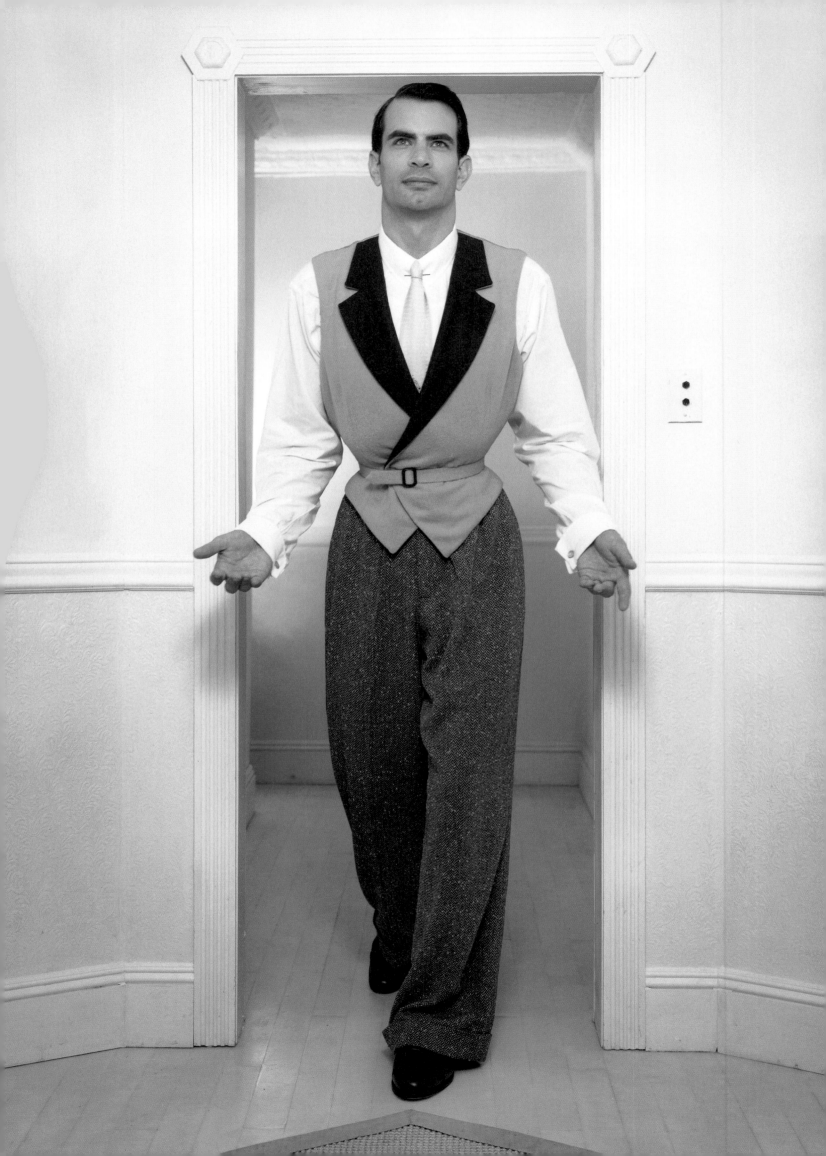

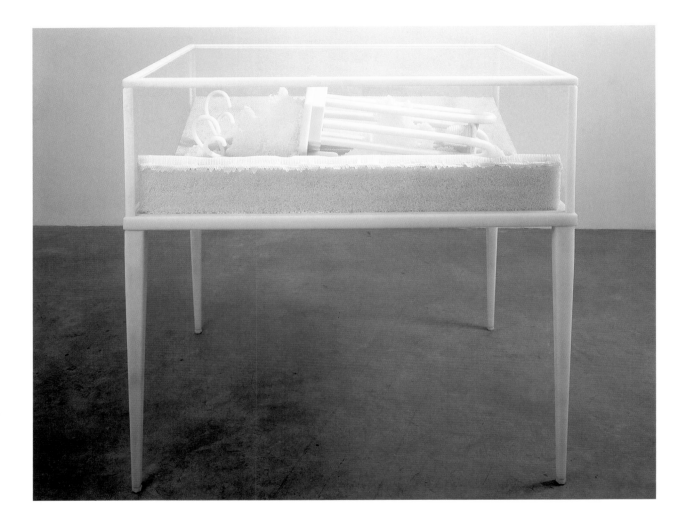

CREMASTER 2

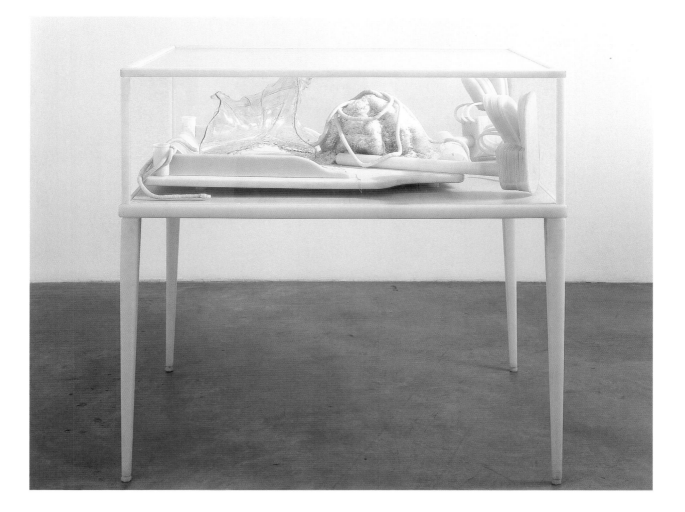

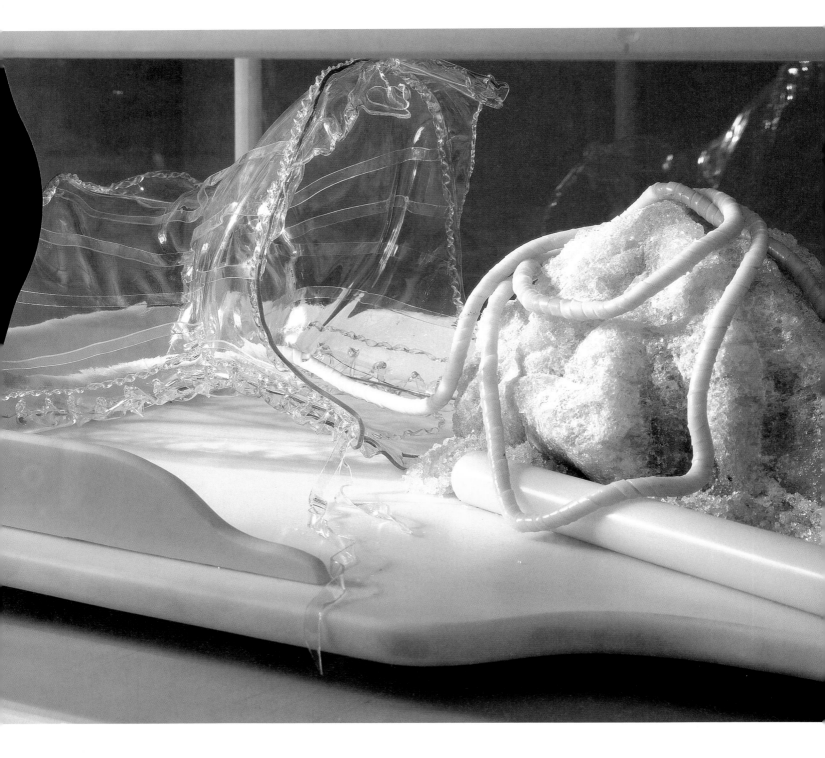

CREMASTER 2

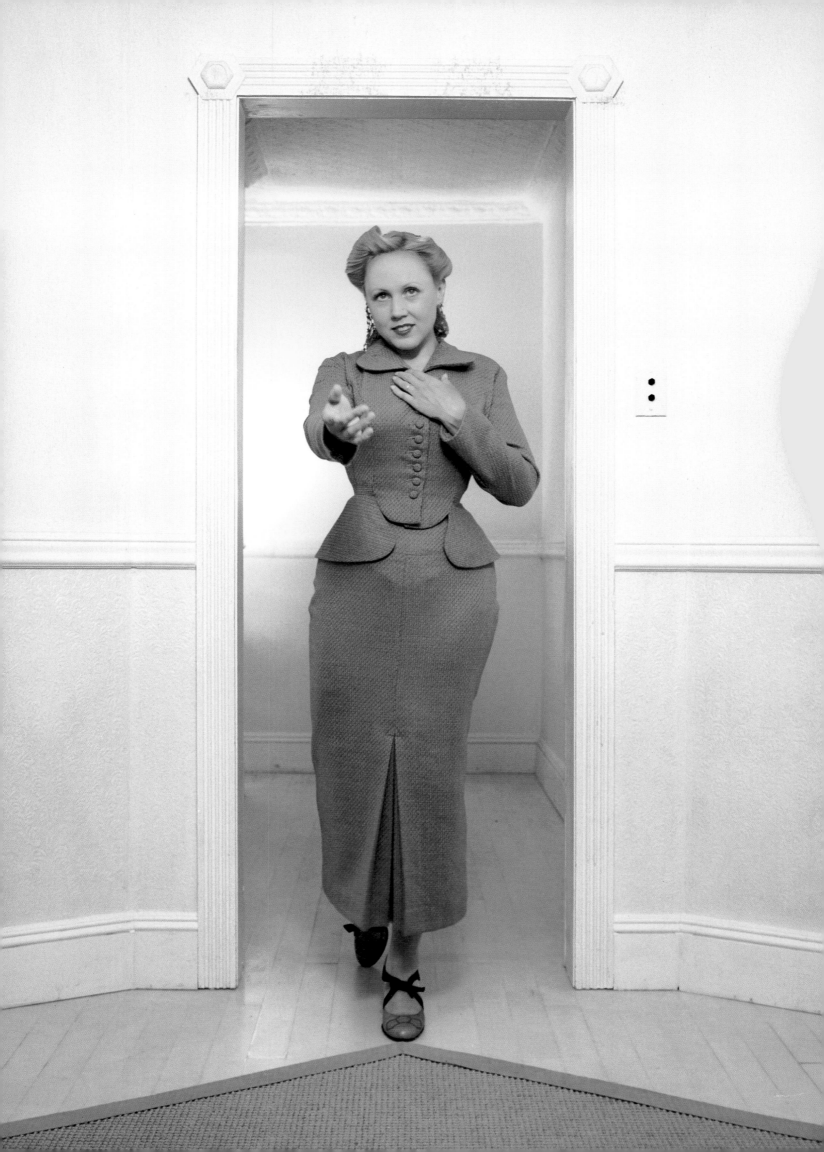

CREMASTER 2

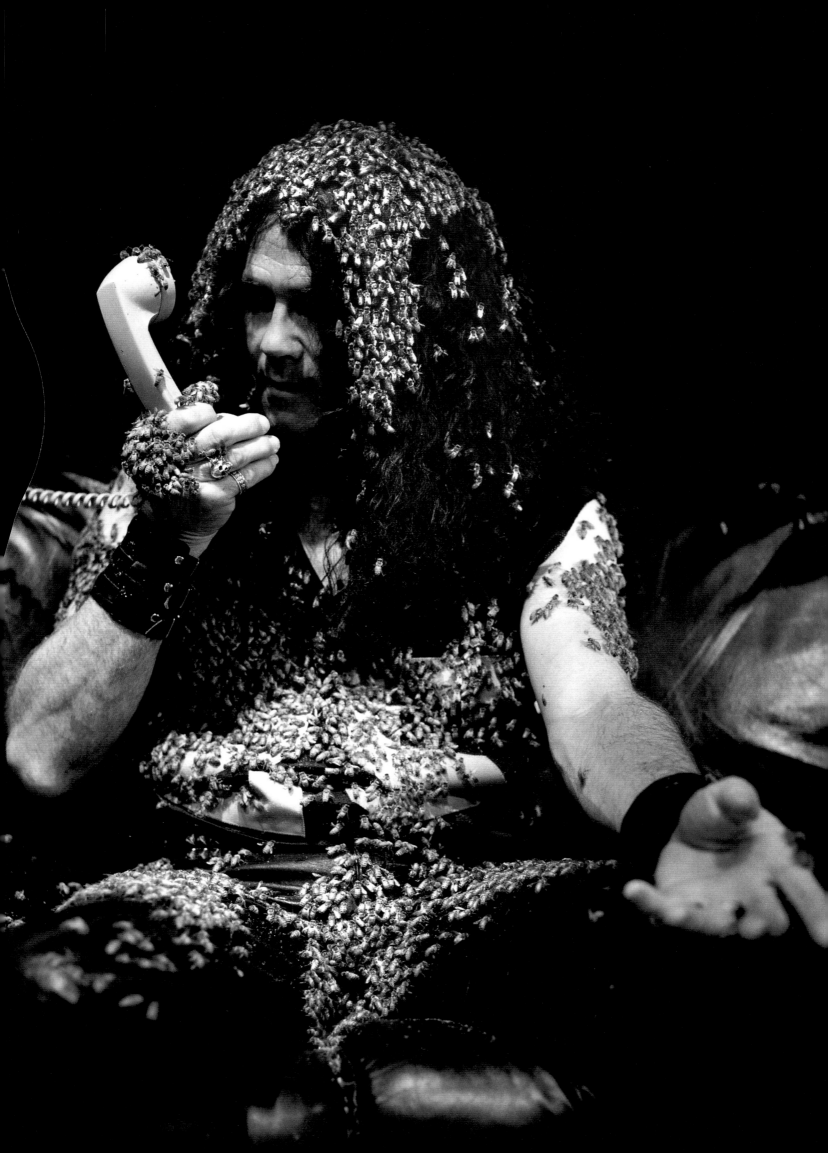

I've told you that I haven't slept lately—the ghosts have descended and set upon me with a force I didn't believe they possessed. I smack 'em down but they sneak back and climb in my ear and demons that they are tell me foul jokes, they want to sap my will, drink my strength, drain my hope leave me derelict bereft of hope lost empty alone foul demon motherfuckers with dirty furry bodies whispering vile things in the nite chortling and laughing with a hideous glee to see me toss sleepless in durance truly vile they plan to pounce on me in a shrieking mad fury when I leave with their hideous yellow long toe and finger claws teeth dripping with rank saliva and mucous thick yellow green. Dirty inhuman beasts jackals hyena rumor monger plague ridden unhappy lost ghostly foul ungodly things unacceptable creeping crawling red eyed bat eared soulless beasts.

They won't let the ol' boy have a nites sleep. God-damned lost motherfuckers.

I need our silver sword against them. They're slippery motherfuckers.

The demon ghosts
trick tease tantalize
bite and claw scratch and screech
weave a web of oldness oldness pull in harness
like oxen a wood creaking tumbrel a gray wood
tumbrel through the cobbled streets of my
ancient mind.

They've attacked me before we have had several bouts they jumped on me like fiends when I was on Prolixin for four months I endured a constant onslaught of demon fury oooooooOOOOOOOOOOOOOH!

Left me drained and 50 pounds lighter but stronger than they will ever be.
they like it when I hurt
And I have been burning lately ——
I hate to say it but in the last week they almost got me they came the closest they ever have and they ever will.

Johnny Cash "Unchained"

WINNER BEST COUNTRY ALBUM

Thanks to those who made a difference - you know who you are.

6

Dec. 31
Friday

Love

Last nite i flew in my dream
like a white bird through the window
came through the night and the cool wind with a few
bright stars in the darkness
And got lost. And Woke up.

Got to go for now
Love you every minet
Nicole

CREMASTER 2

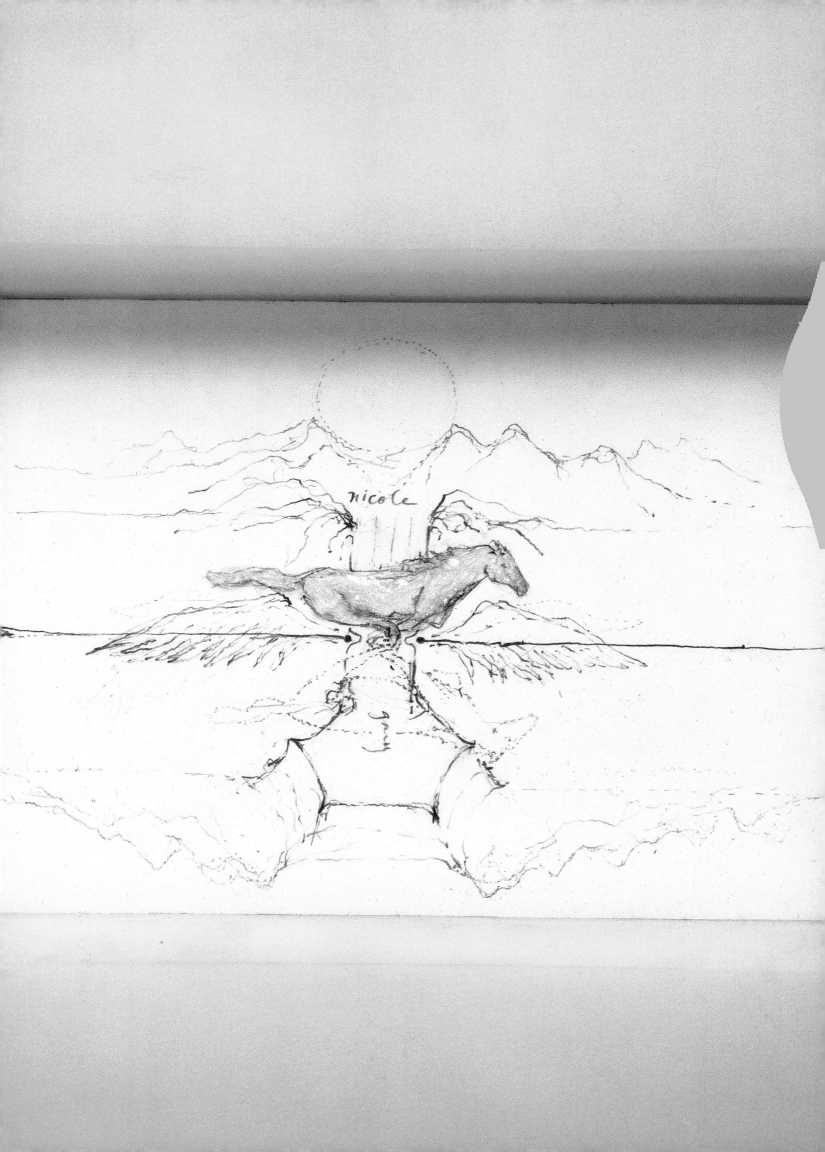

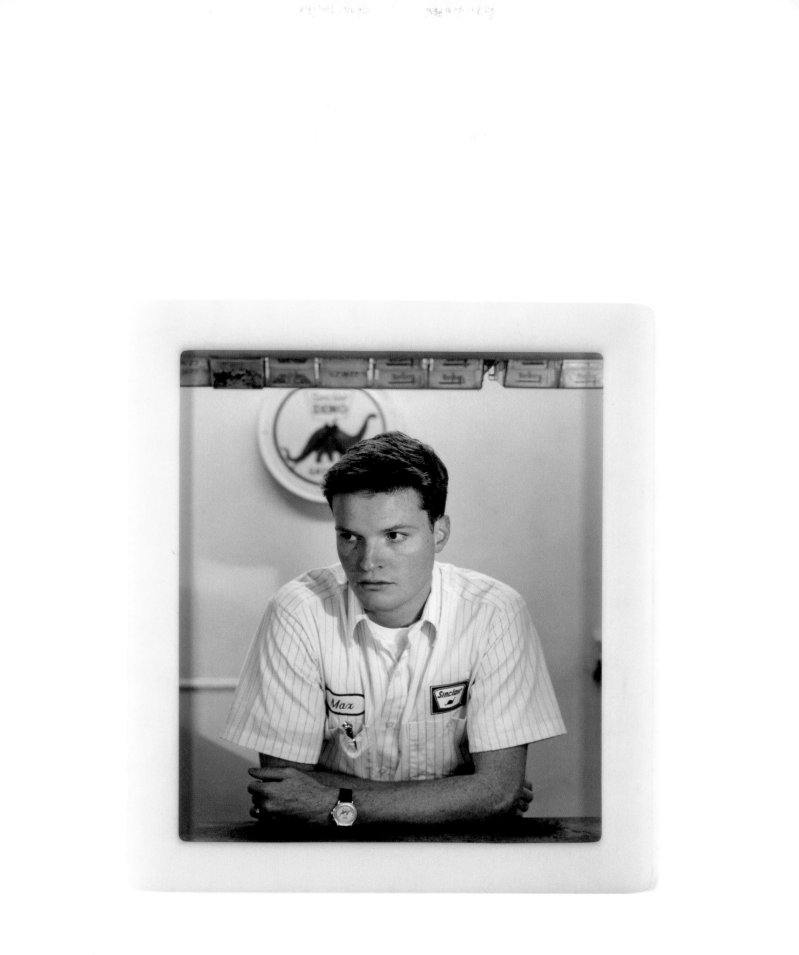

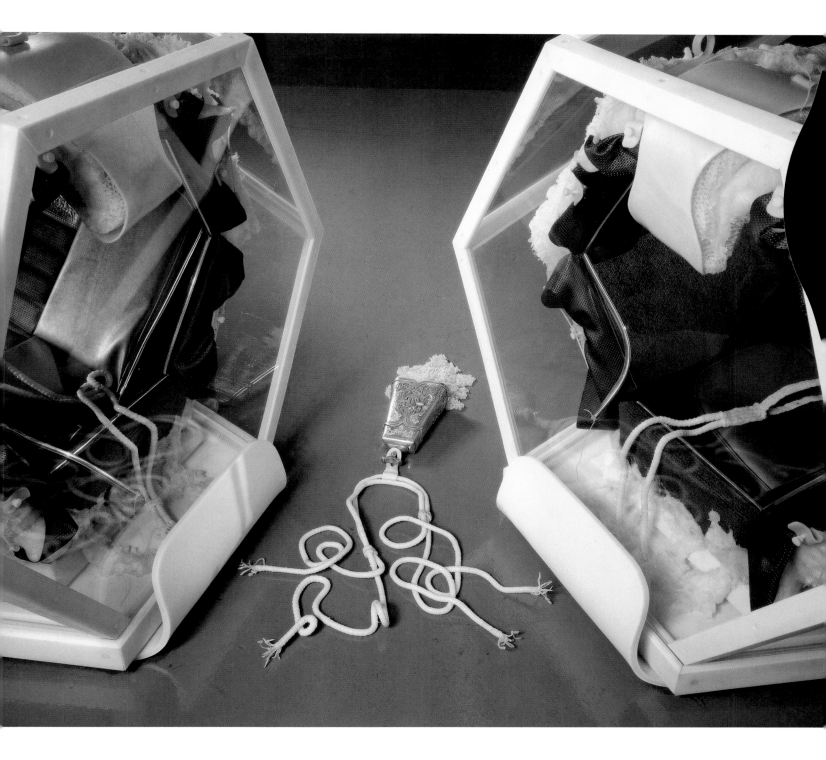

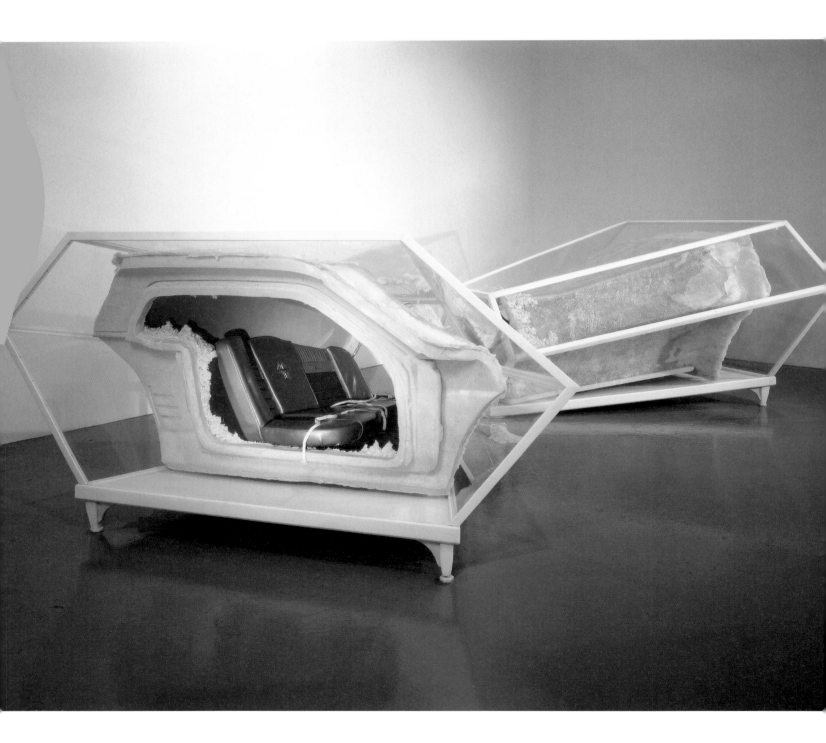

CREMASTER 2

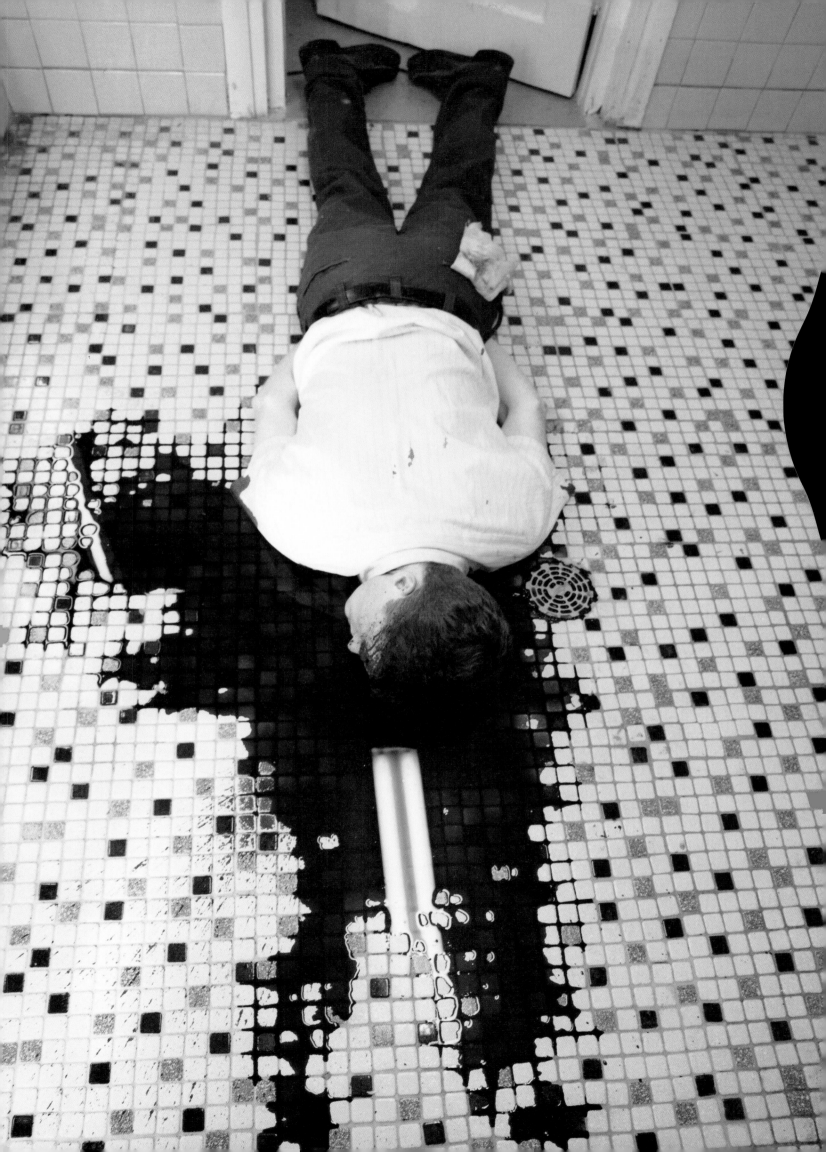

Feeling a backoning wind blow thru
The chambers of my soul I knew
It was time I entered in
I climbed within and stared about—
I was home indeed my very seed
A mirror of me reflecting myself
From every curve and line and shelf
Every surface there Every texture bare
Every color tone and value Each sound
Pride Hate Vanity
Sloth Waste Insanity Lust Envy Want
Ignorance black and green
I felt myself at every turning
Set my very mind to burning
Face to face no way to dodge
Headlong I tumbled thru this lodge
I felt and met alone myself
A red scream rushed forth But I caught
it back and checked its force
It crescendoed into a hopeless heavy weight
in the blood and fell . . .
A beat of wing I felt and heard
Not at all like any bird
Overhead I saw myself contorted black
and brown and twisted mean—borne aloft
by a gray bat wing—growing from
my shoulders there . . .
One thing was peculiar clear
There was no scorn to menace here
This is just the way it is
Laid bare to the bone
And I built this house I alone
I am the Land Lord here

CREMASTER 2

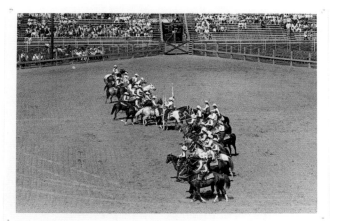

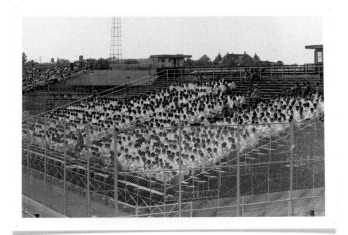

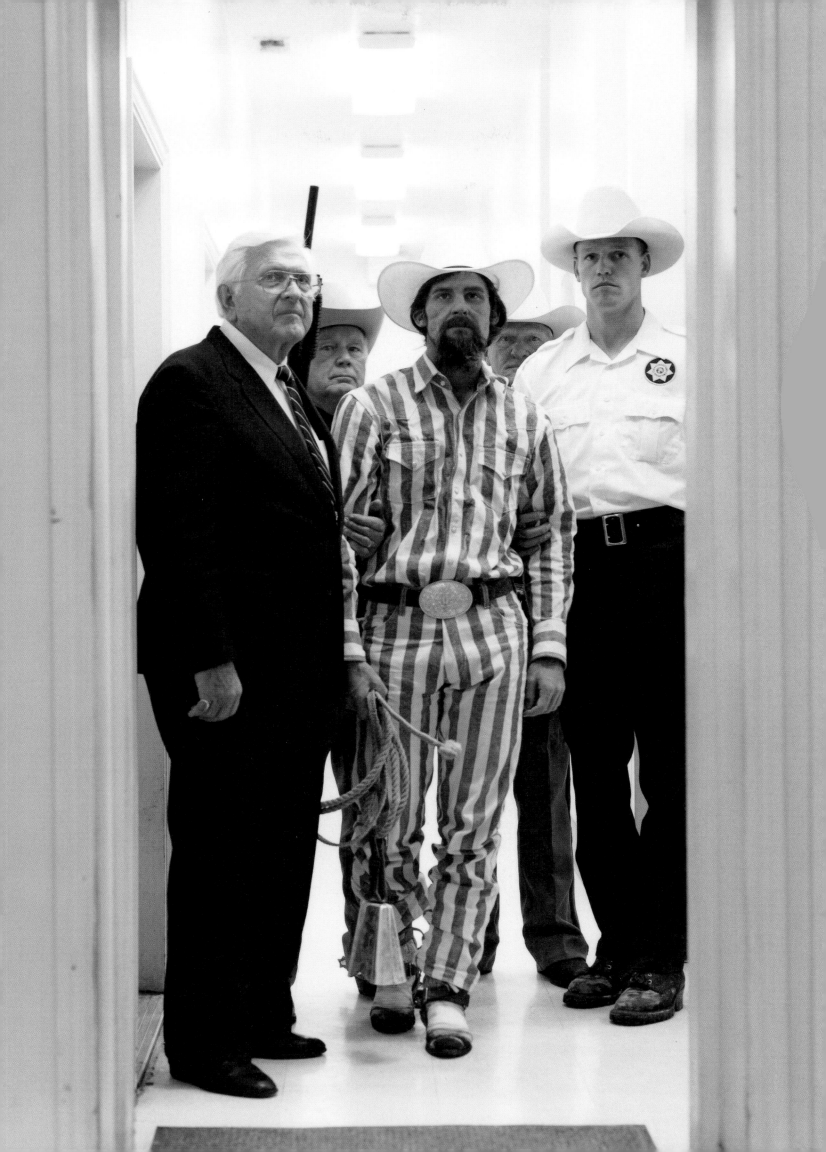

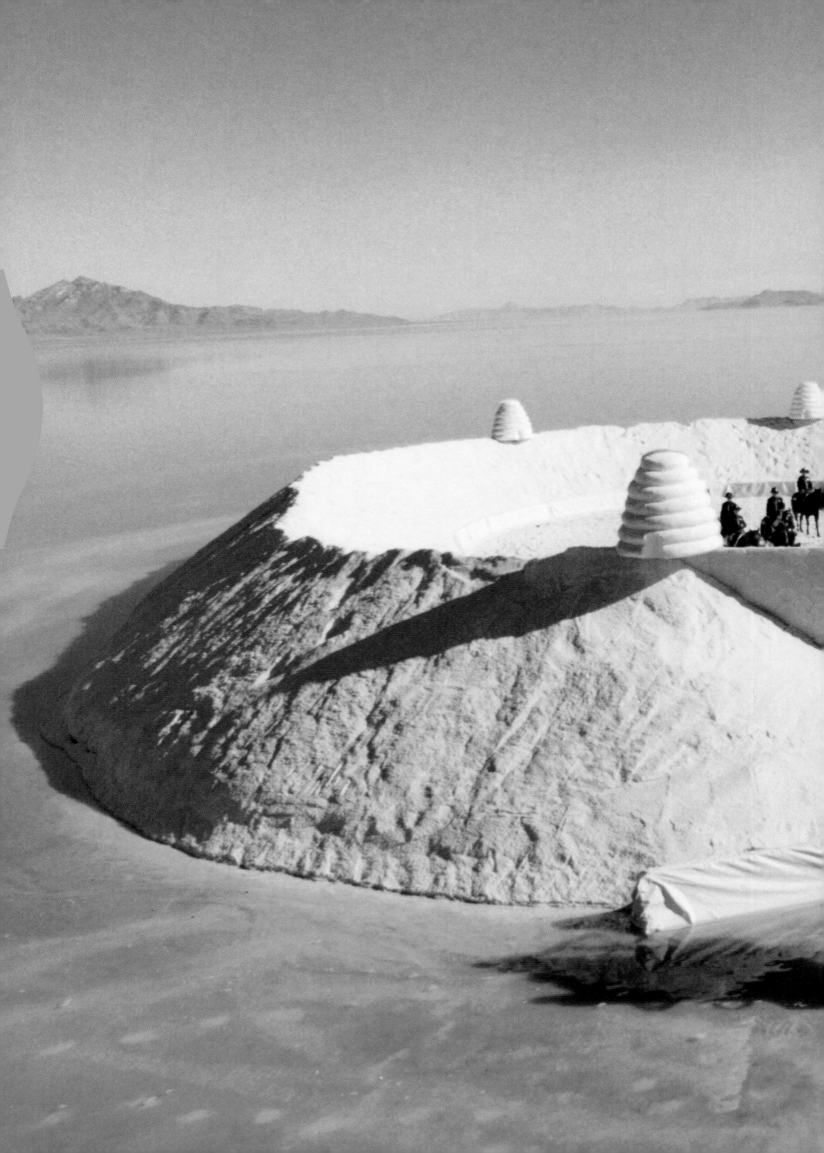

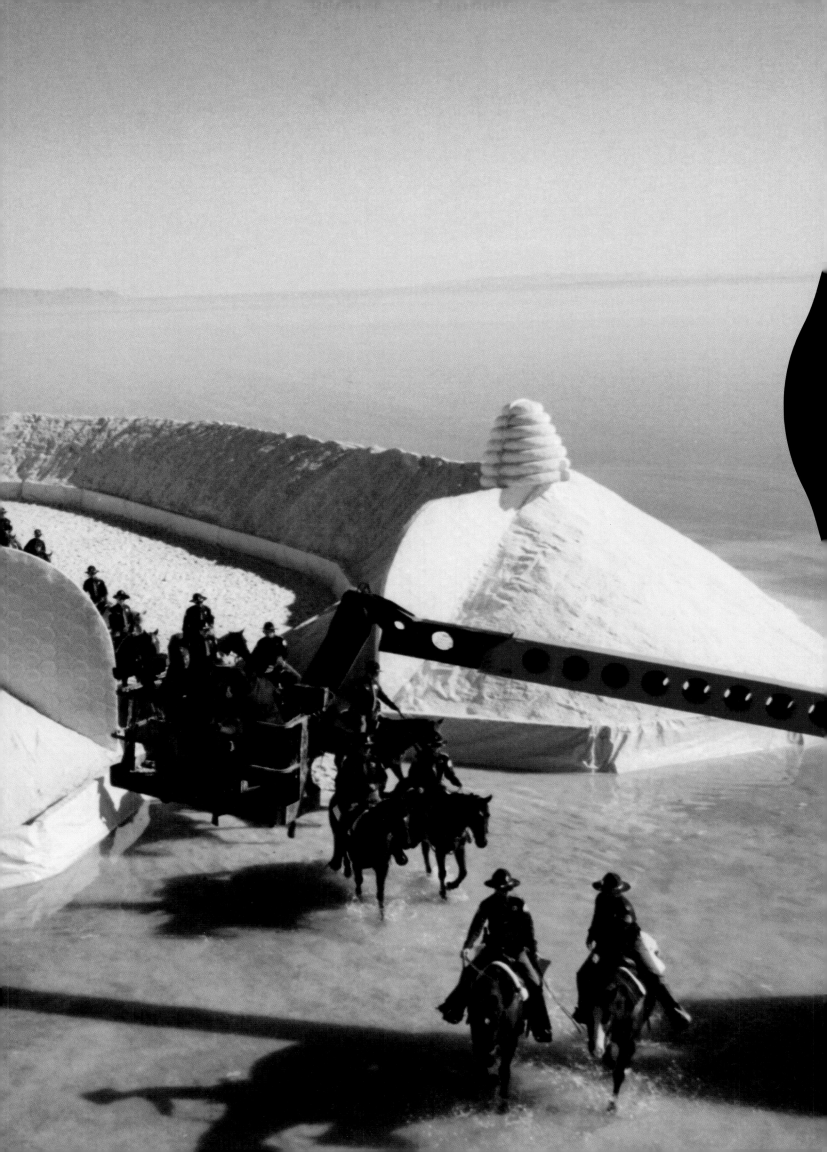

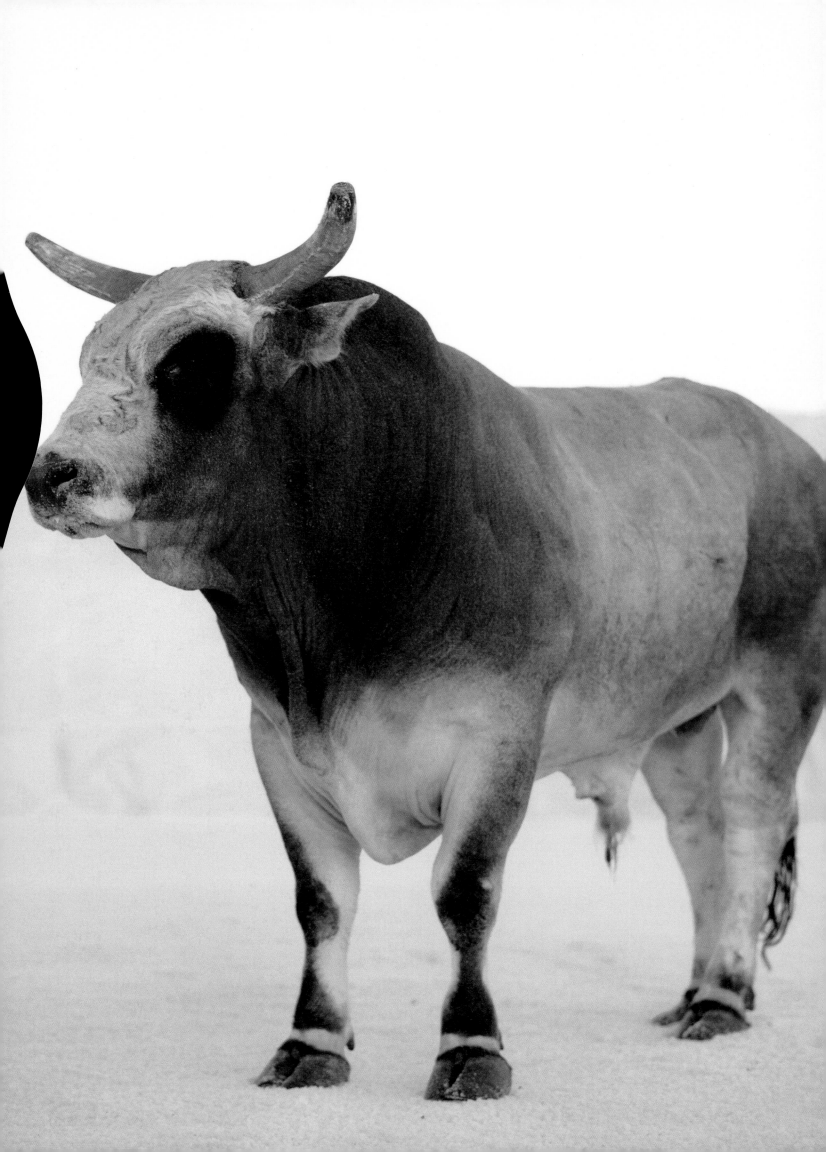

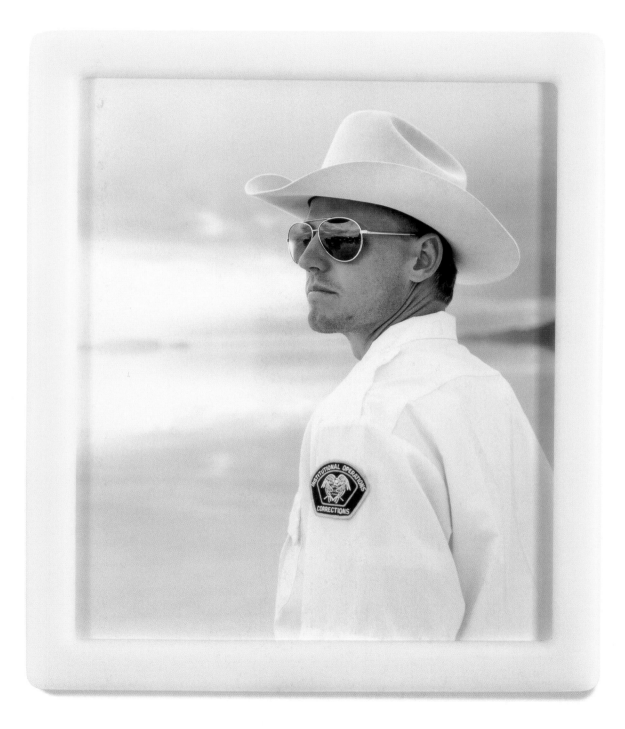

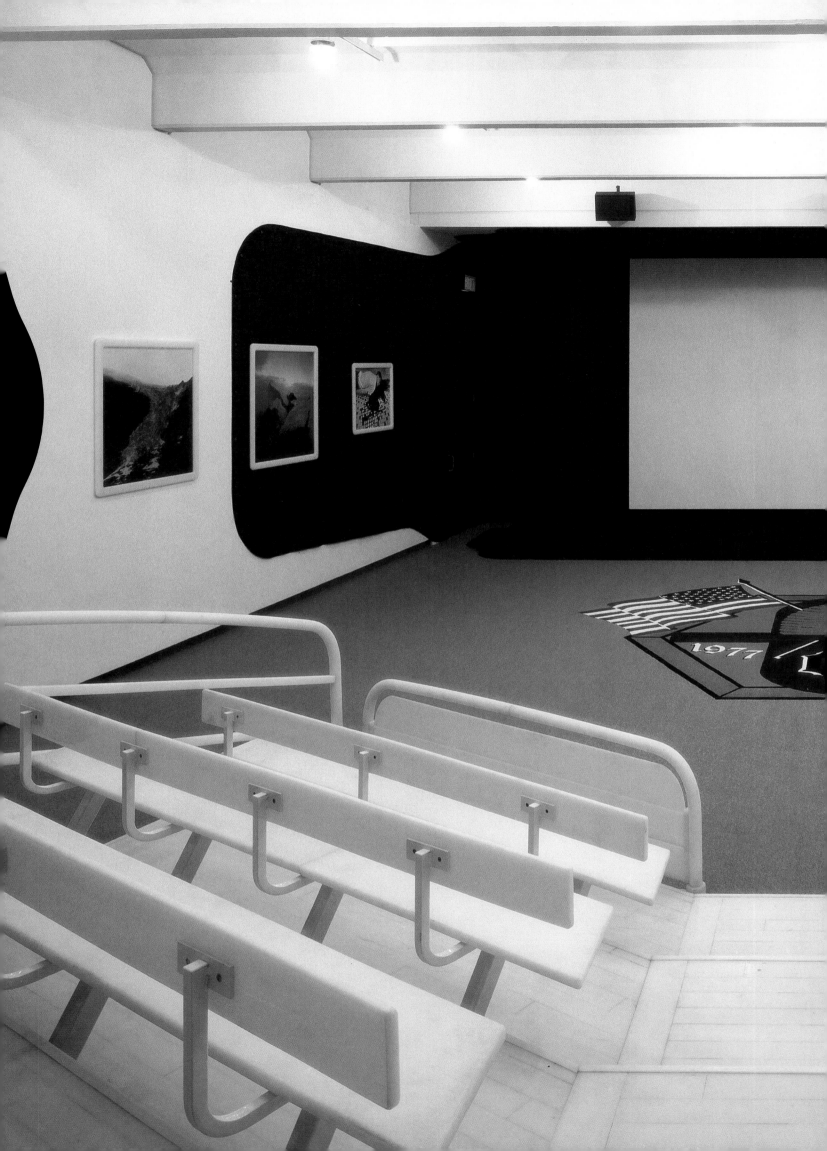

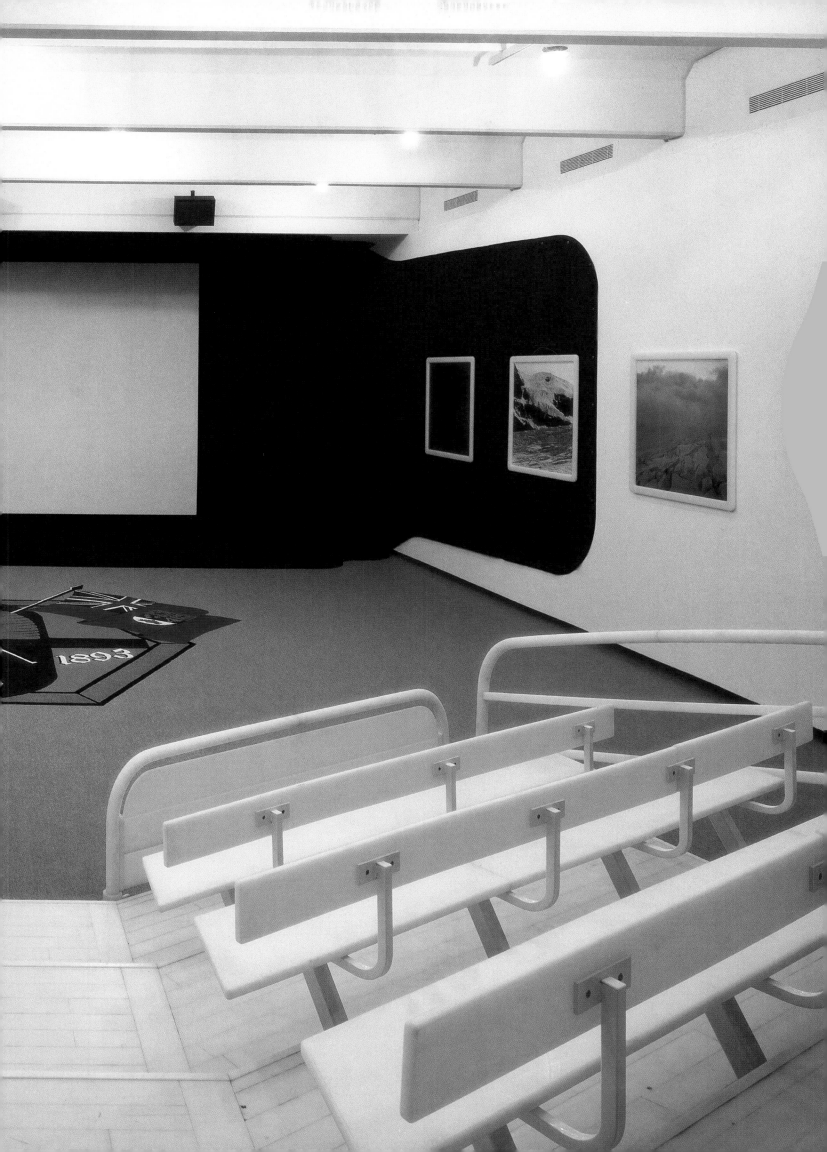

CREMASTER 2

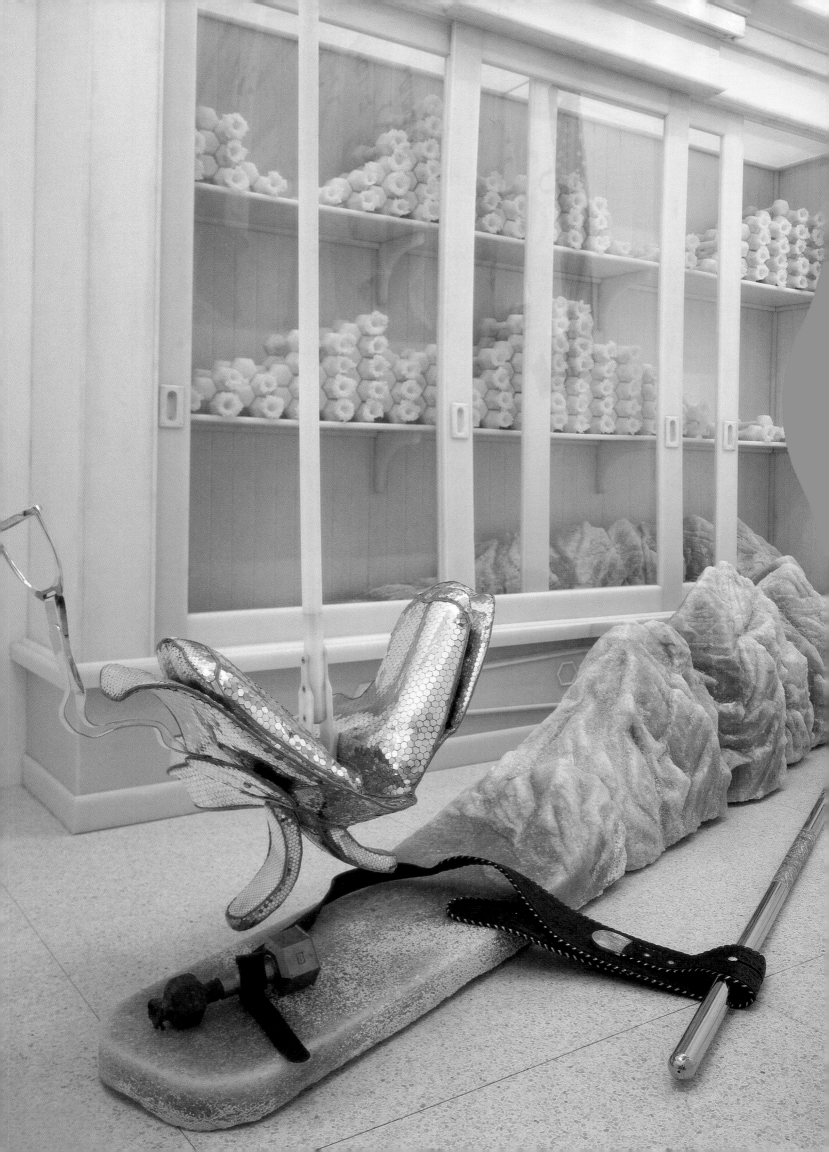

CREMASTER 2

BISON RING upper ³/₄

BISON RING cutaway

BISON RING overhead

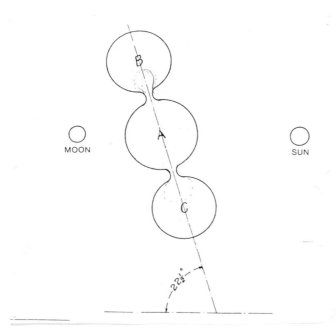

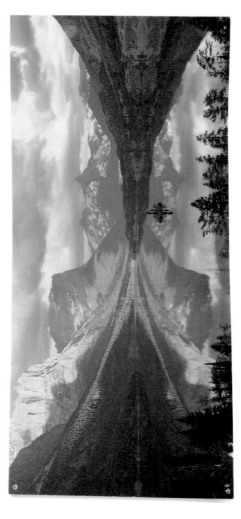

MOON

SUN

CREMASTER 2

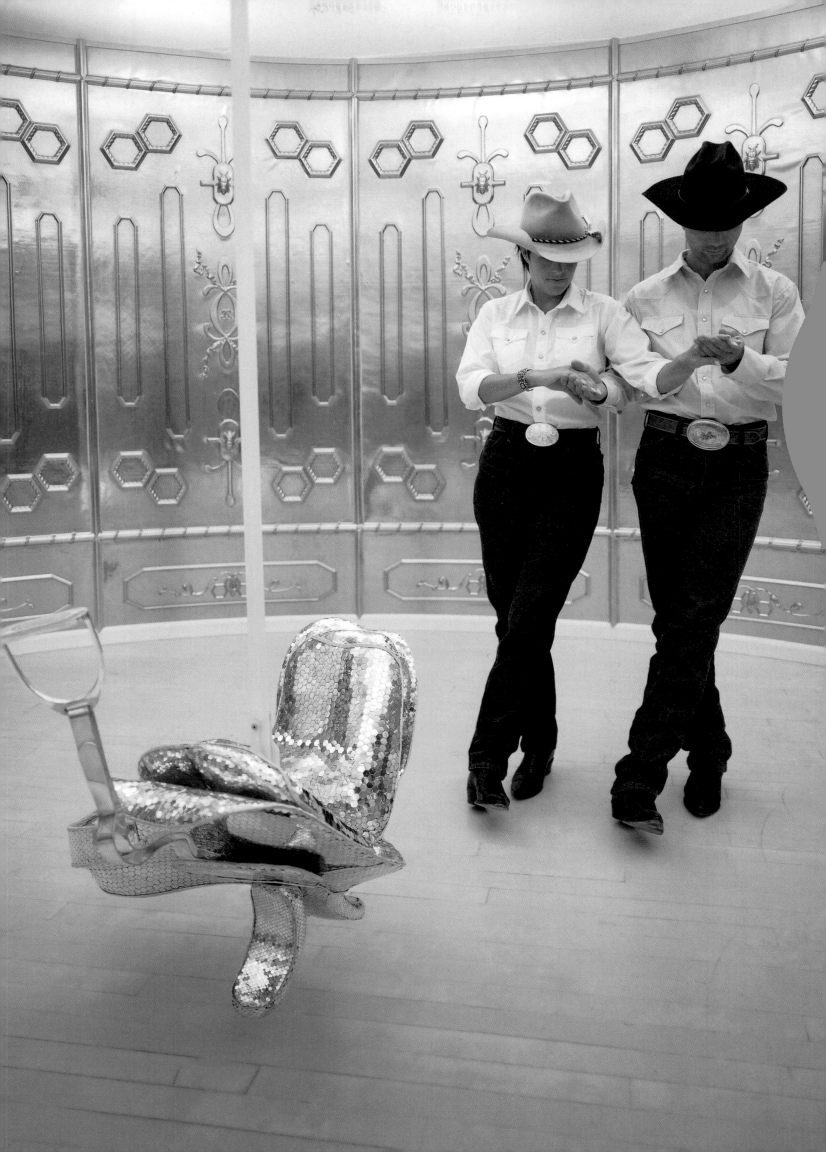

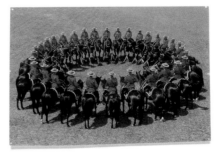

CREMASTER 2

CREMASTER 2

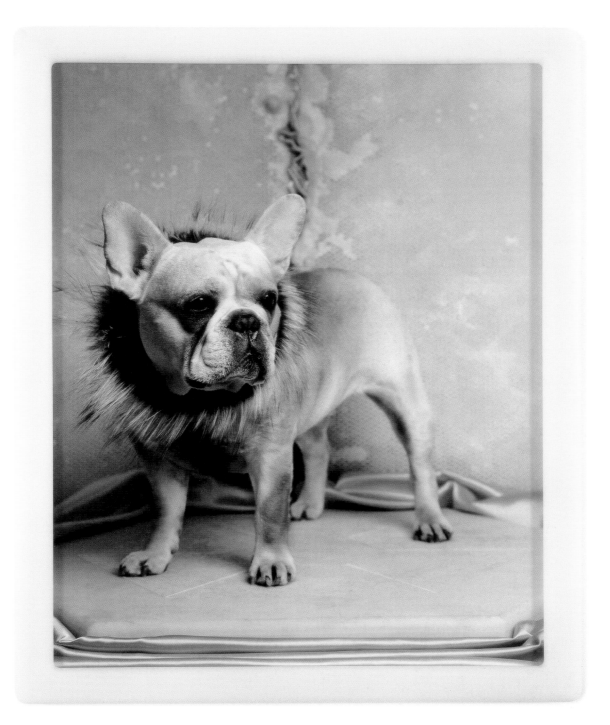

CREMASTER 2

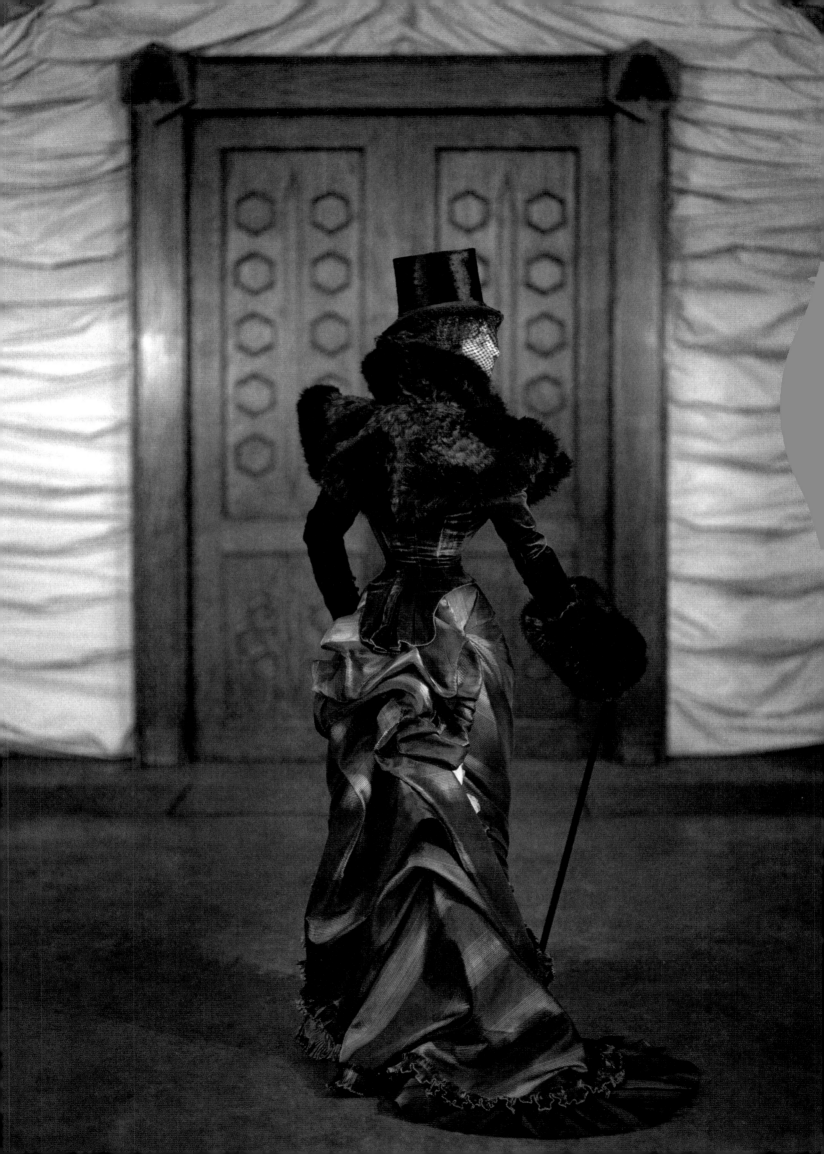

[g. gilmore —————————➔ f. gilmore ·———————➔ h.
 ╲
 ➔ babu

 ↓

 bossie gilmore
 ~ WORKER

don't follow me nowwhere, I'm already g

metamorphosis

→

...lini]———— DRONE / Queen Candidate ——— Cecilia weiss

...iy]——— QUEEN

gemini

CREMASTER

3

2002

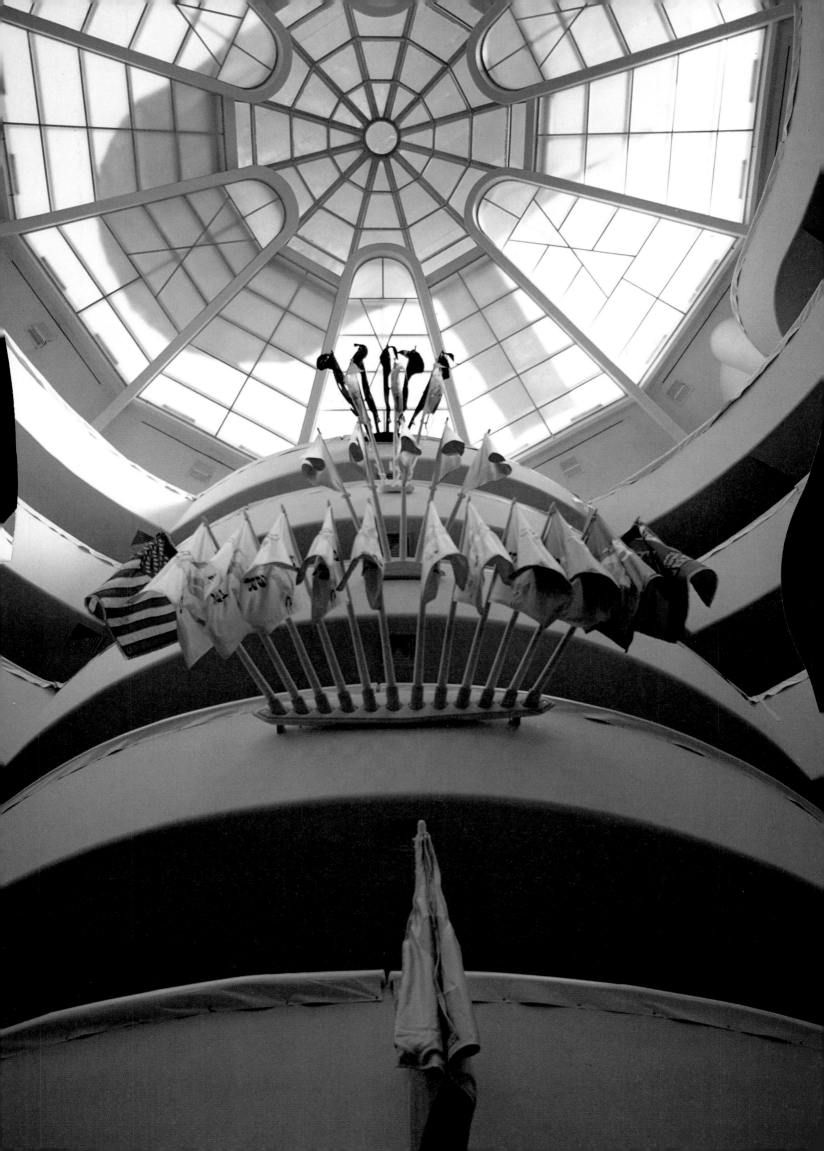

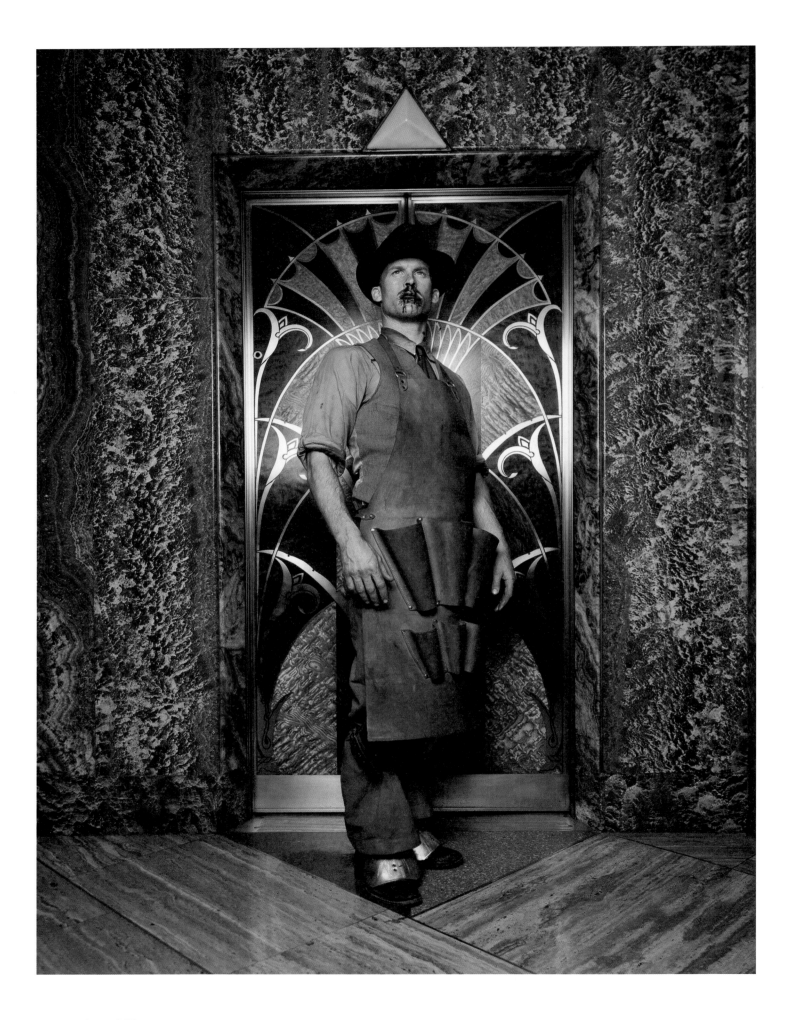

CREMASTER 3

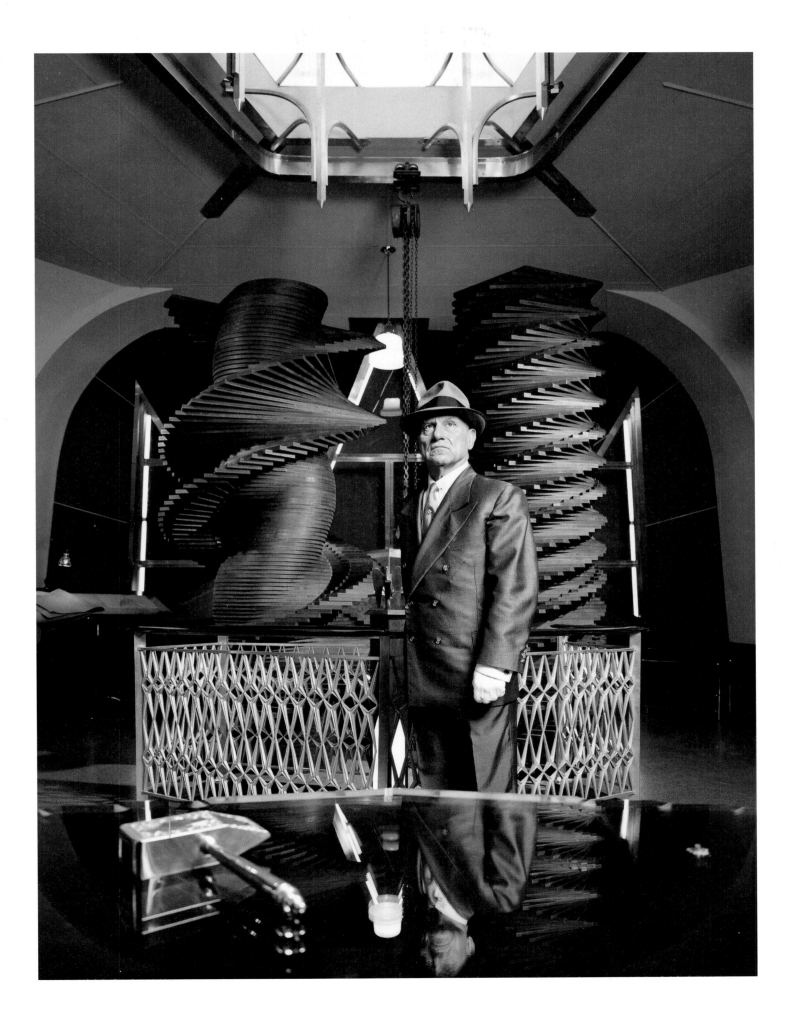

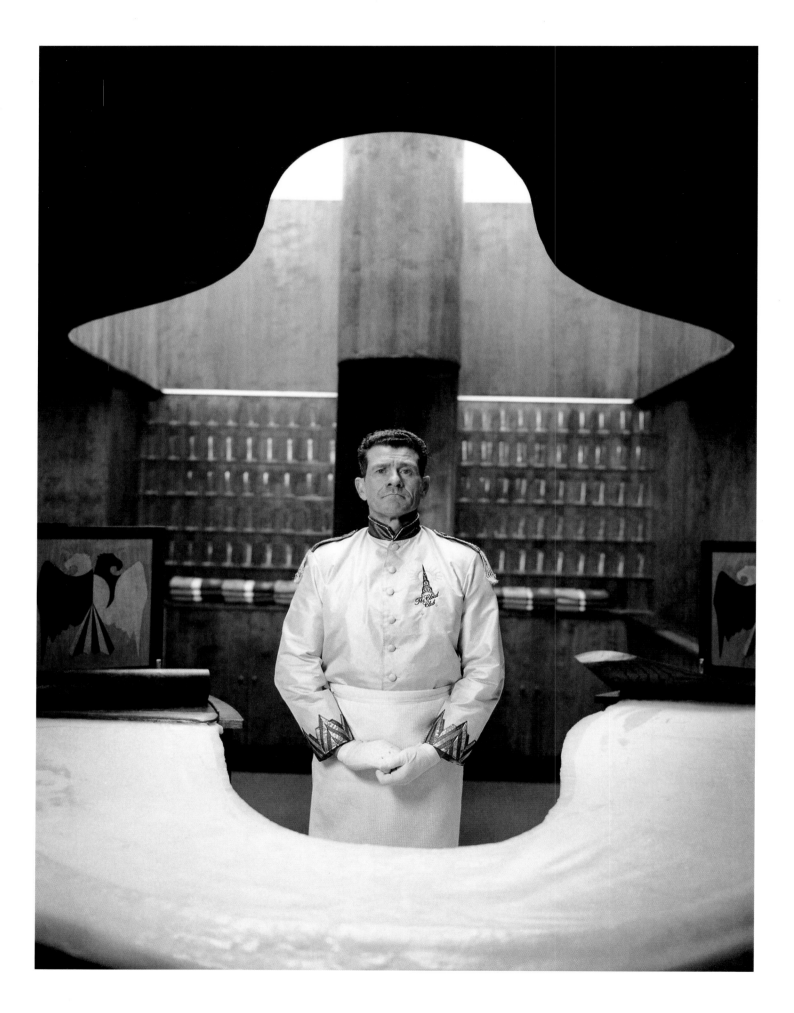

CREMASTER 3

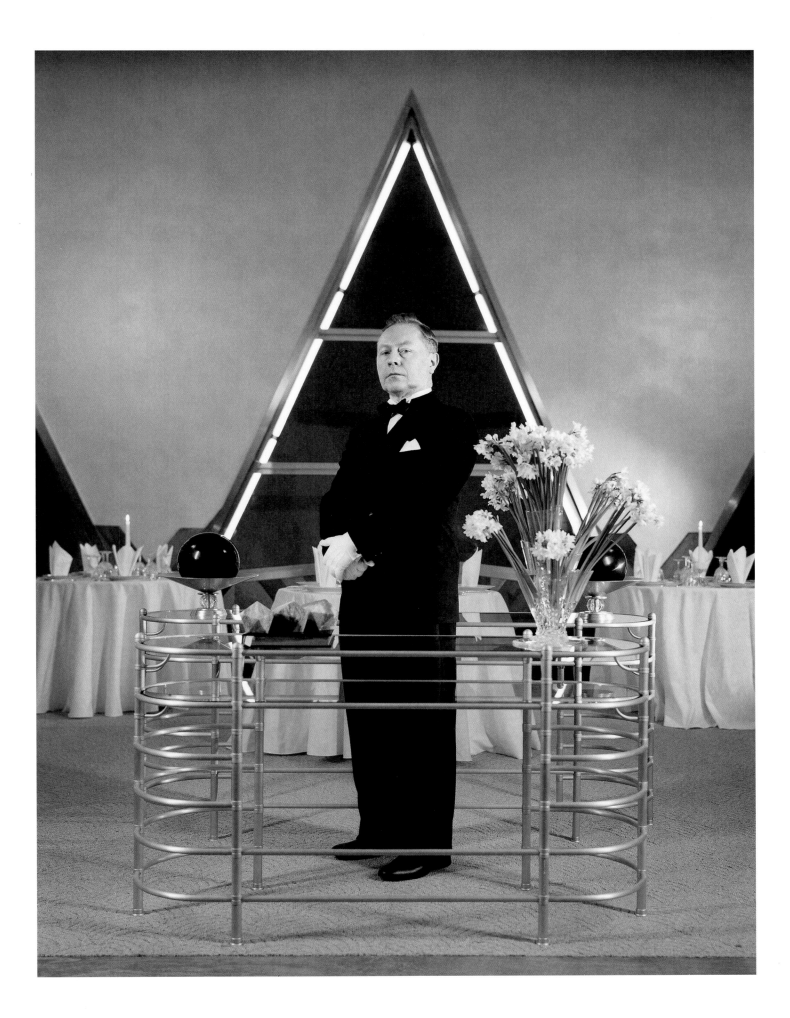

255

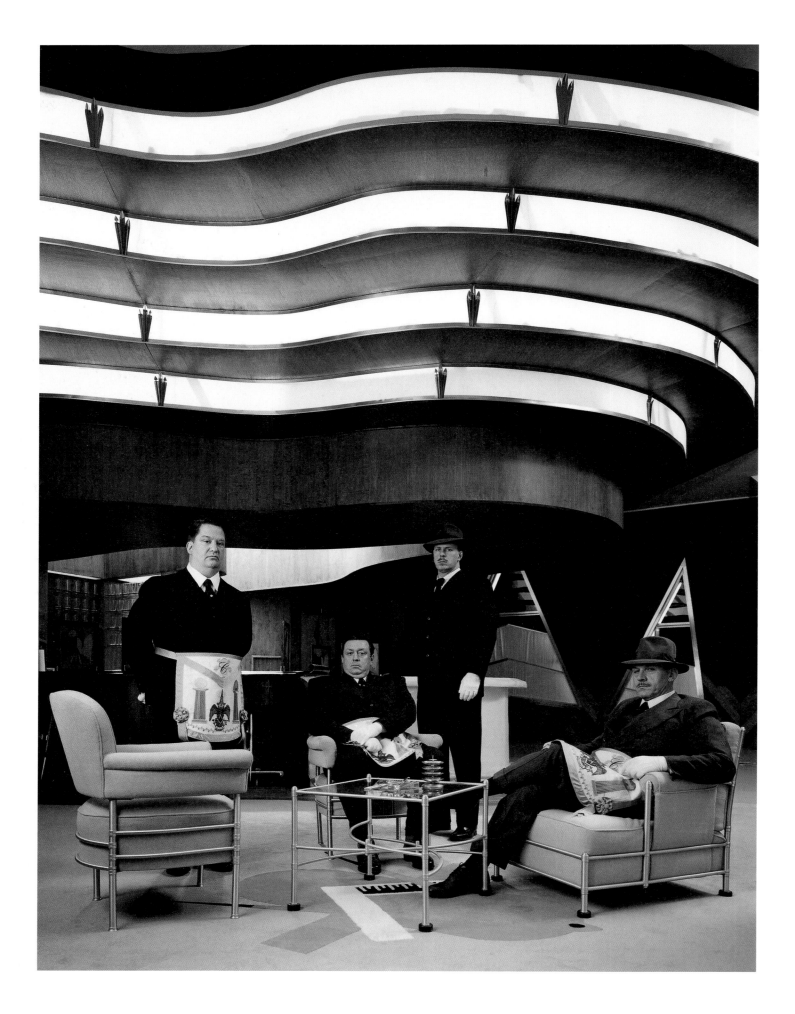

CREMASTER 3

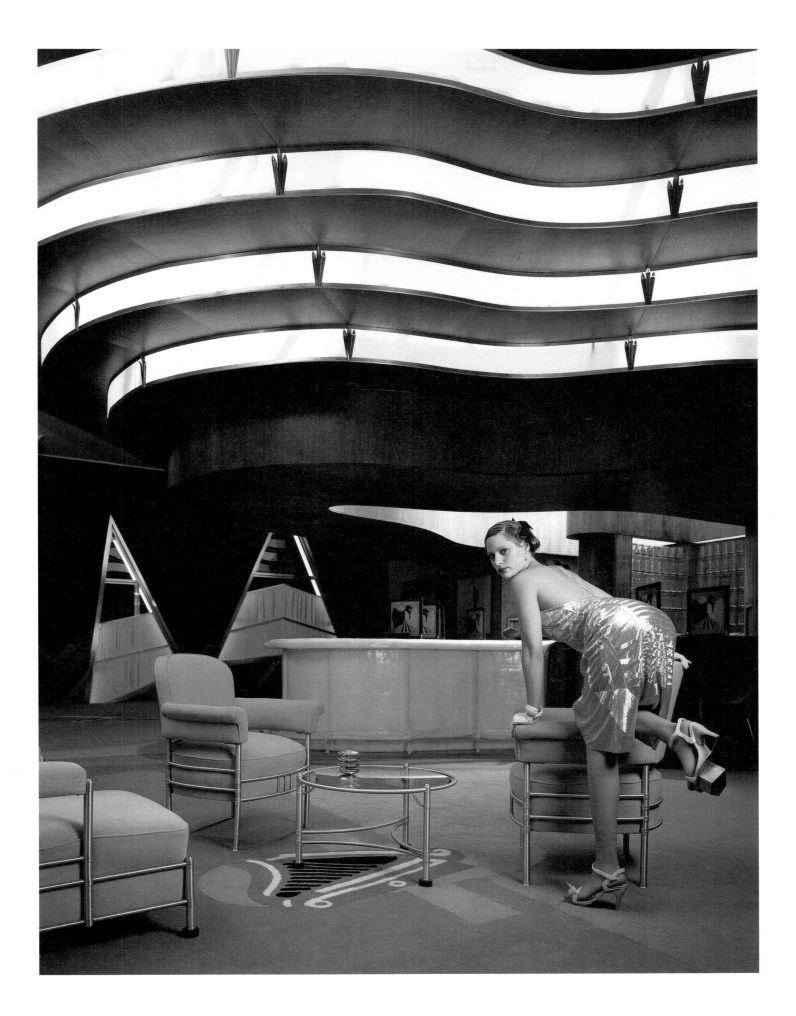

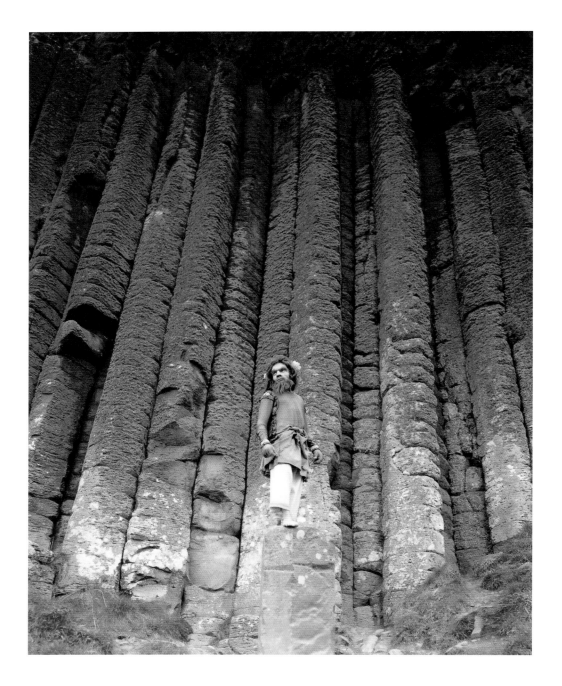

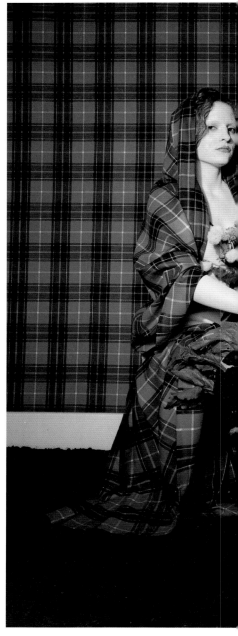

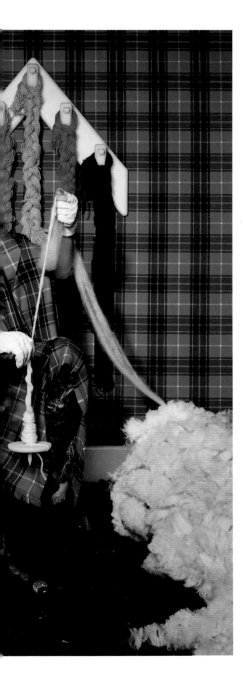

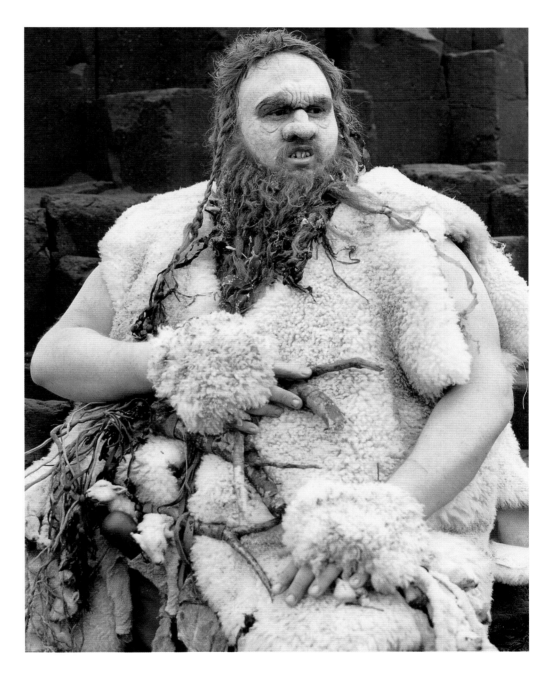

Character is an integration of habits of conduct superimposed on temperament. It is the will exercised on disposition, thought, emotion and action. Will is the character in action. Character in action, Lombardi asserted at the end of his speech, was the great hope of society. "The character, rather than education, is man's greatest need and man's greatest safeguard, because character is higher than intellect. While it is true the difference between men is in energy, in the strong will, in the settled purpose and in the invincible determination, the new leadership is in sacrifice, it is in self-denial, it is in love and loyalty, it is in fearlessness, it is in humility, and it is in the perfectly disciplined will.

Q: Are you an entered apprentice mason?

— I am so taken and accepted among all brothers and fellows.

Q: Where were you first prepared to be made an entered apprentice mason?

— In my heart.

Q: Where secondly?

— In a room adjacent to a legally constituted lodge of such, duly assembled in a place representing the Ground Floor of King Solomons Temple

Q: What makes you an entered apprentice mason?

— My obligation.

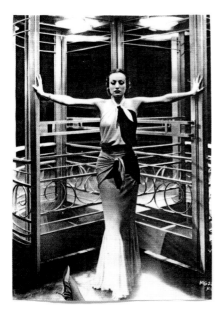

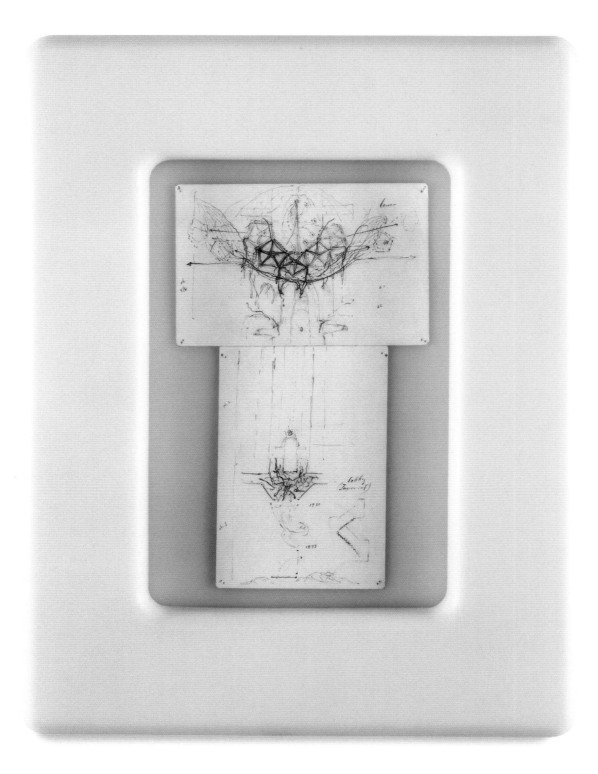

CREMASTER 3

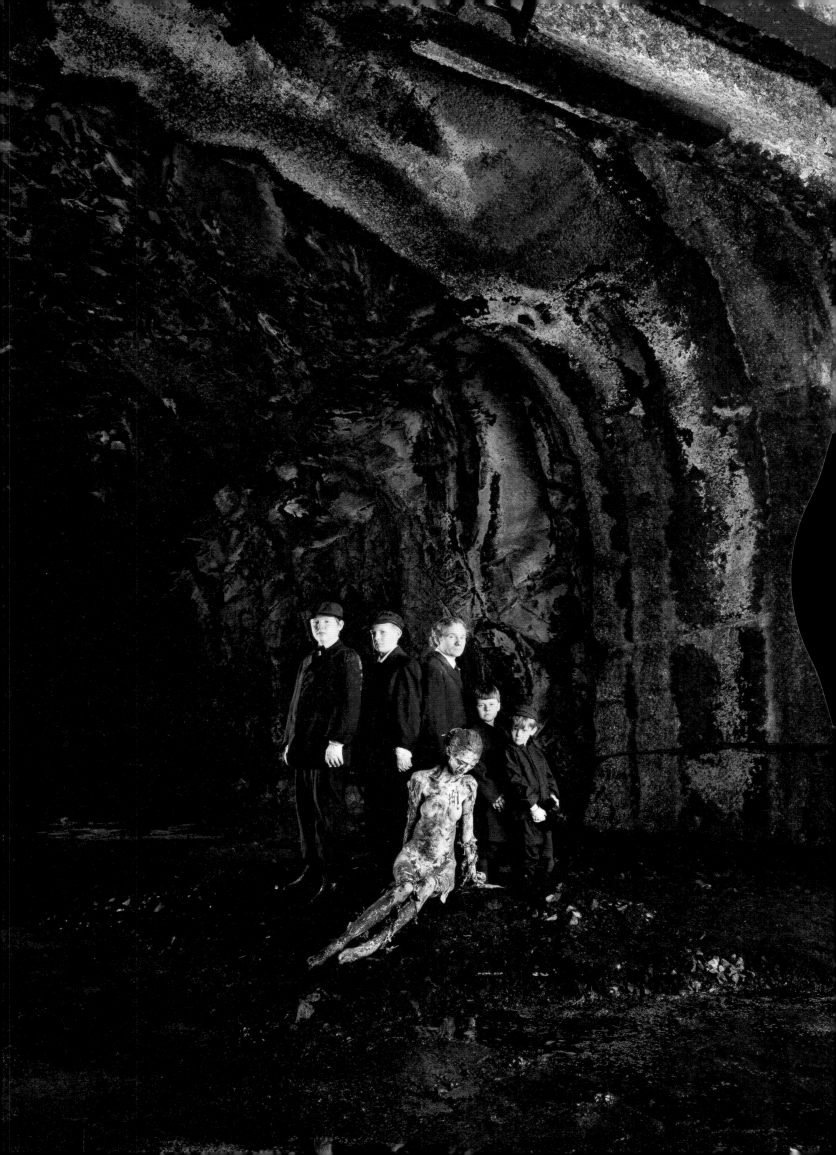

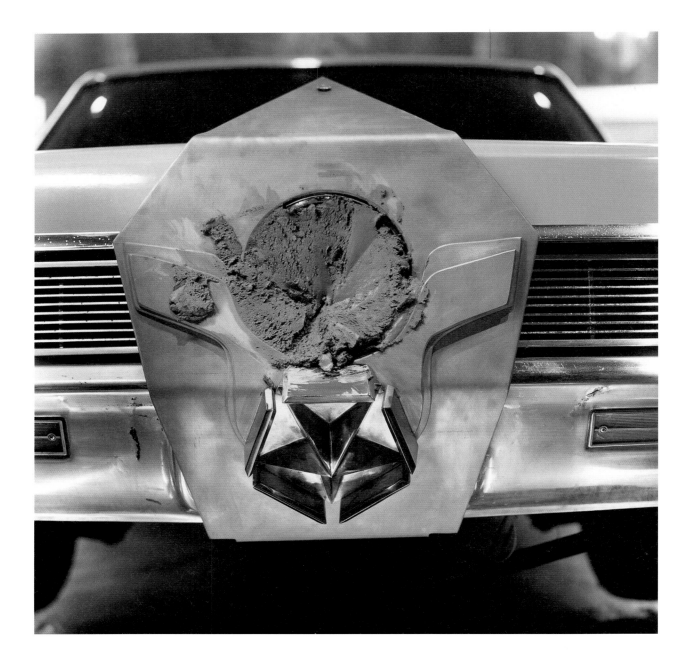

CREMASTER 3

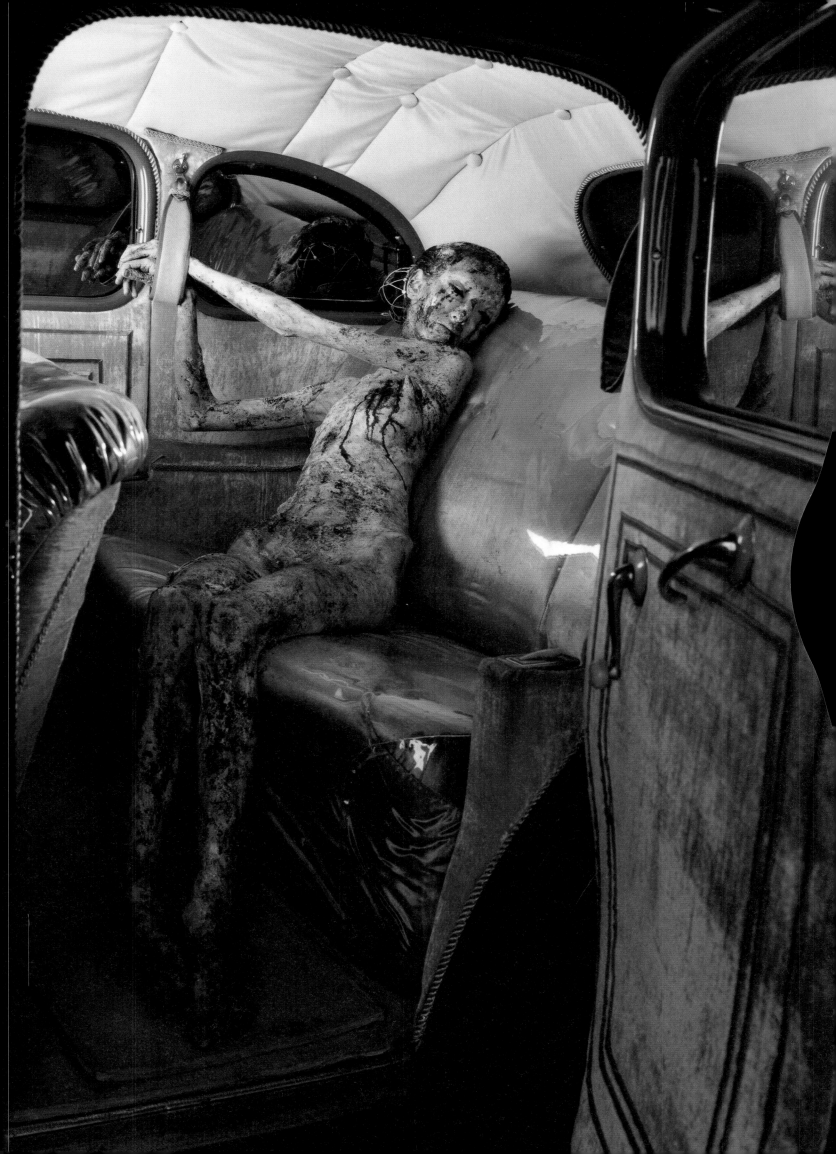

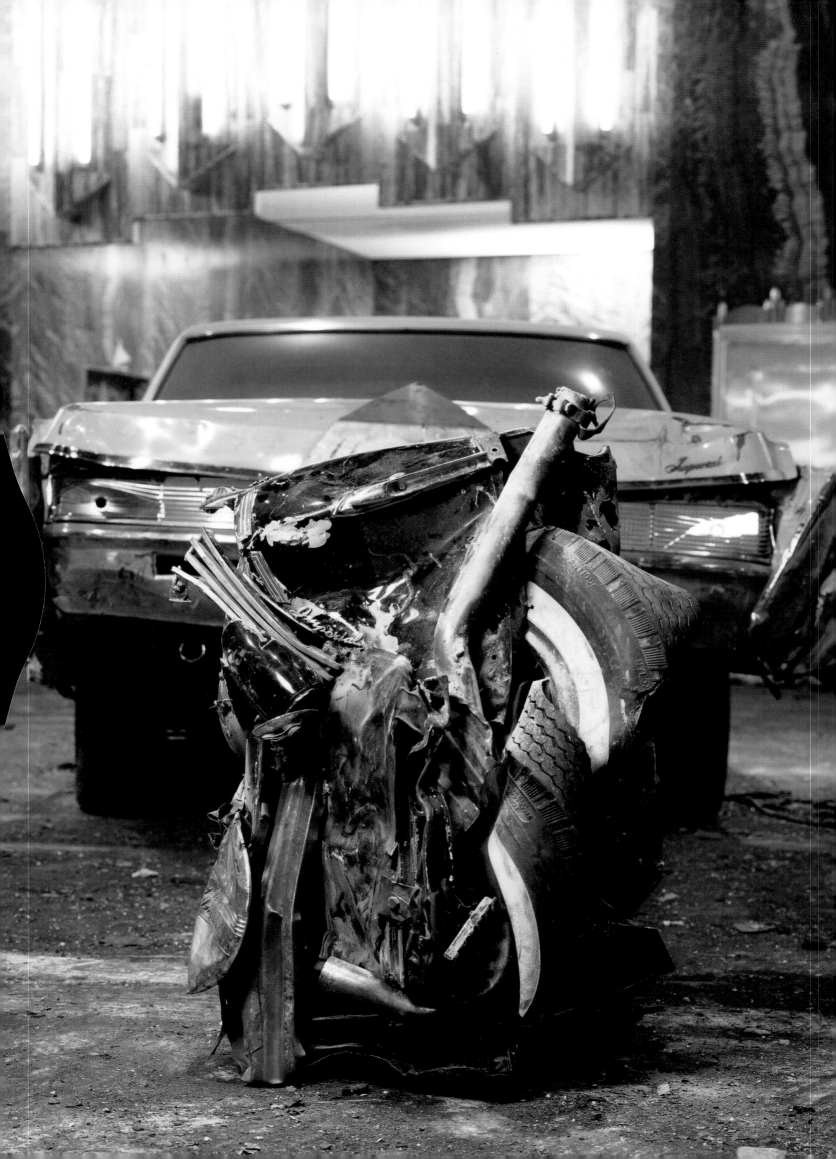

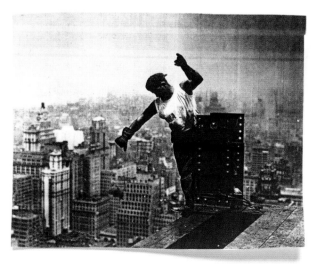
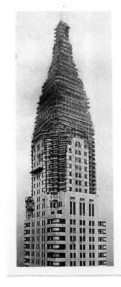

Musique d'Air

on dried skull and thigh bone
a goat grave horizon
with flat feet of hard stone
rough ashler foundation

this is the song of the vertical field
a promising plumbline draped down
 from the skyline

2. new beacon, love witness,
 base, pillar, pediment.
 a gauging of character
 geometry yields judgement

 this is the song of the vertical field
 a towering implement indicates level
 with purest precision, this level shall measure

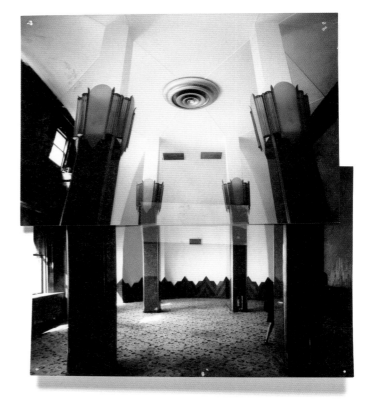

3. gleaming steel arches
 chrome eagle perches
 all in reflection
 the problem in question

 this is the song of the vertical field
 the reflection in question, of unsquare detection

4. white orchid, seed's cycle
 mountain sage, glacial still
 manx gorse, narcissus
 calla lil', all blooming once

 this is the song of vertical field
 once upright this field is now fertile and prove
 with desire put forth for a field that will
 flower
 one narcissus blooms in this unstructured
 tower

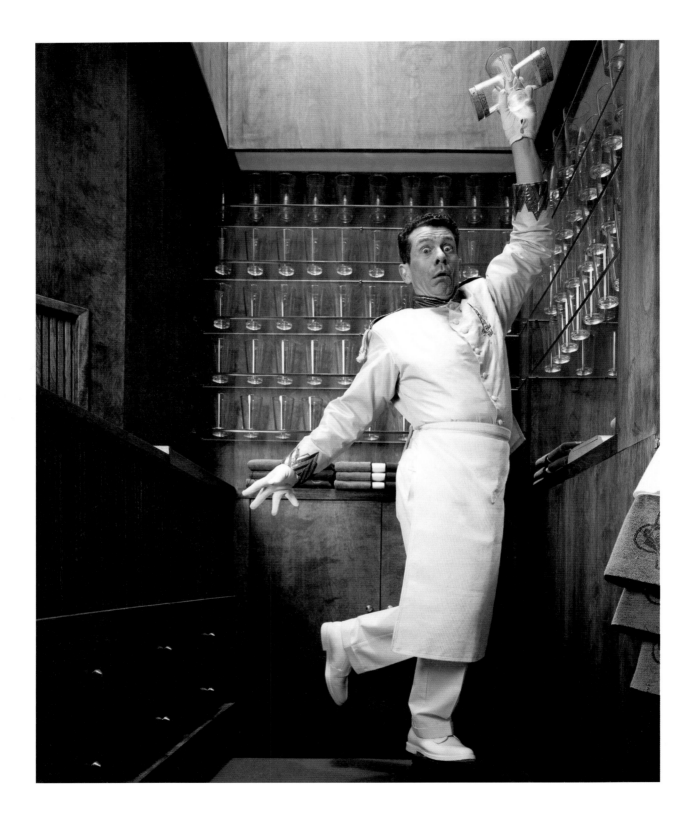

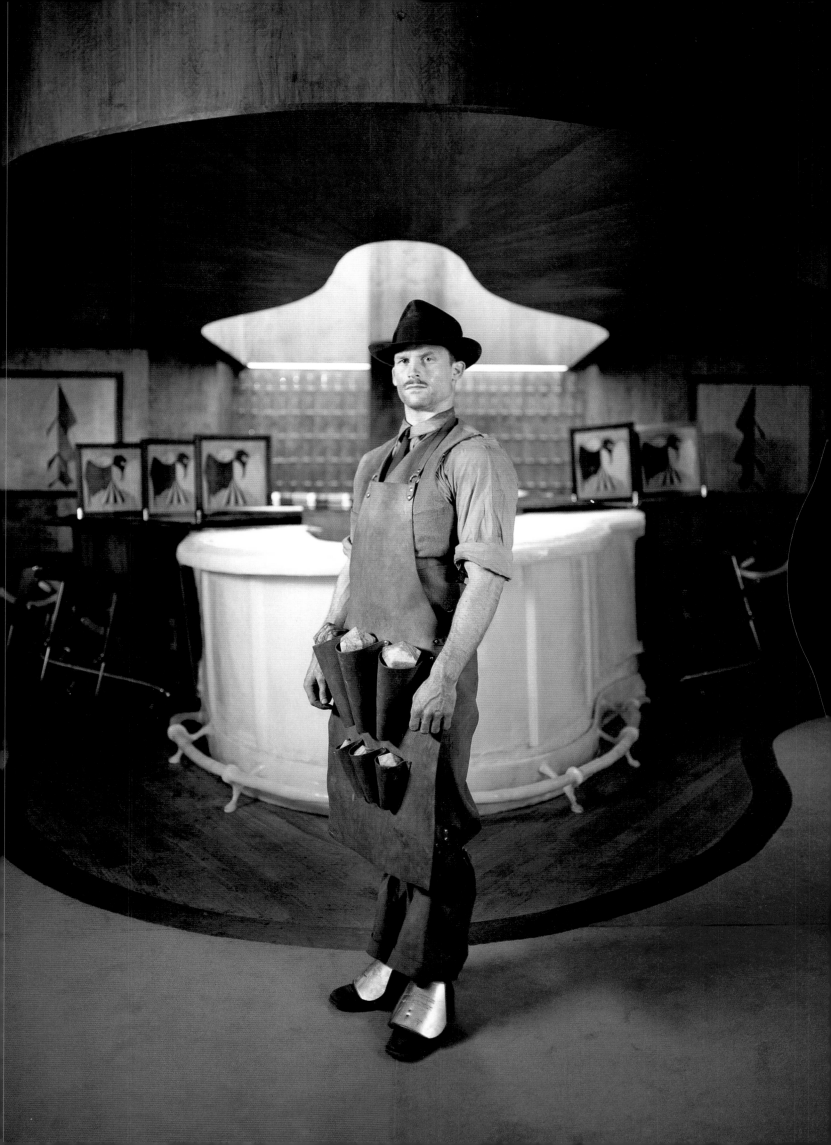

CREMASTER 3

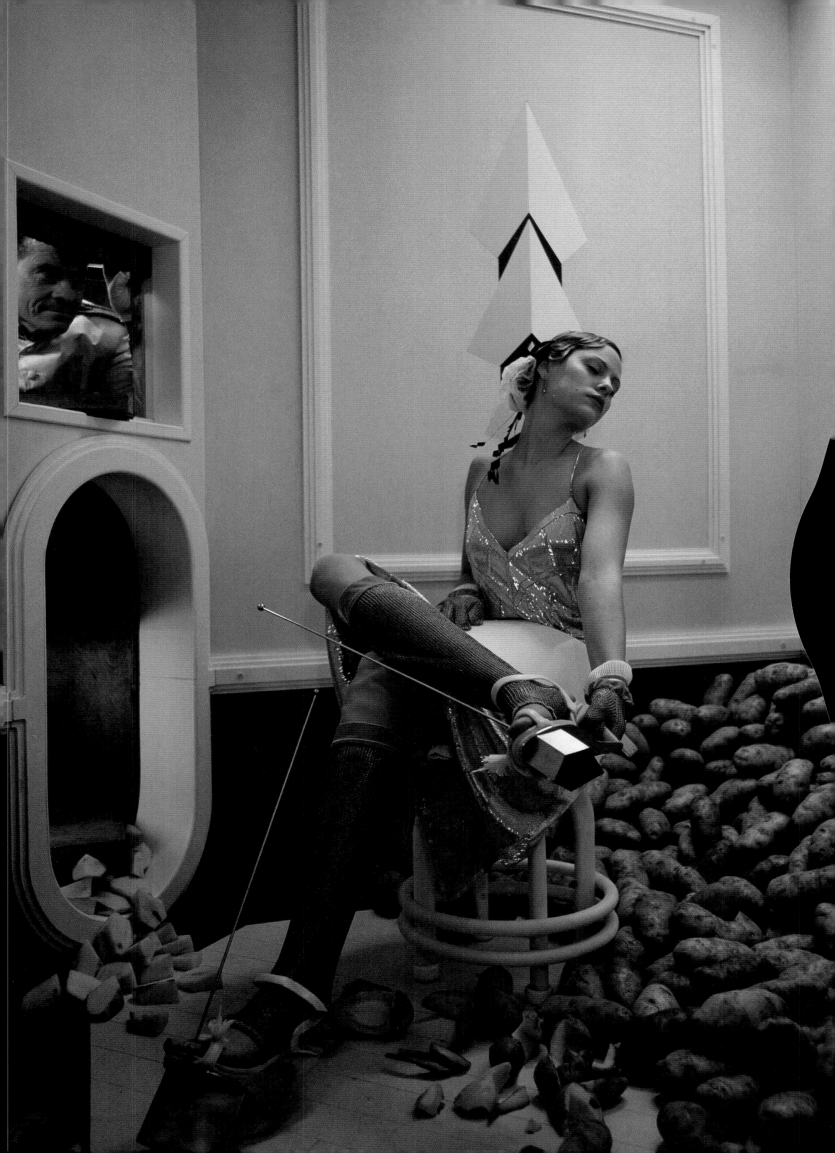

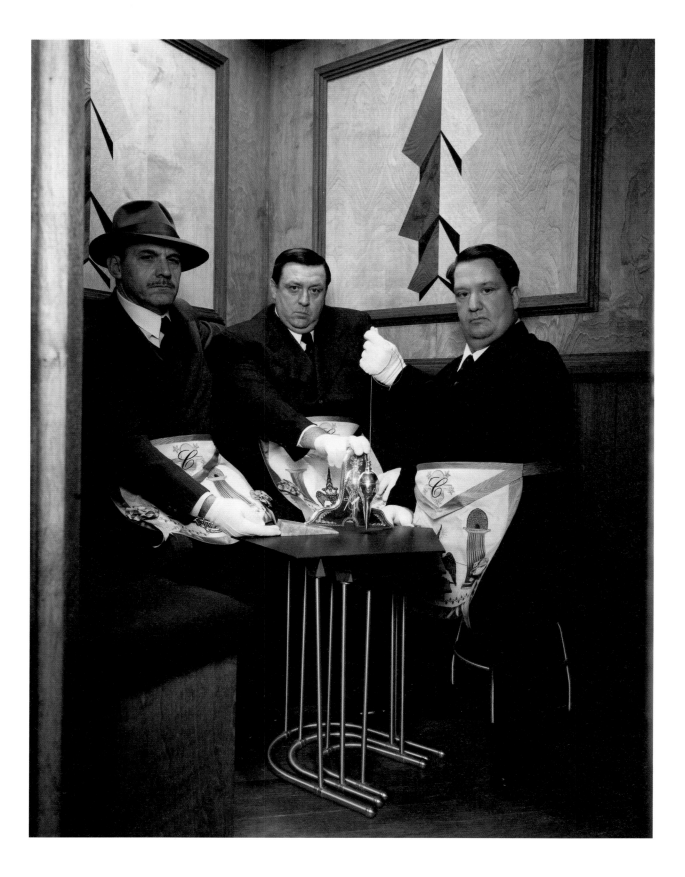

CREMASTER 3

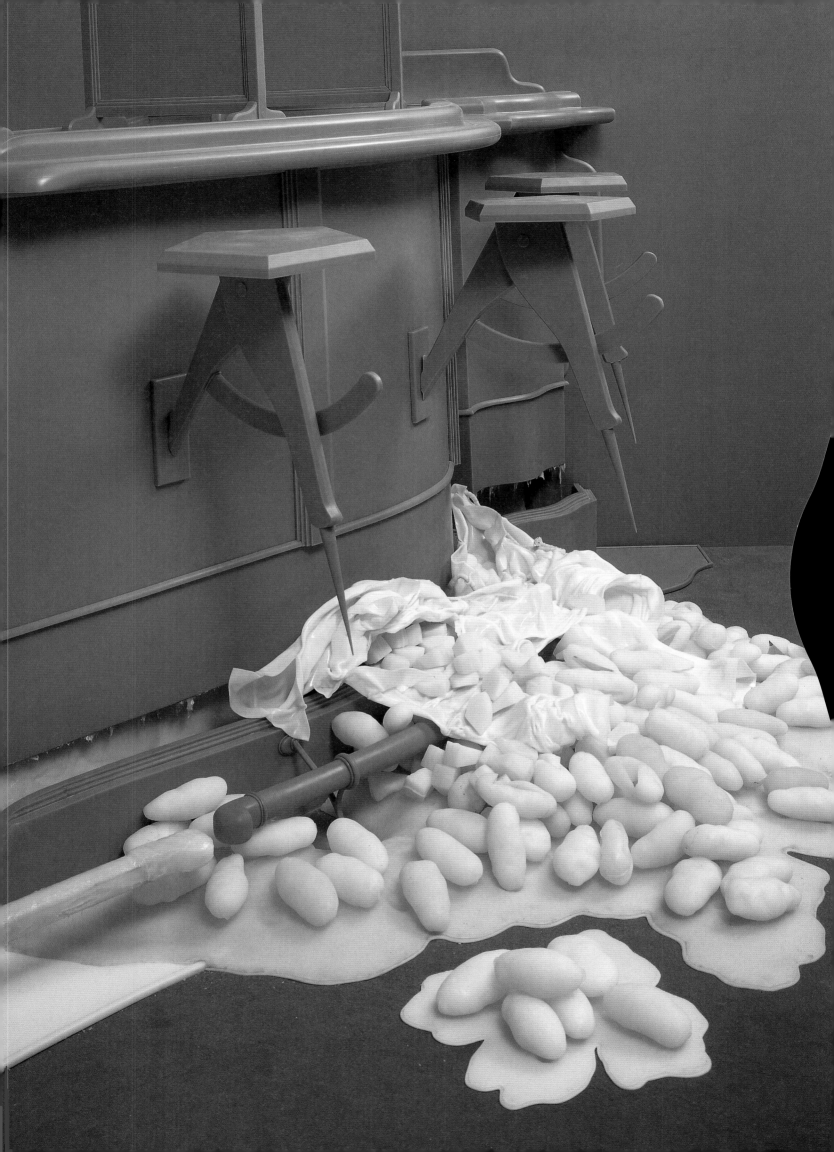

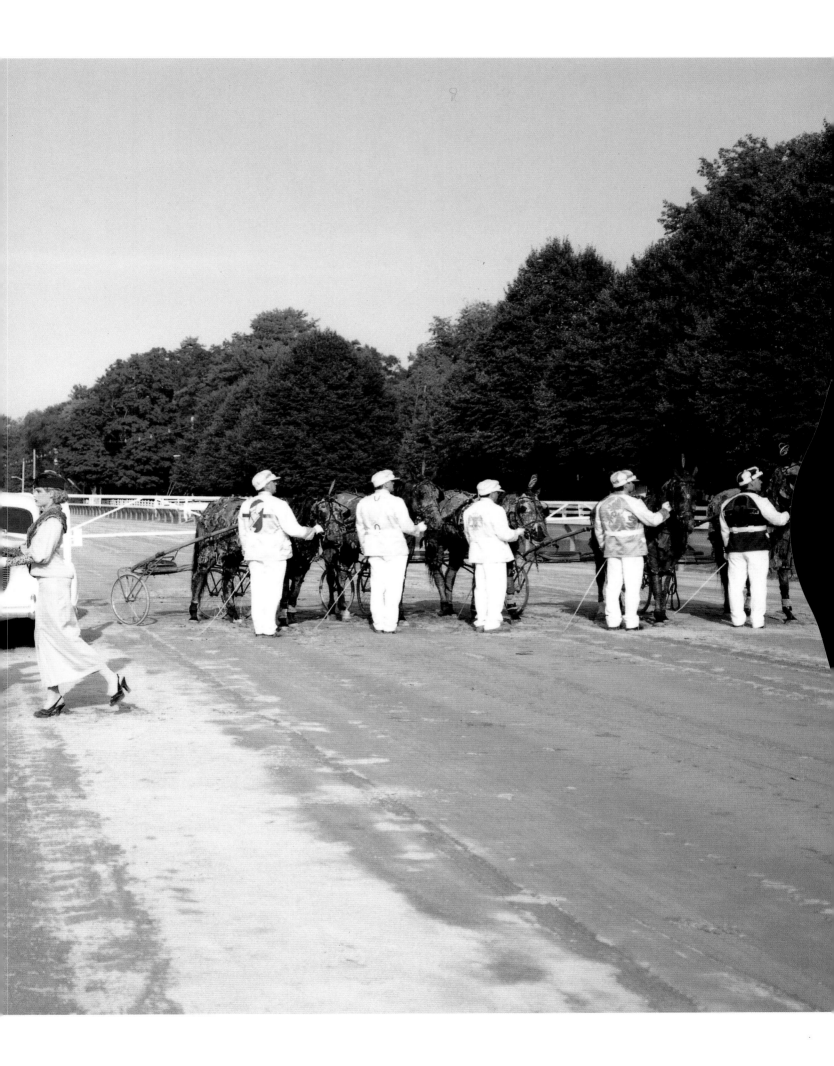

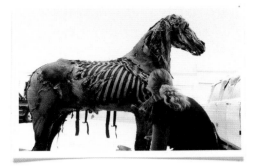

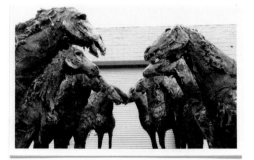

CREMASTER 3

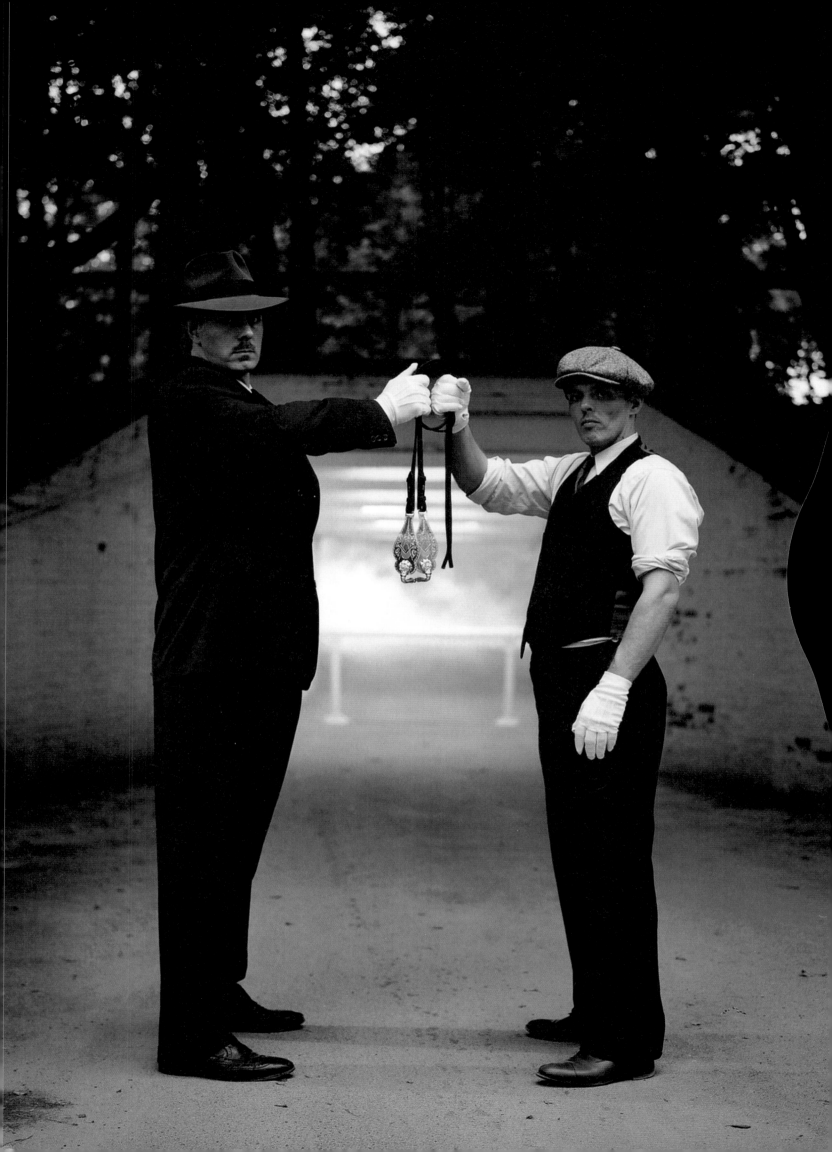

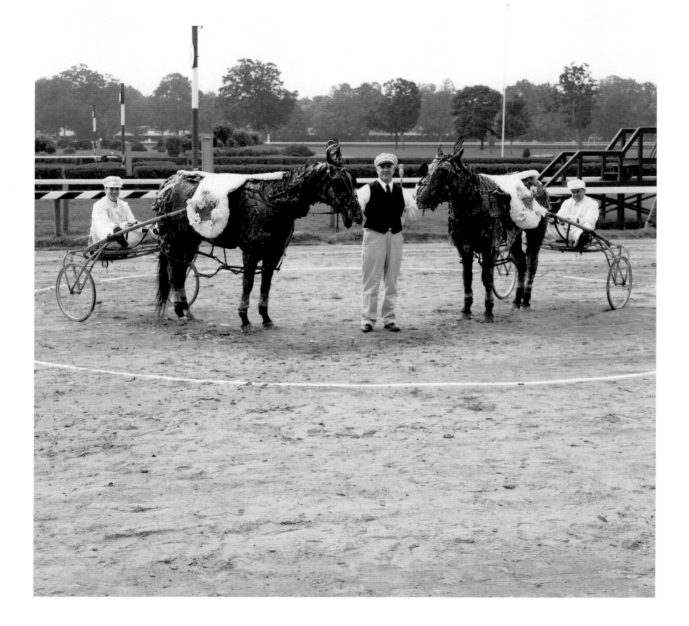

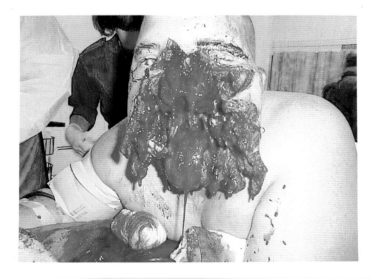

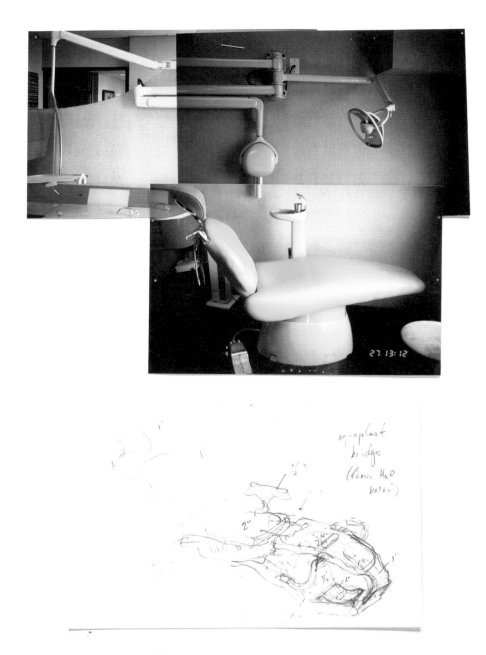

Fig. 281. Types of Class II preparations for gold inlays. (A) Class II preparation, lower first bicuspid. (B) Class II preparation, upper first molar.

Fig. 281 (contd.). Preparation of compound cavities for gold inlays. (A) Class II with lingual groove extension, upper first molar. (B) M.O.D., upper bicuspid, including occal and lingual cusps. (C) M.O.D., lower first molar.

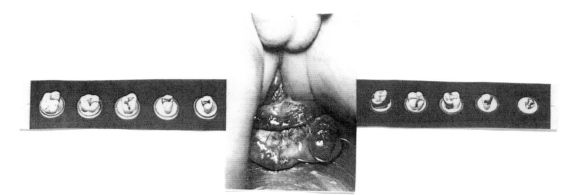

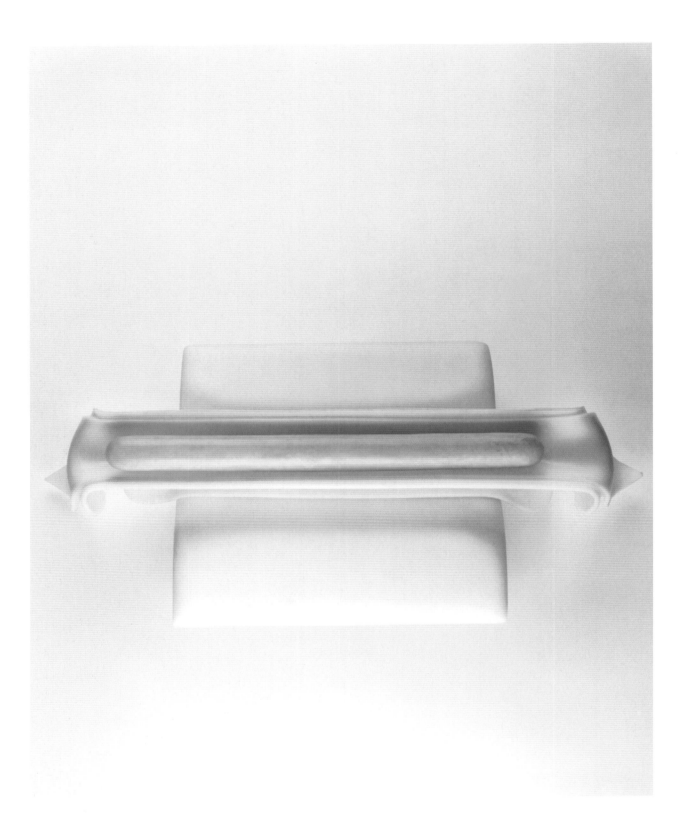

CREMASTER 3

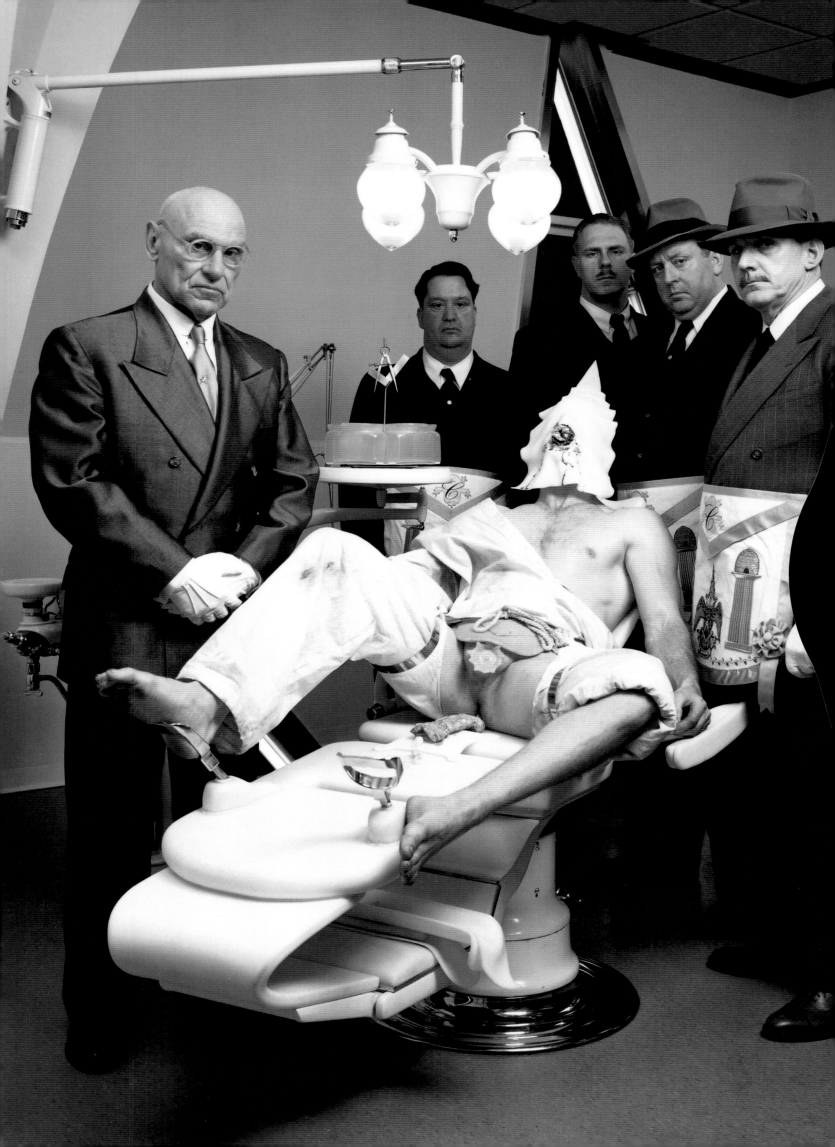

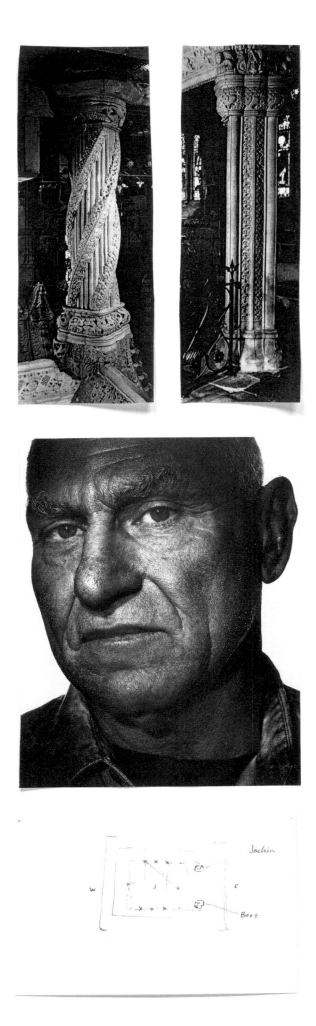

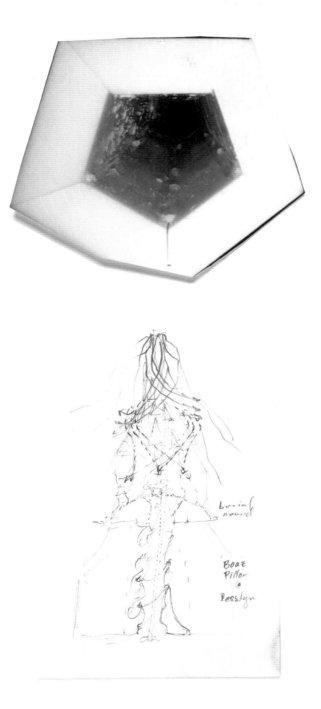

CREMASTER 3

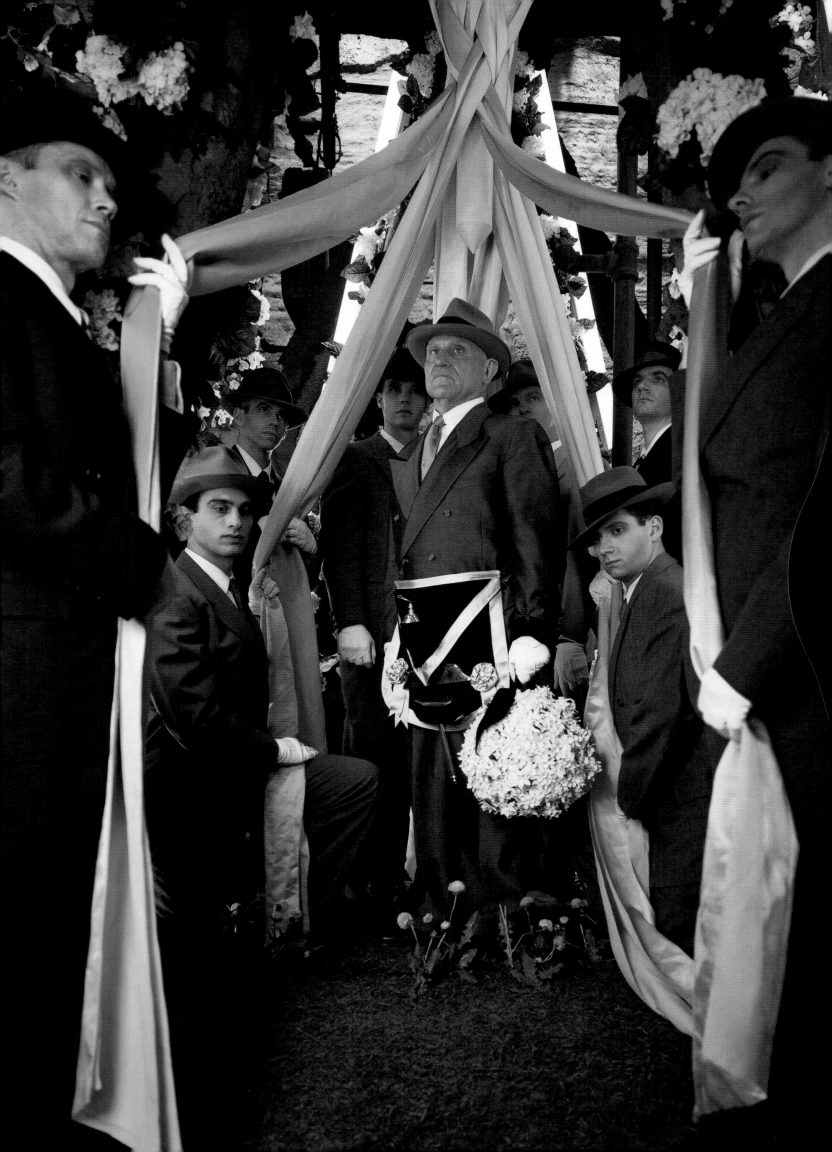

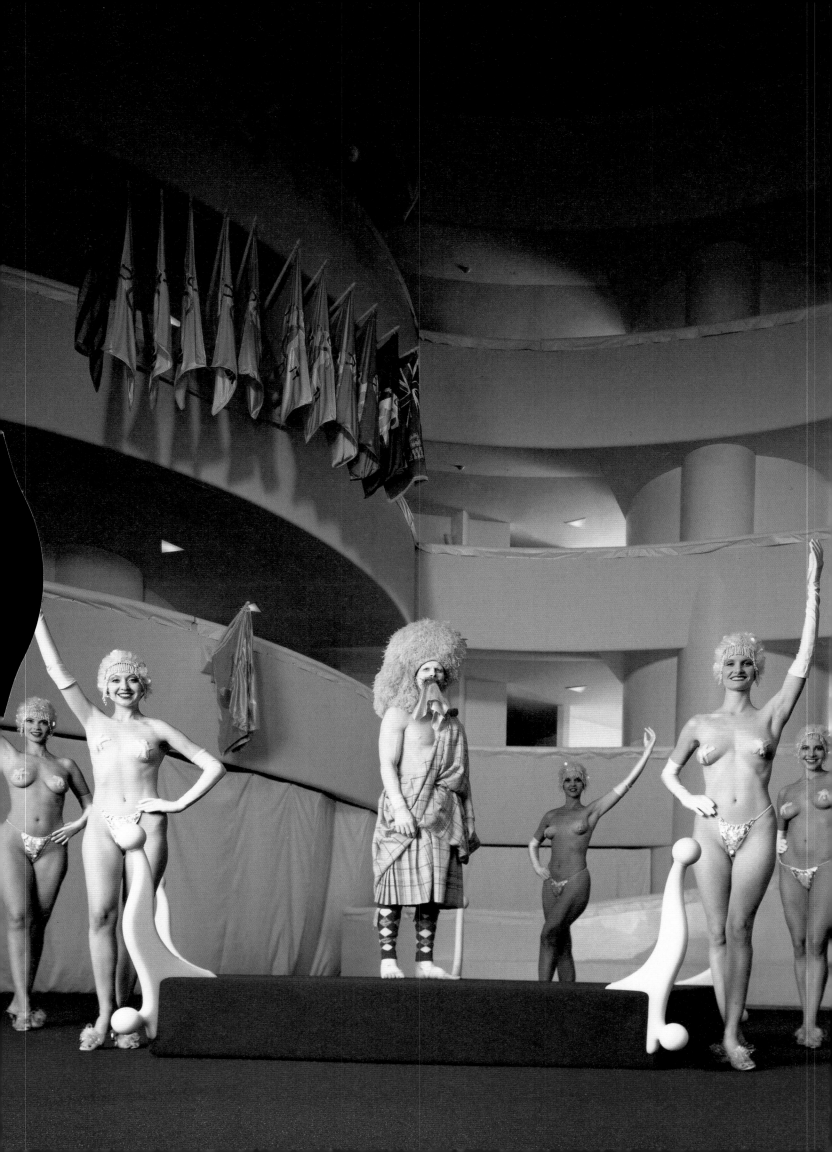

THE ORDER

1st degree (ROCKETTES)	2nd degree (AF vs SSD)	3rd degree (Aimee Mullins)	4th degree (Amazing Grace)	5th degree (Richard Serra)
	"the perfect cube must pass thru the metamorphosis of the cross"	"I die daily"	five points of fellowship	Hiram Abiff

lambskin

ELIMINATE THE LOWER SELF

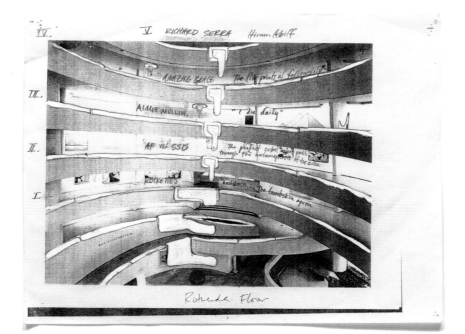

Rotunda: Floor

channel 4/5

3.

S EVENTS ON FIELD

4.

ADVANCE THRU 5 RINGS

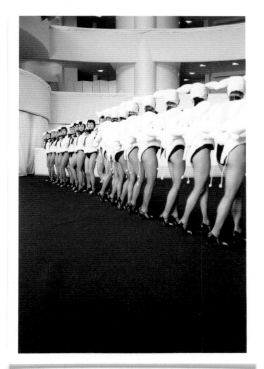

newborn lamb

AF ←⎯⎯⎯⎯→ SSD

ny boston

MURPHY'S LAW

CREMASTER 3

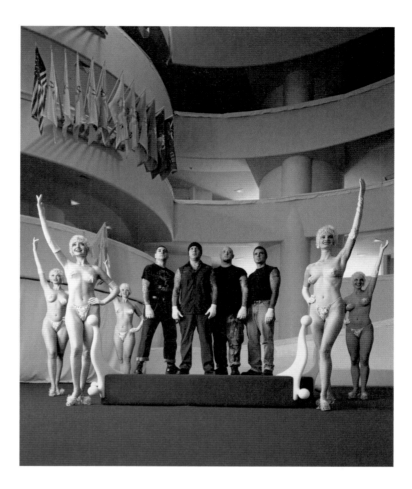

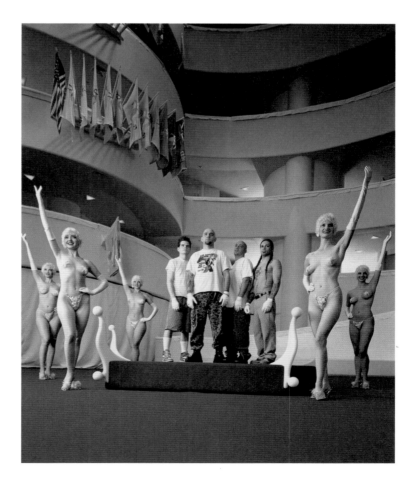

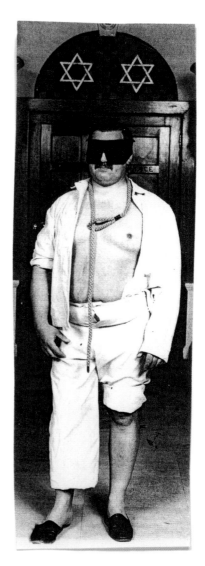

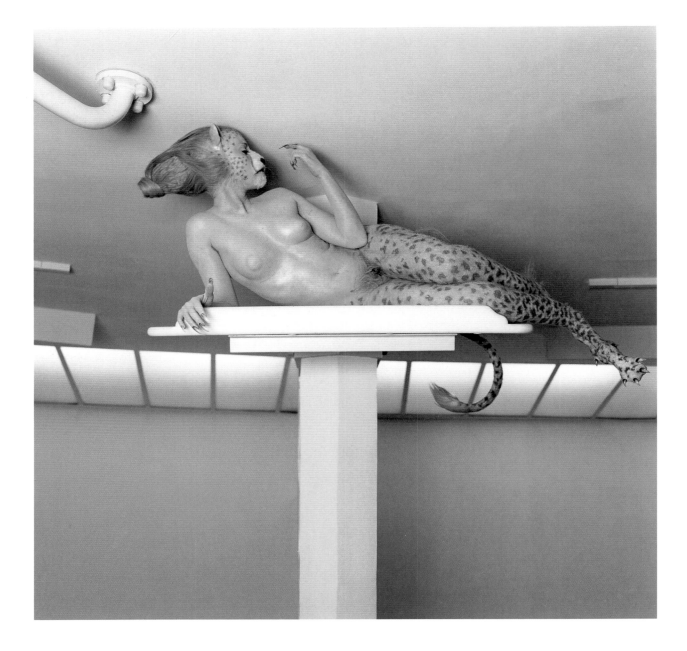

CREMASTER 3

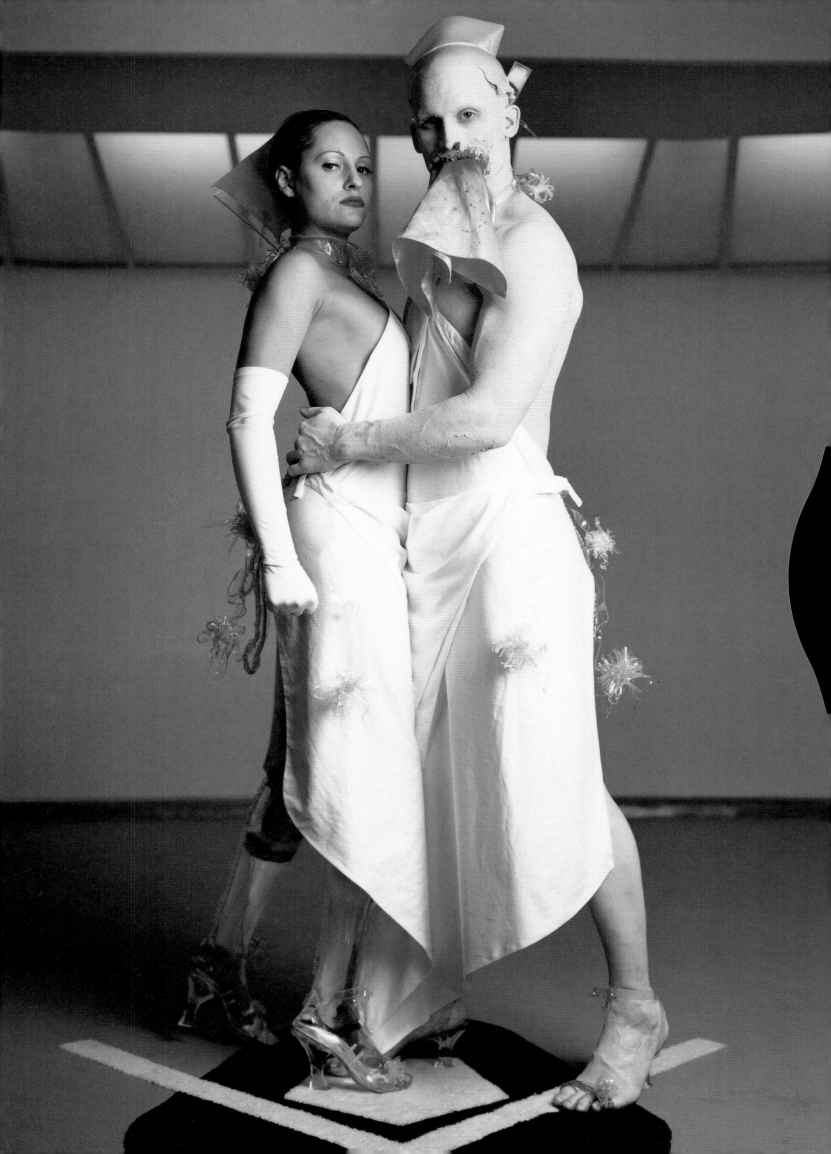

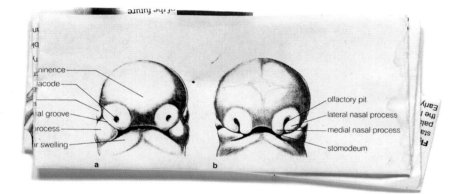

Labels on diagram: nminence, acode, al groove, process, r swelling, olfactory pit, lateral nasal process, medial nasal process, stomodeum

a b

of the future

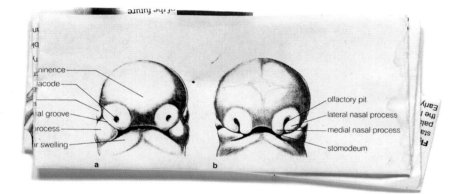

five points of fellowship : Osaka Byu

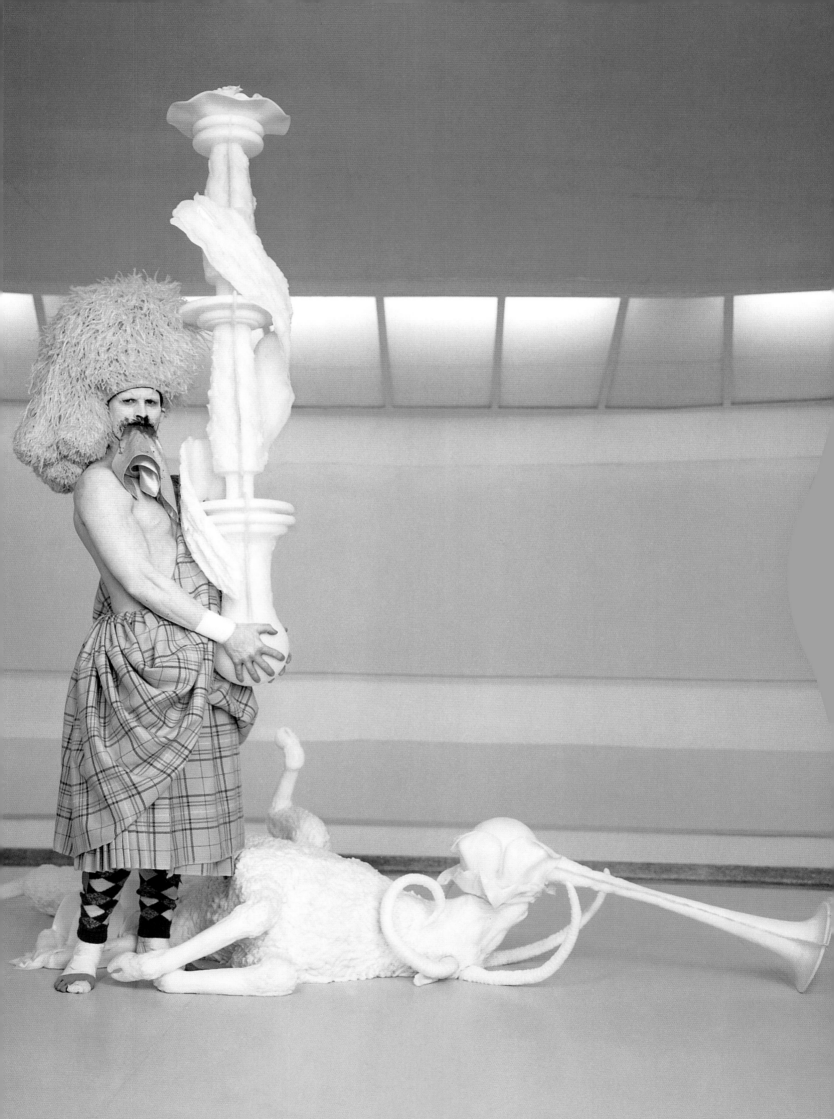

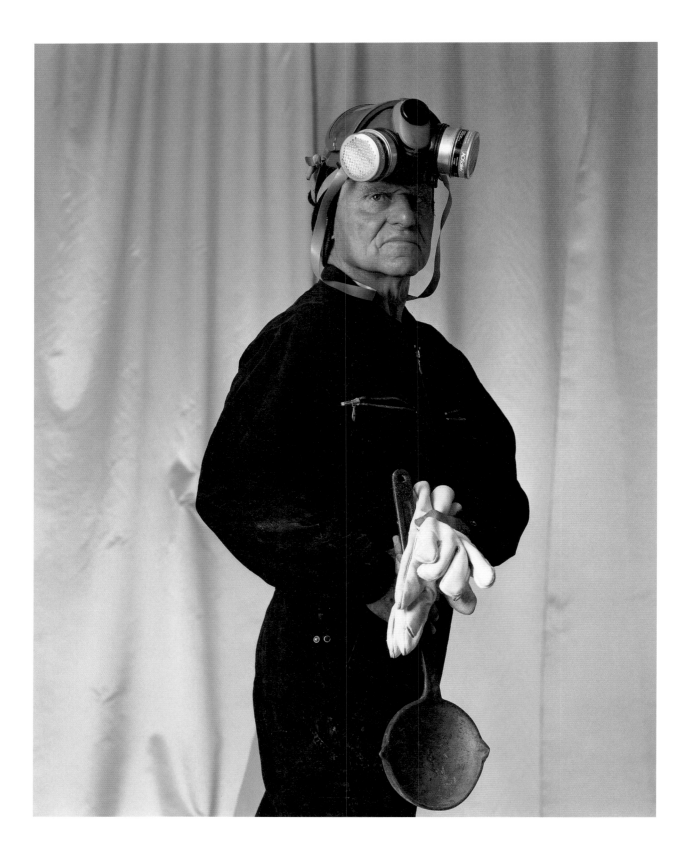

Hiram Abiff

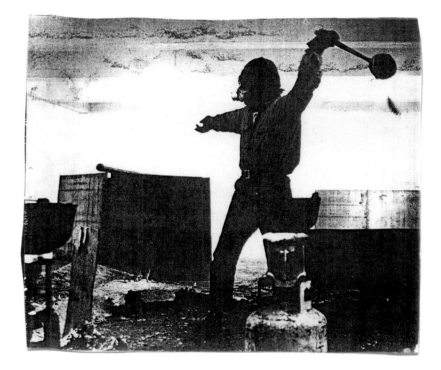

CREMASTER 3

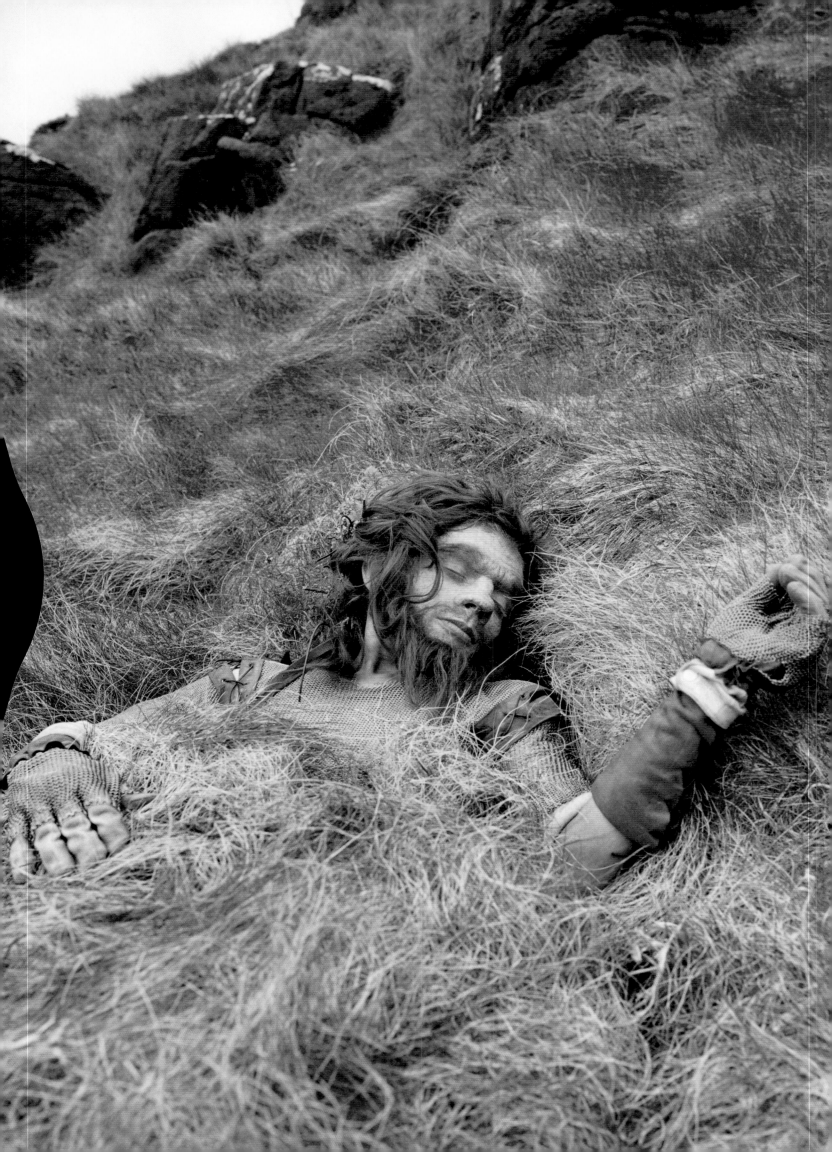

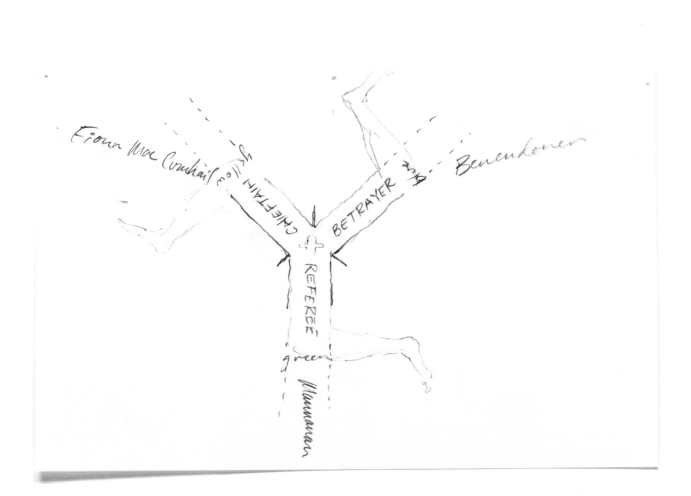

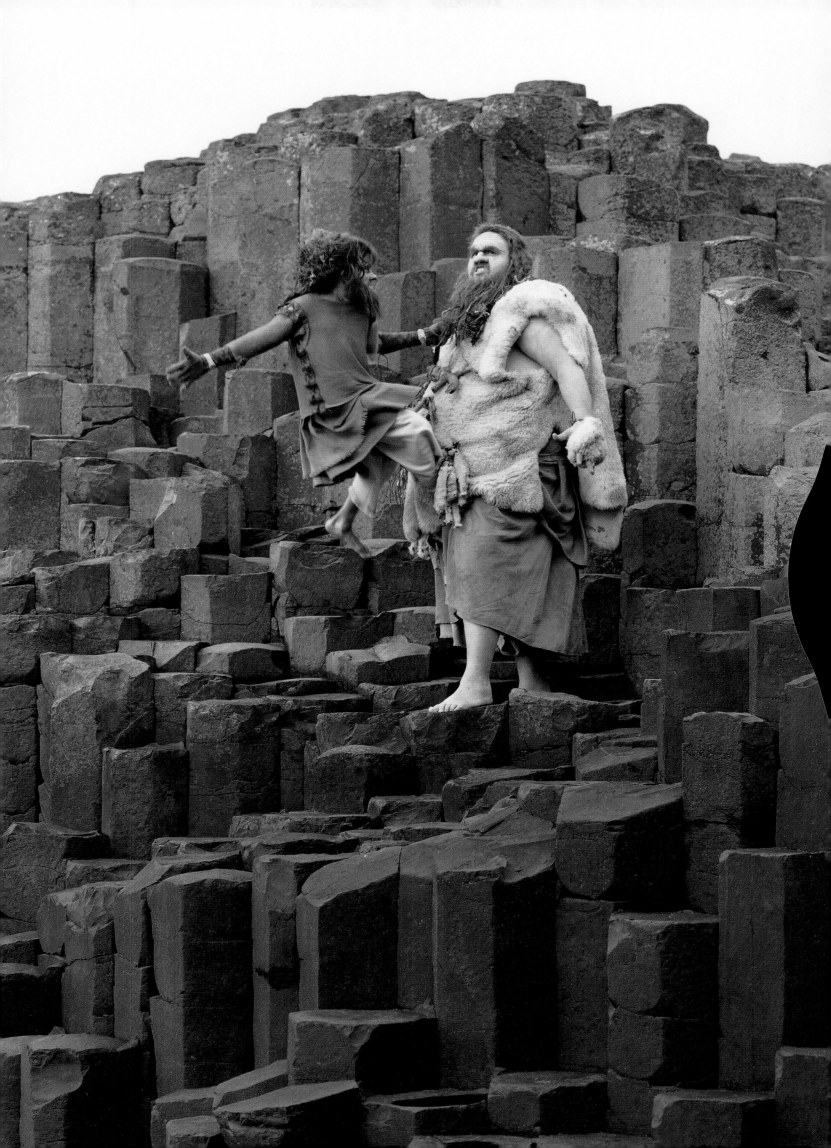

CREMASTER 4

1994

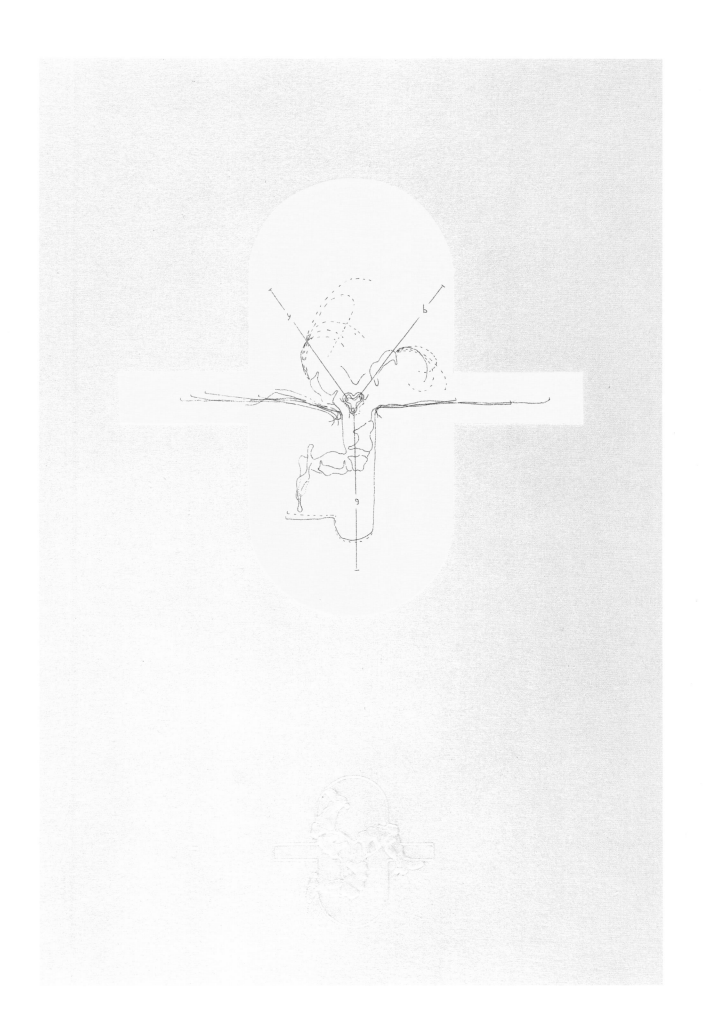

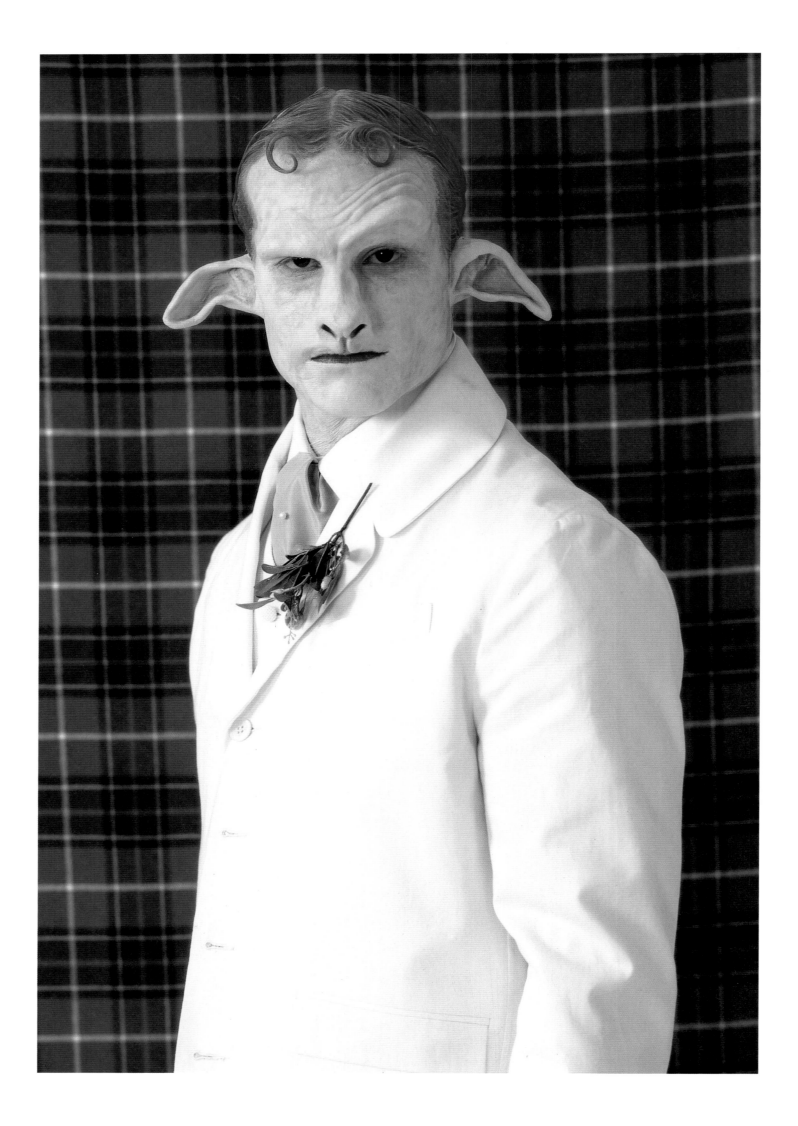

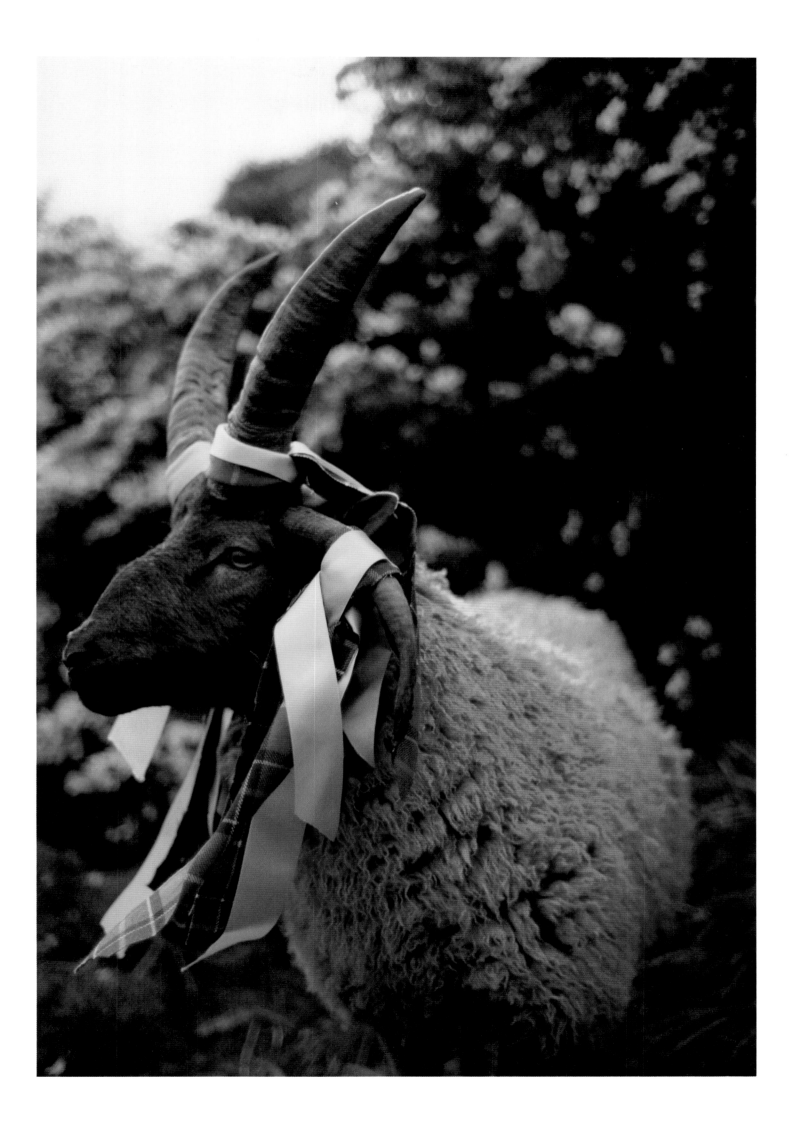

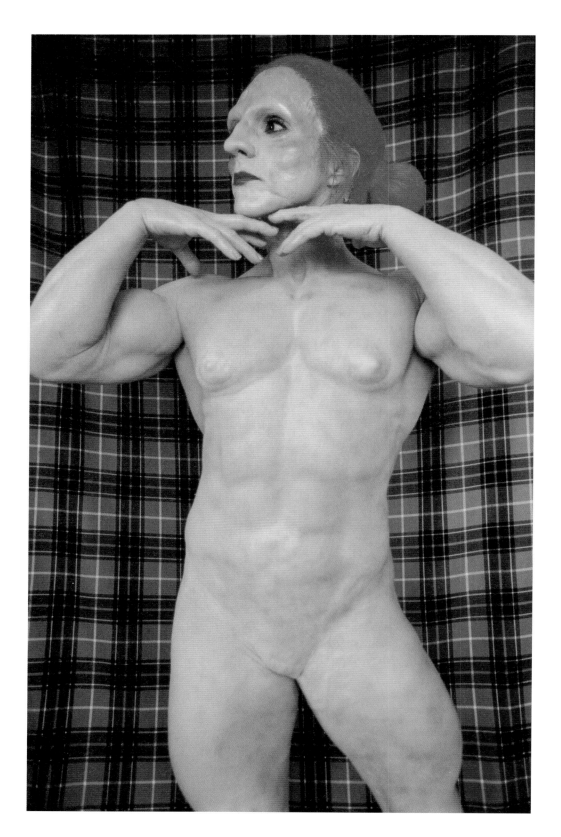

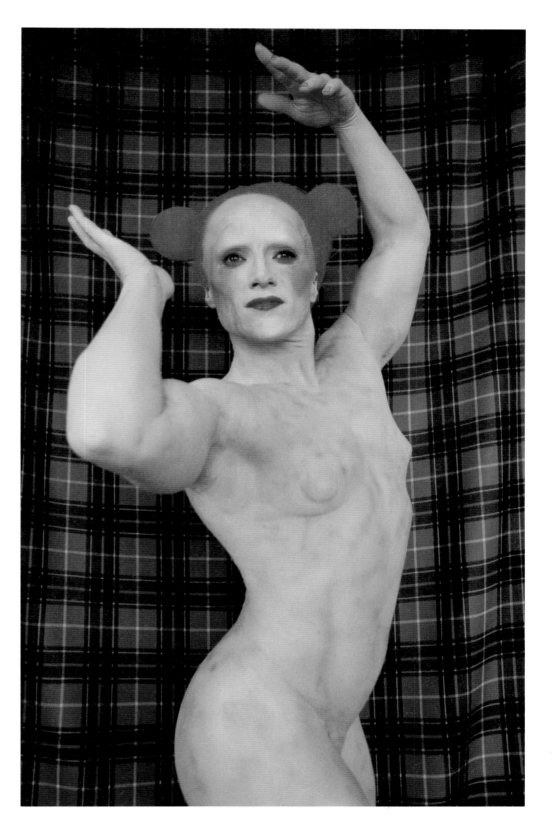

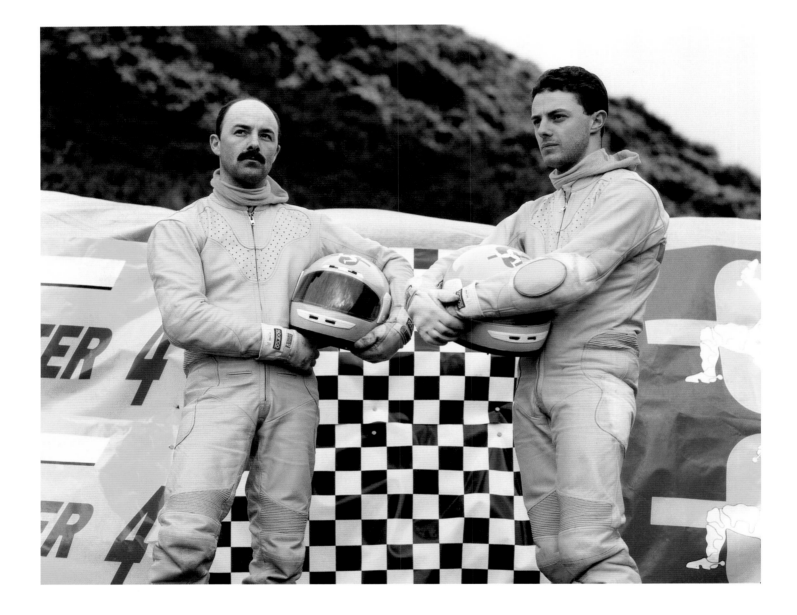

CREMASTER 4

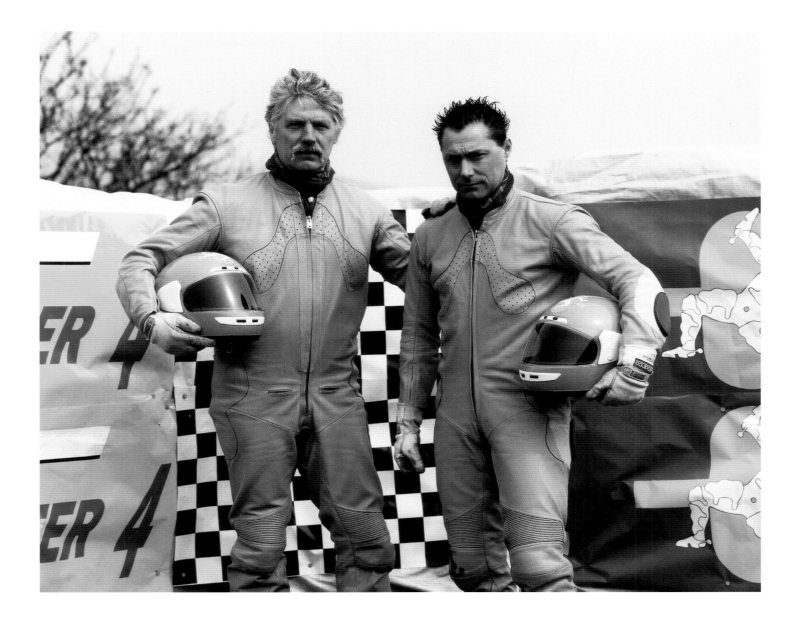

CREMASTER 4

LOUGHTON (candidate)
imagined and assisted

- INFERIOR - RELEASE.
· ENTRY ·

· ascent (y)
(b) descent ·

lateral field lateral field
CABER : PIT :
triple option theater of
LUNCHEON operation
 (aided migration)

LOUGHTON
(evolved)
interception
· three legs of man ·

return
to the
House of
the
Loughton Candidate

CREMASTER 4

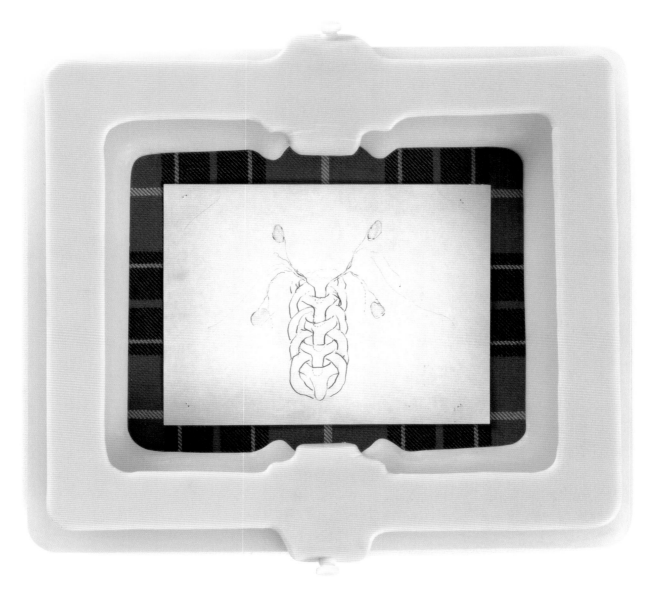

insert in title sequence

(descent - 6)

jelly extrusion

4

jelly (frontal)
- roadway -
tilt up

to signage

2

insert in title sequence

(ascent - 4)

vaseline extrusion
ascent / descent

13

CREMASTER 4

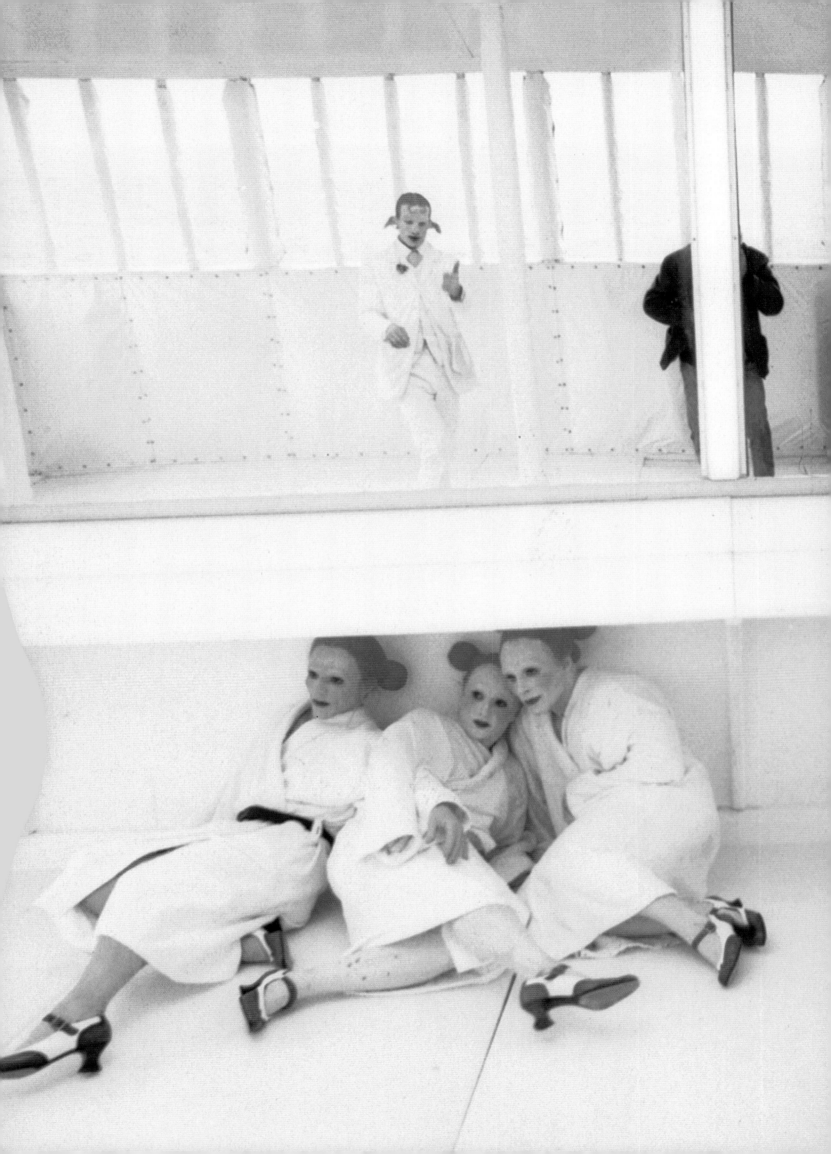

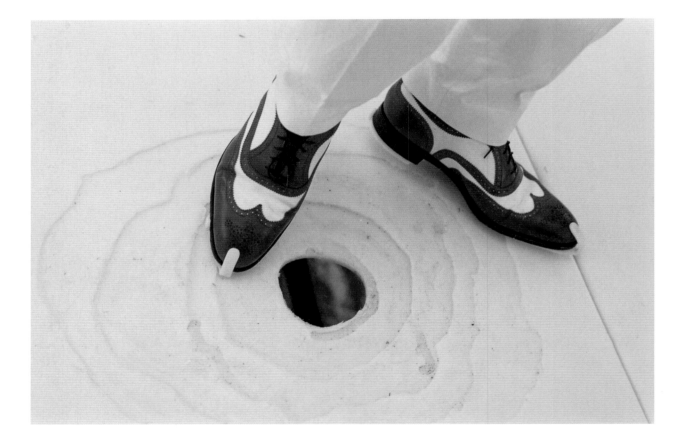

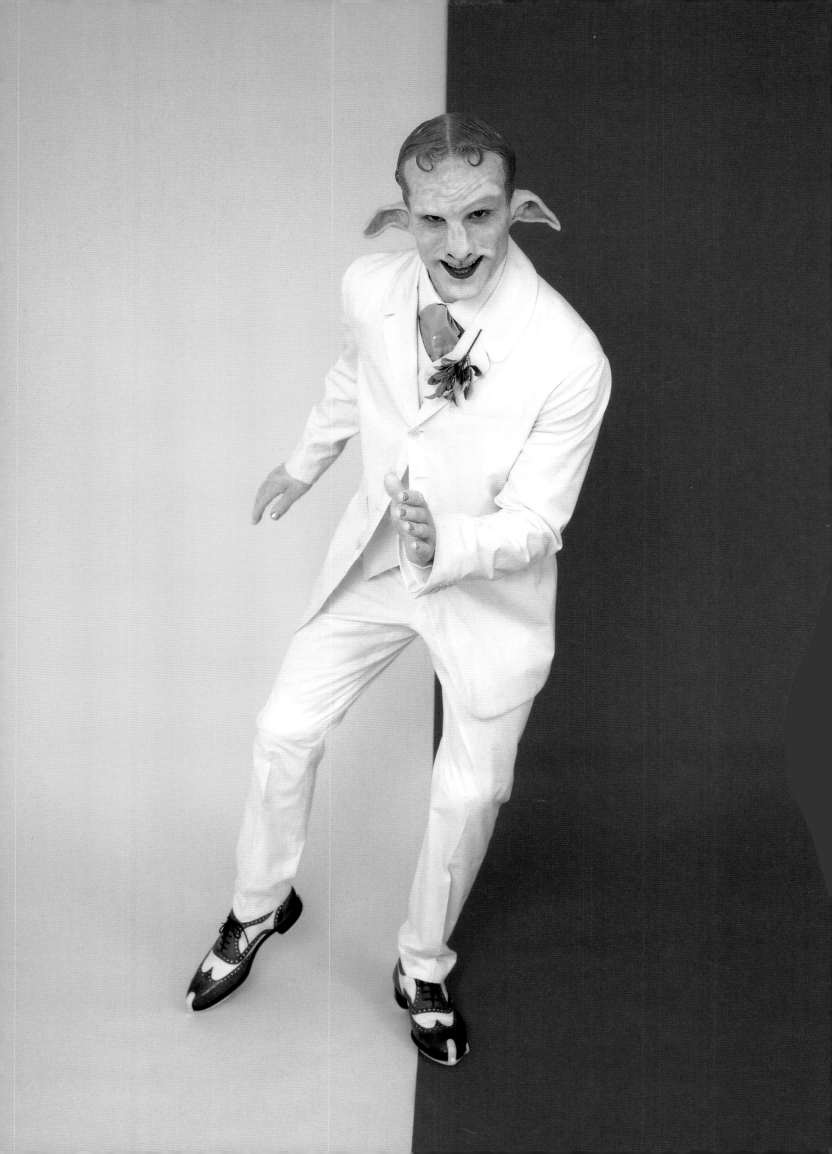

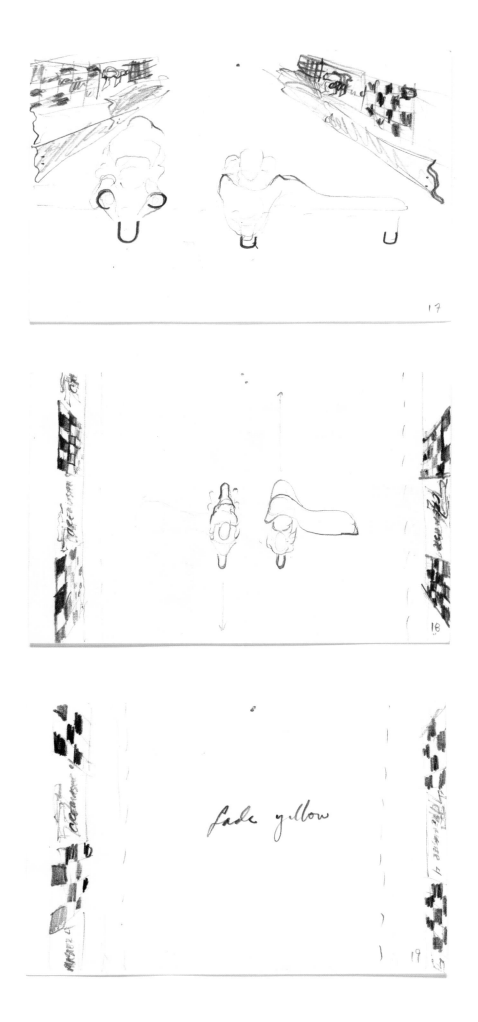

fade yellow

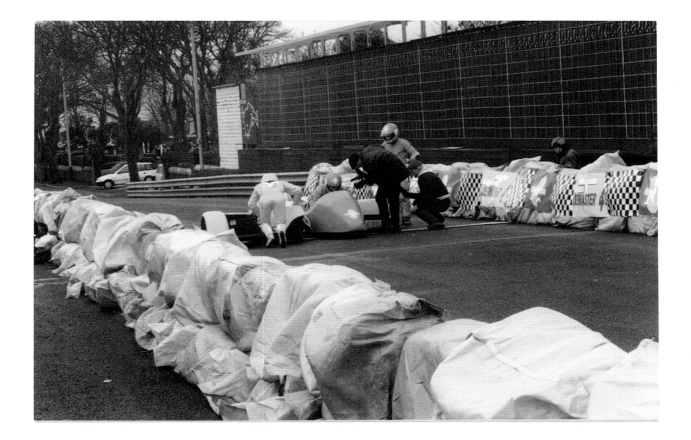

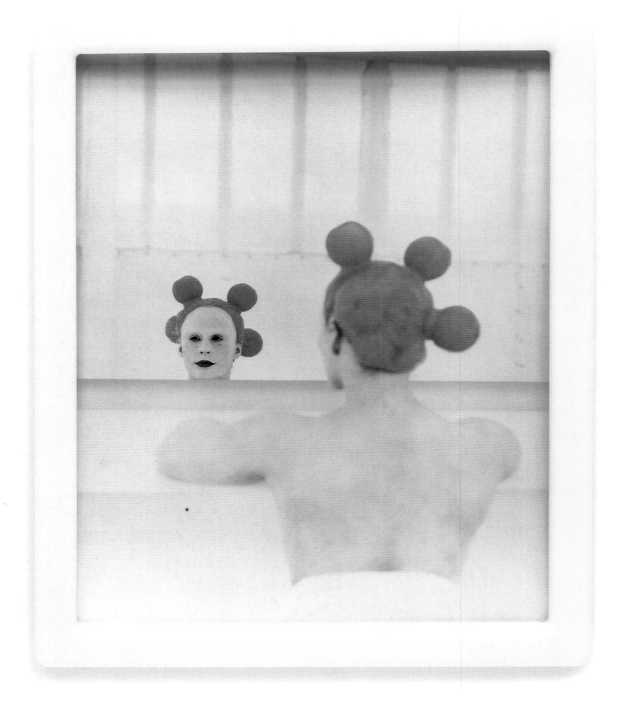

CREMASTER 4

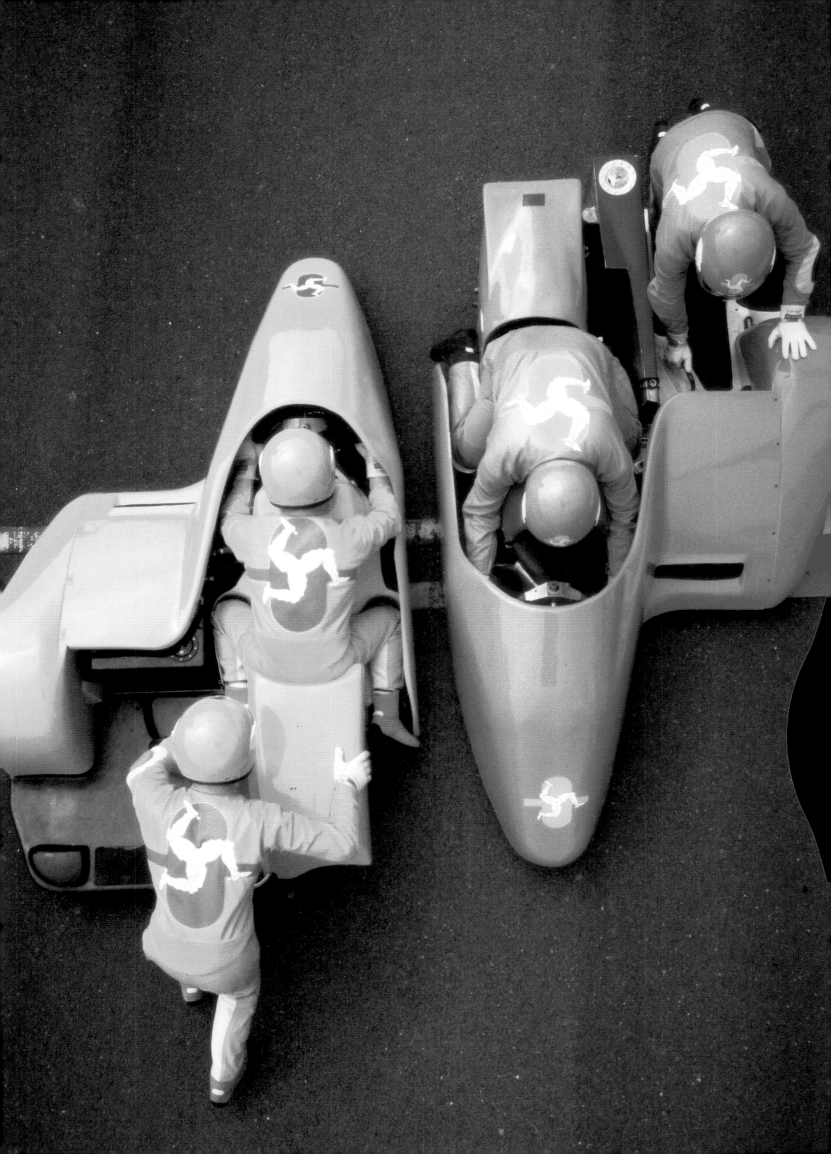

RELEASE

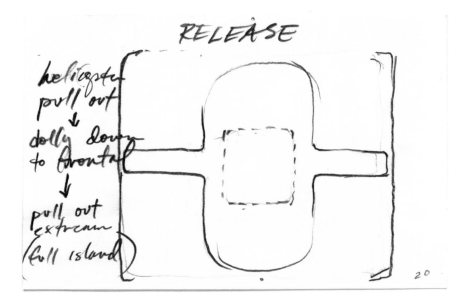

helicopter
pull out
↓
dolly down
to frontal
↓
pull out
extreme
(full island)

20

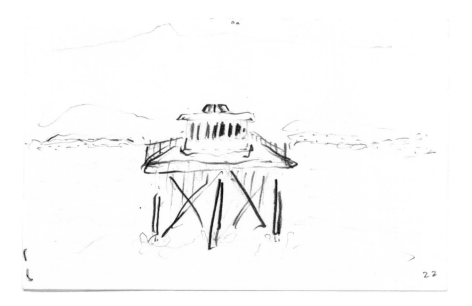

22

23

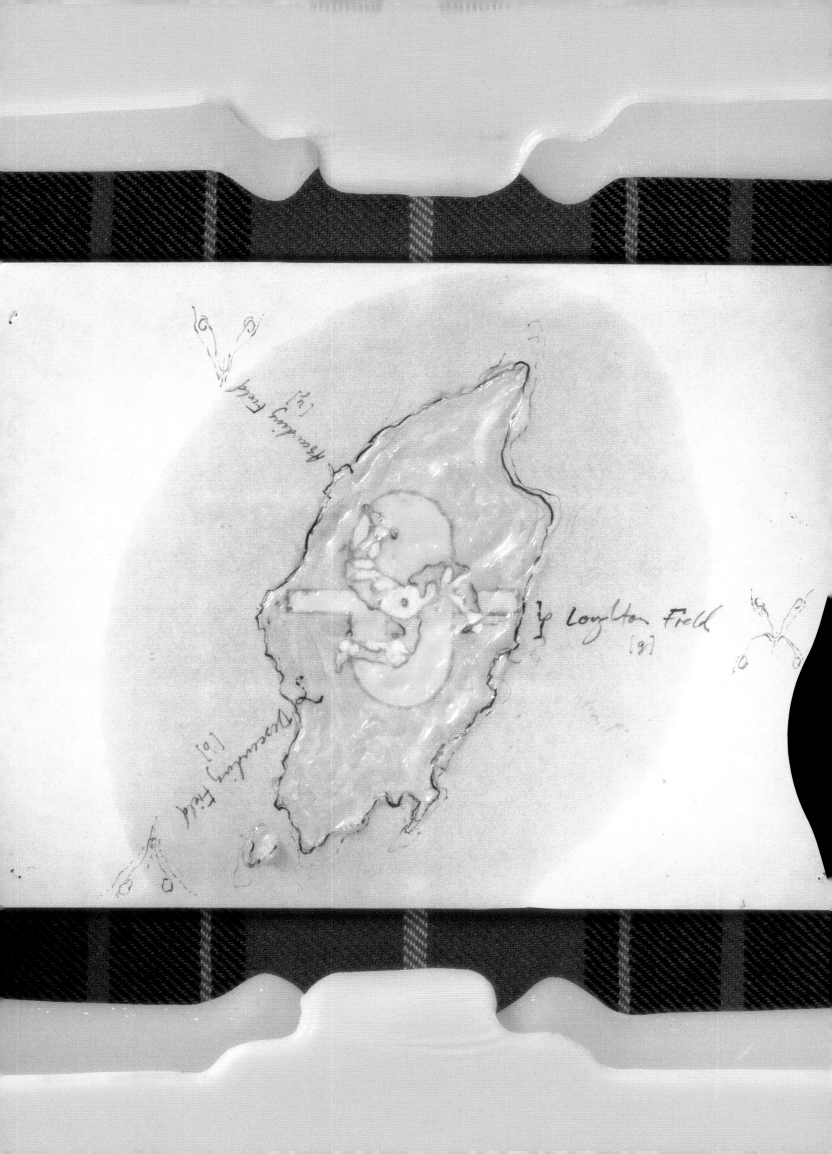

ascent
HAIRPIN

37

flat crack

corkscrew pan

direct overhead
1. in white sand
2. with trestle

DIG
torso

sea → flaf crail → field

pet jelly ⟶ :

CREMASTER 4

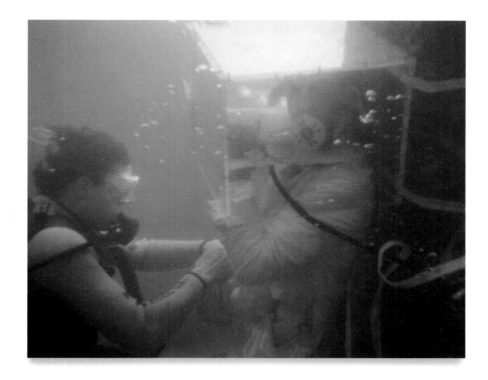

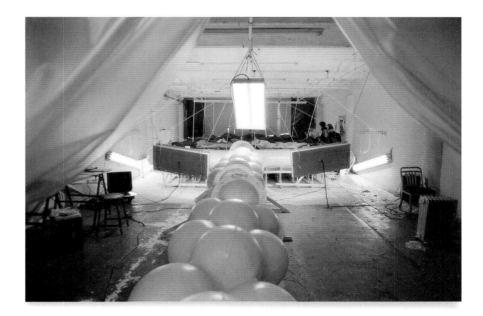

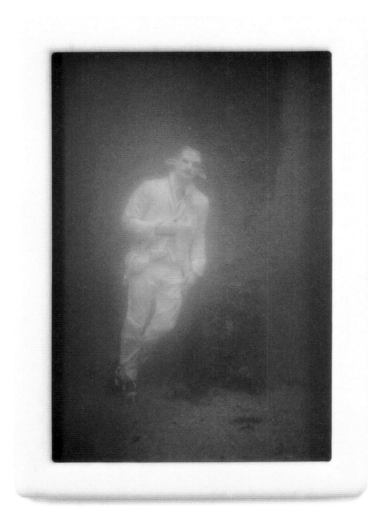

CREMASTER 4

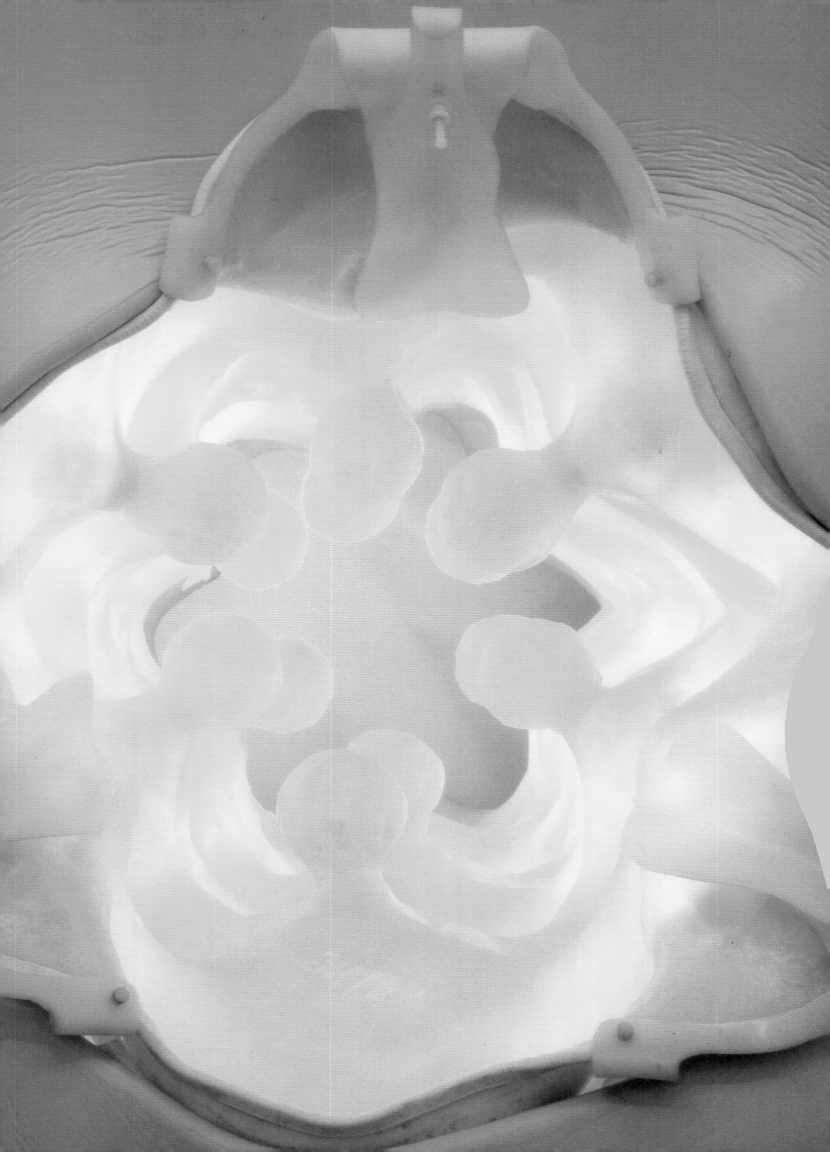

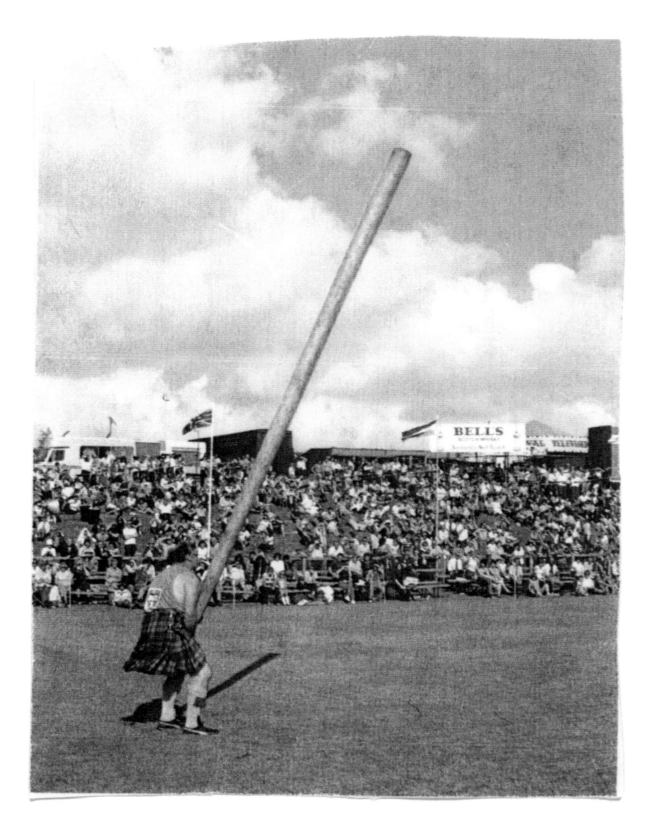

ascending HACK · (4)

38

40

P.O.V.

Boom

track

365

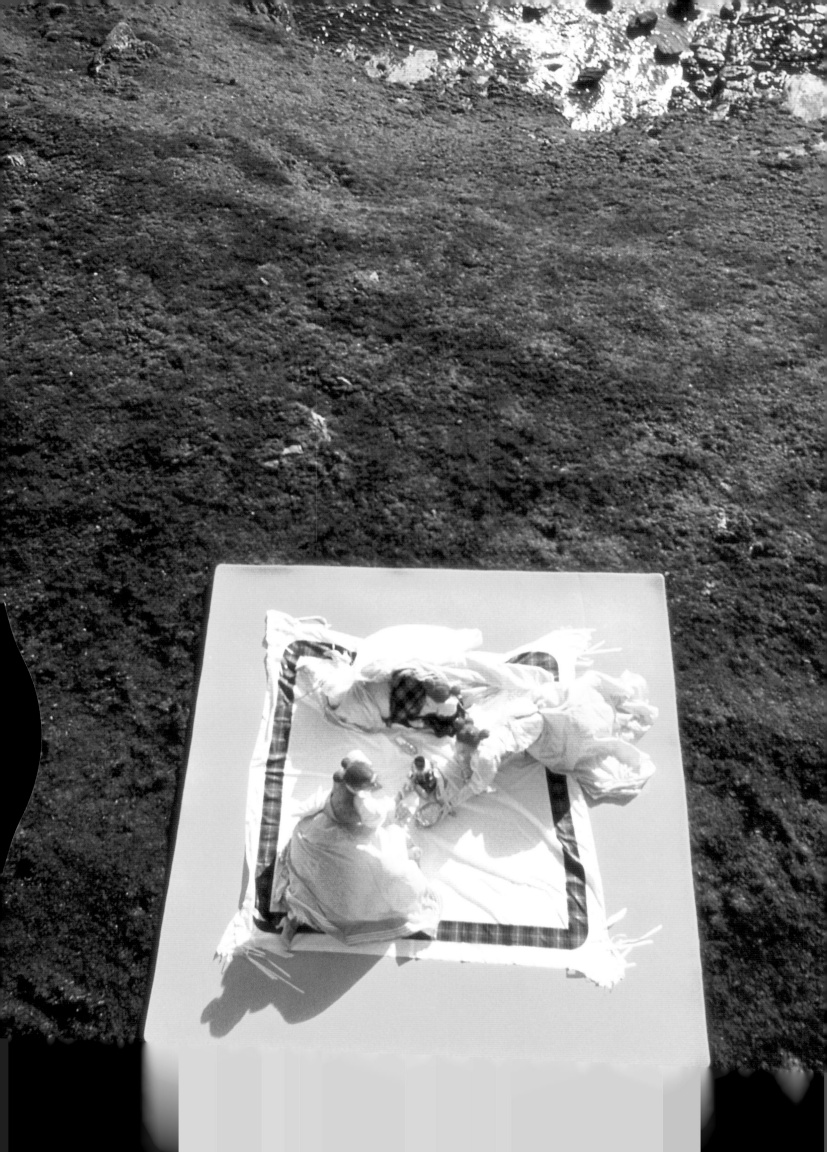

simple option LUNCHEON

42

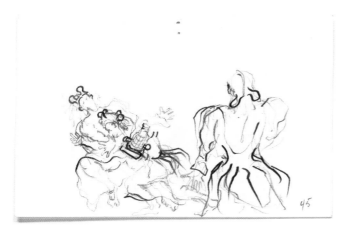

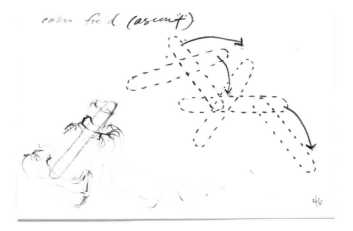

45

caber field (ascent)

46

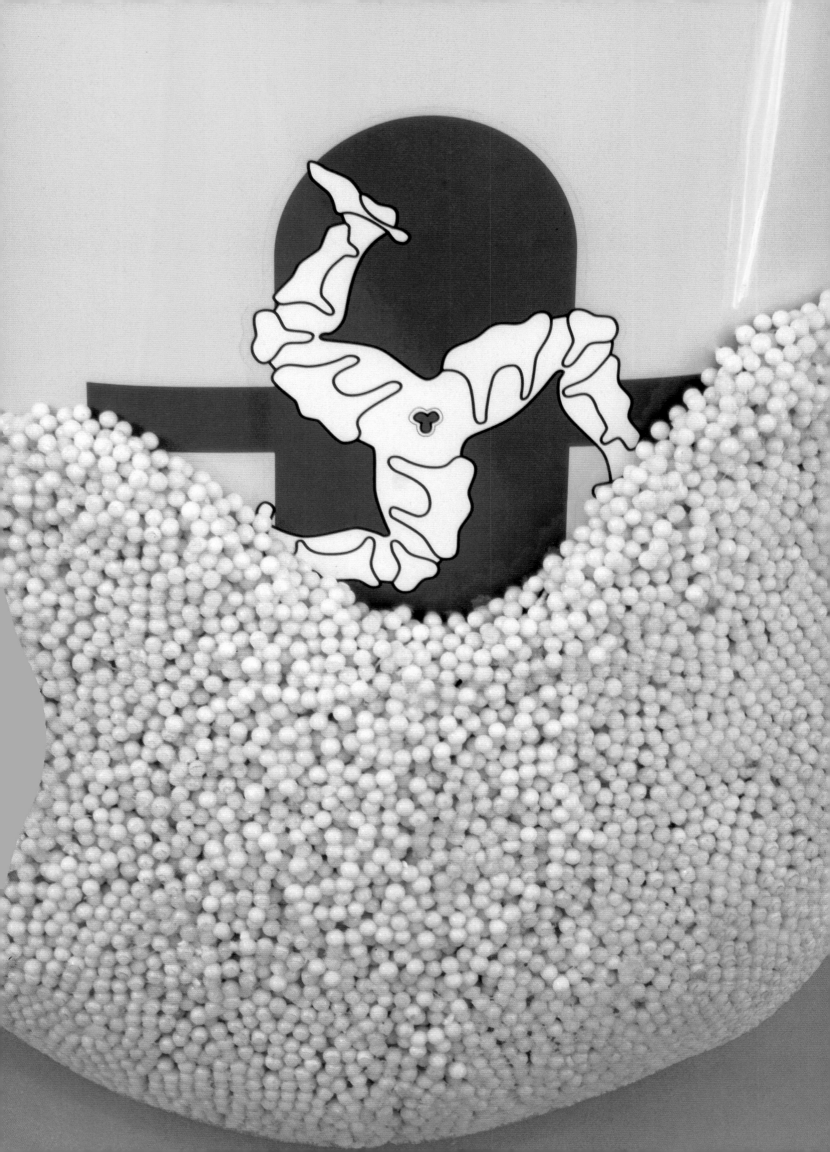

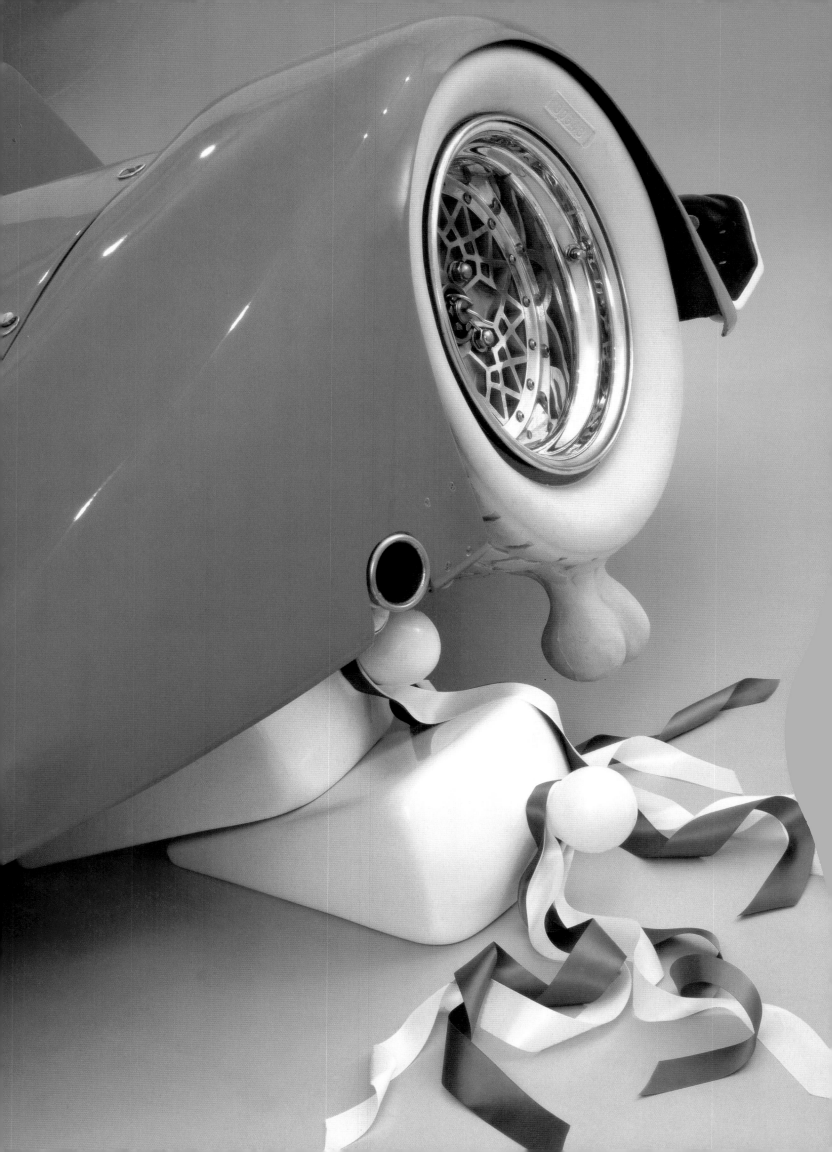

CREMASTER 4

descending HACK (b)²

48

descent (blue)

L

49

50

CREMASTER 4

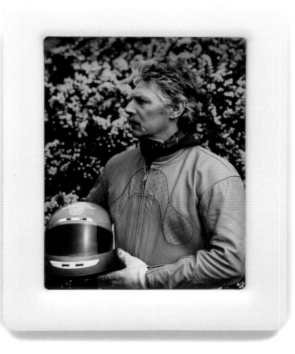

51

52

53

CREMASTER 4

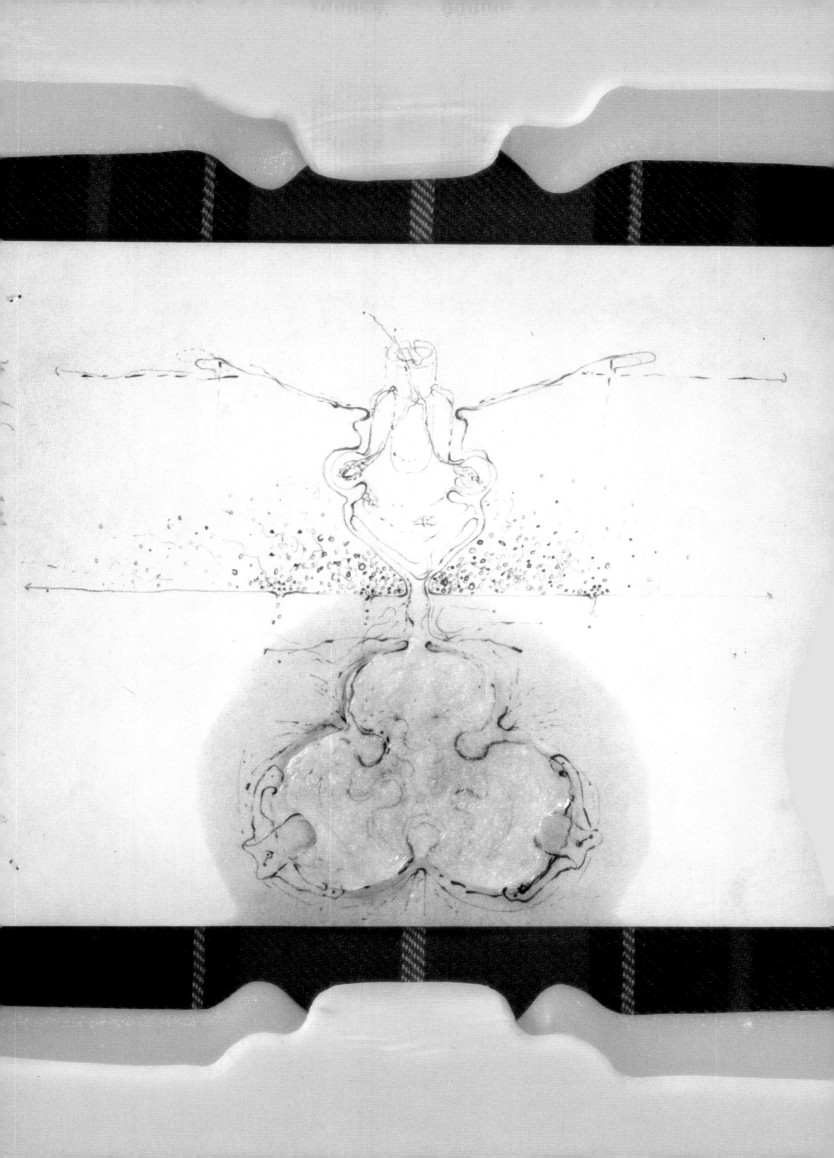

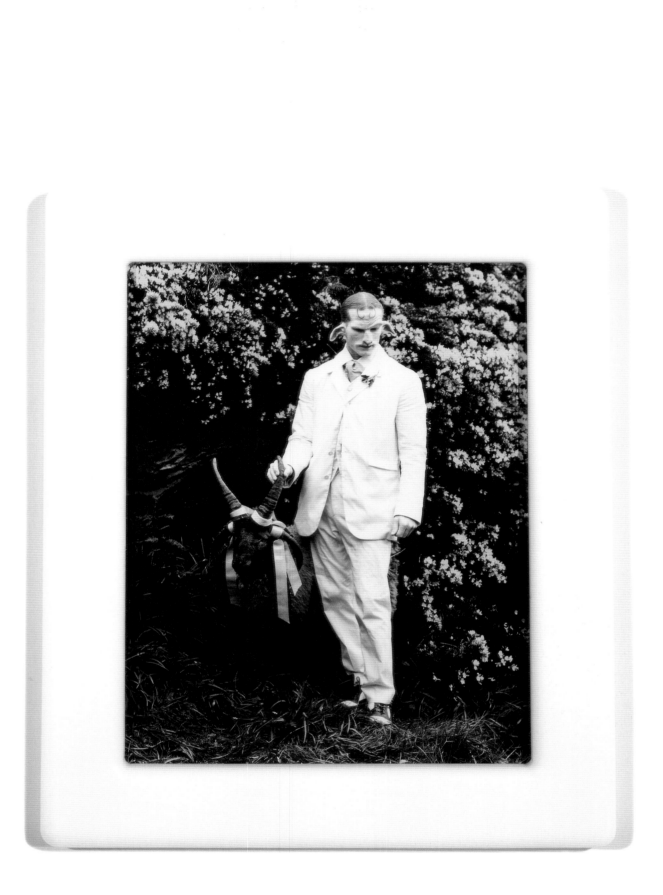

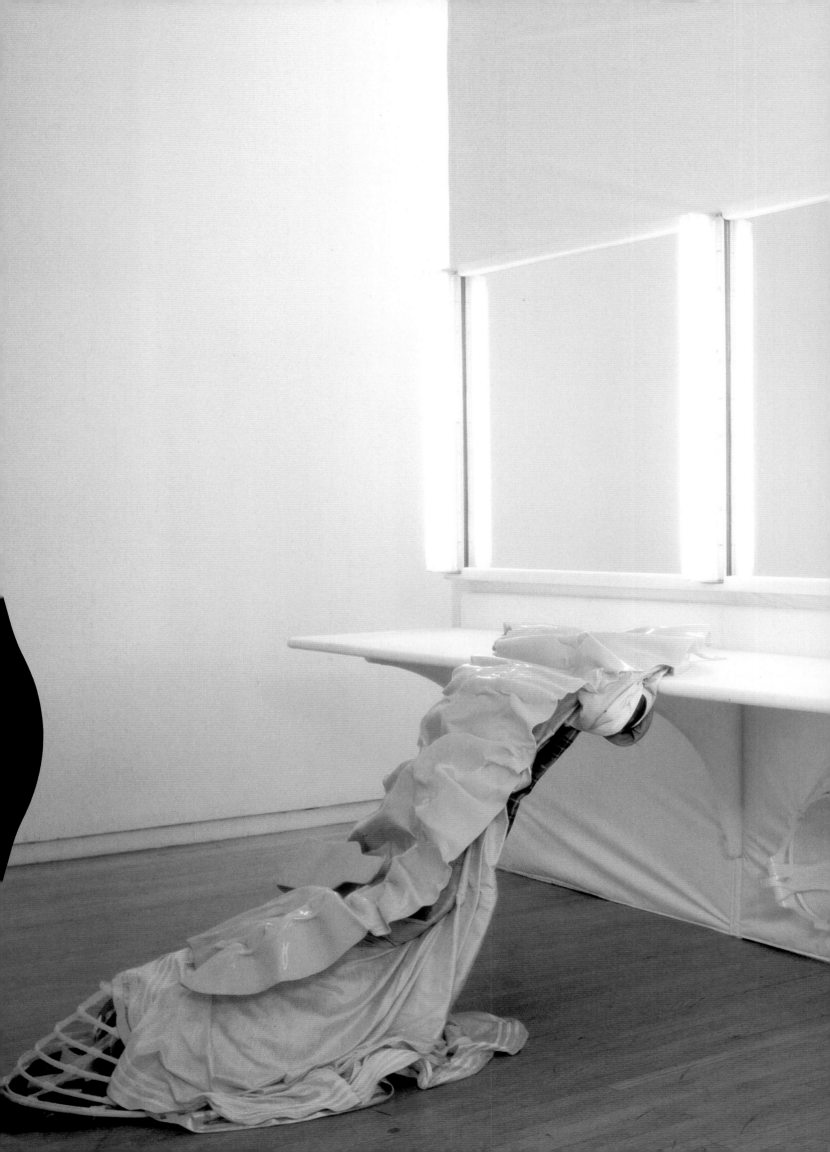

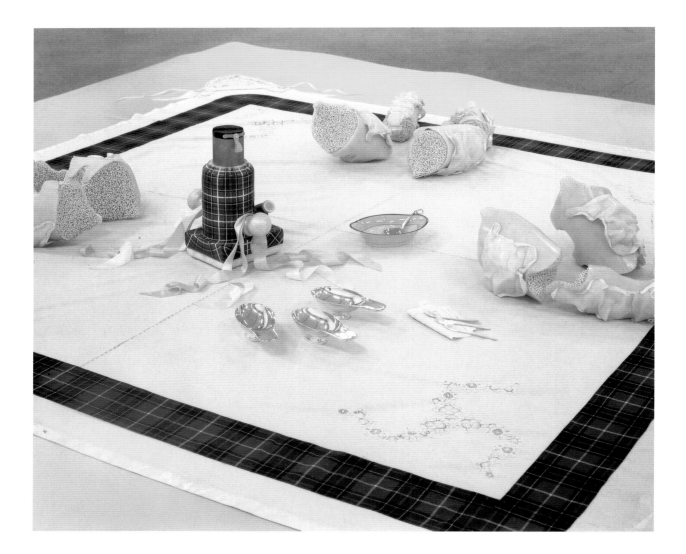

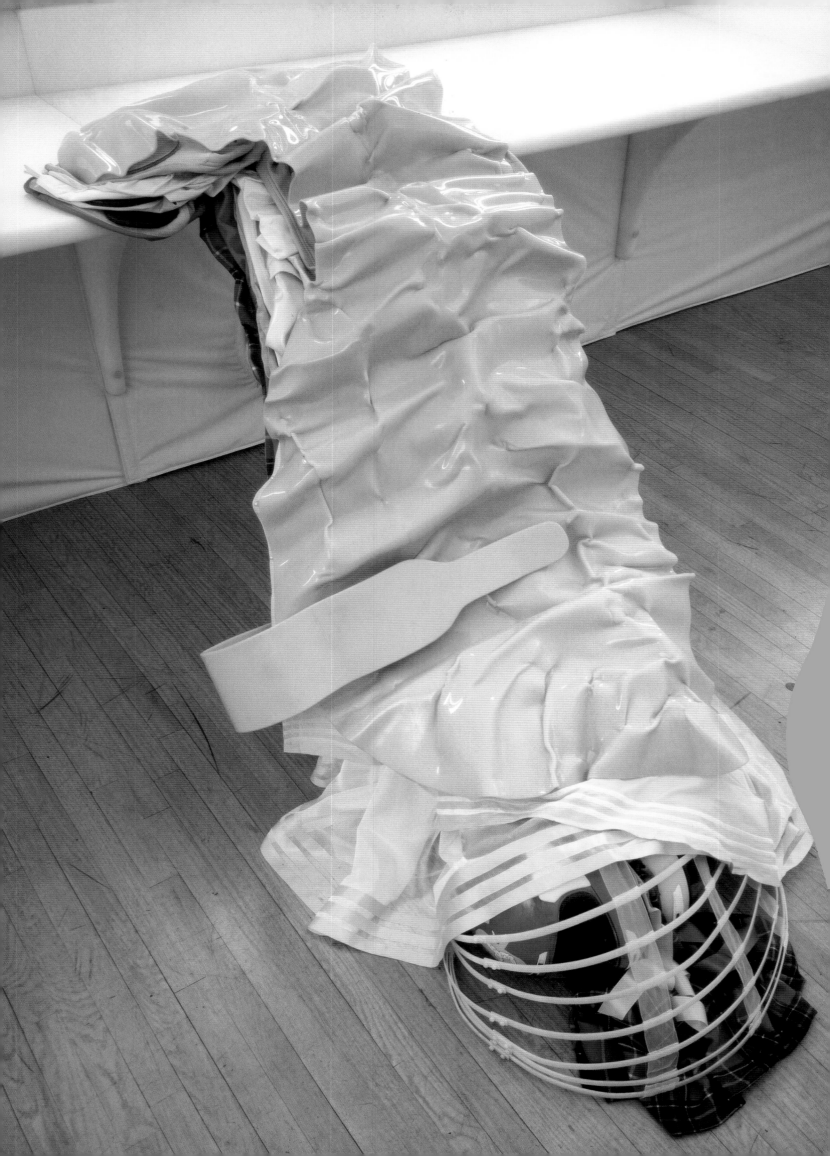

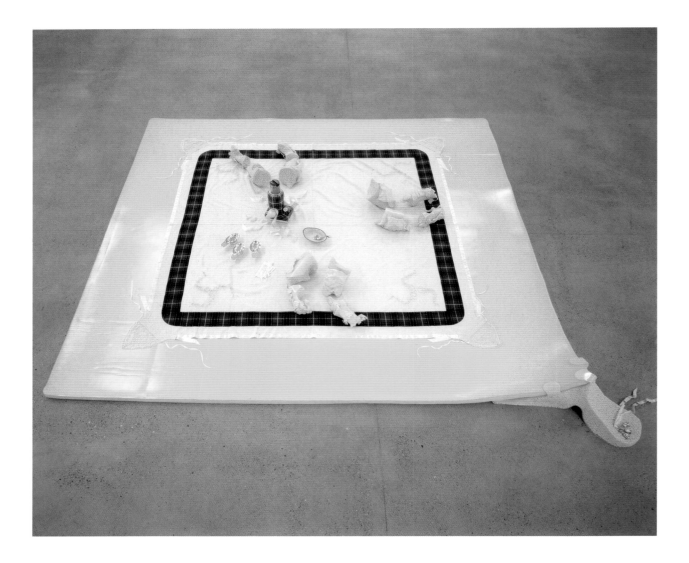

CREMASTER 4

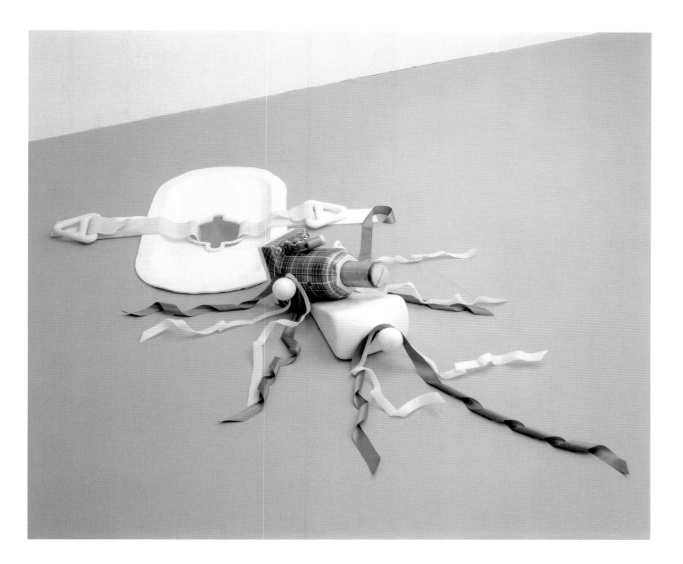

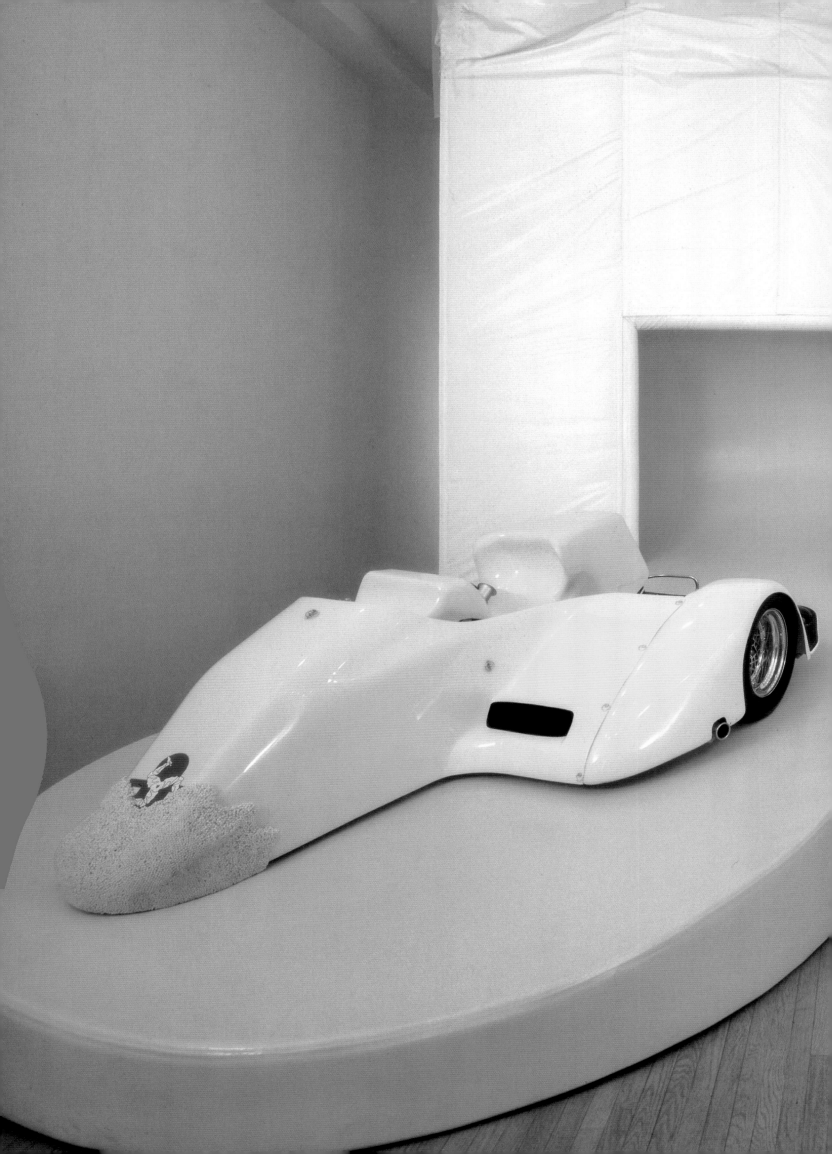

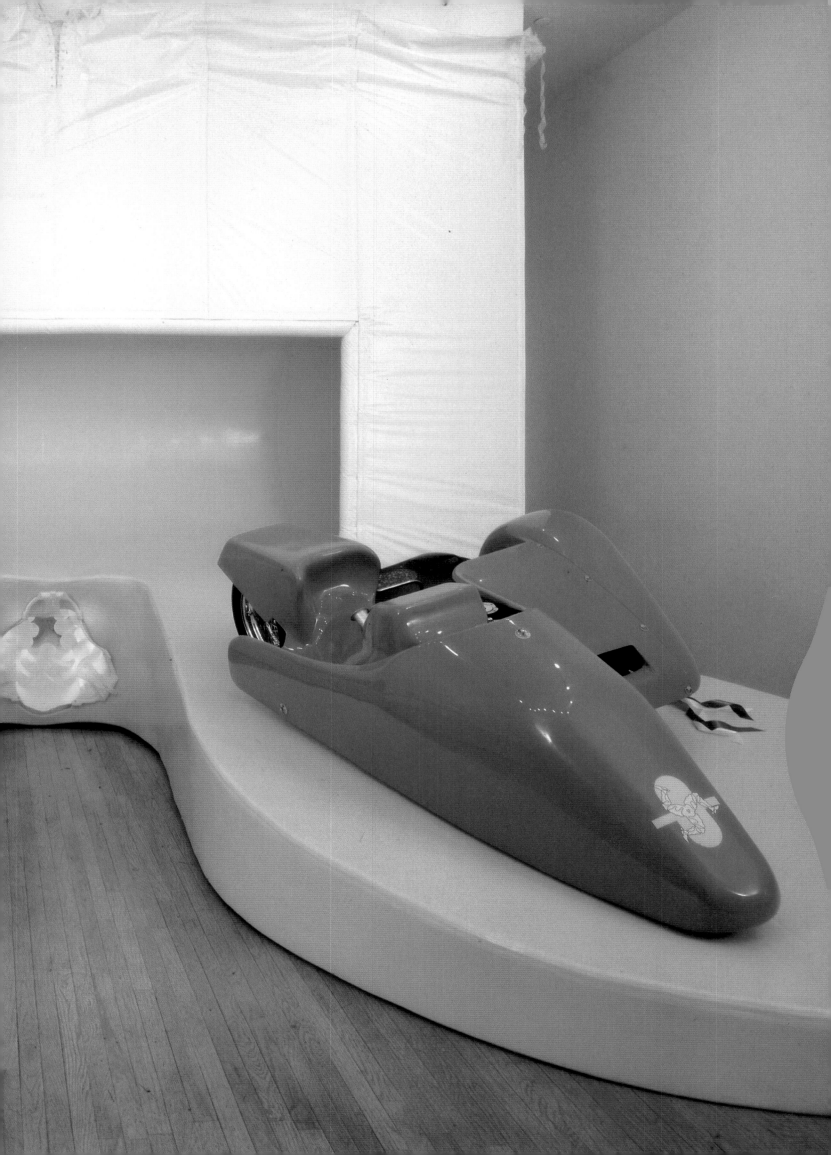

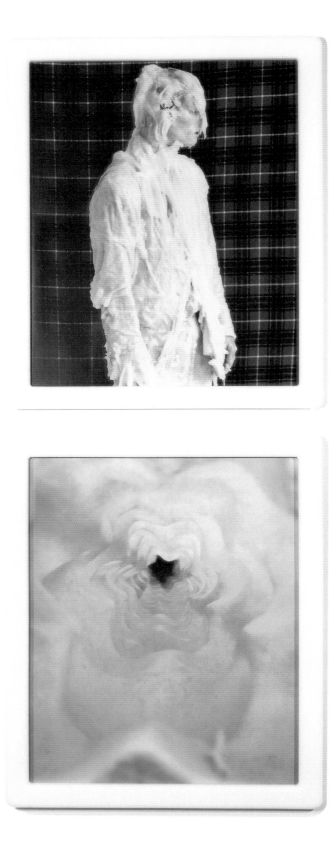

CREMASTER 4

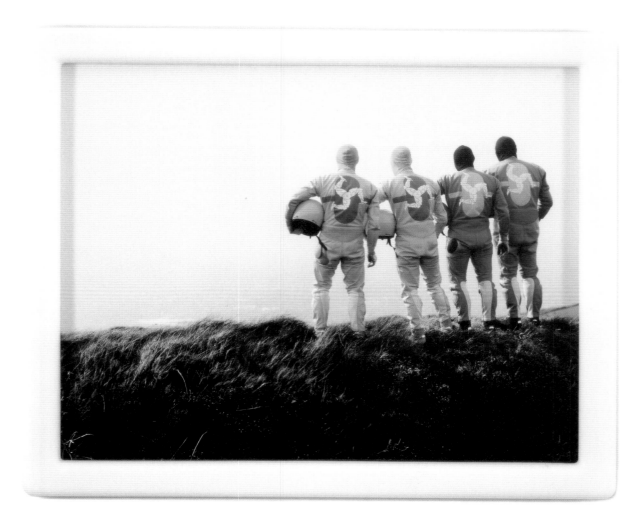

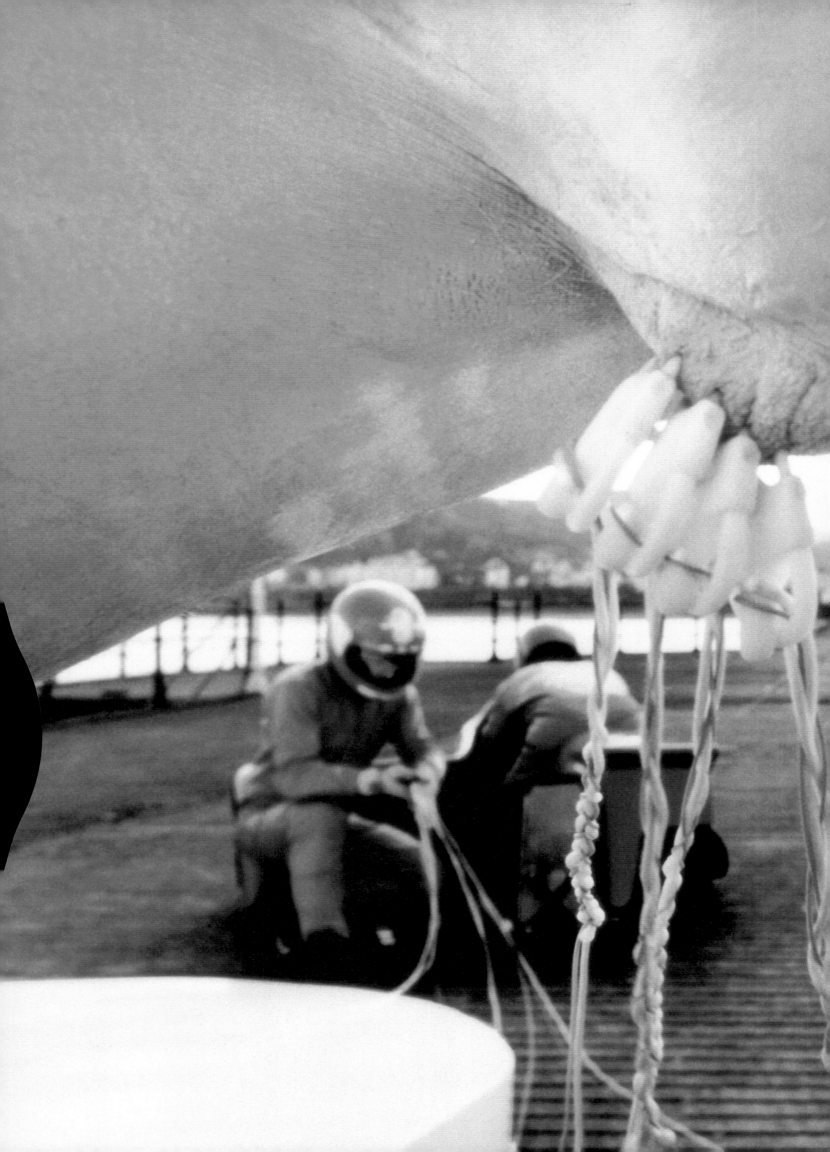

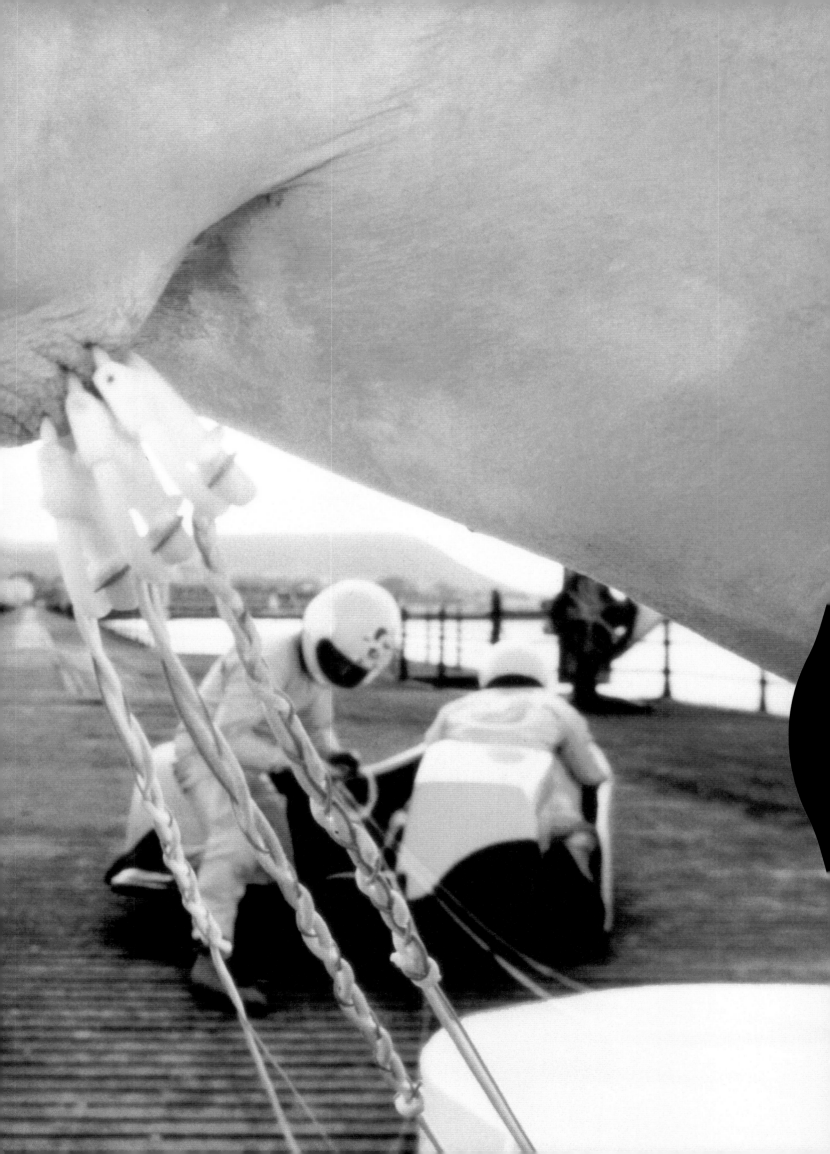

CREMASTER **5**

1997

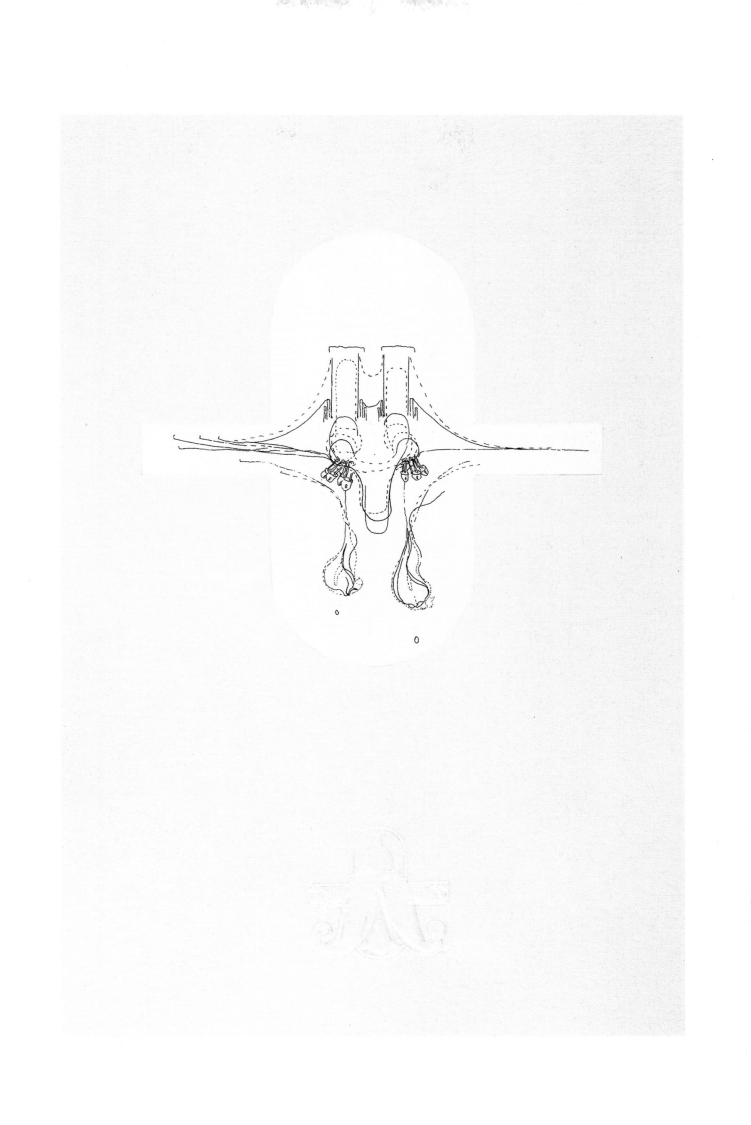

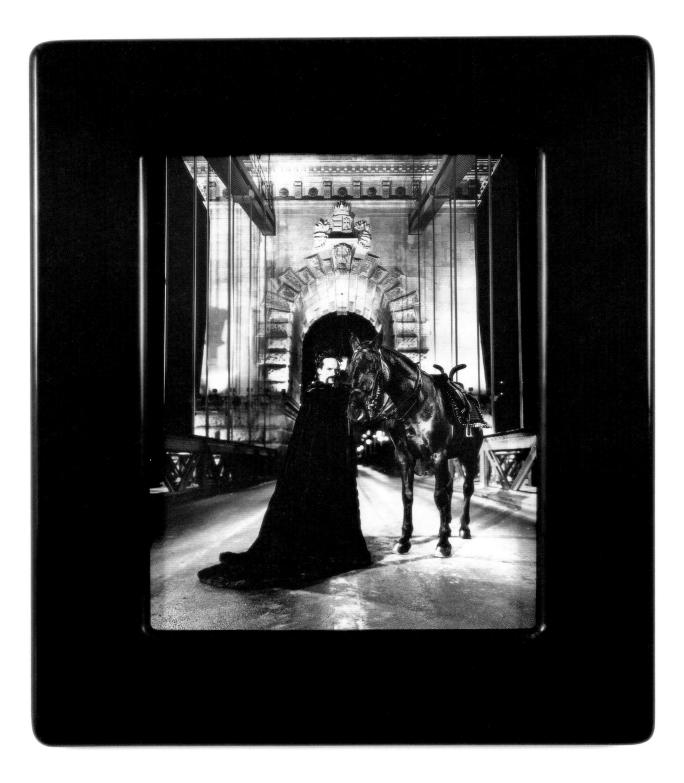

CREMASTER 5

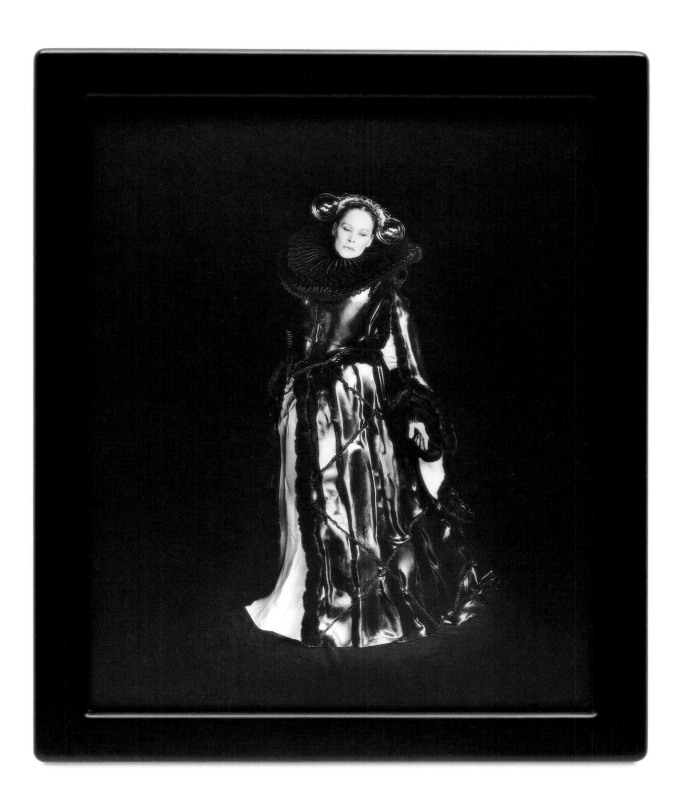

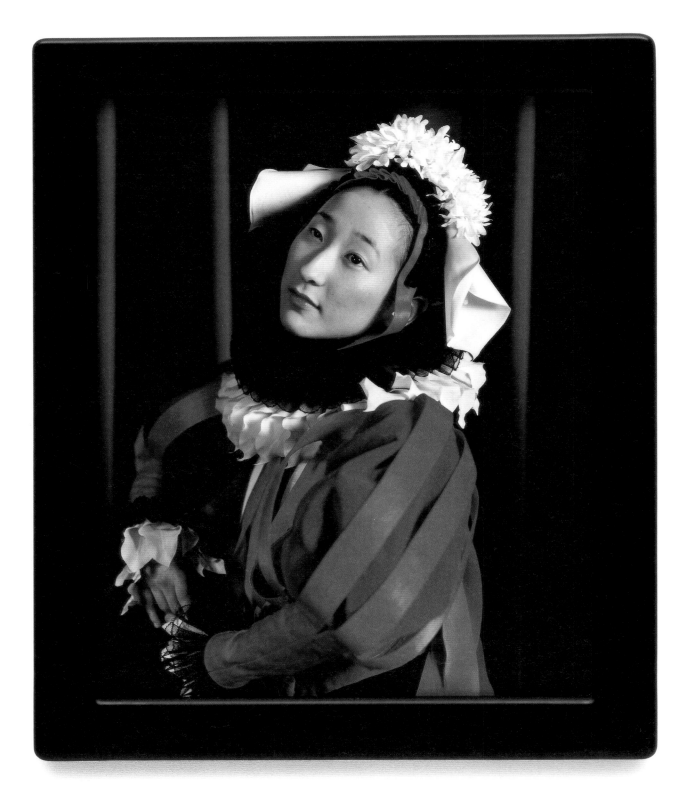

CREMASTER 5

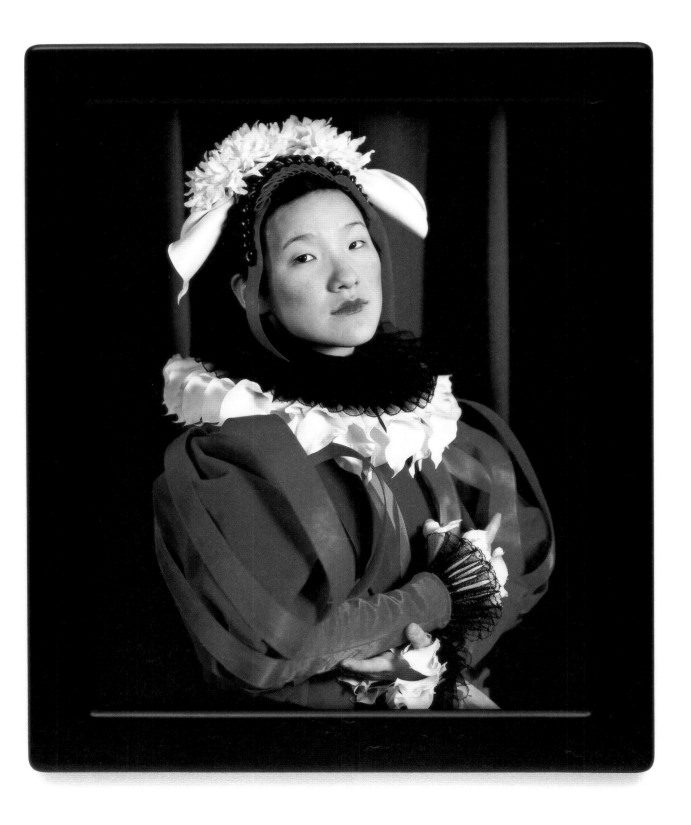

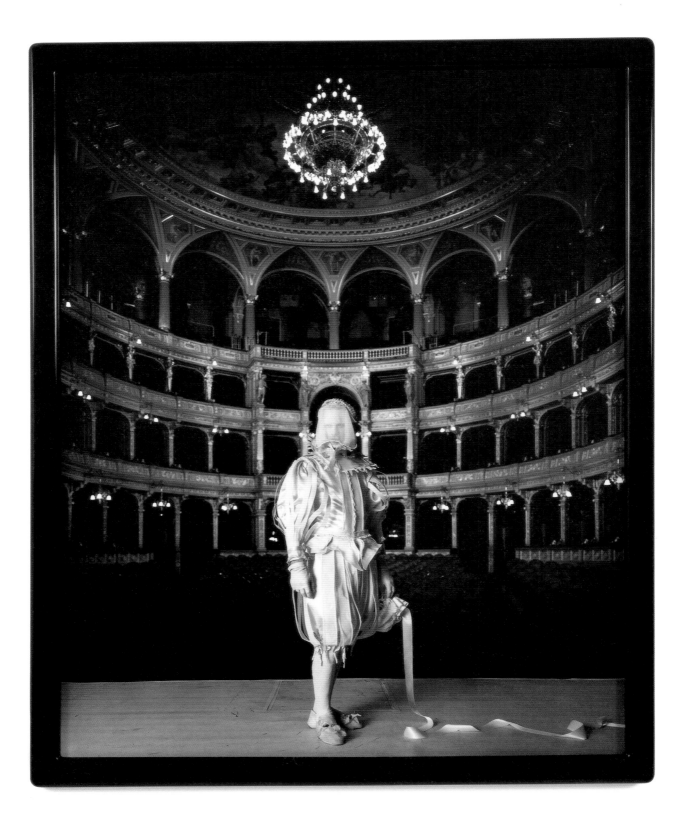

CREMASTER 5

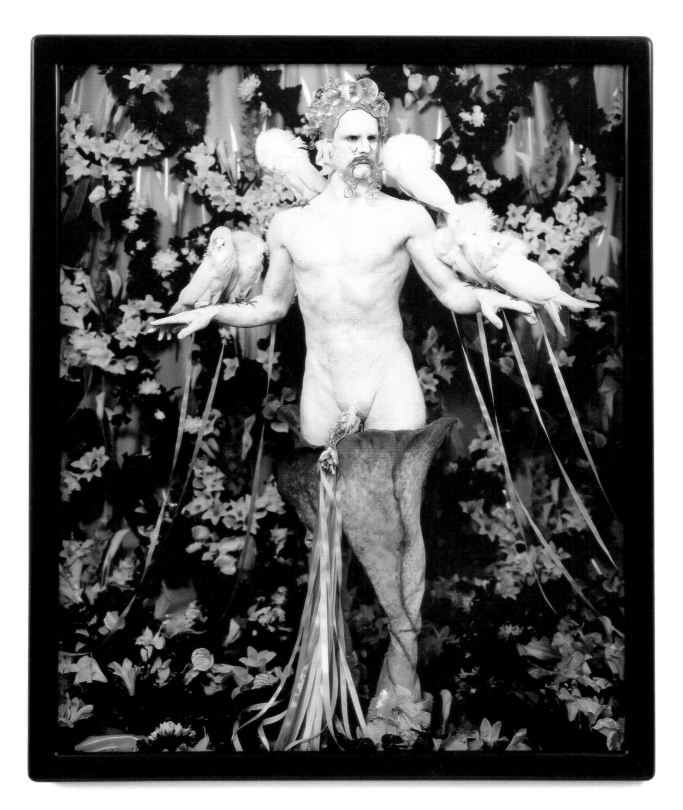

Proscenium : CR 5

royal boots
Bellew

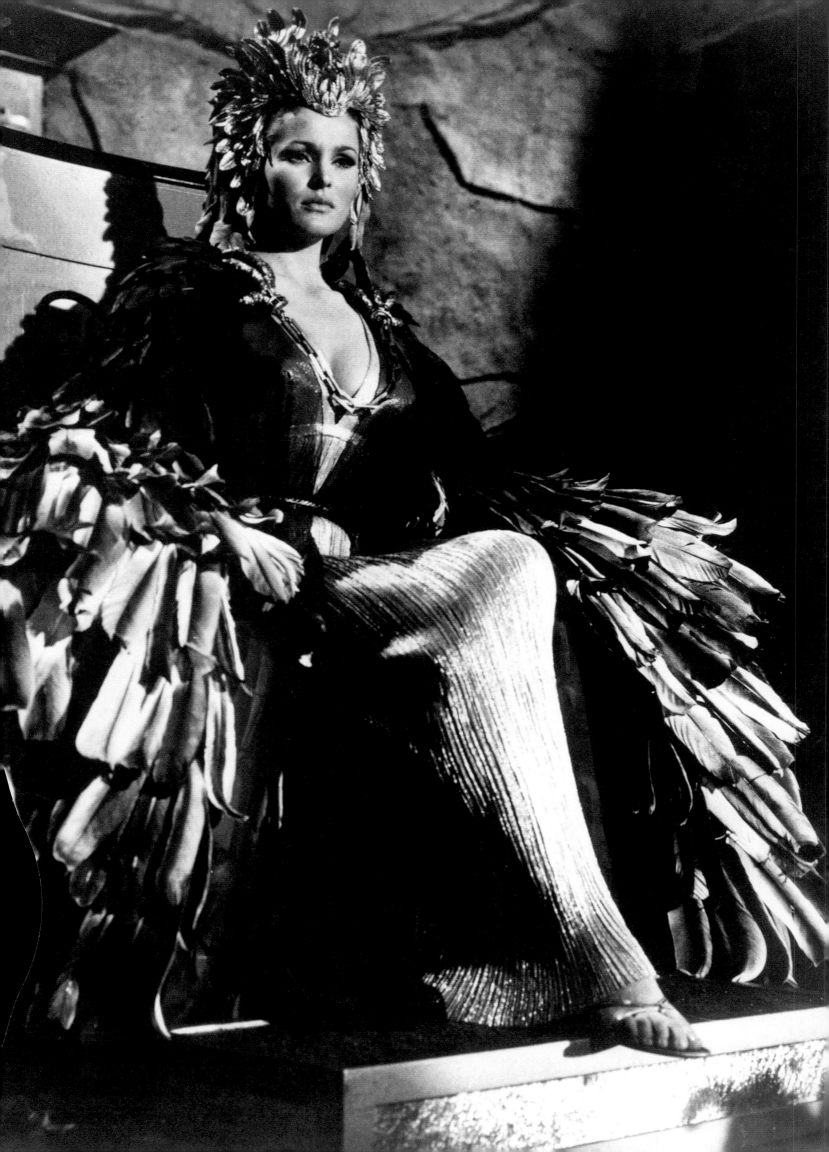

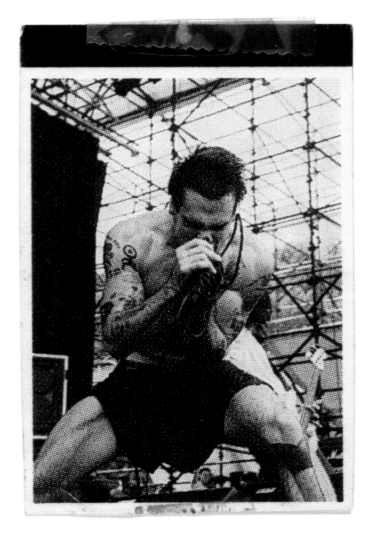

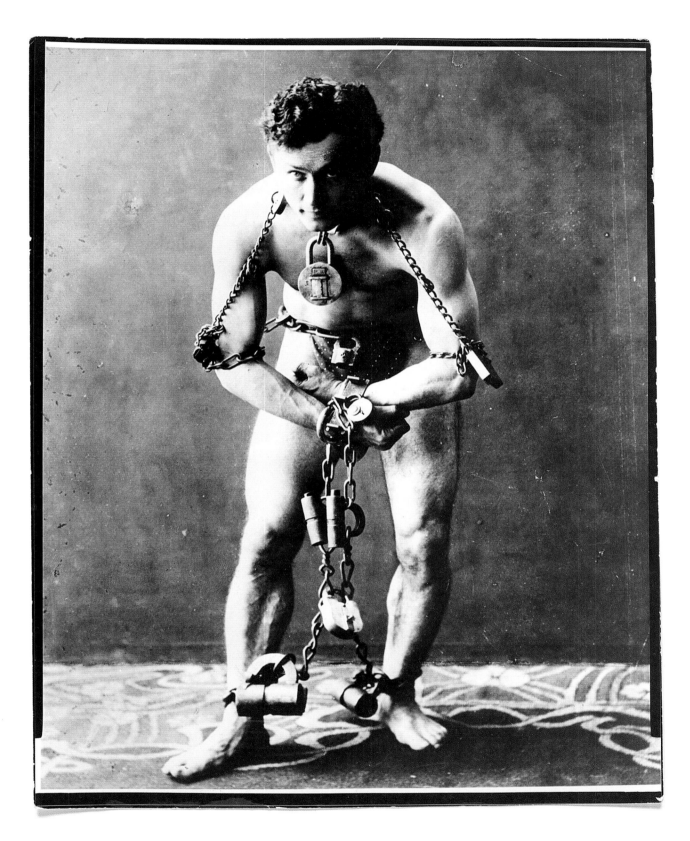

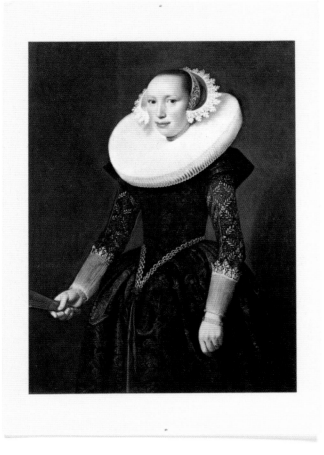

CREMASTER 5

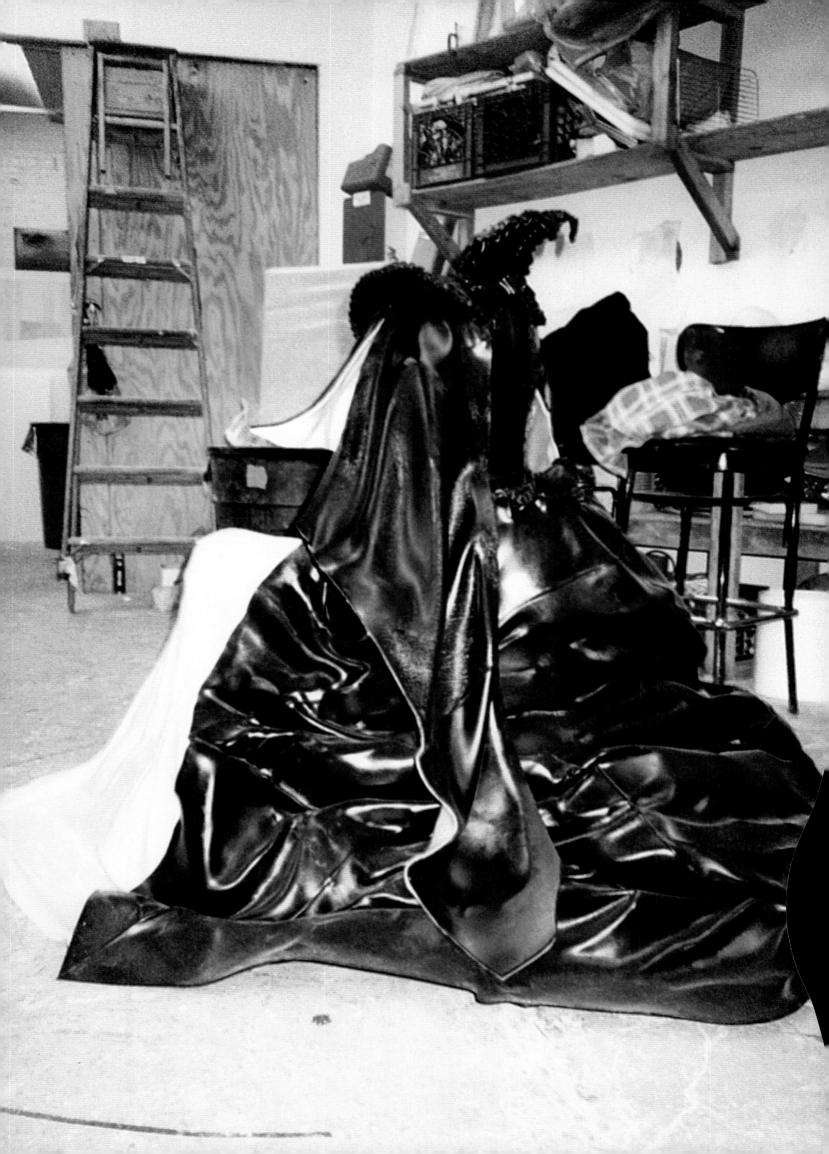

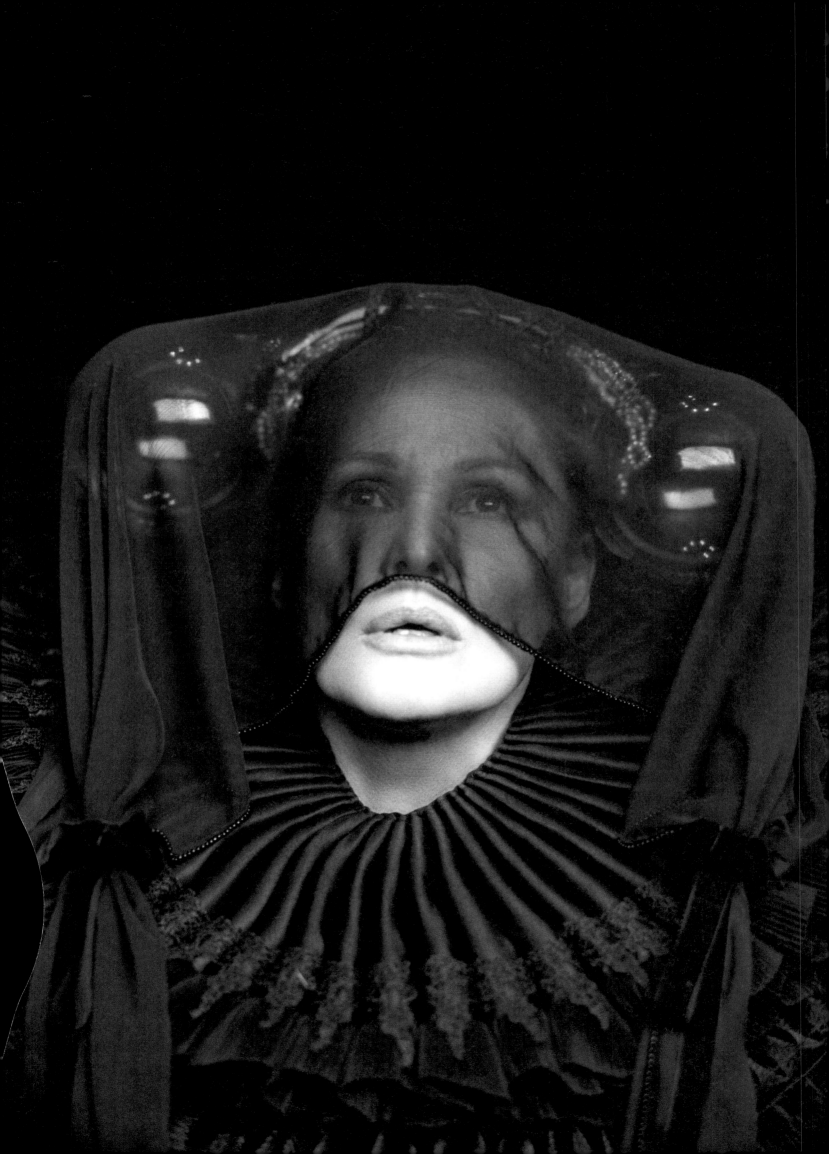

Proscenium

color

rec ZA

In their blue field
He stands alone
A vast expanse surrounds him

white
purple
blue
proscenium

rec 2b

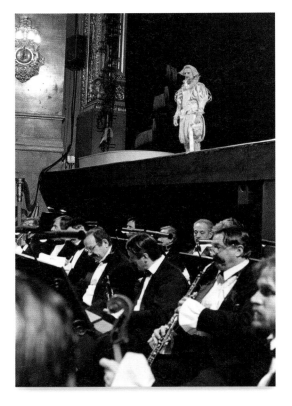

rec 2c

The gilded mint green field
Reflects his image
la a milky white highlight
Only red obscures her green
later: black overcomes red ARIA

SG1 = h. show

[rec 3]

Proscenium

...he... forces the... president
Turning past her axis
for a moment — he is free

avia
foot detail

421

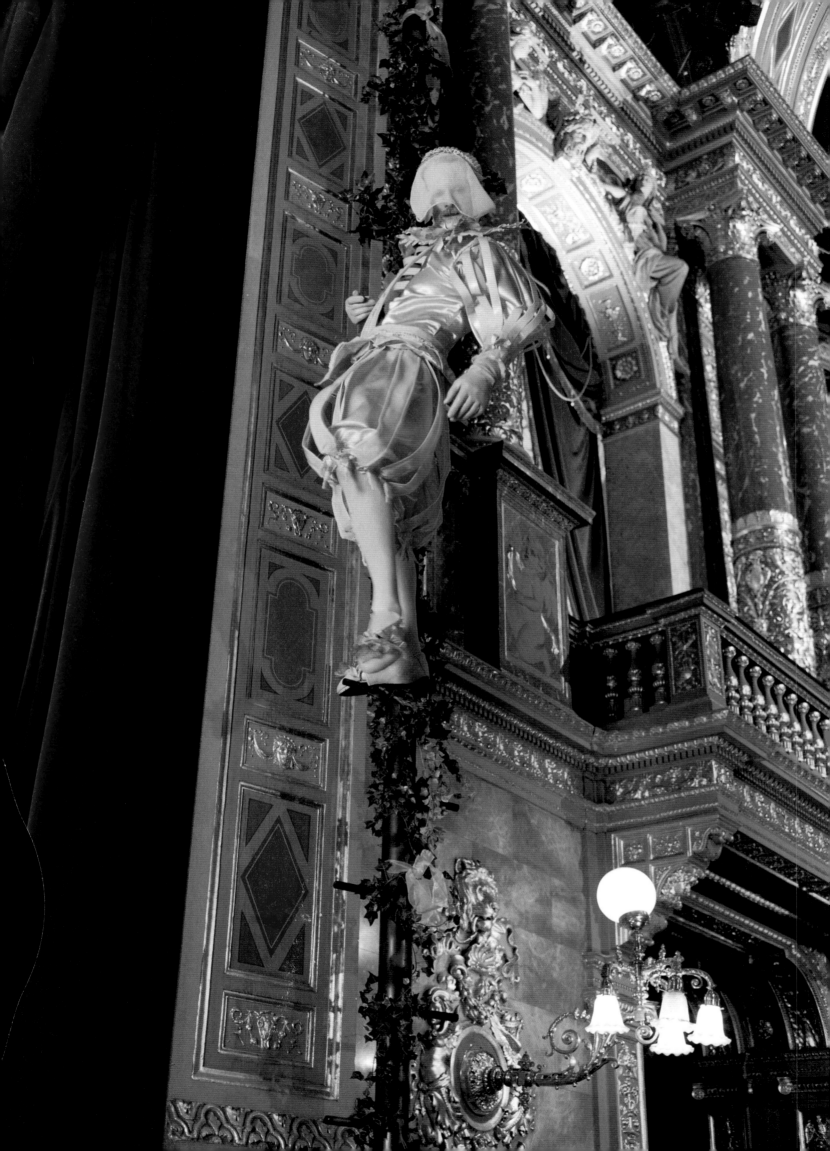

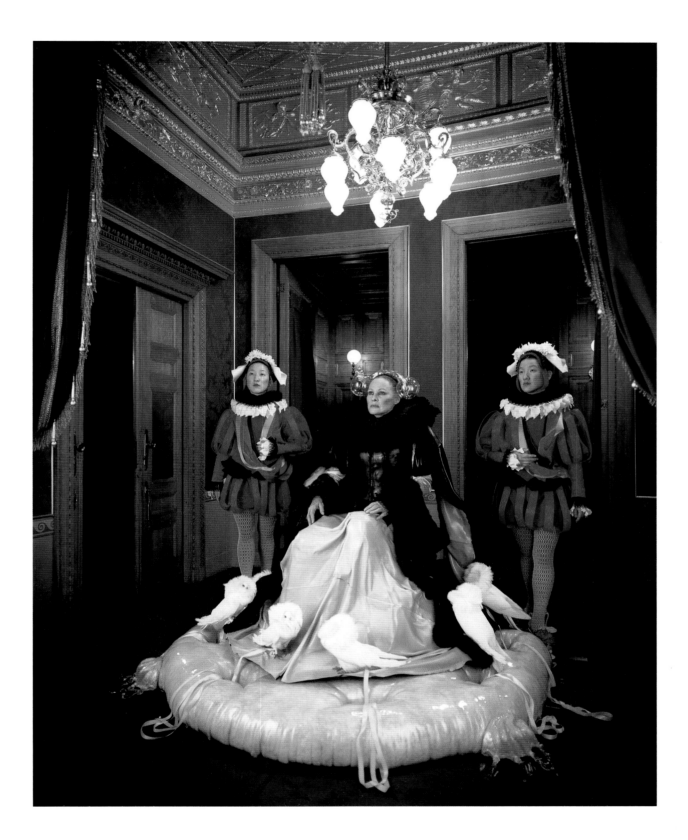

Lanchid

scotch bridge

CREMASTER 5

CREMASTER 5

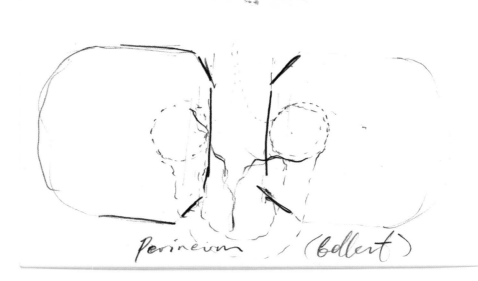

Perineum (bollert)

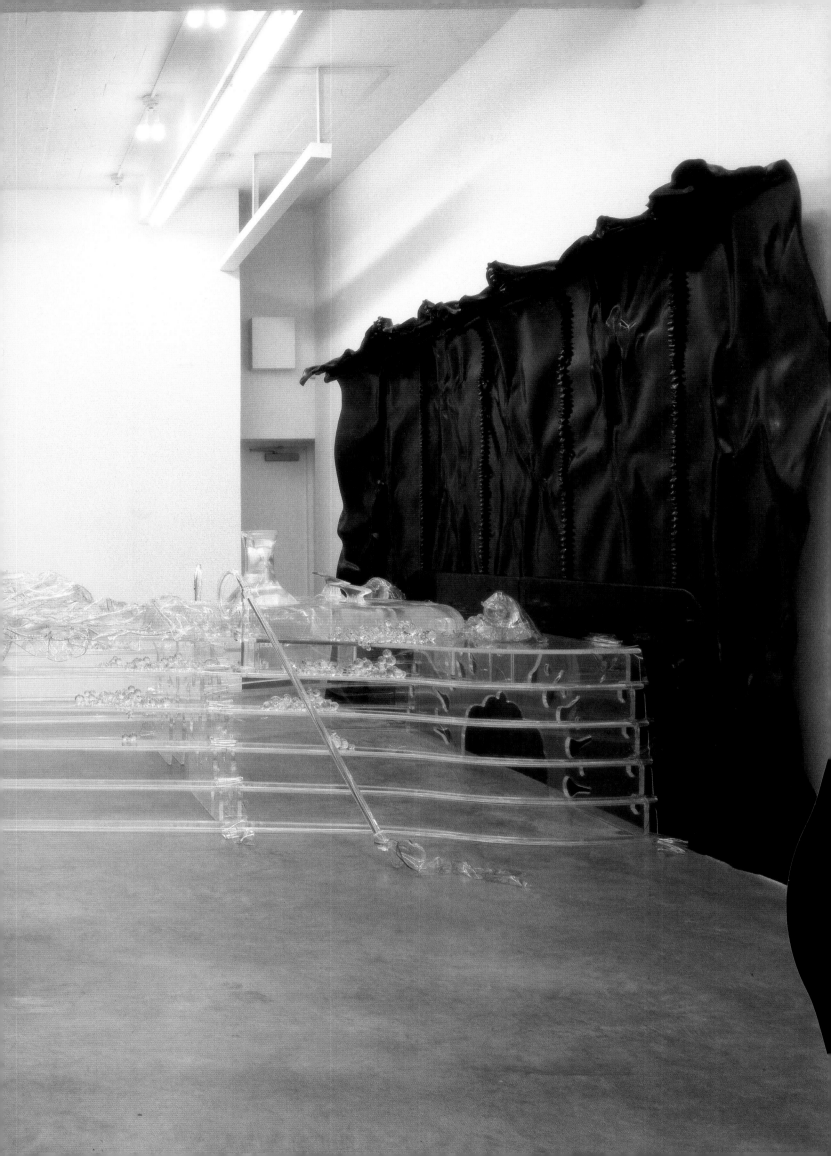

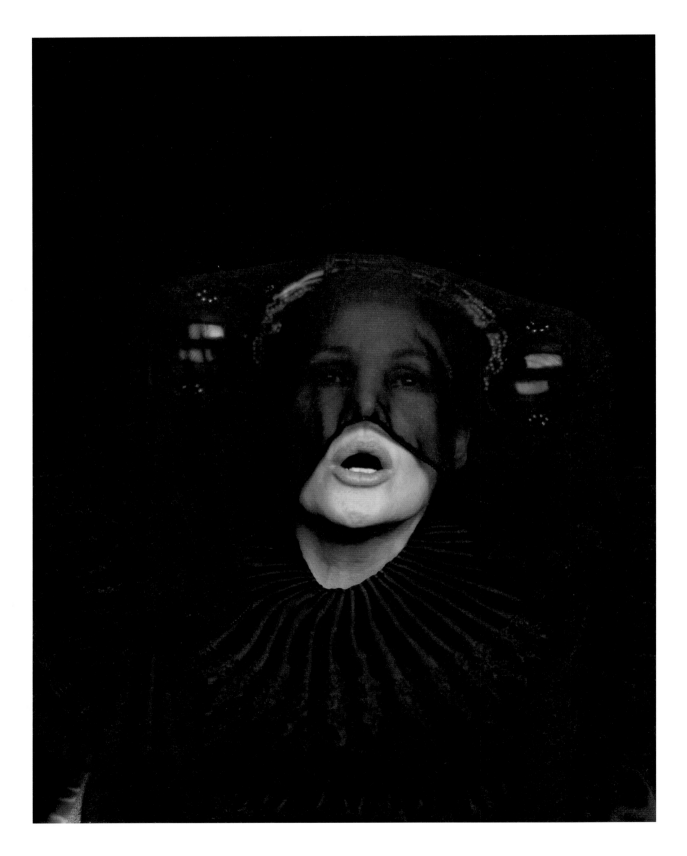

CREMASTER 5

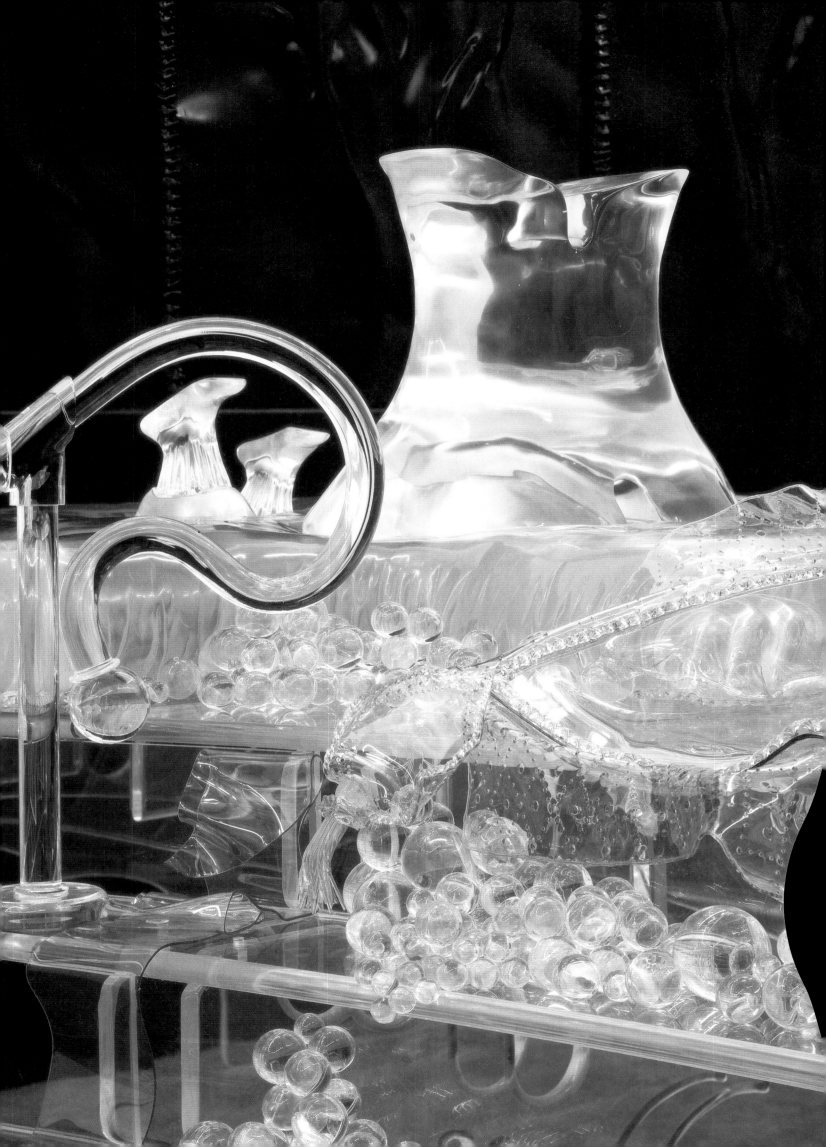

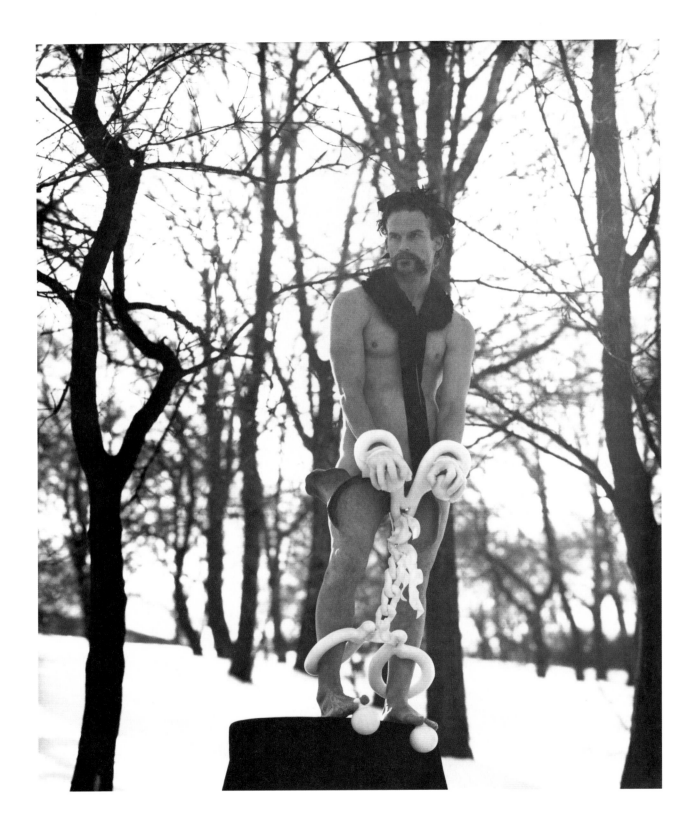

CREMASTER 5

CREMASTER 5

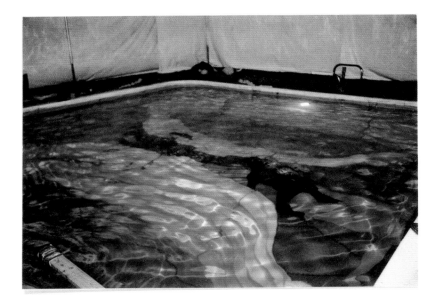

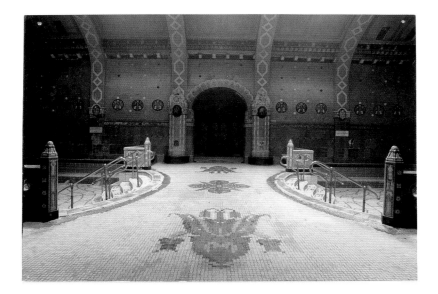

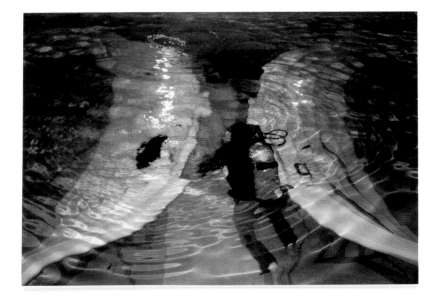

CREMASTER 5

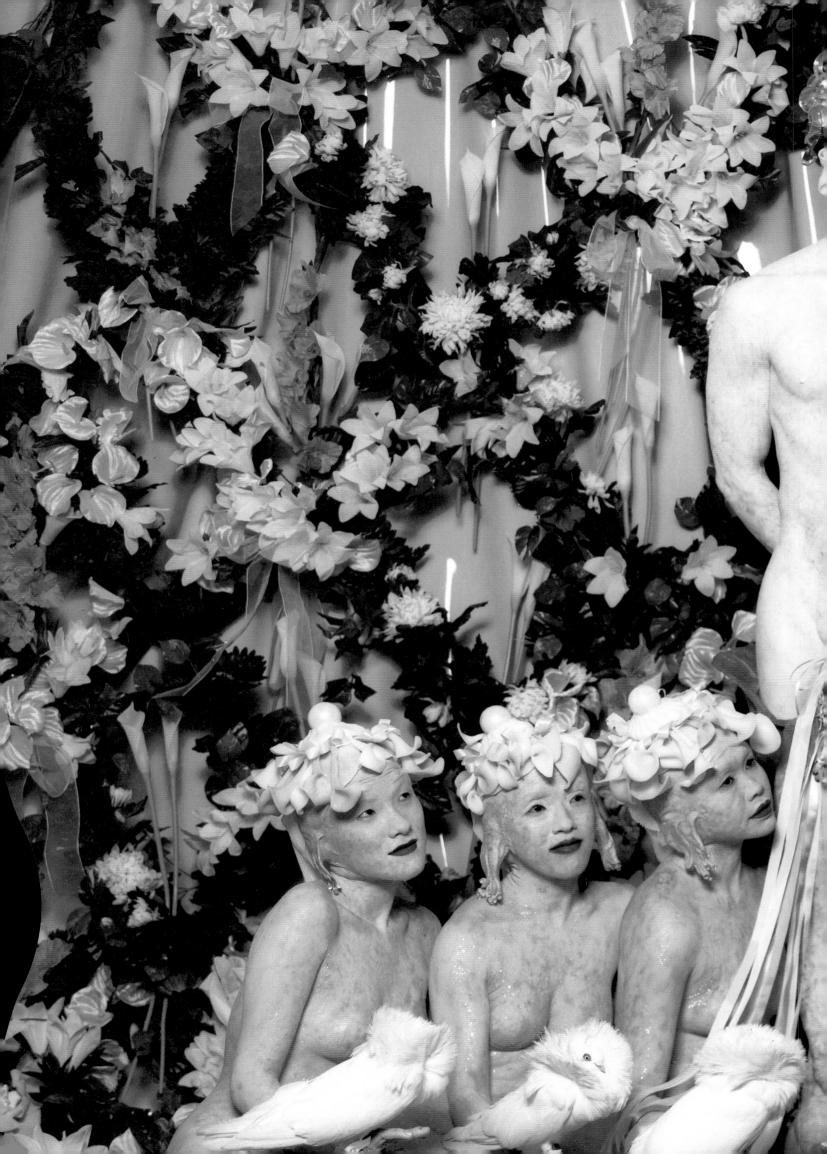

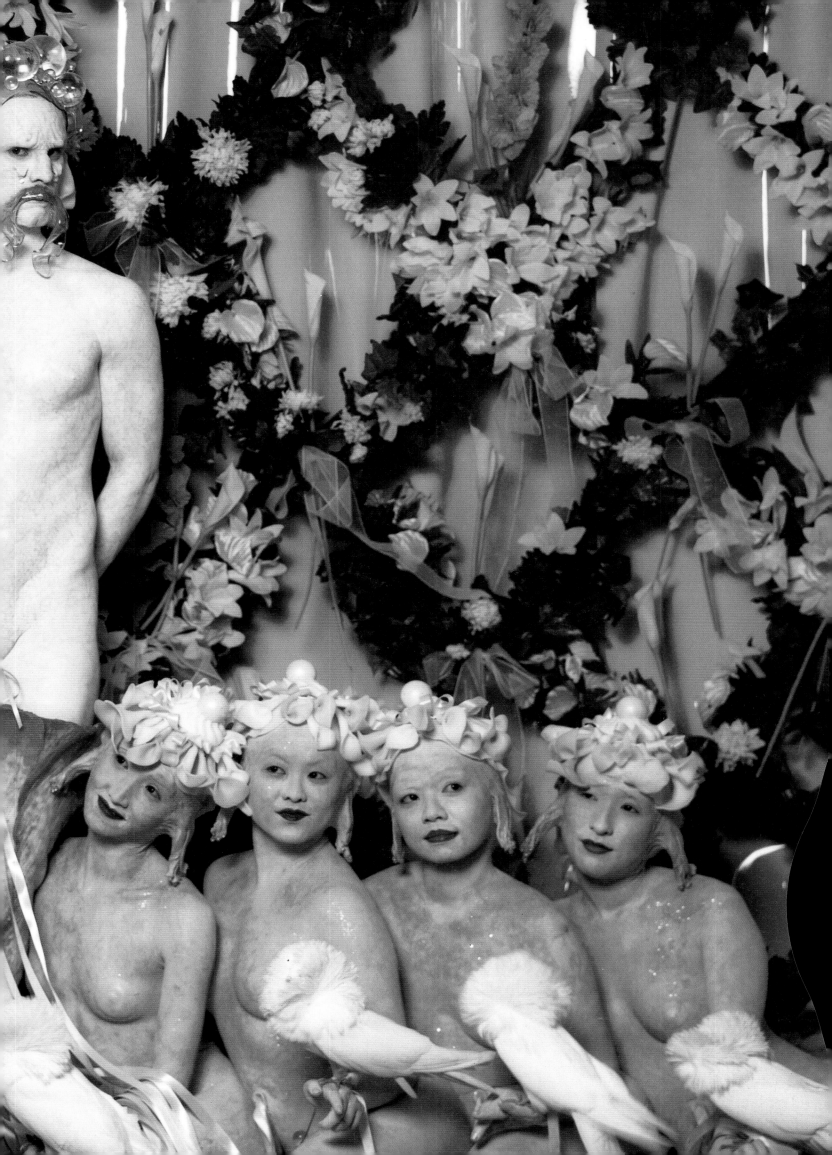

STEIGENBERGER FRANKFURTER HOF

Am Kaiserplatz · D-6000 Frankfurt/Main
Tel. (0 69) 2 15 02 · Tx. 4 11 806 · Telefax (0 69) 21 59 00

CREMASTER 5

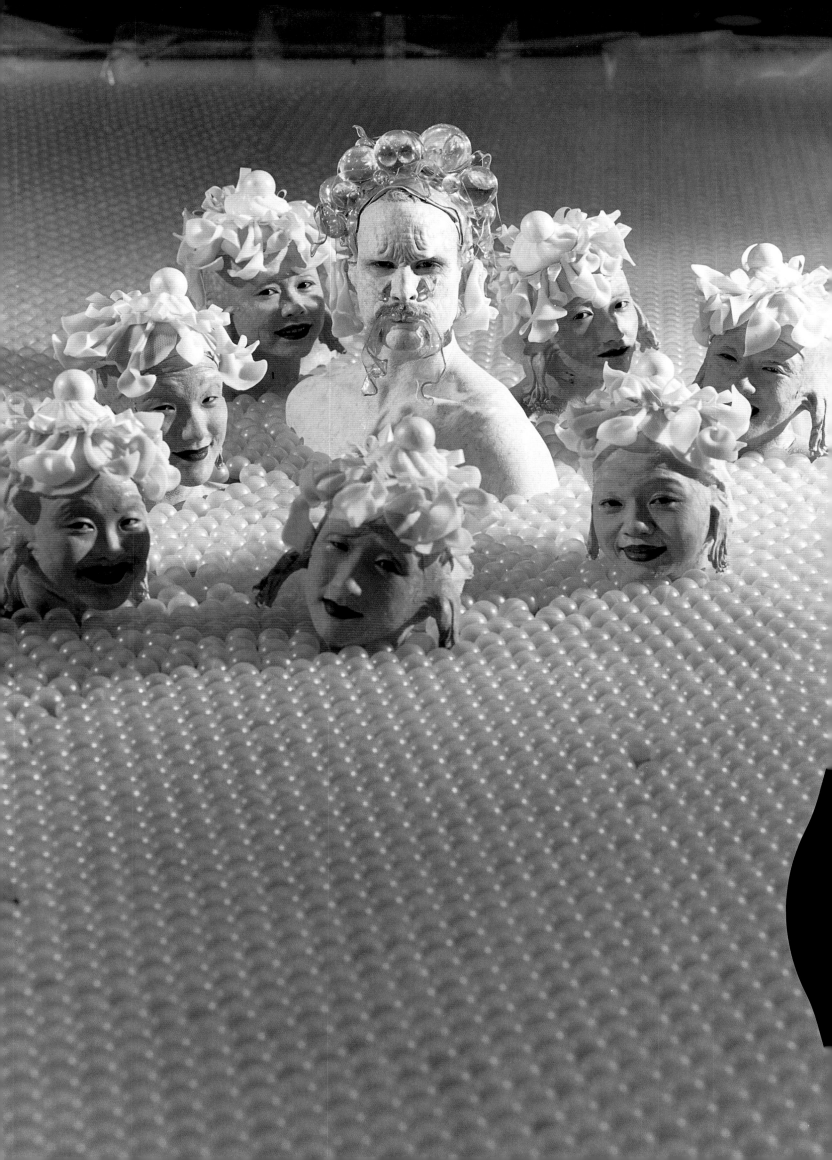

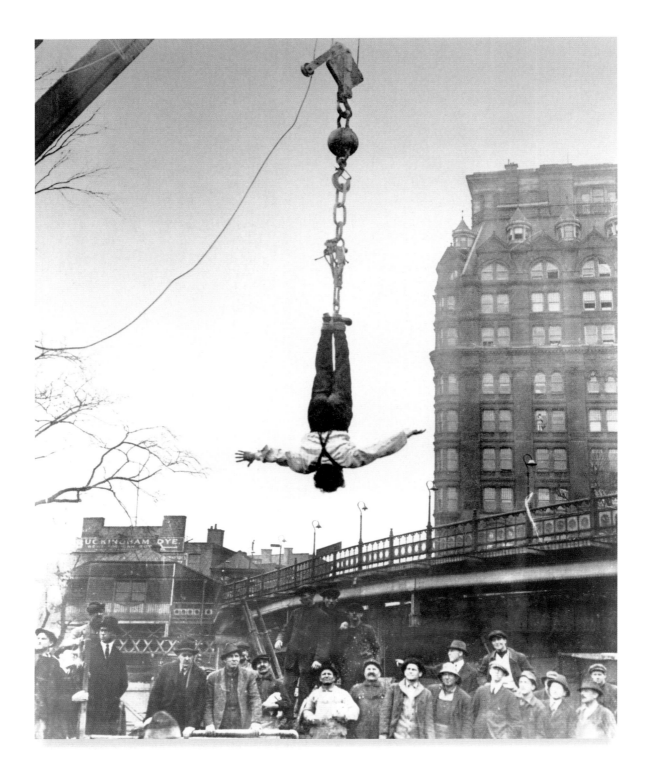

CREMASTER 5

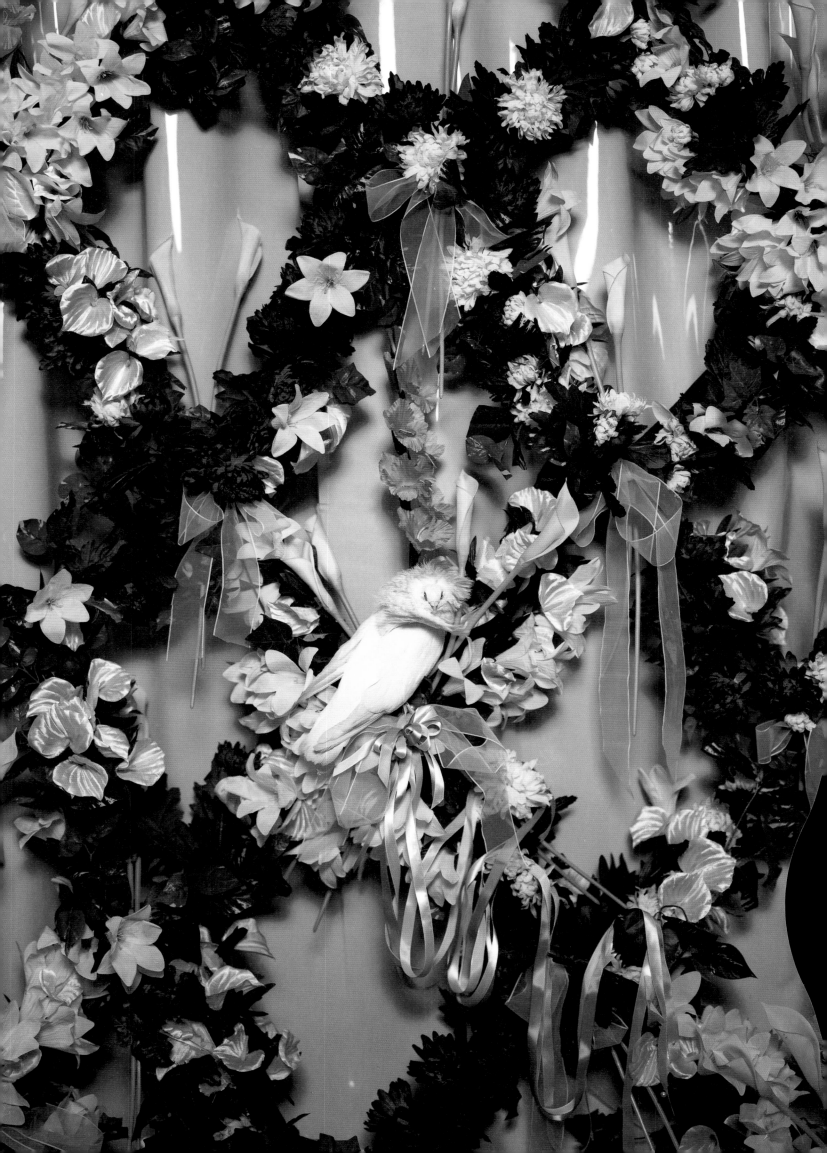

CREMASTER 5

Aria notes possible ending (refrain)

We fall, my love, ~~together~~
Come ~~for~~ me, (until now holding)
Release (until now holding)

Release

Release

Release

scotch bridge

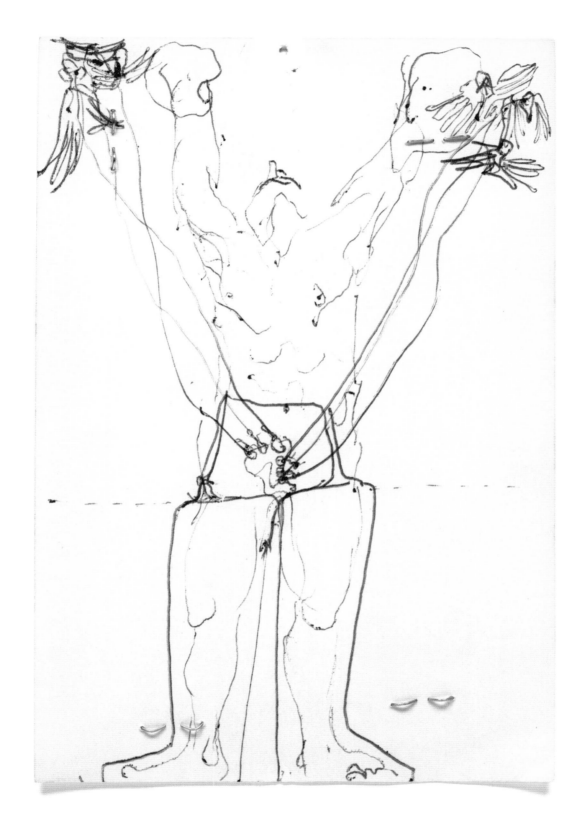

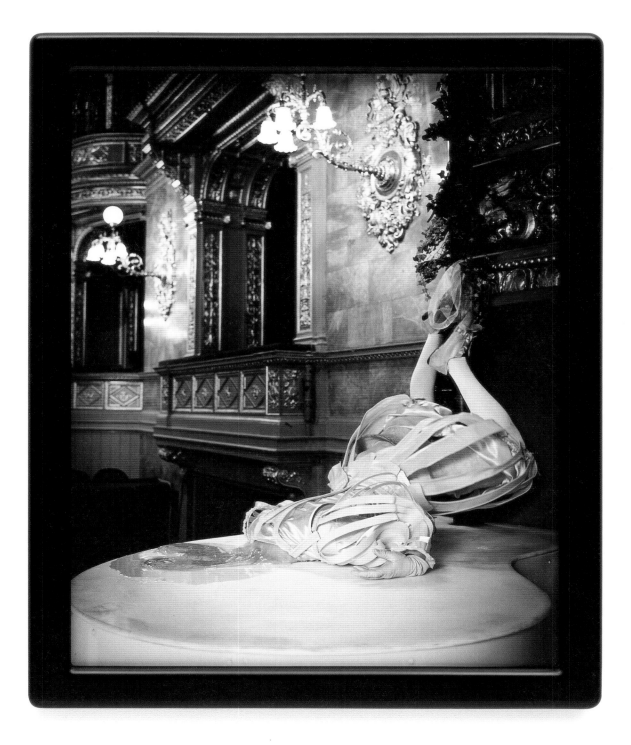

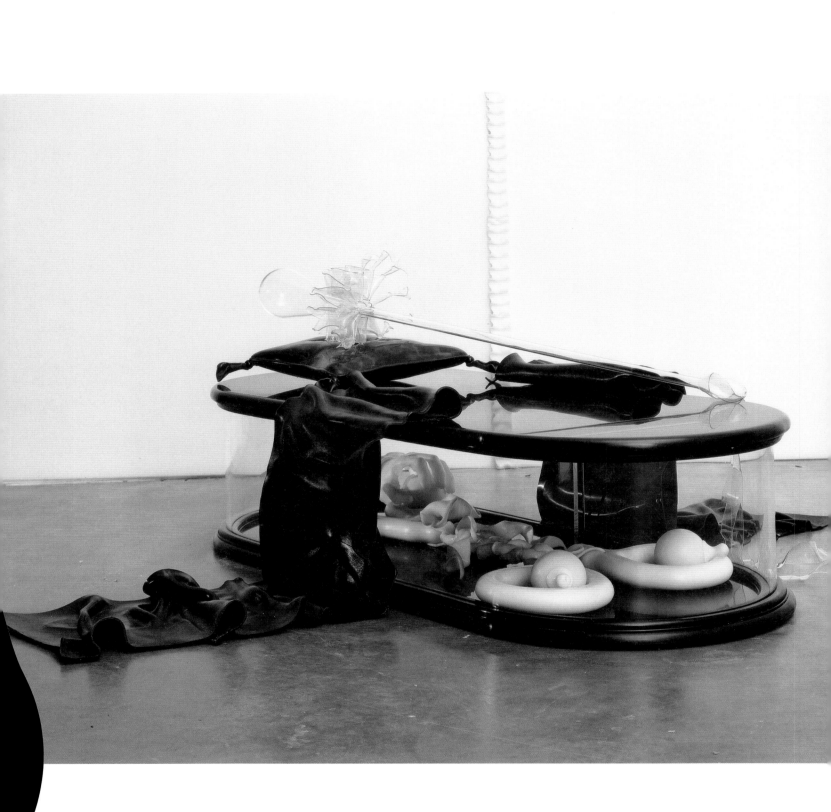

CREMASTER 5

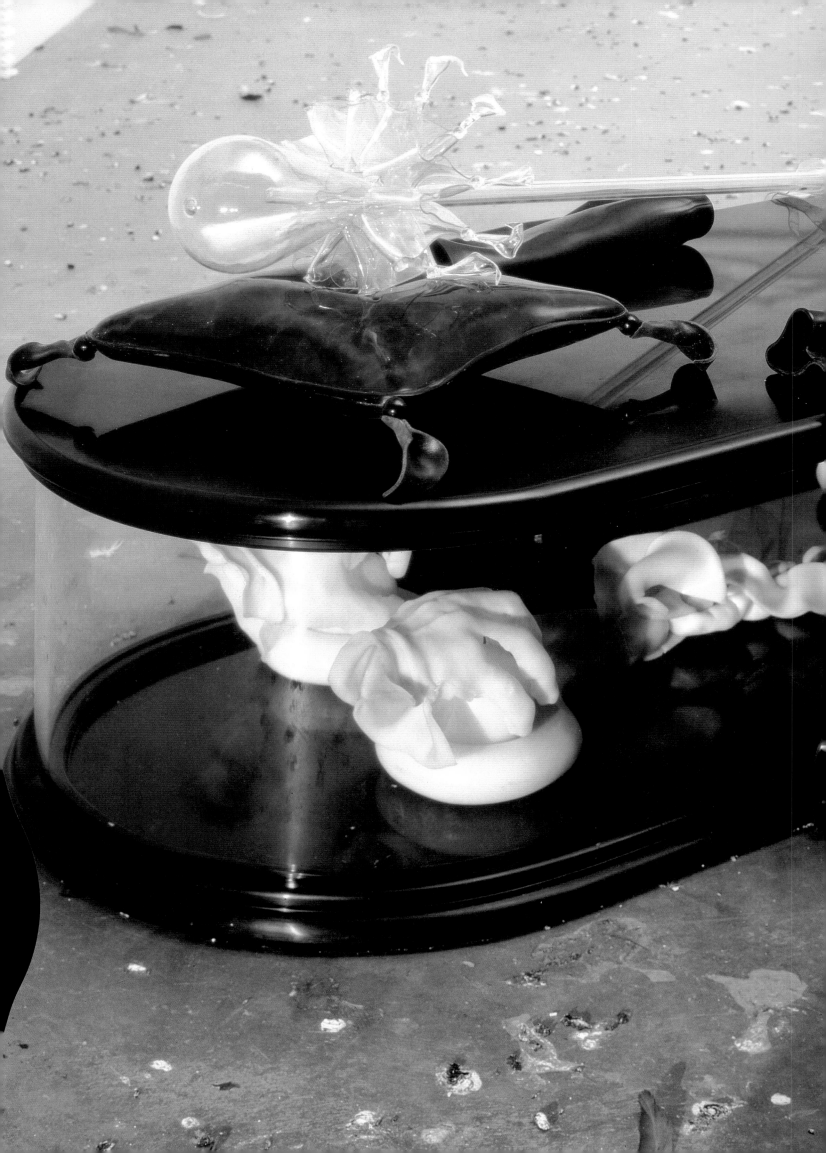

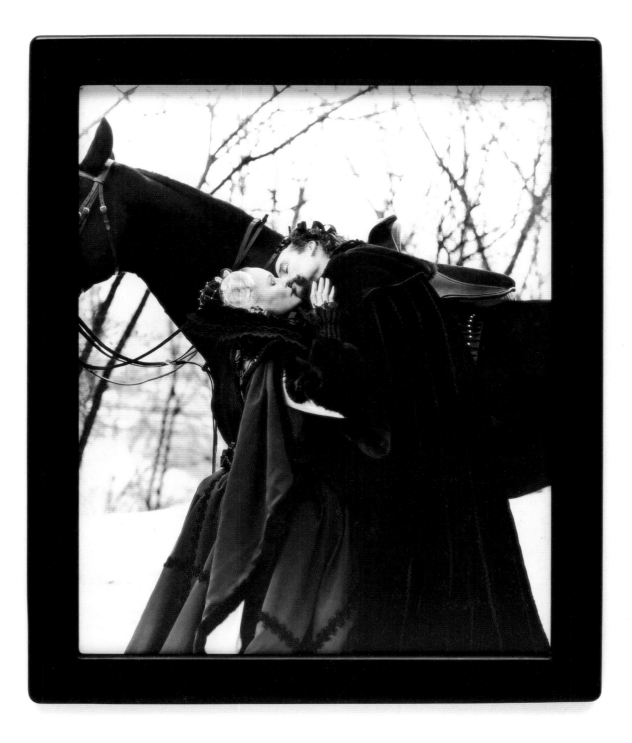

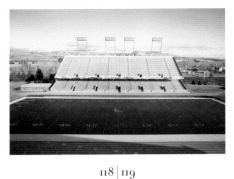

116 | 117

CREMASTER: Field Suite,
2002 (detail)
1 of 5 etchings on Hahnemühle
Copperplate paper

118 | 119

Photograph: Bronco Stadium, Boise State University, Idaho

120 | 121

Photograph: Astroturf, | Photograph: Goalpost,
Bronco Stadium | Bronco Stadium

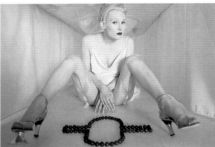

122 | 123

Marti Domination as Goodyear
Production photograph

124 | 125

Photocopy: Reproduction of | Lipstick on napkin,
Goodyear blimp | framed in athletic tape

Polaroid: Video monitor
showing opening titles to the film
Dames (Warner Brothers, 1934)

Magazine clipping:
Chanel advertisement, 1991

126 | 127

Concept drawing on vellum with paper, tape, and pencil:
Field graphics for Goodyear Field

128 | 129

Production photograph: | Clipping: Marti Domination
Goodyear Dancers | performing the "shoe dance"

130 | 131

Concept drawing on index card: | Photograph: Helicopter with
Path of blimps over Goodyear Field | nose-mounted camera

Iris print: Digitally rendered
Goodyear blimp

Concept drawing on index card:
Diagram for helicopter videography

132 | 133

CREMASTER 1: | *CREMASTER 1: Green Lounge*
The Goodyear Waltz, 1995 | *Manual*, 1995
1 of 8 gelatin-silver prints | 1 of 2 gelatin-silver prints in
in self-lubricating plastic frames | self-lubricating plastic frames
(shown unframed)

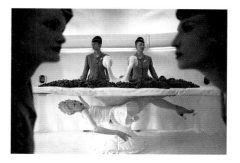

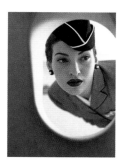

134 | 135

CREMASTER 1: Red Lounge Manual, 1995
1 of 3 gelatin-silver prints in self-lubricating plastic frames
(shown unframed)

136 | 137

Concept drawings on index cards: | Concept drawing on paper:
Choreographic phase two | Choreographic phase one into two
Choreographic phase
two into three
Choreographic phase
three

138 | 139

CREMASTER 1: | *CREMASTER 1: Choreography*
The Goodyear Waltz, 1995 | *of Goodyear*, 1995
1 of 8 gelatin-silver prints | 2 C-prints in self-lubricating
in self-lubricating plastic frames | plastic frames
(shown unframed)

140 | 141

Production still: Golf cart-mounted | *Choreographic Suite*, 1996 (detail)
camera with chorus girls | 1 of 12 drawings: acrylic, petroleum
jelly and pencil on paper in vinyl
floor tile, patent vinyl, and self-
lubricating plastic frames

142 | 143

Production stills: | *CREMASTER 1: Green Lounge*
Choreographic phase one | *Manual*, 1995 (detail)
Chorus girls with orange balloons | 1 of 2 gelatin-silver prints in
Choreographic phase three | self-lubricating plastic frames

144 | 145

Concept drawings on index cards: | Concept drawing on paper:
Choreographic phase four | Choreographic phase four
Choreographic phase four into five
Choreographic phase five

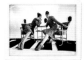

146 | 147

CREMASTER 1: | Polaroid: Red grape position
Red Lounge Manual, 1995 | on honeycomb tiles for animated
1 of 3 gelatin-silver prints in self- | grape sequence
lubricating plastic frames

148 | 149

Production stills: | Three concept drawings
Three costume/choreography | on index cards:
studies, phase six | Choreographic phase six

150 | 151

Concept drawing on paper:
Choreographic phase six

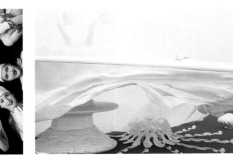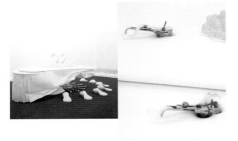

152 | 153

154 | 155

156 | 157

Choreographic Suite, 1996
1 of 12 drawings: acrylic,
petroleum jelly and
pencil on paper in vinyl floor tile,
patent vinyl, and self-
lubricating plastic frames

CREMASTER 1: Orchidella, 1995
C-print in self-lubricating
plastic frame (shown unframed)

Goodyear Field, 1996 (detail)
Self-lubricating plastic, prosthetic plastic, petroleum jelly, silicone,
Astroturf, pearlescent vinyl, cast tapioca, cast polyester, polyester
ribbon, costume pearls, speculae, and Pyrex

Goodyear Field, 1996 (detail) | *Goodyear Field*, 1996 (detail)

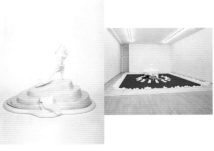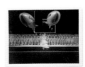

158 | 159

160 | 161

162 | 163

CREMASTER 1, 1995–96 (detail)
Silkscreened laser disk,
cast polyester, prosthetic plastic
and patent vinyl in self-lubricating
plastic and acrylic vitrine

Goodyear Field, 1996
Installation view

Concept drawings on paper:
Choreographic phase seven
into eight
Choreographic phase eight into nine
Choreographic phase nine into ten

Concept drawings on index cards:
Still portrait of Goodyear
with chorus
Choreographic phase seven
cutaway
Choreographic phase seven
cutaway

Concept drawings on index cards:
Choreographic phase ten
Still portrait of air hostesses
Choreographic phase eleven

CREMASTER 1:
Goodyear Chorus, 1995
C-print in self-lubricating
plastic frame

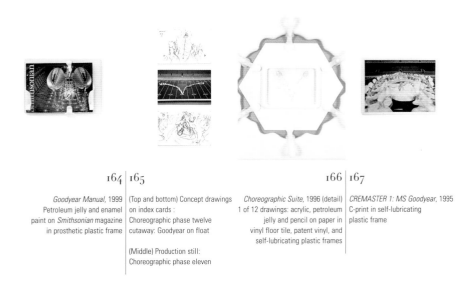

164 | 165

166 | 167

Goodyear Manual, 1999
Petroleum jelly and enamel
paint on *Smithsonian* magazine
in prosthetic plastic frame

(Top and bottom) Concept drawings
on index cards :
Choreographic phase twelve
cutaway: Goodyear on float

(Middle) Production still:
Choreographic phase eleven

Choreographic Suite, 1996 (detail)
1 of 12 drawings: acrylic, petroleum
jelly and pencil on paper in
vinyl floor tile, patent vinyl, and
self-lubricating plastic frames

CREMASTER 1: MS Goodyear, 1995
C-print in self-lubricating
plastic frame

168 | 169

CREMASTER: Field Suite,
2002 (detail)
1 of 5 etchings on Hahnemühle
Copperplate paper

170 | 171

Photograph: Athabasca Glacier, Columbia Icefield, Canada

172 | 173

Photograph: Great Salt Lake, Utah

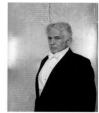

174 | 175

Photograph: Bonneville Salt Flats, Utah

176 | 177

Matthew Barney as Gary Gilmore
CREMASTER 2: Korihor, 1999
Gelatin-silver print in
acrylic frame (shown unframed)

Patty Griffin as Nicole Baker
*CREMASTER 2: The Ballad of
Gary Gilmore,* 1999 (detail)
1 of 3 gelatin-silver prints
in acrylic frames

178 | 179

Anonymous as Baby Fay La Foe
*CREMASTER 2:
Baby Fay La Foe,* 1999
C-print in acrylic frame
(shown unframed)

Norman Mailer as Harry Houdini
*CREMASTER 2:
The Metamorphosis,* 1999
C-print in acrylic frame
(shown unframed)

180 | 181

Photographs: Views of mirrored
saddle at Denim and Diamonds
nightclub, New York City

Preliminary concept drawing
on stationery from Peery Hotel,
Salt Lake City, Utah

Preliminary concept drawing on
notebook paper

182 | 183

Photocopies:
Model in corset
Lauren Pine in corset

Photocopy: Norman Mailer
(Photo: Richard Avedon)

184 | 185

Photocopy: Portrait of Harry Houdini
with wife Bessie Weiss and mother
Cecilia Weiss

Photocopies taped to index card
with notes: Houdini and Bessie
Weiss performing the
"metamorphosis," ca. 1893

Photocopy with pencil drawing:
"Margery" (Mina Crandon)
performing the "ectoplasm"

Notes on paper:
Dialogue for séance scene

Photograph: Beehive-style
ceiling lamp

Photograph: Adjustment of
backrest for séance scene

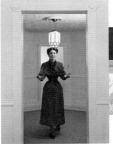

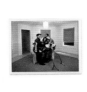
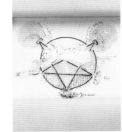

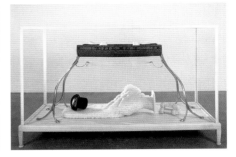

186 | 187

Anonymous as Baby Fay La Foe
CREMASTER 2:
The Royal Cell, 1999
1 of 3 C-prints in acrylic frames
(shown unframed)

The Cabinet of Baby Fay La Foe,
2000 (detail)
Polycarbonate honeycomb,
cast stainless steel, nylon, solar
salt cast in epoxy resin, top hat,
and beeswax in nylon and acrylic
vitrine

188 | 189

CREMASTER 2:
The Ectoplasm, 1999
C-print in acrylic frame

Drawing from *The Drones'*
Exposition, 1999 (detail)
Graphite and petroleum jelly
on paper in nylon frame

190 | 191

The Cabinet of Baby Fay La Foe, 2000

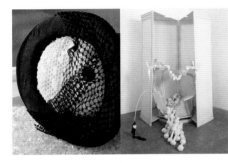

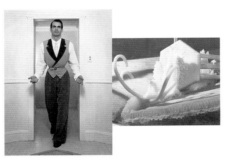

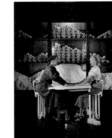

192 | 193

The Cabinet of Baby Fay La Foe,
2000 (detail)

The Cabinet of Harry Houdini, 1999
Cast nylon, solar salt cast in
epoxy resin, woven polypropylene,
prosthetic plastic, and beeswax

194 | 195

Scott Ewalt as Frank Gilmore
CREMASTER 2:
The Royal Cell, 1999
1 of 3 C-prints in acrylic frames
(shown unframed)

The Cabinet of
Frank Gilmore, 1999 (detail)
Solar salt cast in epoxy resin,
nylon, polycarbonate honeycomb,
and beeswax in nylon and acrylic
vitrine

196 | 197

The Cabinet of
Frank Gilmore, 1999

The Cabinet of
Bessie Gilmore, 1999
Salt, solar salt cast in epoxy resin,
nylon, Vivak, and prosthetic plastic
in nylon and acrylic vitrine

198 | 199

The Cabinet of Bessie Gilmore,
1999 (detail)

Lauren Pine as Bessie Gilmore
CREMASTER 2:
The Royal Cell, 1999
1 of 3 C-prints in acrylic frames
(shown unframed)

200 | 201

Pencil drawing on paper and two
orange stickers on photocopy of
Houdini demonstrating technique of
fakir, all stapled to index card
with pencil drawing

Concept drawing on scrap of paper:
Preliminary design for séance table

Clipping from Mormon Temple
brochure: Replica of Golden Tablets

CREMASTER 2:
The Golden Tablet, 1999
C-print in acrylic frame
(shown unframed)

202 | 203

Concept drawings on index cards:
Copulation scene and
conception of Gary Gilmore

Photograph: Fitting of Vivak corset

Polaroid: Video monitor showing
digitally rendered honeybee

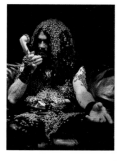

204 | 205 206 | 207 208 | 209

204
CREMASTER 2:
The Ballad of Gary Gilmore, 1999
1 of 3 gelatin-silver prints
in acrylic frames
(shown unframed)

205
Polaroid: Video monitor showing
Gary Gilmore after his arrest
for the murders of Max Jensen
and Ben Bushnell

206
Concept drawing on index card:
Floor plan of sound studio for
Johnny Cash scene

CD packaging insert: Slayer,
Divine Intervention
(American Recordings, 1995)

Photocopies from Norman Mailer's
The Executioner's Song (1979)
stapled to index card: Notation to
lyrics of "The Man in Black"

207
The Man in Black, 1999 (detail)
Graphite, petroleum jelly, and
beeswax on *Billboard* magazine
in nylon frame

208
Photograph: Sinclair gas station,
Spanish Fork, Utah

Production still: 1966 Mustang
gas tank cap

Photocopy from Norman Mailer's
The Executioner's Song (1979)
stapled to index card:
Notation for lyrics of
"The Ballad of Gary Gilmore"

Production still: Fuel pump,
Sinclair gas station

209
Polaroid: Video monitor showing
Nicole Baker

Colored cardboard chip on
photocopied images of 1960s-
model Ford Mustangs

Polaroid: Video monitor showing
Gary Gilmore in police car after
his arrest for murder

210 | 211 212 | 213 214 | 215

210
Photographs: Three views of
bathroom floor at the Sinclair
gas station, Orem, Utah

Postcard: Bighorn sheep

211
*The Ballad of
Nicole Baker*, 1999 (detail)
Graphite and petroleum jelly
on paper in nylon frame

212
*The Cabinet of Gary Gilmore and
Nicole Baker*, 1999–2000 (detail)
Polycarbonate honeycomb,
beeswax, microcrystalline wax,
petroleum jelly, nylon, polyester,
vinyl, carpet, chrome,
prosthetic plastic, solar salt cast in
epoxy resin, sterling silver, and 2
nylon and acrylic vitrines

213
CREMASTER 2: *The Ballad of
Max Jensen*, 1999
1 of 3 C-prints in acrylic frames

214
*The Cabinet of Gary Gilmore and
Nicole Baker*, 1999–2000 (detail)

215
*The Cabinet of Gary Gilmore and
Nicole Baker*, 1999–2000 (detail)

216 | 217 218 | 219 220 | 221

216
*The Cabinet of Gary Gilmore
and Nicole Baker*, 1999–2000
Installation view

217
CREMASTER 2: *The Ballad of
Max Jensen*, 1999
1 of 3 C-prints in acrylic frames
(shown unframed)

218
Photograph: Wasatch Mountains
with Brigham Young University
logo, Provo, Utah

Clipping from Mormon Temple
brochure: Mormon Tabernacle Choir

Polaroid: Video monitor showing
Gary Gilmore after his arrest
for murder

Photocopy from Norman Mailer's
The Executioner's Song (1979)
stapled to index card: Notations for
lyrics used in "Deseret Hymn"

219
Deseret: The Drones' Gate,
1999–2000 (detail)
Cast beeswax, solar salt cast
in epoxy resin, and 1:8 scale model
of the Mormon Tabernacle in
mixed media

220
Clipping: Mounted rodeo posse

Photographs:
Mounted posse and inmates
at Huntsville Prison Rodeo,
Huntsville, Texas

(Left and right) Computer printouts:
Names of lost Hebrew tribes

221
CREMASTER 2:
The Book of Mormon, 1999
C-print in acrylic frame
(shown unframed)

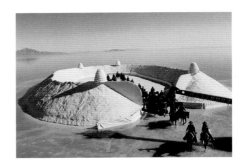

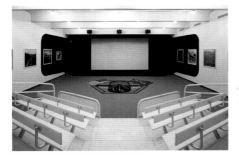

222 | 223

Production still:
Crane-mounted camera filming mounted posse sequence in
3,770-ton solar salt ring, Bonneville Salt Flats, Utah

224 | 225

CREMASTER 2:
Drone Ensemble, 1999
1 of 3 C-prints in acrylic frames
(shown unframed)

CREMASTER 2: Deseret, 1999
1 of 4 C-prints in acrylic frames

226 | 227

The Drones' Exposition, 1999 (view of theater)
35 mm film (color digital video transferred to film with Dolby SR sound);
2-part sculpture installation: nylon, acrylic, steel, salt, solar salt cast in
epoxy resin, chrome-plated engraved brass, leather, sterling silver, brass,
lead, Hungarian sidesaddle, carpet, carpet inlay, and quilted nylon;
12 silk flags with 12 nylon poles and 1 nylon wall mount; 5 drawings:
graphite and petroleum jelly on paper in nylon frames;
and 12 C-prints in acrylic frames

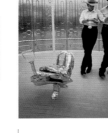

228 | 229

The Drones' Exposition, 1999
(detail of antechamber)

The Drones' Exposition, 1999
(detail of antechamber)

230 | 231

Concept drawing on paper:
Fallen Brahma bull

Photocopy: Baptismal font,
Mormon Temple,
Salt Lake City, Utah

Postcard: American bison

Concept drawings for
bison ring on index cards:
Three-quarter view
Single bison
Overhead view

232 | 233

Photocopy: Diagram by Joseph
Smith showing narrow path
between Polaris ("B") and
Earth ("A"), through which
the Lost Tribes of Israel may
return to Deseret

Fragments of postcards:
Views of the Rocky Mountains,
Canada

CREMASTER 2:
The Executioner's Step, 1999
C-print in acrylic frame (shown
unframed)

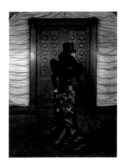

234 | 235

Postcard: Bonneville Salt Flats
Clipping: Great Salt Lake
Photocopies from Norman Mailer's
The Executioner's Song (1979)
stapled to index card: Notation for
lyrics to "The Executioner's Step"
Postcards: Athabasca Glacier and
Banff Springs Hotel
Concept drawing on photocopy
Fragment of postcard: Canadian
Mounted Police

Polaroid: Video monitor showing
monster truck

Photograph: Hanging glacier,
Columbia Icefield, Canada

Polaroid: Video monitor showing
snowmobile

Photograph: Crow's Foot Glacier

Photograph: Monster truck
suspension

236 | 237

Photocopies:
Portrait of Harry Houdini, 1908
Kennel Club advertisement, 1897

CREMASTER 2:
Drone Ensemble, 1999
1 of 3 C-prints in acrylic frames

238 | 239

CREMASTER 2:
The Queen's Exposition, 1999
1 of 4 gelatin-silver prints in
acrylic frames

CREMASTER 2:
The Queen's Exposition, 1999
1 of 4 gelatin-silver prints in
acrylic frames (shown unframed)

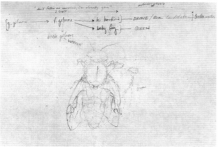

240 | 241

Drawing from *The Drones' Exposition*, 1999
Graphite and petroleum jelly on paper in nylon frame
(shown unframed)

242 | 243

CREMASTER 2: Genealogy, 1999 | Photograph from *The Drones'*
1 of 3 C-prints in acrylic frames | *Exposition*, 1999 (detail)
(shown unframed) | C-print in acrylic frame

244 | 245

CREMASTER: Field Suite,
2002 (detail)
1 of 5 etchings on Hahnemühle
Copperplate paper

246 | 247

Production photograph: | Production photograph:
The Chrysler Building, New York | The Chrysler Building lobby

248 | 249

Photograph: Detail of the Chrysler | Production photograph: Solomon R.
Building spire | Guggenheim Museum, New York

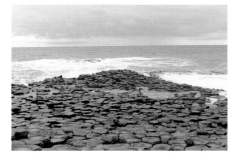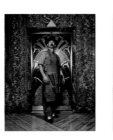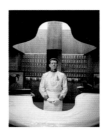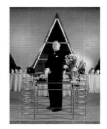

250 | 251

Production photograph: Giant's Causeway, County Antrim,
Northern Ireland

252 | 253

Matthew Barney as The | Richard Serra as Hiram Abiff
Entered Apprentice | *CREMASTER 3: Hiram Abiff*, 2002
CREMASTER 3: Entered | C-print in acrylic frame
Apprentice, 2002 | (shown unframed)
C-print in acrylic frame
(shown unframed)

254 | 255

Terry Gillespie as | Paul Brady as
The Cloud Club Barman | The Cloud Club Maitre d'
CREMASTER 3: Partition, 2002 | *CREMASTER 3: The Song of*
1 of 3 C-prints in acrylic frames | *The Vertical Field*, 2002
(shown unframed) | 1 of 2 C-prints in acrylic frames
(shown unframed)

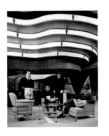

256 | 257

Mike Bocchetti, Jim Tooey, James Pantoleon and David Edward Campbell as The Grand Masters
CREMASTER 3: The Lodge of The Entered Apprentice, 2002
1 of 3 C-prints in acrylic frames (shown unframed)

Aimee Mullins as The Entered Novitiate
CREMASTER 3: The Lodge of The Entered Apprentice, 2002
1 of 3 C-prints in acrylic frames (shown unframed)

258 | 259

Peter Badalamenti as Fionn MacCumhail
CREMASTER 3: The Giants' Causeway, 2002
1 of 3 C-prints in acrylic frames (shown unframed)

Aimee Mullins as Oonagh MacCumhail
CREMASTER 3: Stones of Mann, 2002
1 of 3 C-prints in acrylic frames (shown unframed)

The Mighty Biggs as Fingal
CREMASTER 3: Fionn and Fingal, 2002
1 of 2 C-prints in acrylic frames (shown unframed)

260 | 261

Photocopy: Vince Lombardi, Head Coach, Green Bay Packers, 1959–68

Photocopy: Vince Lombardi, Seventh Granite Pillar from 1967 American Management Association Speech, New York

Concept drawing with petroleum jelly, grease make-up, and REEL Blood on magazine: Resurrection of Gary Gilmore

Notes on paper: Dialogue for first degree Masonic initiation

262 | 263

Concept drawing on index card: Chrysler Building foundation

Photocopy: Reference for resurrection of Gary Gilmore

Concept drawing on index card: Resurrection of Gary Gilmore

Concept drawing on index card: Skeleton from 19th century goat farm on 43rd Street, New York

Photograph: Rehearsal of carrying technique with actress Nesrin Karanouh (Gary Gilmore)

Magazine cover: Miller Harness Company 1999 catalogue

Photocopy: Joan Crawford in rotating door from *Letty Lynton* (MGM, 1932)

264 | 265

Detail from *CREMASTER 3* storyboard, 2000
Graphite on paper in self-lubricating plastic frame

CREMASTER 3: Brethren, 2002
C-print in acrylic frame (shown unframed)

266 | 267

Photographs, stapled together: Chrysler Building lobby, New York

Photographs with *CREMASTER* color chips: 1967 Chrysler Crown Imperials

Photograph: 1938 Chrysler Imperial New Yorker

Photograph: Mailbox, Chrysler Building lobby

Photograph: 1938 Chrysler Imperial New Yorker interior

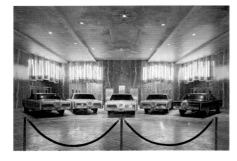

268 | 269

CREMASTER 3: 1967 Chrysler Imperial, 2002
C-print in acrylic frame (shown unframed)

270 | 271

Photograph: Elevator doors, Chrysler Building lobby

Photograph: Masonic tool kit, Masonic Freeman's Hall, Dublin, Ireland

Concept drawing on index card: Elevator car and ballast, Rough Ashler sequence

CREMASTER 3: Rough Ashler, 2002
1 of 11 C-prints in acrylic frames (shown unframed)

272 | 273

CREMASTER 3: Rough Ashler, 2002
1 of 11 C-prints in acrylic frames (shown unframed)

CREMASTER 3: Gary Gilmore, 2002
C-print in acrylic frame (shown unframed)

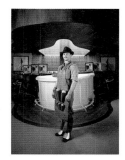

274 | 275

Production photograph: Imperial demolition

Photocopies: Construction workers, the Empire State Building, 1930; Manhattan Skyline; Construction workers, the Empire State Building, 1930; The Chrysler Building spire under construction; Workers installing Chrysler eagle ornament; The Chrysler Building under construction

276 | 277

Notes for "Song of the Vertical Field"

Photographs, taped together: The Cloud Club dining room, 67th Floor, Chrysler Building

Photograph: Doheny & Nesbitts, Dublin
Concept drawing on index card: Plan of the Cloud Club set
Photograph: Gravediggers, Dublin
Folded paper with pencil drawing and photograph

CREMASTER 3: The Cloud Club, 2002
1 of 4 C-prints in acrylic frames (shown unframed)

278 | 279

CREMASTER 3: The Cloud Club, 2002
1 of 4 C-prints in acrylic frames (shown unframed)

Production photograph

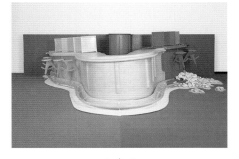

280 | 281

Partition, 2002
Petroleum jelly, internally lubricated plastic, refrigeration system, cast thermoplastic, stainless steel, and Astroturf

282 | 283

Partition, 2002 (detail)

CREMASTER 3: Partition, 2002
1 of 3 C-prints in acrylic frames (shown unframed)

284 | 285

CREMASTER 3: Partition, 2002
1 of 3 C-prints in acrylic frames (shown unframed)

Partition, 2002 (detail)

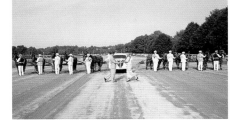

286 | 287

Production photograph

288 | 289

Photocopies with REEL Blood and *CREMASTER* color chips

Production stills: Lycra and latex horse bodysuits

Photocopies: Skin texture references

CREMASTER 3: The Royal Arch, 2002 (detail)
1 of 3 C-prints in acrylic frames

290 | 291

CREMASTER 3: Dead Heat, 2002 (detail)
C-print in acrylic frame

Photographs taped together: Clare Court Tunnel, Saratoga Racetrack, Saratoga Springs, New York

Photocopy: Masonic symbol

Photograph: Motorcycle accident victim

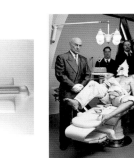

292 | 293

Photographs, taped together: Study for dental operatory set, office of Dr. Charles Weiss DDS, 69th floor, Chrysler Building

Concept drawing on index card: Modified dental chair

Photograph: Study for dental operatory set

Photocopies:
Study for genital appliance for The Entered Apprentice

Ku Klux Klan costuming

Toothless adult dentia

Distended lower colon and preparation of compound cavities for gold inlays

Preparation of compound cavities

294 | 295

Photograph: Porcelain rod from dental operatory sequence

Production photograph

296 | 297

Photocopies: The Apprentice (or Boaz) Pillar and Jachin Pillar Rosslyn Chapel, Roslin, Scotland

Clipping: Richard Serra

Concept drawing on index card: Floor plan of Solomon's temple

Photograph: Cross section of pentagonal tooth-breaking rail

Concept drawing on index card: Section of the Chrysler Building crown

Photocopies of charcoal drawings by Hugh Ferriss: *Verticals on Wide Avenues*, 1926; *New York, Forty-second Street, The Chrysler Building*, 1929; *Religion*, 1925

298 | 299

Ink drawing on newspaper page: Maypole ribbons

Cut Irish tricolor flag and satin ribbon swatches

Photographs, taped together: Exterior of the Chrysler Building

CREMASTER 3: The Dance of Hiram Abiff, 2002
1 of 4 C-prints in acrylic frames (shown unframed)

300 | 301

Production photograph: The Entered Apprentice presented by The Order

Concept drawing on index card: The five degrees of The Order

Concept drawing with correction fluid on photocopy: Elevation plan of The Order

Concept drawing on index card: Preliminary drawing for The Order

302 | 303

Photocopy: Promotional photograph of the Radio City Rockettes

Production photograph: Chorus line for the Order of the Rainbow for Girls

Concept drawing on index card: Tap-fitting for character shoes

Concept drawing on index card: First degree initiate's lambskin apron

CREMASTER 3: The Order, 2002
1 of 7 C-prints in acrylic frames (shown unframed)

304 | 305

CD cover from Agnostic Front, *One Voice* (Relativity Records, 1992)

Polaroid: Nylon level, square, maul and plumb assembled as a cross

Clipping: CD cover from Murphy's Law, *Murphy's Law/Back with a Bong* (Another Planet, 1994)

Concept drawing on index card: Elements of second degree puzzle

Agnostic Front in The Order
CREMASTER 3: The Order, 2002
1 of 7 C-prints in acrylic frames (shown unframed)

Murphy's Law in The Order
CREMASTER 3: The Order, 2002
1 of 7 C-prints in acrylic frames (shown unframed)

306 | 307

Magazine cover: Aimee Mullins

Clipping: Chanel perfume advertisement

Clipping: Cheetah facial markings

Concept drawing on index card: Third degree insignia; "I die daily."

Photocopy: Third degree Masonic initiate

308 | 309

CREMASTER 3: The Third Degree, 2002
1 of 2 C-prints in acrylic frames (shown unframed)

CREMASTER 3: Mahabyn, 2002
1 of 3 C-prints in acrylic frames (shown unframed)

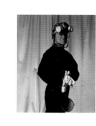

310 | 311

Concept drawing on index card: Highland warpipes

Folded photocopy: Anterior view of the facial development of five- and five-and-a-half-week-old embryos

Concept drawing on index card: Five Points of Fellowship in the fourth degree of The Order, Loughton Ram bagpipe

Diagram: Five Points of Fellowship

CREMASTER 3: Five Points of Fellowship, 2002
C-print in acrylic frame (shown unframed)

312 | 313

CREMASTER 3: The Slope of Hiram, 2002
1 of 3 C-prints in acrylic frames (shown unframed)

Concept drawing on index card: The fifth degree in The Order; tools used in the murder of Hiram Abiff

Photocopy: Richard Serra throwing molten lead for *Castings,* at the Castelli warehouse, New York, 1969.

Photograph: High-density polyethylene plates

314 | 315

Photographs, taped together: Giant's Causeway

Magazine page attached to index card with paper clips: Giant's Causeway

Photograph: Giant's Causeway

Photograph: Isle of Staffa

Photographs, taped together: Fingal's Cave

Clipping: Fingal's Cave

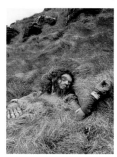

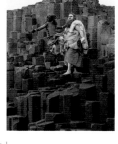

316 | 317

CREMASTER 3: Fionn and Fingal, 2002
1 of 2 C-prints in acrylic frames (shown unframed)

Production photograph: Fingal on the Isle of Staffa

318 | 319

Concept drawing on index card: Diagram of primary character groups with Isle of Man triskelion insignia

Production photograph

320 | 321

Production photograph: The Irish Sea

322 | 323

CREMASTER: Field Suite, 2002 (detail)
1 of 5 etchings on Hahnemühle Copperplate paper

324 | 325

Photograph: Isle of Man

326 | 327

Photograph: Gorse, Isle of Man

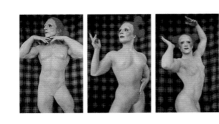

328 | 329

Photograph: Heather, Isle of Man

330 | 331

Matthew Barney as the | John Stud, Jr. as
Loughton Candidate | the Loughton Ram
CREMASTER 4: | *CREMASTER 4:*
The Loughton Candidate, 1994 | *LOUGHTON RAM*, 1994
C-print in cast-plastic frame | C-print in self-lubricating
(shown unframed) | plastic frame (shown unframed)

332 | 333

Collette Guimond, Sharon Marvel, and Christa Bauch
as the Manx Faeries
CREMASTER 4: FAERIE FIELD, 1994
3 of 4 C-prints in self-lubricating plastic frames
(shown unframed)

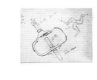

334 | 335

Dave and Graham Molyneux as the Ascending Hack
Steve and Karl Sinnot as the Descending Hack
CREMASTER 4: The Isle of Man, 1994
2 of 3 C-prints in self-lubricating plastic frames
(shown unframed)

336 | 337

Concept drawing on index card: | Map of Isle of Man with notations
Narrative path on | of filming locations
Tourist Trophy (TT) racecourse, |
Isle of Man |

338 | 339

Concept drawing on index card: | Postcard: Loughton ram,
Four horns of Loughton Ram | native to the Isle of Man

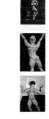

340 | 341

Concept drawings on index cards: | Concept drawings on index cards:
Diagram of narrative path | Loughton Candidate at vanity
| revealing four horn sockets in head
| (two views)
|
| Manx Faeries installing taps
| on Loughton Candidate's shoes

342 | 343

Photograph: Sharon Marvel at | *Manx Manual*, 1994–95
Miss Olympia competition | 1 of 5 drawings: Graphite, lacquer,
| and petroleum jelly on paper in cast
Computer printout: | epoxy, Manx tartan, and prosthetic
Collette Guimond in competition | plastic frames

Photograph: Christa Bauch

344 | 345

Concept drawings on index cards: | Photograph: Queen's Pier, Ramsay,
Vents in groin of Descending Hack | Isle of Man

Starting line of TT racecourse | Concept drawing on index card:
| Loughton Candidate tap dancing
Vents in groin of Ascending Hack | hole through floor of pier house

| Photograph: Queen's Pier, Ramsay,
| Isle of Man

346 | 347

Production still: Manx Faeries

348 | 349

Production photograph | *CREMASTER 4:*
The Isle of Man, 1994
1 of 3 C-prints in self-lubricating
plastic frames (shown unframed)

350 | 351

Concept drawings on index cards: | Production still: Starting line
Starting line sequence

352 | 353

CREMASTER 4: VALVE, 1994 | *CREMASTER 4: T1: ascending*
1 of 4 C-prints in self-lubricating | *HACK descending HACK,* 1994
plastic frames | C-print in self-lubricating
plastic frame (shown unframed)

354 | 355

Concept drawings on index cards: | *Manx Manual,* 1994–95 (detail)
Notation for aerial videography | 1 of 5 drawings: Graphite, lacquer,
at pier house | and petroleum jelly on paper in cast
 | epoxy, Manx tartan, and prosthetic
Overhead view | plastic frames

Frontal view

Wide view

356 | 357

Concept drawings on index cards: | Photographs: TT racecourse,
Ascending and Descending Hacks | Isle of Man
on TT racecourse

Postcards: TT races, Isle of Man

Governors Bridge

Ballaugh Bridge

Governors Bridge

358 | 359

Photograph: Queen's Pier, Ramsay, | Photograph of Queen's Pier
Isle of Man | with notations showing path of
 | Loughton Candidate

Concept drawings on index cards:
Loughton Candidate underwater

Loughton Candidate entering
flat crack beneath Queen's Pier
(two views)

360 | 361

Concept drawings on index cards: | Production stills:
Loughton Candidate in flat crack
 | Resting between shots,
Loughton Candidate entering | West Palm Beach, Florida
tunnel beneath Isle of Man
 | Tunnel in Barney studio
Tunnel beneath Isle of Man

362 | 363

CREMASTER 4: | *The Isle of Man,* 1994–95 (detail)
MANANNAN, 1994 | 2 600 cc sidehacks, wrestling mat,
1 of 3 C-prints in self-lubricating | vinyl, silicone, tapioca, polyester,
plastic frames | petroleum jelly, internally
 | lubricated plastic, prosthetic
 | plastic, fluorescent light, mirror,
 | satin ribbon, and Manx tartan

364 | 365

Photocopy: Caber toss at Highland Games festival

Concept drawings on index cards: Migrating reproductive organs, Ascending Hack (two views)

Rolling helmet of Ascending Hack following collision with stone wall

Faeries at picnic in the ascending field

366 | 367

Production photograph

CREMASTER 4: TRIPLE OPTION, 1994
1 of 3 C-prints in self-lubricating plastic frames

368 | 369

Concept drawings on index cards: Faeries falling from picnic cloth

Faeries performing triple option in ascending field (two views)

Trajectory of pitched hydraulic jack

Manx Manual, 1994–95 (detail)
1 of 5 drawings: Graphite, lacquer, and petroleum jelly on paper in cast epoxy, Manx tartan, and prosthetic plastic frames

370 | 371

The Isle of Man, 1994–95 (detail) | *The Isle of Man*, 1994–95 (detail)

372 | 373

Photograph: TT course pit area and grandstand, Isle of Man

Concept drawings on index cards: Migrating reproductive organs, Descending Hack (two views)

Faeries at pit stop in descending field

374 | 375

CREMASTER 4: DESCENDING MANUAL, 1994
1 C-print in prosethetic plastic frame and 3 C-prints in self-lubricating plastic frames

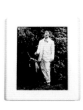
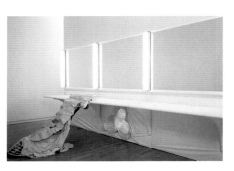

376 | 377

Concept drawings on index cards: Faeries at pit stop in descending field

Migrating reproductive organs, Descending Hack (two views)

Manx Manual, 1994–95 (detail)
1 of 5 drawings: Graphite, lacquer, and petroleum jelly on paper in cast epoxy, Manx tartan, and prosthetic plastic frames

378 | 379

Vanity mirror in pier house

Photograph: Queen's Pier, Ramsay, Isle of Man

Concept drawings on index cards: Pier house with Hacks

Hacks pulling cords from reproductive system in closing sequence

(Right) Intersection of Ascending Hack, Descending Hack and Loughton Candidate with Loughton Ram

CREMASTER 4: LOUGHTON MANUAL, 1994
C-print in self-lubricating plastic frame

380 | 381

The Isle of Man, 1994–95 (detail)

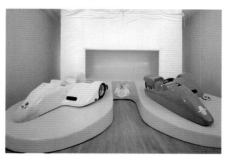

382 | 383

[PITCH] Field of the Ascending Faerie, 1995 (detail)
Wrestling mat, linen, antique lace, Manx tartan, prosthetic plastic, large pearl tapioca, polyester, silicone, satin ribbon, porcelain, sterling silver, and mother-of-pearl

The Isle of Man, 1994–95 (detail)

384 | 385

[PITCH] Field of the Ascending Faerie, 1995

[PIT] Field of the Descending Faerie, 1995
Silicone, prosthetic plastic, hydraulic jack, polyester, and satin ribbon

386 | 387

The Isle of Man, 1994–95
Installation view

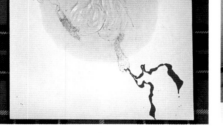
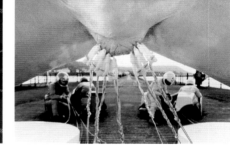

388 | 389

CREMASTER 4: Field of the Loughton Candidate, 1994
2 C-prints in self-lubricating plastic frames

CREMASTER 4: T.1: IRISH SEA, 1994
C-print in self-lubricating plastic frame

390 | 391

Manx Manual, 1994–95 (detail)
1 of 5 drawings: Graphite, lacquer, and petroleum jelly on paper in cast epoxy, Manx tartan, and prosthetic plastic frames

392 | 393

CREMASTER 4: Three Legs of Mann, 1994
C-print in self-lubricating plastic frame (shown unframed)

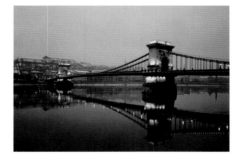
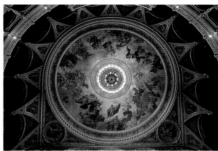

394 | 395

CREMASTER: Field Suite, 2002 (detail)
1 of 5 etchings on Hahnemühle Copperplate paper

396 | 397

Photograph: Chain Bridge, Budapest, Hungary

398 | 399

Photograph: Ceiling, Hungarian State Opera House, Budapest

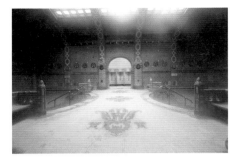

400 | 401

Photograph: Hotel Gellért Baths, Budapest

402 | 403

Matthew Barney as her Magician
CREMASTER 5: her Magician, 1997
Gelatin-silver print in acrylic frame

Ursula Andress as the Queen of Chain
CREMASTER 5: Court of Chain, 1997
Gelatin-silver print in acrylic frame

404 | 405

Susan and Joanne Rha as the Queen's Ushers
CREMASTER 5: Court of Chain, 1997
2 C-prints in acrylic frames

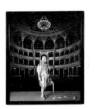 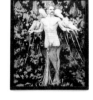 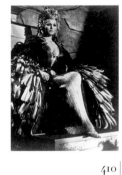

406 | 407

Matthew Barney as her Diva
CREMASTER 5: her Diva, 1997
C-print in acrylic frame

Matthew Barney as her Giant
CREMASTER 5: her Giant, 1997
C-print in acrylic frame

408 | 409

Notes on index card: Proscenium

Postcard: Hungarian State
Opera House, Budapest

Concept drawing on index card:
Preliminary drawing of narrative path

Concept drawings on index cards:
Queen of Chain in royal box

Isometric view of proscenium arch,
royal box, and bath house

410 | 411

Photograph: Ursula Andress in *She*
(Hammerscope, 1965)

Postcard: Caspar David Friedrich,
*The Wanderer Above the Sea
of Fog*, ca. 1818

CD packaging insert: Henry Rollins,
from Rollins Band, *The End of
Silence* (Imago, 1992)

412 | 413

Concept drawings on index cards:
Queen of Chain gesturing
to the Diva

Diagram of "yellow field" and
"blue field," from libretto

Queen of Chain gesturing
to her Diva

Photograph: Harry Houdini,
ca. 1899

414 | 415

Postcards:
Agnolo Bronzino,
Ludovico Capponi, ca. 1550–55

Attributed to Nicholas Eliaz,
Portrait of a Lady, 1632

Photograph: Prosthetic
plastic gown in seated
position in Barney studio

416 | 417

*CREMASTER 5:
The Queen of Chain*, 1997
Gelatin-silver print in acrylic frame
(shown unframed)

Photographs:
Opera house seats, Hungarian
State Opera House, Budapest

Orifice in Queen's throne

Gellért Baths, Budapest

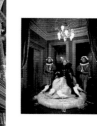

418 | 419

Concept drawings on index cards:
Diva climbing proscenium arch

Libretto notes for "blue field"

Diva climbing proscenium arch

Invitation: Irving Penn photograph
for Robert Isabell perfume

420 | 421

Notes on paper: Libretto notes
for "yellow field"

Production still: Hungarian
State Opera orchestra

Notes on paper: Libretto notes
for "green field"

Concept drawing on index card:
Aerial view of proscenium arch

Notes on paper: Libretto notes
for end of recitative

Concept drawing on index card:
Foot detail of the Queen of Chain

422 | 423

Production photographs

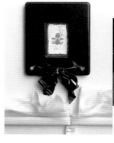

424 | 425

Concept drawing on index card:
her Magician in manacles on
Chain Bridge

Photograph: Chain Bridge and
helicopter with
side-mounted camera

Concept drawing on index card:
Manacles on Chain Bridge

The Tears of Ehrich Weiss, 1998
Acrylic, graphite, and petroleum
jelly on cover of *The Independent
Magazine* in acrylic and prosthetic
plastic frame

426 | 427

Concept drawings on index cards:
Inferior view of the
Queen of Chain

The Queen of Chain

Inferior view of the Queen of Chain
and plan of the Gellért Baths

Concept drawing on index card:
Posterior view of the Queen of
Chain and plan of the Gellért Baths

Polaroid: Clay positive for
prosthetic impression
of the Queen of Chain's throne

Concept drawing on index card:
Plan of the Gellért Baths

428 | 429

The Ehrich Weiss Suite, 1997
(detail)
Acrylic, prosthetic plastic, Vivak,
Pyrex, internally lubricated plastic,
glass, and sterling-silver sculpture;
2 C-prints and 1 gelatin-silver print
in acrylic frames; graphite, acrylic,
and petroleum jelly on paper in
acrylic frame; and 7 Jacobin
pigeons

*Lánchíd: The Lament of the
Queen of Chain*, 1997 (detail)
Acrylic, cast polyurethane,
Vivak, Pyrex, polyethylene,
and prosthetic plastic

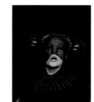

430 | 431

Lánchíd: The Lament of the Queen of Chain, 1997
Installation view

432 | 433

Production photograph

*Lánchíd: The Lament of the
Queen of Chain*, 1997 (detail)

434 | 435

Production photograph

*Lánchíd: The Lament of the
Queen of Chain*, 1997 (detail)

477

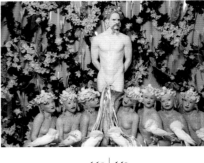

436 | 437

Postcard: Philipp Otto Runge, *Morning*, 1808–09 (detail)

Concept drawing on index card: Füdōr Sprites in bath surrounding her Giant

Photograph: Gellért statuary

438 | 439

Photographs:
Underwater set in Barbara Gladstone's swimming pool

Gellért Baths

Underwater set in Barbara Gladstone's swimming pool

Concept drawings on index cards:
Füdōr Sprite with Jacobin pigeon

Füdōr Sprites surrounding her Giant

Füdōr Sprite encouraging descending organs of her Giant

Jacobin pigeons in flight

440 | 441

Production photograph

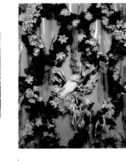

442 | 443

Concept drawing of Jacobin pigeon ruff on stationery from Steinberger Frankfurter Hof, stapled to index card

Postcard: Philipp Otto Runge, *Night*, 1807

Production photograph

444 | 445

Photograph: Houdini suspended from crane hook, after freeing himself from a straight jacket, ca. 1915

*CREMASTER 5:
The Menagerie of the Queen of Chain*, 1996
C-print in cast epoxy frame (shown unframed)

446 | 447

Computer printout of digitally manipulated Gellért Bathhouse tiles, taped to postcard of Philipp Otto Runge, *Morning*, 1808–09

Clipping: Calla lily, Irving Penn photograph for Robert Isabell perfume

Poster with pearlescent acrylic wash: Caspar David Friedrich, *The Wanderer over the Sea of Fog*, ca. 1818

448 | 449

Concept drawing on index card: Queen of Chain singing an aria

Notes on paper: Libretto notes for aria refrain

Concept drawing on index card: her Magician falling from bridge

Concept drawing on index card: Jacobin pigeons lowering reproductive system of her Giant

450 | 451

Ereszkedés, 1998 (detail)
1 of 3 drawings:
Graphite and petroleum jelly on embossed paper in acrylic and Vivak frame

*CREMASTER 5:
Bocáss el*, 1997
1 of 4 C-prints in acrylic frames

452 | 453

Ereszkedés, 1998 (detail)
1 of 3 drawings:
Graphite and petroleum jelly on embossed paper in acrylic and Vivak frame

The Ehrich Weiss Suite, 1997
Installation view

454 | 455

Ereszkedés, 1998 (detail)
1 of 3 drawings:
Graphite and petroleum jelly on
embossed paper in acrylic
and Vivak frame

CREMASTER 5: Bocáss el, 1997
1 of 4 C-prints in acrylic frames

456 | 457

The Ehrich Weiss Suite, 1997
(detail)

Elbocsátás, 1998 (detail)
Graphite, synthetic polymer paint,
and petroleum jelly on paper in
acrylic and Vivak frame

458 | 459

The Ehrich Weiss Suite, 1997
(detail)

CREMASTER 5: Elválás, 1997
Gelatin-silver print in acrylic frame

PERSONAL
PERSPECTIVES

*All statements are edited excerpts from conversations
that took place from March through November 2001.*

Ursula Andress

ACTOR;
QUEEN OF CHAIN, *CREMASTER 5*

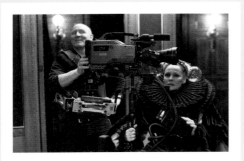

I am always a little skeptical about taking new roles, but Matthew was so persistent. He came to Rome once, twice, three times. The cultural minister of Switzerland called to say that I should work with him. And a man from Swiss television told me that Matthew Barney is the genius of our time and that I had to do the film. At first I told Matthew that I didn't think I should do it. I had seen *Cremaster 1* and it featured so many gorgeous girls. I said, "Why don't you get somebody like Bo Derek—someone younger than I am?" But no, he would not let me go. And with his angel face and this softness and this quiet look, he just said, "No, I want you." And I was not able to run away. He did not let me go.

The whole experience was very moving, but the film was like a big puzzle. It's so difficult to say exactly what it is. It's not really an art film. It's a creation, a form of moving art. I play a queen who is supposed to be sort of a lover-mother—it was never defined if I was the mother or if I was an imagined lover. Matthew just told me that I would perform an opera in this special costume. I would sing in Hungarian, which is so difficult. Someone came from the Hungarian embassy to teach me pronunciation. And then somebody from Budapest sang the lyrics onto a cassette, and I followed that. I learned the words first and then the music. The music was so nice, and the setting was incredible. Matthew touched me when he said, "Ursula, you have to be sad, you have to cry. You have to think that I'm dying."

I was already crying because the makeup person would not allow me to wear anything. I don't even come out of my bedroom without my eyes made up. The only thing I always insist upon is having my eyes made up. But Matthew took everything away. I asked him why he didn't want to make me more beautiful, because he is a very handsome man. He is extremely photogenic. So I said, "For you, I'm not afraid—you look fantastic. But I am afraid. I don't want to look ugly." He said, "Ursula, you will see. That's the way I see you, that's the way I want you to look."

The costume was just torturous. The shoes were marvelous, but I couldn't walk on the plastic pillow. I would just slip and slide around. I thought, "Oh my god, I'm going to look like a horror queen." The dress was molded on my body in stiff, hard plastic. Matthew showed up in Rome one day with his backpack and said, "I'm only here for one day. We have to do the casting." He brought everything: the drop cloths, the clay, even the bucket for water. He had to wrap me entirely—it's like when you have a broken leg. First we did the front and then the back. We couldn't do it all around because he would have needed a saw to get me out. We also made a corset to wear underneath the plastic gown. It took three men to help me climb in the dress and get it closed around me. There were actually three dresses. There was the full one in which I couldn't sit down—I had to stand or lean against something all the time. There was one for sitting on the throne with space for my knees, and there was one for lying down—the dying position.

It was quite an experience. Matthew has such an imagination: the orchestra with no one there; him climbing up the curtain and then falling down and somehow his head falling off and all this funny liquid coming out. I kept wondering, What does he see? What does he think about? With his little tutu on. It was incredible to work with such a creative young man so determined to realize his own vision. He is somebody who is completely committed to art, which is rare to find today.

Gabe Bartalos

ATLANTIC WEST EFFECTS;
PROSTHETIC MAKEUP AND SPECIAL
EFFECTS, *CREMASTERS 2, 3, 4,* AND *5*

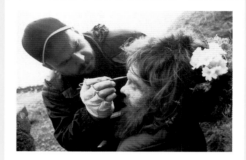

I first worked with Matthew on *Drawing Restraint 7*; I tackled his character and one of the other satyrs. It was just a hoot. Matt and I really got along and laughed a lot—which is always refreshing. There is a very keen sense of humor evilly winking all the way through the veil of his art.

Matthew has been nice enough to ask me back whenever there have been projects that have needed prosthetic effects, which I happily accept, because the work is great and it's fun. As the limelight around Matthew increases, I'm impressed how hands-on he still is. He's very specific about the work we do together. Since the stuff I build for him lands directly on the screen, he's really careful with it, and in a really pleasant way. Sometimes he just describes a scene over the phone. From that I'll do a clay sketch or maquette. Then he'll do sketches. I'll send him a cast and he'll actually push the clay around to show how far he wants the features to go. He's a great sculptor with clay. Technically, he doesn't know how pieces will be cut for prosthetics, but he doesn't need to. That's what we do. It's a fantastic way to get inside his wild imagination. He's already seen the creature in his head and needs it to be built. That way, when you nail it, you know it, and it's not a surprise for him. Which I guess is the whole goal: to get rid of the surprises and to execute the vision. In this way, I see myself as a tentacle off his body. And he's got tentacles going in all directions— wardrobe, set building, the camera. It's pretty impressive. It's easy to rise to the occasion when you see that kind of strength at the top.

For certain makeup effects, Matthew will let me know the root of where it's coming from, and I get a glimpse of the intellect behind the work. This way, I can really help him. For instance, when I learned that the zombie character in *Cremaster 3* is the resurrected Gary Gilmore, it was possible to give it a history, like it had four shots to the heart, it was buried on the left side, etc. All those details help determine the look of the corpse. If you consult your death books, you find that when a body's on its side, the blood puddles in a certain way, and it creates mosaic patterns in the coloring. That's huge for me, because that affects how I'll lay down the paint patterns. For this character, I used a brand-new silicone that you can actually glue things to. I was working with a company that was about to come out with the stuff. I asked for a clear material, because I wanted to use it to do a real forensic look, where you could see through the layers. So I glued down vacu-form bone pieces first. Then I glued down muscles. And then I put this milky clear piece over it and did the makeup. At times, when the zombie moves, it looks like the Visible Woman. When we did the close-ups with the right lighting, you could actually see the architecture underneath the skin. It was incredible.

Another new thing in the makeup-effects business was used for the character of the Giant in *Cremaster 5*, who wore full-body makeup. His leg-flower additions, which were cast directly off Matthew's body, were made by an entirely new process. Instead of pouring rubber into the molds, I layered it in thin sheets and painted the back of each layer, so all the coloring was done intrinsically. When they came out of the mold, they were basically done. It was really difficult to do, so it was personally satisfying. And they looked so strange.

Full-body makeup is very hard to maintain because of all the action. There is no relief. If your talent sits, they may pull a patch of color off, and you're back to a thirty-minute touch-up. At the same time, maintenance is

fun, because you get to watch this weird apparition all day. We just went through that again with the resurrected Gilmore character. Her makeup involved a seven-hour gluing process—a whole workday for most people—and then we went on set and shot for fourteen hours. In cases like this, you have me running around trying desperately to hang onto the humanity of the poor person underneath all the makeup. But at the same time, it's got to look good, because it's my canvas. My work directly makes it onto the screen. Every sculpture—or sculpted wrinkle or pus-filled blister—will end up there. So it's great to see it treated so well under Matthew's direction and Peter's camera work.

Jonathan Bepler

COMPOSER, *CREMASTERS 1, 2, 3, 5*

There's an openness to the way music is allowed to function in the *Cremaster* films. Film music is traditionally asked to engage a narrative by paralleling the emotional aspect of it. But in this case, perhaps because the film is considered sculpture as much as it is a narrative, music is asked to engage the total work. It can be narrative, shape, color, and texture, in addition to having its typical, emotional function. Or it can engage another dimension entirely. This is satisfying because I think music is essentially abstract and does not take kindly to being referential. Perhaps this is one of the reasons why the music and the visual material work well together in the *Cremaster* films. I like to think that in composing for the film I am making the film itself, not just putting sounds to images. This way, music and image can be seen as inseparable, because they embody each other and are not just parts of the same body.

My involvement with the films has increased from project to project. In the beginning, on *Cremaster 1*, Matthew had some music from the Busby Berkeley era and wanted to arrange one of the pieces so that it could serve as an environment for the character in the blimp. I was interested in making some new music. So we worked together and came up with something that was airline Muzak, transformation dance, and field march all in one—a kind of link between the pressurized cabin, the presentation, and the blue field below. Though we didn't go so deep on this first project, I enjoyed how inspiring Matthew's ideas were to me and thought we worked well together. I have always been interested in creating something that has never been heard before—or at least that I have never heard before. I'm interested in sounds that don't yet exist. Matthew uses cultural material as a sculptural medium. He twists and processes things that already exist, and with a creative reverence that I had not understood before. So the music for the *Cremaster* films has often arrived at something in between a language of the unexpected and one of the unexpectedly obvious.

For *Cremaster 5*, Matthew had in mind a character who would sing an operatic aria in turn-of-the-century Budapest. This was when we really began to collaborate and to develop a way to talk about these things. First we began working on the aria idea, and soon it became clear that we were talking about an entire opera or cantata, and that the musical piece and the film would frame each other simultaneously. We began listening to a lot of source material—from Bartók and Kodály, Mahler and Schönberg, to Eastern European folk music and Turkish dance music. The film had

begun to expand from a turn-of-the-century operatic setting to one that included Turkish and Hungarian folklore. It quickly went from the feeling of quoting something to a deeper investigation. This was the first full orchestra score I composed, though I was familiar with the instruments. I have a degree in classical voice but I had been playing very experimental stuff, and I never knew how I would combine these experiences. When I started composing this piece, however, it suddenly made total sense, because I was drawing on everything I loved about classical music while maintaining and developing a voice of my own. I learned a lot about paying homage to a period and a style while still making some of my own sounds. Because Matthew was developing the narrative sequencing at the same time that we were working on the music, we had to do everything by talking about it. It was nicely open and abstract; the pictures were just in our heads. We were sharing ideas about sound and image without the temptation of searching for the perfect sound to match a specific image, which can be a little facile. Because of this, I think, the music and the film really share a language and a sense of period and are truly part of the same work. In the end I was startled at how similar the whole piece was to how I had imagined it while still sitting in a studio in New York.

Cremaster 2 is set in the American West. Matthew and I spent some time at a country-and-western club in New York called Denim and Diamonds, where we learned about the two-step and heard some of the music. In researching the origins of country music, I started thinking about early American folk music, and this eventually led me to Native American music. I listened to a lot of that, especially the scalp songs with singing and a basic drum beat. One of the pieces in Cremaster 2 is a synthesis of cowboy and Native American music in a symphonic, programmatic container.

There was also the idea of Mormon Utah and the Mormon Tabernacle Choir. I was listening to a lot of choral music and found I wanted to tie the indigenous music and the classical choir together. Within Mormonism, there is the idea of the tribunal and brotherhood and the mass ceremony, so we found ourselves listening to some punk rock, sports chants, and other kinds of anthems.

The Tabernacle started my research into pipe organs. I got in contact with the American Guild of Organists and the organist Gregory D'Agostino, and took a tour of all the big organs in New York. We were looking for a place to record, but I was also learning about the instrument, thinking of it as a sort of biological entity and as a piece of architecture. The machinated breath and anemic warmth of the organ ended up serving well as a thread through the whole piece.

Cremaster 3 is probably the most layered and complex. The Chrysler Building is an architectural system that is a functioning organism. We were interested in the sounds that could be produced by the architecture itself. The elevator shaft plays itself via the air moving through it and the openings on various levels. The elevator cables function like the strings of a huge instrument. I made an eighty-foot string instrument in the studio where the sets were being built, based on an instrument made by Glenn Branca, and recorded some of that. It's a very dark and eerie sound, and when I was editing it I discovered that it worked nicely for the zombie section of the film. I started making this scary zombie music with that

instrument as well as with a theremin, which is a prototypical electronic instrument. The sound was inspired by the streamlined idealism associated with 1930s architecture like the Chrysler Building. In this way, sketches began to fall together before anything was shot.

For sources, we studied Masonic history and looked at horror films. There was a time when I was looking at a lot of martial-arts films, since we were talking about dealing with a physical-conflict/video-game structure. I played video games and collected their sound tracks. There's also the 1930s New York element, so I listened to big-band music. And there's the bit with the Rockette-like chorus line, which is where the show tunes come in. A lot of these things are things that I've always kind of hated, you know. But that's one of the nice things about collaboration—you find yourself delving into things that you may have preferred to stay away from, and you find what is appealing in them. You can take a stab at reinvention and try to recontextualize without giving in to irony.

Marti Domination

PERFORMANCE ARTIST;
GOODYEAR, *CREMASTER 1*

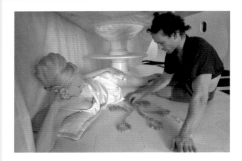

I met Matthew through the Jackie 60 nightclub, where I was performing as a dancer. Matthew was looking for the Goodyear lady, and Michael James O'Brien introduced us. The Jackie 60 dancers were known as "The House of Domination." We called ourselves Method go-go dancers, because we were always dancing "in character." Every week there was a different theme. I might find myself portraying anyone from Kiki de Montparnasse or Tempest Storm to Blanche Dubois or Emma Peel. I had always fantasized about being a glamorous 1930s MGM starlet or a Busby Berkeley showgirl. So I was delighted to be in *Cremaster 1*. It was an exciting thing for a person like me, who always feels as if they're living in the wrong time period.

Being in *Cremaster 1* wasn't like being in a regular film. It was more like being in a silent film. Matthew would talk to me while they were filming. He'd say simple things like, "Get the grapes. Get the grapes." Sometimes he encouraged me like a sports coach: "Go! Go! Go!" He never said, "You're representing a uterus," or anything like that. Instead, it was all about doing little activities. He'd say, "You're hiding under a table, and your goal is to get these grapes." I was on a very small platform under the table; that was my balancing station. There was a pole that I could hold onto and swirl around; I used it like a dancing pole. My rump was supported by the pedestal and I would counterbalance with my legs. It looks relaxing, but the filming was strenuous. I alternated between arching my back and folding myself forward. If you scrutinize the photographs, you'll notice that my veins are protruding. In between shots, I would drop back my neck and relax, but as soon as they started filming, I would raise my head up. So while they were shooting one part of the body, the other parts would be resting. Through the magic of editing, it looks as if I'm floating the entire time. Once I got used to the platform, I started to "swim" in the air whenever they weren't shooting, just to keep my muscles loose. When Matthew saw me doing that, he said, "Just go freestyle. Just do whatever you want to." He ended up putting some of those swimming movements in the movie. It has kind of an aquatic feeling.

Because of the curtain, I felt very isolated and protected under the

table. The starkness helped me focus on doing all my tasks. I realized there were certain details Matthew really wanted. He didn't dictate the exact movements, but I could tell by how things were set up—like the way that the opening was made in the table with the edges perfectly folded back— that things should be done with a certain propriety. I assumed the hairpins I wore in my hair were specially designed, like small sculptures. I knew he would want me to display them for the camera, almost like a product in a commercial. The sequence with the Vaseline was different. In all the other scenes, everything was dainty. But with the Vaseline, Matthew said, "Just grab as much of it as you can. Get it all over your hand." So I stretched my hand out, like a webbed foot, getting copious with the Vaseline.

Just wearing the white satin costume, clear shoes, and pale makeup got me into an otherworldly mood. My eyebrows were completely plucked and redrawn. My whole body was shaved. My hair was dyed the same color as the platinum wig, then it was pulled back really tight in a Marlene Dietrich–type thing. The wig was molded into ridges with silver balls. Inside the balls were bells, and whenever I moved my head they would go "ding ding ding ding ding." You can't hear it in the film, but in real life they jingled. The outfit was so comfortable. I felt very free and naked, without being completely nude. There were duplicate sets of the costume, so at the first hint of a wrinkle in the satin, they would take it off and press it. So it always looks fresh through all the contortions.

In the scene on the field, when I have the blimps, the silver gown did not allow for much freedom of movement. The pink ruffled collar was actually made of very hard plastic. And the skirt had a rigid hoop in it. I had to work within the restrictions of the costume. Under the table, I'd felt positively gymnastic, but in the gown I had to be more stately. I had to balance my body between the two blimps, which had a life of their own. Whichever way they seemed to be going, you had to go with them. They were each about the size of a small room, but they weren't heavy because they were pumped full of helium. Someone was always tending to them, like they were zoo animals. If one of them had escaped, all hell would have broken loose. Anytime I had to grab them, there would be two stagehands helping me, making sure they were really secured in my hands. I know Matthew wanted to show the blimps to their best advantage, and I wasn't supposed to be struggling with them. I was supposed to make it look like I was floating with them. In the end, it worked out very well.

Thomas Kearns

GT CUSTOMS, INC.;
SET AND PROP FABRICATION,
CREMASTERS 1–5

When I met Matthew, he was just beginning the *Cremaster* project, and I went to work for him building sets. He asked me to come by for the weekend to help build the tunnel that the Loughton Candidate crawls through. And I was there for about six months. This was the very beginning. It was really just Matthew by himself, with a couple of recent art-school graduates. It's been pretty amazing to see how it's all grown. During this time, I opened my own fabrication business and started making Matthew's frames and components of the various video editions. For the films, I continued to work on specialized things for the sets that they didn't have the people or the machines to do. I would often make the parts of the sets that would become art later on. Matthew is very particular about his vision, but is open to any suggestions, especially on the technical end of how we get to what's in his mind. But some of that is just trial and error because you can't verbalize these kind of things. It has been a challenge to try and realize his vision in plastic. There's always been a real learning curve. Luckily, a lot of the big companies are very helpful with their technical support. You just glean what you can from where you can. As an example, when we built the underwater set for *Cremaster 5*, we basically built a replica of the bathhouse in Budapest in a swimming pool in the Hamptons. We designed it from postcards and snapshots. We had to figure out how to build it underwater, what the best material would be, etcetera. We even found a way to modify our Makita drills so we could take them scuba diving! We had no idea what the footage would look like. As it turned out, you can hardly tell the difference between the set and the bathhouse.

Unlike other movies, which are usually scripted, Matthew's projects are almost like giant living sculptures in a way. He says, "This is what I'd like to do. How can we do it?" And then, depending on what happens, a set might get worked into the film as a main character and maybe transformed into art. It's a constantly evolving process. For example, when we built the staircase sculpture from the underwater set, he thought at first we'd make it black. So I began to plan how we could build this giant black staircase out of Plexiglas, which I'd never done before. I had kind of figured it out, and then he changed his mind and it wanted it to be clear. So it was back to the drawing board. If it had to be clear, then how would we do the structure? It became a collaborative process to figure out the engineering, which got increasingly complicated. Matthew thought he could cast hollow pillows to go on top, but this was technically unfeasible, so the pillows became solid. Now there was going to be a ton and a half of plastic on top of a staircase that had no structure and no mechanical fasteners and had to be clear. Matthew is always willing to go through a process, and he is very good at encouraging people to do their best and working through it with them. As I've always described it, each one of these films has been like a gauntlet. Originally it was just his gauntlet, and he was going through it alone. But now it seems like there's more and more of us all going through the gauntlet together.

Linda LaBelle

COSTUME DESIGN,
CREMASTERS 1, 2, 3, AND *5*

I think of my work with Matthew as a collaborative process. We share a creative intimacy. There are times when Matthew has very specific ideas in mind, and at other times he will come to me for suggestions. I don't always delve into the deeper meaning of the scenes I'm working on, as knowing too much may hamper my creative process. This way, I can go full force, and then Matthew can put the brakes on if need be.

Each film has its own set of challenges, from having to costume an entire chorus line of dancers I've never seen in *Cremaster 1*, to having to work with only a plaster cast of Ursula Andress's torso to build her costume in *Cremaster 5*. And anyone who has seen the films knows the variety of body types I've had to design for!

I do a lot of research for each project. But when the actual costumes are made, we go more for a feeling of the period than for historical accuracy. Almost all of the work I do is by hand, with the help of one assistant, so the building of the costumes and flags requires a great deal of time and planning. Very often we use materials that were meant to be used for something other than the project at hand. For example, in *Cremaster 3* we made two "couture gowns" out of a Teflon fabric normally used on conveyor belts and to cover bridges, and in *Cremaster 2* I built a metamorphosis pod for Norman Mailer's character out of a plastic waffle-weave fabric used for air-conditioner filters.

For *Cremaster 3* I had the opportunity to create my own fabric. As a weaver, I found this to be one of the most gratifying projects, going from fiber to finished costume. Together, Matthew and I selected the wool and designed a flesh-colored tartan, which I then wove on my loom. The colors were really important—blue, red, and apricot for the veins, arteries, and skin—and Matthew never would have been able to find them in a commercial fabric. Then with the finished fifteen yards of tartan, my assistant Kim Hoffman and I constructed a "Great Kilt" for Matthew to wear in the sequence filmed at the Guggenheim.

With each *Cremaster* film the work has become more intricate and challenging, and I have constantly had to expand upon my creative abilities to keep in step with Matthew and his imagination. As a creative person, I have grown so much through my work on these films.

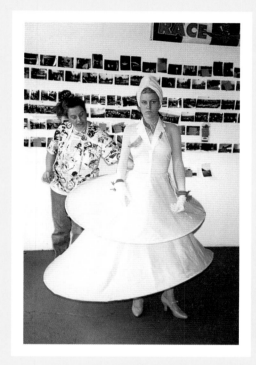

Norman Mailer

FATHER OF NINE;
HARRY HOUDINI, *CREMASTER 2*

Matthew wrote to me and said he'd like me to be in one of his movies. He sent me two *Cremaster* films—I now forget the numbers, as you know he made them out of order. I was impressed with both. His work was altogether different from anything I'd ever seen. I didn't find it particularly easy to comprehend, but at the same time, I respected the intensity and the high focus of his direction. It was obvious he knew what he wanted to do, and that impressed me. He took all sorts of chances, which gave him directorial status in my eyes. Aesthetic status. He wasn't protecting himself at all. He'd get himself into incredibly ugly positions and work through them. And in a certain sense, even though he asked me to play Houdini, I likened him to a Houdini in my own mind. He would work his way through an endless plastic sleeve that might be twenty feet long, covered in all sorts of revolting oils and creams. And would work through it to the very end. And I wouldn't have been surprised if he'd been manacled while he was doing it. All that intrigued me.

When he asked me to be in *Cremaster 2*, I said, "You want me to play Houdini?"—I think I was seventy-five at the time—"I'm seventy-five years old, I'm arthritic, it's all I can do to tie my shoelaces and you want me to play Houdini?" And he said, "It's alright, we'll shoot around you." Which indeed he did. He fulfilled his word. I had one sequence where I had to get out of a box and he had designed the box in such a way that all I had to do was pull one small ring and the rest of it was all taken care of. But it looked reasonable on film.

I didn't feel it was the least bit necessary to understand the concept behind the movie. In a way, the last thing you want an actor to know is the final theme of a work. It'll just get in the actor's way. Actors have to live and work out of the moment that they're in. You assume the director will tell you if you're going in a direction that he finds counterproductive to his work. And if you're left alone, then you just work out the particular problems you have. My problems were mainly physical. As far as the acting aspect of it goes, my first problem was to get myself to some sort of state where I could believe, even for ten seconds, that I was Houdini. Because actors take such chances with their ego and sometimes their soul, they are also very self-protective. I discovered that propensity in myself when I was playing the role. But everything I was given to do was doable, which is crucial to the way you work with an actor. You don't give him something he can't do. The only place where I wasn't altogether happy was with the dialogue. I don't think it is Matthew's forte. In a couple of places I had a few lines to speak. So we talked about them and changed them a bit to make them more agreeable to my palate.

When I saw the movie, having been in it and having it relate very loosely to *The Executioner's Song*, I could understand it better than I had the other films. And I enjoyed it. How could you not enjoy it? The photography was fabulous. And I was pleased I'd worked on it. What impressed me about working with Matthew—because I've directed movies myself and know something about it—was that he kept his good mood all the time. I ended up liking him as much or more after two days of shooting as I had when I started, and that's the sign of someone who's a very good director. He enjoys what he's doing so much that it tends to be very good for morale. He is very athletic, which is a great help to a director. We worked on a platform that was about four feet high. He was leaping up

onto it and jumping down off it all day long. He must have done it thirty, forty, fifty times. Acting is an activity that's halfway between literature and athletics. In other words, the way in which an actor moves is crucial to a performance. I don't think Matthew could ever have conceived his films without knowing that he could call upon himself as an athlete to be able to perform all these inner tasks that became external tasks for the camera.

Tony Morgan

STEP GRAPHICS INC.;
BOOK DESIGN, *CREMASTERS 1, 2, 3,*
AND *5*

The first book project I did with Matthew was *Drawing Restraint 7*, which documents the video work of the same title. He had taken slides from a video monitor, which gave the reproductions that typical bluish, heavily distorted look. We also worked with color and black-and-white portrait and sculpture photography. It was fairly straightforward.

I have worked on all the *Cremaster* publications other than *Cremaster 4*, which came out before *Drawing Restraint 7*. Matthew lays out the books in a purely visual way. It is mostly sequential, following the flow of the film. He likes to do gatefolds [foldouts], which are difficult to print and more difficult to bind. With *Cremaster 4*, the printer let him put the gatefolds wherever he wanted by using a binding technique known as perfect binding, which essentially holds together loosely gathered sheets by wedging them in glue. That binding method is fine for sales catalogues and annual reports, but it's very susceptible to even normal wear and tear. Every book since *Cremaster 4* has been sewn, which means that the gatefolds must fall in certain places having to do with how the pages are printed and folded into sections before being bound. So I work with the printer and figure out how they are going to bind each section and tell Matthew he might have to move a gatefold forward or back. The trim size of the *Cremaster 4* book determined the dimensions of all the subsequent ones. It is an odd size. It is not even metric-specific, even though it was published in Europe. It might have been determined by a given paper size or the printing press.

Occasionally I help Matthew identify the typefaces for the different projects, but oftentimes he chooses them himself. The type treatment is, obviously, very minimal in the books, but still carefully chosen to relate to the overall theme: a script font for the romantic *Cremaster 5*, a gothic font for the edgy, heavy-metal influence in *Cremaster 2*. All of the books have title pages with giant cinematic titles that stretch across two pages, which a designer probably wouldn't normally do. But it's an artist's book, really, and I always trust Matthew's judgment.

Since *Cremaster 1*, Matthew has been able to digitally capture video stills directly from the film's editing systems, thus eliminating the need to photograph video screens and inherit all their defects. As the technology has improved with each film's production, we have been able to reach a level of video-image quality that comes much closer to that of the still photography, to the point where they are almost indistinguishable. Unfortunately I do have to go in and make extensive color corrections to the captured stills to make them suitable for print, but the quality is much higher now.

My role in these books is somewhat akin to that of a production manager: I make sure they get done. I do the typesetting, the mechanicals,

the color corrections, the proofing, and the print supervision. As far as I am concerned, Matthew is really the designer. I know he would give me the design credit, but I wouldn't feel comfortable with that. It's his vision, it's his project.

It's always such an interesting process, and somewhat ironic. I work with the film stills, I see the photographs as they're printed, and so forth, so when I finally sit down to see the film, it's already in my head. I already know it. And it unfolds like a dream, like déjà vu. And it all comes together and makes sense. It's an interesting way to see a movie.

Aimee Mullins

PARALYMPIC ATHLETE, MODEL, AND ACTRESS; THE ENTERED NOVITIATE, OONAGH MACCUMHAIL, AND HERSELF, *CREMASTER 3*

My characters are incarnations of the same being, which is essentially a reflection of Matthew's character. At first there were just three, and then it morphed into others. There was the cheetah character, the runway model with the Teflon apron dress and Masonic tools in her hairpiece, and the Masonic inductee with the noose and the blindfold. It grew from there to include the gangster moll with the fur-collared coat and matching feline accessories; the potato cutter with the gorgeous heavy dress and the long potato-cutting plate on the bottom of her shoe; and Oonagh, the Giant's wife, with legs cast out of dirt and a big brass toe. Some characters are more involved than others, and it was particularly challenging to convey an attitude with no dialogue. The cheetah is aggressive but very upfront about being an aggressor. The cheetah is a payback for the gangster's girl-friend, who gets degraded in the racetrack scene. There's something devious about the runway model; she's a subtle aggressor. She's cold and unfeeling, kind of like an ice princess. There's a sadness about the potato cutter, even though that character is related to the part of the film with the slapstick comedy routine.

Matthew never gives much direction. You don't really get any instructions until right before the shot, which I like. At first it was a little stress-ful—I was wondering when he would tell me what I had to do. But then I realized that it actually took the stress off. He tells you and you do it. You snap into it. I think this really works because of the kind of people he selects for the characters, like Ursula Andress, Norman Mailer, Richard Serra, and me. I don't think he had to give us much direction because he knew that the specific attitude would be there. I think there are certain personalities that intrigue him. He casts them and transforms them for the part, but the viewer still knows who it is. It's Harry Houdini, but it's Norman Mailer. With the Queen of Chain, you still know that it's Ursula Andress walking out of the ocean in that bikini, with her broad shoulders. In some ways this fact connects all of us.

Matthew is interested in the exertion of the will over the body, figura-tively and literally. He casts people who are up for that challenge. The fact that I'm athletic really lent itself to the characters I play in the film. I was able to adapt to the different prosthetic legs we created for each character. Making the legs work for the cheetah was an athletic feat in itself. We were a prosthetic team with no medical background. It was fantastic working with Gabe because his whole world is the aesthetic prosthetic realm and mine is the mechanics of prosthetics. So we learned a lot from each other. For the cheetah legs the first thing we did was to make the armatures. I got

the man who makes my sports legs in San Diego to make a pair of sockets from my molds so that Gabe would have something to work with right away. He traced the basic curvature angle of my sprinting leg and then proceeded from there. He needed to put a hinge in so that the foot would be like an actual paw. Wearing them was like downhill skiing, except that I had to hold my weight up and walk upright—it was a very strange feeling. I thought it would be something similar to the way my sprinting legs feel, but it was nothing at all like that. So at first I could only take baby steps, but within about seven minutes I could actually go from here to there. Just when I was starting to feel very confident, the whole armature of the leg from the bottom of the socket turned completely back to front. Matthew lunged out and caught me, and we were all silent for about ten seconds, humbled. Here we thought we were master creators, that we could actually build legs.

The runway model character's clear polyethylene legs were cast from my everyday legs. Gabe did a cast inside and outside so he could put the two together to get a rudimentary socket. The whole process was trial-and-error because we were playing hodgepodge: we took the sockets from my sprinting legs and used the outside cast of my cosmetic legs, and they didn't match up as they should have. It's like the princess and the pea—if the structure is a hair off, it really makes a huge difference. So Matt Ryle had to keep building up certain areas and sanding off others. The legs were solid, heavy, like two bowling balls. It was like walking on stilts, because just the ball of the foot hit the ground and I had to compensate in the torso. The whole experience was about adapting quickly, which I always have to do anyway when I change legs. And to complicate matters further, all my shots at the Guggenheim were on unlevel ground. Without an ankle on either set of legs, it was difficult for me to make my walk look smooth. This was frustrating because I wanted it to be perfect.

The clear legs ending in man-of-war tentacles worn by the Entered Novitiate evolved as a compromise. Originally Matthew had wanted me to do that scene without prosthetics. He saw this as a way to express the Masonic theory that you have to lose your lower self in order to reach a higher level. I guess the literal representation of that would have been for me to sit on the sled without any limbs below the knee, but that would have been difficult for me because it's very, very intimate. We had a long dialogue about what we could do instead, and Matthew came up with the idea of making the legs appear like jellyfish tentacles because they're not a human form and they're clear. It worked for me because I don't feel so bare where there's something between me and the ground. It was a good compromise and I think Matthew was really pleased. It turned out better than expected. They were really beautiful legs.

When Matthew first told me about the Entered Novitiate character dressed as a candidate for the Masonic First Degree—with the left pant leg and right sleeve rolled up, the left breast exposed, blindfolded and wearing a noose—I thought, "I can't do that." I remember thinking how many disability-rights activists were going to be calling me, outraged. But it all fits together in the end, that's the thing. There's nothing superfluous in it. Everything fits, everything has a reason. Matthew never does anything for the shock value.

Michael James O'Brien

My relationship with Matthew dates back to when he was working as a model and I was primarily a fashion photographer. Matthew was with the Click agency, and they specialized in representing models who weren't conventional models. They really invented that concept, which is now the order of the day, but at that point it was really unusual. I did two major jobs with him. One was for Bergdorf Goodman and the other was for Ralph Lauren. Around that time, I was getting dissatisfied with fashion photography, but I'd still continue to do projects like that, especially if they were fairly serious and complicated. At one point I called Matthew's agent to see if he could do another shoot with me—it was a big job, and he would have made a lot of money. But they told me he had stopped modeling. They said he had finished school, and now he was doing his own work, which I really admired, because it's very hard to make the transition, even from modeling to acting, let alone to something else. So I didn't see Matthew for a while, and the next thing I knew he was having his first show at Barbara Gladstone, dressed in mountain-climbing attire and scaling the walls of the gallery.

It was around that same time that I stopped doing fashion photography. I went cold turkey and decided not to do any commercial photography for a year. I was writing and working on a poetry zine called *Verbal Abuse* with friends of mine who owned the nightclub Jackie 6o. I was also starting a book of photographs of drag queens for Random House. In the process of my research, which involved going out every night to some kind of club, I kept running into Matthew. This led to his asking me to work on the first piece that I did with him—*Drawing Restraint 7*—in 1993. I agreed to do it because a lot of our ideas overlapped. My interest in drag led me to understand the transformative aspects of Matthew's work. With drag, it's the final moment of presentation that counts. Whatever leads up to it is not the issue. Wherever you got your makeup, or who did your dress—whether you stole it or bought it or found it or someone left it to you—doesn't matter. All that is really important is that moment of display. I also liked the way that Matthew took many separate issues and put them together so that the final product was a coherent universe, and the idea that someone would do something simply because they decided to do it—which is what, in a way, drag is. You decide to do something in costume purely for yourself; no one's asked you to. It's one of those "Why'd you climb the mountain?" "Well, because it was there" scenarios. I appreciated how Matthew put these projects together and then threw himself into them, completely, for no other reason than to create a set of rules for himself. In my opinion, the degree to which he lived up to these rules is what makes these works absolutely riveting. Whether or not we accept the premise, I think in some ways is less relevant.

I see the *Cremaster* story as a *cabinet de curiosité*. I've always been fascinated with this nineteenth-century practice, where someone would put together a collection of skulls and rocks and all kinds of strange things from all over the world and display it in a cabinet. When you looked into the cabinet, the pieces became a view of the world—the view of the world of the person who put that collection together. The *Cremaster* cycle is like that; it brings together all these elements that have to do with geography and history and culture. It made me begin to see the world in a new way. Suddenly I began to see a connection between the Isle of Man and

Budapest and very strange places that no one would ever have thought had anything to do with anything else. Budapest has a phenomenal history, and the Isle of Man is a tax shelter with four horned rams in the middle of three seas. All of it is actually very bizarre, but when you start to look into it, it becomes really layered and rich.

After *Drawing Restraint 7*, Matthew and I made a very loose agreement to work together until it wasn't successful for one of us or until something changed. It was nothing more or less binding than that, which I found to be a good thing. When we did *Drawing Restraint 7*, there were about four people working on the project, which suited me perfectly. I'd just come away from commercial projects, which had so many various participants that it was almost impossible to get to the moment when you wanted to take the picture. With Matthew, everything was done on a shoestring, which, I think, often produces extremely good work. It's very close to the bone and you have to make something happen. *Cremaster 4* was similarly done on a small budget, for all its complexity and beauty. We shot a lot of it in the studio. I liked the combination of working both on location and in the studio, where there was a certain intensity and focus. The things created in the studio usually involved the main character's transition through some kind of womb-like, tunnel-like enclosed space into some other kind of universe—like in *Cremaster 4*, where the main character is underwater and has to tunnel himself out and land in a different part of the island. When we went on location, it was to shoot a parallel part of the storyline. That was where we'd have the least control. At one point in *Cremaster 4*, I was photographing in thick fog on a hairpin curve with no one to help us direct traffic, and we couldn't even stop the traffic, because you're not allowed to do that on the Isle of Man. It was raining the whole time, and it was freezing. We had to be barefoot in the house on the pier because it was all white vinyl. We had female body builders who were getting hypothermia. There were no rain dates, no weather days. We didn't have that luxury. I remember taking the final shot of Matthew naked, with the Teflon rings connected by ribbons to the two motorcycle teams. There he was, bare assed, with Gabe painting on prosthetic makeup. There was no retouching then—the prosthetics had to be done on the spot. So I have a picture of Matthew standing, his legs spread apart, scrotum pierced with Teflon rings attached to ribbons, and the motorcycle teams in the back. At that moment, everyone was so happy that Matthew was standing there naked and freezing while we contemplated the driving away of the motorcycles.

In my opinion, the control of the studio was better for photography. We could create a set, light it correctly, and take the pictures, while Matthew focused on the film. Regardless of this, I always knew how to make something look good, even under the worst circumstances, since my background is in commercial photography. I could always create the end gloss or sheen that Matthew wanted, which was often in conflict—in a good way—with the grittiness of the piece. While I had no intention of imposing my own aesthetic, I definitely brought something of my own to the process. There are things that I automatically do, which Matthew clearly appreciated. But there were also things that I wouldn't have done in my own work: He likes low angles; I don't like low angles. He likes wide angles; I never use wide angles. For me, there was never any confusion

about the nature of this kind of collaboration, or where the separate or joint responsibilities lay. Because Matthew and I were interested in similar things, I was able to bring other things to the work as well: I introduced him to Marti and I brought in the hair and makeup artists for four of the pieces.

I didn't work on the last *Cremaster* film because I couldn't be available for the period of time required—a year, really. Matthew needed someone who could be there all the time, because this was such a complicated piece. On the one hand I'm sorry because I love the work, and closure can be fulfilling. On the other hand I like having things left incomplete. I'm happy about the intensity of my involvement, and I have a feeling I'll do something with Matthew again in the future.

Chelsea Romersa

PRODUCTION ASSISTANT, *CREMASTER 1;*
LINE PRODUCER, *CREMASTER 5 ;*
ASSOCIATE PRODUCER, *CREMASTERS 2*
AND *3*

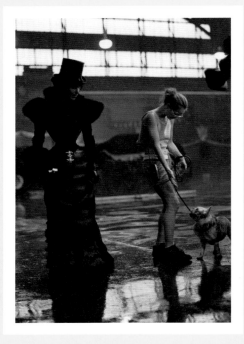

I went to Matthew's first show by happenstance after a long trail of gallery viewings. It was a fight to get in, but I got through the crowd enough to glimpse the work, and it just clicked. I left the gallery thinking, "What a shame I'm never going to meet this guy. We're well-suited." Sounds presumptuous, but that's how I felt. I had just moved to New York from Virginia, where I had been working in television production. I came here to get my MFA in painting. I was running an education program at MoMA, where I introduced students to the art scene in New York by leading field trips to foundations, museums, and artists' studios. I wrote to Matthew asking if we could visit his studio. I sent at least three requests, one per year, before he agreed. When we finally talked, I suggested that these students and I could work for him for free, which he liked very much. Then I got up my gumption and added, "Actually, I want a job with you." The day a group of my students and I appeared to assemble sixty hoop-skirt armatures and headdresses, Matthew said I had a job. An entire year went by before he phoned to ask me to be line producer on *Cremaster 5*. Right from the start, Matthew's work had hit a nerve—I come from an intense family of musicians whose work ethic is through the roof, and my brother is a serious mountain climber who often takes me along into extreme situations. What I learned once I started working with Matthew was that every person in his realm is highly specialized, overtly abstract, hypermotivated, relentlessly critical, funny 'til the cows come home, and smart.

Matthew shares ideas in their conceptual stage with his crew. As he talks through ideas, they morph into a construction, a physical resonance of the idea, until a platform is established from which to depart, or begin, however you see it. It's like the project is a vast pool, and before you go for the compound dive you have to build a diving board. Most of the time Matthew controls the concept, except when the concept can't be controlled.

Although Matthew always respects the integrity of his "materials"— whether polyethylene, salt, bees, pigeons, or people—he pushes them to their absolute limit. Take, for example, the telling in *Cremaster 2* of Houdini's affair with Gary Gilmore's maternal grandmother at the 1893 World Exposition. This scene went from two actors entering a glacial ice cave to a snowmobile being lowered into a crevasse with abstract notions of consummation floating like cherubs around the vague depiction, to the

way it ended up on film: the camera traveling in one continuous shot from aerial to ground, inches from the choppy glacier, to a tilt plunge straight down into a crevasse. Not one of those stages went without research, from consultations with ice experts and lighting and snowmobile vendors to location scouting in Canada and discussions with the director of photography about lenses and camera rigs. Anything we don't use still contributes to the development of the project; nothing is wasted. Another example in *Cremaster 2* is the depiction of the execution of Gilmore as a prison rodeo. A bull can't be worked more than twice in one day, and not more than two days consecutively. It ruins the bull, "kills his spirit." An experienced bull rider might stay on the bull for eight seconds, and can't ride more than once a day. So we realized we had to get at least two identical bulls and two body doubles for Matthew's character. But that still only gave us two bulls times two rides per day times two days times eight seconds per ride, which equals sixty-four seconds of possible filming (while the set would take a month and 144 trucks of salt to build). Of course by the time we arrived to build the salt arena, one bull had died and the flats where we were filming had flooded. The Bureau of Land Management tried everything possible to retract permission for the use of their property, so we commissioned engineers to conduct sheer-vane strength tests on the surface of the flats to prove our operation would do no harm. And we found another bull.

I fondly remember the very last shoot of *Cremaster 5*, where the magician leaps to his death. (Why risk losing the director before the film is shot?) On a scouting venture to Budapest months before, I had stolen a spoon from the breakfast table at the Gellért hotel, and we'd tied it to one end of a spool of fishing line and lowered it to the water's surface from the center of the bridge. When back in the States, we'd had a custom bungee cord made based on that measurement. On the morning of the shoot, which started at three A.M. for a dawn film roll, the bridge was closed to traffic and the water police sat in the Danube scrutinizing our safety. Matthew did his leap successfully, and as his naked, shivering body was whisked away for makeup removal (we were filming in January), every last member of the exhausted but exhilarated crew thirsted for and received their own bungee experience. I kept telling a Hungarian on a walkie-talkie to inform the water police that we hadn't quite got it that time and needed to do it once more. We kept telling them that we needed one more take over and over again.

Acquiring and arranging the myriad wacky elements of each film— from park permits to talent, from legal coverage to helicopters with pilots who'll agree to break laws, from shot lists to insurance—all the way through the tedium of post-production while designing and maintaining a budget for it all is invigorating and tremendously rewarding. Coordinating everything to work together per Matthew's dictate makes for a happy, hermetic (if sleep-deprived) reality that makes everything outside of it just seem odd.

Matthew D. Ryle

SCULPTURE FABRICATION,
CREMASTERS 1 AND *5*;
PRODUCTION DESIGN,
CREMASTERS 2 AND *3*

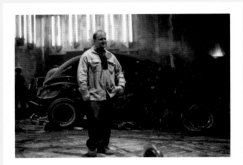

I met Matthew while I was working at a fabrication company that produced artists' projects, casino architecture, theme restaurants, and so on—from really trashy stuff to Vito Acconci's architectural work. Matthew came in to have the dancers' headpieces for *Cremaster 1* fabricated. He was the first artist I worked with who was really interested in materials—especially plastics, which was my specialty. So we hit it off, and I ended up working for him full-time.

Matthew's work ethic is very much geared toward maximizing. This requires a really dedicated crew and a lot of hard work. People visiting the studio seem disappointed to find that it's not filled with frolicking satyrs, but the whole operation is more like a workshop than a fashion shoot.

We never have a master plan for a set or a sculpture, and a lot of it is made up as we go along. Just when an idea starts to become concrete, Matthew will change it completely to keep it from being too familiar too soon. The minute you think you have it nailed, there's a new twist to keep it from being overdetermined. These developments shape and affect the final narrative.

A lot of times, we work from a term or a key phrase that Matthew provides. He described the pillow throne in *Cremaster 5* (which was made of fiberglass and resin) as a fleshy stone, something that was alive, like a jellyfish. He also kept mentioning a bowling ball. Clues like this precipitate the finished work. The language for set design is the same, in that words like "hermetic," "tray," "like a tool" become the details that illuminate the whole. It's most exciting for me to see the sculptures realized as containers for the story. The narrative is rooted in a physical thing—the sculpture as a material drama.

Anyone can have an intimate relationship with the *Cremaster* films or the sculptures because they are not hyped or advertised. In this way they're so reserved. But I think anyone can access them from any point: from fashion, horror movies, architecture, drawing, photography, football, plastics—or just storytelling. The whole project is so porous; there are a million ways to enter it.

Richard Serra

ARTIST; HIRAM ABIFF AND HIMSELF,
CREMASTER 3

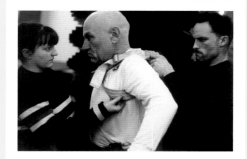

Matthew hasn't set limits on who he is or what he can make as a filmmaker, sculptor, or photographer. What's interesting is how he's been able to involve people in his work, his ability to have people who are non-performers enter into his intensity and become an extension of his imagination. I think if you are going to direct, that's a prerequisite. He's good at what he does. It has a lot to do with Matthew being gracious, intense, and a good listener. I've been around filmmakers. I used to shoot film myself. I've collaborated with Robert Smithson, Philip Glass, and others. When you collaborate, you have to drop your ego because it's not about you anymore. You're just malleable for someone else.

I think Matthew chose me for the film because he likes who I am and what I do, and he thought, "If this person is just who he is in this film, he'll probably be okay." I don't have any illusions about myself as an actor. I thought, "If I'm going do this, I might as well just be a useful tool." I think if you decide to become a tool for somebody, you might as well allow them to use you the best way they can. When he filmed the splashing scene, I thought I could look at it as a satire or as a deconstruction of what I did early on. Or I could see it as him transforming lead, which is a material I use, into his own material in order to make some kind of postmodernist pastiche. Or I could also look at it as a way to make a good fool of myself. But then I remembered the Jean-Luc Godard film *One Plus One*. It's also called *Sympathy for the Devil*. Godard thought he could reduce Mick Jagger to a symbol for the commercialism of the music industry by showing how he records a track. Godard made Jagger sing this riff over and over again. He doesn't get it right. Pretty soon you think, "Poor Jagger's sunk to the lowest depth, selling toothpaste here." The fact of the matter is that after about the twentieth take, Jagger starts to get off on it and does his repetitions with enormous intensity. He does it differently every time with total conviction and passion, to the point that it starts to backfire on Godard, to undermine Godard's initial intention. What was supposed to be a critical take on this performer as an extension of consumerism reverses itself. Well, that's the way I decided to deal with Matthew's use of me in that scene. Me and Mick. I decided to just do what I do, giving it my all every time. How can you possibly go wrong that way?

Peter Strietmann

DIRECTOR OF PHOTOGRAPHY,
CREMASTERS 1–5

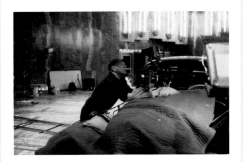

I have some sense of what the *Cremaster* project is as a whole, but then that sense is different for everybody. For me, it's more of a nuts-and-bolts sensibility about how things work together. A lot of Matthew's metaphors escape me at first, because I'm thinking of other things when filming. We always start out with the storyboard, since I need to have a pretty clear idea of how we're going to fit things together before I start rolling. With *Cremaster 4*, Matthew was using those little three-by-five-inch index cards. He would draw a little scene on each card or a significant image from that scene, and those reflected almost verbatim the images he wanted to get. I am still amazed that he could draw these things from his head with correct perspective. And they were never just of a standard kind of shot—establishing the house on the pier or a motorcycle team, for instance. Instead it would be this strange scrotum shot with an extremely wide angle and an impossibly low perspective. Initially it would seem so absurd to me that somebody would even consider creating such views. But then things would drop into place and I'd start shooting and discover that I could find that exact image. The storyboards have really loosened up over the years. They've become much more conceptual. We've developed a whole different kind of method of working, too. Basically, every shot has motion in it, and that's hard to illustrate on a three-by-five index card.

In *Cremaster 1*, people thought the scenes on the field were computer generated, which they weren't. This makes me feel good, because it takes the material out of its element and introduces something that wasn't there before. Basically, it's always been a one-camera shoot, so for every sequence we have to reset the camera and reshoot the same thing to get a different perspective. But recently we've been filming with two cameras and sometimes three. We shoot a master shot, then move in for the tight shots. The ratio of what we shoot to what makes it in the film has gone way up. On *Cremaster 2*, I figure it was thirty-something to one. And for the last one, it's going to be higher than that. It's a tremendous amount of work, but when you film like that, it opens up so many more options when you're piecing it all together. You can have more variations on any one scene. In the past we sometimes struggled to find something to fit.

Matt Wallin

MANTRON CORPORATION;
DIGITAL EFFECTS, *CREMASTERS 2, 3,* AND *5*

I first saw Matthew's films in 1997 while I was working for George Lucas's company, Industrial Light and Magic (ILM). The San Francisco MoMA was showing *Cremaster 1* and *4*. A friend of mine had recommended them, but I was cynical about it, thinking they'd be boring art videos—a total snooze-fest or something. But I thought they were really great. They were so strange and weird. I came to it all as a film person without any real art background. I thought the films had an interesting, nontraditional narrative structure, which I found exciting. And there were some really low-end computer graphics being used, which I also appreciated. So I started doing some research on Matthew. I figured he must have been some European artist, who spoke German or something and wore black rubber clothes. I ordered a back issue of one of the art magazines that had an interview with Matthew, which had been done by Thyrza Nichols Goodeve, who had been my senior thesis advisor at SFSU film school years earlier. It was such a strange coincidence—that I would like these films and that she knew the artist. When I was in New York shooting part of a documentary, I looked her up and she suggested I send Matthew a letter. So I took a piece of ILM letterhead and wrote a letter that basically said how much I liked the work and that I had access to hundreds of millions of dollars worth of some of the most sophisticated computer-graphics equipment in the world. I said, "If you'd ever want to use it for one of your projects, I might be able to find a way to do it off hours." I think it was two weeks later when I was at work and he just called me on the phone and said, "Matt?" And I said, "Yeah." "Hey, this is Matthew Barney." And I said, "Oh, hey. What's going on?" And he said, "I got your letter and it sounds really cool." I've been working with him ever since.

He had just returned from filming *Cremaster 5* in Budapest and wanted to see if I could help add ice to the shots of the Danube River. He sent me a tape to review, and I got permission from the company to work on it as an independent project. I organized a small team of digital artists, and we worked on it in the evenings and on weekends. We did the scene on the bridge: we put ice in the river, and we used dust elements from an old car commercial to make breath, so it looks like it's really cold.

The most interesting thing I did for the next film, *Cremaster 2*, was the circle of bison. There's a shot of ten bison walking backwards to form a circle around the Gary Gilmore character on the bull. And that's all one bison, photographed in a bunch of different positions. We set it up like a clock—one o'clock, two o'clock, three o'clock—and shot it so that we got each mark hit by the animal. Then the footage was stretched and played backwards. The final scene is just a composite of ten or eleven layers. We came up with that idea as a way of getting the bison to do exactly what Matthew wanted—it's hard enough to get one animal to walk backwards, let alone ten.

We're doing a lot of exciting things for *Cremaster 3*, but from New Jersey now, where I have my own computer-graphics company. We're doing design and animation for the title graphics. We've tried to make the emblem that emerges in the title treatment look as if it were made of stainless steel, with a two-headed eagle and the Chrysler Building. And we're doing composites of the giants in Ireland and Scotland by rescaling the actors so they look really, really big. We're also making it look like

one of them is on a swing inside Fingal's Cave on the Isle of Staffa. Matthew actually tried to film this, but when we got to the island it proved too difficult. They were trying to figure out how they were going to rig this swing to support this actor who weighs five hundred pounds above super-rough, raging seas in this rock cave. I think they probably could have done it, but it would have taken a really long time, and it would have been pretty dangerous. So there was a decision made to just shoot the cave, and then in Matthew's studio we set up a green screen, the swing, the actor, and a whole bunch of seaweed and shot that element. And we'll take that and insert it into the shots of the cave.

The most ambitious effect we're doing is to turn the Chrysler Building into a maypole, so there'll be green and orange ribbons wrapped in opposite directions around the crown of the tower. I know Matthew really wanted to try to actually do this as a practical effect, but in the end it would have been very difficult and expensive to get permission to do it. We're also going to put scaffolding on the building so it looks like it's not quite finished yet. Plus we're replacing all of the blue-screened windows on the set of the Cloud Club with the skyline of Manhattan from the 1930s so it looks like it was really shot in the Chrysler Building. At the end of the movie, there's a stone thrown by a giant that turns into a Manx symbol and then crashes into the sea. It sinks and then grows horizontally to become the Isle of Man. These last shots are completely computer-generated— which is really challenging and exciting for my team.

All the *Cremaster*s have been shot on video, to my knowledge. The first one was shot on BETA SP. Then *Cremaster 1* and *5* were shot on Digital BetaCam, which is just a step down from high-definition television. It shoots everything wide-screen, digitally compressing the picture so everybody looks really tall and skinny. It's a digital anamorphic perfect for transferring to film. For *Cremaster 2,* Matthew stepped up to HDTV. And now, for *3*, everything's being shot on another new format called 24P HDTV, which records pictures at twenty-four frames per second, which is the exact same frame rate as film, so it's a direct transfer, giving the video a much more "filmlike" look. Every video frame equals one film frame when it's transferred to 35 mm for theatrical projection. The technology Matthew uses is always on the cutting edge. It always makes for a challenging and exciting time on our end, certainly breaking new ground in the world of video art.

Chris Winget

STILL PHOTOGRAPHY AND
LIGHTING DESIGN, *CREMASTERS 2*
AND *3*

Matthew is very specific about what he wants to do in terms of photography, especially for the character portraits, and I'll always begin by trying to get that image for him. He's against retouching. It's very rare, compared to what everyone is used to seeing in magazines, where almost every picture is retouched. Practically every *Cremaster* photograph is a straight picture that was taken during the shooting of the film. It gets back to being a document of reality. A real thing has happened, and this is the picture of it. I try to record as much as I can through the whole process. I do the established shots that are on our list. I also try to do additional shots of the characters that I think might be good. I take pictures of the event itself. And I try to shoot the sets in a formal way both during and after the filming. In a way, there's something incredible about the sets when the action has already taken place and the characters have left. It's a great moment on each part of the shoot.

As we go along, I get more of a sense of which things deserve emphasis. Things that are fleeting in the films can be highlighted in the still pictures, and Matthew can decide later if and how he wants to pair them off with the character portraits. I have my own idea of what I think Matthew's intention is. Even though he art directs the photographs, he is very open to my input. Everybody down to the guy building the sets is encouraged to have that input. Everyone can give as much as they want to the project. That's what we're being asked to do. There's an idea that doesn't yet have physical form; it's not yet in a frame. And that's what we're brought in to do.

CREMASTER 1

WRITTEN AND DIRECTED BY
Matthew Barney

PRODUCED BY
Barbara Gladstone and
Matthew Barney

DIRECTOR OF PHOTOGRAPHY
Peter Strietmann

PRINCIPAL PRODUCTION TEAM
Chloe Piene, Paul Pisoni, Robert Wogan

CAST

GOODYEAR
Marti Domination

GOODYEAR HOSTESSES IN THE
GREEN LOUNGE
Gemma Bourdon Smith, Kathleen
Crepeau, Nina Kotov, Jessica Sherwood

GOODYEAR HOSTESSES IN THE
RED LOUNGE
Tanyth Berkeley, Miranda Brooks, Kari
McKahan, Catherine Mulchahy

GOODYEAR CHORUS GIRLS
Brooke Albus, Sara Bearce, Celeste Bolin,
Amanda Byram, Holly Carlock, Erin
Caskey, Jennifer Charles, Jessica Corral,
Sandi Davis, Kiley Deakins, Kelsey
Deakins, Bobbi Degraw, Melissa Degroat,
Kim Dias, Jean Doyle, Misty
Friedrichsmeyer, Renata Goralski,
Barbara Greenough, Kira Gruenhagen,
Anna Bree Hardy, Mary Jackson, Kate
Jensen, Rachel Kieffer, Kacy Largan,
Shannon Lincoln, Brenna Manley, B. J.
McKelvy, Shannon Meng, Nicole Michel,
April Mora, Heather Moss, Teena
Overseth, Candess Packard, Dina Parker,
Mickey Parker, Emily Patterson, Terri
Pitz, Tori Post, Nikki Ramsey, Rachel
Reed, Tawnia Rodriguez, Kristi
Schneider, Jessica Sherwood, Natalie
Shields, Katie Splan, Kim Splan, Tarisa
Swenson, Natalie Taylor, Katrina Upshaw,
Melanie Wadsworth, Tahya Wassem,
Jennifer Watson, Antonette Wisdom,
Jennifer Wolf, Michelle Wood

TITLE SEQUENCE CHORUS GIRLS
Anne Bannert, Juliette Vassilkio

CREW

CHOREOGRAPHY
Julie Stevens and Matthew Barney

STILL PHOTOGRAPHY
Michael James O'Brien

3D GRAPHICS ANIMATION
John Baumann for Celefex

WARDROBE DESIGN EXECUTION
Linda LaBelle

HAIR DESIGN
Avram for Vidal Sassoon

MAKE-UP
Andrea Paoletti

SOUND & MUSIC DESIGN
Antony Widoff

ORIGINAL MUSIC COMPOSITION
Jonathan Bepler

WARDROBE FOR THE
GOODYEAR AIR HOSTESSES
Isaac Mizrahi

WARDROBE FOR GOODYEAR
AND THE GOODYEAR CHORUS GIRLS
Linda LaBelle, Karen Young,
Manolo Blahnik

ONLINE EDITOR
Karen Heyson

EDIT FACILITY
Eric Solstein Prod., Inc.

ADMINISTRATIVE ASSISTANT
Mark Fletcher

SET DESIGN ASSISTANTS
Hillary Koob-Sassen, Daniel Sauli

SCULPTURE FABRICATION
GT Custom, Matt Ryle, Kelli Wilding

PRODUCTION ASSISTANTS
Christopher Maius Bone, Carina
Evangelista, Beck Feibelman, Rita
Gonzalez, Martin, Jasmine Moorhead,
Chelsea Romersa

PHOTOGRAPHIC ASSISTANT
Andrea Fracarri

HAIR STYLING ASSISTANT
Odell England of Graber Hair

HELICOPTER SERVICES
Western Airways, Rick Wyman,
Kim Harris

CATERING
Clark Catering

"Starlet in the Starlight" by K. Essex

"Sun Pretty" by A. Mawer

"Orchidella" by P. Dennis

CELLO
Maxine Neuman

HARP
Carol Emanuel

With thanks to Boise State University
Athletic Dept. and the Bronco Football
Team, Dan Termini, Herb Criner,
Larry Burke, and Ed

Special thanks to Shaun Caley,
Stuart Regen, Camilla Nickerson and
Vogue Magazine, NARS Cosmetics,
Charles Quinn at Sony, David Henderson,
Ed Mulick, Bob and Sherrie Barney,
Mary Farley and Zone Six, and all the
helpful parents

© 1995 Matthew Barney

CREMASTER 2

WRITTEN AND DIRECTED BY
Matthew Barney

PRODUCED BY
Barbara Gladstone and
Matthew Barney

DIRECTOR OF PHOTOGRAPHY
Peter Strietmann

MUSIC COMPOSED BY
Jonathan Bepler

ASSOCIATE PRODUCER
Chelsea Romersa

PRODUCTION DESIGN
Matthew D. Ryle

CAST

HARRY HOUDINI
Norman Mailer

GARY GILMORE
Matthew Barney

BABY FAY LA FOE
Anonymous

BESSIE GILMORE
Lauren Pine

FRANK GILMORE
Scott Ewalt

NICOLE BAKER
Patty Griffin

MAX JENSEN
Michael Thomson

JOHNNY CASH
Dave Lombardo, drums
Bruce Steele, with bees
Steve Tucker, voice

TWO-STEP DANCERS
Cat Kubic and Sam Jalahej

BRAHMAN BULL
#55

FRENCH BULLDOG
Jacqueline Molasses

THE MORMON TABERNACLE CHOIR
ANIMATION AND VISUAL EFFECTS PRODUCER
Matthew Wallin

VOICE OF FAY LA FOE
Lenore Harris

CANADIAN MOUNTIES FOR METAMORPHOSIS
James Pantoleon, James T.S. Weelock, Jr.

MOUNTED STATE TROOPERS
Evanston Cowboy Days Ladies Flag Posse

MORMON ELDER
Wally Grant

MOUNTED SHERIFFS
Roy Hadley, Bill Hadlock

CORRECTIONAL OFFICER
Eric P. Reid

DEPUTY SHERIFFS
Gene Hadley, Virgil Neves,
M. Shane Richins

MEDICS
Quinn Horrocks, Boone Kirkman

CANADIAN MOUNTIES AT EXPO ENTRANCE
TJ Davey, Matt Ryle

DRUNKEN EXPO GUESTS
Gabe Bartalos, Chelsea Romersa

EXPOSITION CUSTODIAN
Shusei Sugawara

CREW

PRINCIPAL PRODUCTION TEAM
Timothy J. Davey, Hal McFeely III,
Paul Pisoni, Kristin Schattenfield,
Shusei Sugawara

PROSTHETIC MAKE-UP & EFFECTS
Gabe Bartalos of Atlantic West Effects

VISUAL EFFECTS SUPERVISOR
Karen Ansel of MOBILITY, Inc.

LIGHTING
Chris Winget

COSTUME DESIGN
Linda LaBelle and Laurence Esnault

COSTUME FOR FAY LA FOE
Dean Sonnenberg

HAIR & BEAUTY MAKE-UP
Regina Harris

STILL PHOTOGRAPHY
Michael James O'Brien
and Chris Winget

UTAH

ORGANIZATIONAL SUPPORT FOR RODEO
Roy Hadley

PROSTHETIC MAKE-UP EFFECTS
Steve Lawrence, Cesha Ventre, Al
Venuto, Michael O'Brien, Al Tuskes,
Tammy Lane for Atlantic West Effects

SECOND UNIT VIDEOGRAPHY
Chris Winget, Paul Pisoni

STILL PHOTOGRAPHY ASSISTANT
Carter Berg

SALT ARENA BUILT BY
Shelton Construction

BULL PROVIDED BY
Bar T. Rodeo, Inc.

BUFFALO PROVIDED BY
Richard Davis

BUFFALO TRAINER
Leonard Simpson

BUFFALO WRANGLER
Roy Batty

GILMORE STUNT DOUBLES
Justin Corgatelli, Randy G. Hatch

BODY DOUBLE ON FALLEN BULL
Hal McFeely III

SALT ENGINEERING
Brent Bingham and Brett Dixon of
Bingham Engineering

GAS STATION PROVIDED BY
Richard Johnson, DDS

WHITE 1966 MUSTANG PROVIDED BY
Sean & Dion Gyll

BLUE 1966 MUSTANG PROVIDED BY
Eugene Larson

INTERIORS BY
Automat

SILVER ENGRAVING
Clint Mortenson Saddlery

HELICOPTER PILOT
Mike Stapely of Alpine Helicopters

GRIP & GAFFER SERVICES
Redman Movies & Stories, Phil Shepard
Productions, Ron Hill Imagery

SUPERVISING VETERINARIAN
Joe H. Roundy, D.V.M. of Tooele
Veterinary Clinic

CHUTES MADE BY
Ahlin Livestock Equipment

MUSTANG MECHANIC
Armand D'Agostini

COSTUME RENTAL
Jim Platt of Reel Cops
Costume Rental Corp.

LOCATION MEDIC
Wendover Ambulance

SHIPPING
SOS Global

FOOD SERVICES PROVIDED BY
Fat City Catering

SECURITY
Joe Bishop

With thanks to Janice MaChipiness,
The Bureau of Land Management,
Big O Tires, Steve Perry and the Days Inn
of Wendover, The American Bush, Scott
Olsen, Ed Mulick, Marilyn Toone/Central
Utah Film Commission, Utah State
Highway Patrol, Eagle Travel, Save the
Salt, Chris Sleater and Leigh von der
Esch/Utah Film Commission

NEW YORK

CARPENTRY
Chris Hanson, Derek Haas. Paul Wilke

SCENIC PAINTING
Luther Davis, Zane Mills

GRIP ASSISTANTS
Blithe Riley, Paul Steketee

PRODUCTION ASSISTANTS
Denise Baer, Andres Baiz, Chris Barnes,
Willa Bepler, Brian DeRan, Sam Green,
Tammy Lane, Muneto Maekawa, Matsu,
Andrew Mount, Michael Sean O'Mahony,
Josh Reiman, John Roche, Lisa Vollmer

BODY DOUBLE FOR BESSIE GILMORE
Kembra Pfahler

METAMORPHOSIS CABINET
Thomas Kearns for GT Custom, Inc.

ICE SCULPTURE
Ice Fantasies, Inc.

ADDITIONAL LIGHTING
Bruce Benedict for Hotlights, Inc.

SHOES
Prada

WIGMAKER
Paul Huntley

MANICURIST
Dida Paraschivoiu for
Bradley Curry Management

MILLINER
Lynne Mackey

BEE WRANGLER
Bob Scura

MAKE-UP ASSISTANT
Ramie Roth

EXPO LOCATION
The Bedford Armory, State of New York

VEHICLES IN COLUMBIAN EXPOSITION
PROVIDED BY
20th Century Cars, Ltd., Cofiells Sport
and Power Equipment, Jay Ellis, The
King Cycles, Inc., Shamus Mack, Brian
Martin, Michael Pazienva, John Seasock
for Sudden Impact Racing, Ski
Windham, Leo Terrizzi, Dave Venti

MOLD-MAKING ASSISTANCE
Derek Haffar

FOUNDRY
Polich Art Works

GRIP & GAFFER SERVICES
Camera Services Center, Bexel

MACHINE SHOP
Merka Manufacturing

MIRRORED WESTERN SADDLE PROVIDED BY
Alobar's

FOOD SERVICES PROVIDED BY
The Hall Company

LEGAL SERVICES
Stout & Thomas

INSURANCE CONSULTANT
Ellen Ross, Acordia Northeast

MASTERPOINT VERSE BY
Edgar R. Brewster, Brewster Foundation

MASTERPOINT VOICEOVER
Chelsea Romersa

With thanks to Robert Isabel,
Judith McNally, Jean Stein, Marti
Domination, Jean-Yves Noblet, Me & Ro,
John Romersa, Grace Clark, Maria
Gallerie, Priester, Morris, Paul Barratt,
Stacey Tunis, and Jessica Frost

CANADA

ICE GUIDE
Peter Lemieux of Icewalks

HELICOPTER PILOT
Neil Thompson of Canadian Helicopters

TYLER MOUNT
Panavision Canada Corporation

PRODUCTION ASSISTANTS
Rick Azure, Joy Barrett, Bill Bulek,
Brian Cahill, Jeremy Carnagey,
Scott Denny, Jim Dini, Yvanne Faught,
Tyla Guss, Lori Hinson, Juliet Izatt,
Brad Nelson, Matt Wyatt

BOOM OPERATORS
Mark Gantzert, Andy Clarke, Mike Yarske

With thanks to Glacier Park, Inc.,
Grant Potter, Jasper National Park,
Banff Springs Hotel, North American
Wildlife Museum, The Brewster
Company and Athabasca Ice Center

LOS ANGELES

BEE TRAINER
Bee & Insect People, Unlimited

LODGING
Highland Garden

With thanks to Shaun Caley Regen, Lisa
Overduin, David Korty, Elias Kostis, and
Eric Bonwitt

POST PRODUCTION

SPECIAL VISUAL EFFECTS & ANIMATION
Ira Shain, Mark De Sousa, Xye,
Travis Price, Steve Linn, Dan McNamara,
Jack "Edsel" Haye, Dani Morrow,
Kim Bromley, Michelle Motta,
Jason Rosson, for MOBILITY, Inc.

ONLINE EDITOR
Mike Buday

ONLINE FACILITY
LaserPacific

OFFLINE FACILITY
Christopher Seguine for Sublime Films

TAPE TO FILM TRANSFER
Sony Pictures High Definition
Imaging Center

SOUND MIXER
Chen Harpaz for
Cinema Audio Playground

SOUND EFFECTS EDITOR
Adam Goldstein

C2 GRAPHIC
Lalena Fisher

2D GRAPHICS
Joe Bosack

CAMERA SUPPORT
Plus 8 Video

DUB SERVICES
USA Dubs

TITLES
Pacific Title Digital

COLOR TIMING
Joe Parisella

COLOR LAB
Fotokem

MUSIC
All songs by Jonathan Bepler

All lyrics by Nicole Baker and
Gary Gilmore excerpted from *The
Executioner's Song* by Norman Mailer

"Compression Prelude"

ORGANIST
Gregory D'Agostino

The Norian Philharmonic

RECORDED AT
Riverside Church and
Sorcerer Sound, NY

ENGINEERS
Alan Silverman, Dante DeSole

"The Man in Black"

LYRICS
Gary Gilmore

DRUMS
Dave Lombardo

VOCALS AND BASS
Steve Tucker and 200,000 honeybees

RECORDED AT
Westlake Studios, L.A., and
Sparkle Sound, N.Y.

ENGINEERS
Dante DeSole, Stephen Harrison

"The Ballad of Gary Gilmore"

LYRICS
Nicole Baker and Gary Gilmore

VOCALS
Patty Griffin and Steve Tucker

RECORDED AT
Sparkle Sound, N.Y.

ENGINEER
Dante DeSole

"Interlude Saline"

ORGANIST
Gregory D'Agostino

RECORDED AT
Riverside Church

"Deseret Hymn"

LYRICS
Gary Gilmore

CHORUS
Tabernacle Bass Choir

CONDUCTOR AND ORGANIST
Gregory D'Agostino

RECORDED AT
Riverside Church and
The Warehouse, N.Y.

ENGINEERS
Cynthia Daniels, Alan Silverman

"The Executioner's Step"

LYRICS
Nicole Baker

VOCALS
Patty Griffin

The Norian Philharmonic

RECORDED AT
Sparkle Sound and Sourcer Sound, N.Y.

ENGINEER
Dante DeSole

"Postlude Retreat"

ORGANIST
Gregory D'Agostino

The Norian Philharmonic

RECORDED AT
Riverside Church and
Sourcer Sound, N.Y.

ENGINEERS
Dante DeSole, Alan Silverman

With thanks to Tim Smith, Al Kisys, Maxine Neuman, Ken Levitan and Kathi Whitley for Vector Management, Günter Ford and Dieter Szczypinski for World Management

This film was produced without the participation and approval of the Mormon Tabernacle Choir, and no depiction or reference contained herein is intended to imply any such participation or approval

All animals were handled by professionals under veterinarian supervision.

Special thanks to Norman Mailer and Lawrence Schiller for their generous permission for the use of *The Executioner's Song* in CREMASTER 2, and to Mary Farley and Zone Six

For Stuart

© 1999 Matthew Barney

CREMASTER 3

WRITTEN AND DIRECTED BY
Matthew Barney

PRODUCED BY
Barbara Gladstone and
Matthew Barney

DIRECTOR OF PHOTOGRAPHY
Peter Strietmann

MUSIC COMPOSED BY
Jonathan Bepler

ASSOCIATE PRODUCER
Chelsea Romersa

PRODUCTION DESIGN
Matthew D. Ryle

SPECIAL MAKE-UP EFFECTS
Gabe Bartalos

COSTUME DESIGN
Linda LaBelle

LIGHTING DESIGN
Chris Winget

ASSOCIATE PRODUCTION DESIGNER
Hal McFeely III

PRODUCTION SUPERVISOR
Jessica Frost

PRODUCTION MANAGER
Kristin Schattenfield

VISUAL EFFECTS SUPERVISOR
Matthew Wallin

COMPUTER GRAPHICS SUPERVISOR
Adam Martinez

PRINCIPAL PRODUCTION TEAM
Kanoa Baysa, Nicholas Emmet, Chris Hanson, Dow Kimbrell, Michael Koller

POST-PRODUCTION SUPERVISOR
Christopher Seguine

BEAUTY MAKE-UP
Regina Harris

CAST

HIRAM ABIFF
Richard Serra

THE ENTERED APPRENTICE
Matthew Barney

THE ENTERED NOVITIATE AND
OONAGH MACCUMHAIL
Aimee Mullins

CLOUD CLUB MAITRE D'
Paul Brady

CLOUD CLUB BARMAN
Terry Gillespie

GRAND MASTERS
Mike Bocchetti, David Edward Campbell, James Pantoleon, Jim Tooey

GARY GILMORE
Nesrin Karanouh

FIONN MACCUMHAIL
Peter D. Badalamenti

FINGAL
The Mighty Biggs

THE ORDER

HOSTESSES
Heather Garrett, Maria Goodman, Zerha Leverman, Kari McKahan, Judy Steele

1ST DEGREE
LINE CAPTAIN
Nicole Sistare

PRINCIPALS
Stephanie Jean Bishop, Stephanie Lang, Jennifer Locane, Laura M. McKenzie, Jennifer Merklinger, Courtney Patton, Jennifer Voss-Duran

CHORUS
Rana J. Bonanno, Nita Borchardt, Gwendolyn Bucci, Amy Burnette, Heather Coker, Ashley Eckenweiler, Meg Huggins, Natalie King, Andrea Kron, Janna Naylor, Jennifer Sagan, Alexandra L. Sawyier, Cheryl Scott, Kerry Stichweh, Tara Stiles, Kerry Stugard, Heather Thompson

2ND DEGREE
AGNOSTIC FRONT
Roger Miret, Vinnie Stigma, Jimmy Colletti, Rob Kabula

-VS-

MURPHY'S LAW
Jimmy Gestapo, Ben Shapiro, Aaron Collins, Eric Arce

3RD DEGREE
Aimee Mullins

4TH DEGREE
Five Points of Fellowship

5TH DEGREE
Richard Serra

DEMOLITION DERBY DRIVERS
C1: James "Primmy" Hummel
C2: Michael "Irish Mike" O'Keefe
C3: Bob "Whiplash" Genovese
C4: Scott "Big Mac" McNamee
C5: Ken "Killa" McNamee

DEMOLITION DERBY JUDGE
Lori Weatherly

UNDERTAKERS
Sam Bart, Thomas L. Kearns V, R. Kevin Lalley, Alexander McKeever, William Owens

MAYPOLE DANCERS
Rob Besserer, Todd Hunter, Joshua-Paul Johnian, Bruce L. Jones, Jon Kinzel, Joseph P. McDonnell, Joshua Zimmermann, Greg Zuccolo

MASONIC HITMEN
Joseph Augulis, Brian Bogart, Neal J. Glancy

GOLDEN EAGLE
Hope

BENGAL CAT
Sheba

METAL WORKERS
John Fiore, Ray LaChapelle, Bud Simmons, Joe Vilardi

MAYPOLE WORKERS
Kanoa Baysa, Aron Christensen, Paul O. Colliton, Patrick Dillon, Nicholas Emmet, Jessica Frost, Chris Hanson, Michael Koller, Michael O'Mahony, Kristin Schattenfield, Paul Wilke

SARATOGA RACETRACK DRIVERS
C1: Pascal Beaulieu, Paul C. Dudka
C2: Gary Kamal, David P. Taft
C3: Bruce M. Cooper, Frank McMahon
C4: Joseph D. DeCarlo, Douglas Morton
C5: Bill Dufresne, Scott Mongeon

HARNESS TRACK JUDGE
Robert Barney

BUGLER
Brian Bailey

HARNESS TRACK STEWARD
Larry Finneran

HARNESS TRACK PHOTOGRAPHER
Ron Fazio

PACE CAR GATEMAN
Hal McFeely III

SECURITY IN THE ORDER
Paul Cantelmi, Philip Cantelmi, Douglas M. Carroll, Steve DiBenedetto, Jeff Fallow, Anthony Hernandez

CREW

1ST CAMERA ASSISTANT
Rita Roti

ASSISTANT DIRECTOR IN THE ORDER
Tony Gerber

TECHNOCRANE OPERATOR
Joe Cuzan

CAMMATE OPERATOR
Jeremy Drowne

GAFFER
Chris Hayes

CLAY SCULPTING
Gamble Staempfli

PROPS SCULPTOR
Derek Haffar

CHRYSLER CROWN DRESS
Narciso Rodriguez

ADDITIONAL COSTUME DESIGN
James Livingston

ASSISTANT COSTUME
Kimberly Hoffman

PHOTOGRAPHIC ASSISTANCE
Aaron Wax

HARNESS RACING SUPERVISOR
Robert Morrison

STUNTS SUPERVISED BY
Michael O'Mahony

ADDITIONAL SET FABRICATION
GT Custom, Inc.

NEW YORK

CARPENTERS
Chris Anderson, Thomas Russ Anderson, Stardust Atkinson, Chrissy Baucom, Michael Buckland, Jakub Kuba Dorabialski, Derek Haas, Mark Hislop, Bradley Hoffer, Paul McGeiver, Erik Minter, Matthew Osiol, Ian Patrick, Stephen Rhodes, Brett Rogers, David Servoss, Andrea Stanislav, Seth Wiley, Paul Wilke, Neal Wilkinson, Colin Zaug

SET BUILDERS
Erin A. Bosse, Serena Duenas, Graham Day Guerra, Sarah Johnson, Ben Landers, Sarah Lilley, Melissa Lockwood, Rachel Lowther, Rylan Morrison, Rafael Rangel, Chris Reed, Josh Reiman, Pearl Rucker, Adrienne Smith, Colleen Smiley, Shusei Sugawara

PRODUCTION ASSISTANTS
Thordis Adalsteinsdottir, Ananda Bell, Cricket, James David Ebner, Jr., Nora Griffin, Linda Hirskovitz, Roswitha Hornschu, Roberta Mangini

CAR RESTORATION
Pat Laghezza, Edward Helmore, Tony Bronzene, Praise Auto, John Peoples, Thomas E. O'Keefe

LODGE WARDEN
Matthew D. Ryle

THE SOLOMON R. GUGGENHEIM MUSEUM

ASSISTANT CURATOR
Joan Young

TECHNICAL DEPARTMENT
Barry Hylton, Steve Engelman, Michael
Sarff, Robert Walden, Daniel Reiser

ATLANTIC WEST EFFECTS CREW

SCULPTURE/PROSTHETICS
Gabe Bartalos

SCULPTURE
Jacobien van der Meer, Tom Ovenshire,
John Welby

MOLD DEPT. SUPERVISOR
Rob Lan

MOLD MAKERS
Clayton Martinez, Alan Tuskes, Mark Lan

FIBERGLASS
Julian Hoeber, Brad Cronce

FOAM DEPT. SUPERVISOR
Craig McIntyre

FOAM TECHNICIAN
Chris Jones

FABRICATION
Dan Gates

SUIT CONSTRUCTION
Letticia Sandova, Consuelo Duran,
Maria Duran

MECHANICAL EFFECTS
Mark Setrakian

HAIR PUNCHING
Marlene Stoller

SHOP SUPPORT
Matthew Rainwaters

With thanks to
Amber Milliken & Lord Nelson

1ST ASSISTANT, MAKE-UP AND HAIR
Shannon Reynolds

ASSISTANTS, MAKE-UP AND HAIR
Claudia Andreatta, Jillian Chaittan, Chi
Chi, Kumi Craig, Andre Drykin, Erez
Laor, Miki Mori, Meli Pennington, John
Ruident, Maria Sanchez, Ume

MAKE-UP PROVIDED BY
M•A•C

MCARTHUR FURNITURE LOAN
Fisher Landau Center

LOBBY SCREEN PRINTING
Visual Impact

CAD ARTIST
Don Lee

FURNITURE RENTAL
Wyeth

UPHOLSTERER
Jung Griffin

LEATHERWORK
Clint Mortenson

MACHINISTS
Richard at Merka Manufacturing,
Joey Manson

ENGRAVING
George Khayata

FLOWER DESIGN ASSISTANT
Jeanne Costello

REFRIGERATION
Sound Airconditioning

EMBROIDERY
Penn & Fletcher, Inc.

COSTUME ASSISTANT
Tracy Rowitz

METAL FINISHING
Norman Mooney, Empire Metal Finishing

GLASS WORK
Mark Ferguson

MILLINER
Arnold S. Levine, Inc.

CHORUS COSTUME FABRICATION
Timberlake Studios

COSTUME RENTAL
Cest Manifique, Odds Costume Rental,
Rick's Fashion Americain, Jay Ruckel of
La Crasia Gloves, Uffner Vintage
Clothing L.L.C.

CAMERAS
Henry Bornstein, Plus 8 Video New York

LIGHTING PACKAGES
RGH, Available Light, Goblin Market
Films, Haze Lighting & Grip

GAFFER'S ASSISTANTS
John Kuegel, Scott Levey, Ted Sybor

CRANES
Golden Lamb, Majestic Light

DOLLY
CSC

HELICOPTER
New York Film Flyers

FOCUS PULLER
Hiro Takaoka

2ND UNIT CAMERA
Edin Vélez, Sandor Temlock

LOCATION SOUND
Wharton Tiers

SUPERVISING VETERINARIAN
Charles Bryner

GOLDEN EAGLE PROVIDED BY
All Creatures Great & Small of N.Y.

GOLDEN EAGLE HANDLED BY
Cathryn Long & Brian Robinson

LAMBS PROVIDED BY
Robert Holmes

HORSE HANDLERS
Sandy Beaulieu, Karen Kamal, Cynthia
Milano, John Nazarian, Frank Salino, Jr.,
Paul Zabielski

LODGING
The Brentwood Motel, Gershwin Hotel,
Pickwick Arms, Parkside Hotel

CATERING
Freshdish, Panza's

LEGAL
Stout & Thomas

PRODUCTION INSURANCE AGENT
Ellen Ross, Acordia Northeast

With thanks to Valerie Peltier of
TishmanSpeyer Properties, Rosalie
Benitez, Carter Mull, Ivy Shapiro,Tom
Fuhs, Eric Brown, Marc Hughes, Robert
Wogan, Shawn Sullivan, Stuart Parr,
Robert Isabel, The Lincoln Building, US
Bank Corp, Mike Mack, Jean-Yves Noblet,
Thyrza Nichols Goodeve, Trina
McKeever, Allen Glatter, Mary & Thomas
Kearns, Jim Simari, Harry Macklowe, The
New York Racing Association Inc., Aloy's
Harness & Equipment, Todd Norsten,
Scott Rudin, Karen & Chuck Harrison,
Guy Frost, Emily Fisher Landau, Bill Katz,
Red Burns, John Romersa, D.D.S.,
Charles Weiss, D.D.S., Laumont Digital,
Sherrie Barney

IRELAND / SCOTLAND

LOCATION MANAGER
Aileen Corkery

CARPENTRY & SETS
Laurent Mellet, Dáinne NicAoidh

SHEEP PROVIDED BY
Emma Chambers and Robert Harold

HIGHLAND COWS PROVIDED BY
Alan Dawson

ANGORA RABBITS PROVIDED BY
Angora Rabbit Farm, Isle of Mull

LODGING
Alison's B&B, The Seaview,
Smuggler's Inn, Staffa House

CATERING
Giant's Causeway Visitors'
Center Tearoom

With thanks to The National Trust for
Places of Historical Interest or Natural
Beauty, Northern Ireland Region, Teresa
O'Donnell, The Scottish National Trust,
Small Creek Communications, PDG
Helicopters, Nicola McCullough,
Marie Donnelly

POST PRODUCTION

EDITORS
Matthew Barney, Christopher Seguine,
Peter Strietmann

ONLINE EDIT
Sublime Films

SPECIAL VISUAL EFFECTS & ANIMATION
Mantron Corporation

3D TECHNICAL DIRECTORS/ANIMATORS
Luis Cataldi, Perry Horovas,
Kevin Romond

2D COMPOSITORS
Dan McNamara, Jae Wook Park,
Peter Strietmann

2D LINE PRODUCER
Luke O'Byrne

SYSTEM ADMINISTRATOR
Alexis Martinez

AUDIO POST FACILITIES
Mad Mad Judy, Akme Sound

SUPERVISING SOUND EDITOR
Steve Hamilton

SOUND DESIGNER
Dave Paterson

SOUND EDITOR
Matt Rocker

FOLEY EDITOR
Mary Ellen Porto

ASSISTANT SOUND EDITOR
Jeff Drury

FOLEY ARTIST
Jay Peck

FOLEY ENGINEER
Matt Rocker

RE-RECORDING MIXER
Dave Paterson

RE-RECORDED AT
Dig It Audio, New York

VOICEOVER
Chelsea Romersa

FILM TRANSFER AND COLOR TIMING
DuArt Film and Video

MUSIC

COMPOSED AND ORCHESTRATED BY
Jonathan Bepler

LYRICS BY
Matthew Barney

PART ONE

"Chrysler Chorale Overture"

MONOCHORD
Jonathan Bepler

THERAMINS
Jonathan Bepler, Rob Schwimmer

The Chrysler Philharmonic

The Cloud Club Big Band

SOLO TRUMPET
Chris Jaudes

"Rough Ashler"

MONOCHORD
Jonathan Bepler

The Cloud Club Big Band

"Song of the Vertical Field"

TENOR
Paul Brady

HARP
Zeena Parkins

WINDS
Jonathan Bepler

"Cloud Club Reel"

HIGHLAND PIPES
David Watson

UILLEAN PIPES
Ivan Goff

BODHRAN
Jonathan Bepler

"Initiate's Serenade"

PIANO AND THEREMIN
Rob Schwimmer

"Pace of the Novitiate"

The Cloud Club Big Band

The Chrysler Philharmonic

HARP
Nina Kellman

SOLO TRUMPET
Chris Jaudes

SOLO TROMBONE
Arthur Baron

PART TWO

"Crown Overture"

The Chrysler Philharmonic

The Cloud Club Big Band

"Spire March and Anthem"

TENOR
Paul Brady

The Chrysler Philharmonic

The Cloud Club Big Band

UILLEAN PIPES
Ivan Goff

SOLO FLUTE AND SAXOPHONE
Jack Bashkow

"The Order"

HARDCORE BANDS
Agnostic Front
Murphy's Law

HARDCORE SONGS BY
Agnostic Front
Murphy's Law

The Bathers Boys Choir

The Cloud Club Big Band

The Chrysler Philharmonic

HARP
Nina Kellman

PROGRAMMING AND ELECTRONICS
Jonathan Bepler

"Giant's Causeway Parable"

OONAGH'S VOICE
Sofie Zamchick

GIANTS' VOCALS
Jonathan Bepler

HARP
Nina Kellman

UILLEAN PIPES
Ivan Goff

THE CHRYSLER PHILHARMONIC

CONDUCTOR
Jonathan Bepler

THE CLOUD CLUB BIG BAND

TRUMPETS
Chris Jaudes, Jim O'Connor

TROMBONES
Dan Levine, Arthur Baron

SAXOPHONES
Steve Elson, Jack Bashkow

CONTRABASS CLARINET
Steve Elson

BASS
Jay Elfenbein

PIANO
Rob Schwimmer

DRUMS, VIBRAPHONE
Jeffrey Berman

PERCUSSION
Jonathan Bepler

THE BATHERS BOYS CHOIR

DIRECTOR
Gregory D'Agostino

PRODUCED BY
Jonathan Bepler

MIXED BY
Jonathan Bepler and Matt Rocker at
Fumes Sound, Brooklyn

MUSIC PRODUCTION MANAGER
Sarah Lilley

STUDIO ASSISTANCE
Daniel Teige

DOLBY SOUND CONSULTANT
Steve Smith

ORCHESTRA CONTRACTOR
Cellomax Productions

GAELIC TRANSLATION
Paul Brady

Paul Brady, Sofie Zamchick and the
Bathers Boys Choir recorded at Fumes
Sound, Brooklyn

The Chrysler Philharmonic recorded at
Clinton Studios, N.Y.C.

The Cloud Club Big Band recorded at
Fumes Sound and Systems Two, Brooklyn

Agnostic Front and Murphy's Law
recorded by Wharton Tiers at the
Solomon R. Guggenheim Museum

With thanks to Klaus Biesenbach, Liz
Devlin, Krista Feeney, Dan Froot, Seth
Gallagher, Tony Gerber, Jill Jaffe, Arto
Lindsay, Maxine Neuman, MB Studio,
Brent Nichols, Steven Poss, Jochen
Sandig, Noel Short, Alan Silverman,
C. Despera, Chip, Robin, Marcy, Tim,
Sarah, Bob, Kathy, Alex, Nathalie,
Minty Steele, Willa

All animals were handled by
professionals under
veterinary supervision

With special thanks to Nancy Spector,
Richard Flood, Jerry Speyer, Neville
Wakefield, Bob Barney, and Zone Six

S.K.R.E. flys free

With love to Birch

© 2002 Matthew Barney

CREMASTER 4

WRITTEN AND DIRECTED BY
Matthew Barney

PRODUCED BY
Artangel, James Lingwood,
and Matthew Barney

PRODUCED IN ASSOCIATION WITH
Fondation Cartier pour l'Art
Contemporain, Paris, Barbara Gladstone
Gallery, New York City,
with support from The Arts Council
of England

DIRECTOR OF PHOTOGRAPHY
Peter Strietmann

ASSOCIATE PRODUCER
Hervé Chandès

ASSISTANT DIRECTOR
Tom Johnson

CAST

LOUGHTON CANDIDATE
Matthew Barney

ASCENDING HACK
Team Molyneux: Dave Molyneux, Graham
Molyneux

DESCENDING HACK
Team Sinnot: Steve Sinnot, Karl Sinnot

FAERIES
Loughton Faerie: Sharon Marvel
Ascending Faerie: Colette Guimond
Descending Faerie: Christa Bauch

LOUGHTON RAM
John Stud, Jr.

CREW

WARDROBE DESIGN EXECUTION
Michel Voyski for 8 co.

PROSTHETIC MAKE-UP & SPECIAL EFFECTS
Gabe Bartalos

SOUND DESIGN
Steve Silkensen and Steve Hamilton for
Spin Cycle Post

STILL PHOTOGRAPHY
Michael James O'Brien

TAP CHOREOGRAPHY
Jeannie Hill

MOTORCYCLE SEQUENCE ORGANIZATION
Dave Molyneux

PRODUCTION ASSISTANTS, NEW YORK
Anna Ehrsam, Toland Grinnell,
Thomas Kearns

PRODUCTION ASSISTANTS, ISLE OF MAN
Eric Bonwitt, Simon Withers

ASSISTANT MAKE-UP
Dan Frye

PROSTHETIC ASSISTANT
Matt Singer

UNDERWATER ASSISTANT, FLORIDA
Leigh Fosnot for Dixie Drivers

UNDERWATER ASSISTANT, ISLE OF MAN & CA
Eric Bonwitt

ADMINISTRATIVE ASSISTANTS, NEW YORK
Michael Capotosto, Jay Tobler

ADMINISTRATIVE ASSISTANTS, LONDON
Lisa Harty, Melanie Steel

WARDROBE FOR THE LOUGHTON CANDIDATE
Manos Zorbas, N.Y.

WARDROBE FOR THE SIDECAR TEAMS
Manx Leathers, IOM

WARDROBE FOR THE FAERIES
Michel Voyski for 8 co.

SHOES
Patrick Cox, London

FAERIES REPRESENTED BY
Robin Parker of Physical Culture

John Stud, Jr. courtesy George and
Jan Steriopolis

"BATTLE OF THE TYNE"
Performed by Joe Brady

DRUMS
Rob Di Pietro

TAP DANCE FOLEYS
Lisa Hopkins

SOUND MIX
Reilly Steele for Sound One

SATELLITE IMAGE
NRSC Ltd. / Science Photo Library

COMPUTER ANIMATION
John Baumann for Celefex

ONLINE EDITOR
Schuyler Grant for Arc Pictures,
Eric Solstein for ESPI

OFFLINE EDIT SYSTEM
Burt Barr

AIRBRUSH ARTIST
Mike Ayott

LACE COLLAGIST
Harriet Millman Reed

RACEWAY GRAPHICS
Jean-Yves Noblet

CARPENTRY, IOM
Jimma Ruston, Colin Kinnin

HELICOPTER SERVICES
Keith Walker of Clyde Helicopter

CAMERA BOOM OPERATOR
Chris for Julian Cox

With thanks to Coastal Scuba, West Palm
Beach, The Florida Film Commission,
Doug Baird and Hilary Dugdale of The
Isle of Man Film Commission, Ian Bell,
Inspector Kinrade and the Isle of Man
Constabulary, Captain Michael Brew,
Ramsey Harbor Mastor, Ronaldsway
Airport, Manx Airlines, Athol Van Rental,
John Towle of Sub Aquatic Systems, The
Coffee Pot Restaurant, Pat Molyneux, and
the people of the Isle of Man

Special thanks to Mary Farley, Keith Edmier, Arto Lindsay, Neville Wakefield, Mary Harron, Chris Winget, Zone Six

Artangel is supported by The Arts Council of England and London Arts Board and Artangel Patrons

CREMASTER 5

WRITTEN AND DIRECTED BY
Matthew Barney

MUSIC COMPOSED BY
Jonathan Bepler

PRODUCED BY
Barbara Gladstone and Matthew Barney

DIRECTOR OF PHOTOGRAPHY
Peter Strietmann

CAST

THE QUEEN OF CHAIN
Ursula Andress

HER DIVA, HER GIANT, AND HER MAGICIAN
Matthew Barney

THE QUEEN'S USHERS
Joanne and Susan Rha

THE FÚDŐR SPRITES
Amy Chiang, Mei-Chiao Chiu, Michelle Ingkavet, Yoko Kuroiwa, Kim Nghiem, Joanne Rha, Susan Rha

The Budapest Opera and Philharmonic Orchestra Conducted by Gergely Kaposi with Voice by Adrienne Csengery

CREW

LINE PRODUCER
Chelsea Romersa

SET DESIGN EXECUTION
Robert Wogan

SCULPTURE DESIGN EXECUTION
Paul Pisoni

PROSTHETIC MAKE-UP
Gabe Bartalos

WARDROBE DESIGN EXECUTION
Linda LaBelle, Karen Young

STILL PHOTOGRAPHY
Michael James O'Brien

JACOBIN PIGEONS TRAINED BY
Mary Farley

HAIR DESIGN AND CREATIVE CONSULTATION
Avram Finkelstein for Vidal Sassoon

BEAUTY MAKE-UP
Regina Harris

TITLE ANIMATION AND DIGITAL CHARACTER GENERATION
John Baumann, Dean DeCarlo, Joosten Kuypers, and William Yarrington for Celefex

BUDAPEST

PRODUCTION ORGANIZED BY
Suzanne Mészöly, Director of C3 Center for Culture and Communication, with assistance by Balázs Beöthy

ADDITIONAL LINE PRODUCTION
György Dursi, Toto Komjáti and Péter Rahonyi of Képarnyék

LIGHTING
Péter Petô

STUNTS SUPERVISOR
Timothy J. Davey

PHOTOGRAPHIC ASSISTANT
David Willems

DIRECTOR OF THE BUDAPEST OPERA AND PHILHARMONIC ORCHESTRA
Lénárd Andor

CHORUS
Laszlo Antal, David Balassy, Krisztina Csongrádi, Balázs Kazi, Klaudia Kókai, Szilvia Kósa, Dénes Kósa, Peter Mekis, Ndiko Szabó Rebeli, Csilla Szász

MUSICAL DIRECTOR
Péter Aczél for Magyar Radio

SOUND ENGINEER
Jenó Bányai

TECHNICIANS
Gabor Buczkó, József Abonvi, Tibor Kovács

DISPATCHER
György Tòth

LYRICS TRANSLATOR
Gábor G. Gyukics

PRODUCTION ASSISTANTS
Kate Howard, Tamás Komoróczky, Gergely Molnàr, Sándor Jinx Szabò, Csaba Uglár

BODY DOUBLES FOR DIVA
Climbing: Timothy J. Davey
Fallen: László Birta

BODY DOUBLE FOR QUEEN
Celia Rue

MRS. ANDRESS'S DRIVER
Tamás Laczi

MRS. ANDRESS'S LANGUAGE COACH
Nora Palmai

DRESSER
Mrs. Erzsébet Toth

HORSE TRAINER
Zsolt Balaska

CATERING
Marquis de Salade

LODGING
Hotel Alba, Budapest, Kempenski Hotel, Budapest

With thanks to the Ministry of Culture & Education, Budapest, Budapest Springs & Thermal Baths Co. (Gellért Bath), The Mayor's Office (Lánchíd Bridge),

Miklos Borsa, Technical Director of the Hungarian State Opera House, Katalin Néray, Director of the Ludwig Museum of Contemporary Art, Budapest, Robert McIntosh, and the people of Budapest

NEW YORK

UNDERWATER SET BY
Thomas Kearns, George Gilpin, and David Nyzio for GT Custom, Inc.

DIGITAL GRAPHICS BY
Lalena Fisher

ATLANTIC WEST EFFECTS CREW

PROSETHETIC MAKEUP TEAM
Arnold Gargiullo II, Kelly Gleason, Dane Trask, and Cesha Ventre for Atlantic West Effects

SCULPTURE & DESIGN
Gabe Bartalos

MOLD MAKER
Clayton Martinez

FIBERGLASS
A. J. Venuto

FABRICATION
Eric Wright

SCULPTURE CASTING
Matt Ryle

MOLD MAKING
Derek Haffar

GLASS BLOWER
Karen Lamont

PRODUCTION ASSISTANTS
Johnson Buchanan, Maxie Buchanan, Kelly Chang, Glenn Griffith, Kate Howard, Gail Kennedy, Gigi Sharp, Shusei Sugawara

BODY DOUBLE FOR GIANT
Wayne Neho

CATERING
Kate Burton, Savories Personalized Meals

LODGING
East Hampton House

SERVICES
Applied Graphics Technologies, Exclusive Travel, Donald Shulte & Jay Strong of Frog Boy Pools, Pace Technologies, Peconic Scuba, P. J. McBride, Inc., RGH Lighting

With thanks to the Village of East Hampton, Martin Friedman, Ivy Shapiro, Jennifer Bartlett, Sarah Lilley

POST PRODUCTION

Subsidized access to post production facilities provided by the Bay Area Video Coalition, San Francisco, CA

ONLINE EDITOR
Toshi Onuki for BAVC

AUDIO POST FACILITY
Spin Cycle Post

VISUAL EFFECTS SUPERVISOR
MatthewWallin

TECHNICAL SUPERVISOR
Dan McNamara

FLAME ARTISTS
Mary McCulloh, Grant McGlashan, Jason Ortenberg

TECHNICAL ASSISTANTS
Wendy Bell, Garrick Meeker

PRODUCTION ASSISTANTS
Janet Lewin, Dani Morrow

SPECIAL ADVISOR
Kim Bromley

DIGITAL PAINT
Alexis Van Hurkman

CHYRON OPERATORS
Grace Lan, Heather Weaver

TAPE DUPLICATION
Digital Media Zone, USA Dubs

OFF LINE FACILITY
Creative Media Products

TAPE TO FILM TRANSFER
Four Media

Special thanks to Mark Fletcher, Jay Tobler, Helen Van der Meij, Mary Farley, Zone Six

List of Works in the CREMASTER Cycle

CREMASTER 1

CREMASTER 1, 1995
35-mm film (color digital video transferred to film with Dolby SR sound), 00:40:30

CREMASTER 1, 1995–96
Silkscreened laser disk, cast polyester, prosthetic plastic, and patent vinyl in self-lubricating plastic and acrylic vitrine
91 x 122 x 130 cm
Edition of 10, 2 A.P.

Goodyear Field, 1996
Self-lubricating plastic, prosthetic plastic, petroleum jelly, silicone, Astroturf, pearlescent vinyl, cast tapioca, cast polyester, polyester ribbon, costume pearls, speculae, and Pyrex
1.37 x 6.81 x 8.23 m overall
Emanuel Hoffmann Foundation. On permanent loan to Museum für Gegenwartskunst, Basel

Goodyear Gates, 1997
6 polyester and acetate-satin banners, nylon-acetate ribbon, 6 self-lubricating plastic poles, and 1 self-lubricating plastic wall mount; banners: 90.2 x 139.7 cm each; poles: 106 cm long, 12.1 cm diameter each; mount: 17 x 33 x 17 cm
Courtesy of Barbara Gladstone

Choreographic Suite, 1996
12 drawings: acrylic, petroleum jelly, and pencil on paper in vinyl floor tile, patent vinyl, and self-lubricating plastic frames
45 x 48 x 7 cm each
The Dakis Joannou Collection, Athens

Famous Potatoes, 2000
Graphite and petroleum jelly on paper in nylon frame
25.4 x 30.5 x 3.8 cm
Collection of Todd Levin, New York

Goodyear Manual, 1999
Petroleum jelly and enamel paint on *Smithsonian* magazine in prosthetic plastic frame
24.1 x 33.7 x 5.1 cm
Edition of 6, 1 A.P.

CREMASTER 1: Choreography of Goodyear, 1995
2 C-prints in self-lubricating plastic frames
70.5 x 85.1 x 2.5 cm each
Edition of 3, 1 A.P.

CREMASTER 1: Goodyear, 1995
Gelatin-silver print in self-lubricating plastic frame
83.8 x 109.2 x 2.5 cm
Edition of 6, 2 A.P.

CREMASTER 1: Goodyear Chorus, 1995
C-print in self-lubricating plastic frame
111 x 136.5 x 2.5 cm
Edition of 6, 2 A.P.

CREMASTER 1: Goodyear Lounge, 1995
2 C-prints in self-lubricating plastic frames
60.3 x 65.4 x 2.5 cm each
Edition of 3, 1 A.P.

CREMASTER 1: The Goodyear Waltz, 1995
1 C-print and 8 gelatin-silver prints in self-lubricating plastic frames
C-print: 85.7 x 70 x 2.5 cm; gelatin-silver prints: 64.1 x 54.6 x 2.5 cm each
Edition of 3, 2 A.P.

CREMASTER 1: Green Lounge Manual, 1995
2 gelatin-silver prints in self-lubricating plastic frames
Top: 56 x 67.3 x 2.5 cm; bottom: 65.4 x 57.2 x 2.5 cm
Edition of 3, 1 A.P.

CREMASTER 1: MS Goodyear, 1995
C-print in self-lubricating plastic frame
111 x 136.5 x 2.5 cm
Edition of 6, 2 A.P.

CREMASTER 1: Orchidella, 1995
C-print in self-lubricating plastic frame
136.5 x 111 x 2.5 cm
Edition of 6, 2 A.P.

CREMASTER 1: Red Lounge Manual, 1995
3 gelatin-silver prints in self-lubricating plastic frames
Center: 52 x 67.3 x 2.5 cm; left and right: 56 x 67.3 x 2.5 cm each
Edition of 3, 1 A.P.

CREMASTER 2

CREMASTER 2, 1999
35-mm film (color digital video transferred to film with Dolby SR sound), 1:19:00

CREMASTER 2, 1999
Silkscreened digital video disk, nylon, tooled saddle leather, sterling silver, beeswax, and polycarbonate honeycomb in nylon and acrylic vitrine, with 35-mm print
104.1 x 119.4 x 99.1 cm
Edition of 10, 2 A.P.

The Cabinet of Bessie Gilmore, 1999
Salt, solar salt cast in epoxy resin, nylon, Vivak, and prosthetic plastic in nylon and acrylic vitrine
118.7 x 132.1 x 95.6 cm
Stefan T. Edlis Collection

The Cabinet of Frank Gilmore, 1999
Solar salt cast in epoxy resin, nylon, polycarbonate honeycomb, and beeswax in nylon and acrylic vitrine
118.7 x 121.8 x 95.6 cm
Museum of Contemporary Art, Chicago. Sara Lee Corporation Purchase Fund

The Cabinet of Harry Houdini, 1999
Cast nylon, solar salt cast in epoxy resin, woven polypropylene, prosthetic plastic, and beeswax
2.12 x 1.63 x 1.8 m
Astrup Fearnley Collection, Oslo

The Cabinet of the Man in Black, 1999
Bridal satin, beaver felt, beeswax, petroleum jelly, nylon, and *Billboard* magazine in nylon and acrylic vitrine
101 x 121.3 x 95.6 cm
Collection of Peggy and Ralph Burnet

The Drones' Exposition, 1999
35-mm film (color digital video transferred to film with Dolby SR sound); 2-part sculpture installation: nylon, acrylic, steel, salt, solar salt cast in epoxy resin, chrome-plated engraved brass, leather, sterling silver, brass, lead, Hungarian sidesaddle, carpet, carpet inlay, and quilted nylon; 12 silk banners with 12 nylon poles and 1 nylon wall mount; 5 drawings: graphite and petroleum jelly on paper in nylon frames; and 12 C-prints in acrylic frames
Overall dimensions variable
Walker Art Center, Minneapolis, T. B. Walker Acquisition Fund; and San Francisco Museum of Modern Art through the Accessions Committee Fund, 2000

The Cabinet of Gary Gilmore and Nicole Baker, 1999–2000
Polycarbonate honeycomb, beeswax, microcrystalline wax, petroleum jelly, nylon, polyester, vinyl, carpet, chrome, prosthetic plastic, solar salt cast in epoxy resin, sterling silver, and 2 nylon and acrylic vitrines
1.47 x 5.59 x 2.62 m overall
Private collection, Basel

Deseret: The Drone's Gate, 1999–2000
Cast beeswax, solar salt cast in epoxy resin, and 1:8 scale model of the Mormon Tabernacle in mixed media
3.2 x 7.16 x 7.34 m
Courtesy of Barbara Gladstone

The Cabinet of Baby Fay La Foe, 2000
Polycarbonate honeycomb, cast stainless steel, nylon, solar salt cast in epoxy resin, top hat, and beeswax in nylon and acrylic vitrine
150 x 242.6 x 97.2 cm
The Museum of Modern Art, New York. Committee on Painting and Sculpture Funds

The Ballad of Nicole Baker, 1999
Graphite and petroleum jelly on paper in nylon frame
23.3 x 29.8 x 3.8 cm
Goetz Collection, Munich

Deseret, 1999
Graphite and petroleum jelly on paper in nylon frame
24.1 x 29.8 x 3.8 cm
The Rachofsky Collection, Dallas

The Ectoplasm, 1999
Graphite and petroleum jelly on paper in nylon frame
24.1 x 29.8 x 3.8 cm
Collection of Adam D. Sender, New York City

The Nuptial Flight, 1999
Graphite on paper in nylon frame
24.1 x 29.8 x 3.8 cm
Private collection, Switzerland

C2: Deseret, 1999
Etching on paper
30.5 x 35.6 cm
Edition of 40, 12 A.P., 2 P.P., 1 M.P.
Printed by Todd Norsten, Minneapolis
Published by Walker Art Center, Minneapolis

C2: The Drones' Exposition, 1999
Etching on paper
30.5 x 35.2 cm
Edition of 40, 12 A.P., 2 P.P., 1 M.P.
Printed by Todd Norsten, Minneapolis
Published by Walker Art Center, Minneapolis

The Man in Black, 1999
Graphite, petroleum jelly, and beeswax on Billboard magazine
in nylon frame
40.6 x 35.6 x 3.8 cm
Edition of 6, 1 A.P.

CREMASTER 2: The Executioner's Song, 1998
C-print in acrylic frame
71.1 x 61 x 2.5 cm
Edition of 40, 6 A.P.

CREMASTER 2: The Royal Cell of Baby Fay, 1998
C-print in acrylic frame
71.1 x 50.8 x 2.5 cm
Edition of 40, 6 A.P.

CREMASTER 2: Baby Fay La Foe, 1999
C-print in acrylic frame
135.3 x 109.2 x 2.5 cm
Edition of 6, 1 A.P.

CREMASTER 2: The Ballad of Gary Gilmore, 1999
3 gelatin-silver prints in acrylic frames
Center: 68.6 x 68.6 x 2.5 cm; left and right:
68.6 x 62.2 x 2.5 cm each
Edition of 3, 2 A.P.

CREMASTER 2: The Ballad of Max Jensen, 1999
3 C-prints in acrylic frames
Center: 83.8 x 106.7 x 2.5 cm; left and right:
71.1 x 61 x 2.5 cm each
Edition of 3, 2 A.P.

CREMASTER 2: The Book of Mormon, 1999
C-print in acrylic frame
137.2 x 109.2 x 2.5 cm
Edition of 6, 1 A.P.

CREMASTER 2: Deseret, 1999
4 C-prints in acrylic frames
Left to right: 69.2 x 59.1 x 2.5 cm, 69.2 x 84.5 x 2.5 cm,
69.2 x 191.1 x 2.5 cm, 69.2 x 59.1 x 2.5 cm
Edition of 3, 1 A.P.

CREMASTER 2: Drone Ensemble, 1999
3 C-prints in acrylic frames
107.3 x 86.4 x 2.5 cm each
Edition of 3, 1 A.P.

CREMASTER 2: The Drone's Cell, 1999
C-print in acrylic frame
137.2 x 109.2 x 2.5 cm
Edition of 6, 2 A.P.

CREMASTER 2: The Drone's March, 1999
3 C-prints in acrylic frames
Center: 110.5 x 86.4 x 2.5 cm; left and right:
110.5 x 40.6 x 2.5 cm each
Edition of 3, 2 A.P.

CREMASTER 2: The Ectoplasm, 1999
C-print in acrylic frame
109.2 x 133.4 x 2.5 cm
Edition of 6, 1 A.P.

CREMASTER 2: The Executioner's Step, 1999
C-print in acrylic frame
135.3 x 109.2 x 2.5 cm
Edition of 6, 1 A.P.

CREMASTER 2: Genealogy, 1999
3 C-prints in acrylic frames
Center: 71.1 x 60.3 x 2.5 cm; left and right:
55.2 x 55.2 x 2.5 cm each
Edition of 3, 2 A.P.

CREMASTER 2: The Golden Tablet, 1999
C-print in acrylic frame
133.4 x 109.2 x 2.5 cm
Edition of 6, 1 A.P.

CREMASTER 2: Korihor, 1999
Gelatin-silver print in acrylic frame
109.5 x 86 x 2.5 cm
Edition of 6, 1 A.P.

CREMASTER 2: The Lost Tribes of Israel, 1999
13 C-prints in acrylic frames
73.7 x 63.5 x 3.2 cm each
Edition of 1, 1 A.P.
Collection Emily Fisher Landau, New York

CREMASTER 2: The Man in Black, 1999
C-print in acrylic frame
135.3 x 109.2 x 2.5 cm
Edition of 6, 2 A.P.

CREMASTER 2: The Metamorphosis, 1999
C-print in acrylic frame
137.2 x 109.2 x 2.5 cm
Edition of 6, 1 A.P.

CREMASTER 2: Nicole, 1999
C-print in acrylic frame
111.8 x 132.1 x 2.5 cm
Edition of 6, 1 A.P.

CREMASTER 2: The Queen's Exposition, 1999
4 gelatin-silver prints in acrylic frames
Left to right: 71.1 x 71.1 x 3.8 cm, 105.4 x 85.7 x 3.8 cm,
71.1 x 71.1 x 3.8 cm, 71.1 x 71.1 x 3.8 cm
Edition of 3, 2 A.P.

CREMASTER 2: The Royal Cell, 1999
3 C-prints in acrylic frames
108 x 83.8 x 2.5 cm each
Edition of 3, 1 A.P.

CREMASTER 2: The World's Exposition, 1999
C-print in acrylic frame
111.8 x 111.8 x 2.5 cm
Edition of 6, 1 A.P.

CREMASTER 3
(Works completed at time of publication)

CREMASTER 3, 2002
35-mm film (color digital video transferred to film with
Dolby Digital sound), 3:01:59

CREMASTER 3, 2002
2 silkscreened digital video disks, stainless steel, internally
lubricated plastic, marble, and sterling silver in acrylic vitrine,
with 35-mm print; 110.5 x 119.4 x 101.6 cm
Edition of 10, 2 A.P.

Fingal: The Case of Hiram Abiff, 2002
Internally lubricated plastic, ABS plastic, rapid prototypes,
cast thermoplastic, acrylic, cast brass, sterling silver, graphite,
earth, and potatoes in polyethylene and acrylic vitrine
1.52 x 1.85 x 2.01 m
Courtesy of Barbara Gladstone

Fionn MacCumhail: The Case of The Entered Apprentice, 2002
Internally lubricated plastic, aluminum, cast thermoplastic, marble,
sterling silver, acrylic, earth, and potatoes in polyethylene and
acrylic vitrine; 1.52 x 1.85 x 2.01 m
Courtesy of Barbara Gladstone

Oonagh MacCumhail: The Case of The Entered Novitiate, 2002
Internally lubricated plastic, cast urethane, cast thermoplastic,
prosthetic plastic, stainless steel, acrylic, earth, and potatoes in
polyethylene and acrylic vitrine; 1.52 x 1.85 x 2.01 m
Courtesy of Barbara Gladstone

Chrysler Imperial, 2002
Cast concrete, cast petroleum jelly, cast thermoplastic, stainless
steel, marble, and internally lubricated plastic
4 units: approx. 60 x 150 x 230 cm each; 1 unit:
approx. 1.7 x 4 x 4.3 m
Courtesy of Barbara Gladstone

The Cloud Club, 2002
Mason & Hamlin Symetrigrand piano with stainless steel, silver,
white mother-of-pearl, gold lip mother-of-pearl, black lip mother-
of-pearl, green abalone, quarterbred Honduras mahogany, lace-
wood, walnut, ash burl, redwood burl, madrone burl, and Chilean
laurel marquetry; internally lubricated plastic; potatoes; concrete;
and sterling silver; 1.45 x 2.74 x 2.13 m
Courtesy of Barbara Gladstone

The Five Points of Fellowship, 2002
Cast thermoplastic, prosthetic plastic, wrestling mat, and
Rotomolded polyethylene; overall dimensions variable
Astrup Fearnley Collection, Oslo

Jachin and Boaz, 2002
High-density polyethylene, aluminum, nylon, and chain hoist;
overall dimensions variable
Courtesy of Barbara Gladstone

The Order, 2002
High-density polyethylene and petroleum jelly
Approx. 90 x 90 x 370 cm
Courtesy of Barbara Gladstone

Partition, 2002
Petroleum jelly, internally lubricated plastic, refrigeration system,
cast thermoplastic, stainless steel, and Astroturf
1.93 x 7.92 x 5.36 m
Courtesy of Barbara Gladstone

The Perfect Cube Must Pass Through The Metamorphosis of
The Cross, 2002
Cast epoxy and solar salt, nylon, wrestling mat, and internally
lubricated plastic; overall dimensions variable
Courtesy of Barbara Gladstone

Crown Imperial, 2002
5 banners of silk-faced Duchess satin, polyester bridal satin,
polyester/lurex organza, polyester/lurex lame, rayon, and metallic
embroidery threads; Swiss double-face satin ribbon; 5 aluminum
poles; and 1 stainless-steel wall mount
Banners: 99.1 x 137.2 cm each; poles: 1 at 213.4 cm long,
2 at 182.9 cm long, 2 at 152.4 cm long, 2.5–7.6 cm [tapering]
diameter each; mount: 45.7 x 86.4 x 35.6 cm
Courtesy of Barbara Gladstone

C3: Base/Level, 2002
Graphite and petroleum jelly on paper in acrylic frame
25.4 x 30.5 x 2.5 cm
Courtesy of Barbara Gladstone

C3: Chrysler Crown, 2002
Graphite and petroleum jelly on paper in acrylic frame
25.4 x 30.5 x 2.5 cm
Courtesy of Barbara Gladstone

C3: The Giants' Causeway, 2002
Graphite and petroleum jelly on paper in acrylic frame
25.4 x 30.5 x 2.5 cm
Courtesy of Barbara Gladstone

C3: Imperial, 2002
Graphite and petroleum jelly on paper in acrylic frame
25.4 x 30.5 x 2.5 cm
Courtesy of Barbara Gladstone

C3: Partition, 2002
Graphite on paper in acrylic frame
25.4 x 30.5 x 2.5 cm
Courtesy of Barbara Gladstone

C3: Perfect Ashler, 2002
Graphite and petroleum jelly on paper in acrylic frame
25.4 x 30.5 x 2.5 cm
Courtesy of Barbara Gladstone

C3: The Perfect Cube Must Pass Through The Metamorphosis of
The Cross, 2002
Graphite and petroleum jelly on paper in acrylic frame
25.4 x 30.5 x 2.5 cm
Courtesy of Barbara Gladstone

C3: The Temple of Solomon, 2002
Graphite on paper in acrylic frame
25.4 x 30.5 x 2.5 cm
Courtesy of Barbara Gladstone

C3: The Third Degree, 2002
Graphite on paper in acrylic frame
25.4 x 30.5 x 2.5 cm
Courtesy of Barbara Gladstone

C3: The Vertical Field, 2002
Graphite and petroleum jelly on paper in acrylic frame
25.4 x 30.5 x 2.5 cm
Courtesy of Barbara Gladstone

CREMASTER 3: Eisléireacht Garbh Mar Bhunsraith, 2002
Photogravure
38.1 x 58.4 cm
Edition of 40, 12 A.P., 6 T.P., 2 C.T.P.
Published by Jean-Yves Noblet

CREMASTER 3: Chrysler Imperial, 2001
C-print in acrylic frame
61 x 71.1 x 3.8 cm
Edition of 50, 10 A.P.

CREMASTER 3: Plumb Line, 2001
C-print in acrylic frame
71 x 61 x 3 cm
Edition of 50, 10 A.P.

CREMASTER 3: Base, Pillar, Pediment, 2002
4 gelatin-silver prints in acrylic frames
Left to right: 71.1 x 71.1 x 3.8 cm, 86.4 x 71.1 x 3.8 cm,
71.1 x 71.1 x 3.8 cm, 71.1 x 71.1 x 3.8 cm
Edition of 3, 1 A.P.

CREMASTER 3: Basis Found, 2002
C-print in acrylic frame
137.2 x 111.8 x 3.8 cm
Edition of 6, 1 A.P.

CREMASTER 3: Brethren, 2002
C-print in acrylic frame
137.2 x 111.8 x 3.8 cm
Edition of 6, 1 A.P.

CREMASTER 3: Chorus of The Order, 2002
C-print in acrylic frame
111.8 x 137.2 x 3.8 cm
Edition of 6, 2 A.P.

CREMASTER 3: Chrysler Crown, 2002
2 C-prints in acrylic frames
106.7 x 86.4 x 3.8 cm each
Edition of 3, 2 A.P.

CREMASTER 3: The Cloud Club, 2002
4 C-prints in acrylic frames
Left to right: 71.1 x 61 x 3.8 cm, 106.7 x 86.4 x 3.8 cm,
71.1 x 61 x 3.8 cm, 71.1 x 61 x 3.8 cm
Edition of 3, 1 A.P.

CREMASTER 3: The Dance of Hiram Abiff, 2002
4 C-prints in acrylic frames
Left to right: 106.7 x 86.4 x 3.8 cm, 106.7 x 86.4 x 3.8 cm,
137.2 x 111.8 x 3.8 cm, 106.7 x 86.4 x 3.8 cm
Edition of 3, 2 A.P.

CREMASTER 3: Dance of the Vertical Field, 2002
C-print in acrylic frame
137.2 x 111.8 x 3.8 cm
Edition of 6, 1 A.P.

CREMASTER 3: Dead Heat, 2002
C-print in acrylic frame
111.8 x 137.2 x 3.8 cm
Edition of 6, 1 A.P.

CREMASTER 3: Duegard of The Entered Apprentice, 2002
3 gelatin-silver prints in acrylic frames
Center: 86.4 x 71.1 x 3.8 cm; left and right: 71.1 x 61 x 3.8 cm each
Edition of 3, 1 A.P.

CREMASTER 3: Entered Apprentice, 2002
C-print in acrylic frame
137.2 x 111.8 x 3.8 cm
Edition of 6, 2 A.P.

CREMASTER 3: Entered Novitiate, 2002
C-print in acrylic frame
137.2 x 111.8 x 3.8 cm
Edition of 6, 2 A.P.

CREMASTER 3: Five Points of Fellowship, 2002
C-print in acrylic frame
137.2 x 111.8 x 3.8 cm
Edition of 6, 1 A.P.

CREMASTER 3: Fionn and Fingal, 2002
2 C-prints in acrylic frames
106.7 x 86.4 x 3.8 cm each
Edition of 3, 1 A.P.

CREMASTER 3: Foundation, 2002
3 C-prints in acrylic frames
71.1 x 61 x 3.8 cm each
Edition of 3, 1 A.P.

CREMASTER 3: Gary Gilmore, 2002
C-print in acrylic frame
137.2 x 111.8 x 3.8 cm
Edition of 6, 2 A.P.

CREMASTER 3 : The Giants' Causeway, 2002
3 C-prints in acrylic frames
106.7 x 86.4 x 3.8 cm each
Edition of 3 , 1 A.P.

CREMASTER 3: Hiram Abiff, 2002
C-print in acrylic frame
137.2 x 111.8 x 3.8 cm
Edition of 6, 1 A.P.

CREMASTER 3: I Die Daily, 2002
C-print in acrylic frame
137.2 x 111.8 x 3.8 cm
Edition of 6, 2 A.P.

CREMASTER 3: Imperial Demolition, 2002
Gelatin-silver print in acrylic frame
111.8 x 86.4 x 3.8 cm
Edition of 6, 1 A.P.

CREMASTER 3: Imperial New Yorker, 2002
3 C-prints in acrylic frames
Center: 86.4 x 106.7 x 3.8 cm
Left and right: 86.4 x 71.1 x 3.8 cm each
Edition of 3, 1 A.P.

CREMASTER 3: Jachin and Boaz, 2002
3 C-prints in acrylic frames
Center: 106.7 x 86.4 x 3.8 cm
Left and right: 86.4 x 71.1 x 3.8 cm each
Edition of 3, 1 A.P.

CREMASTER 3: The Legend of Fionn MacCumhail, 2002
3 C-prints in acrylic frames
Center: 111.8 x 86.4 x 3.8 cm
Left and right: 86.4 x 111.8 x 3.8 cm each
Edition of 3, 1 A.P.

CREMASTER 3: Level, 2002
C-print in acrylic frame
86.4 x 71.1 x 3.8 cm
Edition of 6, 1 A.P.

CREMASTER 3: The Lodge of The Entered Apprentice, 2002
3 C-prints in acrylic frames
106.7 x 86.4 x 3.8 cm each
Edition of 3, 1 A.P.

CREMASTER 3: Mahabyn, 2002
3 C-prints in acrylic frames
Center: 111.8 x 137.2 x 3.8 cm; left and right:
106.7 x 86.4 x 3.8 cm each
Edition of 3, 1 A.P.

CREMASTER 3: 1967 Chrysler Imperial, 2002
C-print in acrylic frame
111.8 x 137.2 x 3.8 cm
Edition of 6, 2 A.P.

CREMASTER 3: Oonagh MacCumhail, 2002
C-print in acrylic frame
101 x 137.2 x 3.8 cm
Edition of 6, 2 A.P.

CREMASTER 3: The Order, 2002
7 C-prints in acrylic frames
Left to right: 61 x 71.1 x 3.8 cm, 86.4 x 71.1 x 3.8 cm,
86.4 x 71.1 x 3.8 cm, 86.4 x 71.1 x 3.8 cm, 86.4 x 71.1 x
3.8 cm, 86.4 x 71.1 x 3.8 cm, 61 x 71.1 x 3.8 cm
Edition of 3, 1 A.P.

CREMASTER 3: Partition, 2002
3 C-prints in acrylic frames
86.4 x 71.1 x 3.8 cm each
Edition of 3, 1 A.P.

CREMASTER 3: Pediment, 2002
2 C-prints in acrylic frames
116.8 x 86.4 x 3.8 cm each
Edition of 3, 1 A.P.

CREMASTER 3: Pentastar, 2002
C-print in acrylic frame
106.7 x 86.4 x 3.8 cm
Edition of 6, 1 A.P.

CREMASTER 3: Perfect Ashler, 2002
5 C-prints in acrylic frames
71.1 x 61 x 3.8 cm each
Edition of 3, 1 A.P.

CREMASTER 3: Presiding Judge, 2002
4 gelatin-silver prints in acrylic frames
Left to right: 86.4 x 71.1 x 3.8 cm, 86.4 x 71.1 x 3.8 cm,
86.4 x 106.7 x 3.8 cm, 86.4 x 71.1 x 3.8 cm
Edition of 3, 1 A.P.

CREMASTER 3: The Pride, 2002
5 C-prints in acrylic frames
71.1 x 86.4 x 3.8 cm each
Edition of 3, 1 A.P.

CREMASTER 3: Rough Ashler, 2002
11 C-prints in acrylic frames
Center photograph: 71.1 x 71.1 x 3.8 cm; remaining
10 photographs: 50.8 x 50.8 x 3.8 cm each
Edition of 1, 1 A.P.
Courtesy of Barbara Gladstone

CREMASTER 3: The Royal Arch, 2002
3 C-prints in acrylic frames
Center: 106.7 x 86.4 x 3.8 cm; left and right:
71.1 x 86.4 x 3.8 cm each
Edition of 3, 1 A.P.

CREMASTER 3: The Slope of Hiram, 2002
3 C-prints in acrylic frames
106.7 x 86.4 x 3.8 cm each
Edition of 3, 1 A.P.

CREMASTER 3: The Song of The Vertical Field, 2002
2 C-prints in acrylic frames
106.7 x 86.4 x 3.8 cm each
Edition of 3, 1 A.P.

CREMASTER 3: Stones of Mann, 2002
3 C-prints in acrylic frames
Center: 86.4 x 119.4 x 3.8 cm; left and right:
86.4 x 71.1 x 3.8 cm each
Edition of 3, 1 A.P.

CREMASTER 3: The Third Degree, 2002
2 C-prints in acrylic frames
71.1 x 86.4 x 3.8 cm each
Edition of 3, 2 A.P.

CREMASTER 4
CREMASTER 4, 1994
35-mm film (color video transferred to film with
Dolby SR sound), 00:42:16

CREMASTER 4, 1994–95
Silkscreened laser disk in onionskin sleeve, prosthetic
plastic, bridal-satin banner, and Manx tartan in self-lubricating
plastic and acrylic vitrine; 91.4 x 122 x 104.1 cm
Edition of 10, 2 A.P.

The Isle of Man, 1994–95
2 600 cc sidehacks, wrestling mat, vinyl, silicone, tapioca,
polyester, petroleum jelly, internally lubricated plastic, prosthetic
plastic, fluorescent light, mirror, satin ribbon, and Manx tartan;
4.29 x 5.64 x 7.9 m overall
Museum Boijmans Van Beuningen, Rotterdam

Manx Manual, 1994–95
5 drawings: graphite, lacquer, and petroleum jelly on paper
in cast epoxy, Manx tartan, and prosthetic plastic frames
33 x 38.1 x 5.1 cm each
Collection of Cristina and Thomas Bechtler, Switzerland

CREMASTER 4: ascending HACK: the Chasm at Sugarloaf, 1994
C-print in self-lubricating plastic frame
64.8 x 89.5 x 2.5 cm
Edition of 6, 1 A.P.

CREMASTER 4: ASCENDING MANUAL, 1994
2 gelatin-silver prints in self-lubricating plastic frames
Top: 57.2 x 42 x 3.8 cm; bottom: 42 x 57.2 x 3.8 cm
Edition of 3, 1 A.P.

CREMASTER 4: DESCENDING MANUAL, 1994
1 C-print in prosthetic plastic frame and 3 C-prints in self-lubricating plastic frames
Left to right: 44.5 x 36.8 x 3.8 cm, 44.5 x 36.8 x 3.8 cm,
29.2 x 33 x 3.8 cm, 44.5 x 36.8 x 3.8 cm
Edition of 3, 1 A.P.

CREMASTER 4: FAERIE FIELD, 1994
4 C-prints in self-lubricating plastic frames
Left to right: 44.5 x 32.4 x 3.8 cm, 70 x 84.5 x 3.8 cm,
44.5 x 32.4 x 3.8 cm, 44.5 x 32.4 x 3.8 cm
Edition of 3, 1 A.P.

CREMASTER 4: Field of the Ascending Faerie, 1994
2 C-prints in self-lubricating plastic frames
Top: 60 x 76.2 x 2.5 cm; bottom: 66 x 56 x 2.5 cm
Edition of 6, 1 A.P.

CREMASTER 4: Field of the Loughton Candidate, 1994
2 C-prints in self-lubricating plastic frames
84.5 x 70 x 3.8 cm each
Edition of 3, 1 A.P.

CREMASTER 4: Gob ny Creggan Glassey, 1994
1 C-print in self-lubricating plastic frame and 2 C-prints
in prosthetic plastic frames
Center: 71.1 x 101.6 x 2.5 cm; left and right:
43.2 x 48.3 x 2.5 cm each
Edition of 3, 1 A.P.

CREMASTER 4: The Isle of Man, 1994
2 C-prints in Manx tartan and self-lubricating and prosthetic plastic
frames and 3 C-prints in self-lubricating plastic frames
Left to right: 42 x 38.1 x 3.8 cm, 70 x 84.5 x 3.8 cm, 84.5 x
70 x 3.8 cm, 70 x 84.5 x 3.8 cm, 42 x 38.1 x 3.8 cm
Edition of 3, 1 A.P.

CREMASTER 4: The Loughton Candidate, 1994
C-print in cast plastic frame
49.5 x 45.3 x 2.5 cm
Edition of 30, 2 A.P.

CREMASTER 4: LOUGHTON HEAD, 1994
C-print in self-lubricating plastic frame
71.1 x 101.6 x 2.5 cm
Edition of 6, 1 A.P.

CREMASTER 4: LOUGHTON MANUAL, 1994
C-print in self-lubricating plastic frame
63.5 x 53.3 x 2.5 cm
Edition of 6, 1 A.P.

CREMASTER 4: LOUGHTON RAM, 1994
C-print in self-lubricating plastic frame
84.5 x 59.7 x 3.8 cm
Edition of 6, 1 A.P.

CREMASTER 4: manual A, 1994
Video still in prosthetic plastic frame
31.8 x 40 x 3.8 cm
Edition of 10, 1 A.P.

CREMASTER 4: MANANNAN, 1994
3 C-prints in self-lubricating plastic frames
Center: 71.1 x 101.6 x 2.5 cm; left and right: 71.1 x 50.8 x 2.5 cm
each
Edition of 3, 1 A.P.

CREMASTER 4: Three Legs of Mann, 1994
C-print in self-lubricating plastic frame
71.1 x 101.6 x 2.5 cm
Edition of 6, 1 A.P.

CREMASTER 4: TRIPLE OPTION, 1994
3 C-prints in self-lubricating plastic frames
71.1 x 86.4 x 2.5 cm each
Edition of 3, 1 A.P.

CREMASTER 4: T↓: ascending HACK descending HACK, 1994
C-print in self-lubricating plastic frame
100.3 x 70 x 3.8 cm
Edition of 6, 1 A.P.

CREMASTER 4: T↓ : IRISH SEA, 1994
C-print in self-lubricating plastic frame
71.1 x 86.4 x 2.5 cm
Edition of 6, 1 A.P.

CREMASTER 4: VALVE, 1994
4 C-prints in self-lubricating plastic frames
84.5 x 70 x 3.8 cm each
Edition of 3, 1 A.P.

CREMASTER 4: ↑ ↔↓, 1994
3 C-prints in self-lubricating plastic frames
Left: 42 x 49.5 x 3.8 cm; center and right: 49.5 x 42 x 3.8 cm
Edition of 6, 1 A.P.

CREMASTER 5
CREMASTER 5, 1997
35-mm film (color digital video transferred to film with
Dolby SR sound), 00:54:30

CREMASTER 5, 1997
Silkscreened laser disk, polyester, acrylic, velvet, and
sterling silver in acrylic vitrine, with 35-mm print
88.9 x 119.4 x 94 cm
Edition of 10, 2 A.P.

The Ehrich Weiss Suite, 1997
Acrylic, prosthetic plastic, Vivak, Pyrex, internally lubricated
plastic, glass, and sterling silver; 2 C-prints and 1 gelatin-silver
print in acrylic frames; graphite, acrylic, and petroleum jelly
on paper in acrylic frame; and 7 Jacobin pigeons; overall
dimensions variable
Adam D. Sender

Lánchíd: The Lament of the Queen of Chain, 1997
Acrylic, cast polyurethane, Vivak, Pyrex, polyethylene,
and prosthetic plastic
3.05 x 6.1 x 4.88 m
Astrup Fearnley Collection, Oslo

Proscenium, 1997
10 banners of polyester bridal satin, antique satin, silk satin,
rayon/cotton bengaline, acetate taffeta, poly-charmeuse, and
crepe; satin ribbon; 10 nylon flagpoles; 2 nylon mounts; and 10
sterling silver thimbles
Banners: 86.4 x 132.1 cm each; poles: 182.9 cm long, 7.6 cm
diameter each; mounts: 16.5 x 91.1 x 40.6 cm each
Courtesy of Barbara Gladstone

Elbocsátás, 1998
Graphite, synthetic polymer paint, and petroleum jelly on
paper in acrylic and Vivak frame
35.6 x 30.5 x 3.2 cm
The Museum of Modern Art, New York. Gift of the Friends
of Contemporary Drawing

Ereszkedés, 1998
3 drawings: graphite and petroleum jelly on embossed
paper in acrylic and Vivak frames
45.5 x 40.4 x 3.2 cm each
Goetz Collection, Munich

The Tears of Ehrich Weiss, 1998
Acrylic, graphite, and petroleum jelly on *The Independent
Magazine* in acrylic and prosthetic plastic frame
32.4 x 28 x 4.4 cm
Edition of 5, 1 A.P.

CREMASTER 5: The Menagerie of the Queen of Chain, 1996
C-print in cast epoxy frame
76.2 x 59.7 x 2.5 cm
Edition of 30, 6 A.P.

CREMASTER 5: Bocáss el, 1997
4 C-prints in acrylic frames
96.8 x 69.2 x 2.5 cm each
Edition of 3, 1 A.P.

CREMASTER 5: Court of Chain, 1997
2 C-prints and 1 gelatin-silver print in acrylic frames
Center: 106 x 87 x 2.5 cm; left and right:
89.2 x 74.3 x 2.5 cm each
Edition of 3, 1 A.P.

CREMASTER 5: A Dance for the Queen's Menagerie, 1997
7 C-prints in acrylic frames
137.2 x 110.5 x 2.5 cm each
Edition of 2, 1 A.P.

CREMASTER 5: Elválás, 1997
2 C-prints and 1 gelatin-silver print in acrylic frames
Center: 105.1 x 87.6 x 2.5 cm; left and right:
90 x 75.2 x 2.5 cm each
Edition of 6, 1 A.P.

CREMASTER 5: her Diva, 1997
C-print in acrylic frame
134 x 108.3 x 2.5 cm
Edition of 6, 2 A.P.

CREMASTER 5: her Giant, 1997
C-print in acrylic frame
134 x 108.3 x 2.5 cm
Edition of 6, 2 A.P.

CREMASTER 5: her Magician, 1997
Gelatin-silver print in acrylic frame
69.2 x 58.4 x 2.5 cm
Edition of 6, 1 A.P.

CREMASTER 5: The Queen of Chain, 1997
Gelatin-silver print in acrylic frame
104.8 x 87 x 2.5 cm
Edition of 6, 2 A.P.

CREMASTER 5: The Queen's Menagerie, 1997
C-print in acrylic frame
96.8 x 69.2 x 2.5 cm
Edition of 6, 1 A.P.

CREMASTER Field, 2002
High density polyethylene, prosthetic plastic, cast
petroleum jelly, 5 color digital videos with Dolby SR sound
CREMASTER 1, 1995, 00:40:30
CREMASTER 2, 1999, 1:19:00
CREMASTER 3, 2002, 3:01:59
CREMASTER 4, 1994, 00:42:16
CREMASTER 5, 1997, 00:54:30
Installation dimensions variable
Courtesy of Artangel and Barbara Gladstone

CREMASTER Suite, 1994–2002
5 C-prints in self-lubricating plastic frames
112 x 86 x 3.2 cm each
Edition of 10, 2 A.P.

CREMASTER: Field Suite, 2002
5 etchings on Hahnemühle Copperplate paper
40 x 27.3 cm each
Edition of 40, 10 A.P., 4 P.P., 1 B.A.T.
Published by Jean-Yves Noblet

Exhibition History

EDUCATION/PRIZES

1989 Bachelor of Arts, Yale University, New Haven, Conn.

1993 Europa 2000 Prize, XLV Venice Biennale

1996 Hugo Boss Prize, Guggenheim Museum, New York

1999 Skowhegan Medal for Combined Media, Skowhegan School of Painting and Sculpture, Skowhegan, Maine

2000 James D. Phelan Art Award in Video, Bay Area Video Coalition, San Francisco Foundation

2001 Glen Dimplex Award, Irish Museum of Modern Art, Dublin

SOLO EXHIBITIONS

1989 Payne Whitney Athletic Complex, Yale University, New Haven, Conn., *Field Dressing*, Sept. 9–Oct. 2.

1991 Stuart Regen Gallery, Los Angeles, *Matthew Barney: [facility of INCLINE]*, May 22–June 22. Works exhibited: *Anabol [A]: PACE CAR for the HUBRIS PILL* (1991), *case BOLUS* (1989–91), *DELAY OF GAME* (1991) (video action), *DELAY OF GAME (manual A)* (1991), *HYPOTHERMAL PENETRATOR* (1991), *HYPOTHERMAL PENETRATOR (dorsal)* (1991), *The Jim Otto Suite* (1991), *MILE HIGH Threshold: FLIGHT with the ANAL SADISTIC WARRIOR* (1991) (video action), *REPRESSIA* (1991), *TRANSEXUALIS* (1991), and *unit BOLUS* (1991).

> McKenna, Kristine. "Body and Soul." *Los Angeles Times*, June 4, 1991, section F, p. 4.
>
> Schneider, Greg. "A Sporting Subversion: Matthew Barney at Stuart Regen Gallery." *Artweek* (San Jose, Calif.), June 20, 1991, p. 13.
>
> Pagel, David. "Matthew Barney." *Art Issues* (Los Angeles), no. 19 (Sept.–Oct. 1991), p. 39.
>
> Selwyn, Marc. "Matthew Barney Personal Best." *Flash Art* (Milan) 24, no. 160 (Oct. 1991), p. 133.

Barbara Gladstone Gallery, New York, *Matthew Barney: 00*, Oct. 19–Nov. 16. Works exhibited: *Anabol [A]: PACE CAR for the HUBRIS PILL (équipe)* (1991), *BLIND PERINEUM* (1991) (video action), *case BOLUS* (1989–91), *CONSTIPATOR BLOCK: shim BOLUS* (1991), *HYPOTHERMAL PENETRATOR* (1991), *The Jim Otto Suite* (1991), *RADIAL DRILL* (1991) (video action), *REPRESSIA (decline)* (1991), *STADIUM* (1991), *TRANSEXUALIS (decline)* (1991), and *unit BOLUS* (1991).

> Smith, Roberta. "Matthew Barney's Objects and Actions." *New York Times*, Oct. 25, 1991, section C, p. 28.
>
> Larson, Kay. "Getting Physical." *New York Magazine*, Nov. 18, 1991, pp. 99–100.
>
> Cottingham, Laura. "Art and Thought." *NYQ* (New York), Nov. 24, 1991, p. 41.
>
> Cameron, Dan. "Critical Edge: The Changing Tide." *Art & Auction* (New York) 14, no. 6 (Jan. 1992), pp. 50–54.
>
> Johnson, Ken. "Matthew Barney at Barbara Gladstone." *Art in America* (New York) 80, no. 1 (Jan. 1992), pp. 115–16.
>
> Dworkin, Norine. "Matthew Barney." *Artnews* (New York) 91, no. 2 (Feb. 1992), pp. 123–24.
>
> Padon, Thomas. "Matthew Barney: Barbara Gladstone Gallery, New York." *Sculpture* (Washington, D.C.) 11, no. 2 (March–April 1992), p. 68.
>
> Kaplan, Steven. "Matthew Barney: Barbara Gladstone Gallery." *Etc. Montréal*, no. 19 (Aug. 1992), pp. 64–66.

Kunz, Martin. "USA – Blickpunkt Eastcoast: Neue Leitsterne – Neue Wertungen." *Kunstforum International* (Ruppichteroth), no. 119 (1992), pp. 164–74 (German).

San Francisco Museum of Modern Art, *Matthew Barney: New Work*, Dec. 12, 1991–Jan. 30, 1992. Works exhibited: *Away Gown: JIM BLIND (fem.)* (1991), *DELAY OF GAME* (1991) (video action), *DELAY OF GAME (manual A)* (1991), *DRILL TEAM: screw BOLUS* (1991), *HYPOTHERMAL PENETRATOR* (1991), *MILE HIGH Threshold: FLIGHT with the ANAL SADISTIC WARRIOR* (1991) (video action), *REPRESSIA* (1991), *STADIUM* (1991), and *TRANSEXUALIS* (1991). Artist's book with introduction by Robert R. Riley.

1994 Regen Projects, Los Angeles, *Matthew Barney: CREMASTER 4*, Nov. 3–Dec. 3. Works exhibited: *CREMASTER 4* photographs and drawings.

1995 Fondation Cartier pour l'Art Contemporain, Paris, *Matthew Barney: CREMASTER 4*, March 3–April 16. Works exhibited: *CREMASTER 4* (1994; premiere), *[PIT] Field of the Descending Faerie* (1995), and *[PITCH] Field of the Ascending Faerie* (1995). Artist's book with introduction by James Lingwood (English and French), published by Fondation Cartier pour l'Art Contemporain; Artangel, London; and Barbara Gladstone Gallery, New York.

> Lebovici, Elisabeth. "L'outre-monde fantastique de Barney." *Libération* (Paris), March 21, 1995, p. 35 (French).
>
> Séguéla, Valérie. "Barney Barnum." *Les Inrockuptibles* (Paris), March 29–April 4, 1995, p. 66 (French).
>
> de Andrés, Alberto. "M. Barney." *Scènes Magazine* (Geneva), no. 85 (April 1995), p. 63 (French).
>
> Jarton, Cyril. "Barney: Sexe et Mécanique." *Beaux Arts Magazine* (Paris), no. 133 (April 1995), p. 117 (French).
>
> Pellet, Christophe. "Matthew Barney." *La Cote des Arts* (Marseille), May–June 1995, p. 9 (French).

Barbara Gladstone Gallery, New York, *Matthew Barney: CREMASTER 4*, April 8–May 6. Works exhibited: *The Isle of Man* (1994–95) and *Quocunque Jeceris Stabit* (1995).

> Houser, Craig. "Reviews: New York: Matthew Barney." *World Art* (New York), no. 3 (March 1995), p. 100.
>
> Kimmelman, Michael. "Matthew Barney's Surreal Visions, on Film and in the Gallery." *New York Times*, April 28, 1995, section C, p. 34.
>
> Stevens, Mark. "Candid Camera." *New York Magazine*, 28, no. 18 (May 1, 1995), pp. 68–69.
>
> Schjeldahl, Peter. "The Isle of Male." *The Village Voice* (New York), 40, no. 19 (May 9, 1995), p. 87.
>
> Ritchie, Matthew. "Spotlight: Matthew Barney." *Flash Art* (Milan), 28, no.184 (Oct.–Nov. 1995), p. 105.

Tate Gallery, London, *Art Now: OTTOshaft*, May 2–June 18. Brochure.

> Hall, James. "A Sporting Chance: Matthew Barney at the Tate." *The Guardian* (Manchester), May 5, 1995, p. 19.
>
> Cork, Richard. "Games Reveal a New Winner." *The Times* (London), May 9, 1995, p. 12.
>
> Januszczak, Waldemar. "Triumphs in the Field of Dreams." *The Sunday Times* (London), May 14, 1995, Culture, pp. 4–5.

Lewandowski, Simon. "Test Tubes and Tapioca at the Tate." *New Scientist* (London), May 20, 1995, p. 42.

Sladen, Mark. "Assault Course." *Art Monthly* (London), no. 187 (June 1995), pp. 8–11.

Cohen, David. "Reviews: London." *Sculpture* (Washington, D.C.) 14, no. 4 (July–Aug. 1995), pp. 49–50.

Museum Boijmans Van Beuningen, Rotterdam, *Matthew Barney: PACE CAR for the HUBRIS PILL*, Oct. 21, 1995–Jan. 1, 1996. Works exhibited: *CREMASTER 1* (1995), *CREMASTER 4* (1994), *The Isle of Man* (1994–95), *Vertical Game* (1995), pre-*CREMASTER* cycle works, including *Anabol [A]: PACE CAR for the HUBRIS PILL* (1991), *Anabol [A]: PACE CAR for the HUBRIS PILL (équipe)* (1991), *DELAY OF GAME* (1991) (video action), *DRILL TEAM: screw BOLUS* (1991), *RADIAL DRILL* (1991) (video action), *TRANSEXUALIS (decline)* (1991), *unit BOLUS* (1991), *OTTOshaft* (1992), *Drawing Restraint 7* (1993), and *ENVELOPA: Drawing Restraint 7* (1993), *MARCH with the ANAL SADISTIC WARRIOR*, parade, held Oct. 21. Catalogue, with essays by Richard Flood and Neville Wakefield (English and Dutch, English and French, and English and German editions). Traveled to capc Musée d'Art Contemporain, Bordeaux, Jan. 26–April 8, 1996; and Kunsthalle Bern, May 17–June 23, 1996.

Pontzen, Rutger. "De videomythen van Matthew Barney." *Vrij Nederlander* (Amsterdam), Nov. 11, 1995, pp. 52–55 (Dutch).

Lebovici, Elisabeth. "Barney dessine la carte du muscle." *Libération* (Paris), Feb. 8, 1996, pp. 30–31 (French).

Flood, Richard. "Real Life Rock." *Artforum* (New York) 34, no. 6 (Feb. 1996), p. 24.

Janus, Elizabeth. "Matthew Barney." *Artforum* (New York) 34, no. 7 (March 1996), p. 110.

1996 San Francisco Museum of Modern Art, *Matthew Barney: TRANSEXUALIS, 1991, and REPRESSIA, 1991*, April 23–Aug. 11.

1997 Portikus, Frankfurt am Main, *Matthew Barney: CREMASTER 5*, June 18–Aug. 10. Works exhibited: *CREMASTER 5* (1997; premiere). Artist's book, with introduction by Thyrza Nichols Goodeve, published by Portikus and Barbara Gladstone Gallery, New York.

Bevan, Roger. "Reason to Visit Germany Number III . . . and IV." *The Art Newspaper* (London) 8, no. 71 (June 1997), special supplement, pp. 46–47.

Erfle, Anne. "Das alternative Geschlecht: Matthew Barney's 'Cremaster 5' im Frankfurter Portikus." *Süddeutsche Zeitung* (Munich), July 7, 1997, p. 14 (German).

Schaub, Mirjam. "Die Kunst als Foltergeschirr." *Die Zeit* (Hamburg), no. 31 (July 25, 1997), p. 47 (German).

Czöppan, Gabi. "Houdinis Enkel." *Focus* (Munich), no. 31 (July 28, 1997), p. 102 (German).

Schmid, Karlheinz. "Der Satyr: Matthew Barney in Frankfurt." *Kunstzeitung* (Regensburg), no. 11 (July 1997), p. 9 (German).

Jürgs, Alexander. "Phantome der Oper." *Texte zur Kunst* (Cologne), no. 27 (Sept. 1997), pp. 140–42 (German).

Barbara Gladstone Gallery, New York, *CREMASTER 5*, Oct. 22–Dec. 20. Works exhibited: *CREMASTER 5: A Dance for the Queen's Menagerie* (1997), *The Ehrich Weiss Suite* (1997), *Lánchíd: The Lament of the Queen of Chain* (1997), and *Proscenium* (1997).

Rogers, Ray. "Flesh Prince." *New York Post*, Nov. 1, 1997, pp. 26–27.

Smith, Roberta. "From a Fantasy Film, Luxury Transformed." *New York Times*, Nov. 14, 1997, section E, p.43.

Ritchie, Matthew. "Spotlight: Barney's Cremaster 5." *Flash Art* (Milan) 31, no. 198 (Jan.–Feb. 1998), pp. 108–09.

Kunsthalle Wien, *Matthew Barney: CREMASTER 1*, Nov. 28, 1997–Feb. 8, 1998. Works exhibited: *CREMASTER 1* (1995) and *Goodyear Field* (1996). Artist's book with insert, essays by Alexander Horwarth and Gerald Matt (German), published by Kunsthalle Wien and Museum für Gegenwartskunst, Basel. Traveled to Museum für Gegenwartskunst, March 28–June 28, 1998. Brochure with essays by Theodora Vischer and Hansmartin Siegrist (English and German).

Illies, Florian. "Muskelspiele einer neuen Mythologie." *Frankfurter Allgemeine Zeitung* (Frankfurt am Main), Jan. 10, 1998, p. 33 (German).

Schaub, Mirjam. "Barocke Kunst-Genitalien." *Freitag* (Berlin), Jan. 16, 1998, p. 15 (German).

Horwath, Alexander. "Le Crémystère: Einige Bilder zu Matthew Barney." *Noëma* (Salzburg), no. 46 (Jan.–Feb. 1998), pp. 30–39 (German).

Hofleitner, Johanna. "Wien: Photo- und Medienszene." *Eikon* (Vienna), no. 23 (1998), pp. 56–58 (German).

1998 Regen Projects, Los Angeles, *CREMASTER 5*, March 7–April 11. Works exhibited: *Proscenium* (1997) and *CREMASTER 5* photographs and drawings.

1999 Walker Art Center, Minneapolis, *Matthew Barney CREMASTER 2: The Drones' Exposition*, July 18–Oct. 17. Works exhibited: *CREMASTER 2* (1999; premiere) and *The Drones' Exposition* (1999). Artist's book with introduction by Richard Flood. Traveled to San Francisco Museum of Modern Art, May 20–Sept. 5, 2000.

Madoff, Steven Henry. "Hallucinatory Acts." *Time* (New York), Aug. 30, 1999, pp. 67, 70.

Girst, Thomas. "Kin to the Magician: Matthew Barney's Cremaster 2." *NY Arts* (New York) 4, no. 8 (Sept. 1999), pp. 19, 21, 23.

Erickson, Karl. "Matthew Barney." *New Art Examiner* (Chicago) 27, no. 3 (Nov. 1999), p. 42.

Eichler, Dominic. "Matthew Barney." *Frieze* (London), no. 48 (Nov.–Dec. 1999), p. 98.

Gilman, Tom, and Frantiska Sevcik. "Spotlight: Cremaster 2." *Flash Art* (Milan) 33, no. 210 (Jan.–Feb. 2000), p. 113.

Helfand, Glen. "Projections: Bruce Conner and Matthew Barney Create Provocative Multimedia Films." *San Francisco Bay Guardian*, May 31, 2000, p. 61.

Baker, Kenneth. "'Cremaster 2': The Horror." *San Francisco Chronicle*, June 18, 2000, Datebook, p. 62.

2000 Wiener Staatsoper, Vienna, *Proscenium*, organized by museum in progress, Sept. 2000–June 2001. Brochure, with essay by Nancy Spector and interview with the artist by Hans-Ulrich Obrist (German and English editions).

SELECTED GROUP EXHIBITIONS

1990 Hallwalls Contemporary Arts Center, Buffalo, N.Y., *Viral Infection: The Body and Its Discontents*, Nov. 17–Dec. 21.

1992 capc Musée d'Art Contemporain, Bordeaux, *Périls et Colères*, May 22–Sept. 6. Catalogue with essay on the artist by Dan Cameron (English and French).

Museum Fridericianum, Kassel, Germany, *Documenta IX*, June 13–Sept. 20. Work exhibited: *OTTOshaft* (1992; premiere). Catalogue (three volumes), with essays by Jan Hoet, et al. (English and German), published by Cantz, Ostfildern, Germany, in association with Harry N. Abrams, New York.

FAE Musée d'Art Contemporain, Pully/Lausanne, Switzerland, *Post Human*, June 14–Sept. 13. Catalogue with essay by Jeffrey Deitch. Traveled to Castello di Rivoli, Turin, Oct. 1–Nov. 22; DESTE Foundation Centre for Contemporary Art, Athens, Dec. 3, 1992–Feb. 14, 1993; and Deichtorhallen, Hamburg, March 12–May 9, 1993.

Universitätsbibliothek, U-Bahnstation Bockenheimer Warte, Frankfurt am Main, *Spielhölle-Ästhetik und Gewalt*, Nov. 27–Dec. 23. Brochure, with essay by Robert Fleck (German). Traveled to Grazer Kunstverein, Graz, Austria, Feb. 19–March 21, 1993.

1993 Whitney Museum of American Art, New York, *1993 Biennial Exhibition*, Feb. 24–June 20. Work exhibited: *Drawing Restraint 7* (1993; premiere). Catalogue with essays by Elisabeth Sussman, et al. Traveled to Museum of Contemporary Art, Seoul, Aug. 1–Sept. 8.

XLV Biennale di Venezia, Venice, *Aperto '93: Emergency/Emergenza*, June 14–Oct. 10. Work exhibited: *ENVELOPA: Drawing Restraint 7* (1993). Catalogue, *XLV Esposizione Internazionale d'Arte: Punti cardinali dell'arte* (two volumes), with essays by Achille Bonito Oliva, et al. (English and Italian editions), published by Marsilio Editori, Venice. Additional catalogue, *Flash Art: Aperto '93: Emergency/Emergenza*, with essays by Achille Bonito Oliva, et al. (English and Italian), published by Giancarlo Politi Editori, Milan.

1994 Henry Moore Gallery, Royal College of Art, London, *Acting Out: The Body in Video, Then and Now*, Feb. 22–March 13. Catalogue with essays by Liz Kotz, et al.

Musée National d'Art Moderne, Centre Georges Pompidou, Paris, *Hors Limites: L'Art et la vie 1952–1994*, Nov. 9, 1994–Jan. 23, 1995. Catalogue edited by Jean de Loisy, with essays by Jean-Pierre Bordaz, et al. (French).

1995 MIT List Visual Arts Center, Cambridge, Mass., *The Masculine Masquerade*, Jan. 21–March 26. Catalogue edited by Andrew Perchuk and Helaine Posner, with essays by Harry Brod, et al., published by MIT Press, Cambridge, Mass.

Museum of Contemporary Art, Helsinki, Finland, *Yksityinen/julkinen = Private/Public: ARS 95*, Feb. 11–May 28. Catalogue with essays by Tuula Arkio, et al. (Finnish and English).

Whitney Museum of American Art, New York, *1995 Biennial Exhibition*, March 23–June 4. Catalogue with essays by Klaus Kertess, et al. Traveled to Veletržní palác, Museum of Modern Art, Prague, Sept. 21–Dec. 3, and Statens Museum for Kunst, Copenhagen, May 31–Aug. 11, 1996.

Watari Museum of Contemporary Art, Tokyo, *Ripple Across the Water*, Sept. 2–Oct. 1. Catalogue with essays by Jan Hoet, et al. (Japanese).

The Museum of Modern Art, New York, *Drawing on Chance: Selections from the Collection*, Oct. 12, 1995–Jan. 23, 1996. Brochure with essay by Laura Hoptman.

Museu de Arte de São Paulo, *DAS AMERICAS II: Corpo & Espaço*, Nov. 7–Dec. 10. Catalogue, with essay by Ivo Mesquita (Portuguese).

Musée d'Art Moderne de la Ville de Paris, *Passions Privées: Collections particulières d'art moderne et contemporain en France*, Dec. 21, 1995–March 12, 1996. Catalogue with essays by Suzanne Pagé, et al. (French).

1996 Museum of Contemporary Art, Miami, *Defining the Nineties: Consensus-Making in New York, Miami and Los Angeles*, Feb. 24–April 6. Catalogue with essays by Bonnie Clearwater, et al.

De Appel, Amsterdam, *Hybrids*, June 1–Aug. 18. Catalogue with introduction by Saskia Bos and essay on the artist by Annie Fletcher (Dutch and English).

Museum für Gegenwartskunst, Basel, *Fremdkörper*, June 1–Sept. 29. Catalogue, with essay by Theodora Vischer (German).

Goetz Collection, Munich, *Matthew Barney, Tony Oursler, and Jeff Wall*, July 22, 1996–Jan. 31, 1997. Catalogue, with essay on the artist by Jerry Saltz and interview with the artist by Thyrza Nichols Goodeve (English and German).

10th Biennale of Sydney: Jurassic Technologies Revenant, Sydney, July 27–Sept. 22. Catalogue with essays by Lynne Cooke, et al., and entry on the artist by Vivian Bobka.

Guggenheim Museum SoHo, New York, *The Hugo Boss Prize: 1996*, Nov. 20, 1996–Jan. 19, 1997. Catalogue with essay by Nancy Spector and essay on the artist by Jon Ippolito.

1997 Solomon R. Guggenheim Museum, New York, *A Rrose is a Rrose is a Rrose: Gender Performance in Photography*, Jan. 17–April 27. Catalogue with essays by Jennifer Blessing, et al. Traveled to The Andy Warhol Museum, Pittsburgh, Sept. 13–Nov. 30.

Setagaya Art Museum, Tokyo, *De-Genderism*, Feb. 8–March 23. Catalogue, with essay by Yuko Hasegawa (English and Japanese).

Centre d'Art Contemporain, Geneva, *La Vengeance de Veronique*, Feb. 28–May 11. Traveled to Rencontres Internationales de la Photographie, Arles, France, June 25–Aug. 25; Museum van Hedendaagse Kunst, Antwerp, Belgium, Nov. 21, 1997–Jan. 18, 1998; Deichtorhallen, Hamburg, Feb. 25–June 1; The City Gallery, Prague, June 23–Sept. 6; Het Domain, Sittard, The Netherlands, Oct. 17–Dec. 13; Musée National d'Histoire et d'Art, Luxembourg, March 6–April 25, 1999; Congrescos e Exposiciones de Pontevedra, Pontevedra, Spain, Oct. 4–Nov. 27; Centro Portuguès de Fotografia, Porto, Dec. 9, 1999–Feb. 4, 2000; Museum for Moderne Kunst, Arken, Denmark, June 3–Sept. 3; and Museum of Contemporary Art, Sydney, Nov. 16, 2000–March 4, 2001. Catalogue edited by Elizabeth Janus, with essays by Jennifer Blessing, et al., published by Scalo, Zurich, Berlin, New York (German and English editions).

4e Biennale d'art contemporain de Lyon: L'Autre, France, July 9–Sept. 24. Catalogue with essays by Harald Szeemann, et al. (French).

1998 Moderna Museet, Stockholm, *Wounds: Between Democracy and Redemption in Contemporary Art/Mellan Demokrati och Förlösning i Samtida Konst*, Feb. 14–April 19. Catalogue (two volumes), with essays by David Elliot, et al. (Swedish and English editions).

Deichtorhallen, Hamburg, *Emotion: Junge britische und amerikanische Kunst aus der Sammlung Goetz/Young British and American Art from the Goetz Collection*, Oct. 30, 1998–Jan. 17, 1999. Catalogue edited by Zdenek Felix, with essays by Iwona Blazwick, et al. (German and English).

1999 Granship, Shizuoka, Japan, *The Balloon Art Festival, HOT AIR*, organized by Nanjo and Associates, Tokyo, April 16–25. Catalogue with essays by Midori Matsui and Fumio Nanjo (Japanese and English).

Hirshhorn Museum and Sculpture Garden, Washington, D.C., *Regarding Beauty: A View of the Late Twentieth Century*, Oct. 7, 1999–Jan. 17, 2000.

Catalogue, with essays by Neal Benezra, et al. Traveled to Haus der Kunst, Munich, Feb. 12–May 1, 2000 as *Beauty Now: Die Schönheit in der Kunst am Ende des 20 Jahrhunderts*.

San Francisco Museum of Modern Art, *Seeing Time: Selections from the Pamela and Richard Kramlich Collection of Media Art*, Oct. 15, 1999–Jan. 9, 2000. Catalogue with essays by Robert R. Riley, et al., and essay on the artist by Chrissie Iles.

Carnegie Museum of Art, Pittsburgh, *Carnegie International 1999/2000*, Nov. 6, 1999–March 26, 2000. Catalogue (two volumes), with essays by Madeleine Grynsztejn, et al., and essay on the artist by Nancy Spector.

Kunstmuseum Bonn, *Zeitwenden – Ausblick: Global Art Rheinland 2000*, Dec. 4, 1999–June 4, 2000. Catalogue edited by Dieter Ronte and Walter Smerling, with essays by Lóránd Hegyi, et al., and essay on the artist by Robert Storr (German). Traveled to Museum Moderner Kunst Stiftung Ludwig Wien, 20er Haus, and Künstlerhaus, Vienna, July 5–Oct. 1, 2000.

2000 Contemporary Arts Museum, Houston, *Outbound: Passages from the '90s*, March 3–May 7. Catalogue, with essays by Dana-Friis Hansen, et al., and essay on the artist by Paola Morsiani.

Museum of Contemporary Art, Chicago, *Age of Influence: Reflections in the Mirror of American Culture*, April 8–June 4.

Musée d'Art Moderne de la Ville de Paris, *Voilà: Le monde dans la tête*, June 15–Oct. 29. Catalogue, edited by Suzanne Pagé, Beatrice Parent, Christian Boltanski, and Bertrand Lavier, published in 2001 (French).

Seoul Metropolitan Museum of Art, *media_city seoul 2000*, Sept. 2–Oct. 31. Catalogue, edited by A.B. Onfante-Warren, with introduction by Misook Song and essays by Barbara London, et al. (Korean and English editions).

Shanghai Art Museum, *Shanghai Biennale 2000*, Nov. 6, 2000–Jan. 6, 2001. Catalogue, entitled *Shanghai Spirit* (Chinese and English).

Kunsthaus Zurich, *HYPERMENTAL: Rampant Reality 1950–2000, From Salvador Dali to Jeff Koons*, Nov. 17, 2000–Jan. 21, 2001. Catalogue, with essays by Bice Curiger, et al. (German and English editions). Traveled to Hamburger Kunsthalle, Hamburg, Feb. 16–May 6, 2001.

2001 Stazione Leopolda, Florence, *Uniform: Order and Disorder*, Jan. 11–Feb. 18. Catalogue with essays by Francesco Bonami, et al., published by Edizioni Charta, Milan (Italian and English editions). Traveled to P. S. 1 Contemporary Art Center, Long Island City, May 20–Sept. 3.

The Museum of Contemporary Art, Los Angeles, *Public Offerings: Works by 25 Young Artists Shaping International Contemporary Art*, April 1–July 29. Catalogue edited by Howard Singerman, with essays by Paul Schimmel, et al., and essay on the artist by Leslie Dick.

The Museum of Modern Art, New York, *Collaborations with Parkett: 1984 to Now*, April 5–June 5. Catalogue, *Parkett Collaborations & Editions Since 1984*, with essays by Susan Tallman and Deborah Wye, published by Parkett Publishers, Zurich, New York.

Irish Museum of Modern Art, Dublin, *The Glen Dimplex Artists Award Exhibition 2001*, May 18–Oct. 29. Catalogue edited by Sarah Glennie, with essay on the artist by Annie Fletcher.

Selected Bibliography

Entries are ordered chronologically within each section. All publications are in English unless otherwise noted.

ARTIST'S PROJECTS AND BOOKS

Matthew Barney: New Work (exh. cat.). San Francisco: San Francisco Museum of Modern Art, 1991. With introduction by Robert R. Riley.

"Headlever Near Side Cradle." *Verbal Abuse* (New York), no. 2 (fall 1993), pp. 26–27.

CREMASTER 4 (exh. cat.). Paris: Fondation Cartier pour l'Art Contemporain; London: Artangel; and New York: Barbara Gladstone Gallery, 1995. With introduction by James Lingwood (English and French).

Drawing Restraint 7. Ostfildern, Germany: Cantz, 1995. With essay by Klaus Kertess (English and German).

PACE CAR for the HUBRIS PILL (exh. cat.). Rotterdam: Museum Boijmans Van Beuningen, 1995. With essays by Richard Flood and Neville Wakefield (English and Dutch, English and French, and English and German editions).

CREMASTER 1 (exh. cat.). Vienna: Kunsthalle Wien; and Basel: Museum für Gegenwartskunst, 1997. Insert, with essays by Alexander Horwarth and Gerald Matt (German).

CREMASTER 5 (exh. cat.). Frankfurt am Main: Portikus; and New York: Barbara Gladstone Gallery, 1997. With introduction by Thyrza Nichols Goodeve.

Statement in "Flash Art XXXI Years: Three Decades Inside Art." *Flash Art* (Milan) 32, no. 201 (summer 1998), pp. 78–79.

"Die Verwandlung." *Süddeutsche Zeitung Magazin* (Munich), Nov. 13, 1998, pp. 1–33.

"Art in the News." *The Tampa Tribune* (Fla.), March 21, 1999, Baylife, p. 9.

CREMASTER 2 (exh. cat.). Minneapolis: Walker Art Center, 1999. With introduction by Richard Flood.

Der Standard (Vienna), Sept. 2–3, 2000, pp. 8–9.

CREMASTER 3, New York: Solomon R. Guggenheim Museum, 2002.

BOOKS

The 20th Century Art Book. London: Phaidon, 1996, p. 29.

Ammann, Jean-Christophe. "Matthew Barney als 'Anal Sadistic Warrior' – Gedanken zu 'Cremaster 5,'" In *Das Glück zu sehen – Kunst beginnt dort, wo Geschmack aufhört.* Regensburg: Lindiger und Schmid, 1998, pp. 103–08.

Arnason, H. H. *History of Modern Art: Painting, Sculpture, Architecture, Photography,* 4th ed. New York: Harry N. Abrams, 1998, pp. 767, 783.

Goldberg, RoseLee. *Performance: Live Art Since 1960.* New York: Harry N. Abrams, 1998, pp. 98, 124–25, 202–03, 214.

Obrist, Hans-Ulrich and Nancy Spector. "Matthew Barney." In Gilda Williams, ed. *Cream: Contemporary Art in Culture.* London: Phaidon, 1998, pp. 64–67.

Rush, Michael. *New Media in Late-Twentieth-Century Art.* New York: Thames and Hudson, 1999, pp. 93, 150–51, 165.

Tobler, Jay, ed. *The American Art Book.* London: Phaidon, 1999, p. 26.

Anton, Saul. "Dead Meat: From Aitken to Barney Through Hitchcock/De la viande: d'Aitken à Barney, en passant par Hitchcock." In France Choinière and Stephen Horne, eds. *Fiction or Other Accounts of Photography.* Montreal: Dazibao, 2000, pp. 47–55 (English), pp. 47–56 (French).

Hopkins, David. *After Modern Art: 1945–2000.* Oxford: Oxford University Press, 2000, pp. 195, 244, 245.

Storr, Robert. *Modern Art Despite Modernism* (exh. cat., *MoMA 2000: Making Choices*). New York: The Museum of Modern Art, 2000, pp. 95, 217.

Warr, Tracey, ed. *The Artist's Body.* London: Phaidon, 2000, pp. 186, 287. (Excerpts from Stuart Morgan, "Of Goats and Men," *Frieze* [London], no. 20 [Jan.–Feb. 1995], pp. 35–39, and Thyrza Nichols Goodeve, "Travels in Hypertrophia: A Project for *Artforum,*" *Artforum* [New York] 33, no. 9 [May 1995], pp. 66–71, 112, 117.)

Goldberg, RoseLee. *Performance Art: From Futurism to the Present,* rev. ed. London: Thames and Hudson, 2001, pp. 222–23.

Rainbird, Sean. *A Twentieth-Century Enigma: Matthew Barney's* Ottoshaft, *1992* (booklet). London: Tate Foundation, 2001.

Ribettes, Jean-Michel. "Matthew Barney." In Burkhard Riemschneider and Uta Grosenick, eds. *Art Now.* Cologne: Taschen, 2001, pp. 18–19.

Sollins, Susan, et al. *Art: 21—Art in the Twenty-First Century.* New York: Harry N. Abrams, 2001, pp. 14–15, 194–201, 208.

INTERVIEWS

Helfand, Glen. "Matthew Barney." *Shift 14* (San Francisco) 6, no. 2 (1992), pp. 36–41.

Siegel, Jeanne. "Matthew Barney: A Conversation with Jeanne Siegel." *Tema Celeste* (Siracusa, Italy), no. 40 (spring 1993), pp. 66–67. Reprinted in *Tema Celeste* (Milan), no. 79–80 (May–June 2000), pp. 132–35 (Italian).

Goodeve, Thyrza Nichols. "Travels in Hypertrophia" *Artforum* (New York) 33, no. 9 (May 1995), pp. 66–71, 112, 117.

Lingwood, James. "Keeping Track of Matthew Barney." *TATE: The Art Magazine* (London), no. 6 (summer 1995), pp. 52–53.

Perrin, Frank. "Les combinaisons organiques: Matthew Barney." *Bloc Notes* (Paris), no. 9 (summer 1995), pp. 12–17 (French), 102–03 (English).

Sans, Jérôme. "Matthew Barney: Héros modernes/Modern Heroes." *Art Press* (Paris), no. 204 (July–Aug. 1995), pp. 25–32 (French and English).

Lebovici, Elizabeth. "Barney dessine la carte du muscle." *Libération* (Paris), Feb. 8, 1996, pp. 30–31 (French).

Doswald, Christoph. "Matthew Barney: Der Körper als Instrument." *Kunstforum International* (Ruppichteroth), no. 135 (Oct. 1996–Jan. 1997), pp. 312–21 (German).

Gächter, Sven. "Ich will nicht provozieren." *Profil* (Vienna), Nov. 24, 1997, pp. 110–11 (German).

Kämmerling, Christian. "Mein Kopf ist wie ein Cockpit." *Süddeutsche Zeitung Magazin* (Munich), Nov. 13, 1998, pp. 34–38, 40 (German).

Yablonsky, Linda. "A Portrait of the Artist as a Gun Man." *Time Out New York,* Oct. 14, 1999, p. 200.

Romney, Jonathan. "Matthew Barney." *Transcript* (Dundee, Scotland) 3, no. 3 (1999), pp. 85–102.

McKenna, Kristine. "Gary Gilmore, Meet Harry Houdini: Matthew Barney on His Film Cremaster 2." *LA Weekly,* Feb. 11, 2000, p. 35.

Jones, Jonathan. "Lonesome Cowboys—Matthew Barney." *Untitled* (London), no. 21 (spring 2000), pp. 4–6; republished at www.postmedia.net (Milan).

Porter, Amy Jean. "Fluid Talk: A Conversation with Matthew Barney." *CIRCA* (Belfast), no. 92 (summer 2000), pp. 30–31.

Obrist, Hans-Ulrich. "Conversation." In *Matthew Barney, Safety Curtain, 2000/2001* (German and English brochures). Vienna: Wiener Staatsoper; and Vienna: museum in progress, 2000. Reprinted in *KW Magazine* (Berlin) 2, no. 1 (2001), pp. 48–50 (English and German).

ARTICLES

Relyea, Lane. "Openings: Matthew Barney." *Artforum* (New York) 30, no. 1 (May 1991), p. 124.

Saltz, Jerry. "Wilder Shores of Art." *Arts Magazine* (New York) 65, no. 9 (May 1991), pp. 29–31.

Bonami, Francesco. "Matthew Barney: The Artist as a Young Athlete." *Flash Art* (Milan) 25, no. 162 (Jan.–Feb. 1992), pp. 100–01, 103.

Weil, Benjamin. "Matthew Barney." *Flash Art* (Milan) 25, no. 162 (Jan.–Feb. 1992), p. 102.

Adams, Brooks. "Matthew Barney: Nouvel Androgyne." *Art Press* (Paris), no. 167 (March 1992), pp. 36–39 (French).

Vogel, Sabine B. "Matthew Barney: Sport, Sex, und Kunst." *Artis* (Bern) 44 (June 1992), pp. 40–42 (German).

Saltz, Jerry. "The Ten Commandments of Taste." *Art and Auction* (New York) 15, no. 4 (Nov. 1992), pp. 104–09.

Gallagher, Ed. "Fine Tune: Notes on Matthew Barney." *Publicsfear* (New York) 1, no. 1 (1992), pp. 71–73.

Smolik, Noemi. "Matthew Barney und Constantin Zvezdochotov." *Kunstforum International* (Ruppichteroth), no. 119 (1992), pp. 155–57 (German).

Fleissig, Peter. "Lèche-Vitrine." *Parkett* (Zurich), no. 35 (March 1993), pp. 102–07 (English), 108–13 (German).

Lewis, Jim. "Anatomy of an Artist." *Harper's Bazaar* (New York), no. 3,375 (March 1993), pp. 272–77, 321.

Rankin-Reid, Jane. "Pocket Pool: A Matthew Barney Exclusive." *Art and Text* (Sydney), no. 45 (May 1993), pp. 42–47.

Saltz, Jerry. "Ten Artists for the '90s." *Art and Auction* (New York) 15, no. 10 (May 1993), pp. 122–25, 155.

Rees, Michael. "Yale Sculpture." *Flash Art* (Milan) 26, no. 170 (May–June 1993), pp. 65–67.

Rosen, Roee. "The Spectacle of the Heroic Masturbator: On Matthew Barney's Climb." *Studio Israeli Art Magazine* (Tel Aviv), no. 45 (July–August 1993), pp. 20–27.

Burn, Gordon. "Barney is Their Darling." *Observer Magazine* (London), Sept. 12, 1993, pp. 30–33.

Siegel, Jeanne. "Dévoiler le corps masculin/Unveiling the Male Body." *Art Press* (Paris), no. 183 (Sept. 1993), pp. 25–29 (French), E12–E15 (English).

Haus, Mary. "Fast Forward: Matthew Barney." *Artnews* (New York) 92, no. 9 (Nov. 1993), pp. 123–24.

Wooster, Ann-Sargent. "Face to Face: Matthew Barney." *Du* (Zurich) 53, no. 1 (Jan. 1994), p. 16 (German).

Holert, Tom. "Too Much, Too Young? Barneys Raum." *Texte zur Kunst* (Cologne), no. 13 (March 1994), pp. 102–11 (German).

Wakefield, Neville. "Matthew Barney's Fornication with the Fabric of Space." *Parkett* (Zurich), no. 39 (March 1994), pp. 118–24 (English), 125–30 (German).

Watney, Simon. "Aphrodite of the Future." *Artforum* (New York) 32, no. 8 (April 1994), pp. 75–76, 119.

Cameron, Dan. "Self-Determination." *Vogue* (New York), July 1994, pp. 152–58.

McKenna, Kristine. "This Boise Life, or Hut Hut Houdini." *Los Angeles Times*, Nov. 20, 1994, Calendar, pp. 85, 92.

Morgan, Stuart. "Of Goats and Men." *Frieze* (London), no. 20 (Jan.–Feb. 1995), pp. 35–39.

Barker, Nicola. "Perfect Body Language, Androgynous Faeries, TT Racers and a White-Suited Satyr." *The Guardian* (Manchester), April 30, 1995, p. 5.

Boyer, Charles-Arthur. "Matthew Barney: Histoires d'hommes sur l'île de Man." *Tribus Magazine* (Bagnolet, Belgium), June 1995, pp. 6–7 (French).

Karcher, Eva. "Narziss und Fegefeuer." *Art: Das Kunstmagazin* (Hamburg), no. 6 (June 1995), pp. 72–80 (German).

Tazzi, Pier Luigi. "Berichten uit de polymorfe zone. De mythografie van Matthew Barney." *Metropolis M* (Amsterdam) 16, no. 5 (Oct. 1995), pp. 18–23 (Dutch).

Als, Hilton. "Downtown Artthrob." *The New Yorker*, Nov. 6, 1995, pp. 61–62.

Hainley, Bruce. "Best and Worst of 1995: Creamy Kids' Stuff." *Artforum* (New York) 34, no. 4 (Dec. 1995), p. 64.

Bryson, Norman. "Matthew Barney's Gonadotrophic Cavalcade." *Parkett* (Zurich), no. 45 (December 1995), pp. 29–35 (English), 36–41 (German).

Goodeve, Thyrza Nichols. "Matthew Barney 95: Suspension [Cremaster], Secretion [Pearl], Secret [Biology]." *Parkett* (Zurich), no. 45 (December 1995), pp. 67–69 (English), 70–73 (German).

Onfray, Michel. "Mannerist Variations on Matthew Barney." *Parkett* (Zurich), no. 45 (December 1995), pp. 42–49 (German), 50–57 (English).

Seward, Keith. "Mathew Barney and Beyond." *Parkett* (Zurich), no. 45 (December 1995), pp. 58–61 (English), 61–66 (German).

Aukeman, Anastasia. "Rising Stars Under 40." *Artnews* (New York), special issue (1995), pp. 30–41.

Woods, Vicki. "Matthew Barney's Personality Parade." *Vogue* (New York), Jan. 1996, pp. 160–63.

Span, Paula. "Becoming a Player." *Washington Post*, Feb. 18, 1996, section G, p. 6.

Ammann, René. "Kunstgeburt." *Das Magazin* (Bern), May 11, 1996, pp. 32–42 (German).

Saltz, Jerry. "The Next Sex." *Art in America* (New York) 84, no. 10 (Oct. 1996), pp. 82–91.

Alphen, Ernst van. "Mannen zonder kloten." *De Gids* (Amsterdam), no. 11–12 (Nov.–Dec. 1996), pp. 1,004–13 (Dutch).

Crump, James. "Third Person Singular: Profiles and Personae." *See: A Journal of Visual Culture* (San Francisco) 2, no. 3 (Dec. 1996), pp. 57–61.

Pedrosa, Adriano. "Matthew Barney." *Poliester* (Col. Condesa, Mexico) 5, no. 17 (winter 1996–97), pp. 22–25 (Spanish and English).

Erfle, Anne. "Matthew Barneys Plazentäre Phantasmagorien-die Fünfte." *Neue Bildende Kunst* (Berlin), no. 4 (April 1997), pp. 48–52 (German).

Hasegawa, Yuko. "Utopistics: Non-Determinative Eros." *Bijutsu Techo* (Tokyo) 49, no. 742 (June 1997), pp. 39–41 (Japanese).

Frankel, David. "Hungarian Rhapsody." *Artforum* (New York) 36, no. 2 (Oct. 1997), pp. 76–79.

Madoff, Steven Henry. "After the Roaring 80's in Art, A Decade of Quieter Voices." *New York Times*, Nov. 2, 1997, Arts and Leisure, pp. 1, 45.

Camhi, Leslie. "Crossover Artists." *The Village Voice* (New York), Dec. 16, 1997, p. 76.

Romney, Jonathan. "Sheep or Goat?" *The Guardian* (Manchester), March 13, 1998, Friday Review, pp. 4–5.

Van Alphen, Ernst. "Matthew Barney: Cremaster 4." *Museum Boijmans Van Beuningen Rotterdam*, no. 49 (April 1998), unpaginated (Dutch and English).

Van Proyen, Mark. "Matthew Barney's Blarney: Sartoriasis and Self-Spectacle in Contemporary Art." *Bad Subjects* (Berkeley), no. 38 (May 1998), www.eserver.org/bs.

Cereijido, Fabiàn. "Just Because Nobody Claims to Be Able to Bring You the Future Doesn't Mean that It Isn't Coming . . ." *Flash Art* (Milan) 31, no. 200 (May–June 1998), pp. 65–67.

Sladen, Mark. "Unspeakably Beautiful." *Art Monthly* (London), no. 217 (June 1998), pp. 1–4.

Russell, Bruce Hugh. "Matthew Barney's Testicular Anxieties." *Parachute* (Montreal), no. 92 (Oct.–Dec. 1998), pp. 36–43.

Rickels, Laurence A. "Phantoms of Opera." *Art/Text* (Sydney), no. 63 (Nov. 1998–Jan. 1999), pp. 60–66.

Siegel, Katy. "Nurture Boy." *Artforum* (New York) 37, no. 10 (summer 1999), pp. 132–35.

Plagens, Peter. "Barney for Grown-ups." *Newsweek* (New York), Aug. 23, 1999, p. 64.

Poschardt, Ulf. "Schläge für den Menschenpark." *Süddeutsche Zeitung* (Munich), Oct. 1, 1999, p. 18 (German). Reprinted in *KW Magazine* (Berlin) 2, no. 1 (2001), pp. 40–44 (English and German).

Kimmelman, Michael. "The Importance of Matthew Barney." *The New York Times Magazine*, Oct. 10, 1999, pp. 62–69.

Syman, Stefanie. "Matthew Barney's Garden of Earthly Delights." *Feed* (New York), Dec. 7, 1999, www.feedmag.com.

"Best of the '90s." *Artforum* (New York) 38, no. 4 (Dec. 1999), pp. 114, 116, 118, 122. (Lists compiled by Daniel Birnbaum, Alissa Quart, David Rimanelli, and Robert Rosenblum, and statement by Karen Cooper.)

Pollack, Barbara. "The Wizard of Odd." *Artnews* (New York), 98, no. 11 (Dec. 1999), p. 138.

Knöfel, Ulrike. "Showmaster der Mutanten." *Der Spiegel* (Hamburg), Feb. 14, 2000, pp. 236–38 (German).

Hodge, Roger D. "Onan the Magnificent: The Triumph of the Testicle in Contemporary Art." *Harper's Magazine* (New York) 300, no. 1,798 (March 2000), pp. 77–80.

Muller, Vannessa Joan, Matthias Muhling, Anke Kempkes, and Heiki Foll. "Matthew Barney/Cremaster 2." *Texte zur Kunst* (Cologne) 10, no. 38 (June 2000), pp. 112–18 (German).

Levine, Karen A. "Matthew Barney's Cremaster 2: A Conversation with David Ireland." *Open: The Magazine of the San Francisco Museum of Modern Art*, no. 2 (summer 2000), pp. 44–47.

Kim, Hong-hee. "Odyssey Toward the Third Sex." *Monthly Art Magazine* (Seoul) 2, no. 8 (Sept. 2000), pp. 74–81 (Korean).

Coleman, Beth. "Soft Machines." *Artbyte Magazine* (New York) 3, no. 3 (Sept.–Oct. 2000), pp. 42–49.

Becker, Ilka. "Einblendung." In Tom Holert, ed. *Jahresring 47*. Cologne: Oktagon, 2000, pp. 176–91 (German).

Spector, Nancy. "Matthew Barney." In *Matthew Barney, Safety Curtain, 2000/2001* (German and English brochures). Vienna: Staatsoper; and Vienna: museum in progress, 2000. Reprinted in *KW Magazine* (Berlin) 2, no. 1 (2001), pp. 45–47 (English and German).

Poels, Jan-Willem. "Master, Let Me Enter." *Frame* (Amsterdam), no. 23 (Nov.–Dec. 2001), pp. 78–85.

Frankel, David. "Engine." *2wice: Inside Cars* (New York) 5, no. 2 (2001), pp. 38–45.

CREMASTER
Screening History

1995

CREMASTER 4 (premiere), Fondation Cartier pour l'Art Contemporain, Paris, March 3–April 16 (presented as part of the exhibition *Matthew Barney: CREMASTER 4*).

CREMASTER 4, The Public Theater, New York, April 8–May 6.

CREMASTER 4, Metro Cinema, London, May 9–14 (presented by Artangel, London).

CREMASTER 1 (premiere) and *CREMASTER 4*, New York Video Festival, Walter Reade Theater, New York, Oct. 7–9.

1996

CREMASTER 1, The Museum of Modern Art, New York, Feb. 12 (presented as part of the program *Video Viewpoints*).

CREMASTER 4, School of the Museum of Fine Arts, Boston, Feb. 23–27.

CREMASTER 1 and *CREMASTER 4*, Los Angeles County Museum of Art, May 16.

CREMASTER 1 and *CREMASTER 4*, Film Forum, New York, July 17–23.

> Bernstein, Paula. "Attention Art Snobs: Pretentious 'Cremaster' Your Cup of Tea." *The Star-Ledger* (Newark, N.J.), July 17, 1996, p. 31.
>
> Holden, Stephen. "Of Sexuality as Darwinian Olympics." *New York Times*, July 17, 1996, section C, p. 10.
>
> Kehr, Dave. "A Mythic Odd-yssey into Life." *Daily News* (New York), July 17, 1996, p. 38.
>
> Worth, Larry. "When '4' and '1' Equals Zero." *New York Post*, July 17, 1996, p. 37.
>
> Taubin, Amy. "Making Tracks." *The Village Voice* (New York), July 23, 1996, p. 66.
>
> Yehya, Naief. "Cremaster 1 y 4, de Matthew Barney." *uno más uno* (Mexico City), July 28, 1997, p. 23 (Spanish).

CREMASTER 1 and *CREMASTER 4*, The Flicks, Boise, Idaho, July 28.

CREMASTER 1 and *CREMASTER 4*, c³: Center for Culture and Communication, Budapest, Sept. 5–22 (*CREMASTER 1*), Sept. 23–Oct. 10 (*CREMASTER 4*).

1997

CREMASTER 5 (premiere), Portikus, Frankfurt am Main, June 18–Aug. 10 (presented as part of the exhibition *Matthew Barney: CREMASTER 5*).

CREMASTER 5, c³: Center for Culture and Communication, Budapest, July 3–25.

CREMASTER 1 and *CREMASTER 4*, Goethe-Institut, Atlanta, July 18 (presented by Nexus Contemporary Art Center, Atlanta).

CREMASTER 5 and *MARCH with the ANAL SADISTIC WARRIOR*, Film Forum, New York, Oct. 22–Nov. 4, Nov. 14–Dec. 20.

> Holden, Stephen. "Modernist Twist to Macho Mythology." *New York Times*, Oct. 22, 1997, section E, p. 5.
>
> Gell, Aaron. "Film Review: Cremaster 5 and March with the Anal Sadistic Warrior." *Time Out New York*, Oct. 23–30, 1997, p. 65.
>
> Taubin, Amy. "Hellraisers." *The Village Voice* (New York), Oct. 28, 1997, p. 79.
>
> Ratner, Megan. "Matthew Barney's Obscure Objects of Desire." *NY Arts* (New York) 2, no. 11 (Dec. 1997), pp. 20–21.

1998

CREMASTER 5, Slamdance Film Festival, Park City, Utah, Jan. 21.

CREMASTER 5 and *MARCH with the ANAL SADISTIC WARRIOR*, 27th International Film Festival, Rotterdam, Jan. 29, Feb. 6–7.

CREMASTER 5, Facts and Fiction: Film and Video Festival, Cinema de Amicis, Milan, Feb. 3.

CREMASTER 5 and *MARCH with the ANAL SADISTIC WARRIOR*, Nat Film Festival, Copenhagen, Feb. 27–28.

CREMASTER 4 and *CREMASTER 5*, Nuart Theater, Los Angeles, March 6-13.

> McKenna, Kristine. "A Pop Audience Pleaser?" *Los Angeles Times*, March 5, 1998, Weekend, pp. 25–26.

CREMASTER 1 and *CREMASTER 5*, Metro Cinema, London, *CREMASTER 1*: March 20, 25–26; *CREMASTER 5*: March 20–26 (presented by Artangel, London).

> O'Farrell, Maggie. "The Muscle Man Cometh, Again." *The Independent on Sunday* (London), March 15, 1998, p. 10.
>
> Carlisle, Isabel. "Ursula Andress Is Now a Work of Art." *The Times* (London), March 19, 1998, Arts & Film, p. 38.
>
> Elley, Derek. "Cremaster 5 (Musical Fantasy)." *Variety* (New York), March 30, 1998, p. 43.

CREMASTER 5, Théâtre 14 Juillet, Paris, March 23–April 5.

> Lebovici, Elisabeth. Mutations polymorphes en poly-phonie." *Libération* (Paris), March 25, 1998, p. 31 (French).

CREMASTER 5, Stadtkino Basel, April 2, 5 (presented by Öffentliche Kunstsammlung Basel).

CREMASTER 5, San Francisco Museum of Modern Art, April 2–19.

> Bonetti, David. "A Different Kind of Barney." *San Francisco Examiner*, April 2, 1998, section C, p. 1.

CREMASTER 5, The Grand Illusion Cinema, Seattle, April 3–9.

> Hackett, Regina. "Matthew Barney's Cremaster Series Reaches Delirious Heights in '5.'" *Seattle Post Intelligencer*, April 3, 1998, p. 26.

CREMASTER 5, Images Festival of Independent Film and Video, Toronto, April 30.

CREMASTER 1 and *CREMASTER 5*, Sala Montcada, Fundació "la Caixa," Barcelona, June 30, July 1, 7–8 (presented as part of the exhibition series *El Jo Divers*). Catalogue, with essays by Juan Antonio Álvarez Reyes and Dan Cameron (in Spanish, English, and Catalan).

CREMASTER 4 and *CREMASTER 5*, Tel Aviv Cinematheque, Dec. 2 (presented by Center for Contemporary Art, Tel Aviv).

CREMASTER 5, Woodruff Arts Center, Atlanta, Dec. 3 (presented by Nexus Contemporary Art Center, Atlanta, and Atlanta College of Art).

CREMASTER 5, James A. Little Theater, Santa Fe, New Mexico, Dec. 5 (presented by SITE Santa Fe).

1999

CREMASTER 4 and *CREMASTER 5*, International Film Festival, Tower City Cinemas, Cleveland, March 23.

> Green, Frank. "Anatomy: Matthew Barney's Extrava-ganzas." *Cleveland Free Times*, March 17, 1999, p. 56.

CREMASTER 5, The Tampa Theater, Tampa, Florida, March 28 (presented by University of South Florida Contemporary Art Museum as part of the project *Art in the News*).

CREMASTER 5, Texas Union Theater, The University of Texas at Austin, April 1 (presented by Austin Museum of Art; Jack S. Blanton Museum of Art, The University of Texas at Austin; and Artpace, San Antonio).

CREMASTER 4 and *CREMASTER 5*, Virginia Museum of Fine Arts, Richmond, April 13 (presented as part of the performance program *Fast / Forward*).

CREMASTER 5, Meeting House Square, Temple Bar, Dublin, April 29.

CREMASTER 5, Artspace, Auckland, New Zealand, May 6.

CREMASTER 4 and *CREMASTER 5*, Instituto Valenciano de Arte Moderno, Centre Julio González, Valencia, May 22–23, 29–30. Brochure, with text by Enrique Juncosa.

CREMASTER 5, Walker Art Center, Minneapolis, July 18.

CREMASTER 2 (premiere), Walker Art Center, Minneapolis, July 18-Oct. 17 (presented as part of the exhibition *Matthew Barney CREMASTER 2: The Drones' Exposition*).

CREMASTER 1 and CREMASTER 5, Cinemateket, Oslo, Sept. 6 (presented by Astrup Fearnley Museet for Moderne Kunst, Oslo).

CREMASTER 4 and CREMASTER 5, Glassel School of Art, Houston, Sept. 18–19.

CREMASTER 2, Teatro Rondò di Bacco, Palazzo Pitti, Florence, Sept. 22–28 (presented by Pitti Immagine Discovery).

CREMASTER 1 and CREMASTER 4, Meeting House Square, Temple Bar, Dublin, Sept. 23.

CREMASTER 1 and CREMASTER 5, The Detroit Institute of Arts, Sept. 30.

CREMASTER 2, Film Forum, New York, Oct. 13–Nov. 4.

> Holden, Stephen. "It's About a Murderer and Yes, Bees, Houdini . . ." *New York Times*, Oct. 13, 1999, section E, pp. 1, 5.

> Lumenick, Lou. "'2' Slow a 'Song.'" *New York Post*, Oct. 14, 1999, p. 51.

> Anton, Saul. "Film Review: Cremaster 2." *Time Out New York*, Oct. 14–21, 1999, p. 103.

> Bernard, Jami. "'Cremaster' Is Arty and Opaque." *Daily News* (New York), Oct. 14, 1999, p. 50.

> Anderson, John. "Fertile Imagery." *Newsday* (New York), Oct. 15, 1999, Weekend Part 2, p. B12.

> Taubin, Amy. "Good Egg in Bad Straits; Erratic Artist with Sequel Syndrome." *The Village Voice* (New York), Oct. 19, 1999, p. 140.

> Jones, Oliver. "Cremaster 2." *Daily Variety* (Los Angeles), Oct. 22, 1999, p. 8; reprinted in *Variety* (New York), Oct. 25, 1999, p. 39.

> Weil, Rex. "Matthew Barney's Cremaster 2." *Artnews* (New York) 99, no. 1 (Jan. 2000), pp. 163–64.

CREMASTER 2, Museum of Contemporary Art, Chicago, Oct. 29–30.

> Stamets, Bill. "'Cremaster 2' at the MCA." *Chicago Sun Times*, Oct. 28, 1999, p. 43.

CREMASTER 1 and CREMASTER 5, Artsonje Center, Seoul, Nov. 18–19.

CREMASTER 4 and CREMASTER 5, Filmmuseum Munich, Dec. 6 (presented by Goetz Collection, Munich).

2000
CREMASTER 2, The Grand Illusion Cinema, Seattle, Jan. 1–13.

CREMASTER 5, Ecole Supérieure des Beaux-Arts, Tours, Jan. 10.

CREMASTER 2, Filmcasino Wien, Vienna, Jan. 25, 30, Feb. 6, 13 (presented by Kunsthalle Wien, Vienna).

CREMASTER 2 and CREMASTER 4, Metro Cinema, London, Jan. 28–Feb. 3 (CREMASTER 2), Jan. 28–30 (CREMASTER 4).

> Mullins, Charlotte. "And It's All Beautifully Executed." *The Independent on Sunday* (London), Jan. 23, 2000, Culture, p. 5.

> Dorment, Richard. "The Making of a Man." *The Daily Telegraph* (London), Jan. 26, 2000, p. 23.

> Romney, Jonathan. "Barney and the Beehive." *The Guardian* (Manchester), Jan. 26, 2000, G2, p. 15.

> Smith, Gavin. "Come Dancing with Gary in Utah." *Sight and Sound* (London) 10, no. 2 (Feb. 2000), p. 4.

> Staple, Polly. "Cremaster of Crime." *Art Monthly* (London), no. 234 (March 2000), pp. 48–49.

> Evans, Gareth. "The Body Politic: In the Ring with Brisley and Barney." *DPICT* (London), no. 1 (April–May 2000), pp. 22–23.

CREMASTER 2, 23rd Göteborg Film Festival, Sweden, Jan. 29–30, Feb. 3.

CREMASTER 2, Museum Boijmans Van Beuningen, Rotterdam, Feb. 5–6.

> Hettig, Frank-Alexander. "Cremaster 2." *Metropolis M* (Utrecht, The Netherlands) 21, no. 2 (April–May 2000), p. 54 (Dutch).

CREMASTER 2, MK2 Beaubourg, Paris, Feb. 9.

> Lebovici, Elisabeth. "Le Barnum de Barney." *Libération* (Paris), Feb. 9, 2000, p. 34 (French).

CREMASTER 2, Berlin International Film Festival, Feb. 13.

CREMASTER 2, Nuart Theater, Los Angeles, Feb. 18–21.

> Harvey, Doug. "Barney's Sticky Adventure Beyond Death." *LA Weekly*, Feb. 11, 2000, p. 35.

> Thomas, Kevin. "Screening Room." *Los Angeles Times*, Feb. 17, 2000, Weekend, pp. 20–26.

> Willis, Holly. "Cremaster 2." *LA Weekly*, Feb. 18, 2000, p. 64.

CREMASTER 2, Images Festival of Independent Film and Video, Toronto, March 3 (presented by the Power Plant Contemporary Art Gallery, Toronto).

> Goddard, Peter. "Cremaster 2 More Than Just Genital Art." *The Toronto Star*, March 3, 2000, section D, p. 9.

> Groen, Rick. "What Planet Is He From?" *The Globe and Mail* (Toronto), March 3, 2000, The Globe Review, p. R3.

> Whyte, Murray. "Two-Stepping Cowboys, Harry Houdini, Mormons and Bees . . . It Must Be Art." *National Post* (Toronto), March 3, 2000, section B, p. 3.

CREMASTER 2, Filmmuseum Munich, March 3–5 (presented by Goetz Collection, Munich).

CREMASTER 2 and SCABACTION, Irish Film Centre, Dublin, May 9.

CREMASTER 2, Meeting House Square, Temple Bar, Dublin, May 11.

> Dunne, Aidan. "What's It All About, Barney?" *Irish Times* (Dublin), May 11, 2000, Arts, p. 13.

CREMASTER 2, San Francisco Museum of Modern Art, May 20–Sept. 5 (presented as part of the exhibition *CREMASTER 2: The Drones' Exposition*).

> Bonetti, David. "Giving Art a Bad Name?" *San Francisco Examiner*, May 22, 2000, section C, p. 1.

CREMASTER 2, Grand Illusion Movie Theater, Santa Fe, New Mexico, May 23 (presented by SITE Santa Fe).

> Villani, John. "Filmmaker's Artwork Sure to Challenge His Audience." *Albuquerque Journal*, May 21, 2000, section F, p. 4.

CREMASTER 2, Mayan Theater, Denver, June 9–11.

> Denerstein, Robert. "Imagery Is Everything in 'Cremaster 2.'" *Denver Rocky Mountain News*, June 4, 2000, section D, p. 11.

> Rosen, Steven. "'Cremaster 2': Unique Movie's Multilevel Themes Generate Art in the Sense of Abstract Sculpture." *Denver Post*, June 4, 2000, section I, p. 1.

> Rosen, Steven. "'Cremaster 2': True Work of Art with Symbolism, Bold Visuals." *Denver Post*, June 9, 2000, section F, p. 5.

CREMASTER 2, Dendy Opera Quays, Sydney, June 11, 15 (presented as part of Sydney Film Festival and the exhibition *12th Sydney Biennale*).

CREMASTER 2, Stadtkino Basel, June 18–19, 24–25.

CREMASTER 2 and CREMASTER 4, Museo Nacional Centro de Arte Reina Sofía, Madrid, July 5, 21, Aug. 2 (CREMASTER 2), July 13, 28 (CREMASTER 4) (presented as part of the film and video program *Cine y casi cine*).

CREMASTER 4 and CREMASTER 5, 21st Century Contemporary Art Museum, Kanazawa, Japan, Sept. 9–15.

CREMASTER 2, Cleveland Cinematheque, Cleveland Institute of Art, Sept. 30, Oct. 1.

CREMASTER 2, Festival do Rio, Rio de Janeiro International Film Festival, Oct. 5–19.

CREMASTER 2, Künstler-Verein Malkasten, Düsseldorf, Oct. 13–14.

CREMASTER 2, The Detroit Institute of Arts, Oct. 18.

CREMASTER 1 and CREMASTER 4, Filmmuseum Munich, Nov. 10–11 (presented by Goetz Collection, Munich).

CREMASTER 4, Cinéma Lux, Caen, France, Nov. 14 (presented by FRAC Basse-Normandie).

CREMASTER 4, Woodruff Arts Center, Atlanta, Dec. 5 (presented by Atlanta Contemporary Art Center and Atlanta College of Art as part of the film program *Sound and Vision: New Films by Contemporary Artists*).

CREMASTER 2 and CREMASTER 5, Filmtheater 't Hoogt, Utrecht, The Netherlands, Dec. 14–20.

2001
CREMASTER 2, Kunstverein Hannover, March 8 (presented as part of the exhibition *Close Up*).

CREMASTER 2, The Flicks, Boise, Idaho, March 22–29.

CREMASTER 1 and CREMASTER 2, Tel Aviv Cinematheque, April 1–2 (presented by Center for Contemporary Art, Tel Aviv).

CREMASTER 1 and CREMASTER 2, Jerusalem Cinematheque, April 3 (presented by Center for Contemporary Art, Tel Aviv).

CREMASTER 4, Bard College, Annandale-on-Hudson, New York, April 23 (presented as part of the exhibition *Flesh and Fluid*). Traveled to Ramapo College of New Jersey, Mahwah, Sept. 12.

CREMASTER 2, Showcase Cinemas, Cincinnati, May 3 (presented as part of Intermedia 2001).

CREMASTER 1, Wilhelm-Lehmbruck Museum, Duisburg, Germany, May 6 (presented as part of 25. Duisburger Akzente).

CREMASTER 2, The National D-Day Museum, New Orleans, May 9 (presented in conjunction with the 154th Annual Meeting of the American Psychiatric Association).

CREMASTER 5, Wiener Staatsoper, Vienna, June 16 (presented by museum in progress).

CREMASTER 2, Lakewood Theater, Dallas, Sept. 16 (presented by the McKinney Avenue Contemporary, Dallas).

CREMASTER 1 and CREMASTER 2, Festival International de la Nouvelle Danse, Montreal, Sept. 24–25.

CREMASTER 2, The Hamptons International Film Festival, East Hampton, New York, Oct. 18–19.

CREMASTER 2, Maryland Institute College of Art, Baltimore, Nov. 6.

CREMASTER 2, Institute of Contemporary Art, University of Pennsylvania, Philadelphia, Nov. 11.

2002
CREMASTER 2 and CREMASTER 5, IFIstanbul: 1st AFM/International Independent Film Festival, Istanbul, Jan. 19, 27.

CREMASTER 5, The Museum of Modern Art, Ibaraki, Japan, Jan. 20.

CREMASTER 1 and CREMASTER 5, Aichi Arts Center, Nagoya, Japan, March 15.

CREMASTER 1 and CREMASTER 4, Images Festival of Independent Film and Video, Toronto, April 19.

CREMASTER 3 (premiere), Ziegfeld Theater, New York, May 1 (organized as a benefit for the Solomon R. Guggenheim Museum).

CREMASTER 3, Film Forum, New York, opening May 15.

PHOTO CREDITS AND SOURCE MATERIAL

All reproductions of artwork courtesy Barbara Gladstone

All production photographs, video stills and source materials courtesy Matthew Barney

All photographic artworks for *CREMASTERS 1, 4,* and *5* are by Michael James O'Brien. All photographic artworks for *CREMASTER 3* are by Chris Winget. For *CREMASTER 2*, photographic artworks on pages 35, 176, 178, 179, 186, 188, 194, 199, 201, 213, 217, 221, 225, 233, 239, and 242 are by Michael James O'Brien; photographic artworks on pages 36, 177, 204, 224, 237, 238, and 243 are by Chris Winget.

All video stills are by Peter Strietmann (except where noted in the captions).

Credits are by page number.

Opening and closing sequences: Chris Winget, courtesy Barbara Gladstone

"Only the Perverse Fantasy Can Still Save Us": All drawings and concept photographs are by Matthew Barney. 2: Michael James O'Brien; 20, 26–29: Ellen Labenski; 39: Michael James O'Brien; 44, 46 (bottom), 51 (top), 54: Chris Winget; 61 (bottom), 63 (bottom): Michael James O'Brien; 74–75: Ellen Labenski

"The Cremaster Glossary": All video stills are by Peter Strietmann with the exception of: anus island: Satellite photo, NRSC Limited Science Library; blood atonement, bloodbath, bloodline, bloodshed, bodybuilding: Michael James O'Brien; Bronco Stadium: Robert Wogan; Budapest, chorus, curtain call: Michael James O'Brien; decomposition: Chris Winget; delay of game: Michael James O'Brien; Dino Supreme, drones: Chris Winget; ectoplasm, excess, faerie isle: Michael James O'Brien; Fingal's Cave, glaciation: Chris Winget; golden plates: Michael James O'Brien; "Hollow Earth" theory: Chris Winget; Houdini, kin to the magician: Michael James O'Brien; larval memory: Chris Winget; Loughton Ram, mediation: Michael James O'Brien; Morbid Angel: Chris Winget; Mormon doctrine: Chelsea Romersa; mythopaeic conditioning, physical culture, prison rodeo, prosthetics, sacrificial crisis: Michael James O'Brien; satyr: Peter Strietmann; symphony of will, wingfoot: Michael James O'Brien

CREMASTERS 1–5: Unless indicated, all drawings and concept photographs are by Matthew Barney; reproductions for the catalogue by Ellen Labenski.

122–23: Michael James O'Brien
129: Laure Leber, *Hustler's Leg World* magazine (Beverly Hills, Calif.), August 1998, p. 28
130: (center) Courtesy Celefex, New York
131: Paul Pisoni
140: Michael James O'Brien
142: (top and bottom) Paul Pisoni; (center) Robert Wogan
165: (center) Paul Pisoni
174–75: Kelly Rigby, Courtesy Bureau of Land Management, Utah
182: (left) Ruven Afandor, *Surface* magazine (San Francisco), no. 11 (July/August 1997), p. 83; (right) Travis Hutchison, *Skin Two* magazine (London), no. 23 (1998), p. 42
183: Richard Avedon, *The New Yorker* magazine, April 20 1998, p. 61
184: (top) *Houdini on Magic*, ed. Walter B. Gibson and Morris N. Young (New York: Dover Publications, 1953); (left center) Kenneth Silverman, *Houdini!!!: The Career of Ehrich Weiss* (New York: HarperCollins, 1996); (bottom) Ruth Brandon, *The Life and Many Deaths of Harry Houdini* (London: Secker & Warburg, 1993)
205: *Biography: Gary Gilmore: A Fight to Die* (A&E, 1996)
206: (center) Stephen Stickler
208: (gas tank cap) Chris Winget
209: (top and bottom) *Biography: Gary Gilmore: A Fight to Die* (A&E, 1996)
210: (right) Dennis Schmidt

218: (bottom) *Biography: Gary Gilmore: A Fight to Die* (A&E, 1996)
220: (top) Courtesy Arabian Nights; (center and bottom) Courtesy Huntsville Prison Photo Archive
230: (center) Courtesy New York Public Library Picture Collection; (bottom) Courtesy Alberta Color Productions
232: (center right) Tom Danielsen, courtesy Impact
234: (left top two) Courtesy Salt Lake Convention and Visitors Bureau; (left center) James W. and Daniel B. Shepp, *Shepp's World's Fair Photographed* (Chicago: Globe Bible Publishing Co., 1893); (left bottom) Courtesy Alberta Color Productions; (right top) Douglas Leighton
235: (monster truck) *The Monsters of Rock 'n' Roar* (SRO Pace Productions, 1993); (snowmobile) *The Twenty-Second Annual World Championship Snowmobile Hillclimb* (Slice of Life Video Productions, 1997)
236: (top) *Houdini on Magic*, ed. Walter B. Gibson and Morris N. Young (New York: Dover Publications, 1953)
246–47: Chris Winget
248: Courtesy Tishman/Speyer
249–51: Chris Winget
260: (top) Vernon V. Blever
262: (photocopy) www.anorexic-rec.com
263: (center) Erica Mutch
274: Chris Winget
275: (Empire State Building images) Lewis Hine, from *America & Lewis Hine: Photographs 1904–1940* (New York: Aperture, 1977); (skyline) John A. Kouwenhoven, *The Columbia Historical Portrait of New York: An Essay in Graphic History* (Garden City, NY: Doubleday, 1953), p. 477; (Chrysler Building images) www.luciddreams.com
280–82, 285: Ellen Labenski
288: (production stills) Gabe Bartalos; (texture references) Miss Janet Fendick, from G. Austin Gersham, *A Colour Atlas of Forensic Pathology* (London: Wolfe Medical Publications, 1975)
291: (center) W. L. Wilmshurst, *The Meaning of Masonry* (New York: Gramercy Books, 1980); (bottom) www.sickestsites.com
293: (Ku Klux Klan costuming) www.freemasonwatch.freepress-freespeech.com; www.1-888implant.com; (dentia) W. H. O. McGehee, H. A. True, E. F. Inskipp, *A Textbook of Operative Dentistry*, 4th ed. (New York: McGraw Hill, 1956), pp. 348, 478
294: Chris Winget
296: (pillars) Christopher Knight and Robert Lomas, *The Hiram Key: Pharoahs, Freemasons and the Discovery of the Secret Scrolls of Jesus* (Rockport, MA: Element Books, 1997); (Serra) Richard J. Burbidge, *Frieze* magazine, no. 7 (Nov–Dec 1992)
297: (Ferriss drawings) Hugh Ferriss, *The Metropolis of Tomorrow* (Princeton, N.J.: Princeton Architectural Press, 1986)
298: (top) Horst Hamann, advertisement for NYU School of Continuing Education, *The New York Times*, August 9, 1999
304: (bottom) B. J. Papas
306: (left) Nick Knight, *Die Zeit* magazine (Hamburg), November 5, 1998, cover; (right bottom) advertisement for Irwin Research & Development, Inc., *Plastics Technology*, March 2000
307: (right) Christopher Knight and Robert Lomas, *The Hiram Key: Pharoahs, Freemasons and the Discovery of the Secret Scrolls of Jesus* (Rockport, MA: Element Books, 1997)
310: (left center) Ira Fowler, *Human Anatomy* (Belmont, CA: Wadsworth Publishing Company, 1984), p. 131
313: (center) Gianfranco Gorgoni
317, 319–21: Chris Winget
326–27, 346–48: Michael James O'Brien
351: Gabe Bartalos
356: (postcards) Courtesy Welldon Cards
361: (top) Peter Strietmann; (bottom) Michael James O'Brien
366: Michael James O'Brien
367: J.-L. Losi, courtesy Fondation Cartier pour L'Art Contemporain

396–97: Michael James O'Brien
398–99: Courtesy BOAVI
400–1: © Roman Soumar/CORBIS
408: Féjer Gábor, courtesy BOAVI
411: (top) Courtesy Hamburger Kunsthalle, Hamburg, Germany
414: (top) Courtesy Frick Collection, New York; (bottom) Courtesy Birmingham Museum and Art Gallery, England
420 (center), 422–23: Michael James O'Brien
424: (center) Jean Pierre Lehmann
432, 434: Michael James O'Brien
436: (top) Courtesy Hamburger Kunsthalle, Hamburg, Germany
438: (top and bottom) Thomas Kearns
440–41: Michael James O'Brien
442: (bottom) Courtesy Hamburger Kunsthalle, Hamburg, Germany
443: Michael James O'Brien
444: Courtesy Sidney H. Radner Collection, Houdini Historical Center, Appleton, Wisconsin
446 (top), 447: Courtesy Hamburger Kunsthalle, Hamburg, Germany

"Personal Perspectives":
482: David Willems
483: Matthew D. Ryle
484: Matthew Barney
486: Robert Wogan
488: Peter Strietmann
489: Matthew Barney
490: Chris Winget
491: Paola Gribaudo
492: Chris Winget
494: Gabe Bartalos
496: Chris Winget
498: Chris Winget
499: Peter Strietmann
500: David Willems
501: Chris Winget
503: Peter Strietmann

PROJECT TEAM

CURATORIAL
Nancy Spector, Curator of Contemporary Art
Joan Young, Assistant Curator
Nat Trotman, Project Curatorial Assistant

Rosalie Benitez, Nadia Chalbi, Laetitia Chauvin, Tori Cohen,
Lilian Davies, Anne Dressen, Dong-Yeon Koh, Anne Reeve,
Tania Sidawi, Marie von Finck, Interns

ART SERVICES AND PREPARATIONS
Barry Hylton, Senior Exhibition Technician
Scott Wixon, Manager of Art Services and Preparations
Mary Ann Hoag, Lighting Designer
Richard Gombar, Construction Manager
Michael Sarff, Assistant Construction Manager
James Nelson, Chief Preparator
Elisabeth Jaff, Associate Preparator for Paper
Jeffrey Clemens, Associate Preparator
David Bufano, Senior Exhibition Technician
Derek DeLuco, Technical Specialist

CONSERVATION
Eleonora Nagy, Sculpture Conservator
Mara Guglielmi, Paper Conservator

EDUCATION
Kim Kanatani, Gail Engelberg Director of Education
Pablo Helguera, Senior Education Program Manager, Public
Programs
Sharon Vatsky, Senior Education Program Manager, School
Programs

EXHIBITION AND COLLECTIONS MANAGEMENT
AND DESIGN
Marion Kahan, Exhibition Program Manager
Paul Kuranko, Media Arts Specialist
Marcia Fardella, Chief Graphic Designer
Karen Meyerhoff, Managing Director for Exhibitions,
Collections, and Design
Ana Luisa Leite, Senior Exhibition Design Coordinator
Angelo Morselo, Exhibition Design Assistant

EXTERNAL AFFAIRS
Helen Warwick, Director of Individual Giving and Membership
Kendall Hubert, Director of Corporate Development
Bruce Lineker, Director of Institutional Development
Gina Rogak, Director of Special Events
Stephen Diefenderfer, Special Events Manager
Peggy Allen, Special Events Coordinator

FABRICATION
Peter Read, Manager of Exhibition Fabrications and Design
Stephen Engelman, Technical Designer/Chief Fabricator

FILM AND MEDIA ARTS
John G. Hanhardt, Senior Curator of Film and Media Arts
Maria-Christina Villaseñor, Associate Curator of Film and
Media Arts

FACILITIES
Michael DeBenedetto, Manager of Building Services

GLOBAL PROGAMS, BUDGETING AND PLANNING
Anna Lee, Director of Global Programs, Budgeting and
Planning
Keena Hammond, former Senior Financial Analyst

LEGAL
Brendan Connell, Assistant General Counsel
Maria Pallante, Associate General Counsel

MARKETING
Laura Miller, Director of Marketing

PHOTOGRAPHY
Ellen Labenski, Associate Photographer
David M. Heald, Director of Photographic Services and Chief
Photographer
Kim Bush, Manager of Photography and Permissions

PUBLIC AFFAIRS
Betsy Ennis, Director of Public Affairs
Sasha Nicholas, Public Affairs Coordinator

PUBLICATIONS
CATALOGUE AND EXHIBITION, EDITORIAL
Anthony Calnek, Managing Director and Publisher
Elizabeth Franzen, Manager of Editorial Services
Stephen Hoban, Editorial and Administrative Assistant
Meghan Dailey, Associate Editor
Edward Weisberger, Editor
David Frankel, Editor
Stephen Frankel, Editor
Jennifer Knox White, Editor

CATALOGUE, PRODUCTION
Elizabeth Levy, Managing Editor/Manager of Foreign Editions
Melissa Secondino, Associate Production Manager
Tracy L. Hennige, Production Assistant
Jess Mackta, Associate Production Manager
Susan McNally
Tony Morgan, Step Graphics Inc.

CATALOGUE, DESIGN
J. Abbott Miller and Roy Brooks, Pentagram

REGISTRAR
Alexia Hughes, Associate Registrar
Jill Kohler, Associate Registrar
Meryl Cohen, Head Registrar

THEATER AND MEDIA SERVICES
Michael Lavin, Director of Theater and Media Services
Christopher Allen, Theater Technician
Norman Proctor, Projectionist

VISITOR SERVICES
Stephanie King, Director of Visitor Services

FILMING OF *CREMASTER 3* AT
THE GUGGENHEIM MUSEUM
Tom Foley, Director of Security, and Security Department staff
Robert Rominiecki, Manager of Safety
Amy Kaufman, Director of Planning and Operations, Special
Projects, and Visitor Services Department staff
Ramon Gilsanz and Victoria Arbitrio, Ramon Gilsanz
Consulting Engineers
Richard Burgess, Production Service
Robert Walden, Art Handler
Joe Adams, Assistant Manager of Art Services
Walter Christie, Electrician
Mark de Mairo, Director of Facilities
Carolyn Padwa, Registrar
Dan Reiser, Exhibition Designer

MATTHEW BARNEY STUDIO:
CREMASTER 3 AND CYCLE EXHIBITION TEAM:
Kanoa Baysa
Jonathan Bepler
Nicholas Emmet
Jessica Frost
Derek Haas
Chris Hanson
Mark Hislop
Thomas Kearns
Dow Kimbrell
Michael Koller
Linda LaBelle
Melissa Lockwood
Hal McFeely III
Chelsea Romersa
Matthew D. Ryle
Chris Seguine
Kristin Schattenfield
Staff of Barbara Gladstone Gallery
Gamble Staempfli
Andrea Stanislav
Peter Strietmann
Monika Tichacek
Seth Wiley
Chris Winget

PRINCIPAL PRODUCTION TEAM FOR
CREMASTERS 1, 2, 4, AND *5:*
Timothy J. Davey
Lalena Fisher
Mark Fletcher
Tom Johnson
Chloe Piene
Paul Pisoni
Shusei Sugawara
Jay Tobler
Robert Wogan

PHOTOGRAPHIC PRINTING
Anthony Accardi, Green Rhino
LTI
MV Labs
Schneider/Erdman
68°

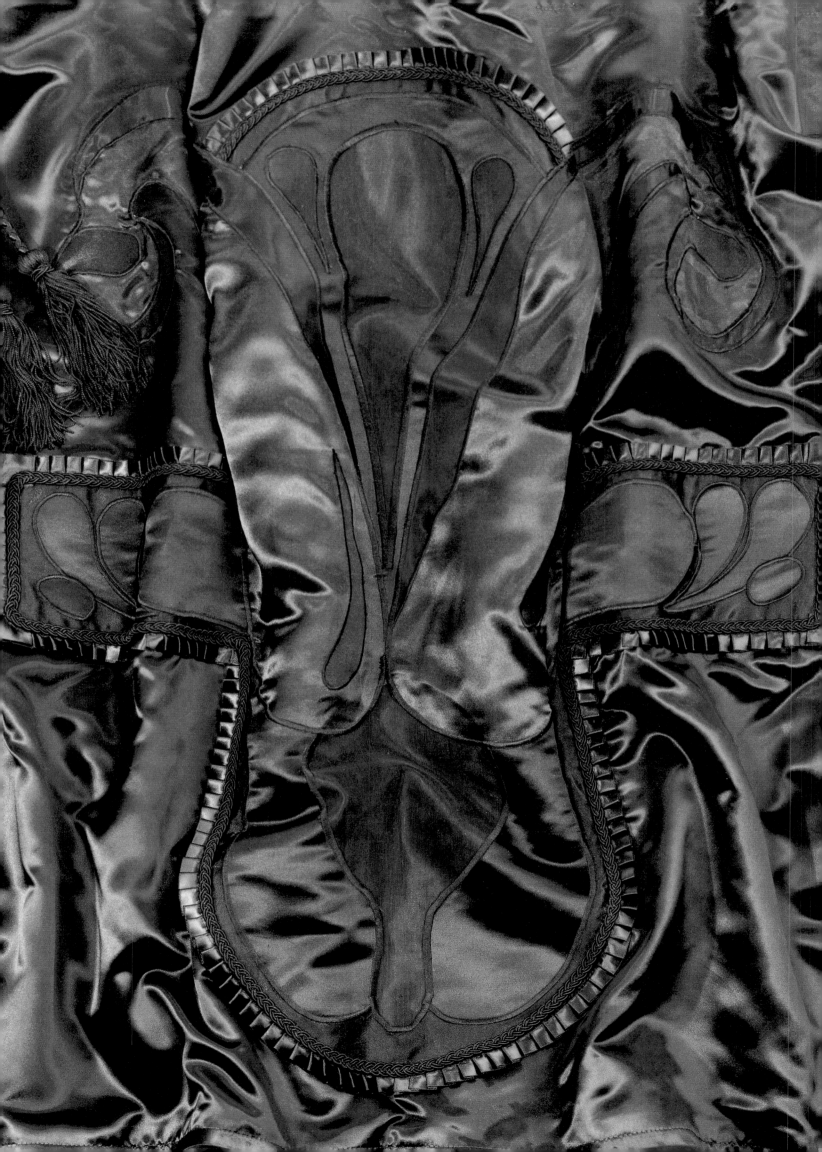

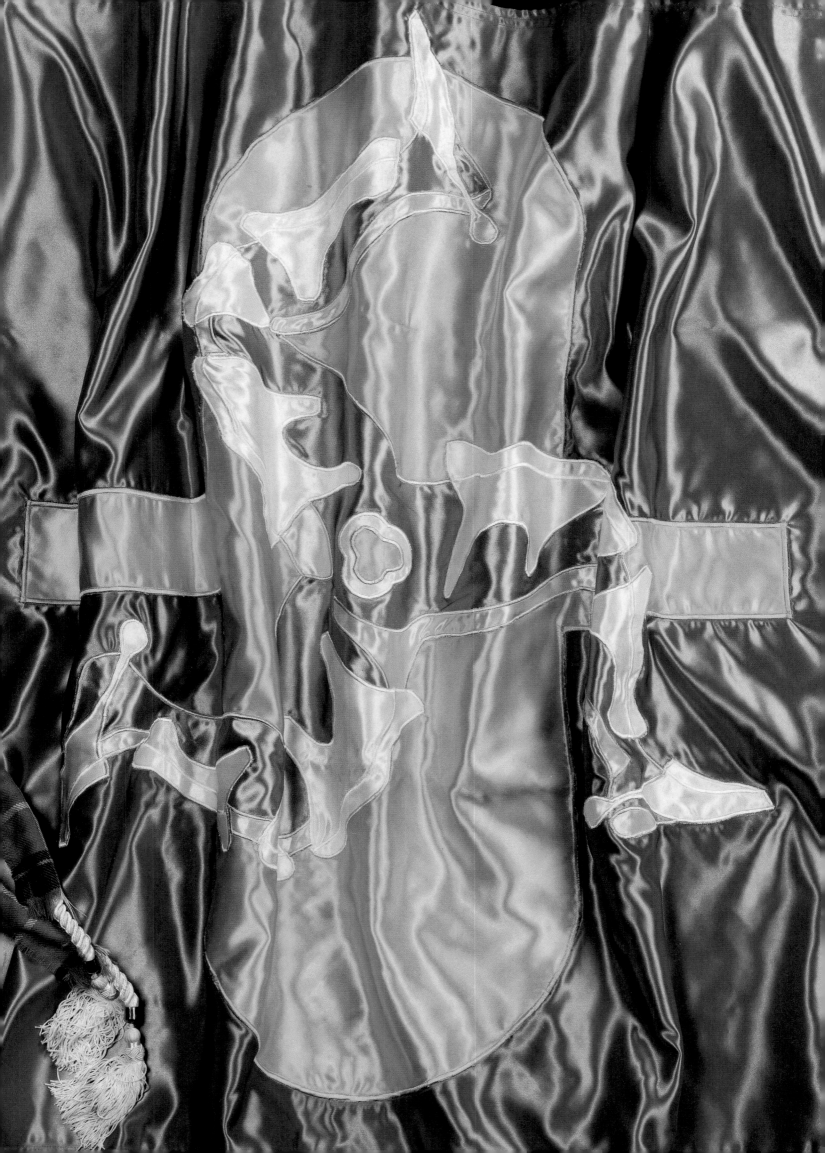

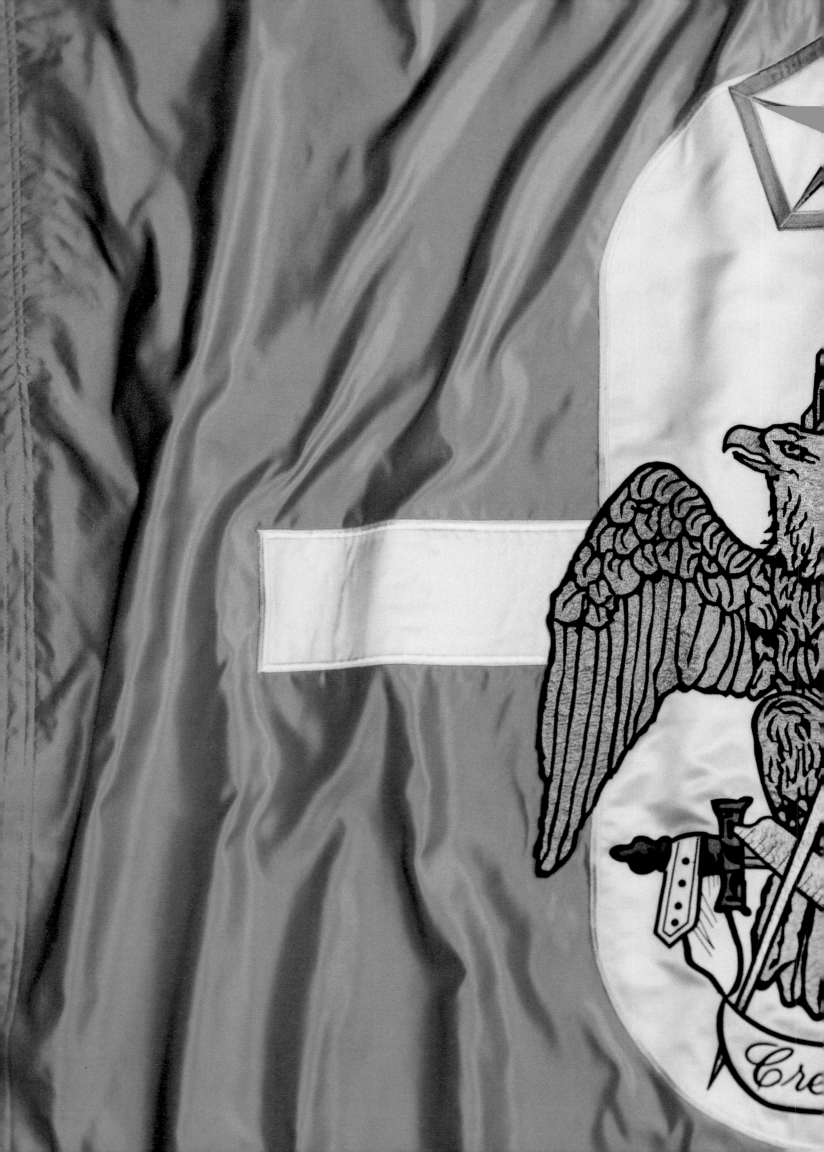

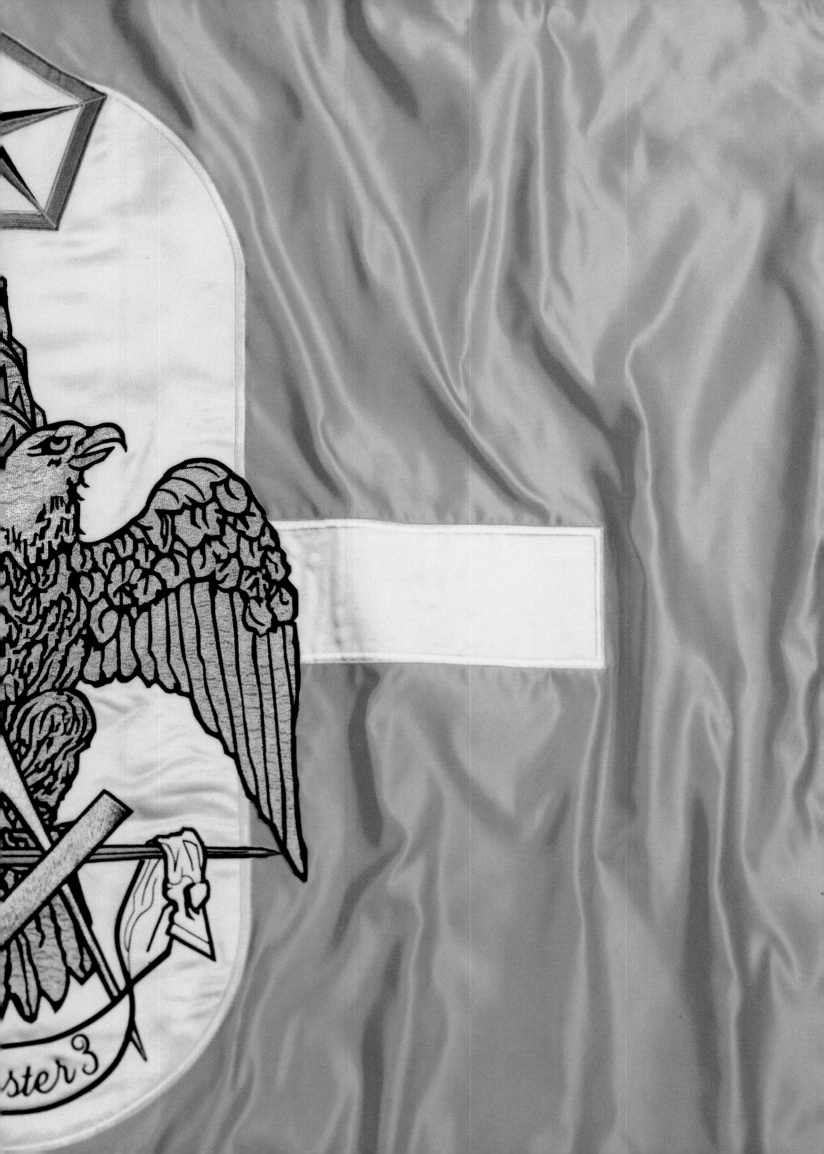